Which California?

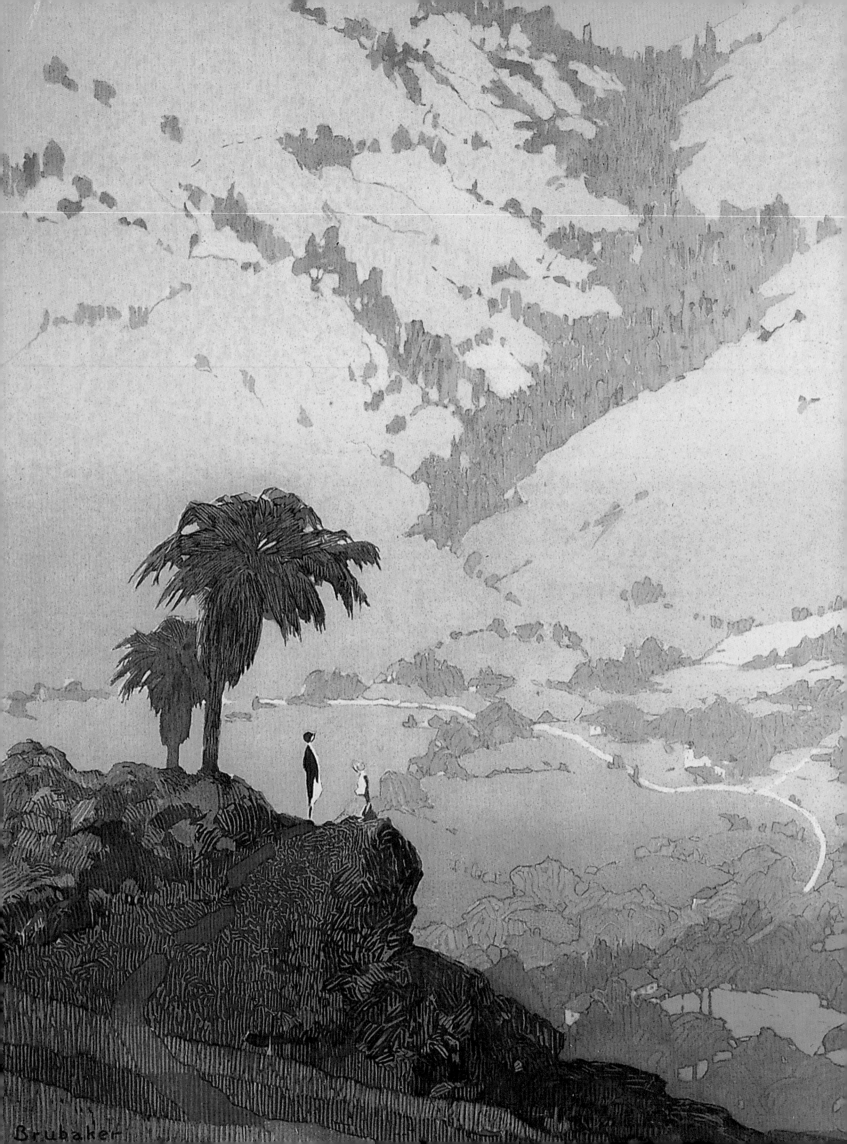

Brubaker

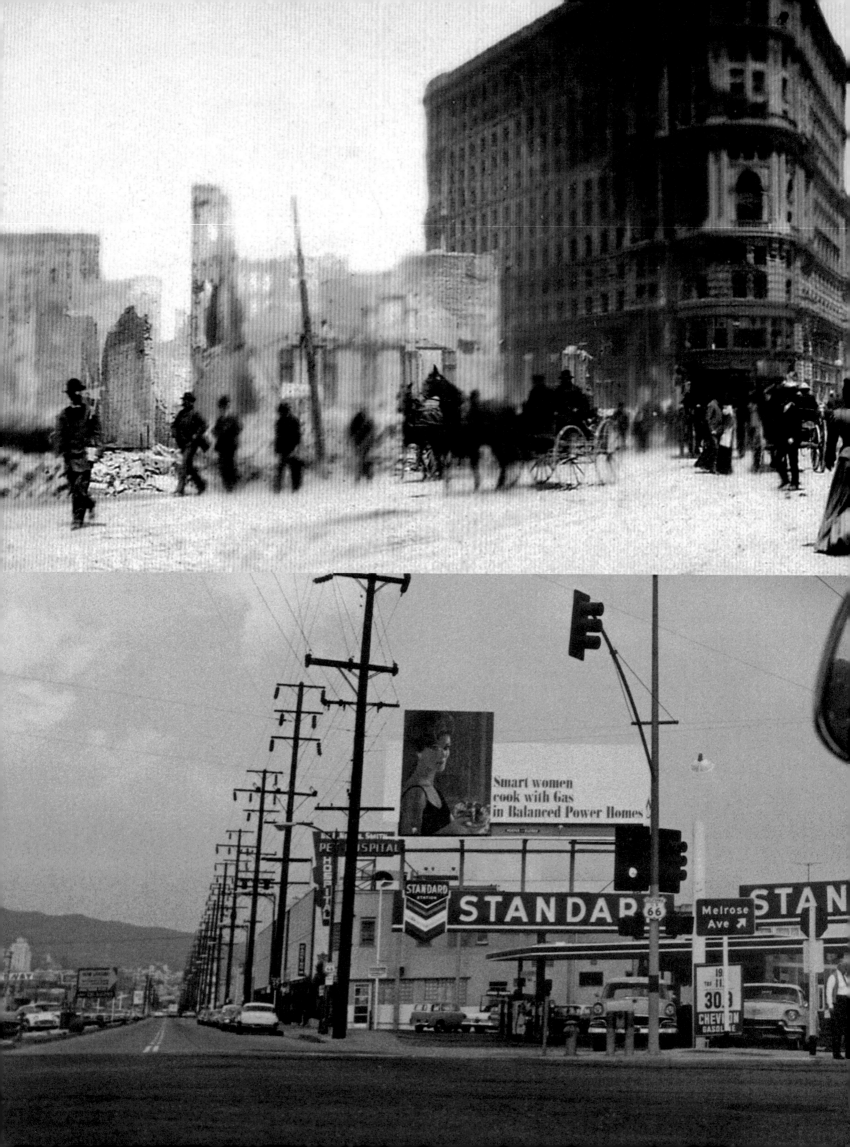

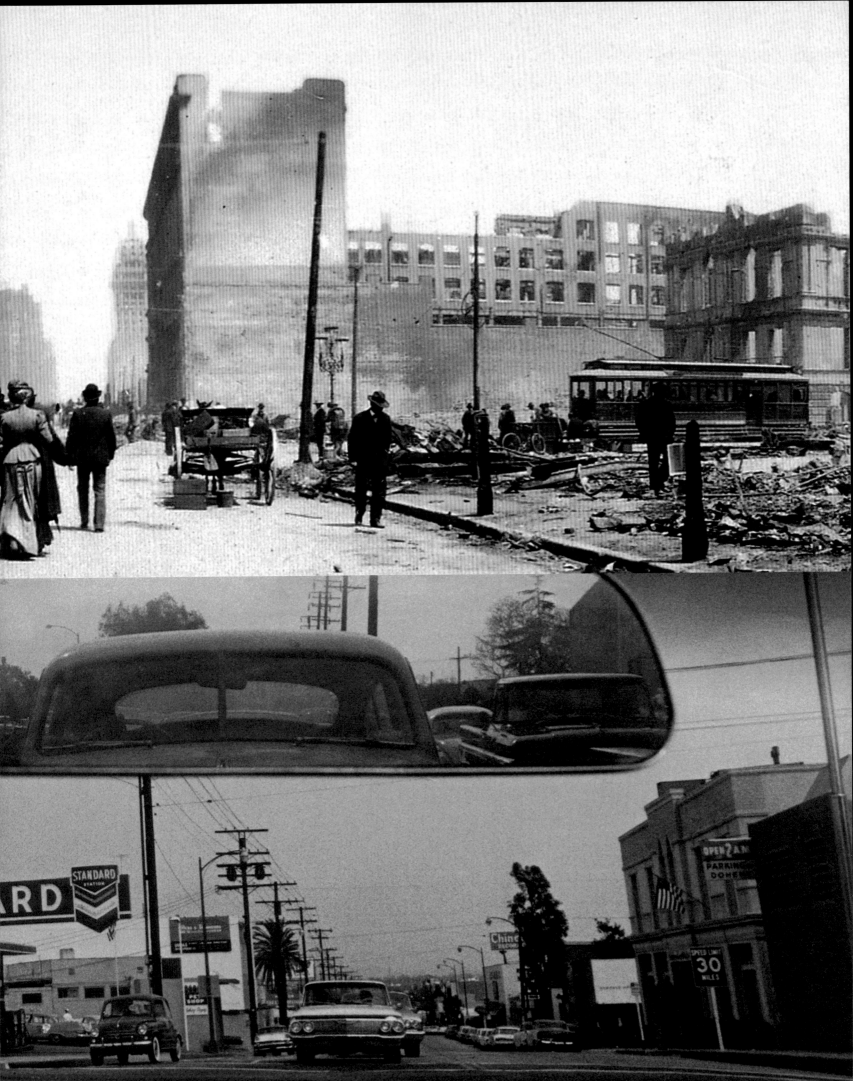

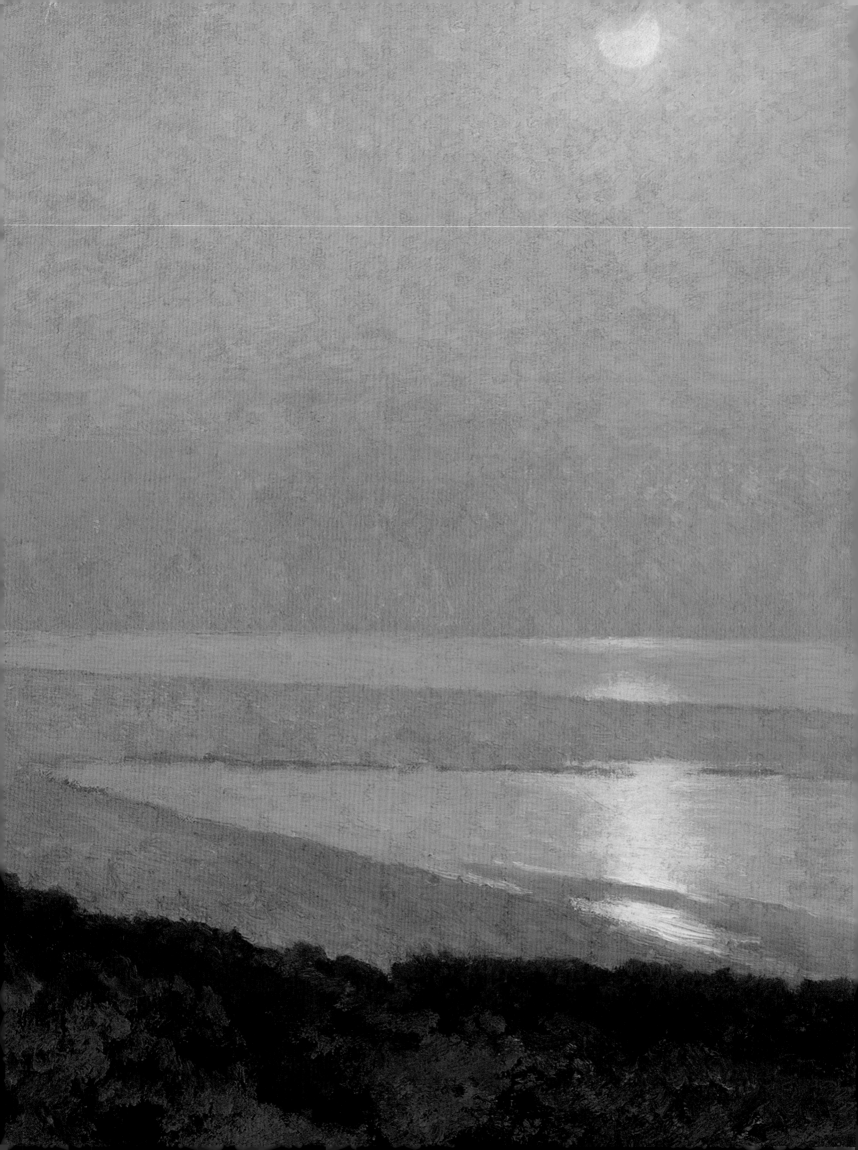

Whose California?

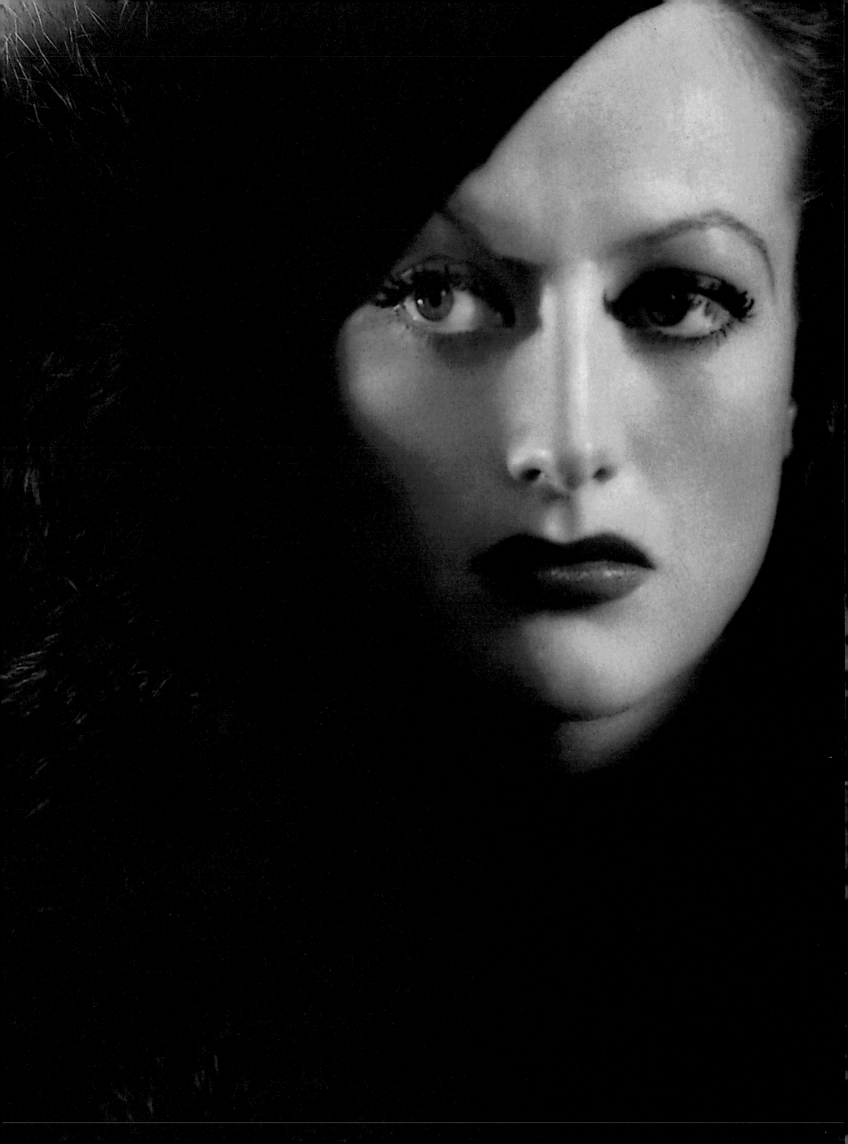

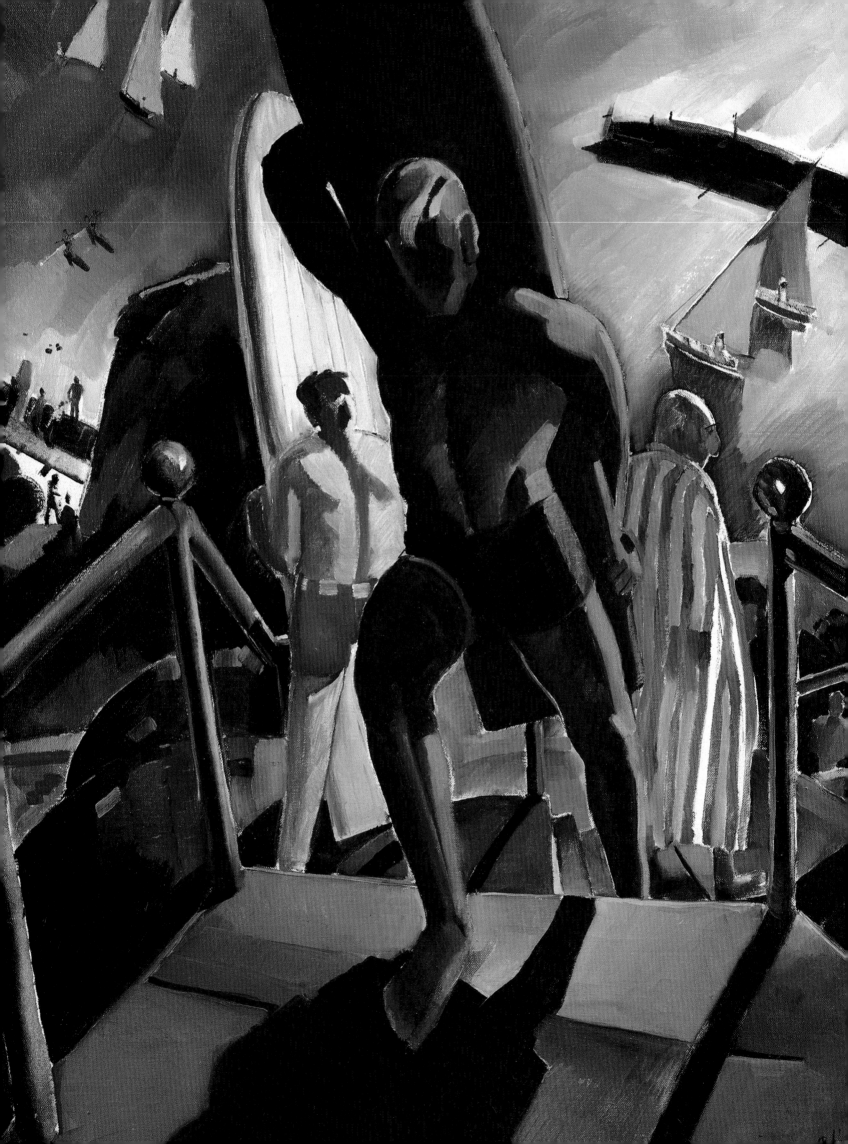

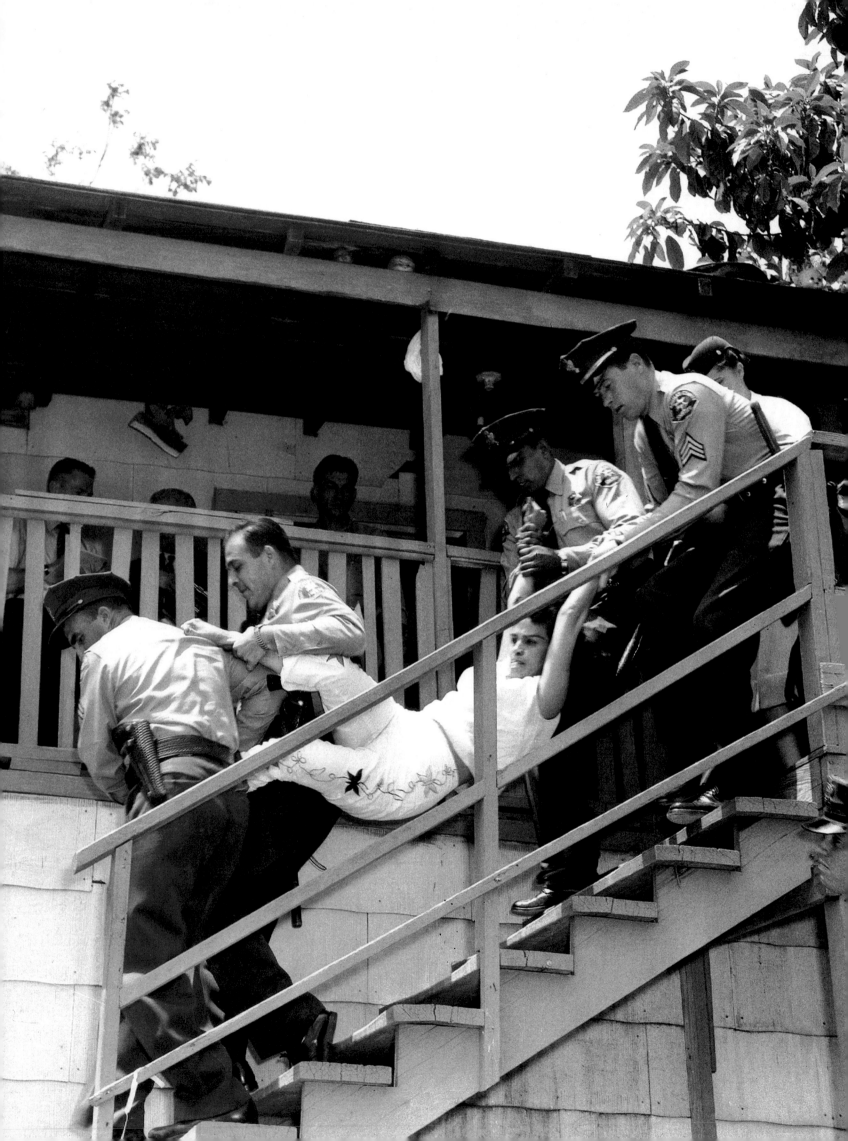

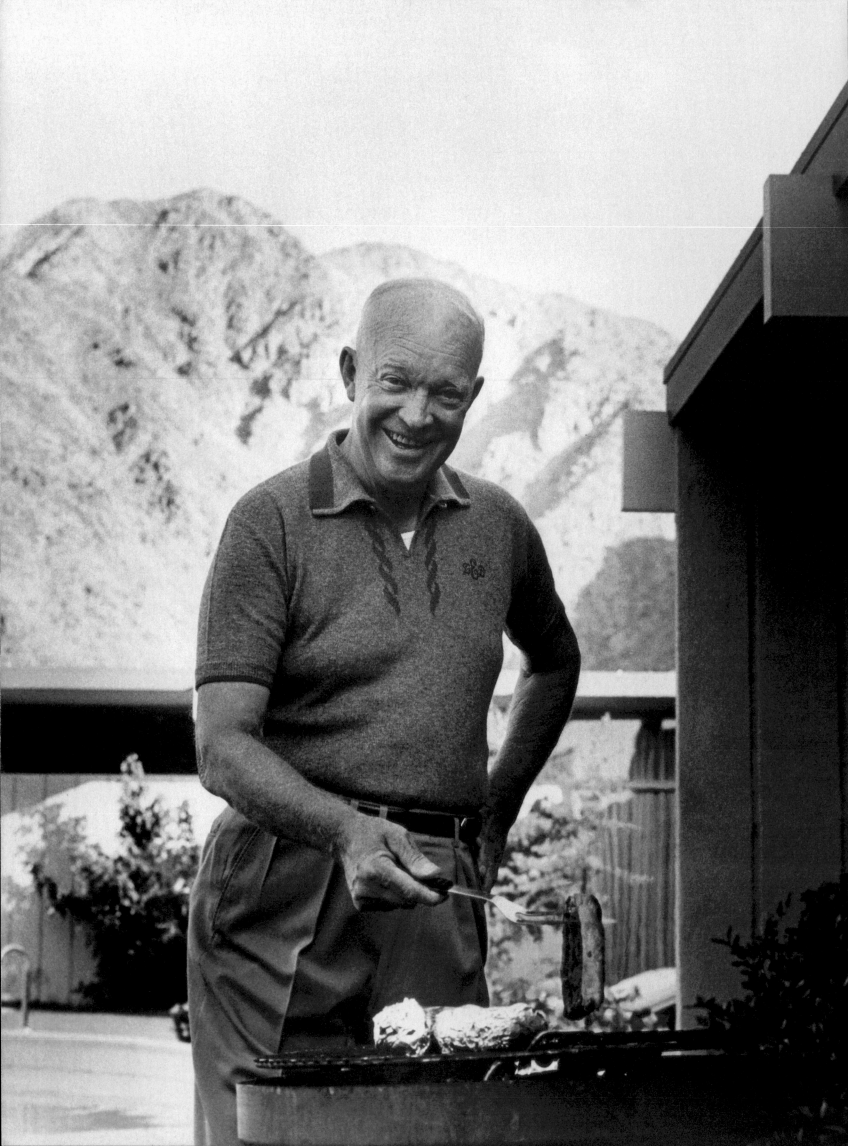

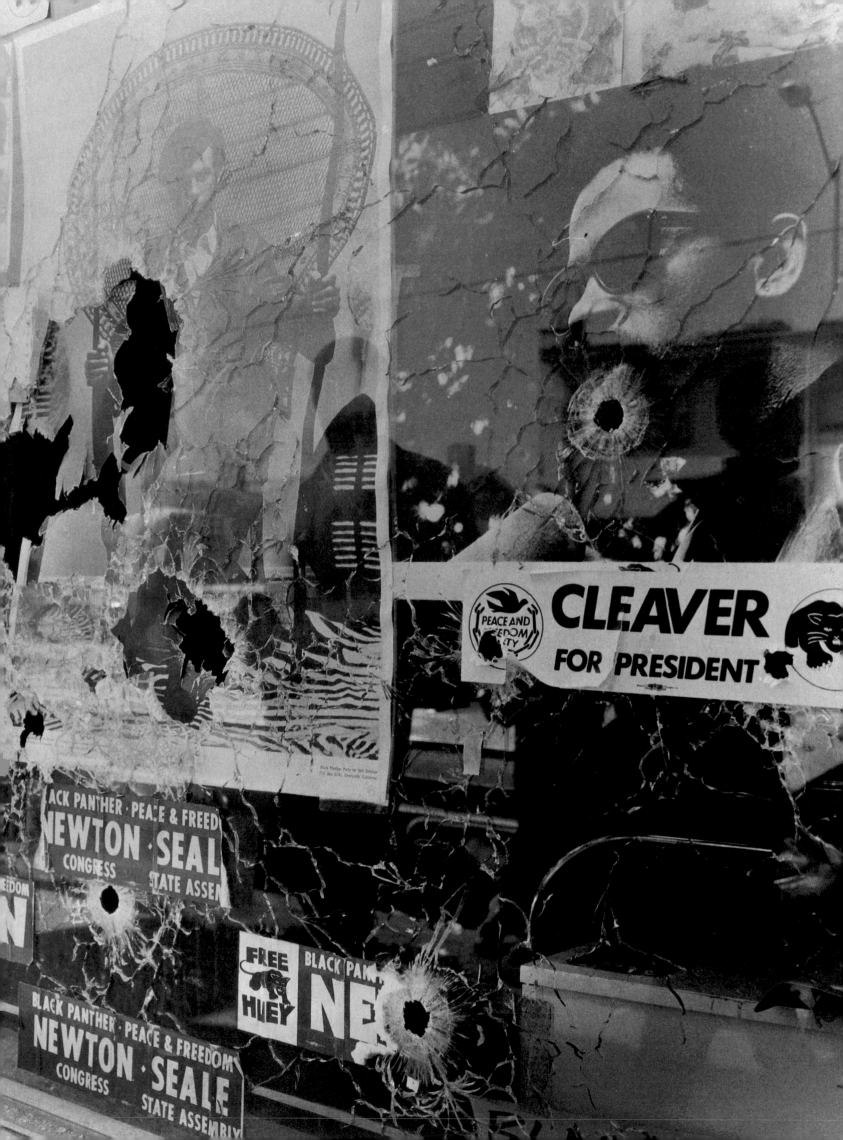

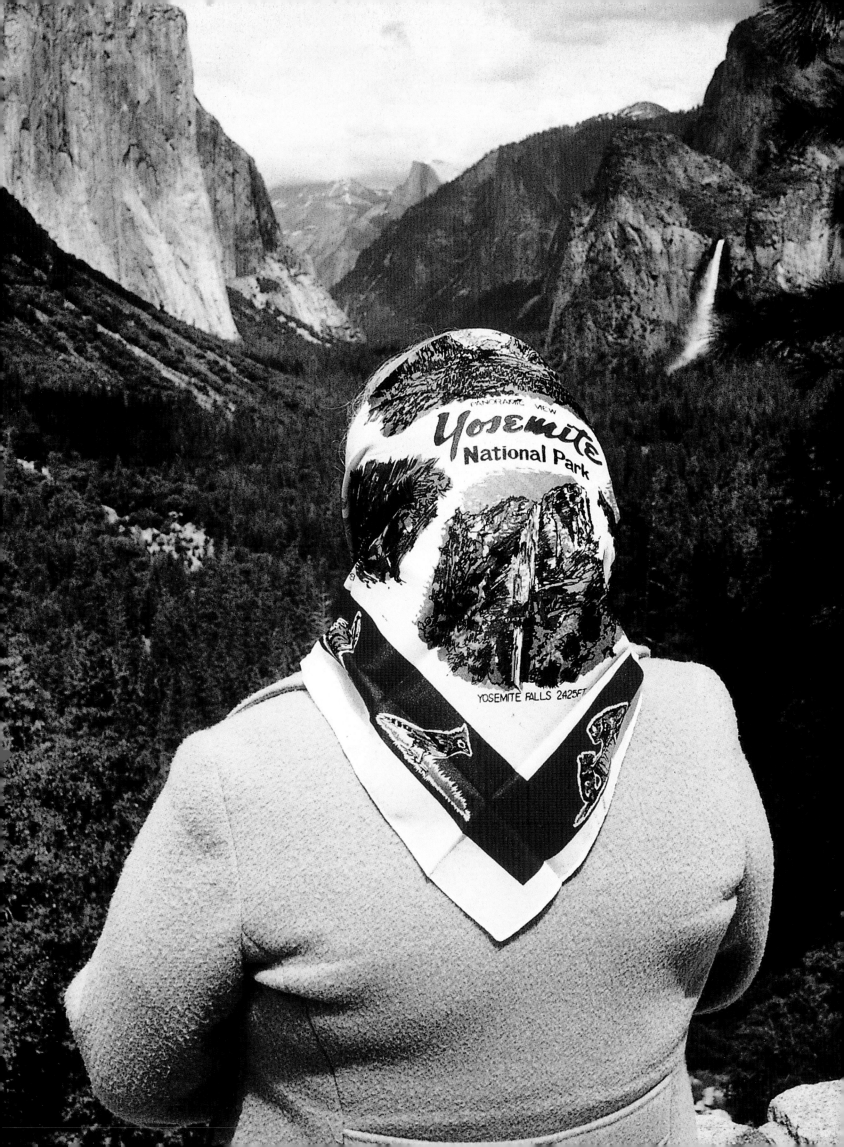

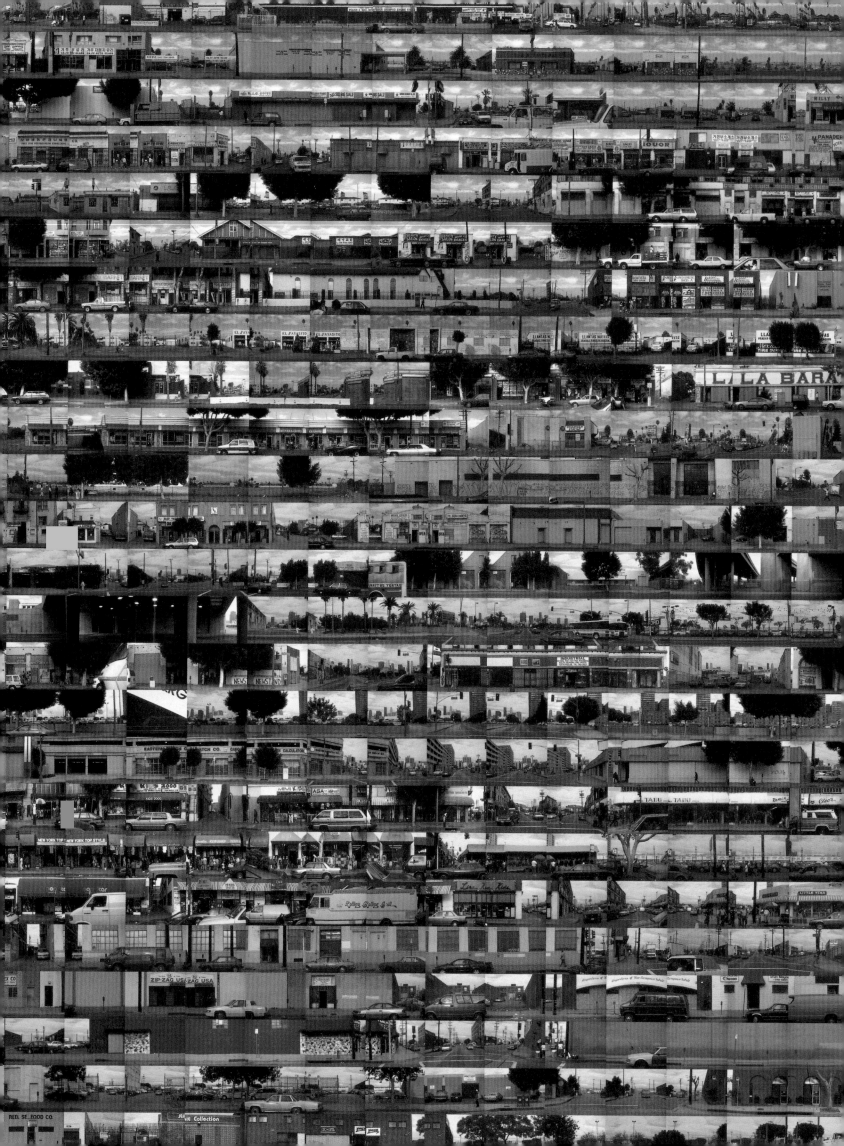

MADE IN
CALIFORNIA

ART, IMAGE, AND IDENTITY, 1900–2000

Stephanie Barron

Sheri Bernstein

Ilene Susan Fort

with essays by

Stephanie Barron

Sheri Bernstein

Michael Dear

Howard N. Fox

Richard Rodriguez

Los Angeles County Museum of Art

University of California Press BERKELEY · LOS ANGELES · LONDON

This book was published in conjunction with the exhibition *Made in California: Art, Image, and Identity, 1900–2000*, organized by the Los Angeles County Museum of Art. The exhibition was made possible by a major grant from the S. Mark Taper Foundation, founded in 1989, a private family foundation dedicated to enhancing the quality of people's lives. Additional support was provided by the Donald Bren Foundation, the National Endowment for the Arts, Bank of America, Helen and Peter Bing, Peter Norton Family Foundation, See's Candies, the Brotman Foundation of California, and Farmers Insurance. Primary in-kind support for the exhibition was provided by FrameStore. Additional in-kind support was provided by KLON 88.1 FM, Gardner Lithograph, and Appleton Coated LLC.

Exhibition Schedule
Section 1:
October 22, 2000–March 18, 2001
Sections 2, 3, and 4:
October 22, 2000–February 25, 2001
Section 5:
November 12, 2000–February 25, 2001

Copublished by the Los Angeles County Museum of Art, 5905 Wilshire Boulevard, Los Angeles, California, 90036, and University of California Press, Berkeley, Los Angeles, and London.

Library of Congress
Cataloging-in-Publication Data:

Barron, Stephanie, 1950–
 Made in California : art, image, and identity, 1900–2000 / Stephanie Barron, Sheri Bernstein, Ilene Susan Fort ; with essays by Stephanie Barron ... [et al.].
 p. cm.
 Published in conjunction with an exhibition held at the Los Angeles County Museum of Art, Los Angeles, Calif., Oct. 22, 2000–Feb. 25, 2001.
 Includes bilbiographical references and index.
 ISBN 0-520-22764-6 (cloth : alk. paper) —
ISBN 0-520-22765-4 (pbk. : alk paper)
 1. Arts, American—California—Exhibitions. 2. Arts, Modern—20th century—California—Exhibitions. 3. California—In art—Exhibitions. I. Bernstein, Sheri, 1966– II. Fort, Ilene Susan. III. Los Angeles County Museum of Art. IV. Title.

NX510.C2 B37 2000
704.9'499794053—dc21
 00-055217

Director of Publications: Garrett White
Editors: Nola Butler and Thomas Frick
Designer: Scott Taylor
Production coordinators: Rachel Ware Zooi and Chris Coniglio
Supervising photographer: Peter Brenner
Rights and Reproductions coordinator: Cheryle T. Robertson

Printed by Gardner Lithograph, Buena Park, California, on Appleton Utopia Two Matte Text

Most photographs are reproduced courtesy of the creators and lenders of the material depicted. For certain artwork and documentary photographs we have been unable to trace copyright holders. We would appreciate notification of additional credits for acknowledgment in future editions.

The typefaces used in this catalogue, Minion (Adobe), Tarzana and Emperor (Emigre), and Chicago (Apple), were designed in California. The title font, based on the letterforms on a 1940 California license plate, was created for the exhibition.

Front cover

Background:
Granville Redmond, *California Poppy Field* (detail), n.d., oil on canvas

Circular details, from left to right, top to bottom:

Julius Shulman, *Case Study House #22*, 1958, gelatin-silver print

James Weeks, *Two Musicians*, 1960, oil on canvas

José Moya del Piño, *Chinese Mother and Child*, 1933, oil on canvas

John Divola, *Zuma No. 21*, 1977, from the portfolio *Zuma One*, 1978, dye-imbibition print

Roger Minick, *Woman with Scarf at Inspiration Point, Yosemite National Park*, 1980, dye-coupler print

Carlos Almaraz, *Suburban Nightmare*, 1983, oil on canvas

Will Connell, *Make-Up*, from the publication *In Pictures*, c. 1937, gelatin-silver print

Chris Burden, *Trans-Fixed*, 1974, photo documentation of performance

California for the Settler, brochure produced by the Southern Pacific Railroad, 1911

Maurice Braun, *Moonrise over San Diego Bay*, 1915, oil on canvas

Back cover

Background:
Maurice Braun, *Moonrise over San Diego Bay*, 1915, oil on canvas

Circular details, from left to right, top to bottom:

David Hockney, *The Splash*, 1966, acrylic on canvas

Willie Robert Middlebrook, *In His "Own" Image*, from the series Portraits of My People, 1992, sixteen gelatin-silver prints

Elmer Bischoff, *Two Figures at the Seashore*, 1957, oil on canvas

Catherine Opie, *Self-Portrait*, 1993, chromogenic development (Ektacolor) print

Alfredo Ramos Martínez, *Woman with Fruit*, 1933, charcoal and tempera on newsprint

Official program for the San Francisco–Oakland Bay Bridge celebration, 1936

Rubén Ortiz-Torres, *California Taco, Santa Barbara, California*, 1995, silver dye-bleach (Cibachrome) print

Dorothea Lange, *Pledge of Allegiance, at Raphael Elementary School, a Few Weeks before Evacuation/One Nation Indivisible, April 20, 1942*, 1942, gelatin-silver print

Millard Sheets, *Angel's Flight*, 1931, oil on canvas

Larry Silver, *Contestants, Muscle Beach, California*, 1954, gelatin-silver print

California: America's Vacation Land, poster produced by New York Central Lines, with illustration by Jon O. Brubaker, c. 1930

Pages 2–18

p. 2: *California: America's Vacation Land* (detail), poster produced by New York Central Lines, with illustration by Jon O. Brubaker, c. 1930

p. 3: Joel Sternfeld, *After a Flash Flood, Rancho Mirage, California* (detail), 1979, chromogenic development print

pp. 4–5, top: Dana and Towers Photography Studio, *#121. Looking East on Market Street* (detail), 1906, gelatin-silver print

pp. 4–5, bottom: Dennis Hopper, *Double Standard* (detail), 1961, printed later, gelatin-silver print

p. 6: Maurice Braun, *Moonrise over San Diego Bay* (detail), 1915, oil on canvas

p. 7: John Divola, *Zuma No. 21* (detail), 1977, from the portfolio *Zuma One*, 1978, dye-imbibition print

p. 8: Dorothea Lange, *Untitled [End of Shift, 3:30, Richmond, California, September 1942]*, 1942, gelatin-silver print

p. 10: Edward S. Curtis, *Mitat—Wailaki*, from *The North American Indian*, vol. 14 (1924), pl. 472, photogravure

p. 11: George Hurrell, *Joan Crawford* (detail), 1932, gelatin-silver print

p. 12: Phil Dike, *Surfer* (detail), c. 1931, oil on canvas

p. 13: Eviction of the Arechiga family from Chavez Ravine, May 8, 1959

p. 14: Sid Avery, *Dwight D. Eisenhower in La Quinta, California*, 1961, gelatin-silver print

p. 15: Pirkle Jones, *Window of the Black Panther Party National Headquarters* (detail), 1968, gelatin-silver print

p. 16: Catherine Opie, *Self-Portrait*, 1993, chromogenic development (Ektacolor) print

p. 17: Roger Minick, *Woman with Scarf at Inspiration Point, Yosemite National Park* (detail), 1980, dye-coupler print

p. 18: Robbert Flick, *Pico B* (detail), 1998–99, silver dye-bleach (Cibachrome) print

CONTENTS

The Los Angeles County Museum of Art has a long history of originating innovative exhibitions that seek to place art and artists within a particular historical, political, social, and economic context. *Made in California: Art, Image, and Identity, 1900–2000* continues that tradition. In this exhibition, LACMA has undertaken the ambitious task of focusing attention on the art created about California in the twentieth century. It is fitting that an exhibition of such far-reaching scope should be organized here, not simply because LACMA is the only encyclopedic museum in the western United States with a comprehensive collection of twentieth-century art, but more importantly because *Made in California* extends the museum's commitment to groundbreaking thematic exhibitions with relevance to contemporary life. From its founding early in the twentieth century, the Los Angeles Museum of History, Science, and Art supported California art through the presentation of annual exhibitions devoted to painting, sculpture, and the graphic arts. The museum also hosted the annual exhibitions of the California Watercolor Society from the 1920s through the 1940s.

The international regard enjoyed by visual artists active in California today attests to the richness and vitality of the work produced here. California no longer generates only the booster images popular at the beginning of the twentieth century, it is also at the center of national debates on a wide range of issues, from agriculture, technology, and entertainment to affirmative action and immigration. The state is the focus of utopian as well as dystopic views of contemporary society. With that background in mind, *Made in California* was not intended as an art historical survey or a selection of a pantheon of artists. We hope, rather, to encourage new ways of thinking about many familiar ideas and objects and to inspire our audience to discover unfamiliar work. The exhibition will provoke some, surprise others, and challenge many.

Any exhibition claiming to address the image of California and how it has been championed, contested, and disseminated by artists and through popular culture must consider the questions of which and whose California is being traced. The exhibition was conceived by an interdisciplinary team that created a thematic show in which paintings, sculptures, graphic and decorative art, costumes, and photography are seen in new and sometimes surprising juxtapositions in the same rooms with related examples of newspapers, pamphlets, posters, and advertisements—what we refer to here and elsewhere as "material culture." In this way, the exhibition attempts to situate art within a broader social context.

Made in California has been an extraordinary undertaking for LACMA, particularly considering its complex subject and the collaborative approach employed to produce it. Encompassing more than 50,000 square feet in six separate exhibition spaces, and on view for more than five months, the exhibition has called for remarkable cooperation among several curatorial departments, as well as early and consistent participation from the museum's education, exhibitions, design, and publications departments. The exhibition effort was adeptly led by Stephanie Barron, Senior Curator of Modern and Contemporary Art and Vice President of Education and Public Programs, who worked closely with Curator of American Art Ilene Susan Fort and Exhibition Associate Sheri Bernstein. They have coordinated the hard work of their colleagues in conceiving and producing this show for our audiences. The content of the exhibition has also been continually enriched through close involvement with a group of outside advisors from many fields. Their names are listed on page 334; their counsel and commitment to the project have contributed immeasurably to its success.

Made in California draws on the depth of LACMA's collections in that approximately 20 percent of the art in the show comes from our holdings in many departments. To the hundreds of lenders, institutional and private, who have truly made this undertaking possible, we extend our deepest thanks.

Presenting an exhibition this ambitious is a costly undertaking, and we are tremendously grateful to the S. Mark Taper Foundation for its early commitment to *Made in California* and for a major grant that made this exhibition possible. Given the S. Mark Taper Foundation's extraordinary commitment to enhancing the quality of people's lives in California, it was an ideal partner in this project.

Additionally, we are delighted to acknowledge the Donald Bren Foundation, the National Endowment for the Arts, Helen and Peter Bing, Peter and Eileen Norton, See's Candies, the Brotman Foundation of California, and Farmers Insurance for their sponsorship. In-kind support was provided by FrameStore, KLON 88.1 FM, Gardner Lithograph, and Appleton Coated LLC.

LACMA's departments of film, music, and education, the LACMA Institute for Art and Cultures, and LACMALab have all planned innovative programming for adults, students, families, and children during the extensive run of *Made in California.* We are also gratified that a number of fellow visual and performing arts and other institutions have joined with us in focusing their programming on aspects of the arts and California. LACMA is pleased to have worked with colleagues from a number of these institutions, including the Automobile Club of Southern California, the Autry Museum of Western Heritage, the Japanese American National Museum, the Los Angeles Chamber Orchestra, the Los Angeles Conservancy, the Los Angeles Philharmonic, the Los Angeles Public Library, the MAK Center for Art and Architecture, the Mark Taper Forum, the Museum of Television and Radio, the Pacific Asia Museum, the Petersen Automotive Museum, the Santa Barbara Contemporary Arts Forum, the Santa Monica Museum of Art, the Skirball Cultural Center, the Society of Architectural Historians, the USC Fisher Gallery, and the USC Schools of Fine Arts, Theatre, Architecture, and Music. Together these programs offer our region's visitors a tremendously diverse array of programs and events.

Andrea L. Rich
President and Director
Los Angeles County Museum of Art

The S. Mark Taper Foundation takes great pride in partnering with the Los Angeles County Museum of Art as primary sponsor of *Made in California: Art, Image, and Identity, 1900–2000.* Sharing this millennial exhibition with the residents of California and visitors to our state represents a profound fulfillment of the Foundation's mission to enhance the quality of people's lives.

The broad scope of this exhibition, the largest in LACMA's history, illuminates California's evolving popular image and its rich and varied contributions to the arts throughout the past one hundred years. The California image as depicted in an enormous range of art and cultural documentation—from paintings, prints, literature, architectural drawings, photography, decorative arts, film, and music to fashion, posters, magazines, and tourist brochures—has influenced and inspired people worldwide. *Made in California* brings together this astonishing wealth of images in a coherent context for the enlightenment of museum visitors.

The works that have been selected all relate directly to the central theme of the exhibition: how the arts have shaped, promoted, complicated, and challenged popular conceptions of California over the course of the twentieth century. A team of more than a dozen LACMA curators and educators has worked together for more than six years to create the exhibition, and they deserve our warmest congratulations for this unprecedented effort and the exceptional result.

The start of a new century is an appropriate time to pay tribute to the culture of our great state. Because my father was, since the 1950s, one of the most significant developers of the state of California, I feel it most fitting that his foundation should collaborate with LACMA on this extraordinary exhibition. The S. Mark Taper Foundation, a private family foundation founded in 1989, is pleased to join the museum in making *Made in California* possible. In keeping with the Foundation's traditions, we chose *Made in California* as a project worthy of our support.

All of us at the S. Mark Taper Foundation look forward to sharing these myriad artworks as well as LACMA's incisive scholarship with museum visitors from across the state and around the world. I hope that you find *Made in California* both enjoyable and thought provoking.

Janice Taper Lazarof
President
S. Mark Taper Foundation

MADE IN CALIFORNIA
ART, IMAGE, AND IDENTITY
1900–2000

Note to the reader

Lenders of posters, brochures, and other ephemeral material in the exhibition are noted in the illustration captions.

Lenders of artworks in the exhibition are listed in the checklist (pp. 281–324).

Artworks not in the exhibition are indicated by a bullet (·).

Alexis Smith
Sea of Tranquility, 1982,
mixed-media collage

INTRODUCTION

THE MAKING OF MADE IN CALIFORNIA

Stephanie Barron

In 1994 a group of curators at the Los Angeles County Museum of Art came together to discuss an exhibition that would explore the great richness and diversity of California art in the twentieth century. Conceived collaboratively by members of nine different LACMA departments,[1] the exhibition that developed over the next several years, *Made in California: Art, Image, and Identity, 1900–2000*, would not be a traditional art historical survey, nor would it attempt to establish a new canon or identify certain types of artistic production as distinctively "Californian." Rather, it would investigate the relationship of art to the image of California and to the region's social and political history.

Our goal was to avoid the boosterism that has often characterized surveys of California art, which have tended to emphasize utopian or dystopic extremes, and to illuminate, against the backdrop of historical events that have impacted artistic production, the competing interests and ideologies that informed the arts and shaped popular conceptions of the state in the twentieth century.

Made in California is the largest and most complex exhibition ever mounted at LACMA, comprising more than 1,200 artworks, ephemera, and other cultural artifacts that reflect the increasingly disparate images of the state produced and circulated from 1900 to 2000. From vast, sweeping poppy fields to crowded suburban beaches, from Hollywood to Yosemite Valley, from beatnik San Francisco to a disaster-prone Los Angeles, the twentieth-century imagination was infused with popular iconography derived from California. Yet there was never a single, prevailing image of the state. There are and have been, in fact, many Californias, multiple perceptions of the region shaped not only by predictable forces such as the tourist or real estate industries but also by artists who at times reinforced prevailing views and at others complicated, subverted, or refuted them. The title of the exhibition and accompanying catalogue thus refers not simply to art produced in California but to work that bears the imprint of or projects one of the many images of the state.

In view of the diversity—whether hidden or acknowledged—that has always defined the California experience, questions about the exhibition's audience and voice surfaced at an early stage. In the census of 1870, half of the population of San Francisco was shown to be foreign born. Today both San Francisco and Los Angeles—a city more than 75 percent Anglo just twenty-five years ago—are more than 50 percent non-Anglo. Now the major nonwhite urban center in the United States, Los Angeles represents a new type of city, what Charles Jencks refers to as a "heteropolis" and Edward Soja calls a contemporary cosmopolis.[2] Some ninety languages are spoken within its more than 400-square-mile city limits. Immigrants to California from around the world have created a more diverse population than ever before. And as groups that were previously in the minority have grown, the state's identity has been profoundly altered. This ethnic and cultural diversity is key to any effort to review artistic production in California.

With such diversity in mind, what can it mean to try to capture a history of the image of California during the past one hundred years? Consider these two observations: "Every museum exhibition, whatever its overt subject, inevitably draws on the curatorial assumptions and resources of the people who make it." And: "Visitors can deduce from their experience what we, the producers of exhibitions, think and feel about them—even if we have not fully articulated those thoughts to ourselves."[3] Both statements underscore the obligation of exhibition organizers to reflect carefully on the message they wish to convey and its intended audience. In the last two decades, with the spectacular growth of museums and museum attendance, scholars have sought to examine more thoroughly the role of museums in our society. Even at the most basic level of the selection, arrangement, and juxtaposition of objects, the strategies adopted by museum curators directly affect an audience's interpretation of the material on display. Curators have a responsibility, then, to convey a clearly articulated point of view. As Carol Duncan has noted, exhibitions allow communities to examine old truths and search for new ones. They become the center of a process in which past and future intersect.[4] Our initial question therefore implies a number of others: Whose California? What image? Which history?

Since their advent in the late eighteenth century, museums have been treasured as harbors of a sense of time and space that sets them apart from the bustle of the outside world. They have been revered, in fact, as places similar to churches, with the power to transform, cure, or uplift the soul.[5] Museums at the beginning of the twenty-first century, however, are at an unusual crossroads. Never before has there been such interest in visiting them. Newspapers routinely report that more people visit special exhibitions than go to sporting events. Surveys show furthermore that those who visit museums come in search of connections between the art on display and their own lives.[6] And yet most museums still present art in hushed, elegant galleries, contemplative spaces that are often disconnected from everyday experience and may even appear elitist or intimidating.

In the late 1970s, beginning with the Centre Georges Pompidou in Paris, with its transparent façade, large urban square, and popular five-story escalators leading to spectacular views of the city, museum architecture began to be employed to break down the rarefied image of traditional art museums. Yet while museum architecture has certainly been transformed in the past twenty-five years, accounting for some of the most exciting buildings of our time, what lies inside and how it is presented have changed little in the last century. Within art museums, as debate continues about the appropriate balance between education and entertainment, museum directors, curators, and educators are searching for strategies of presentation—encompassing thematic as well as chronological organizational modes—that will engage new audiences. "Compelling stories and opportunities that manage to engage all the senses are the experiences that succeed in attracting new and returning visitors," a recent study claims.[7]

Academic discourse on installations of museum permanent collections and special or temporary exhibitions has called into question presentation strategies and focused discussion on issues of curatorial voice and intended audience, particularly in relation to class, gender, and race.[8] Author Alan Wallach claims, however, that the revisionism that has transformed much of art history in the universities in the past generation has had little impact on art museums and their audiences. Despite the difficulty of raising funds for shows that confront or question accepted canons, Wallach argues for the need to mount revisionist exhibitions. By exposing museum-going audiences to exhibitions that present art in relation

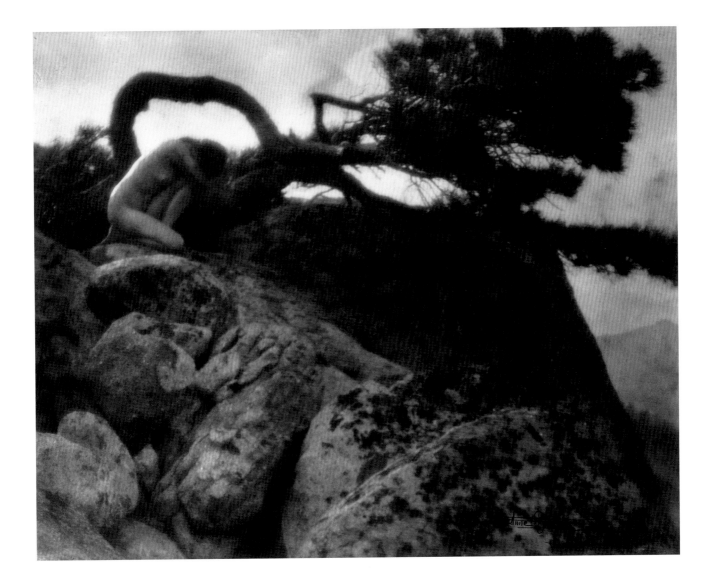

Anne W. Brigman
The Lone Pine, c. 1908,
gelatin-silver print

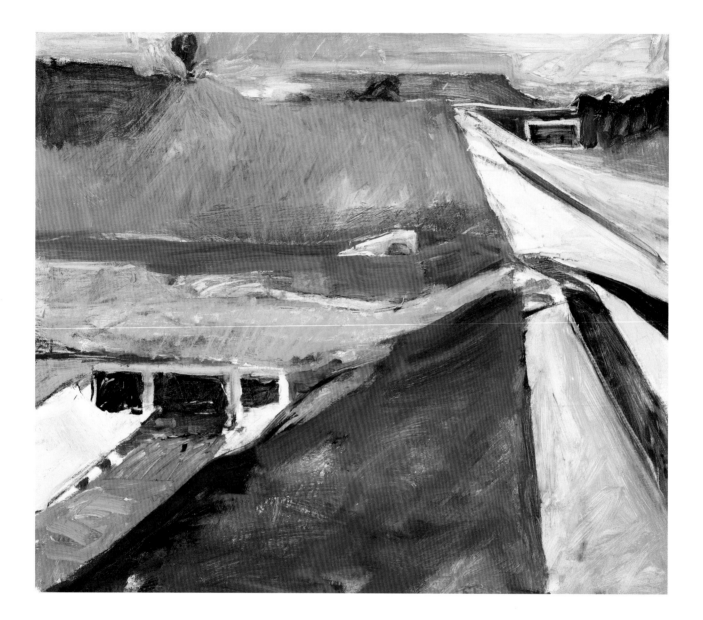

Richard Diebenkorn
Freeway and Aqueduct,
1957, oil on canvas

to its social, political, and historical context, the public will grow to value artworks as more than timeless, transcendent, or universal objects of beauty that speak for themselves.[9] Often such shows inspire fierce critical and public debate. In 1991 the National Museum of American Art mounted *The West as America*,[10] a critical historical approach to representations of nineteenth-century America. Rather than merely celebrating its subject, the exhibition explored, according to museum director Elizabeth Broun, the intentions of artists and their patrons in the context of the history of westward expansion, unearthing a deeper, more troubling story that poses questions for American society today.[11]

The West as America generated a firestorm of criticism for daring to subject cherished myths to critical scrutiny, and it was attacked for what was seen by some as an aggressive lack of objectivity. Yet after nearly a decade of reflection, we can see that the exhibition was important for at least two reasons: By critically examining images long familiar to generations of Americans, it effectively countered the perception of museums as nothing more than places of inspiration or repositories of beauty isolated from the everyday world; and it ushered in a decade of debate on the meaning and interpretation of western American art. In its examination of image and identity and its reassessment of traditional perspectives, *Made in California* draws upon the example set by *The West as America*, especially with regard to lessons learned about how best to frame questions and raise interpretative issues for a broad public.[12]

Despite the reaction caused by such exhibitions, museums have shown a growing interest in new strategies of interpretation. Exhibitions have begun to appear that locate works of art in relation to social and historical conditions; explore issues of audience and reception; consider the roles of the art market, curatorial taste, and collecting practices; invite artists to interpret or curate works by other artists; examine the intersection of art, politics, and national identity; and present permanent collections through thematic lenses.[13]

These are some of the approaches that informed the conceptualization of *Made in California*. From our earliest discussions of the project, a fundamental decision was made that the exhibition should not be a succession of "greatest hits" of California art. In general, questions of cultural or historical relevance took precedence over issues of aesthetic innovation, a strategy that necessarily resulted in the exclusion of certain artists or works by which a given artist is usually known. The exhibition is divided into five sections, each covering twenty years and organized thematically rather than according to formal categories. Each section freely mixes paintings, prints, sculpture, decorative art, costumes, and photography, along with examples of material culture—tourist brochures, labor pamphlets, rock posters, and periodicals. Additionally, twenty-four media stations were commissioned, providing visitors with archival film footage, poetry recordings, examples of popular music, and clips from Hollywood films. Three of the sections contain lifestyle environments, joining together examples of furniture, design, and architecture. The overriding aim of *Made in California* is to situate art making within the broader context of image making and, more specifically, the creation of California's image in the twentieth century. Many familiar images—a glamorous Hollywood, a beachfront or agricultural paradise, a suburban utopia—have prevailed in the popular imagination not only in the United States but around the world. (Indeed, California, especially as the home of a global film industry, may arguably be the site in the twentieth century in which image permanently detached itself from reality.) *Made in California* examines the significant role of the arts in generating, shaping, and disseminating such popular images while presenting works that corroborate, challenge, complicate, or refute them. Conflicting images have

always been present; our aim has been to widen the established discourse to include them. In so doing, *Made in California* questions the canon of images and ideas long associated with the art of California and encourages a critical examination of recent history.

A similar approach has governed the organization of the main body of the catalogue: The first three sections, written by Exhibition Associate Sheri Bernstein, cover the years 1900 to 1960. Sections 4 and 5 were written by Howard Fox, Curator of Modern and Contemporary Art, and cover the years 1960 to 2000. To set the stage for the catalogue sections, geographer Michael Dear has provided a synoptic social history that charts the confluences and conflicts of the varied peoples whose destinies have continually forged and reconfigured the California Dream. Closing the volume, noted essayist Richard Rodriguez has contributed a uniquely personal vision of the paradoxical state of mind we know as California.

Made in California differs methodologically from most previous exhibitions that have attempted to address California art, but it has benefited from the scholarship that preceded it. There are, for example, a number of key books that have laid the art historical groundwork for our project in terms of California art scholarship. Although controversial upon publication in 1974, Peter Plagens's *Sunshine Muse: Contemporary Art on the West Coast* was the first attempt at a history of modern art in the region.[14] In 1985 Thomas Albright published his comprehensive study *Art in the San Francisco Bay Area, 1945–1980,* which followed the unique development of Bay Area figuration, Pop, Funk, Conceptualism, realism, and other movements. Richard Cándida Smith's *Utopia and Dissent: Art, Poetry, and Politics in California* (1995) charted a history of ideas spawned by California's art and poetry movements from 1925 to the mid-1970s and explored their embodiment in mainstream American culture. For his 1996 publication *On the Edge of America: California Modernist Art, 1900–1950,* Paul Karlstrom assembled essays by several authors who collectively sought to challenge the familiar association of California with popular culture and Hollywood, tracing a history of regional California art in a variety of media in the context of a larger modernist framework.

Most exhibitions that have dealt with California art of the last century have been organized according to geography (California, Los Angeles, the Bay Area); art historical movements (California Impressionism, Bay Area Conceptualism, Bay Area figuration); medium (assemblage, ceramics, printmaking); or subject (landscape, the Gold Rush, women painters). Most were boosterist, and nearly all were devoted solely to examples of fine art. By the middle of the twentieth century, with pride in American as opposed to European art, exhibition organizers began to identify aspects of California art that set it apart from that of New York. Exhibitions mounted for export often focused on geography; those intended for a regional audience could perhaps rely more frequently on individual artists. In either case, however, organizers typically selected works of art according to formal or geographic principles, paying scant attention to artists working with political or socially conscious themes. Beginning in the 1960s, museums outside California began to host exhibitions of work by emerging West Coast artists, including, for example, *Fifty California Artists* (1962), organized by the San Francisco Museum of Modern Art (SFMOMA) and shown at the Whitney Museum of American Art,[15] and *Ten from Los Angeles* (1966), organized for the Seattle Art Museum by John Coplans, then director of the art gallery at the University of California, Irvine. The latter featured artists who shared an affinity for shiny, elegant surfaces, including Billy Al Bengston, Tony DeLap, Craig Kauffman, and others, many of whom showed at the Ferus Gallery. In 1971 London's Hayward Gallery hosted *11 Los Angeles Artists,* organized by Maurice

Los Angeles souvenir,
1957. Lent by Jim Heimann

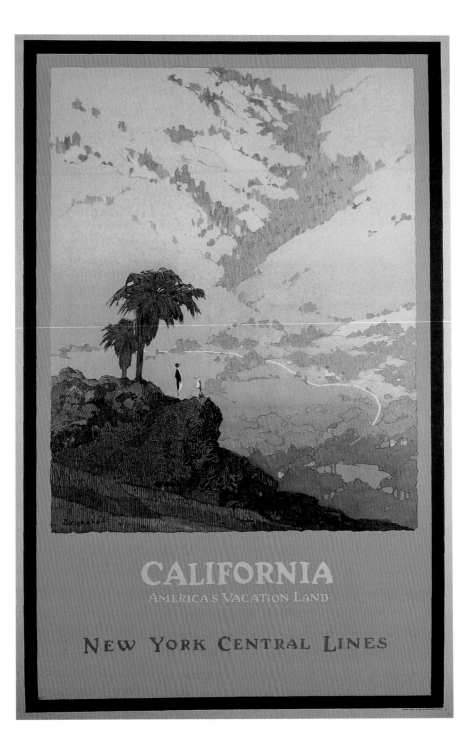

California: America's Vacation Land, poster produced by New York Central Lines, with illustration by Jon O. Brubaker, c. 1930. Lent by Steve Turner Gallery, Beverly Hills

Tuchman and Jane Livingston. Within the state, exhibition activity increased significantly in the 1970s. The Oakland Museum of California has organized a number of formative exhibitions on California art in a broad range of media.[16] In the 1980s and 1990s, the Laguna Art Museum organized and hosted some two dozen exhibitions devoted to either individual California artists or particular aspects of artistic activity in California. These and other exhibitions in the past twenty-five years have greatly increased our knowledge of artists in California. And yet it may be argued that because much of this scholarship focused on the project of validation, it lagged significantly in efforts to incorporate a multidisciplinary approach that would include, for example, political and social history, gender studies, and cultural studies.

More recently, a tendency has emerged to present West Coast art as a contrast in stark opposites: blight and bounty, abundance and drought, the golden and the noir.[17] A duality has been established (admittedly with precedents earlier in the century in popular literature and film) that may reflect, as Norman Klein suggests, nothing more than equally mythical counterparts promoted by the white middle-class for its own consumption.[18] In the past twenty years, this Edenic/dystopic dualism has been elevated to heroic proportions in literature, film, and art. Images from Ridley Scott's *Blade Runner* (1982), for example, became a widely accepted stylistic shorthand for envisioning the future of cities among urbanists and art and architecture critics. A decade later, curator Paul Schimmel presented *Helter Skelter* (1992) at the Museum of Contemporary Art, Los Angeles, calling out a group of artists, including Chris Burden, Victor Estrada, Llyn Foulkes, Mike Kelley, Paul McCarthy, Manuel Ocampo, Raymond Pettibon, Lari Pittman, Charles Ray, and Nancy Rubins, whose provocative styles became emblematic of Los Angeles in the 1990s. Presented in opposition to the often bright, beautiful, hedonistic Los Angeles art characterized by Plagens in *Sunshine Muse*, the show offered another construct in its place that was largely accusatory and dark. The 1998 traveling exhibition *Sunshine and Noir: Art in L.A., 1960–1997*, organized by Lars Nittve and Helle Crenzien at the Louisiana Museum of Modern Art in Humlebaek, Denmark, explicitly followed this dualistic approach.

A number of other important exhibitions have been devoted to tracing movements and "isms" in California art history. As noted above, these often focused on differences between California artists and their East Coast or European confreres. Beginning in the mid-1970s, Henry Hopkins, then director of SFMOMA, presided over several exhibitions devoted to aspects of California art, including his major survey show, *Painting and Sculpture in California: The Modern Era* (1977),[19] which was organized stylistically and included 200 artists and 340 works of art. Although the exhibition was ambitious in scope, covering seventy-five years of California art history, there was a noted lack of feminist, Chicano, and African American artists in the show, and of the 200 artists included, 182 were men. In 1981 Suzanne Foley's *Space, Time, Sound: Conceptual Art in the San Francisco Bay Area: The 1970s* for SFMOMA identified Bay Area Conceptualism as based more on personal experience than its New York counterpart. Foley also focused on centers of production: alternative spaces, university galleries, periodicals, and theaters. Two exhibitions, *Bay Area Figurative Art* (1989), organized by Caroline Jones for SFMOMA, and *The San Francisco School of Abstract Expressionism* (1996), organized by Susan Landauer for the Laguna Art Museum, featured major and less well-known figures, grouped stylistically, and touched on the role of art schools in their work and their relationships to politics and social history.[20] Paul Karlstrom and Susan Ehrlich's *Turning the Tide: Early Los Angeles Modernists, 1920–1956* for the Santa Barbara Art Museum (1990) and Ehrlich's *Pacific Dreams: Currents of Surrealism and Fantasy in California Art,*

1934–1957 for the Armand Hammer Museum of Art and Cultural Center at UCLA (1995) sought to examine what sets California modernism and California Surrealism apart from European models. Together these exhibitions did much to legitimize specific art movements within California for a national and international audience.

Museum exhibitions organized around a particular medium have tended to emphasize fields in which California artists have been leaders, especially ceramics, photography, printmaking, and the assemblage tradition. Led by Peter Voulkos in Los Angeles in the 1950s, and Robert Arneson and others in the Bay Area in the 1960s, ceramists transformed their art by creating massive sculptural vessels using fired clay.[21] Their work made ceramics a defining medium in postwar California art and was included in numerous exhibitions in the 1960s, among them solo shows at LACMA featuring Voulkos (1965) and John Mason (1966).[22] Printmaking workshops in California, including Tamarind, Gemini G.E.L., Cirrus Editions, Crown Point Press, and Self-Help Graphics, have pioneered the medium in the postwar era. Cirrus alone among them has concentrated on the work of California artists; in 1995 this work was surveyed for LACMA by curator Bruce Davis.[23] *Proof: Los Angeles Art and Photography, 1960–1980*, organized by Charles Desmarais for the Laguna Art Museum in 1992, presented a group of artists whose influential work blurred the boundaries between photography and other media. In 1994, the J. Paul Getty Museum and the Huntington Library and Art Collections jointly mounted *Pictorialism in California: 1900–1940*, organized by Michael G. Wilson, which explored the unique contributions of California photographers working in the Pictorialist idiom. Additionally, California assemblage artists, whose work is strongly linked to the Dada tradition, have been the subject of a number of exhibitions.[24] Exhibitions of artwork in these and other media served to acquaint a larger audience with a number of aesthetic innovations specific to California.

Like *Made in California*, the most recent exhibitions have tended to be organized around particular themes. They have embraced a wide range of artists, and sought to find an appropriate context for their work. The Fine Arts Museums of San Francisco's exhibition *Facing Eden: 100 Years of Landscape Art in the Bay Area* (1995), organized by Steven Nash, was a multidisciplinary show that included painters, sculptors, photographers, landscape architects, and environmental artists. Issues of gender grounded Patricia Trenton's *Independent Spirits: Women Painters of the American West, 1890–1945* (1995). In 1999, at the Iris and B. Gerald Cantor Center at Stanford University, *Pacific Arcadia: Images of California, 1600–1915* charted an image of a California in which economic bliss could be achieved in a spectacular natural setting. In the catalogue to the exhibition, Claire Perry investigated how and why the familiar vision of California as a land of promise was developed and marketed to tourists and residents. She introduced paintings, drawings, and photographs alongside popular Currier and Ives lithographs, maps, printed ephemera, and book and newspaper illustrations. As part of an investigation into how the canvases and photographs of Carleton E. Watkins, Arnold Genthe, Albert Bierstadt, William Hahn, and James Walker functioned within a network of promotional material, *Pacific Arcadia* included guidebooks, railroad brochures, travel posters, sermons, and songs. This sensitive presentation of fine art and material culture anticipates the current exhibition.

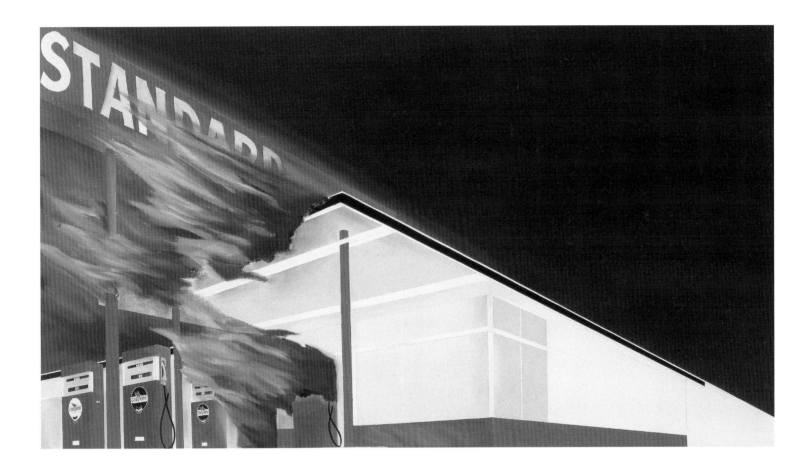

Edward Ruscha
Burning Gas Station,
1965–66, oil on canvas

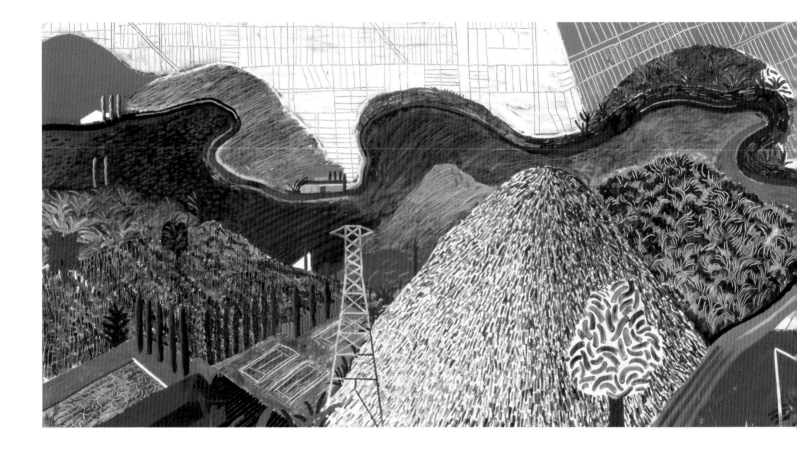

Art historical debate has increasingly centered on the idea of a body of art generally recognized as "the canon" and those who have been excluded from it through political and social domination. Edward Said, Homi Bhabha, James Clifford, and others working in the discipline of cultural studies have raised questions on topics such as power, class, ethnicity, and identity and their impact on the creation and reception of works of art. The exploration and depiction of the western landscape and its relationship to American history have been the subject of a number of provocative studies in the past decade. Anne Hyde, for example, has argued that such images played an instrumental role in the building of American nationalism,

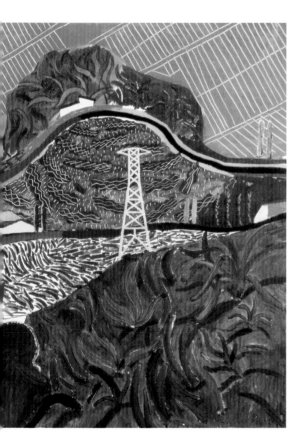

fueling railroad expansion and westward tourism.[25] If here the canon represents traditional images of California, our goal is not to remove it but rather to question it by presenting multiple points of view. While tracing mainstream images of the state, *Made in California* considers alternative conceptions, often produced by minorities, that challenge the popular ones. In this effort to uncover the disparate ways in which artists have produced and responded to popular images of California in the twentieth century—and the ways in which these images have been used by others—the exhibition weaves together examples of fine art (works intended primarily for museum and gallery presentation) and images that appeared in advertisements and promotional material, newspapers, magazine articles, posters, films, postcards, popular music, and documentary photographs. This contextual approach will, we hope, diminish or destabilize the conventional hierarchies, thereby expanding the dialogue about California and the art it has produced.

While each of the five main sections of *Made in California* contains topics related to a given twenty-year period—Hollywood glamour, spirituality, subcultures and countercultures, beach and car culture, to name a few—two overriding themes prevail throughout: the landscape, including both the natural and the built environment, and the complex relationship California continues to have with the cultures of its two neighbors, Latin America and Asia.

Section 1, 1900–1920, examines how paintings, prints, and photographs, as well as images circulated on postcards, travel brochures, periodicals, orange-crate labels, and in promotional films, created a vision of a largely Edenic, abundant California, encouraging migration and tourism, much of it from the white middle-class Midwest. The myth of the virgin land, unspoiled by modern life, was for the most part the prevailing image. Early landscapes, whether inland or coastal scenes, rarely included human figures; as such they are unspoiled by economic considerations, either of labor or of ownership. This homogeneous image of the California landscape was shared by boosters of tourism, developers, and artists, many of whom were themselves new arrivals hired by the tourist industry (railroads, hotels, chambers of commerce) to promote California.

David Hockney
Mulholland Drive, The Road to the Studio,
1980, acrylic on canvas.
Los Angeles County
Museum of Art
•

In the early years of the century, images of California frequently exploited a widespread but carefully sanitized interest in Native American and immigrant cultures. A dominant theme was the state's Spanish mission past, romanticized in art, literature, theater, architecture, furniture, clothing design, and popular songs. Tonalist painters and Pictorialist photographers, for example, represented the missions in wistful scenes that gave no hint of the devastating treatment of Native Americans by Spaniards and Anglos. The Chinatowns of San Francisco, Los Angeles, and smaller cities also became the subject of an Anglo fascination that frequently characterized the Chinese as exotic and old-fashioned. At the same time, in the era of the Asiatic Exclusion League, the Chinese Exclusionary Act, and aggression on the part of the American Federation of Labor, Chinese populations were subject to attacks by xenophobic Americans. Rarely did artists show Anglos and Chinese interacting or depict the Chinese engaged in modern, productive activities.

Section 2, 1920–1940, reveals pronounced shifts in popular conceptions of the state. The 1920s are characterized by increased tourism, migration, and expansion brought about by a boom economy. With the rapid rise of the automobile, tourists were able to travel to the newly promoted California desert, captured by photographers who aestheticized its desolate beauty. Images of rural life were sold to art collectors, and idyllic farms were depicted in agribusiness publications. The virgin landscapes of earlier decades gave way to agrarian scenes in which laborers—the migrants who tilled the land and picked the crops—at times appeared in the work of painters and photographers. Such cultivated landscapes were still picturesque and often showed no signs of burgeoning agribusiness and farming conglomerates. At the same time, a new type of image began to emerge in which California was represented as a land of newly constructed bridges, dams, and oil rigs. A number of artists also began to depict a thriving aviation industry.

In the 1920s and 1930s, the earlier cohesive image of California was shaken by unrest that often focused on Latin and Asian immigrants, many of whom were migrant laborers working in agriculture. Artists, writers, and musicians aligned themselves with the migrant laborers and sympathetically documented their working conditions. Fueled by Roosevelt's Pan-Americanism, Californians responded with initial enthusiasm, and commissions were given to the Mexican muralists who had temporarily migrated northward, including Diego Rivera and David Alfaro Siqueiros. There was a general vogue for Latin American themes throughout the arts, from painting and ceramics to Mayan Revival architecture.

During the Depression in the 1930s, California struggled with the rest of the nation against unemployment, farm foreclosures, massive debt, and a rising distrust of foreigners. While promotion of an Edenic California persisted, new images celebrated growth and modernism but also suggested the rise of urban problems. If, as W. J. T. Mitchell suggests,[26] we think of attitudes toward landscape as part of a process by which social and subjective identities are formed, images of California can be seen here to alternate between capitalist boosterism and socialist criticism. More often than not, idyllic images were challenged by the realities of newspaper headlines.

With the Depression, a new kind of migration swelled California's population, as refugees from the Dust Bowl sought relief in the Golden State. Haunting portrayals of migrants in visual and literary works would come to stand for an indelible chapter in American history. Radical artists emerged as a significant social presence, and sympathetic portrayals of urban poverty and labor strikes appeared with increasing frequency. During this time of widespread deprivation, California's newest industry, motion

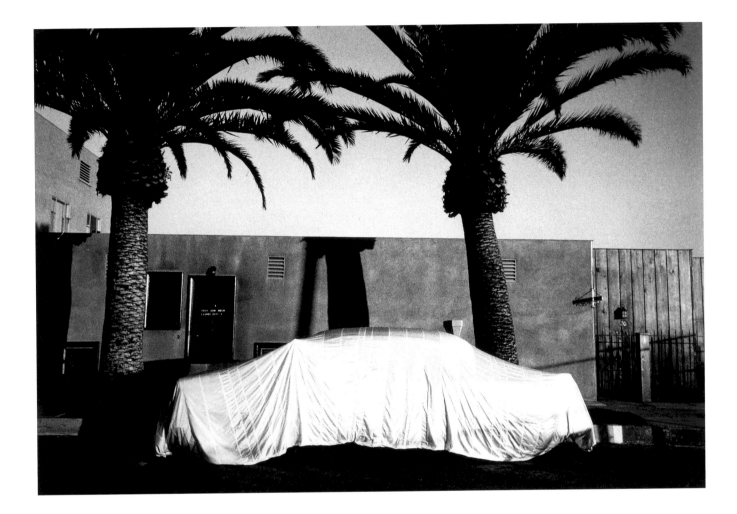

Robert Frank
Covered Car, Long Beach,
California, 1956, gelatin-
silver print

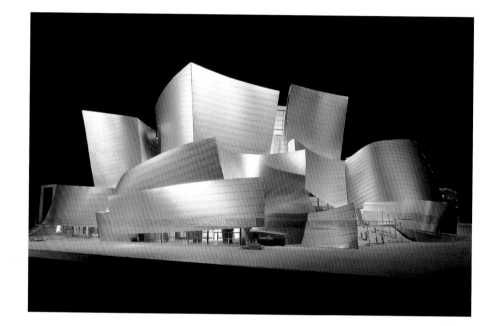

pictures, consolidated its national and international audience, feeding an insatiable hunger for the imagined lifestyles, sophistication, sensuality, fashion, and glamour of Hollywood and its stars.

California's role as a national force grew significantly from 1940 to 1960, the period covered in Section 3 of the exhibition. The state led the nation in the wartime production of aircraft and ships, built in large part by a labor pool that migrated from other states. The need to feed a nation at war led to increased demands on agricultural production, which were satisfied with the temporary importation of Mexican farmworkers. An increase in racism and the widespread xenophobia sparked by the war led to local as well as national attacks on various ethnic groups. Thousands of Japanese nationals and Japanese Americans were interned as a result of Executive Order 9066. The effect of this mood on artistic production was swift. Collectors, museums, and galleries were rarely interested in supporting Mexican or Asian artists in California during this period.

In the years immediately following the war, California's image as a natural paradise and recreational destination was once again promoted by the mass media, the tourist industry, and a number of artists. Photographer Ansel Adams's inspiring images of Yosemite, for example, were sold in galleries and published in *Life* magazine; at the same time, he produced commercial work for corporations such as Kodak. Other artists relied upon the landscape to create a new image of California, in keeping with a trend toward abstract art. Less naturalistic landscapes, such as those painted by Helen Lundeberg, evoke the cool minimalism of the period; others, such as the "flux" paintings of Knud Merrild, prefigure the gestural paintings of the New York School.

Low-cost housing led to the rapid growth of suburban communities, which in turn fostered an increased reliance upon an ambitious system of freeways that forever changed California's landscape. Booster images of the built and natural environment now coexisted more precariously with images of the darker side of expansion. Although the population swelled with an ethnically heterogeneous workforce, the dominant promotional image was still of a homogeneous, white, middle-class population. Nevertheless, with the emergence of the anticommunist fervor of the 1950s, the Golden State began to be associated as well with unconventional and subversive political activities. Beat artists, writers, and musicians routinely challenged white middle-class values, traditional gender roles, and suburban consumer culture. A number of counterculture artists brought aspects of alternative philosophies and religions into their work, and they were attracted in particular to the spiritual beliefs of Zen Buddhists and Native Americans.

California's popular image entered the mainstream of American culture during the 1960s and 1970s, which form Section 4 of the exhibition. By the end of the sixties, beach and car culture as well as the counterculture had been absorbed and commodified by the fashion, tourist, advertising, music, television, and film industries. To some extent, of course, these industries actually helped to create aspects of these cultures, at least as they now existed in the national psyche.

Landscape and nature-oriented traditions continued, reflecting personal artistic concerns and styles. Increasingly artists ricocheted between boosterist idealism and social criticism. Although the Edenic image of California continued to be celebrated, even in artists' depictions of freeways and swimming pools, landscape increasingly came to signify a contested territory in which pollution, environmental disasters, and monotonous urban sprawl prevailed. In the shadow of a vast system of freeways and a relatively modest mass transit system, car ownership became virtually synonymous with mobility and

Frank Gehry
Model of the Walt Disney Concert Hall, Los Angeles, 1998, mixed media

•

Frank Gehry
Drawing of the Walt Disney Concert Hall, Los Angeles, 1991, ink on paper

individual identity. Cars were popularly fetishized and adorned with exuberant decorations, often serving as symbols of power and machismo. A number of artists shared this passion and took pride in their motorcycles, race cars, and pickup trucks, later applying to their art the seamless paint finishes employed by the automotive industry. New materials developed in the aerospace industry, such as resin, plastic, Rhoplex, vacuum-coated glass, Plexiglas, and fiberglass, were used to make slick-looking paintings and sculptures. Other artists made use of these same new materials to explore the immateriality of objects, seeking connections to science and philosophy through issues of space, light, and perception.

In the 1960s, art and politics converged, as artists engaged the civil rights movement in their work and turned to repressed or ignored African American, Chicano, and feminist histories for inspiration. California gave birth to the Chicano art movement, in which artistic, cultural, and political issues coalesced. Through posters, performances, and political action, migrant labor in California also gained a voice. The movement quickly spread to other parts of the country, as oppressed migrant farmworkers sought to unionize. Many Chicano artists felt compelled to use their cultural and ethnic identity as the basis for their work, taking part in actions against the political and cultural system. Although these artists remained marginalized by the mainstream art establishment during the 1960s and into the 1970s, the issues they raised concerning identity and their relationship to the dominant culture would dramatically alter art making in the ensuing decades. The national emergence of art based on personal and political identity, frequently in nontraditional media such as installation, film, video, and performance, took many of its cues from California artists.

During the period covered by Section 5, 1980–2000, California became the subject of international attention, not as an idyllic destination but as the site of unpredictable calamities such as earthquakes, floods, forest fires, aberrant weather patterns, urban riots, police brutality, racial unrest, freeway shootings, gang violence, and cult killings. In Southern California, a wave of dystopic images was captured by artists in the early nineties, fueled by natural and man-made disasters that seemed to occur with frightening regularity. Mike Davis's *City of Quartz* (1992) and *Ecology of Fear* (1998), along with the *Helter Skelter* exhibition at MOCA (1992), did much to replace earlier beatific views of Southern California with a dark, cynical, and apocalyptic image of Los Angeles as overdeveloped, dysfunctional, environmentally precarious, and filled with racial and cultural distrust. Hollywood obliged with a spate of violent disaster films set in Los Angeles.

Following a healthy economic recovery after the recession of the early nineties, California again appears to be viewed as the land of the future. Gradually, despite the vast problems that remain, the state has come to represent diversity and multiple perspectives, and cultural and identity issues have increasingly preoccupied California artists. Characteristic of national and international trends, globalization (the breaking down of borders) and particularization (the attention to specific communities and the boundaries that divide them) are now key elements of artistic production. Artists routinely work in a variety of media, in which the traditional divisions between art and material culture have become difficult to discern. Indeed, in the arts and the culture at large, a profusion of multiple, competing images of California has finally replaced the unified, idyllic vision that predominated early in the century.

Billboard poster for
Sutro Baths, c. 1912.
Lent by Marilyn Blaisdell
Collection

Michael C. McMillen
*Central Meridian, The
Garage*, 1981, mixed media

1 The nine departments included American art, costume and textiles, decorative arts, education, film, modern and contemporary art, music, photography, and prints and drawings.

2 See Paul Ong and Evelyn Blumberg, "Income and Racial Inequality in Los Angeles," in Allen J. Scott and Edward W. Soja, *The City: Los Angeles and Urban Theory at the End of the Twentieth Century* (Berkeley and Los Angeles: University of California Press, 1997), 323–24, and, in the same volume, Edward Soja, "Los Angeles, 1965–1992," 442–60.

3 In Ivan Karp and Steven D. Lavine, eds., *Exhibiting Cultures: The Poetics and Politics of Museum Display* (Washington, D.C.: Smithsonian Institution Press, 1991), 1; and Elaine Heumann Gurian, "Noodling around with Exhibitions," in Karp and Lavine, 176.

4 Carol Duncan, *Civilizing Rituals: Inside Public Art Museums* (London: Routledge, 1995), 133–34.

5 See, for example, discussions of Goethe, Niels von Holst, and William Hazlitt in Duncan, *Civilizing Rituals*, 14–15.

6 Marcia Tucker, "Museums Experiment with New Exhibition Strategies," *New York Times*, Jan. 10, 1999, sec. 2.

7 Bonnie Pitman, "Muses, Museums, and Memories," in the special "America's Museums" issue of *Daedalus* (summer 1999), 15.

8 See, for example, Karp and Lavine, *Exhibiting Cultures*; Marcia Pointon, *Art Apart: Art Institutions and Ideology across England and North America* (Manchester: Manchester University Press, 1994); Daniel J. Sherman and Irit Rogoff, eds., *Museum Culture: Histories, Discourses, Spectacles* (Minneapolis: University of Minnesota Press, 1994); Lynne Cooke and Peter Wollen, eds., *Visual Display: Culture beyond Appearances* (New York: New Press, 1995); Duncan, *Civilizing Rituals*; Reesa Greenberg, Bruce W. Ferguson, Sandy Nairne, eds., *Thinking about Exhibitions* (London: Routledge, 1996); Mary Anne Staniszewski, *The Power of Display: A History of Exhibition Installations at the Museum of Modern Art* (Cambridge: MIT Press, 1998); and Alan Wallach, *Exhibiting Contradictions: Essays on the Art Museum in the United States* (Amherst: University of Massachusetts Press, 1998).

9 Wallach, *Exhibiting Contradictions*, 6.

10 See William H. Truettner, ed., *The West as America: Reinterpreting Images of the Frontier, 1820–1920*, exh. cat. (Washington, D.C.: Smithsonian Institution Press, 1991).

11 Truettner, *The West as America*, vii.

12 See "The Battle over 'The West as America,'" in Wallach, *Exhibiting Contradictions*, 105–17; and Steven C. Dubin, *Displays of Power, Memory, and Amnesia in the American Museum* (New York: New York University Press, 1999), 153–273.

13 See Pierre Bourdieu's *The Field of Cultural Production: Essays on Art and Literature*, Randal Johnson, ed. (New York: Columbia University Press, 1993), 29–73, in which Bourdieu describes "fields of cultural production," which include the creation of art and the strategies and goals of artists and the world of collectors, publishers, galleries, museums, academies, critics, etc. Recent catalogues for exhibitions that reflect these new approaches include Johann Georg Prinz von Hohenzollern and Peter-Klaus Schuster, eds., *Hugo von Tschudi und der Kampf die Moderne* (Munich: Prestel, 1996); Stephanie Barron et al., *Exiles and Emigrés: The Flight of European Artists from Hitler* (Los Angeles: Los Angeles County Museum of Art, 1997); Norman Kleeblatt and Kenneth E. Silver, *Expressionist in Paris: The Paintings of Chaim Soutine* (New York: Jewish Museum, 1998); Kynaston McShine, *The Museum as Muse* (New York: Museum of Modern Art, 1999). In addition, a thematic approach was also taken in the recent series of exhibitions MOMA 2000, organized by the Museum of Modern Art, New York, and the presentation of the permanent collection of Tate Modern, 2000.

14 This book has been reprinted as *Sunshine Muse: Art on the West Coast, 1945–1970* (Berkeley and Los Angeles: University of California Press, 1999).

15 In 1962, *Artforum* magazine was established in San Francisco, giving California artists a national platform for exposure in their own state; the magazine moved to L.A. in 1965 and then decamped for New York in 1967.

16 For example, *The Potter's Art in California, 1885 to 1955* (1980), *100 Years of California Sculpture: The Oakland Museum, Oakland* (1982), *Twilight and Reverie: California Tonalist Painting, 1890–1930* (1995), and *Art of the Gold Rush* (1998).

17 "*Chinatown*, Part Two?" in David Read, ed., *Sex, Death, and God in L.A.* (New York: Random House, 1992).

18 See Norman M. Klein, *The History of Forgetting: Los Angeles and the Erasure of Memory* (New York: Verso, 1997), 73–93.

19 The show traveled to the National Museum of American Art in Washington, D.C.

20 See also Thomas Albright, *Art in the San Francisco Bay Area, 1945–1980* (Berkeley and Los Angeles: University of California Press, 1985). For a discussion of the role of California's art schools in the state's art, see Paul J. Karlstrom, "Art School Sketches: Notes on the Central Role of Schools in California Art and Culture," in *Reading California: Art, Image, and Identity, 1900–2000* (Los Angeles: Los Angeles County Museum of Art in association with University of California Press, Berkeley and Los Angeles, 2000).

21 For example, *The Potter's Art in California, 1885–1955* (1980) at the Oakland Museum,

and *West Coast Ceramics* (1979) at the Stedelijk Museum in Amsterdam.

22 Other important exhibitions include *Abstract Expressionist Ceramics*, organized by John Coplans for the Art Gallery, University of California, Irvine (1966); Peter Selz's *Funk* at the University Art Museum, Berkeley (1967); *A Century of Ceramics*, curated by Garth Clark and Margie Hughto for the Everson Museum of Art in Syracuse, New York (1979); and, most recently, *Color and Fire: Defining Moments in Studio Ceramics, 1950–2000*, curated by Jo Lauria at the Los Angeles County Museum of Art.

23 *Made in L.A.: The Prints of Cirrus Editions* presented the work of a generation of printmakers.

24 For example, the exhibitions *Assemblage in California: Works from the Late '50s and Early '60s* at the University of California, Irvine (1968), *Lost and Found in California: Four Decades of California Assemblage* (1988) at the James Corcoran Gallery, Santa Monica, and *Forty Years of California Assemblage at the Wight Art Gallery*, UCLA (1989).

25 Anne Hyde, *An American Vision: Far Western Landscape and National Culture, 1820–1920* (New York: New York University Press, 1990). See also Patricia Nelson Limerick, *The Legacy of Conquest: The Unbroken Past of the American West* (New York: W. W. Norton, 1987) and *Something in the Soil: Legacies and Reckonings in the New West* (New York: W. W. Norton, 2000), and Richard White, "*It's Your Misfortune and None of My Own*": *A History of the American West* (Norman: University of Oklahoma Press, 1991).

26 See W. J. T. Mitchell, ed., *Landscape and Power* (Chicago: University of Chicago Press, 1994).

Acknowledgments

I want to thank Sabine Eckmann for her assistance in shaping this essay. Additional thanks are due to Garrett White, Sheri Bernstein, and Ilene Susan Fort for cogent comments.

47

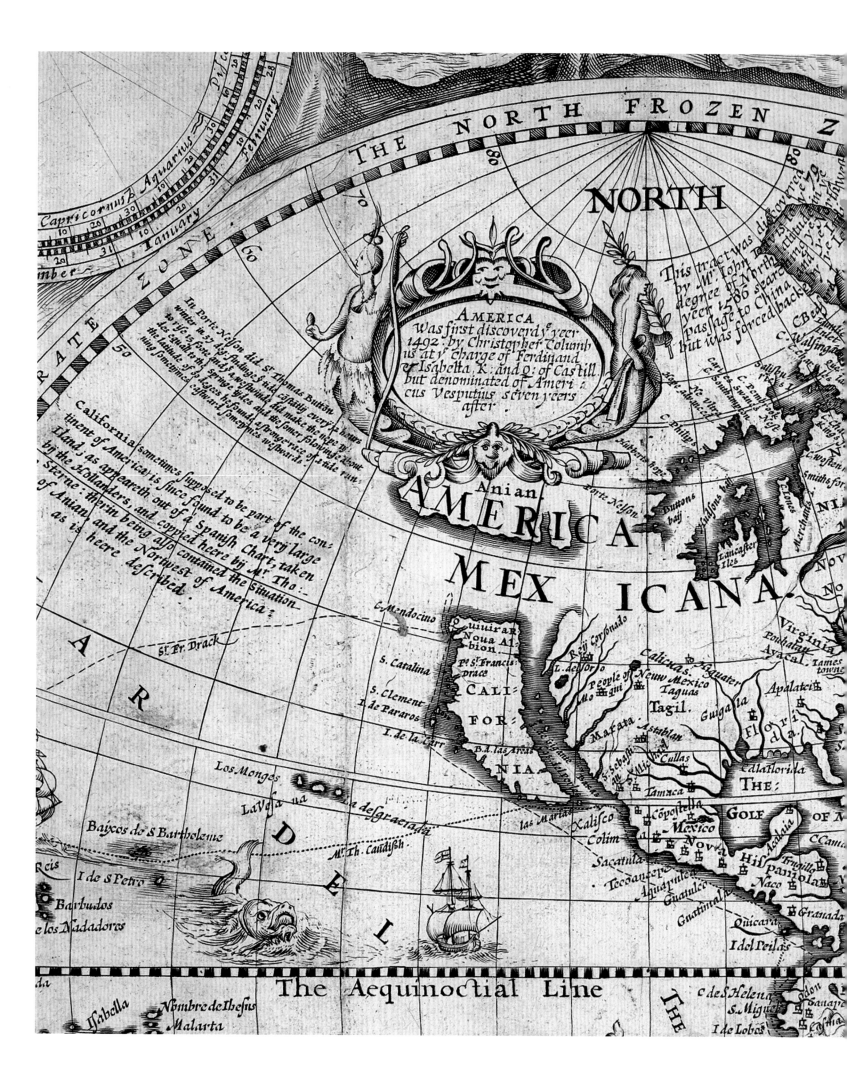

THE NORTH FROZEN Z

NORTH

This tract was discovered
by M.r John Davis & here in .76
degree of North latitude yeer 1585 in yr
yeer 1586 seard here to find a
passage to China
but was forced back

AMERICA
Was first discoverd yᵉ yeer
1492 by Christopher Columbᵘ
us at yᵉ charge of Ferdinand
& Isabella K: and Q: of Castill.
but denominated of Ameri :
cus Vesputius seven yeers
after

Anian
AMERICA-
MEXICANA.

In Porte Nelson did S.r Thomas Button
winter in 57 degr. finding yᵉ tide
to rise 15 foote, and yᵉ flud constantly everij 12 houres
des equall to yᵉ minute make the ebbes
the latitude of 58 degrees his springe tides and the somer following about
ing sometimes castward & sometimes westward, did make the nipes yᵉ
ing sometimes castward & sometimes westward

California, sometimes supposed to be part of the con :
tinent of America, is since found to be a verij large
Iland, as appeareth out of a Spanish Chart, taken
bij the Hollanders, and copiied heere bij M.r Tho :
Sterne : therin being also contained the Situation
of Anian, and the Nortwest of America ;
as is heere described.

A
R
C
T
I
C

D
E
L

St. Fr. Drack

C. Mendocino
Quiuira
Noua Al-
bion
P.o S.t Francis
S. Catalina prace
L. del Oro
CALI- People of
S. Clement Mo gui
I. de Pararos FOR-
I. de la Torr NIA.
B.a las Arcas

Los Monges

La Vesa na desgraciada

Baixos do S Bartholeme

M.r Th. Caudissh

Reis
I de S Petro
Barbudos
e los Nadadores

Isabella Nombre de Ihesus
Malarta

CBeu
C. Walsingam
Salisbur.
C Pembrook
C Phillips
Porte Nelson
Buttons
baij
Hudsons baij

Lancaster
Iles

Raij Coronado
Calixas. Aquater
Virginia
Neuw Mexico Pouhatan
Taguas Ayacal. Iames
Tagil. Guigala tounne
Apalatei
Mafata Astablan
S.ebast Florida
Mighal Cullas
Tamaca CdlaFlorida
THE:

las Martas Copostella GOLF OF M
Xalisco Mexico
Colim Nova
Sacatula Acadaia CCana
Tecoantepe Hispaniola
Aguapulco Trugillo
Guatuleo Naco
Guatimala Quicara
Idel Peilas
Granada

C de S Helena
S. Miguel
I de Lobos

The Aequinoctial Line

PEOPLING CALIFORNIA

Michael Dear

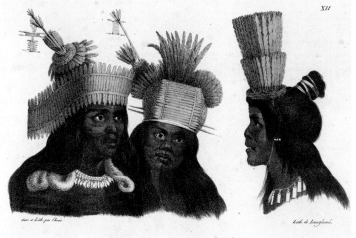

Coiffures de danse des habitans de la Californie.

**Know that to the right hand of the Indies was an island called California,
very near to the region of the Terrestrial Paradise, which was populated
by black women, without there being any men among them, that almost
like the Amazons was their style of living . . . There ruled on that island,
called California, a queen great of body, very beautiful for her race,
at a flourishing age, desirous in her thoughts of achieving great things,
valiant in strength, cunning in her brave heart, more than any other
who had ruled that kingdom before her . . . Queen Calafia.**

GARCI ORDÓÑEZ DE MONTALVO from *Las sergas del muy esforzado caballero Esplandián, hijo del excelente rey
Amadís de Gaula,* a novel published in Spain about 1500.

Map of North America showing
California as an island,
William Grent, 1625

Ceremonial headdresses of
the Costanoan Indians of
California, Louis Choris, 1822

Humans have lived on the land called California
for more than 10,000 years. By the time of European
contact, California, a land of unsurpassed natural
bounty, was probably the most densely settled area
north of Mexico, occupied by diverse groups of
migrants and settlers later referred to as "Indians."
The discovery of the New World by Columbus inspired
a fantastic mythology about untold riches, earthly
paradise, and great peoples. But California remained
isolated from Europe and Asia until the early sixteenth
century, when Spain sent a war expedition to Mexico
under the leadership of Hernán Cortés, who conquered
and plundered the Aztec empire, including its capital
Tenochitlán (today's Mexico City) in 1521. A 1542 expe-
dition on behalf of the Spanish crown allowed Juan
Rodríguez Cabrillo to gaze on Alta California (roughly
the present-day state of California). England's Francis
Drake anchored off San Francisco Bay in 1579. And in
1602, Spain sent Sebastian Vizcaíno to explore the
California coastline for safe anchorages for its merchant
fleets. He issued a hugely exaggerated report on
California's attractions but failed to notice San Francisco
Bay, like many before him.[1]

There then followed almost two centuries of
colonial indifference, until Spain began to take a new
interest in Alta California late in the eighteenth century.
This was because the British and French had grabbed
parts of Canada and Louisiana, and Russians were mak-
ing incursions along the west coast of North America.
So the Spanish crown decided to use Alta California
as a buffer state to protect its holdings in New Spain.

Lacking the resources to conquer California in
a single offensive, Spain adopted its tried-and-tested
method of sending soldiers and missionaries to co-opt
the indigenous populations and establish a colonial
order. (Land grants could be used later to entice civilian

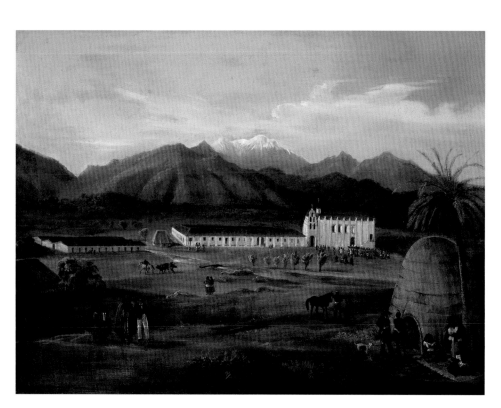

settlers.) The first major push began in 1769, under the joint stewardship of Captain Gaspar de Portolá and the Franciscan Father Junípero Serra. Over the next fifty years, the Spaniards established twenty-one mission settlements in Alta California, as well as a number of pueblos and presidios hugging the coast from San Diego to Sonoma.[2]

The task of settling a relatively sparsely populated, semiarid region far from the Spanish homeland proved difficult. Half a century later, the region remained relatively underdeveloped, small in population and military power. One factor that hampered Spanish ambitions was the continuous resistance by native Californians. Despite the myths of harmonious mission life, the colony was violent and unruly. Missionary efforts displaced Indian communities from their villages, disrupted family and tribal life, meted out severe punishments, and introduced often-lethal new diseases. Between 1769 and 1846, the number of California Indians declined to about 100,000, or one-third of earlier totals. Some groups fomented open rebellion; others escaped to the interior, far from the reach of both priest and pestilence. Those who stayed frequently offered passive resistance. Yet it was they

who provided the primary agricultural and artisanal labor force for Spanish California, without whom the colony may not have endured.[3]

When the state of Mexico was cut loose from Spain in 1821, the mission system faced determined opposition from Alta California's new government. Under Mexican secularization acts, mission lands were seized, intended for redistribution among Indian residents of the mission. In practice, however, they were usually sold into private hands, thus further excluding Indians from their homelands.

The people from colonial Mexico who settled on the California frontier during this time of transition from Spanish to Mexican rule came to be called "Californios." Proud of their links to Spain (via the Franciscans), Californios were a ranching elite (based on a cattle economy, including the production of hides and tallow) who referred to themselves as *gente de razón*, or people of reason. Many of the great families claimed they carried in their veins the *sangre azul* (blue blood) of Spain. The Indians, somewhat predictably, were regarded as *gente sin razón*, people without reason. Such terminology reflected an ancient theological divide between civilization and savagery but was also strongly imbued with racial overtones.[4] Required to work on the remaining undistributed mission properties to maintain the Mexican territorial government, many Indians found themselves under a regime that was barely distinguishable from Spanish rule. Miguel Léon-Portilla uses the Nahuatl term *nepantla* to describe indigenous people's experience of "cultural woundedness," brought about because the colonizers usurped the ethical and spiritual foundations of their world.[5]

During the late 1820s, more Anglo Americans started arriving in California.[6] Some married into Spanish-speaking Californio families and thus gained access to land, power, and status. Others converted to

Catholicism, became Mexican citizens, and adopted Mexican customs. However, many Anglos were contemptuous of the way in which both Spain and Mexico seemed unable to realize California's promise. Richard Henry Dana's *Two Years before the Mast* (1840) was perhaps the most prominent popular narrative that denigrated Indian, Californio, and Mexican alike. Dana's patronizing lament—"In the hands of an enterprising people, what a country this might be!"— was fatefully echoed in the rising sentiment favoring the Manifest Destiny of the United States: the extension of its territorial reach all the way to the Pacific Ocean.[7] This belief was to provide a powerful impetus in the Mexican War of 1846–48, as a result of which Mexico lost a third of its territory to the United States, including the land known as Alta California.

The Treaty of Guadalupe Hidalgo in 1848 ended hostilities between the United States and Mexico.[8] In less than eighty years, the land tended by Indians for millennia had passed from Spanish to Mexican to United States control. In law, the treaty protected the civil and property rights of Mexican citizens in California. But all Mexican holdings were formally called into question by the California Land Act of 1851, which required proof of clear title to land. The enormous expense this effort entailed was one reason for the swift sale and subdivision of the ranchos in the early 1860s.[9] The Californios soon became relegated to second-class citizenship. In addition, the United States federal government rarely recognized the Mexican land grants of the very few Indians who held them. Bumped down in the pecking order by Anglo Americans and Californios, indigenous Indians became third-class citizens. Their continuing resistance and efforts to gain legal title to their lands were instrumental in producing the first Indian reservations in Southern California in 1865.[10]

On the morning of January 24, 1848, at Coloma, on the South Fork of the American River near Sutter's Fort, James Marshall discovered gold. A small, back-page article in *The Californian* of March 15, 1848, announced curtly: "Gold Mine Found." Suddenly, California became the target of one of the largest, swiftest migrations in

human history. "More newcomers now arrived each day in California than had formerly come in a decade," was how historian Leonard Pitt summed up the beginnings of the world-famous Gold Rush.[11]

Before news of the gold strike spread, California's non-Indian population was put at 14,000. By the end of 1849, on the eve of statehood, it had risen to almost 100,000; by 1852, it would exceed 200,000 people. A few short years of gold fever accomplished what a century of deliberate colonial efforts had failed to achieve: growth. California's economic boom pushed the Golden State early into integration with the United States. Its admission as a free state in 1850 was not without rancor, but as one journalist-historian put it: "The Union is an exclusive body, but when a millionaire knocks at the door, you don't keep him waiting too long, you let him in."[12] As competition for gold escalated, Anglo Americans moved covetously to protect the claims for themselves. The Foreign Miners' Tax of 1850 effectively barred Chinese, Mexicans, Europeans, and even Californios from an equal chance at the riches. Yet despite these constraints, the California Dream was firmly established in minds across the nation and the world. California was where ordinary folk went to become fabulously rich!

San Francisco (renamed from Yerba Buena in 1847) was ground zero for urban growth during the Gold Rush. Sacramento also acted as a supply center, as did Stockton, and Southern California's cow counties even got caught up in the demands of their northern neighbors. But everything that came into and out of the Mother Lode country had to pass through San Francisco. By 1860, the city had a population of 57,000, making it America's fifteenth-most-populous urban center, the largest city west of the Mississippi River.[13]

Known for its volatile politics, mob justice, and loose social climate, San Francisco witnessed the rapid development of business institutions, churches, newspapers, and elite neighborhoods. The city became California's first great manufacturing center, based on machinery and metalworking connected to resource-extractive industries. By the late nineteenth century, it had 80 percent of the state's manufacturing capacity,[14] earning its machine shops the title of "graduate school

52

of mechanics."[15] Approximately half the city's population was foreign-born during most of the second half of the century. Many of the Gold Rush migrants came from New England and the Pacific Northwest, but they were joined by a large contingent of Chinese and Mexican people, plus a couple of thousand free African Americans and a handful of runaway slaves. Already, San Francisco was the capital of California's nineteenth century.

Carey McWilliams portrayed the breakneck speed of California's entry into the modern world in these words:

Elsewhere the tempo of development was slow at first, and gradually accelerated as energy accumulated. But in California the lights went on all at once, in a blaze, and they have never been dimmed.[16]

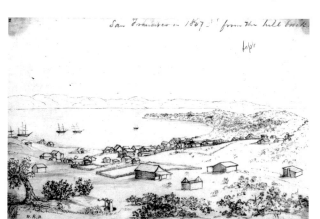

It was during the latter half of the nineteenth century, under the stark illumination of the world's gaze, that California became (according to Mark Twain) a mecca for "astounding enterprises."[17] Silver miners, agriculturalists, railroad magnates, bankers, and others rushed in to seize the

moment. The spirit of the times, as expressed by historian J. S. Holliday, was "stand back, make way for the hydraulickers, wheat ranchers, railroad builders, stockbrokers, and tycoons of commerce."[18]

As if gold were not enough, silver was discovered in 1860 in an indecently rich vein known as the Comstock Lode, on the eastern slopes of the Sierra Nevada. From deep mines, wage-earning miners hoisted to the surface between 1860 and 1880 ore worth $300 million. And as before, everything that went into and came out of the instant town of Virginia City had to pass through San Francisco. To shore up these mines, unimaginable quantities of timber were cut. As one contemporary observed: "The Comstock Lode may truthfully be said to be the tomb of the forests of the Sierra."[19] In addition, wildlife was decimated for food, and river valleys were destroyed by the new hydraulic-power hoses used in gold mining. The whole California economy, it seemed, was instantly and insistently (in geographer Richard Walker's memorable phrasing): "digging up, grinding down, and spitting out the gifts of the earth."[20]

The gold miners' seemingly untouchable aristocracy was challenged by a persistent group of farmers downstream in the Sacramento and San Joaquin valleys. By the early 1880s, the value of California's agricultural production exceeded that of mining. This bolstered the farmers' case against the miners, whose upstream operations were periodically flooding

William Rich Hutton
San Francisco, 1847
•

William Hahn
Harvest Time, 1875
•

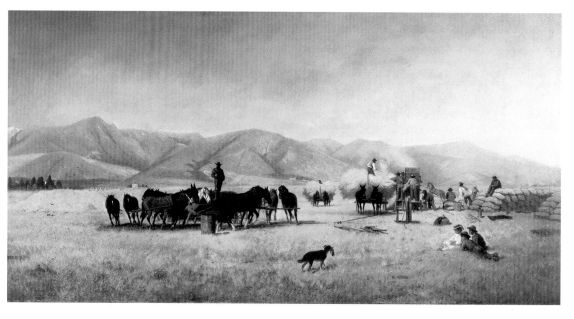

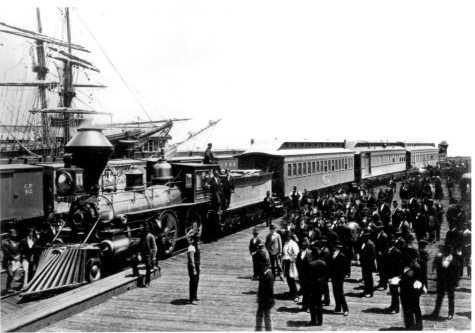

and burying the agriculturalists' crops and towns. Ultimately, after a long legal struggle, hydraulic mining techniques were banned in California in January 1884, thereby ushering in the end of the Gold Rush era.[21]

The agricultural enterprise that sprang out of the plethora of unsettled land titles in the Central Valley was large in scale and operation. The valley's unmatched ecologies, based upon wetlands (*cienegas*), riparian woodlands, lakes, and rivers, were systematically drained and plowed under for agricultural production. Historian William Fulton described the consequent agribusiness as "capital-intensive, highly mechanized, concentrated in its land ownership patterns, and oriented toward export markets."[22] By the 1870s, more than half the land in California was owned by .2 percent of the state's population.[23] The initial boom crop, the "grower's gold," was wheat.[24] In 1881, 4 million acres of wheat fields, stretching throughout the Central Valley and covering two-thirds of all cultivated land in the state, yielded $34 million on the world market—almost twice the value of the gold produced that year.[25] But just as the demise of gold mining was swift and stark, so the end of wheat's hegemony was surprising and speedy. Competition from home and abroad, rapid soil depletion, and a market slump effectively eliminated California wheat production by the early 1890s.

On its completion in 1856, Theodore Judah had won fame as the engineer who surveyed and promoted California's first railroad—twenty-two miles of track between Sacramento and the foothill town of Folsom, supply center for the mining camps along the American River. Judah optimistically approached San Francisco investors with a plan for a transcontinental railroad, which they huffily rejected, viewing such a pipe dream (quite correctly, it turns out) as a threat to their ocean-oriented transportation monopoly.

So Judah went to Sacramento. There he met four merchants—Collis Huntington, Mark Hopkins, Charles Crocker, and Leland Stanford. The Big Four, as they came to be called, were risk takers and skillful entrepreneurs. They brought the Central Pacific Railroad (CPRR) from Sacramento to meet the westward-moving Union Pacific Railroad at Promontory, Utah.

The last spike in this celebrated connection between east and west was struck on May 10, 1869, changing California and the nation forever. Despite their success, the avaricious, monopolistic barons of the newly formed Southern Pacific Railroad (SP), which absorbed the CPRR, inspired Californians' contempt on more than one occasion, and played a pivotal role in state politics in the ensuing five decades. For instance, Charles Crocker's decision to import 12,000 Chinese laborers to complete the most difficult and dangerous work on the railroad had serious repercussions. Unhappy with this competition, the state's white working class developed strong anti-Chinese sentiments. California workers led the charge for a complete federal ban on Chinese immigrants in 1885, an exclusionary outlook on race that persists today in various incarnations. Residents also rebelled against the SP juggernaut itself, directing their resentment toward the monopoly's apparent greed and corruption. The attempt to derail "the Octopus" (so known for its propensity to extend its tentacles to control every aspect of the state) defined California politics into the Progressive Era.[26]

In the 1870s, the CPRR and its subsidiaries constructed rail track along the entire length of the Central Valley, thus releasing the fullest development of the valley's agricultural potential.[27] The SP conglomerate helped transform the landscape by bankrolling start-up farms, researching railcar refrigeration, and nurturing experimentation with new crops.[28] Another distinctive feature of California's agricultural boom was the growers' exchange, which encouraged farmers to pool resources and work together to develop export markets. But the availability of cheap agricultural labor was the most critical human factor in the state's burgeoning agribusiness. Recounting California's almost unbelievable dependence on ethnic migrant farmworkers, Walter Stein wrote: "Chinese in the 1870s; Japanese in the

Carleton E. Watkins
Transcontinental Rail Terminal, 1876
.

1890s; East Indians after the turn of the century; Mexicans and Filipinos during and after World War I; Okies during the 1930s; southern blacks along with Filipinos and Mexicans again during the 1940s."[29] The most critical natural factor in California agriculture was water.[30] One of the nineteenth century's least noticed but most fundamental innovations was the 1887 Irrigation District Act, which allowed farmers to cooperatively build and operate watering systems.[31] By the mid-1920s, innovative farming and intensive irrigation had allowed California to become the nation's leading agricultural state.

The railroad also changed the way California built cities. By September 1876, the SP arrived in Southern California from the north. In 1885, it opened a direct line to the east. But, most importantly, in 1887 the first Santa Fe Railroad train snaked through the San Bernardino Mountains into Los Angeles, thus breaking the SP monopoly. The ensuing rate war (a one-way ticket from Kansas City to L.A. fell from $125 to $1!) inaugurated Southern California's first major land boom. It also, in Leonard Pitt's words, "sealed the coffin of the old California culture."[32]

Turn-of-the-century Los Angeles offered itself as paradise for land and property speculators, sunseekers and tourists, homesteaders and health fanatics. As early as 1886, local wags claimed it had more real estate agents per acre than any other city in the world.[33] City boosters were, however, anxious to nourish a more conventional industrial base. The discovery of oil helped somewhat (Edward L. Doheny had sunk the first well in 1892), but it required impressive investments in urban infrastructure—rail, water, power, and port—to properly realize L.A.'s potential. For instance, San Pedro harbor (opened in 1899 and annexed to the City of Los Angeles in 1906) very quickly became the state's first-ranked port. And in 1913, the amazing Owens Valley Aqueduct reached L.A., enabling engineer William Mulholland to boldly declare, "There it is. Take it!," as the first waters gushed over the aqueduct's sluiceway. The date was November 5, 1913. It was the earliest indication that Los Angeles was to become the capital of California's twentieth century.

Still, San Francisco continued to view its southern neighbors with complacency. It sought to confirm its arrival on the world scene early in the twentieth century by hiring the eminent Chicago architect Daniel Burnham to prepare a city plan. In addition, an exposition was scheduled to celebrate the much-anticipated 1915 opening of the Panama Canal. But in 1906 an earthquake ignited a huge fire that devastated the metropolis. Neighboring towns anticipated that "the City" would never recover, but recover it did. In 1915, San Francisco opened a new civic center and hosted the Panama-Pacific International Exposition. Their architectural designs conjured up visions of a cosmopolitan, classical, Beaux-Arts City by the Bay.

That same year in San Diego, quite a different exposition was mounted. The Panama-California Exposition was determinedly Southern Californian in outlook. As social historian Phoebe Kropp makes clear, both the Panama-Pacific in the north and the Panama-California in the south were self-promotional sorties in the wars between cities.[34] Against San Francisco's studied cosmopolitanism, San Diego advertised agricultural and commercial possibilities, plus a distinctly Spanish Colonial sensibility and heritage. While San Francisco aspired to worldly sophistication, Southern California had found a regional identity and had begun to compete for national attention. By 1920, California was the eighth most populous state in the Union, and the growth momentum had shifted south, to Los Angeles.

Since the turn of the century, the local chamber of commerce had hyped Los Angeles into becoming one of the best-publicized places in the United States. Tourists and prosperous Midwesterners were particularly targeted, and these efforts ignited successive rushes of untrammeled urban growth. In 1918, 6,000 building permits were issued in Los Angeles; by 1923 (the peak of the boom), this number had climbed to more than 62,000, with a total value of $200 million. By 1925, L.A. had no fewer than 600,000 subdivided lots standing vacant. The city had already parceled out enough land to accommodate 7 million people, fifty years before the reality of population growth would catch up with the speculators' appetites!

Very early during these boom years, the traditions of immigration to Southern California from northern and western Europe were displaced. Southern and eastern Europeans took their place, joined by peoples of Mexican, Japanese, and African American origin. By 1930, Mexicans were by far the largest minority group in Los Angeles, which already had a racial/ethnic diversity unmatched anywhere along the West Coast.

Not everyone regarded the California development juggernaut with equanimity. One prominent critic was John Muir, who anticipated present-day environmentalism by insisting on the ecological bond between people and nature. In 1892, Muir founded the Sierra Club, an influential conservationist group as well as a social club for wilderness outings. Muir and the Sierra Club won federal jurisdiction for Yosemite Valley in 1906 but lost battles over the Hetch Hetchy Valley and the Owens River, when San Francisco and Los Angeles tapped Sierra rivers during this period.[35]

The taint of conspiracy, collusion, and corruption surrounding so many urban water projects gave impetus to California Progressivism during the early twentieth century. Another favorite target was the Octopus. One quintessential Progressive organization was the California Lincoln-Roosevelt League, initiated in 1907 by reform-minded Republicans. The league set out to free its party from railroad domination but also furthered Progressive goals such as the initiative, referendum, and recall statutes; public regulation of utilities and railroads; and the direct primary election. The league endorsed women's voting rights, providing the impulse for equal suffrage in California (the sixth state in the union to establish this, in 1911), as well as other Progressive issues, including minimum-wage laws, control of child labor, and the deterrence of alcoholism, gambling, and vice.

Yet for all the efforts to extend democracy, the Progressive Era in California was tainted by campaigns of racial exclusion (as were earlier, presumably less-progressive times). Labor leaders and Progressive

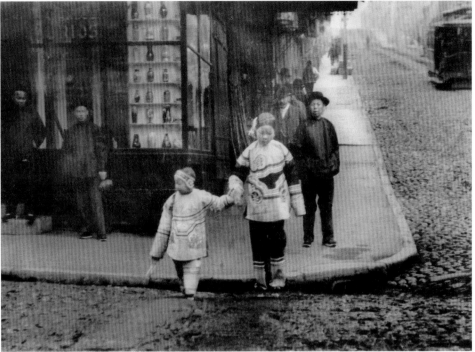

"Ramona"-style pageant, San Gabriel Mission, early twentieth century

Arnold Genthe
Chinatown, San Francisco, 1898, gelatin-silver print

reformers together instituted the Asiatic Exclusion League in 1905, advocating such measures as school segregation and immigration restrictions. Resentment of the success of Japanese farmers led to the Alien Land Law Act of 1913, which forbade noncitizens from owning real property in the state. The California Dream and United States citizenship remained determinedly white. And while unions were strong in the Bay Area, fear of labor radicalism (especially following the 1910 bombing of the *Los Angeles Times* building) fostered an antiunion, "open-shop" attitude in L.A. that persists to this day.[36]

Throughout the booming 1920s, the difficult 1930s, and the coming of war, California continued to attract people. In the decade of the 1920s, 2 million Americans became Californians, most of them settling in the Southland, and most of them from white Midwestern states. It was the greatest relative population increase of any decade in the state's history, and the most homogeneous in terms of origins.

The motion picture industry—Hollywood!— did much to broadcast California's appeal.[37] Begun in New York and San Francisco, production companies soon recognized that Southern California's landscapes and climate were ideal for moviemaking. No less than 70 picture studios had established themselves in and

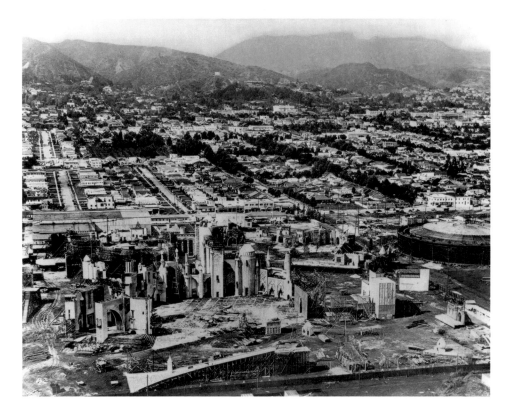

Pickford/Fairbanks Studios,
Santa Monica Boulevard,
Los Angeles, c. 1926

Dorothea Lange
Resettled, El Monte,
California, 1936, gelatin-
silver print

around Hollywood by 1914. By the late 1920s, industry integration had given birth to the studio system, dominated by Paramount, Fox, MGM, Universal, Warner Brothers, and RKO. For locals as well as tourists, it became increasingly difficult to see where movie fantasy stopped and the real world began.[38] Certainly, the movies advertised a seductive lifestyle that became part of the mythos of California. Moviemaking occupied the streets and vacant lots of Los Angeles, even after production was consolidated in large studio-run facilities. The Industry also attracted filmmakers from Europe, who were often fleeing the rise of fascism, and spawned a tradition of artist-in-exile that was to indelibly stamp Southern California cultural life for the rest of the century.[39] Immigrants typically wanted a single-family home in the suburbs, but decidedly not the urbanism that characterized the eastern and Midwestern cities from whence they came, and the homebuilding industry was determined to satisfy those needs. By 1930, Los Angeles housed 94 percent of its residents in single-family homes (the highest percentage in the nation).[40]

Another significant sponsor of suburbanization was the automobile, which simply accelerated the process already begun by suburban railways. The Automobile Club of Southern California and the California State Automobile Association were both founded in 1900. With the introduction of the relatively affordable Ford Model T, car ownership rose rapidly, but nowhere faster than in Los Angeles. By 1925, Los Angeles had one auto for every three people, more than twice the national average.[41] The automobile irrevocably altered the landscapes of California, not only with the hundreds of miles of paved roads and highways it demanded but also with the new social forms it inspired—the

supermarket, drive-in theater, and flamboyant roadside architecture.[42]

Literally fueling this mass motorization were the region's abundant oil supplies. Oil had been found in Los Angeles in the early 1890s, provoking the steady development of exploration, refinery construction, and conversion from coal usage. But a series of exceptionally productive discoveries in the 1920s, accompanied by increasing demand, conspired to make California the nation's largest oil-producing state through the 1930s (including output from the legendary Signal Hill and the Tulare Basin in the south Central Valley). The state produced oil worth more than $2.5 billion during that decade, a half billion dollars more than all the gold ever mined in the state. Prospectors and property speculators tripped over each other in many L.A. subdivisions; suburbanites dug deep for oil in their own backyards. Yet by decade's end, the oil industry had faded in Southern California, and elsewhere in the state it had become consolidated into a few corporate entities.[43]

The Great Depression brought about acute personal hardship, bitter labor struggles, and heightened racial antagonisms. San Francisco staggered under a 25 percent unemployment rate; Los Angeles's rate was 20 percent. The 1934 General Strike in San Francisco, called in retaliation against the National Guard's violent suppression of the earlier International Longshoremen

Association's strike, was less than a success. In L.A., city officials and Anglo workers blamed Mexican workers for their troubles. In 1930, a "repatriation" effort was begun, which ultimately returned to Mexico one-third of the city's Mexican and Mexican American populations (approximately 35,000 people). It was also during this time that 300,000 poverty-stricken Midwestern farmers arrived in California and transformed the state's farm labor force. They came from the Dust Bowl regions, largely between 1935 and 1939, and quickly acquired the generic name "Okies." They came at a time when growers faced the possibility of rising wages for the first time in many years, and their willingness to accept low pay kept farm wages down, undercut union efforts, and displaced Mexican farm laborers for years to come.[44]

Ultimately, it was federal money invested in New Deal projects that began to pull the state out of depression. The Civilian Conservation Corps, the Works Progress Administration, and many other public-works projects created a state infrastructure that has endured as both the material and mental underpinnings of the California Dream. Along with such familiar monuments as the Golden Gate and San Francisco–Oakland Bay bridges, federal agencies oversaw construction of the Colorado River project (including the Hoover Dam), which brought water to sustain Southern California's urban growth.[45] Then World War II erupted in Europe.

California was well positioned to supply the nation for war. In 1919, the U.S. Navy had divided its newly modernized and enlarged fleet, sending half to the West Coast and thereby triggering a nervous struggle among West Coast ports as to who would get what. San Diego, Los Angeles, San Francisco, Vallejo, and Seattle battled furiously for naval bases, but also for the potential of revitalized merchant marine and shipbuilding industries. This particular conflation of national politics (Senator James D. Phelan led the charge in Washington, D.C., to ensure that the West Coast got its share of the Navy spoils), unstoppable urban growth, and city-father hucksterism ultimately created what historian Roger Lotchin called "Fortress California."[46]

HOW A PLAYGROUND GOES TO WAR !

Planning Your Victory Vacation in Southern California

How a Playground Goes to War!, brochure, 1943. Lent by Jim Heimann

More than $35 billion in public monies were sunk into California industries during World War II, roughly 10 percent of all government funds. Fueled by fear of a Japanese invasion following the attack on Pearl Harbor, this investment sparked not only strong economic recovery in California, but also a tremendous expansion in scientific and technological enterprises. Some referred to it as the "Second Gold Rush."[47] In Northern California, shipbuilding was dominant; the Kaiser shipyards in the East Bay suburb of Richmond employed tens of thousands of workers constructing warships in record time. In the south, the aircraft industry employed more than half the aircraft workers in the nation. These wartime industries drew large numbers of women into the labor force for the first time and intensified migration by African Americans.[48] In 1940, African Americans composed only 1.8 percent of the state's population; by 1950, this proportion had risen to 4.3 percent.

The rapid pace of in-migration plus war-initiated shortages created social problems and exacerbated racial antagonisms. A dearth of affordable housing, aggravated by discrimination in housing markets,

58

solidified the tendency toward racially segregated communities throughout California.[49] During the 1943 Zoot Suit riots in Los Angeles, hundreds of white servicemen attacked flamboyantly dressed Mexican youths because the Anglos interpreted their garb as disloyal. Police arrested the zoot-suiters for disturbing the peace.[50] Long-standing racial prejudice and wartime fears for national security led also to the internment of more than 100,000 people of Japanese descent, two-thirds of whom were American citizens. For the duration of the war, many Japanese Californians found themselves in isolated camps set in some of the more desolate parts of the Mojave Desert, the eastern Sierras, and elsewhere.[51]

After 1945, a long period of economic prosperity settled upon California. The Cold War and the conflicts in Korea and Vietnam prompted continuing high levels of defense-related expenditures. By 1960, aerospace industries employed 70 percent of San Diego's and 60 percent of Los Angeles's manufacturing workers. Such growth, together with further diversification in employment patterns, pushed population to new heights. California became the nation's most populous state in 1962, passing New York, having grown from 6.9 million in 1940 to 15.7 million in two short decades. Prosperity fueled social experimentation. The Beat writers congregated in San Francisco during the 1950s, establishing an intellectual counterculture based on pacifism, radicalism, and experimentalism that fundamentally informed the student movements of the following decade. Republican governor Earl Warren (and his Democratic successor, Edmund G. Brown) used much of the state's postwar budget surplus to create a model higher-education system in California.

Needless to say, the postwar boom did not benefit everyone equally. Under the provisions of the wartime Emergency Farm Labor Program, an agreement

Participants in the Bracero program awaiting final roll call and distribution of identification papers, Mexico, 1944

negotiated with the Mexican government often known as the Bracero program, Mexican workers were to be offered contracts with guaranteed wages, housing, and health care. Kept in operation until 1964, the bracero effort never lived up to its ideals, in part because it was constantly undermined by the continuing high demand for labor, which encouraged unofficial immigration from Mexico. When in 1952 the U.S. government sponsored "Operation Wetback" to stall unauthorized crossings from south of the border, California encountered an ironic situation whereby one government agency was recruiting foreign workers while another was turning them away.

The decade of the 1960s became the contradictory apex of prosperity and protest in California.[52] The Free Speech Movement at Berkeley adopted tactics of the civil rights movement to provoke confrontations on academic freedom and students' rights. Intensified by opposition to the Vietnam War, the movement's tactics escalated toward more violent expressions of civil disobedience. At the same time, however, a more pacifist hippie counterculture carried on the Beat traditions, and experimentation with psychedelic drugs became a rite of passage for California youth (and copycats the world over). But students and young people were not the only ones who took to the streets in the 1960s. Cesar Chavez led one of the most successful attempts to organize California farmworkers. Gaining the support of an ethnically diverse pool of workers, Chavez combined the traditional goals of higher wages, better living conditions, and improved benefits with innovative techniques of coalition building and organized boycotts. In his most famous and ingenious campaign, Chavez expanded the Delano grape strike in 1965 by calling for a nationwide boycott of table grapes. This strategy not only netted national publicity for La Causa but also pressured growers to accede to union demands.[53]

The most telling indicator that all was not well with the good ship California was the Watts riots of 1965.[54] Proposition 14 had been approved by a margin of two to one by predominantly Anglo voters in 1964. This revoked the Rumford Act of 1963, which banned racial discrimination in housing, and would have

curtailed desegregation efforts had it not been declared unconstitutional in later years. For African Americans in South Central Los Angeles, the passage of Proposition 14 was the last straw in an ongoing legacy of discrimination. Between 1940 and 1964, L.A.'s African American population had grown from 40,000 to nearly 650,000. At the same time, residential opportunities had not expanded far beyond the crowded streets of South Central. Following arrests and persistent rumors of police brutality, violent clashes broke out between police and African Americans, leaving $40 million in property damage and thirty-four people dead, all but three black. Before the six days of rioting were over, a National Guard force of 13,900 had been deployed to restore order. In the aftermath of Watts, a more militant black power movement emerged, most notably with the establishment of the Black Panther party in Oakland. Founded by Huey P. Newton and Bobby Seale, the Panthers couched black power in a rhetoric of socialism and armed resistance.

Another reaction to student activism was a wave of political conservatism. In this atmosphere, former actor Ronald Reagan emerged as standard-bearer for the Republican Party. Serving as California governor between 1967 and 1974, Reagan began to implement widely promised campaign goals to cut taxes and roll back government. At the time of his election, the Los Angeles–San Diego corridor was home to 41 percent of the state's population, as against the Bay Area's 15 percent. And more than 90 percent of the state's residents lived in metropolitan areas (increasingly the suburban counties), making California the nation's most urbanized as well as its most populous state.

The passage of Proposition 13 in 1978 marked a watershed in post–World War II California politics. In journalist Peter Schrag's words, it separated "that period of postwar optimism, with its huge investment in public infrastructure and its strong commitment to the development of quality education systems and

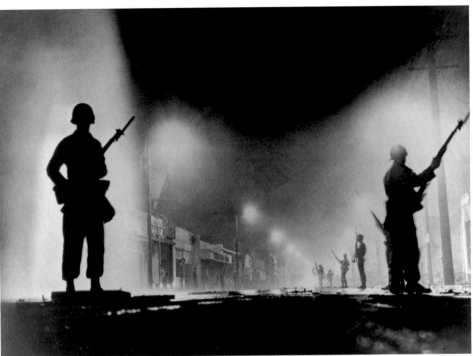

other public services, and a generation of declining confidence and shrinking public services."[55] Since 1978, he asserts, Californians have been involved in a "nearly constant revolt against representative government."[56]

The initiative, referendum, and recall mechanisms that enabled Proposition 13 had been in place since 1911, when Progressive Era reformers were looking for ways to curtail the excesses of a state government dominated by a handful of powerful interests, especially the Southern Pacific Railroad. For most of the twentieth century these checks were used sparingly, until 1978, when Proposition 13 (sponsored by Howard Jarvis and Paul Gann) initiated a tax revolt that changed the practice of California politics to this day.

Proposition 13 was basically designed to cut state and local property taxes. In this it was successful; in just four years the state and local tax burden was lowered by more than 25 percent.[57] Local officials sought to replace lost revenues with new fees and service charges. California's public schools began a path of decline from which they have yet to recover. Ironically, about one

Restricted housing tract, Los Angeles, c. 1950

National Guardsmen during the Watts riots, 1965

60

quarter of the $50 billion that Californians "saved" during the first five years of Proposition 13 was returned to the federal government through personal and corporate income taxes.

The Proposition 13–induced squeeze on tax revenues and public services began to bite just when the state was undergoing a demographic transition of major proportions and entering a period of economic uncertainty that would culminate in the recession of the early 1990s. No one yet understands the precise interconnections among these three events, but their combined impacts on California have been breathtaking. By 1962, 110 years after statehood, California had become the nation's most populous state, with 17.5 million inhabitants. It took only thirty-five more years to double that figure. A large proportion of this enormous expansion was fueled by international migration. Changes in immigration quotas, culminating in the

Common Threads Artists Group

"Guess Who Pockets the Difference?," poster, 1995

•

1986 Immigration Reform and Control Act, allowed 2.5 million illegal entrants to become legal citizens; it also radically altered the complexion of new immigrants. After 1970, the white share of the state's population dropped precipitously (from three-quarters to one-half); people of Latino and Asian origins tripled their share; and the African American population remained at about 7 percent. During these decades, nonwhites began to play an increasingly active role in state and local politics.

Simultaneously, the California economy underwent a series of wrenching changes that became very visible during the 1980s and 1990s, even though the seeds of change had taken root in earlier decades. The deindustrialization phenomenon closed manufacturing

plants across the nation, most affecting car manufacture, steel production, and other heavy industries. California's adjustment trauma was exacerbated by a decline in defense-related expenditures that severely depleted employment opportunities in aircraft manufacture, shipbuilding, and ancillary industries. Between 1991 and 1994 (when economic recovery began) California experienced a net domestic out-migration of over 600,000 people, unprecedented in its history.

In place of manufacturing, service industries sprouted overnight all over the state, including retailing, information and financial services, and similar activities that some view as characteristic of a "postindustrial" society. The most fabled success story of this economic restructuring was, of course, Silicon Valley.[58] But many other places, especially in Southern California (the "Silicon Coast"), enjoyed the benefits of the computer revolution.[59] However, California boosters often overlook the darker side of this high-tech boom. Many high-skill, high-wage jobs were being created, but there was an even larger explosion of low-wage, low-skill jobs. For example, apparel manufacturing (often involving sweatshop conditions) employs twice as many people as computer manufacturing; and agriculture and canning engage 400,000 workers, more than all the high-tech manufacturers combined.[60] As a result, the "new" California economy is increasingly polarized between rich and poor. The rising tide of homelessness, first noticed in the early 1980s, is a direct result of this recession and restructuring.[61] In addition, the federal government's radical undoing of the nation's welfare programs during the 1990s hit California's major cities especially hard.

Many dark clouds conspired to hide the warm glow brought about by the state's much-vaunted economic recovery. A persistent mean-spiritedness was evident in the parade of ballot initiatives that infested the political process since the 1978 tax revolt. In 1990, Proposition 140's tight legislative term limits inspired a game of "musical seats" among state and local politicians. Proposition 187 (1994) brought back echoes of a century-long xenophobia, with its denial of schooling to children of undocumented immigrants and their exclusion from virtually all other public services. Proposition

Los Angeles Fine Arts Squad
(Victor Henderson and
Terry Schoonhoven)
Isle of California, 1973,
pencil and acrylic on
photograph

209 (the confusingly titled 1996 "California Civil Rights Initiative") prohibited affirmative action in public education, contracting, and employment. While many of the propositions' specifics remain subject to challenge in the courts, government by initiative is now firmly ensconced as part of the political artillery of advocates of all political persuasions in California.[62]

According to Peter Schrag, California shifted from being "a national model of high civic investment and engagement" in the 1950s and 1960s, to become "a lodestar of tax reduction and disinvestment" in the 1980s and 1990s.[63] The single most important dynamic in this transition was Proposition 13, and perhaps its most emblematic moment occurred when Orange County declared bankruptcy on December 6, 1994. Local voters adamantly refused to approve even a modest tax increase to bail themselves out.[64]

Since 1769, California's history has been an ongoing narrative about conquest and immigration, about resources and development. Grabbed by the United States in search of its Manifest Destiny, the state of California was, quite literally, bulldozed by its long twentieth century. At breath-snatching speed, in a spectacular succession of material and metaphysical revolutions, the Golden State was transformed first by gold, then by green gold (agriculture), black gold (oil), gunmetal gold (defense contracts), and now e-gold (high technology). With hindsight, we can recognize that a new kind of society was in the making at the continent's isolated edge, brought about by a restless collision

between peoples and place. As the twenty-first century dawns, the rules are changing again. The state's multiple charismas of nature, wealth, diversity, and counterculture fold into one another to create an incandescent galaxy of inventiveness and experimentation. At the same time, however, one cannot escape Joan Didion's prescient and oft-quoted reminder about California:

The mind is troubled by some buried but ineradicable suspicion that things had better work here, because here, beneath that immense bleached sky, is where we run out of continent.[65]

California has been a remarkably lucky island. Throughout its American century, the state has avoided the principal depredations of the past one hundred years—that "most murderous" of centuries with its dour record of war, famine, and genocide.[66] Now, as the global geopolitical balance shifts starkly from the Atlantic to the Pacific Ocean, California is poised to become the capital of America's Pacific Rim.

It goes almost without saying that California is a test bed for a new kind of American society. Even as a Proposition 13 mentality persists, the state remains at the forefront of the nation's environmental consciousness, its voters elected two women to the United States Senate, and a revitalized labor movement looks to California for its lead. The precise architecture of the twenty-first century's social contract remains to be uncovered, but one of its principal determinants is already abundantly clear: the Latinization of the state, most evident in many Southern California cities

62

(including Los Angeles) where Latinos are now the majority ethnic group.[67] This demographic shift perhaps represents the ultimate legacy of the Treaty of Guadalupe Hidalgo—a peaceful reconquest of Alta California.

The search for California's twenty-first century commenced with the 1992 civil unrest in Los Angeles that followed the announcement of the Rodney King verdicts.[68] Much has been written about these events, the worst urban violence in an American city during the twentieth century. Some have interpreted the clashes as a continuation of leftover business from the 1965 Watts riots, and certainly racism, poverty, and discrimination played their parts. Others have regarded 1992 not as a "riot" but as an "uprising" by a constellation of marginalized minorities, prefiguring an emergent, reconstituted social order. The truth is most probably somewhere between; the events of 1992 were both a residual bitterness and a novel political hybrid. The cry of "No justice, no peace" that greeted the King verdicts was an expression of rage at a manifest injustice. But the multiculturalism of those who participated in the unrest plus the reconstructive efforts that followed are indicative of something different, something positive.

Californians remain alert to Wallace Stegner's challenge to create a civilization worthy of its setting, but time and space are running out. The Southern California megalopolis, extending from Santa Barbara across the international border into Baja and landward to the Inland Empire, is already a single urban system. It is an ecosocial hybrid based on no single heritage; it can be defined only on its own terms; and it is the city of the future.[69] And our Golden State is no longer an isolated margin but, instead, the geographical pivot of America's Pacific century. No longer an exception to the rules governing urban development, it is instead the prototype of a burgeoning multicultural, urban America. Watch California. Ready or not, it is the shape of things to come.

1 See Joshua Paddison, ed., *A World Transformed: Firsthand Accounts of California before the Gold Rush* (Berkeley: Heyday Books, 1999), intro. The literature on California's history is large and increasingly rich. Kevin Starr's five volumes are indispensable: *Americans and the California Dream, 1850–1915* (1973); *Inventing the Dream: California through the Progressive Era* (1985); *Material Dreams: Southern California through the 1920s* (1990); *Endangered Dreams: The Great Depression in California* (1996); and *The Dream Endures: California Enters the 1940s* (1997) (New York: Oxford University Press).

2 J. S. Holliday, *Rush for Riches: Gold Fever and the Making of California* (Berkeley: Oakland Museum of California and University of California Press, 1999), chap. 1.

3 A careful accounting of the impact of colonization on the indigenous populations of Alta California is to be found in Robert H. Jackson and Edward Castillo, *Indians, Franciscans, and Spanish Colonization: The Impact of the Mission System on California Indians* (Albuquerque: University of New Mexico Press, 1995). See also Lillian McCawley, *The First Angelenos: The Gabrielino Indians of Los Angeles* (Banning: Malki Museum Press and Ballena Press, 1996).

4 See Lisbeth Haas, *Conquest and Historical Identities in California, 1769–1936* (Berkeley and Los Angeles: University of California Press, 1955), 2–3, 30–32, 37.

5 Ibid., 26–28, 43.

6 The significance of immigration on Californian identity is discussed by Doyce B. Nunis Jr., "Alta California's Trojan Horse: Foreign Immigration," in Ramón A. Gutiérrez and Richard J. Orsi, eds., *Contested Eden: California before the Gold Rush* (Berkeley and Los Angeles: University of California Press, 1998), chap. 11.

7 Richard Henry Dana Jr., *Two Years before the Mast* (New York: Penguin Books, 1981), quoted and discussed in Paddison, *A World Transformed*, 202.

8 The treaty and its legacy are well documented in Richard Griswold del Castillo, *The Treaty of Guadalupe Hidalgo: A Legacy of Conflict* (Norman: University of Oklahoma Press, 1990).

9 Haas, *Conquest and Historical Identities*, 63, 67, 77.

10 Ibid., 57–61.

11 Leonard Pitt, *The Decline of the Californios: A Social History of the Spanish-Speaking Californians, 1846–1890* (1966; reprint, Berkeley and Los Angeles: University of California Press, 1998), 52–53.

12 Quoted in Holliday, *Rush for Riches*, 171.

13 A thorough history of the transformation of Yerba Buena is Roger W. Lotchin, *San Francisco, 1846–1856: From Hamlet to City* (1974; reprint, Urbana: University of Illinois Press, 1998).

14 Mel Scott, *The San Francisco Bay Area: A Metropolis in Perspective* (Berkeley and Los Angeles: University of California Press, 1985), 73.

15 Richard A. Walker, "California's Golden Road to Riches: Natural Resources and Regional Capitalism, 1848–1940," *Annals of the American Association of Geographers* (in press).

16 Carey McWilliams, *California: The Great Exception* (1949; reprint, Berkeley and Los Angeles: University of California Press, 1999), 25. See also his classic account *Southern California: An Island on the Land* (1946; reprint, Salt Lake City: Peregrine Smith Books, 1973).

17 Quoted in Holliday, *Rush for Riches*, 29.

18 Ibid.

19 Ibid., 227.

20 Walker, "California's Golden Road to Riches," 25.

21 Holliday, *Rush for Riches*, chap. 7.

22 William Fulton, *California: Land and Legacy* (Englewood, Colo.: Westcliffe Publishers, 1998), 44.

23 Stephen Johnson, Gerald Haslam, and Robert Dawson, *The Great Central Valley: California's Heartland* (Berkeley and Los Angeles: University of California Press, 1993), 41.

24 Holliday, *Rush for Riches*, 277.

25 Ibid.

26 For a brief history of the railroad in Northern California, see Holliday, *Rush for Riches*, 229–43; for California as a whole the standard account is William Deverell, *Railroad Crossing: Californians and the Railroad, 1850–1910* (Berkeley and Los Angeles: University of California Press, 1994). The anti-Chinese movement is recounted in Alexander Saxton, *The Indispensable Enemy: Labor and the Anti-Chinese Movement in California* (1971; reprint, Berkeley and Los Angeles: University of California Press, 1995).

27 Johnson, Haslam, and Dawson, *The Great Central Valley*, 41.

28 Fulton, *California*, 46.

29 Quoted in Johnson, Haslam, and Dawson, *The Great Central Valley*, 47.

30 For a classic account of water in the American West, consult Marc Reisner, *Cadillac Desert: The American West and Its Disappearing Water*, rev. ed. (New York: Penguin Books, 1993). See also Donald Worster, *Rivers of Empire: Water, Aridity, and the Growth of the American West* (New York: Pantheon Books, 1985).

31 Johnson, Haslam, and Dawson, *The Great Central Valley*, 45.

32 Pitt, *The Decline of the Californios*, 249.

33 Edward W. Soja and Allen J. Scott, "Introduction to Los Angeles: City and Region," in Allen J. Scott and Edward W. Soja, eds., *The City: Los Angeles and Urban Theory at the End of the Twentieth Century* (Berkeley and Los Angeles: University of California Press, 1996), chap. 1.

34 Phoebe S. Kropp, "'There is a little sermon in that': Constructing the Native Southwest at the San Diego Panama-California Exposition of 1915," in Marta Weigle and Barbara A. Babcock, eds., *The Great Southwest of the Fred Harvey Company and the Santa Fe Railway* (Phoenix: Heard Museum, 1996), 36–46.

35 For a sweeping perspective on land development in California during the twentieth century, see Stephanie S. Pincetl, *Transforming California: A Political History of Land Use and Development* (Baltimore: Johns Hopkins University Press, 1999). The case of Southern California in the late

twentieth century is dramatically invoked by Mike Davis, *Ecology of Fear: Los Angeles and the Imagination of Disaster* (New York: Metropolitan Books, 1998).

36 California's Progressive Era is reviewed in William Deverell and Tom Sitton, eds., *California Progressivism Revisited* (Berkeley and Los Angeles: University of California Press, 1994); for the case of Southern California the authoritative account is Mike Davis, *City of Quartz: Excavating the Future of Los Angeles* (New York: Verso Books, 1990).

37 A good overview of the culture and history of Hollywood is provided by Richard Maltby, *Hollywood Cinema* (Oxford: Blackwell Publishers, 1995).

38 For one quirky account of Hollywood urbanism, see Greg Williams, *The Story of Hollywoodland* (Los Angeles: Papavasilopoulos Press, 1992).

39 See, for instance, Stephanie Barron, et al., *Exiles and Emigrés: The Flight of European Artists from Hitler* (Los Angeles: Los Angeles County Museum of Art, 1997).

40 The classic narratives of the birth of Los Angeles urbanism in the early twentieth century are Robert M. Fogelson, *The Fragmented Metropolis: Los Angeles, 1850–1930* (1967; reprint, Berkeley and Los Angeles: University of California Press, 1993); and Greg Hise, *Magnetic Los Angeles: Planning the Twentieth Century* (Baltimore: Johns Hopkins University Press, 1997). An excellent account of San Francisco's urban history is by Gray Brechin, *Imperial San Francisco: Urban Power, Earthly Ruin* (Berkeley and Los Angeles: University of California Press, 1999). See also Philip J. Ethington, *The Public City: The Political Construction of Urban Life in San Francisco, 1850–1900* (Cambridge: Cambridge University Press, 1994).

41 Scott Bottles, *Los Angeles and the Automobile: The Making of the Modern City* (Berkeley and Los Angeles: University of California Press, 1987).

42 Two excellent accounts of the architectural consequences of automobilization are those by Richard Longstreth, *City Center to Regional Mall: Architecture, the Automobile, and Retailing in Los Angeles, 1920–1950* (Cambridge: MIT Press, 1997); and *The Drive-In, the Supermarket, and the Transformation of Commercial Space in Los Angeles, 1914–1941* (Cambridge: MIT Press, 1999).

43 A colorful history of the oil era in Southern California is by Jules Tygiel, *The Great Los Angeles Swindle: Oil, Stocks, and Scandal during the Roaring Twenties* (New York: Oxford University Press, 1994).

44 On Mexican repatriation and the Okies, I recommend the following: Francisco E. Balderrama and Raymond Rodriguez, *Decade of Betrayal: Mexican Repatriation in the 1930s* (Albuquerque: University of New Mexico Press, 1995); and James Gregory, *American Exodus: The Dust Bowl Migration and Okie Culture in California* (New York: Oxford University Press, 1989).

45 The progress and legacy of the New Deal in Southern California's landscapes is reported in Starr, *Endangered Dreams*, chaps. 10–13.

46 See Roger W. Lotchin, *Fortress California, 1910–1961: From Warfare to Welfare* (New York:

Oxford University Press, 1992).

47 Marilynn S. Johnson, *The Second Gold Rush: Oakland and the East Bay in World War II* (Berkeley and Los Angeles: University of California Press, 1993).

48 For a brief account of the Bay Area's war industries, see Scott, *The San Francisco Bay Area*, chap. 15; also Johnson, *The Second Gold Rush*.

49 A beautifully illustrated and wide-ranging account of the impact of wartime on the built environment of California is the collection of essays in Donald Albrecht, ed., *World War II and the American Dream: How Wartime Building Changed a Nation* (Washington, D.C.: National Building Museum and MIT Press, 1995).

50 The standard account of the Mexican experience in Southern California is George J. Sánchez, *Becoming Mexican American: Ethnicity, Culture, and Identity in Chicano Los Angeles, 1900–1945* (New York: Oxford University Press, 1993).

51 See Ronald Takaki, *Strangers from a Different Shore: A History of Asian Americans* (New York: Penguin Books, 1989), chap. 10.

52 A brief account of the Bay Area in the 1960s is Charles Wollenberg, *Golden Gate Metropolis: Perspectives on Bay Area History* (Berkeley: Institute of Governmental Studies, 1985), chap. 19. A provocative and engaging reappraisal of the legacy of this era is contained in James Brook, Chris Carlsson, and Nancy J. Peters, eds., *Reclaiming San Francisco: History, Politics, and Culture* (San Francisco: City Lights Books, 1998).

53 See Pincetl, *Transforming California*, chaps. 4–5.

54 An interesting perspective on this well-documented event is by David Wyatt, *Five Fires: Race, Catastrophe, and the Shaping of California* (New York: Oxford University Press, 1997), chap. 8.

55 Peter Schrag, *Paradise Lost: California's Experience, America's Future* (New York: New Press, 1998), 10. Schrag's is the most penetrating account of this period in California politics.

56 Ibid.

57 A comprehensive balance sheet of Proposition 13's first five years is drawn up by Terry Schwadron and Paul Richter, *California and the American Tax Revolt: Proposition 13 Five Years Later* (Berkeley and Los Angeles: University of California Press, 1984).

58 The best scholarly account of what went into producing Silicon Valley is by AnnaLee Saxenian, *Regional Advantage: Culture and Competition in Silicon Valley and Route 128* (Cambridge: Harvard University Press, 1994).

59 An influential analysis of Southern California's "technopoles" is by Allen J. Scott, *Technopolis: High-Technology Industry and Regional Development in Southern California* (Berkeley and Los Angeles: University of California Press, 1993).

60 Schrag, *Paradise Lost*, 113.

61 The connection between global forces and local outcomes in the case of homelessness in Los Angeles is explored by Jennifer Wolch and Michael Dear, *Malign Neglect: Homelessness in an American City* (San Francisco: Jossey-Bass, 1993).

62 Once again, let me recommend Schrag's

Paradise Lost as the best overview of "proposition politics" in late-twentieth-century California.

63 Ibid., 275.

64 A useful retelling of the Orange County bankruptcy is Mark Baldassare, *When Government Fails: The Orange County Bankruptcy* (Berkeley and Los Angeles: University of California Press, 1998).

65 Joan Didion, *Slouching toward Bethlehem* (New York: Noonday Press, 1990), 172.

66 The phrase is from Eric Hobsbawm, *The Age of Extremes: A History of the World, 1914–1991* (New York: Vintage Books, 1994), one of the most insightful (if somewhat pessimistic) histories of the twentieth century yet to appear.

67 The Latinization of Los Angeles is discussed in Gustavo Leclerc, Raúl Villa, and Michael Dear, eds., *Urban Latino Cultures: La vida latina en L.A.* (Thousand Oaks: Sage Publications, 1999).

68 For a detailed appraisal of the genesis and impact of the Rodney King beating, trials, and aftermath see Lou Cannon, *Official Negligence: How Rodney King and the Riots Changed Los Angeles and the LAPD* (New York: Times Books, 1997).

69 There is much debate about California's urban future. See, for example, Michael Dear, *The Postmodern Urban Condition* (Oxford: Blackwell Publishers, 2000), as well as the collections of essays in Scott and Soja, *The City*, and Michael Dear, H. Eric Schockman, and Greg Hise, eds., *Rethinking Los Angeles* (Thousand Oaks: Sage Publications, 1996).

Acknowledgments

I am grateful to friends at LACMA for inviting me to become engaged in this project, especially Stephanie Barron, Paul Holdengräber, and Sheri Bernstein. Thomas Frick, Nola Butler, and Garrett White provided useful guidance that assisted me in the preparation of this essay. I am especially indebted to Phoebe Kropp, who prepared many documents and materials that both informed and challenged my understanding. Thanks also to Greg Hise, Selma Holo, Gustavo Leclerc, Aandrea Stang, Kevin Starr, Dick Walker, and Jennifer Wolch, whose advice and comments transformed my understanding of our Golden State, and this essay. Dallas Dishman assisted in preparing images; I am grateful to all those who granted permission for us to use them. None of the individuals mentioned in this note is responsible for any errors or interpretive aberrations that may adorn this essay.

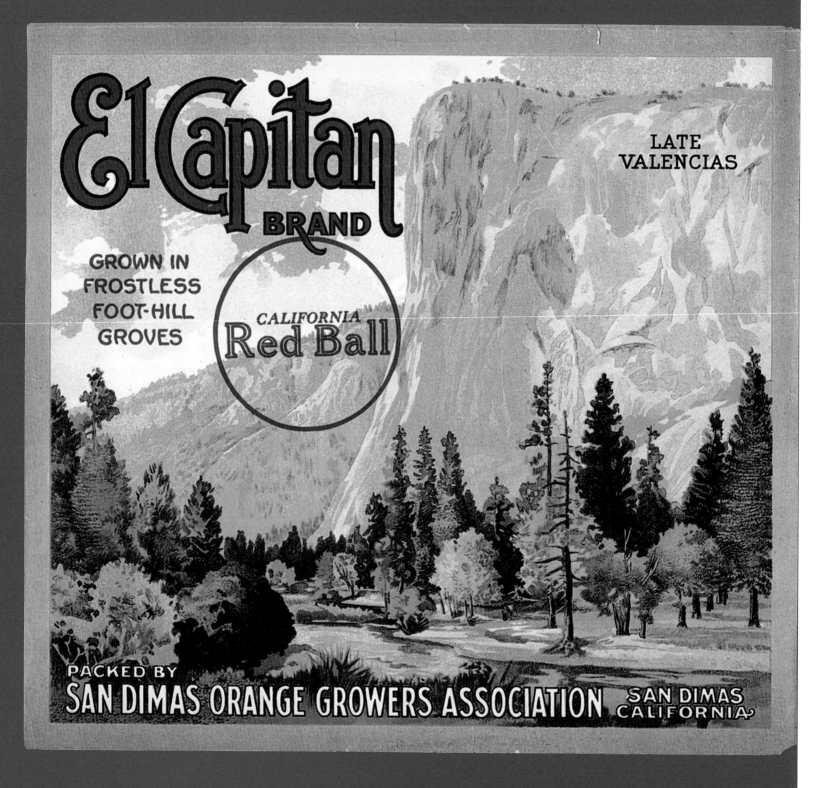

Sheri Bernstein

California officially became the Golden State in the 1960s, but its image in the popular imagination was never more singularly golden than during the first two decades of the twentieth century. Nor did the arts ever play a more pivotal role in the gilding of California. With remarkably few exceptions, artists and writers from the turn of the century through the 1910s, along with California's promoters in industry, regional government, and the press, embraced a vision of the state as the quintessential Garden of America, an unspoiled and bountiful paradise. This powerful Edenic vision has proven even more enduring than the notion of the Wild West associated with the Gold Rush period. It lies at the heart of myriad booster images—used here to mean propagandistically positive conceptions, often serving the interests of the white mainstream—that to varying degrees have persisted in shaping popular visions of the state and in influencing artistic production to the present day.

On first consideration it might seem curious that an expressly premodern, Edenic conception of California was so pervasive from 1900 through the 1910s, given that significant portions of the state, like other areas in the country, had already experienced or were then in the throes of urbanization and industrial development. San Francisco was already a considerable metropolis of 343,000 at the turn of the century, growing to 500,000 by 1920; Los Angeles's population mushroomed from 102,000 in 1900 to over 550,000 in 1920, with a 100 percent increase in manufacturing registered between 1900 and 1910 alone.[1]

The droves of white middle-class tourists and new residents then descending on California—many of whom were Midwesterners leaving their farms to resettle in cities[2]—had a psychological need to see the region as free of the complexities and ills of modern life. Newcomers were often of retirement age and sought to enjoy their final days leisurely in a private bungalow in the sun. Many

of the region's copious tourists—the word *tourist* was probably coined in Southern California during the nineteenth century[3]—were looking for a healthful respite from the frantic pace and ubiquitous grime of everyday urban living. It is understandable, then, that the state's transportation, tourist, and agricultural industries, its chambers of commerce, and its powerful individual boosters exerted enormous effort to present white Midwestern audiences with precisely the idyllic images of California they craved, even amid the massive development of the region. Promises of personal well-being and financial prosperity were among the most popular and effective selling strategies. "Oranges for Health—California for Wealth," the slogan for a 1907 promotional campaign organized by the California Fruit Growers Exchange and financed by the Southern Pacific Railroad to attract Iowans, is a typical example.[4]

At times the sunny, boosterist conceptions of California had explicitly racist overtones. One of the region's unwavering proponents, Massachusetts-born newspaperman and Southwest Museum founder Charles Fletcher Lummis, championed Southern California in his widely read magazine, *Land of Sunshine* (later renamed *Out West*), as "the new Eden of the Saxon home-seeker." Further, he boasted of Los Angeles in 1895 that "the ignorant, hopelessly un-American type of foreigner which infests and largely controls Eastern cities is almost unknown here."[5] Indeed, for many of the new Anglo arrivals, the image of California as unaffected by the massive immigration from southern and eastern Europe then changing the complexion of the country's major East Coast and Midwestern urban centers was a strong attraction. While it is true that California was home to few European immigrants during these years, its urban population was in fact quite heterogeneous ethnically,

Crate label for El Capitan brand oranges, San Dimas Orange Growers Association, n.d. Lent by the McClelland Collection

a

a
California for the Settler,
brochure produced by the
Southern Pacific Railroad,
1911. Lent by the Seaver
Center for Western History
Research

with sizable numbers of Mexicans, Japanese, and African Americans in Los Angeles and a large community of Chinese in San Francisco.[6] Generally, however, the California image promulgated by boosters was ostensibly more benign than Lummis's, aimed at enticing the broadest possible spectrum of the populace.

To a considerable degree, as Susan Landauer has persuasively argued with respect to plein air landscape painting in Southern California, artists of the period participated either consciously or unconsciously in this discourse of California boosterism.[7] Reasons for this are easy to come by. First, many of the artists were themselves newcomers to the state—most of the plein air painters, for example, were recent arrivals from the Midwest and the East—and were undoubtedly swayed in their perceptions of the region by the same promotional strategies that had attracted others. Second, from a more practical standpoint, there was a staggering market for such images, both regionally and nationally. One of the most insightful and prescient commentators on the state, journalist and lawyer Carey McWilliams, remarked that "many of [the Southern California painters] saw the region through glasses colored by subsidies."[8] The Southern Pacific and Santa Fe railroads sponsored trips for numerous artists in exchange for scenic paintings and photographs of the California

landscape that could be exhibited in railway stations across the country. Moreover, the state's two most important promotional magazines— *Sunset*, founded in San Francisco in 1898 by the Southern Pacific Railroad, and Lummis's *Land of Sunshine*, financed by the Los Angeles Chamber of Commerce—often featured work by artists and writers that glorified the California landscape. In addition, many of the newly constructed tourist hotels, including the Hotel Del Coronado in San Diego, the Hotel Del Monte in Monterey, and the Mission Inn in Riverside, boasted their own art galleries and regularly held exhibitions seen by tourists and locals that featured landscape paintings. Without question, then, there was a healthy demand for scenic, picturesque views of California.

Conversely, no real market existed for images that pictured the state in urban terms, which might have paralleled work then being produced on the East Coast, such as the Ashcan School's gritty scenes of New York City life. The comparatively few urban images of California produced during these years were principally photographs, often depicting the devastation wreaked by the 1906 San Francisco earthquake. Even William Coulter's highly anomalous painting of the fire that accompanied the earthquake and consumed the city is ultimately a coastal scene rather than an urban one. Moreover, although this depiction initially appears apocalyptic, with smoke dramatically billowing from the shore and blackening the sky, Coulter's intention was to put a positive spin on the catastrophe. His subject is San Francisco's successful maritime rescue of more than 30,000 of its residents from the flaming city.[9]

b

c

Dana and Towers Photography Studio

#121. Looking East on Market Street, 1906, gelatin-silver print

William A. Coulter

San Francisco Burning, April 18, 1906, 1907, oil on canvas

•

67

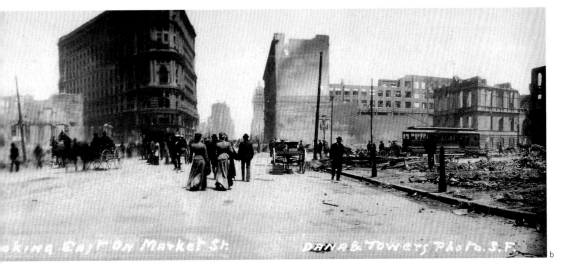

b

c

a
John O'Shea
The Madrone, 1921, oil on canvas

b
Guy Rose
The Old Oak Tree, c. 1916, oil on canvas

c
Marion (Kavanaugh) Wachtel
Sunset Clouds #5, 1904, watercolor on paper

d
Oscar Maurer
Eucalyptus Grove Silhouetted against a Cloudy Sky, Golden Gate Park, San Francisco, c. 1915, gelatin-silver print

e
Gustave Baumann
Windswept Eucalpytus, c. 1929, color woodcut

68

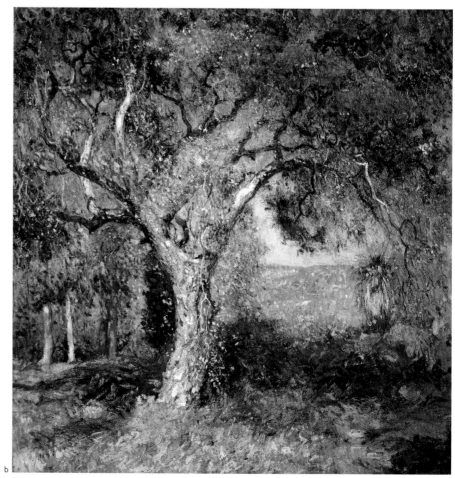

In addition to perpetuating an escapist, premodern vision of California that eschewed regional realities as well as monumental international events such as World War I, scenic California images of this period share other traits. Compared with nineteenth-century California landscapes, generally grand panoramic vistas intended to communicate nature's sublimity, early-twentieth-century variants tend to be smaller in size and narrower in visual scope, focusing on a small expanse of terrain or a single tree, as in John O'Shea's *The Madrone*. They aim less at elevating nature than at conveying a readily accessible, consumable vision of it. In part, these differences bespeak a shift in the country at large toward a more bourgeois—or touristic, consumer-oriented—sensibility among patrons and producers of the arts. Yet California landscapes do stand apart from other scenic American paintings of the period, specifically in the frequency with which they present a "virgin land," untouched by modern life.[10]

69

c

d

e

a
Frances Hammel Gearhart
On the Salinas River, 1920s,
color woodcut

b
William Wendt
*Where Nature's God Hath
Wrought*, 1925, oil on canvas

c
*California: The Campers'
Paradise*, brochure produced
by the Southern Pacific
Railroad, 1909. Lent by the
California State Railroad
Museum

d
John Marshall Gamble
*Breaking Fog, Hope Ranch,
Santa Barbara*, c. 1908,
oil on canvas

e
Leopold Hugo
Untitled, c. 1920, gum
bichromate print

70

The motif of the virgin land is common to an otherwise diverse array of images of California produced at the time, including Guy Rose's Impressionist rendering of a Southern California oak tree in dappled light; Frances Gearhart's highly decorative, Japanese-inspired color wood-block print of the Salinas River; and Oscar Maurer's moody Pictorialist photograph of a eucalyptus grove in Golden Gate Park. Only a tiny farmhouse dots the landscape in William Wendt's exalted view of a California mountainside. In the words of the Bavarian-born Wendt, who had lived in Chicago before coming to California as a tourist in the 1890s, "Here, away from conflicting creeds and sects, away from the soul-destroying hurly-burly of life, it feels that the world is beautiful; that man is his brother; that God is good."[11] Despite its spiritual inspiration, Wendt's painting echoes images featured in promotional materials, such as the Southern Pacific Railroad brochure *California: The Campers' Paradise*, in its boldly composed, celebratory vision of the California landscape.

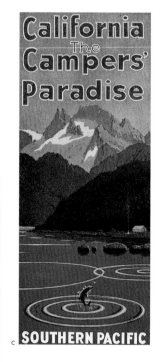

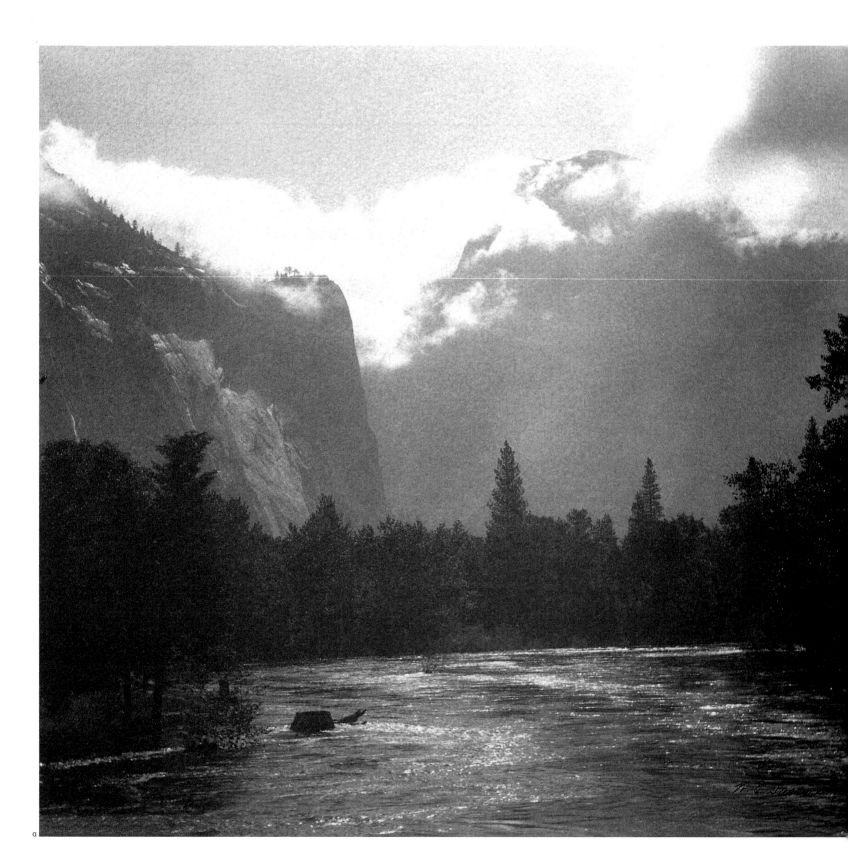

a

William Dassonville

Half Dome and Clouds,

Merced River, Yosemite Valley,

c. 1905, platinum print

b

Underwood and Underwood

Publishers

Yosemite Valley, 1902,

stereograph

b

One of the premier tourist destinations for Americans by the turn of the century was Yosemite, billed as "Our National Playground" after its establishment as a national park in 1890. The creation of the park transpired through the efforts of two unlikely allies—the Southern Pacific Railroad, which featured Yosemite in the first issue of *Sunset*, and the Sierra Club, cofounded by renowned naturalist John Muir in 1892. Indeed, the principal contention over the fate of the parklands was not between the naturalists and the railroads. Rather, it was between the naturalists and those who viewed the region as an answer to San Francisco's need for water, a need that continued to plague the entire state over the course of the century. At stake in particular was the proposed use of the Hetch Hetchy Valley, adjacent to Yosemite Valley, as a reservoir site. Muir and his allies vehemently opposed the idea, and in 1907 Muir urged the public to send letters of protest to the federal government.[12] The proposal's advocates disseminated literature supporting their position—for example, a brochure illustrated with altered photographs approximating what the valley would look like submerged under water—and claimed that the reservoir would only enhance the park's scenic appeal.[13] After a protracted and bitter debate, the Hetch Hetchy proposal passed in 1913.

While Albert Bierstadt and others had painted spectacular majestic views of Yosemite

Valley in the nineteenth century, it was predominantly among photographers that Yosemite remained a popular artistic subject in the early 1900s. Following in the footsteps of Carleton Watkins, photographers such as William Dassonville created images of the park that were exhibited and published as fine art while also promoting Yosemite to high-end audiences as a place to visit. Disseminated to a broader public, stereographic images produced by the company of Underwood and Underwood also appeared on postcards and other souvenir materials. Unlike nineteenth-century variants, these photographs often contain one or two figures dramatically posed at a scenic vista—for example, at the edge of Yosemite's famed Overhanging Rock—through whom the viewer vicariously experiences the scene. The fact that both popular and fine-art images promoted Yosemite to actual and potential visitors—paving the way for the subsequent work of Ansel Adams—reveals that the arts and California's booster industries functioned in tandem in fostering tourism and outdoor recreation in the state.[14]

a

Selden Conner Gile

Boat and Yellow Hills,
n.d., oil on canvas

b

William Keith

*Looking across the Golden
Gate from Mount Tamalpais,*
c. 1895, oil on canvas

c

Maurice Braun

Moonrise over San Diego Bay,
1915, oil on canvas

d

Haruyo Matsui, *Coronado as
Seen through Japanese Eyes,*
booklet, c. 1910. Lent by
the Southwest Museum,
Los Angeles

e

Vacation Land, brochure
produced by the Santa Fe
Railroad, 1915. Lent by the
Seaver Center for Western
History Research

74

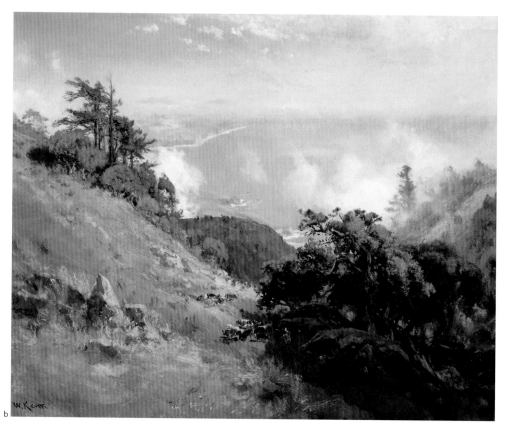

Even more frequently than inland locales, the celebrated California coastline was presented in the arts as an utterly vacant and untouched paradise, despite the explosion of seaside leisure and real estate development by the early 1900s. Here, too, although artists adopted a wide range of stylistic approaches—from William Keith's misty view of San Francisco's Golden Gate painted in the Barbizon tradition to the luminous rendering of San Diego's shoreline by plein air painter Maurice Braun—they almost always eliminated signs of a human presence. In contrast, human figures did appear in materials promoting coastal tourism, where—as in William H. Bull's poster for Monterey's Hotel Del Monte—they were generally engaged in such elite leisure pursuits as golf or polo.

The absence of such references to human activity in California plein air painting, as Landauer has noted, is one of the important factors that distinguishes it from the frequently leisure-filled scenes by the Impressionists working in Europe and on the East Coast.[15] By creating images of a pristine, uninhabited coastline, California artists enabled viewers to imagine themselves according to their own desires, unencumbered by such contemporary realities as tourists, hotels, residences, and local industry. When these artists did include signs of humanity in their works—and this was the case even with modernists such as Selden Conner Gile, a member of the Northern California–based Society of Six—they generally depicted quaint villages or seaports rather than scenes of industrialized, modern life. This choice bespeaks a pervasive nostalgia for an earlier halcyon period among the region's artists, an impulse not as evident among European and East Coast Impressionists, who generally sought to record the contemporary world.[16]

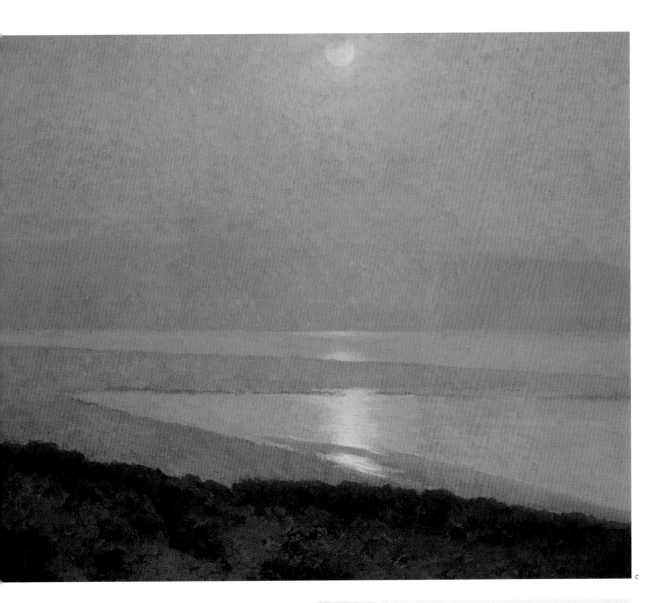

c

e

One of the key coastal spots for creative figures as well as tourists and new residents was the Monterey Peninsula, and particularly the quaint town of Carmel-by-the-Sea. Founded in 1903 by real estate developers who promoted it as an artist colony, Carmel became a particularly attractive refuge for Bay Area artists and literati following the earthquake and fires that ravaged San Francisco in 1906. In 1910 a *Los Angeles Times* headline facetiously characterized Carmel as the "Hotbed of Soulful Culture, Vortex of Erotic Erudition...Where Author and Artist Folk Are Establishing the Most Amazing Colony on Earth."[17]

d

a
Carmel by the Sea, brochure produced by the Carmel Realty Co., c. 1905. Lent by Victoria Dailey

b
William H. Bull, *Polo at Del Monte*, poster, 1917. Lent by Steve Turner Gallery, Beverly Hills

c
Bertha Lum
Point Lobos, 1921, color woodcut

76

a

b

c

d

William Wendt

Malibu Coast [Paradise Cove],
c. 1897, oil on canvas

e

Guy Rose

Carmel Dunes, c. 1918–20,
oil on canvas

Yet artists were not the only people to partake of this region. After the construction of a railroad line from San Francisco in the late nineteenth century, the Monterey Peninsula gained popularity as a convenient getaway for wealthy locals.[18] Whereas its central creative figures, writers George Sterling and Mary Austin, romanticized Carmel as a bohemian enclave isolated in the wilderness, California historian Kevin Starr has characterized it as "an early example of the leisure community," imbued with artistic charm, available at reasonable prices.[19] Emphasizing the artiness of this area, the Carmel Realty Company included a painter's palette on the back cover of its brochure *Carmel by the Sea*. Without doubt, Carmel was a place where the interests of boosters and the creative community often overlapped.

As for the numerous artists who flocked to Carmel during these years, they unquestionably were affected by the commercial development of the region. As Ilene Fort has speculated with

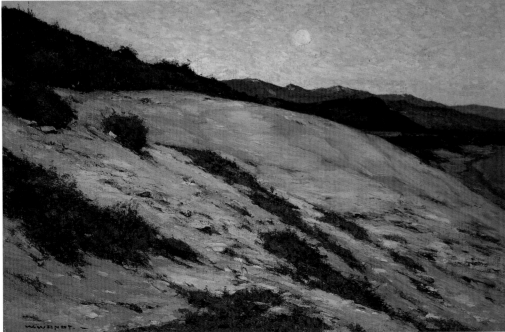

regard to Guy Rose, who made a series of paintings of the Carmel coastline in the 1910s, many artists probably chose to paint vistas that they had read about previously in guidebooks, and their works were influenced by those written descriptions.[20] Rose and others exhibited their scenic, unpopulated seascapes at the Hotel Del Monte, an exclusive resort hotel opened in Monterey in 1880 by the real estate arm of the Southern Pacific Railroad, where they were accessible to wealthy collectors from across the country.[21] Thus, informed by their creators' touristic experiences, these works in turn became visual souvenirs of California for affluent visitors and "advertisements" of the state for friends at home.

78

a

b

In addition to its purportedly unspoiled natural beauty, a salient aspect of the state's image as the Garden of America was its prominence in horticulture, especially citrus and grapes. Indeed, California, which between 1880 and 1920 became an industrialized agricultural empire,[22] was promoted by agribusiness and other booster industries as a veritable cornucopia, where everything from indigenous fruits and flowers to imported palms flourished in gargantuan proportions. Even international tourists sent this image of bounty home, as indicated by a postcard titled *A Carload of Mammoth Strawberries*, which bears a message in Japanese on the back. This conception of profuse natural abundance had a profound impact on the commercial arts in California. For example, it infused visual images that adorned orange crates, which played an enormous role in shaping popular conceptions of the state. It also affected the fine arts, where it fueled the market for certain types of work. Artist Granville Redmond complained that although he preferred other subjects to California's state flower, poppies were what people wanted to buy. He could scarcely paint them quickly enough to satisfy the demand.[23] The flower paintings of Paul de Longpré were also tremendously popular. He was lauded as "Le Roi des Fleurs" (The King of the Flowers), and the

c

a
A Carload of Mammoth Strawberries, postcard, 1910. Lent by the McClelland Collection

b
Crate label for Rose brand oranges, Redlands Orange Growers' Association, c. 1910. Lent by the McClelland Collection

c
Franz Bischoff
California Poppies Vase, n.d., porcelain

d
Granville Redmond
California Poppy Field, n.d., oil on canvas

d

80

a
Postcard showing the garden at Paul de Longpré's home in Hollywood, 1905. Lent by Victoria Dailey

b
Paul de Longpré
Roses La France and Jack Noses with Clematis on a Lattice Work, No. 36, 1900, watercolor on paper

c
Anne M. Bremer
An Old Fashioned Garden, n.d., oil on canvas

d
Mathews Furniture Shop
Rectangular Box with Lid, 1929, painted wood

e
Ira Brown Cross, untitled photograph of agricultural workers, 1908. Courtesy of the Bancroft Library, University of California, Berkeley

f
Randal W. Borough, poster for the Portola Festival, San Francisco, 1909. Lent by Steve Turner Gallery, Beverly Hills

81

e

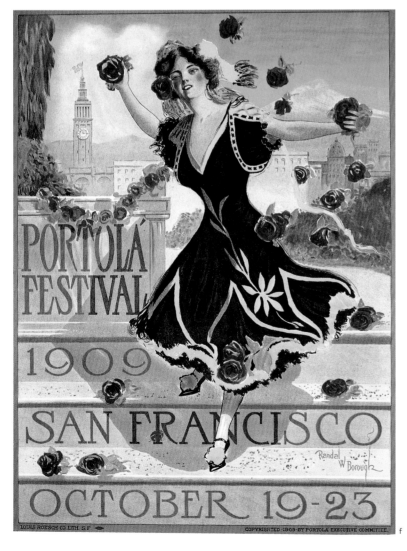
f

spectacular garden at his Hollywood home was a popular tourist attraction during this period. Collectors also loved the delicately painted floral porcelains of Franz Bischoff.[24] Already accomplished in this medium before moving west from Detroit, Bischoff chose to settle and cultivate his private gardens in Pasadena, a city made famous as a horticultural mecca by the Tournament of Roses parade held there since 1890.

In popular imagery, views of neatly planted orange groves adjacent to cozy bungalows—California's answer to the American yearning for private, healthful, and affordable living—fostered a distinctly domestic conception of the state. This vision sharply contrasted with the nineteenth-century image of an uncivilized frontier associated with the Gold Rush. Yet idyllic images of California's domesticated landscape rarely so much as hinted at the human effort expended—largely by Mexican, Japanese, Italian, and other immigrant laborers—to cultivate the natural terrain. Subjects of this sort only appeared in rare documentary images of the period, such as a 1908 photograph by economics professor Ira Brown Cross. Nor did booster images ever allude to the instances of unrest among migratory farmworkers—for example, the violent Wheatland hop-pickers strike of 1913, which was organized by the radical labor organization the Industrial Workers of the World (IWW).[25] Rather, the standard booster conception of the cultivated landscape, serving the interests of agribusiness and largely promoted by the arts, was that of a serene, verdant place that miraculously eschewed the need for human toil, effectively obscuring the harsh realities of the agricultural labor system in California.

82

a

b

In addition to producing fantasy images of the physical environment, California's booster industries and individuals presented the cultural landscape to Anglo audiences through a variety of mythologizing and exoticizing lenses. Often references to disparate cultures were mixed and overlaid, fostering a sort of pan-exoticism in California, whereby Mexico was crossed with the Middle East or Asia with classical Greece. At times, however, attention was focused on specific ethnic or cultural groups—either their contemporaneous manifestation or their historical past. In most cases, the groups in question were inaccurately envisioned by Anglo culture as indelibly ancient peoples, whose age-old customs needed to be documented before they vanished. While such identities were ascribed in the guise of celebrating or aiding these peoples, in fact they enabled an Anglo assertion of cultural dominance and superiority over the state's nonwhite populations.

Another such means of asserting cultural superiority, especially popular within literary and artistic circles and among wealthy Bay Area collectors, entailed ignoring California's nonwhite populations altogether and mythologizing the state as a Mediterranean haven along the lines of ancient Athens or Rome. Influenced by the American Renaissance style's Italianizing impulse, which permeated cultural production nationwide,[26] artists visually echoed the sentiments of popular writers. Charles Dudley Warner, author of *Our Italy* (1891), for example, asserted that the Mediterranean sensibility was perfectly matched with California's indigenous climate and terrain. Venerated Bay Area artist and teacher Arthur Mathews frequently invoked classical Mediterranean culture in the publication he edited, *Philopolis*. He asserted that contemporary (Anglo) Californians should adopt the more balanced lifestyle of the ancient Greeks and Romans.

a
Arthur Frank Mathews
California, 1905, oil on canvas

b
Mathews Furniture Shop
Desk, c. 1910–15, carved and painted maple [?], oak, tooled leather, and replaced hardware

c
Gottardo Piazzoni
Untitled Triptych, n.d., oil on canvas

d
Arthur Bowen Davies
Pacific Parnassus, Mount Tamalpais, c. 1905, oil on canvas

e
Anne W. Brigman
Infinitude, c. 1905, gelatin-silver print

83

This enthusiasm for the classical past infused the work of Mathews and his wife, furniture designer Lucia Mathews. Both were major figures in the Arts and Crafts movement, an artistic reaction against industrialization that called for a return to handcraftsmanship and a life led in harmony with nature. Although it began in England, the movement found its ideal home in California. The handsome, highly decorative objects produced by the couple's furniture

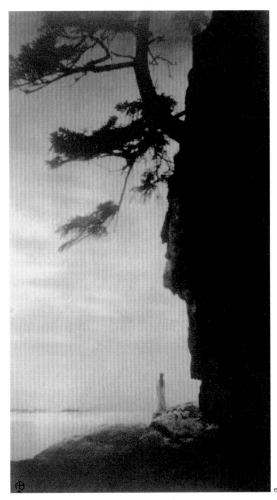

shop were commonly adorned with colorful arcadian scenes of classicized figures communing with nature. In addition to other Arts and Crafts artists, Bay Area figures who shared the Mathewses' penchant for the ancients included painters Gottardo Piazzoni and Xavier Martinez. Piazzoni, for example, used classical columns to divide the three sections of his moody *Untitled Triptych*.

a

b

Many of the writers and artists who invoked these classical associations, including Martinez and Piazzoni, were members of the Bohemian Club of San Francisco. Founded in 1872, this exclusive confederation of prominent businessmen, journalists, writers, and artists—a major cultural force in the region at this time—regularly congregated outdoors. One writer mused in the Bohemian Club publication *The Lark* that immersing himself in the woods of Northern California invariably transported him to an ancient Arcadia: "We had a camp there which was an Arden in an Arcady. We were all young, happy, and sane beneath those boughs, and there came to us there a revelation of simple living, and clean-minded pastimes."[27] These associations served to strengthen a white, anti-urban conception of California. Moreover, they attempted to legitimize the region's cultural heritage by linking California to the ancient nucleus of Western civilization.

In Southern California, particularly with the impact of early Hollywood on Pictorialist photographers (including award-winning cinematographer Karl Struss and Arthur Kales, who often used actresses and dancers as models), the Mediterranean metaphor took on a decidedly theatrical bent. This taste for theater also infused real estate developer Abbot Kinney's grand conceptualization of Venice, California (begun in 1892; finished in 1904), as a replica of its European namesake, complete with canals, gondolas, and a doge's palace.

In Hollywood, and further south in the San Diego area, the classicizing impulse also manifested itself in the spiritual enclaves of Krotona, founded by Albert P. Warrington, and Katherine Tingley's Lomaland. These communities drew the spiritually hungry and the curious from all over the world to California. And Lomaland, the international headquarters for

a
Karl Struss
Monterey Coast, 1910–15,
gelatin-silver print

b
Arthur Kales
The Sun Dance, c. 1920,
gelatin-silver print

c
Edouard A. Vysekal
Springtime, 1913, oil on
paper, mounted

d
Rex Slinkard
Infinite, c. 1915–16, oil on
canvas

c

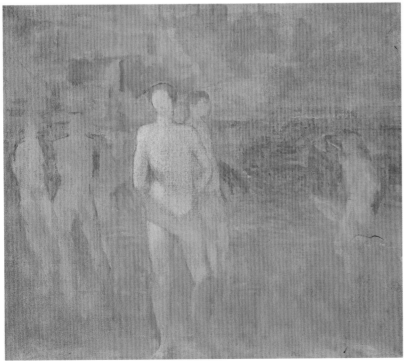

d

a
Souvenir album of Lomaland,
Point Loma, 1913. Lent by
the Theosophical Society
(Pasadena)

b
*Diotima, Myrto, and
Aspasia*, frontispiece from
The Theosophical Path
(November 1911). Lent by
the Theosophical Society
(Pasadena)

c
Reginald Machell
*Katherine Tingley's Chair,
The Theosophical Society,
Point Loma*, c. 1905–10,
carved and painted wood

86

a

b

c

the Universal Brotherhood and Theosophical
Society, attracted a considerable number of
artists. In their designs for Theosophical publica-
tions and in individual works of art, many of
these figures fostered Lomaland's aesthetic, which
incorporated elements of classical, medieval, and
Near Eastern sources, among others. Reginald
Machell, the principal designer of Lomaland's
ceremonial rooms, carved an elaborately filigreed
screen and the principal ceremonial chair used
by Tingley. Machell's screen is pictured in a
photograph of three Theosophical devotees—
described only as "Diotima, Myrto, and
Aspasia"—at Lomaland's Greek Theater. Such
figures and the enclaves where they congregated
supported a premodern vision of California as
safely (if eccentrically) locked in a spiritually
nourishing, ancient past.

Classical antiquity was but one cultural
lens through which California was viewed.
Perhaps the most pervasive cultural mythology
of the period, which continues to have an impact
on conceptions of California today, involved the
romanticization of the state's Spanish mission
history. The impetus for this mythology was the
publication of Helen Hunt Jackson's immensely
popular *Ramona* (1884), a sentimental tale of

d
Frederick J. Schwankovsky
Woman at the Piano,
c. 1925, oil on canvas

e
Robert Wilson Hyde
A House Book, 1906, suede
and brass cover, suede
flyleaves, parchment, wove
rag paper, and ink

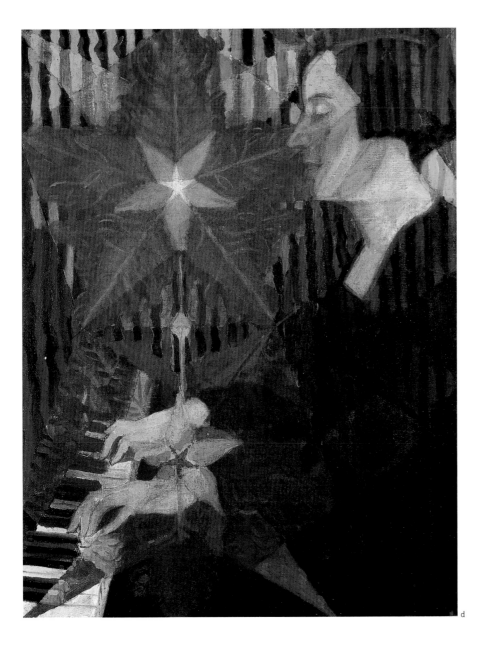

d

CALIFORNIA LIVING

Arts and Crafts

At the turn of the nineteenth century, travelers to California sought a paradise that promised renewal, a healthy lifestyle, and a connection to nature. This spirit informed the Arts and Crafts movement, which flourished in California from the 1880s to the 1920s. This social reform movement was originally driven by the philosophies of Englishmen John Ruskin and William Morris, whose tenets of simplicity and usefulness had direct application to architecture and decorative arts. Ruskin and Morris protested the quality of the products of the Industrial Revolution, and they rejected mechanization in favor of handcrafting, rustic simplicity, indigenous materials, and motifs inspired by nature. Arts and Crafts reformers advocated a harmonious integration of elements to create a comfortable and healthy environment. They believed that homes designed according to such principles

e

background
Greene and Greene
Robert R. Blacker House,
Pasadena, South Elevation,
Drawing #6, 1907, black ink
on linen

a
California Faience
Vase, c. 1920, earthenware

88

a

b

promoted physical and spiritual well-being, both assuring a healthful society.

The classic Arts and Crafts home was the low-profile, horizontal wooden bungalow. Among the most celebrated designers in this style were the architects Bernard Maybeck and Charles Keeler of Northern California and the brothers Charles Sumner and Henry Mather Greene, founders of the Pasadena architectural firm Greene and Greene in Southern California. Bungalows were originally intended to be economical and of simple design. Maybeck and Keeler adhered to these paradigms, whereas Greene and Greene's four California bungalow commissions were lavish, monumental structures with elegant custom furnishings and were therefore christened "ultimate bungalows."

The Arts and Crafts period environment in the *Made in California* exhibition featured original Greene

and Greene furniture from the Robert R. Blacker and William R. Thorsen house commissions, art pottery, metal accessories, a hand-carved fireplace screen, and California Indian baskets. The mahogany furniture with ebony joinery is inlaid with metal and shell in a naturalistic Japanese motif that fuses Asian and Western design and honors nature as the wellspring of inspiration.

In the ideal Arts and Crafts home, light fixtures were intended to softly illuminate the interior, windows framed outdoor vistas, the fireplace served as a welcoming beacon, and pottery and baskets celebrated handcrafting: This was the ambience of warmth, comfort, harmony, and inspired aesthetic living that defined the Arts and Crafts lifestyle.

JO LAURIA

I think C. Sumner Greene's work beautiful . . . Like [Frank] Lloyd Wright the spell of Japan is on him, he feels the beauty and makes magic out of the horizontal line. C. R. ASHBEE, 1909

SOUTH ELEVATION.
Scale. One quarter-inch = One foot.

b
California Faience
Vase, c. 1920, earthenware

c
Greene and Greene
*Bedroom Cabinet from the
Robert R. Blacker House,
Pasadena*, 1907, mahogany,
ebony, oak, boxwood, copper,
silver-plated steel, and
abalone

d
Dirk Van Erp Copper Shop
Table Lamp, c. 1915, copper
and mica

e
Greene and Greene
*Bedroom Rocking Chair from
the Robert R. Blacker House,
Pasadena*, 1907, mahogany,
ebony, oak, boxwood, copper,
silver-plated steel, abalone,
and cotton upholstery

89

c

d

e

a
Helen MacGregor
Reclining Woman with Guitar,
c. 1921, gelatin-silver print

b
Souvenir book for John Steven
McGroarty's *The Mission Play,*
1928. Lent by Jim Heimann

c
Cover illustration for a
brochure published by the
Los Angeles Chamber of
Commerce promoting
Los Angeles County, 1930s.
Lent by Jim Heimann

d
Alvin Langdon Coburn
*Giant Palm Trees, California
Mission,* 1911, platinum print

90

ill-fated love between an Indian man and Ramona, a so-called half-breed. Set in enchanting Old California, Jackson's novel precipitated a veritable tourist craze, inspiring pilgrimages to the sites where Ramona's tragic drama unfolded. By means of the Mission Myth, the region's boosters recast California's mission history in glorifying terms and whitewashed the Spaniards' gross mistreatment and colonization of Native Americans, thereby supplying tourists and displaced newcomers with a comforting, shared vision of a golden regional past. As Carey McWilliams has dryly characterized it, the Mission Myth reenvisioned the missions as "havens of happiness and contentment" for the local Indians and sentimentalized Californios (the descendants of the Spanish colonists) of the subsequent rancho era as "members of one big happy guitar-twanging family, [who] danced the fandango and lived out days of beautiful indolence."[28]

e

Charles Rollo Peters
Adobe House on the Lagoon,
n.d., oil on canvas

Manuel Valencia
*Santa Barbara Mission at
Night,* n.d., oil on canvas

f

California's twenty-one missions symbolized a romantic, bygone era. In addition to spawning the antimodernist Mission Revival style in architecture—epitomized by Frank Miller's famous Mission Inn in Riverside—the missions were the focus of concerted preservationist efforts, bespeaking the idealism of the Progressive Era. The Landmarks Club was founded to this preservationist end in 1894 by Charles Fletcher Lummis, whose enthusiasm for Alta California inspired him to dress in Old Spanish attire and to go by "Don Carlos." (The appellation "Don" associated Lummis with the Spanish landlords of Indian land and labor grants.) Advocates such as Lummis sought not to restore the missions but to preserve them in all of their picturesque, crumbling beauty.[29] Not surprisingly, the numerous artists who depicted this subject matter for eager audiences—among them many Pictorialist photographers and Tonalist painters, such as Charles Rollo Peters—tended toward moody, often nocturnal scenes that nostalgically invoked the image of a beautiful, waning civilization.

An emblem of progressivism, Jackson's *Ramona* was intended to foreground the plight of contemporary Indians. It did give rise to the Sequoya League, which aided 300 displaced Native Americans, albeit with the patronizing aim "To Make Better Indians."[30] Yet the proponents of the Mission Myth conceived of Native Americans in primitivizing terms, as an abject, disappearing race rather than as a vital contemporary presence. In addition to eccentric ethnographer and collector George Wharton James, others who promoted a conception of California's Indians as noble yet impotent vestiges of an ancient culture included photographers Edward Curtis and Adam Clark Vroman. Their images, populated by women and the elderly, presented Native American culture as

a

a
Channel P. Townsley
Mission San Juan Capistrano,
1916, oil on canvas

b
W. Edwin Gledhill
Santa Barbara Mission,
c. 1920, gelatin-silver print

92

posing no threat to contemporary Anglo society, in contrast to pervasive earlier depictions of Indians as a savage race of brutal warriors. They fueled the widespread notion that California's Native Americans were an especially pitiable subgroup from the bottom of the evolutionary chain. As an 1897 *New York Herald* article reported, "It seems to have been the consensus of opinion of all ethnologic students that California gave birth to nearly the lowest type of human creatures who have inhabited the earth. It is the belief of … [a] noted ethnologist that the Pacific coast tribes, all in all, are the most primitive and least physically and mentally developed of any of the tribes of North America."[31] Demeaning images such as *The Belles of San Luis Rey Mission*, which was printed on postcards and published in an 1894 issue of *Land of Sunshine* that accompanied a nostalgic article on Alta California, reinforced this perception.[32]

Unable to escape being labeled as Other by the dominant culture, the living members of these objectified cultures at times utilized the stereotypes to their own ends. For example, California's Native Americans used the perception of their culture as pitiful to garner support from Anglos in protecting their lands from encroachment by ranchers and others. And though in part fulfilling Anglo expectations of what constituted Native American culture, California Indians responded to the vogue for woven baskets and rugs among tourists and local collectors by fashioning functional objects into decorative consumer goods. These objects—for example, a finely woven trinket basket probably made expressly for sale by Elizabeth Hickox of the Northern California Karok tribe—were more elaborate than traditional utilitarian objects, such as a gathering basket in openwork style eventually acquired by George Wharton

c
Edward S. Curtis
A Desert Cahuilla Woman from
The North American Indian,
vol. 15 (1924), pl. 522,
photogravure

d
Adam Clark Vroman
San Gabriel Mission, c. 1910,
gelatin-silver print

e
*The Belles of San Luis Rey
Mission*, postcard, 1903. Lent
by the McClelland Collection

f
Edward S. Curtis
Mitat—Wailaki from
*The Native North American
Indian*, vol. 14 (1924), pl. 472,
photogravure

94

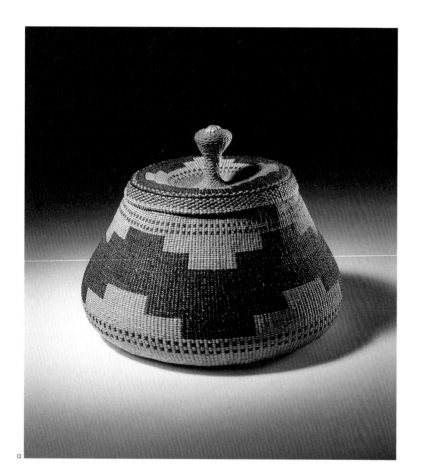

a

James, the California booster and enthusiast of Native American culture.

The Mission Myth was also fostered by Californios such as Manuel Valencia, a descendant of one of the first Spanish families in California, who painted romantic, nocturnal scenes of missions. The same is true of Don Antonio de Coronel, mayor of Los Angeles in the 1850s, who effectively marketed himself as an old-world Spaniard, serving as an advisor to Helen Hunt Jackson and others.[33] As these men undoubtedly recognized, the romanticized image of the dons of Alta California was far preferable to the derogatory view of contemporary Mexicans that prevailed within the dominant culture. By and large, proponents of the mission mythology remained unsympathetic to descendants of the cultures they sentimentalized, preferring instead to hold Spanish fiestas, study traditional Native American basket-weaving techniques, and wistfully laud the waning cultures of yore.

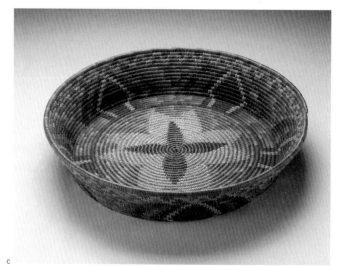

c

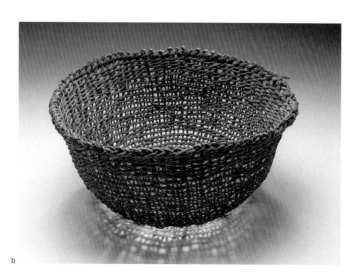

b

95

One contemporary ethnic group—those of Chinese descent who inhabited the Chinatowns of San Francisco, Los Angeles, San Diego, and smaller California locales—was a visible subject of fascination and contention within the dominant culture. On the one hand, Chinatowns were popularized as exotic destinations for Anglo tourists and locals and were a great source of intrigue for aesthetes in the Bay Area, including members of the Bohemian Club. On the other, Chinese immigrants were attacked by a number of forces—among them, the Asiatic Exclusion League, the American Federation of Labor, and even California senator (and former San Francisco mayor) James Phelan—as vice- and disease-ridden detriments to society who threatened the American labor system by depressing wages.[34] These detractors sought to uphold the Chinese Exclusionary Acts, which had barred further Chinese immigration to the United States as of 1882, and a host of subsequent anti-Asian laws. That Phelan, one of the most vehement proponents of these laws and author of the publication *Keep California White*, was a president of the Bohemian Club demonstrates that sometimes these attacks came from the same camps in which Asian culture was celebrated on an aesthetic level. Notable among the voices that rose to counter these anti-Asian sentiments was that of Chinese consul Ho Yow. In a 1901 article in *Overland Monthly*, the consul characterized his fellow countrymen in terms intended to appease—as "a sober, temperate, and industrious class...intelligent and easy to control." He promised that "by employing Chinese labor you get your money's worth of faithful, steady toil."[35]

Except for portraits of residents by local Chinese photographers, virtually all of the extant visual images of California's Chinatowns from before 1920 were produced by and for whites. Those created by artists, including

d

e

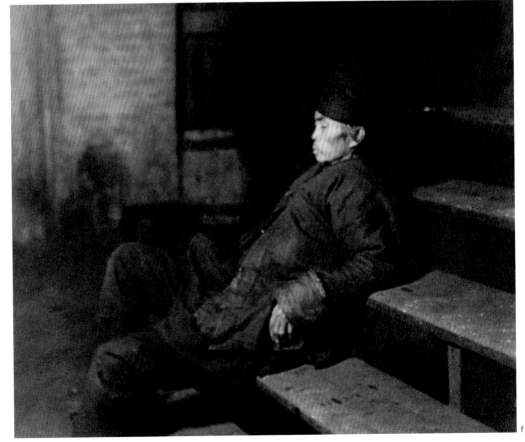

f

96

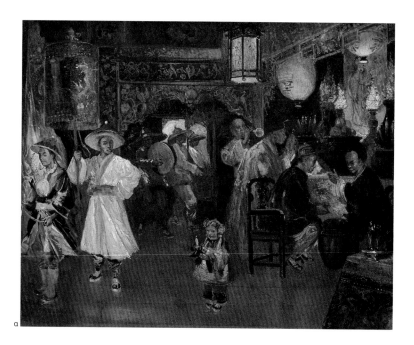

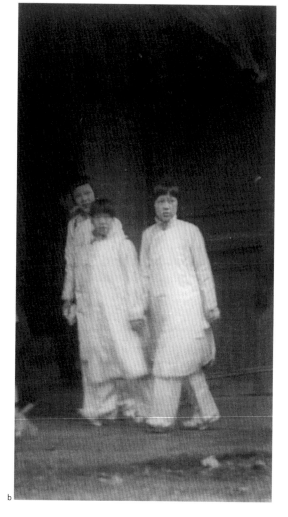

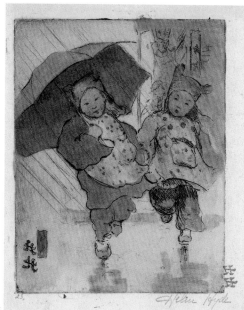

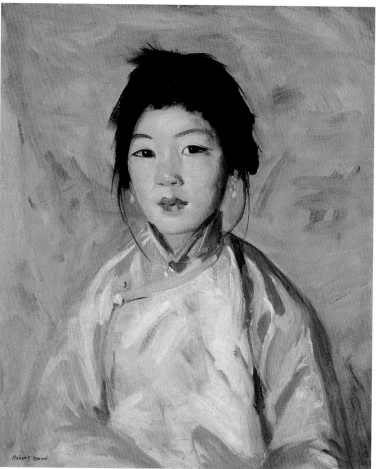

a
Henry Nappenbach
Chinese New Year Celebration, San Francisco, 1904, oil on canvas

b
Herman Oliver Albrecht
Three Women in White, c. 1910, gelatin-silver print

c
Helen Hyde
Imps of Chinatown, 1910s, etching with hand color

d
Robert Henri
Tam Gan, 1914, oil on canvas

e
Arthur Burnside Dodge
Taken by Surprise, n.d., watercolor on paper

97

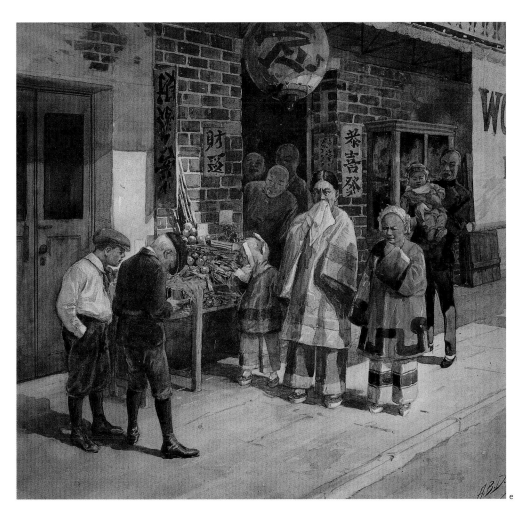

German emigré Arnold Genthe's photographs, strongly resemble the images that appeared on postcards and other mass-market tourist souvenirs. In fact, Genthe's initial intention in taking photographs of Chinatown was to capture what he saw as the exotic flavor of the place for his family in Germany.[36]

Many of the Chinatown images created by artists were meant to be positive in that they presented their subjects as visually appealing, nonthreatening, and generally sympathetic. Thus it is not surprising that photographs by Genthe were used to illustrate Consul Ho Yow's article in defense of his immigrant countrymen (although Genthe was a faithful member of the Bohemian Club, which had elected Asian xenophobe Phelan as its president). Yet Genthe and the majority of white artists picturing Chinatown objectified and exoticized their subjects, revealing the voyeuristic sensibility of a distanced, invisible observer. By far the subjects of choice were passive women, children, and elderly people, as well as opium dens and late-night celebrations, as opposed to intact nuclear families or men engaged in daily labor. The most popular images nostalgically featured San Francisco's Old Chinatown before the enclave had been devastated by the 1906 earthquake and rebuilt as a more tourist-oriented space, as evidenced by the success of Genthe's widely circulated *Pictures of Old Chinatown* (1908). These images depicted Chinese subjects exclusively in traditional dress, thereby effacing any evidence of cultural assimilation or modernization.

Among the few artists to diverge somewhat from this characterization was Arthur Burnside Dodge. Although Dodge persisted in portraying Chinese subjects in traditional attire, he depicted less conventional views of Los Angeles's Chinatown. These include a group of men reading want ads and an encounter between tourists and local residents that acknowledges the presence of whites as visual and financial consumers of Chinatown. In general, however, California's artists accorded with its tourist industries in promoting notions of the Chinese as an effete and enigmatic people and of the state's Chinatowns as authentic, hermetically sealed, and expressly premodern spaces on the verge of vanishing. Ironically, the romantic vision of Chinese culture as being on the brink of extinction proved sadly accurate: anti-immigration laws were in fact successfully shrinking the state's Chinese population.

a
Official program, Panama-
Pacific International
Exposition, San Francisco,
1915. Lent by the California
Historical Society, North
Baker Research Library,
Ephemera Collection

b
Postcard from the Panama-
Pacific International
Exposition, San Francisco,
featuring the Tower of Jewels
and James Earle Fraser's
statue *The End of the Trail*,
1915. Lent by the McClelland
Collection

c
Souvenir stamps, Panama-
Pacific International
Exposition, San Francisco,
1915. Lent by the California
Historical Society, North
Baker Research Library,
Ephemera Collection

98

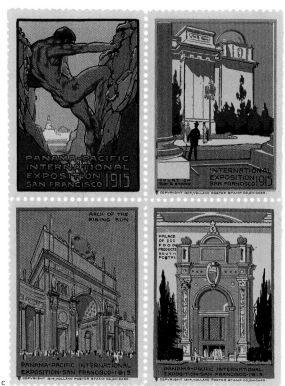

All of the prevailing mythologies of California, involving both the regional culture and the natural environment, were promoted forcefully at the expositions of art and culture that featured or were hosted by California during these years. Among the most notable examples are the Chicago World's Columbian Exposition of 1893, the first international fair to have a separate building devoted solely to California, and the two expositions held in San Francisco and San Diego in 1915. The latter were, respectively, the Panama-Pacific International Exposition (PPIE), which celebrated the opening of the Panama Canal; and the Panama-California Exposition (PCE), intended to rival the PPIE once San Francisco had been declared the site of the official international exposition. Like other expositions held in the United States during this period, these three were federally subsidized and organized by prominent members of the local business community intent on expanding regional commerce and celebrating America as an imperial power. According to Robert Rydell, expositions of this period fostered a sense of unity among whites of disparate classes by promoting a Darwinian conception of racial progress that culminated in the ascension of the Anglo race.[37] The message communicated at the two 1915 California expositions was that the American West was the final frontier where this history of racial ascendancy played itself out: first, with the Spanish subjugation of the Indians, then with the Anglo conquest of Alta California.[38]

At the 1893 Chicago exposition, many of the mythologies of California that would become central to its early-twentieth-century image— notably, its physical beauty, its fecundity, and its romantic mission past—were encapsulated and intermingled in the fair's displays and in promotional materials devoted to the state. In honor of

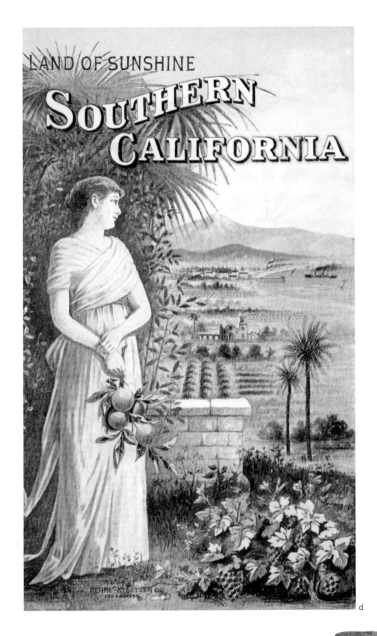

d

d

Harry Ellington Brook's
*Southern California: The Land
of Sunshine*, booklet spon-
sored by the Los Angeles
Chamber of Commerce for the
Chicago World's Columbian
Exposition, 1893

e

Official guidebook, Panama-
California Exposition,
San Diego, 1915. Lent by the
Sierra Madre Public Library

f

Brochure promoting the
Panama-California Exposition
produced by the U. S. Grant
Hotel, San Diego, 1915. Lent
by Victoria Dailey

9 9

this sense of regional identity was communicated
at the San Francisco exposition through the use
of Mission Style architecture in the California
Building (most of the fair's other buildings were
rendered in a Beaux-Arts style), it was stressed
even more forcefully at the San Diego PCE.
There, the entire complex was designed by archi-
tect Bertram Goodhue in an ornate Spanish
Colonial–Baroque style that resuscitated the
Spanish imperial past in unequivocally glowing
terms. As one reporter marveled, "It is as
though one stood on a magic carpet, wished
himself on the shores of Spain three centuries
ago and found the wish fulfilled." Embracing
the idealized conception of Spanish culture that
was being served up to visitors, another enrap-
tured writer dubbed the exposition grounds
"a sweet and restful land where 'castles in Spain'
seem realities; a land in which you loaf and
invite your soul."[40]

the exposition, the Los Angeles Chamber
of Commerce issued the publication *Southern
California: The Land of Sunshine*.[39] Published in
conjunction with the opening of the California
Building, it features on its cover a classicized alle-
gorical figure of California. The burgeoning
orange bough clasped near her womb conveys
the fertility of the region. Behind her lies a thriv-
ing cultivated landscape with palm trees and,
beyond that, a classic picturesque mission. This
idyllic conception, fervently marketed to the mil-
lions of visitors who attended the fair, reappeared
on a grander scale at the two major California
expositions of 1915.

 Heavily supported by the railroads and
other booster industries, the San Francisco and
San Diego expositions perpetuated visions of
California as a scenic, bountiful paradise with a
distinct regional history and ethnic flavor. While

e

f

a

b

100

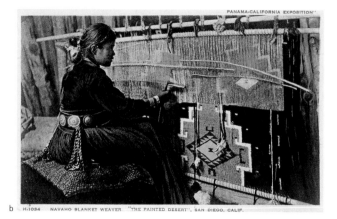

While ethnicity was addressed in anthropological exhibits on the main exposition grounds at both of the 1915 fairs, California's nonwhite ethnic groups were largely ghettoized in adjacent entertainment-oriented midways, intended as counterbalances to the "serious" exhibitions of art, anthropology, and technology. For example, both the PPIE's Joy Zone and the PCE's Isthmus, as these midways were respectively called, featured a little Chinatown, where Chinese culture was presented as exotic, illicit, and sinister. In the San Diego version, a journalist reported on "an underground opium den where effigies in wax depicted the horrors of addiction."[41] The similarly denigrating Underground Chinatown at the PPIE was closed after protest by San Francisco's Chinese business community—the closure marked an effort by white local business to foster economic relations with China—only to be replaced by a virtually identical concession called Underground Slumming.[42] Another PPIE Joy Zone attraction was a fantasy reconstruction of a Mexican village. While outfitted for modern commerce with a restaurant and theater, it was staffed by "primitive" Mexicans working at what was described as "characteristic handicrafts."[43] The term was clearly meant to distinguish the objects they were producing from contemporary "fine" art.

One of the most popular concessions at the PCE was the Painted Desert. A ten-acre exhibit, it featured pueblos re-created on the site and a group of present-day Native Americans actually engaging in the traditional practices of basket, pottery, and rug making for the viewing and buying pleasure of exposition-goers.[44] Tellingly, it was placed opposite a display celebrating California's modern technological advances in agriculture, reinforcing the contrast between the "primitive" past and the vital present.[45] Although dubbed a "living exhibit," the Painted Desert proved quite the opposite, sounding a death knell on Native American culture by presenting Indians as ancient artifacts. It is hardly surprising that the Atchison, Topeka, and Santa Fe Railroad sponsored this display, for this decision made good business sense. Such presentations of the region's non-Anglo cultures as disappearing were tremendously appealing and comforting to white visitors, effectively drawing great numbers of them to the expositions and, more generally, to California.

For this brief period early in the century, booster images of California as a premodern, Edenic paradise dominated cultural production in the state. Yet California was far from the homogeneous haven for Anglo culture that it was purported to be. Although largely suppressed during these years, views of California that diverged from the white booster image did exist and would soon gain greater visibility. Indeed, this was the last period in which a glowing conception of the state prevailed, or in fact when any cohesive image could be said to dominate. After this point, California would become a contested Eden.

1 For migration statistics, see Robert M. Fogelson, *The Fragmented Metropolis: Los Angeles, 1850–1930* (Berkeley and Los Angeles: University of California Press, 1967), 78. On manufacture increase, see Carey McWilliams, *Southern California: An Island on the Land* (1946; reprint, Salt Lake City: Peregrine Smith, 1990), 130.

2 On the migrant population in Los Angeles, as distinct from San Francisco as well as other American cities at the turn of the century, see Fogelson, *Fragmented Metropolis*, 68–81.

3 Ibid., 143.

4 On the role of the railroads in promoting California and other western states, see Alfred Runte, "Promoting the Golden West: Advertising and the Railroad," *California History* 70 (1991): 62–65.

5 Kevin Starr, *Inventing the Dream: California through the Progressive Era* (New York: Oxford University Press, 1985), 89.

6 Ibid., 76–77, 82–83.

7 Susan Landauer, "Impressionism's Indian Summer: The Culture and Consumption of California 'Plein-Air' Painting," in *California Impressionists*, exh. cat. (Athens, Ga.: Georgia Museum of Art, University of Georgia, and the Irvine Museum, in association with University of California Press, Berkeley and Los Angeles, 1996), 11–49.

8 McWilliams, *Southern California*, 149.

9 For further discussion of this painting and other images of the San Francisco earthquake and fire, see Claire Perry, *Pacific Arcadia: Images of California, 1600–1915*, exh. cat. (New York: Oxford University Press, 1999), 187–92.

10 Henry Nash Smith uses the term "virgin land" to characterize mythic conceptions of the West in the nineteenth-century popular imagination that culminated in Frederick Jackson Turner's frontier hypothesis. Smith is referring to an essentially agrarian utopia, as opposed to a land completely devoid of habitation. See Smith's *Virgin Land: The American West as Symbol and Myth* (New York: Vintage Books, 1950). East Coast Impressionists also painted nostalgic visions of the premodern natural landscape. See H. Barbara Weinberg, Doreen Bolger, and David Park Curry, *American Impressionism and Realism: The Painting of Modern Life, 1885–1915*, exh. cat. (New York: Metropolitan Museum of Art, 1994), 67–77.

11 Quoted in Landauer, "Impressionism's Indian Summer," 21.

12 The protest letter, signed by John Muir et al., Nov. 1, 1907, stated, "As a lover of the Yosemite National Park, I most devoutly protest against the use of one of its most important and beautiful features, the Hetch Hetchy, as a reservoir. An abundance of water can be had elsewhere to supply San Francisco." William Badé Papers, Hetch Hetchy folder, Bancroft Library, University of California, Berkeley. On the Hetch Hetchy controversy, see Gray Brechin, *Imperial San Francisco: Urban Power, Earthly Ruin* (Berkeley and Los Angeles: University of California Press, 1999), 101, 102, 108–10.

13 John R. Freeman, *On the Proposed Use of a Portion of the Hetch-Hetchy, Eleanor and Cherry Valleys* (San Francisco: Rincon, 1912).

14 Similarly, in Southern California the arts contributed to the promotion of such tourist destinations as Mt. Lowe in the San Gabriel Mountains.

15 Landauer, "Impressionism's Indian Summer," 22.

16 Ibid., 40.

17 Willard Huntington Wright, "Hotbed of Soulful Culture, Vortex of Erotic Erudition," *Los Angeles Times*, May 22, 1910.

18 Earl Pomeroy, *In Search of the Golden West: The Tourist in Western America* (New York: Knopf, 1957), 23.

19 Kevin Starr, *Americans and the California Dream: 1850–1915* (New York: Oxford University Press, 1973), 268. On the art community at Carmel, see also Michael Orth, "Ideality to Reality: The Founding of Carmel," *California Historical Society Quarterly* 48 (1959): 195–210.

20 Ilene Susan Fort, "The Cosmopolitan Guy Rose," in Patricia Trenton and William H. Gerdts, *California Light 1900–1930*, exh. cat. (Laguna Beach: Laguna Art Museum, 1990), 111.

21 On tourism and the Hotel Del Monte, see Pomeroy, *In Search of the Golden West*, 19–20.

22 On California's agricultural history told from the perspective of labor, see Cletus E. Daniel, *Bitter Harvest: A History of California Farmworkers, 1870–1941* (Ithaca, N.Y.: Cornell University Press, 1981).

23 *A Time and Place: From the Ries Collection of California Painting*, exh. cat. (Oakland: Oakland Museum Art Department, 1990), 34.

24 *Reflections of California: The Athalie Richardson Irvine Clarke Memorial Exhibition*, exh. cat. (Irvine: Irvine Museum, 1992), 158.

25 On Wheatland and the involvement of the IWW in organizing migratory laborers through World War I, see Daniel, *Bitter Harvest*, 86–98.

26 See Starr, *Inventing the Dream*, 77.

27 *Bayside Bohemia: Fin de Siècle San Francisco and Its Little Magazines* (San Francisco, 1954), 20–21, quoted in Starr, *Americans and the California Dream*, 259.

28 McWilliams, *Southern California*, 22.

29 John Ott, "Missionary Work: Labor, Nostalgia, Philanthropy, and the California Mission Revival, 1883–1920," paper delivered at American Studies Association conference, Seattle, Nov. 1998.

30 "To Make Better Indians" was the motto of the Sequoya League. See their second bulletin, *The Relief of Campo* [c. 1905]. Archives of the Southwest Museum, Sequoya League, Bulletins folder.

31 "Pictures of Misery: California's Mission Indians, the Most Pitiable Band on the American Continent. What They Really Need," *New York Herald*, Mar. 21, 1897. Topical California Collection, Mission Indians Box, Huntington Library, Prints and Drawings Department, San Marino, California.

32 Harry Ellington Brook, "Olden Times in Southern California," *Land of Sunshine*, July 1894, 29–31.

33 Starr, *Inventing the Dream*, 56–57.

34 K. Scott Wong, "Cultural Defenders and Brokers: Chinese Responses to the Anti-Chinese Movement," in *Claiming America: Constructing Chinese American Identities during the Exclusion Era*, ed. K. Scott Wong and Sucheng Chan (Philadelphia: Temple University Press, 1998), 5.

35 "The Chinese Question," *Overland Monthly* 38, no. 4 (Oct. 1901): 257, 256.

36 Keith F. Davis, *An American Century of Photography: From Dry-Plate to Digital, The Hallmark Photographic Collection*, 2nd ed. (Kansas City, Mo.: Hallmark Cards in association with Harry N. Abrams, New York, 1995), 32–33.

37 Robert W. Rydell, *All the World's a Fair: Visions of Empire at American International Expositions, 1879–1916* (Chicago: University of Chicago Press, 1984), 235–37.

38 Ibid., 209, 211.

39 Harry Ellington Brook, *Southern California: The Land of Sunshine, An Authentic Description of Its Natural Features, Resources, and Prospects* (Los Angeles: World's Fair Association and Bureau of Information, 1893).

40 Both are quoted in Phoebe S. Kropp, "'There is a little sermon in that': Constructing the Native Southwest at the San Diego Panama-California Exposition of 1915," in *The Great Southwest of the Fred Harvey Company and the Santa Fe Railway*, ed. Marta Weigle and Barbara A. Babcock, exh. cat. (Phoenix: Heard Museum, 1996), 43.

41 Ibid.

42 Rydell, *All the World's a Fair*, 229.

43 Ibid., 228.

44 For the best analysis of the Painted Desert, see Kropp, "'There is a little sermon in that,'" 36–44.

45 Ibid., 36, 44.

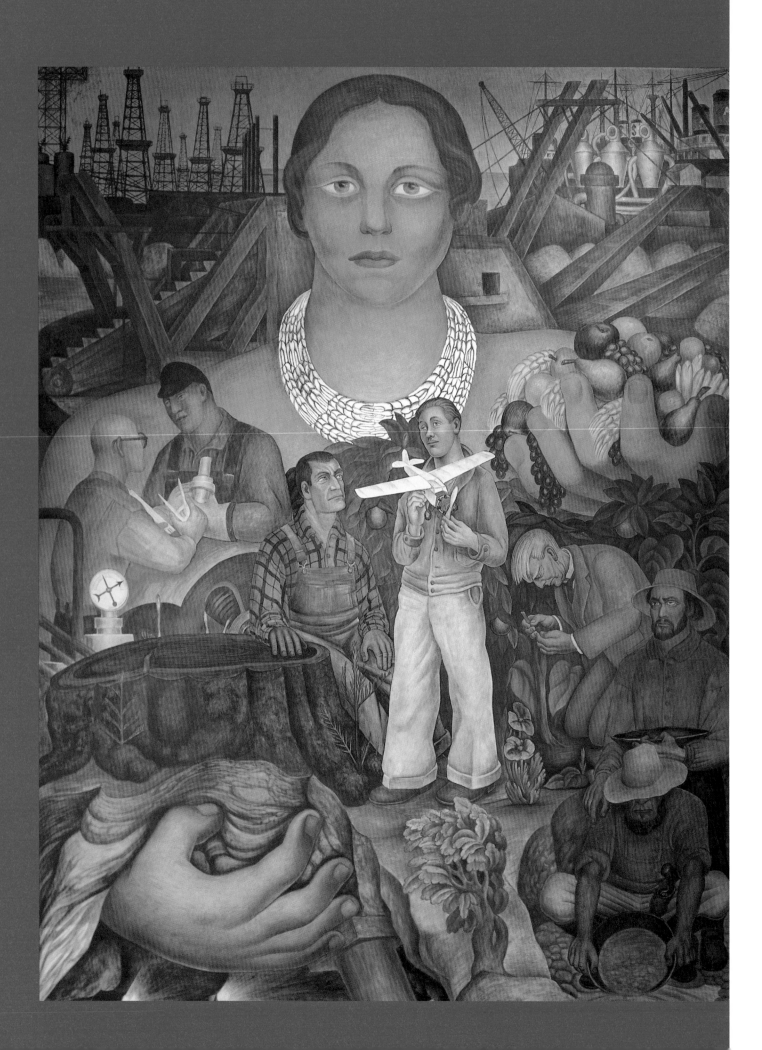

Sheri Bernstein

Throughout the first twenty years of this century, an idyllic and remarkably cohesive picture of California dominated the popular imagination as well as cultural production. This was far from the case, however, in the subsequent decades between the two world wars, during which the country experienced profound shifts of dramatic proportions. The boom of the 1920s, which historian William E. Leuchtenberg has characterized as a decade of "piping prosperity,"[1] gave way to blight in the 1930s, as the entire nation struggled through the Great Depression. Whereas California was lauded as being at the epicenter of the boom—celebrated for the first time as much for its modern sophistication as for its beauty and bounty—its glowing booster image was powerfully contested during the Depression years. At that time, critical visions of the state often put forward by and on behalf of the working class circulated widely. Yet along with these more sobering views, a fairy-tale image of Hollywood permeated the national consciousness, providing a much-needed antidote to the troubles of the day. Complicating the state's image even further was the fact that a considerable range of perspectives on California's ethnic character—including those of non-Anglos—were promulgated throughout this twenty-year span, informed by the nation's struggle to define its complex relationship to Latin America and Asia. For these reasons, as well as because of the incessant migration of an unprecedented number and diversity of newcomers, multiplicity and inconstancy aptly characterize the image of California during the 1920s and 1930s.

A salient new aspect of California's image was its urban character, which had been largely eclipsed until the 1920s by Edenic visions of the state as a premodern paradise. The proliferation of urban views of California spoke to the massive urban growth then occurring in the Bay Area and, to an even greater extent, in Southern California. The vast majority of the 1.5 million people who flooded into the Southland between 1920 and 1930 settled in urban areas, sparking a major surge in real estate development and the creation of eight new cities in Los Angeles County alone. By 1920 Los Angeles had surpassed San Francisco as the largest city in California; and by the end of that decade, in the wake of the oil boom, it had emerged as the fourth-largest urban center in America. Not surprisingly, Los Angeles had begun to develop the problems of a modern city. With two automobiles for every three people in Los Angeles by 1929, traffic became a constant, defining feature. San Francisco, too, although it had fewer people and cars than Los Angeles, was a sizable metropolis of 630,000 residents by 1930, with a thriving corporate and commercial sector and an identity as the West Coast hub for maritime trade.

With big business striving to attract and provide for increasing numbers of tourists and new residents, boosterism in California reached an all-time high during the 1920s. The Los Angeles Chamber of Commerce and its institutional counterparts in other California cities expanded their ongoing efforts, and new organizations sprang up, such as the All-Year Club of Southern California, which was founded in 1921 by *Los Angeles Times* publisher Harry Chandler to promote summer tourism in the region. In addition, the Automobile Club of Southern California significantly expanded its publication *Touring Topics* (renamed *Westways* in 1934) under the editorship of Phil Townsend Hanna. Far more than a travel magazine, *Touring Topics* became a central cultural voice in the area, employing numerous artists and writers, from the conventional to the modernist. This publication's existence, like that of *Land of Sunshine* during the previous two decades, attests to the faithful marriage of boosterism and the arts that existed in Southern California, a marriage then flourishing to varying degrees in different regions nationwide.

Diego Rivera

Allegory of California
(detail), 1931, mural, Stock
Exchange Building (now City
Club of San Francisco)
(scale reconstruction in
exhibition)

a
Miki Hayakawa
Telegraph Hill, n.d., oil on canvas

b
Millard Sheets
Angel's Flight, 1931, oil on canvas

c
Barse Miller
Apparition over Los Angeles, 1932, oil on canvas

d
Charles Payzant
Wilshire Boulevard, c. 1930, watercolor on paper

e
Frederic Penney
Madonna of Chavez Ravine, c. 1932, watercolor on paper

104

Particularly by the late 1920s, a considerable number of artists began to celebrate California's urban landscape. Some stressed the picturesque quality of the state's burgeoning cities, which necessitated altering the less scenic realities of urban life. Miki Hayakawa, for example, chose to efface any trace of the bustling, bohemian community of Telegraph Hill in San Francisco, producing a distinctly Cézannesque rendering of buildings peacefully nestled on the hillside. A similarly picturesque though more humanistic perspective was offered by American Scene painter Millard Sheets, who pictured the everyday life of Bunker Hill, a working-class residential neighborhood in downtown Los Angeles. The title, *Angel's Flight*, refers to the funicular that transported residents up and down Bunker Hill's steeply graded incline, but Sheets opted not to depict this mechanical convenience. Instead he concentrated on two flights of stairs that led up the hill and falsely portrayed their ascent as circuitous rather than straight so as to enhance the charm of the scene. Once a haven for the city's elite, Bunker Hill had a sizable poor immigrant population by the 1920s. Yet Sheets's painting includes only white subjects; in fact, he used his own wife as a model for the two main figures. Many other white artists also shied away from

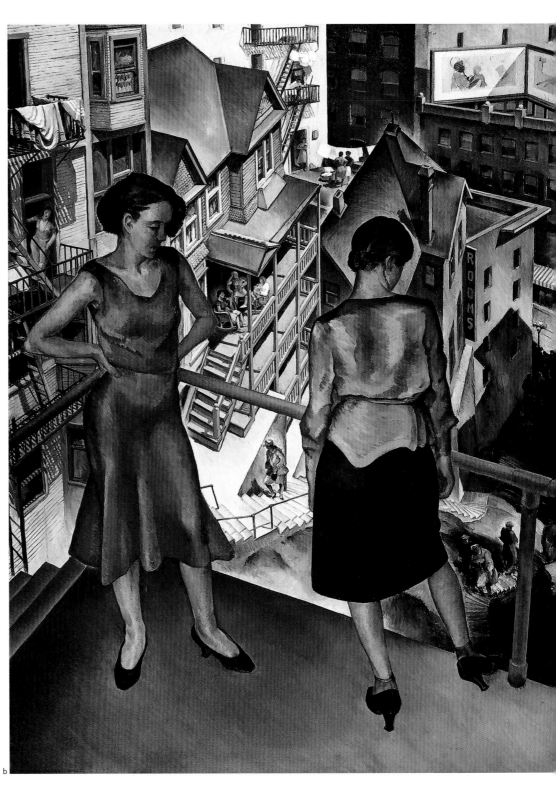

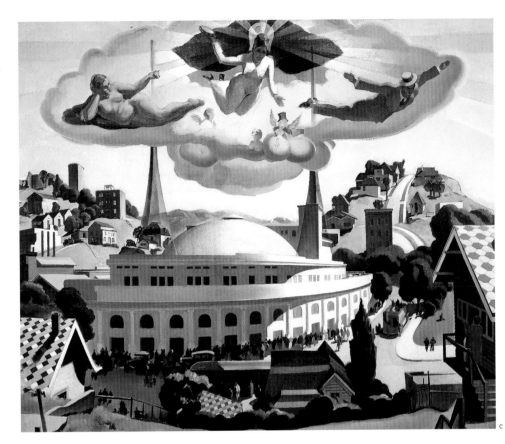
c

105

d

depicting the ethnic minorities who were rele-
gated to particular urban neighborhoods by
restrictive real estate covenants and unregulated
racist practices throughout the state. As one
realtor in Whittier boasted, "Race segregation is
not a serious problem with us. Our realtors do
not sell [to] Mexicans and Japanese outside cer-
tain sections where it is agreed by community
custom they shall reside."[2] Booster organizations
such as the Los Angeles Chamber of Commerce
similarly avoided depicting nonwhite ethnic
communities in their countless photographs of
city life. On the rare occasions when such com-
munities were represented, either in promotional
literature or in a fine-art context, they appeared
as if eternally frozen in a romantic and spiritual
past. This is the case, for example, in *Madonna
of Chavez Ravine* by Frederic Penney. While the
artist clearly intended to honor the Mexican
people of Chavez Ravine by portraying them as
saints, he effectively denied their existence as
contemporary, ordinary individuals. In contrast
to the proponents of the picturesque urban land-
scape, other artists heralded the modern aspects
of California's cities. Many focused, for example,
on industrial subjects or public works, including
the recently erected dams that collected water
from the Colorado River (Southern California's

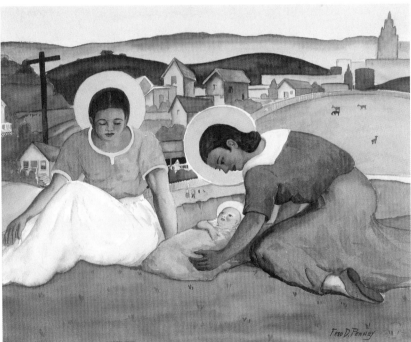
e

a

Childe Hassam
California Oil Fields, 1927,
etching

b

*California Highways and
Public Works* magazine,
January 1940. Lent by the
Caltrans Transportation
Library

c

Shinsaku Izumi
Tunnel of Night, c. 1931,
gelatin-silver print

d

Peter Stackpole
The Lone Riveter, 1935,
gelatin-silver print

e

Official program for the
San Francisco–Oakland Bay
Bridge celebration, 1936.
Lent by Jim Heimann

f

Alma Lavenson
Carquinez Bridge, 1933,
gelatin-silver print

106

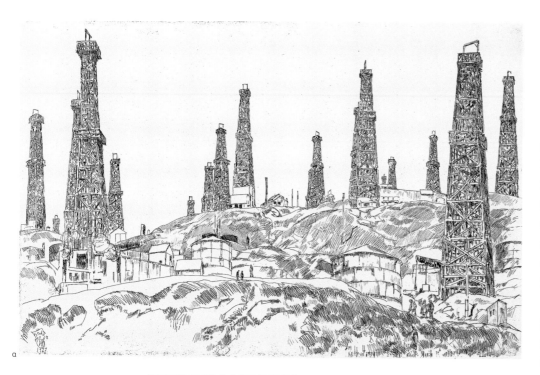

a

new major water source as of 1928) or on the bridges that numbered among the significant public-works projects of the mid-1930s. Some naturalized these subjects. Childe Hassam's oil derricks—veritable icons of the Southern California landscape in the early 1920s, most notably in Signal Hill, Huntington Beach, and Long Beach—suggest a forest of trees. Others humanized their modern scenes by adding figures. Peter Stackpole's breathtaking views of the San Francisco–Oakland Bay Bridge under construction, which appeared in *Life* magazine, celebrate the technological and psychological feats of erecting this structure.

Still other creative figures, predominantly photographers and designers rather than painters, employed a visual language of sleek forms and smooth textures, closely in keeping with industrialization, in addressing the California landscape. Photographer Alma Lavenson, for example, rejected the filmy aesthetic of Pictorialism in favor of the cleaner look of "straight" photography associated with

b

c

d

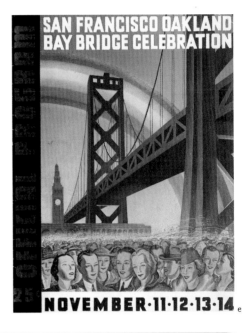

e

f

a
Maynard Dixon
Airplane, c. 1930, gouache on paper

b
Brochure produced by the Los Angeles Department of Water and Power, 1928. Lent by USC, Regional History Center, Department of Special Collections

c
Edward Biberman
Sepulveda Dam, n.d., oil on canvas

108

the California-based Group f/64. In their cool exactness and industrial subject matter, her works were also in sympathy with the paintings of contemporaneous East Coast–based Precisionists. Among the California designers most directly inspired by the new technology was Kem Weber; a clean, minimal aesthetic is visible in the streamlined form of his *Airline Armchair* of 1934–35.

Weber's enthusiasm for the airplane was shared by many. Indeed, excitement over the thriving aviation industry pervaded Southern California culture in the 1920s and 1930s. Boosters seized every opportunity to bill the region as the aviation capital of the world, heavily publicizing such events as Charles Lindbergh's triumphal return to Los Angeles after completing a trans-Atlantic flight from New York to Paris in 1927.[3] Public interest in aviation not only infused the work of designers such as Weber but also fueled production in the visual arts, thereby providing another point of confluence between boosterism and artistic production. *Touring Topics,* for example, featured a painting of an airplane by Maynard Dixon on its December 1930 cover; this was the culminating work in a twelve-part series on the history of transportation that Dixon executed for the magazine. Helen Lundeberg also celebrated air flight as the pinnacle of transportation history in her eight-panel mural for Centinela Park in Inglewood. Publications that promoted industry, such as *Southern California Business,* devoured these images, vastly preferring them to picturesque visions of urban life. Yet chamber of commerce and All-Year Club publications featured both types of urban views—the forward looking and the nostalgic—often within a single issue or brochure, since both highlighted marketable aspects of California's appeal to tourists and newcomers.

d
Helen Lundeberg
The History of Transportation in California (Panel 8), study for mural in Centinela Park, Inglewood, 1940, gouache on paper

e
Kem Weber
Airline Armchair, c. 1934–35, hickory, alder, maple, metal, and leather

f
Julius Shulman
Lovell "Health" House, 1950, gelatin-silver print

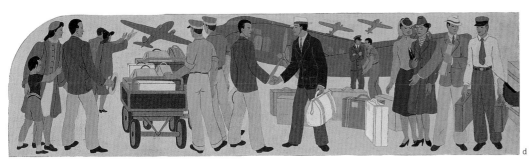
d

f

e

CALIFORNIA LIVING

Early Modernism

Many architects and designers who emigrated from Europe to the United States were drawn to Los Angeles, where they created innovative buildings, interiors, and furniture. They brought with them the principles of modernism, which found beauty in the useful and strove for originality. Modernism sought to join purity of design and utility, and those influenced by it championed new technologies, mass production, and the use of geometric shapes and spare lines. The aggressive and experimental approach of transplanted Europeans led to the synthesis of the California Modern style. Two important immigrants were Viennese architects Rudolph Schindler and Richard Neutra. Schindler designed his own residence, the radical Studio House on Kings Road,

background
Rudolph Schindler
Milton Shep Residence
[Project], Los Angeles,
Perspective Elevation,
1934–35, colored pencil on
paper

a
Porter Blanchard
Coffee Set and Tray, 1930–50,
pewter and hardwood

b
Rudolph Schindler
Armchair and Ottoman,
1936–38, gumwood and wool
upholstery

c
Maria Kipp
Textile Length for Drapery,
c. 1938, mohair, Lurex, and
chenille

110

of concrete and redwood, with an open plan and sliding porch doors that dissolved boundaries between indoors and outdoors. Neutra created the Lovell "Health" House, the first U.S. structure with a steel frame. Its expanses of glass united the interior with the hillside surroundings, creating an environment for the signature California lifestyle.

The *Made in California* period environment featured furniture designed by Schindler in the 1930s for the Shep Residence, a commission that was never realized. Schindler called these pieces "unit furniture." Not just knock-down or sectional, they are composed of parts that can be assembled in various combinations. These austere and tasteful pieces are all low, wide, and horizontal, echoing the low horizon of the Southern California landscape. The living room included a modular sofa, an armchair, an ottoman, an end table, and a stackable storage chest, all of which reflect the architect's interest in economy of space and multiple use. The dining

area showcased an expandable table with alternating chairs and stools. Schindler created an aesthetically integrated modernist interior by using a versatile suite of movable components—the furniture—and by carefully selecting the appropriate backdrops in the draperies and carpets. In this way he was able to unite all elements into an elegant, clean-lined, and efficient interior space expressive of the new modern style in California. JO LAURIA

a

The garden will become an integral part of the house. The distinction between indoors and outdoors will disappear. RUDOLPH SCHINDLER

d
Glen Lukens
Gray Bowl, c. 1940,
earthenware

e
Rudolph Schindler
Bedroom Dresser with Hinged Half-Round Mirror, 1936–38,
gumwood and mirror

c

b

d

e

a
Fletcher Martin
Trouble in Frisco, c. 1935, lithograph

b
Herman Volz
San Francisco Waterfront Strike, 1934, lithograph

c
Lee Everett Blair
Dissenting Factions, 1940, watercolor on paper

d
Behind the Waterfront, designed and illustrated by Giacomo Patri, c. 1940. Lent by San Francisco State University, Labor Archives and Research Center

112

e

Bernard Zakheim
Library, 1934, mural,
Coit Tower, Pioneer Park,
San Francisco
(scale reconstruction in
exhibition)

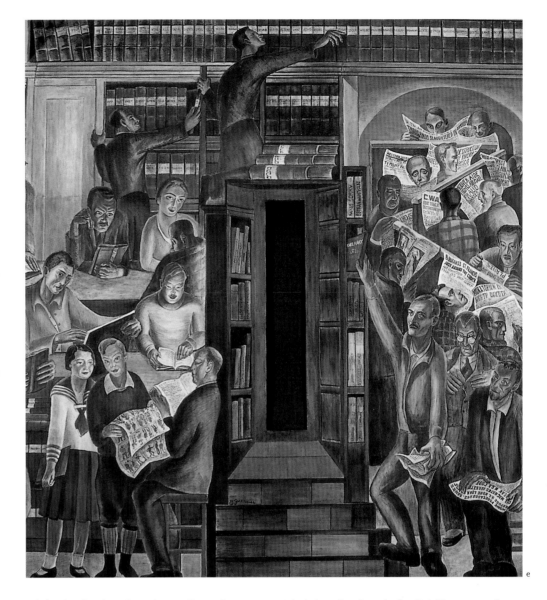

e

Not all of the urban images generated by artists during this period, however, supported boosterism. While criticisms of California had been issued earlier in the century, mainly by radical voices such as the Industrial Workers of the World, in the 1930s they began to permeate the visual arts. This coincided, of course, with the onset of the Depression and the growing visibility of the political Left. The latter was plainly evidenced by the capture of the Democratic gubernatorial nomination in 1934 by writer and left-wing populist Upton Sinclair, who authored the End Poverty in California (EPIC) program. As never before in the state, radical artists became a strong and vocal presence. This mirrored a trend in the country at large, which had been prefigured by a strong tradition of political activism among New York artists and intellectuals since the turn of the century. Within California, radicalism could be felt most forcefully in San Francisco. There, creative figures on the far Left—including many Jewish and other European immigrants—formed an alliance known as the Artists' and Writers' Union, loosely affiliated with the then ethnically diverse and aesthetically open-minded local branch of the Communist Party.[4] Predictably, the works of these and other leftists in California were principally concerned with the state's organized labor: its inherent dignity and its exploitation.

One much-treated subject by radical artists—most notoriously by Anton Refregier in his controversial Rincon Annex murals of the 1940s—was the General Strike of 1934, in which more than 34,000 San Francisco waterfront and maritime workers walked off their jobs, virtually paralyzing the city.[5] This uprising occurred under the forceful leadership of Australian-born labor activist Harry Bridges, who became a cult hero for the Left. Herman Volz was among the artists to depict the grave events of July 5, known as the

strike's Bloody Thursday, when police action resulted in the deaths of two longshoremen. Italian immigrant Giacomo Patri was another figure sympathetic to labor. He illustrated publications for the waterfront union and the local branch of the Communist Party and authored the powerful *White Collar: A Novel in Linocuts* (1940), which documented the mobilization of workers in support of the labor movement.

A contemporaneous instance in which radicalism came to the fore was the mural project for San Francisco's Coit Tower, a structure built from 1932 to 1933 to eulogize prominent Bay Area benefactor Lillie Hitchcock Coit. Conservative responses to several of the twenty-seven murals produced for the tower's interior—all of which related to the theme "Aspects of California Life, 1934"—were exacerbated by the events of the 1934 waterfront strike. Federally funded through the short-lived Public Works of Art Project (PWAP), which preceded the Work Projects

Administration (WPA), the Coit Tower murals were masterminded by one of San Francisco's old-guard patrons, Herbert Fleishhacker. Fleishhacker appears to have conceived of the murals as a means of curbing budding militant radicalism in the area by appeasing leftist artists such as Bernard Zakheim and Victor Arnautoff, whom he named the project's idea man and its supervisor, respectively.[6]

Yet under the leadership of Zakheim and Arnautoff, who had both worked with Mexican muralist Diego Rivera and were members of the Artists' and Writers' Union, the project in fact yielded a handful of highly charged murals on labor-related subjects. Several of these inspired accusations in the mainstream press of Communist propagandizing. Zakheim's depiction of a library scene, for example, was deemed "red propaganda" in the *San Francisco Chronicle*, because it included such details as a newspaper headline that obliquely referenced Harry Bridges

114

a

b

c

a
Booklet produced by the
Southern California
Proletarian Culture League,
cover by Yotoku Miyagi, 1931.
Lent by UCLA Library,
Department of Special
Collections

b
John Gutmann
The Cry, 1939, gelatin-
silver print

c
John Langley Howard
The Unemployed, 1937, oil on
cardboard

d
Otto Hagel
*Untitled [Maritime Workers
Looking for Work]*, c. 1935,
gelatin-silver print

e
Dorothea Lange
*A Sign of the Times—
Depression—Mended
Stockings—Stenographer,
San Francisco*, c. 1934,
gelatin-silver print

115

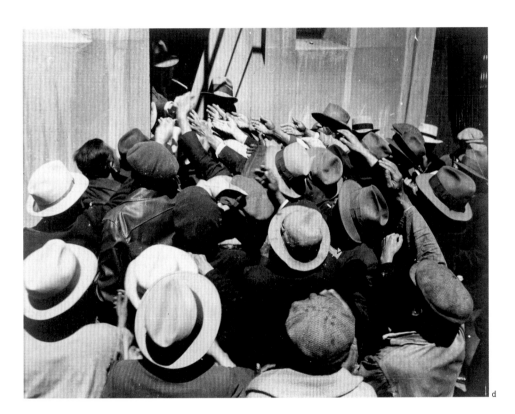

such as *Life*, as well as in leftist publications such as *Survey Graphic*. Photographs by Dorothea Lange and Otto Hagel, for example, humanized their subjects for broad audiences. Those who took a more elliptical approach included German Jewish emigré John Gutmann, whose photographs of San Francisco's urban poor, such as *The Cry*, were informed by Surrealism and offered the more distanced perspective of a European observer.

While urban views of California proliferated during these years, the natural landscape remained an enduring motif. Its identity became increasingly contested, however, as images of cultivated landscapes came to rival those of untouched terrain, which had dominated cultural production before 1920. Evidence of human labor—either the actual presence of workers or their implied presence in the form of farmhouses and tilled fields—especially characterized the cultivated landscape. The preponderance of signifiers of labor in images of California from the 1920s and 1930s attests to the increased attention given to workers in American society during these years.

The disparate approaches to California's agrarian landscape taken by artists of the period speak directly to competing perspectives on the then highly charged subject of agricultural labor. As Carey McWilliams powerfully recounts in *Factories in the Field* (1939), by the 1920s California's agricultural economy had become heavily industrialized and consolidated. It was no longer controlled by individual farmers and ranchers but by "absentee landlords"—large and impersonal corporations or wealthy businessmen—who hired itinerant laborers to work for meager wages and under substandard conditions.[8]

This shift in California away from the Jeffersonian ideal of small-scale farming toward an agribusiness economy elicited feelings of nostalgia among the very people who had benefited

as well as an image of artist John Langley Howard reaching for a copy of Karl Marx's *Das Kapital*.[7] Eventually, the PWAP elected to whitewash part of one mural by Clifford Wight that contained a hammer and sickle. In addition, Coit Tower was closed to the public for several months after the waterfront strike in an effort to avoid further galvanizing leftists within the city.

Less militant and more sentimental than the subject of a united working class was that of urban poverty and unemployment, which garnered the interest of New Deal centrists and a spectrum of leftists during the Depression years. John Langley Howard, who painted one of the Coit Tower murals, was the brother-in-law of a waterfront worker who participated in the strike. Howard bemoaned the plight of California's unemployed by means of a critical realist style popular among artists of the far Left. Some images of poverty and joblessness in California circulated more widely in mainstream magazines

a
Edward Weston
Tomato Field, 1937,
gelatin-silver print

b
Millard Sheets
California, c. 1935, oil on
canvas

c
Phil Paradise
*Ranch near San Luis Obispo,
Evening Light*, c. 1935,
oil on canvas

d
Selden Conner Gile
The Soil, 1927, oil on canvas

e
Rinaldo Cuneo
California Landscape, 1928,
oil on canvas set in three-part
screen

f
The Land of Oranges, a
coloring book for children
produced by the California
Fruit Growers Exchange, 1930.
Lent by the McClelland
Collection

116

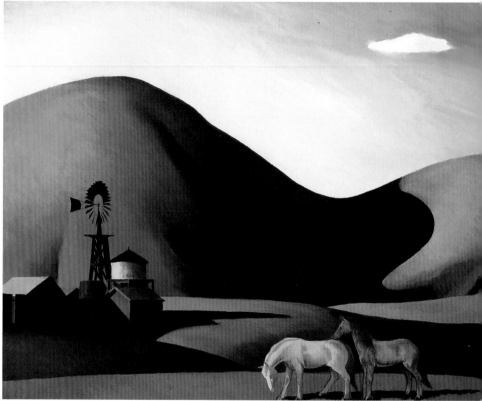

from the transition. The heads of agribusiness—
many of whom were patrons of important
cultural institutions, such as San Francisco's
Bohemian Club and the California School of Fine
Arts—gravitated toward picturesque images of
the agrarian landscape that naturalized or effaced
the presence of big business.[9] San Francisco artist
Rinaldo Cuneo's highly decorative painted
screen, *California Landscape*, offers a bountiful
expanse of neatly ordered lettuce rows set against
the Northern California hills. It echoes the visual
language used in such agribusiness booster
publications as *The Land of Oranges* (1930), a
children's book published by the California Fruit
Growers Exchange. Cuneo himself romanticized
and aestheticized agricultural production, com-
paring the process of cultivating the landscape
to that of composing a painting.[10] Other pictur-
esque agrarian visions include scenes of small
farms or ranches executed in a range of styles—
from the modernism of Selden Conner Gile,
whose palette was inspired by the French Fauve
painters, to the down-home regionalism of
Phil Paradise. Many of these booster images of
California are devoid of laborers or, in fact, of
any sign of utilitarian purpose. Yet the farms
and ranches pictured appear thriving and well

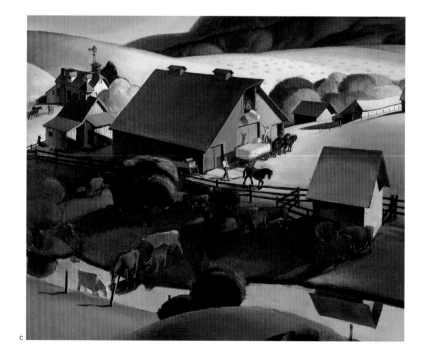

117

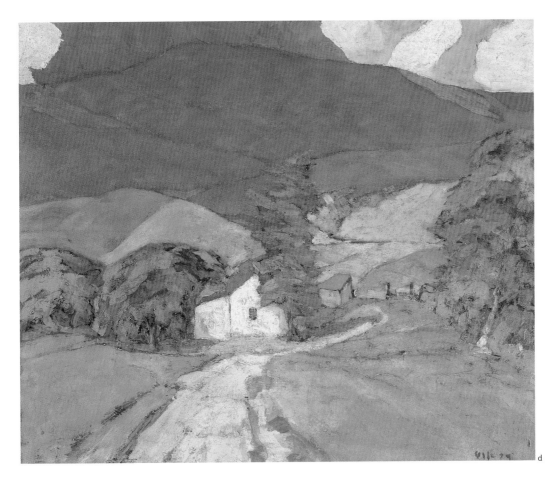

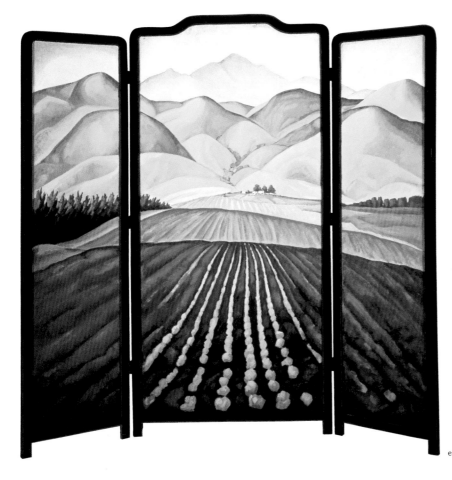

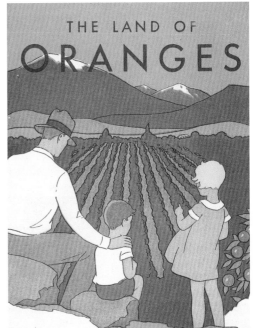

118

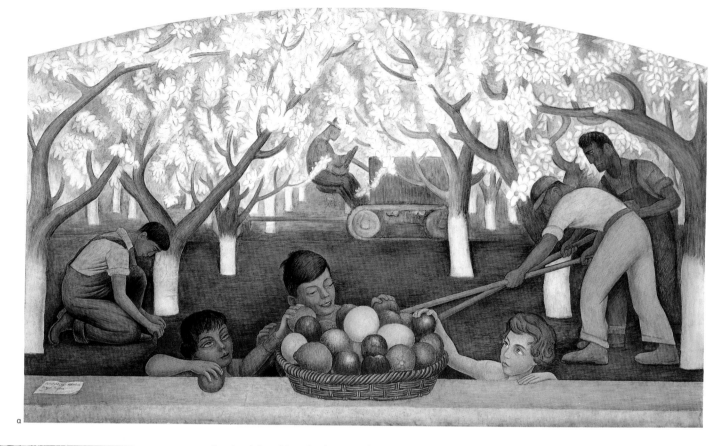

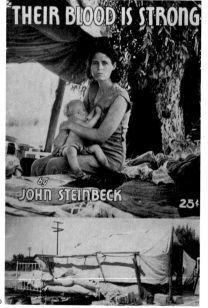

maintained, invoking the fantasy of land that works itself with remarkably little effort.

Yet a great number of laborers were, in fact, working the land in California, with heavy concentrations of activity in the Sacramento, Santa Clara, San Joaquin, and Imperial valleys. In the 1920s the labor force was dominated by Mexican and Filipino immigrants, the former comprising more than 30 percent of California's total agricultural workforce by the early 1930s, and the latter representing 90 percent of the labor pool in Northern California by 1938.[11] In the Imperial Valley alone, there were 20,000 Mexican laborers by the late 1920s. Extremely poor conditions gave rise to union organizing, particularly among Mexican workers, and a number of uprisings occurred, including the San Joaquin Valley cotton strike of 1933 and the Imperial Valley lettuce strike of 1934. Mexican unionizing and strikes met with "vigilante terrorism...repressive activities of large growers ...use of arrest, intimidation, etc.," as John Steinbeck noted in *Their Blood Is Strong*, a collection of reports from the field originally published in the *San Francisco News*. He added, "As with the Chinese and Japanese, [the Mexicans] have

committed the one crime that will not be permitted by the large growers. They have attempted to organize for their own protection."[12]

Steinbeck's sympathetic perspective was one of myriad views voiced at that time on immigrant agricultural labor in California. Closely aligned with him was Dorothea Lange, whose photographs illustrated *Their Blood Is Strong*. Yet the tone of Lange's images—particularly those approved for circulation by Roy Stryker, director of the federally funded Farm Security Administration (FSA), which employed Lange during the Depression—is generally more appeasing than inflammatory. Her *Filipinos Cutting Lettuce, Salinas Valley, California*, which recalls François Millet's ennobling yet depersonalized nineteenth-century images of workers, presents her subjects in universalizing, nonconfrontational terms. It can be contrasted with an unattributed FSA photograph of Mexican picketers from the 1930s. Since Lange was the principal FSA photographer working in California, it is quite possible that she took the latter picture as well, but this image of blatant protest probably would not have met the objectives of the FSA.

a

Diego Rivera

Still Life and Blossoming Almond Trees, 1931, fresco, University of California, Berkeley

•

b

Their Blood Is Strong: A Factual Story of the Migratory Agricultural Workers of California by John Steinbeck, photographs by Dorothea Lange, 1938. Lent by San Francisco State University, Labor Archives and Research Center

c

Stanton MacDonald-Wright

Revolt, 1936, lithograph

d

Dorothea Lange

Filipinos Cutting Lettuce, Salinas Valley, California, c. 1935, gelatin-silver print

e

Mexican women bound for a picket line, Farm Security Administration photograph, 1933. Powell Studio Collection, Bancroft Library, University of California, Berkeley, courtesy of the Library of Congress

119

In its celebration of labor, Lange's *Filipinos Cutting Lettuce* is compatible with Rivera's mural *Still Life and Blossoming Almond Trees*, commissioned by Mr. and Mrs. Sigmund Stern for their private residence in the Bay Area (now in Stern Hall at the University of California, Berkeley). One of three murals executed by Rivera during a yearlong stay in California from 1930 to 1931 and initially orchestrated as part of a United States cultural rapprochement with Mexico, *Still Life* depicts a happy, productive, and integrated workforce. Surprisingly mild in its message considering Rivera's leftist political sympathies, this work provides a sharp contrast to David Alfaro Siqueiros's Los Angeles mural *Tropical America*, a scathing critique of North America's exploitation of Mexican labor (see p. 139).

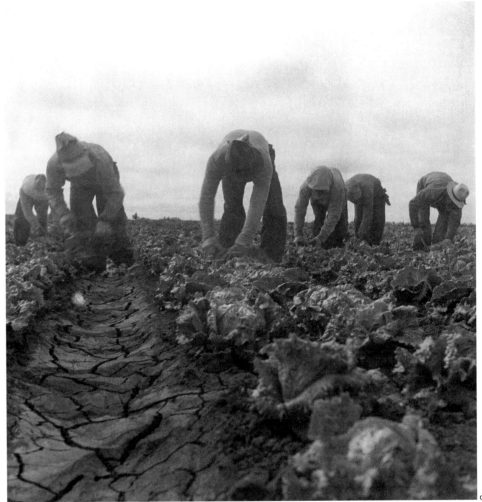

d

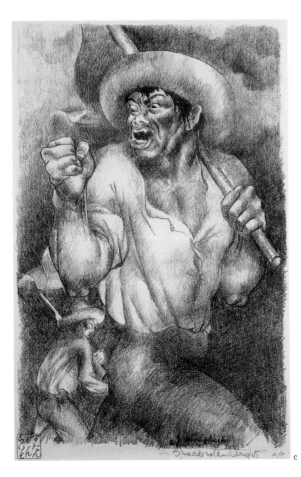

c

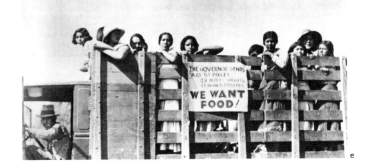

e

120

a

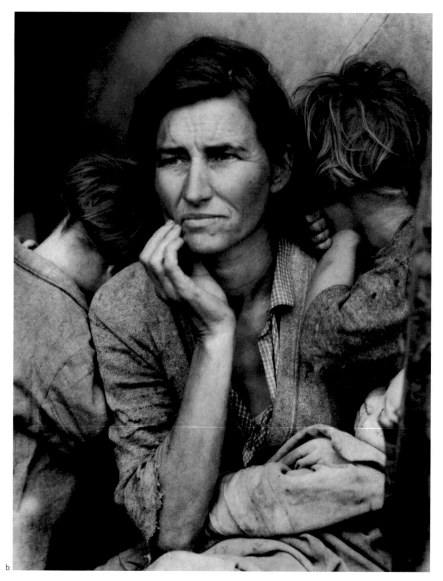

b

Most Depression-era images of agricultural labor in California reflect the pronounced changes that occurred in the composition of the state's workforce during the 1930s. By 1937 nearly 150,000 Mexican laborers had been deported to Mexico from the United States,[13] replaced by a flood of white migrants from the blight-stricken Dust Bowl of America—predominantly Oklahoma but also Texas, Arkansas, Kansas, and Missouri. The popular conception of California through most of the 1930s was of a promised land for migrants in search of work, but as John Steinbeck described in his monumental novel *The Grapes of Wrath* (1939), these newcomers were hardly welcomed by California's booster industries. All-Year Club guides of the 1930s, for example, bore the following admonition:

WARNING! While attractions for tourists are unlimited, please advise anyone seeking employment not to come to Southern California, as natural attractions have already drawn so many capable, experienced people that the present demand is more than satisfied.[14]

Whereas the interests of the newly unemployed migrants conflicted with those of the region's boosters, national publications like *Fortune* magazine could afford greater empathy for them. *Fortune* published two articles in its April 1939 issue sympathetic to the plight of California's new migrants, distinguishing these "native whites" from "foreigners: Chinese, Japs, Hindus, Filipinos, Mexicans" who had previously constituted the labor force.[15] Illustrated with watercolors by Millard Sheets and photographs by Dorothea Lange and fellow documentary photographer Horace Bristol, the articles emphasized the industriousness of the migrants and their families.

a
Millard Sheets
Migratory Camp near Nipomo, 1936, watercolor on paper

b
Dorothea Lange
Migrant Mother, Nipomo, California, 1936, printed later, gelatin-silver print

c
Horace Bristol
Joad Family Applying for Relief, 1938, printed 1970, gelatin-silver print

d
Paul Sample
Celebration, 1933, oil on canvas

e
Barse Miller
Migrant America, 1939, oil on canvas

121

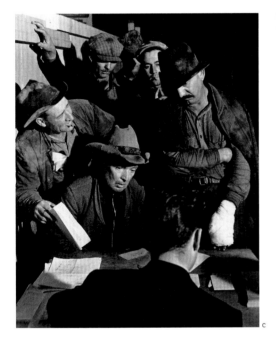
c

d

e

a	b	c	d	e	f
Charles Reiffel	**Paul Landacre**	**Kirby Kean**	**Agnes Pelton**	**Imogen Cunningham**	**Helen Forbes**
Late Afternoon Glow, c. 1925, oil on canvas	*Desert Wall*, 1931, wood engraving	*Night Scene near Victorville*, c. 1937, gelatin-silver print	*Sandstorm*, 1932, oil on canvas	*Aloe Bud*, 1930, gelatin-silver print	*Manley's Beacon, Death Valley*, c. 1930, oil on canvas

122

a

Even during the Depression years, picturesque images of the California landscape continued to appear widely in both popular culture and the fine arts, perpetuating the escapist image put forth earlier in the century. Insofar as these visions changed after 1920, a principal cause was the massive growth of the automobile industry and car culture. By the 1920s many vacationers and new residents toured California by car rather than by train. Among the effects of this shift was the new accessibility of desert locales such as Death Valley, one of the hottest and driest places on earth, which was made a national monument in 1933 and became a tourist destination. Visual artists were among those who now flocked to California deserts. While few works of art actually pictured the intrusion of cars into the landscape—Kirby Kean's *Night Scene near Victorville* is a rare exception—this intrusion did give rise to a plethora of new imagery, from Charles Reiffel's plein air vistas filled with desert flora to Agnes Pelton's ethereal abstracted scenes.

b

c

123

a
Edward Weston
*Twenty Mule Team Canyon,
Death Valley*, 1938, gelatin-
silver print

b
Touring Topics magazine,
December 1929, cover
painting by Henrietta Shore.
Lent by Victoria Dailey

c
Album of California desert
flower postcards, c. 1930s.
Lent by USC, Regional History
Center, Department of Special
Collections

124

a

As it had earlier in the century, the California landscape served as a point of intersection between boosterism and the fine arts during these years. Desert landscapes frequently appeared, for example, in publications of the Auto Club, then feverishly promoting desert travel in *Touring Topics* with dramatically titled articles such as "'In the Beginning, God Created Desolation'—Death Valley."[16] Edward Weston, cofounder of Group f/64 and one of the key modernist figures in American photography, was among the favorites of the Auto Club. In addition to featuring his desert imagery in multiple issues of *Touring Topics*, the club published a handsome book of Weston's photographs called *Seeing California with Edward Weston* (1939). While never venturing beyond a rather mild modernism in the paintings they published, *Touring Topics* and other booster publications like the *Standard Oil Bulletin* did feature works by Henrietta Shore, Maynard Dixon, and other painters. Such works lent an air of

c

b

d
Henrietta Shore
*Untitled (Cypress Trees, Point
Lobos)*, c. 1930, oil on canvas

e
Kaye Shimojima
Edge of the Pond, c. 1928,
gelatin-silver print

f
Julius Cindrich
Evening, Green Bay, c. 1925,
gelatin-silver bromide print

respectability and sophistication to the region's booster industries.[17]

While paradisal images of California's coastal and inland locales remained popular among tourist industries and artists alike, there was a greater stylistic range of images generated and disseminated during this period. In photography, figures such as Julius Cindrich continued to create misty Pictorialist images of the shoreline—welcomed in *Touring Topics* along with the works of Weston and Shore—while Kentaro Nakamura and others created more stylized, abstracted views. What most united the formally disparate body of art from these years and linked it to earlier picturesque scenes was a pronounced absence of people, despite their actual presence in increasing numbers. For this reason, Phil Dike's scenes of a bustling coastline, such as *Surfer* and *California Holiday*, were unusual for the period.

a

b

a
Anne M. Bremer
The Sentinels, c. 1918, oil on canvas

b
Clayton S. Price
Coastline, c. 1924, oil on canvas

c
Phil Dike
Surfer, c. 1931, oil on canvas

d
Kentaro Nakamura
Evening Wave, c. 1926,
gelatin-silver bromide print

e
Poster designed by Maurice
Logan, produced by the
Southern Pacific Railroad,
1923. Lent by Steve Turner
Gallery, Beverly Hills

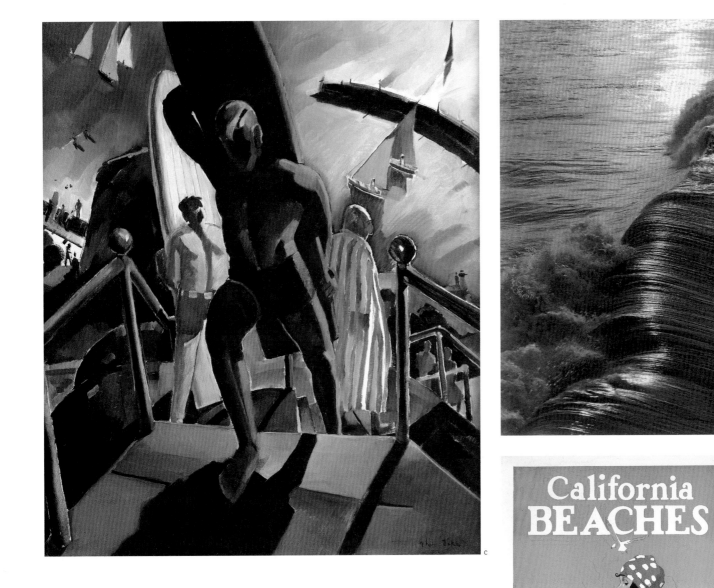

a

Christine Fletcher

Fog from the Pacific (No. 4),
c. 1931, gelatin-silver print

b

Motoring thru the Yosemite,
written by H. B. MacGill, 1926.
Lent by The Huntington
Library, San Marino

c

Chiura Obata

New Moon, Eagle Peak, 1927,
sumi and watercolor on paper

d

Ansel Adams

Monolith, the Face of Half
Dome, Yosemite National
Park, 1927, printed 1980,
gelatin-silver print

e

Frank Morley Fletcher

California 2. Mt. Shasta,
c. 1930, color woodcut

128

a

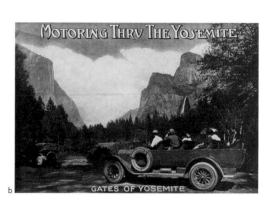

b

c

Artists persisted in aestheticizing the land-
scape, even into the 1930s. Chiura Obata—who
produced limpid watercolors of Yosemite in the
manner of traditional Japanese ink painting
(*sumi-e*) before being deported to an internment
camp in the early 1940s—expressed the belief
that "Nature knows no Depression."[18] Obata's
perspective approached that of Weston, who
defended himself against accusations of escapism
during the Depression with the contention that
"there is just as much 'social significance in a
rock' as in a 'line of unemployed.'"[19] That a
sizable number of California artists persisted
in generating idyllic landscapes during the
Depression years owes much to the aesthetic and
political leanings of these individual figures, as
well as to the ongoing valorization of touristic
perspectives by the state's booster industries.

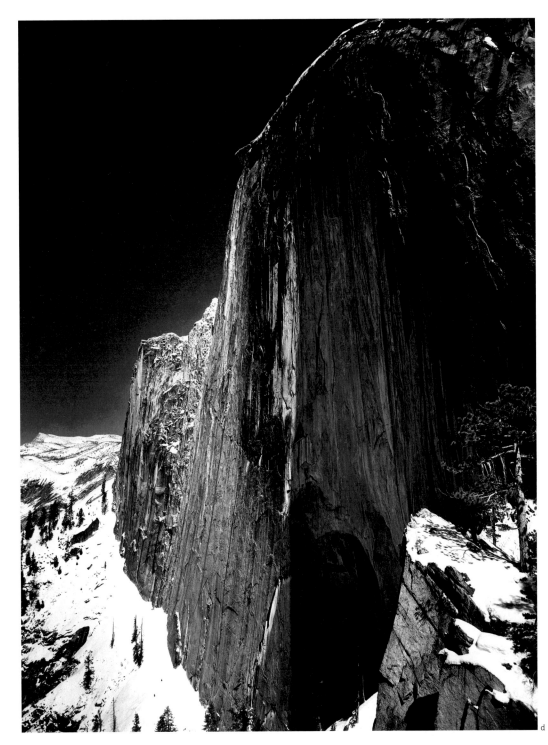

d

e

a
George Hurrell
Norma Shearer, 1929,
gelatin-silver print

b
George Hurrell
Ramon Novarro, 1930,
gelatin-silver print

c
George Hurrell
Joan Crawford, 1932,
gelatin-silver print

d
Gilbert Adrian
*Costume for Joan Crawford,
created for "Letty Lynton,"*
MGM, 1932, silk crepe and
sequins

130

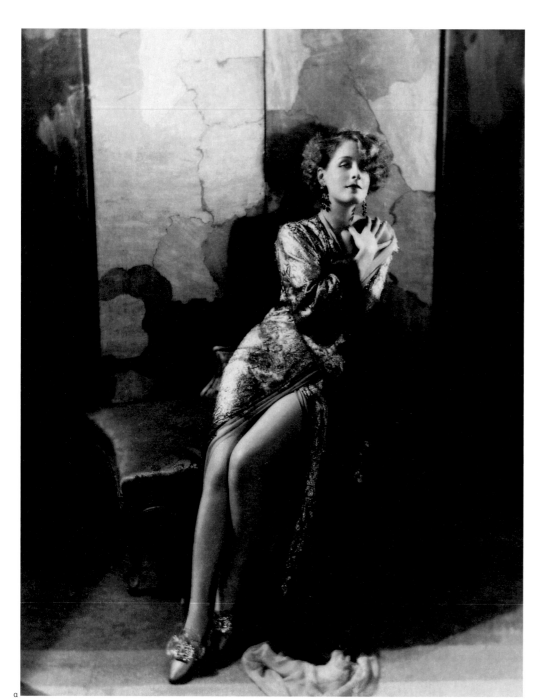

a

The most powerful California export to
rival the boosterist Edenic landscape in the first
quarter of the century was the dazzling image
of Hollywood, which emerged with the rapid
ascendance of the film industry in Southern
California in the 1910s and 1920s. While sharing
certain traits with the pastoral vision of
California—an obsession with visual beauty
and abundance, and an aversion to signs of
labor or hardship—the image of newly born
Hollywood nevertheless marked a clear depar-
ture. None of the nostalgic associations with
Old California that had appealed primarily to
Anglo Midwesterners were at play; rather,
Hollywood evoked sophistication, sensuality,
modernity, and, above all else, glamour.

Not only did this new image reach a
wider audience—upwardly mobile whites of dif-
ferent ethnic backgrounds and financial means—
but it was also promoted by a thoroughly
different cadre of boosters than the Protestant
elite who had monopolized California's image
until this time. In large part, these new boosters

b

131

c

were Jewish immigrants from eastern Europe, men who had arrived in California by way of New York in search of financial opportunity, and who had founded the Big Eight film studios that dominated the industry by the mid-1920s.[20] As Lary May has noted, it is not surprising that many of these early Hollywood moguls, including studio founders Samuel Goldwyn, Jesse Lasky, and Adolph Zukor, had previously worked in the garment industry, where image-brokering was also central to business success.[21] Once in California, they fashioned an image of Hollywood that sold tremendously well to American and international audiences of the day and that continues to powerfully influence popular perceptions of the state.

The Hollywood motion picture industry was already launched by the mid-1910s, with the production of such monumental films as D. W. Griffith's *The Birth of a Nation* (1915). Yet it was not until after the advent of the "talkie" in the late 1920s that it truly burgeoned and the Hollywood star system was born.[22] At that time, silent film star Mary Pickford, known for her demure and understated persona, was superseded as the quintessential Hollywood starlet by such sultry figures as Jean Harlow, Marlene Dietrich, and Joan Crawford, each a carefully crafted embodiment of the Hollywood "siren." An entire industry developed around the production of these stars—promoting their glamorous and eternally youthful appearances and their opulent lifestyles—and it lured creative talent to Hollywood from across the United States and abroad.

Nothing shaped or conveyed the image of Hollywood more effectively than celebrity photography. Among the top industry photographers of the period were Clarence Sinclair Bull and George Hurrell, both of whom had aspired initially to be painters before pursuing careers in

Hollywood. Bull was Greta Garbo's exclusive photographer throughout the 1930s, powerfully fueling her mystique with his intense, dramatically lit portraits, while Hurrell was the photographer of choice for Crawford and Norma Shearer. Hurrell's first Hollywood job had been to transform the boyish Ramon Novarro into an emblem of virility, and the photographer was known thereafter for his ability to tastefully enhance the sexual allure of his sitters. Similarly, in his initial photo session with Shearer in 1929, he was charged with spicing up her screen image: "The idea was to get her looking real wicked and siren-like, which wasn't the image she had at the time...I suppose nobody thought she could get away with it."[23] Indeed, stylized, highly theatrical portraits by celebrity photographers transformed ordinary people into stars. Their work defined Hollywood for generations of viewers, encouraging popular perceptions of Southern California as home to the most beautiful and alluring people in the world.

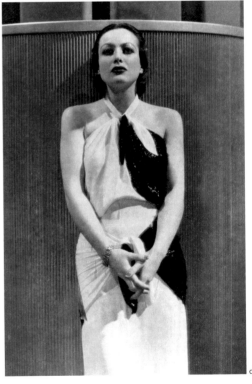

d

Costume designers also began to assume tremendous importance in producing the much-coveted and highly cultivated Hollywood look—conveying glamour, sensuality, and sophistication—from the mid-1920s onward, when

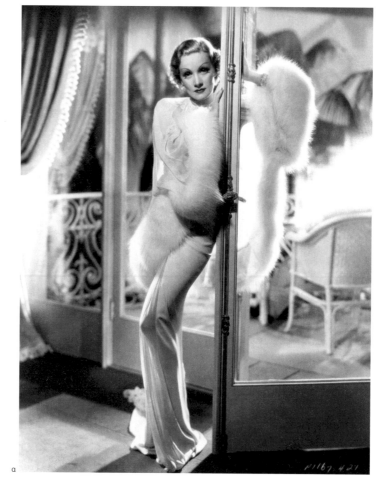

132

director Cecil B. DeMille began importing major figures in the fashion world to work on his films. Adrian, who designed for DeMille and served as head of fashion at Metro-Goldwyn-Mayer from the early 1930s through 1942, powerfully shaped the look through his elaborate costumes. The sleek sequined gown he created for Crawford to wear in *Letty Lynton* (1932), for example, was designed expressly to show off her famous shoulders. In response to being dubbed "The Most Copied Girl in the World" in 1937 by *Motion Pictures Magazine*, Crawford herself attributed her remarkable popularity to Adrian's flattering costumes. Travis Banton, head of fashion at Paramount Pictures during the 1930s, designed softer, more lushly elegant gowns for Marlene Dietrich, in contrast to the graphic, dramatic quality of Adrian's designs for Crawford. Lavish creations such as these embodied the qualities of opulence and excess intrinsic to the carefully crafted image of Hollywood glamour.

During these years, critiques of Hollywood came almost exclusively from writers, rather than from visual artists, perhaps because of the latter's greater dependence on patrons. Before the advent of film noir in the 1940s, its counterpart in 1930s literature—exemplified by the novels of James M. Cain, Raymond Chandler, and Dashiell Hammett—counted among its central themes the seamy underside of the Hollywood dream. One artist who offered a satirical perspective on Hollywood, if not a full-blown critique of it, was Will Connell. A successful fine-art photographer who also did commercial work for Hollywood and local booster organizations, Connell produced a witty exposé entitled *In Pictures* (c. 1937), which dismantled the flawless façade the Hollywood industry sold to the public. His photograph *Make-Up*, for example, spoke directly to the mass marketing of such beauty aids as Max Factor's "Cinema Sable" lip brush,

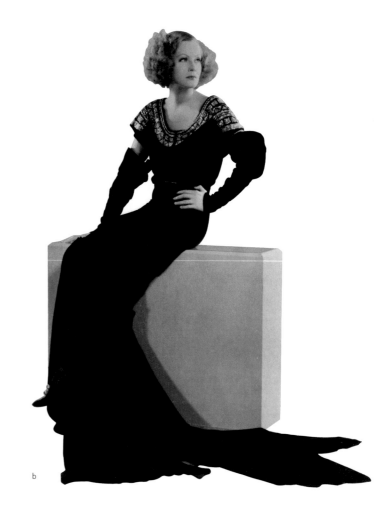

b

a

Travis Banton

Costume for Marlene Dietrich
created for "Desire,"
Paramount, 1935, silk chiffon,
silk crepe, and fox fur

b

Gilbert Adrian

Costume for Greta Garbo
created for "Inspiration,"
MGM, 1930, silk crepe, paste
stones, and rhinestones

c

Will Connell

Make-Up, from the publica-
tion *In Pictures*, c. 1937,
gelatin-silver print

d

Ernest Bachrach

Dolores Del Rio, 1932,
gelatin-silver print

133

which promised women the ability to "draw
'real' cinema lips … with all the deftness of a
Hollywood make-up man, so [they] … appear as
perfect and beautiful as those you see on the
screen."[24] It is not surprising that Connell's book,
created during the Depression, never became
widely popular. Among American audiences,
there was no real market for such visual satires
of Hollywood in the 1930s.

In fact it was during this period, arguably
the bleakest in the nation's history, that the
Hollywood glamour image reached its apex.
Films, celebrity magazines such as *Photoplay*,
and other forms of mass media disseminated the
notion of fantasy lifestyles to millions of finan-
cially and emotionally downtrodden viewers
from widely diverse walks of life. Yet despite the
considerable scope of its appeal, the larger-than-
life image of the movie star that Hollywood
cultivated during these years proved to be a
constricted and contricting one, particularly in
terms of ethnic identity.

a
Roberto Montenegro
Margo, 1937, oil on canvas

b
C. S. Bull
Anna May Wong, 1927,
gelatin-silver print

c
Adele Elizabeth Balkan
*Sketch for Costume for
Anna May Wong, created for
"Daughter of the Dragon,"
Paramount*, 1936, gouache
on board

d
Stanton MacDonald-Wright
Cañon Synchromy (Orange),
c. 1920, oil on canvas

e
Bernard von Eichman
China Street Scene No. 1,
1923, oil on cardboard

f
Gladding McBean Pottery
Encanto Chinese Red Vase,
c. 1930, ceramic

134

a

b

c

While Hollywood fostered a controlled
exoticism in the promotion of such stars as
Anna May Wong and Dolores Del Rio, nonwhite
actors who could not be made to fit ethnic
stereotypes found less favor. The Mexican actress
Margot Albert, known as Margo, was repeatedly
passed over by Hollywood casting directors
because she did not have the pale skin of a
"Spanish seductress."[25] Nor did she conform to
the accepted Anglo image of the Hollywood
starlet. Mexican artist Roberto Montenegro
makes this point in his portrait *Margo*,
identifiable as a Hollywood portrait only by the
inclusion of the word *Hollywood* in the lower
right. His subject's heavy robe and brooch, her
vacant expression, and her formal, somewhat
stiff pose in three-quarter view liken her more
to a Renaissance sitter than to a modern-day
film icon.

Latin American actresses such as Margo
were generally given caricatural parts rather
than glamour roles. As she commented, "Most
of the time, we were viewed by the producers as
'local color.'"[26] This attitude was even more
common in the casting of African Americans,
who were portrayed in strictly stereotypical
terms in pre–World War II Hollywood films
such as *The Birth of a Nation*. Posters and lobby
cards for these films served to further reinforce
what often proved to be racist constructions
of black identity.[27]

d

Despite the stereotypically white Hollywood image, a key aspect of California's character in the popular consciousness continued to revolve around ethnic identity, with the keenest focus on Latin American and Asian cultures. The period of the 1920s and 1930s witnessed both shifts and continuities in how and by whom nonwhite ethnic identity was defined. Anglo boosterist conceptions remained pervasive; there was an even greater interest than previously in Latin American and Asian aesthetics and picturesque or exotic subjects, fueled by United States Pan-Americanism and economic interests in Pacific Rim countries. In the fine arts this penchant informed, for instance, Mayan Revival paintings, furniture, and architecture as well as the Asian-inspired works of Los Angeles painter Stanton MacDonald-Wright.

e

f

a
Dorr Bothwell
Translation from the Maya,
1940, oil on Celotex

b
Donal Hord
Mayan Mask, 1933,
polychromed and gilded
mahogany

c
Toyo Miyatake
Untitled, 1929, gelatin-silver
print

d
Bilingual brochure for the
Miyako Hotel, Los Angeles,
c. 1920s. Lent by Jim Heimann

e
J. T. Sata
Untitled (Portrait), 1928,
gelatin-silver print

136

A moderate increase in openness to Latin
American and Asian voices within the dominant
culture also occurred, coupled by a strengthening
and diversification of California's nonwhite
ethnic subcultures. These subcultures ranged
from the centrist (for example, the Japanese
Camera Pictorialists of California, who were
based in Los Angeles and included such members
as Kaye Shimojima and J. T. Sata) to the radical
leftist (including the artists affiliated with the
Communist newspaper *Rodo Shinbun* in San
Francisco). Still, only the most benign forms of
cultural production were sanctioned by Anglo
culture, which ignored or silenced anything that
threatened its hegemony. Moreover, the celebra-
tion of what was envisioned as "Asia" and "Latin
America" on an aesthetic level coincided with
ongoing discriminatory policies and practices
toward all but the most elite members of these
cultures. Examples include the aggressive policing

a

b

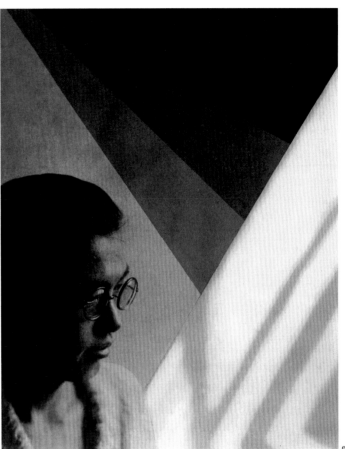

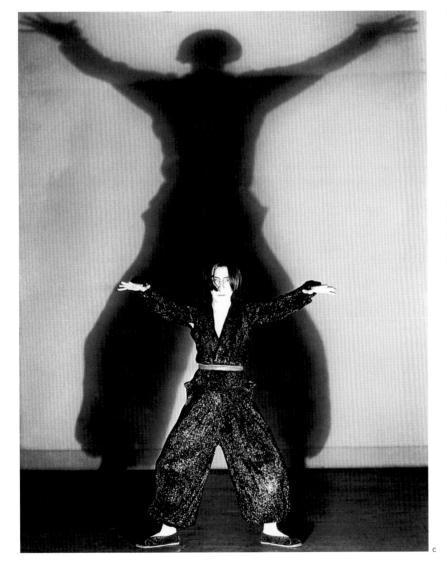

of Chinatowns and the mass deportation of Mexicans, many of whom were American citizens, in the 1930s.[28]

With the implementation of Franklin Delano Roosevelt's Good Neighbor policy, there was a push for Pan-American unity nationwide during the 1930s. This fact, coupled with the increasingly repressive climate in Mexico for artists who diverged from the nationalist program, compelled a number of highly regarded Mexican painters to cross the border into California in the early 1930s. Among them were "Los Tres Grandes"—muralists Diego Rivera, David Alfaro Siqueiros, and José Clemente Orozco—as well as Alfredo Ramos Martínez, Frida Kahlo, and Jean Charlot. To the extent that their visions of California and Mexico coincided with or challenged dominant cultural views, they met with varying responses.

Rivera, for example, who had been expelled from the Communist Party in 1929, came to San Francisco the following year to do a painting for the Stock Exchange building—arguably the epicenter of capitalism in California—at the urging of prominent businessman and collector Albert Bender and U.S. Ambassador to Mexico Dwight Morrow. Bitter over the awarding of this

a
Frida Kahlo
Frida and Diego Rivera, 1931, oil on canvas

b
Diego Rivera
Allegory of California, study for mural in San Francisco Stock Exchange Building, 1931, graphite on paper

138

b

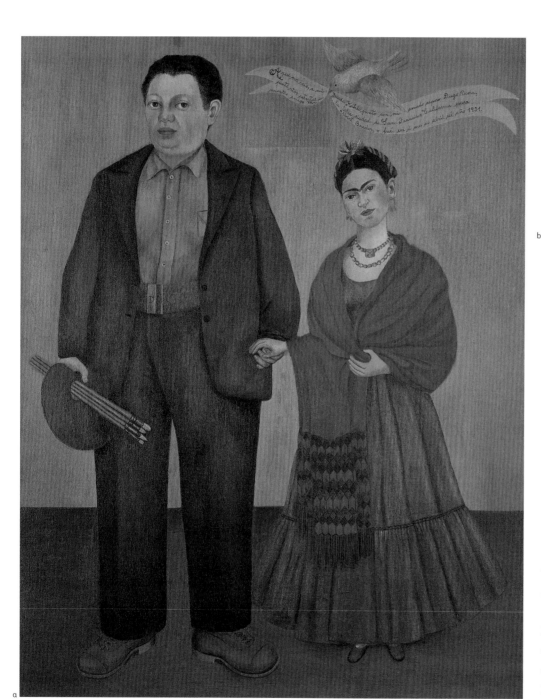

a

important commission to a foreigner, the local community of artists conjectured that Rivera would "not overlook a golden chance to exercise his communistic visions."[29] Yet *Allegory of California*, also known as *Riches of California*, celebrated the state's agricultural bounty and industrial fortitude and proved quite far removed from the politically radical murals he had executed in Detroit and New York. Although he was to characterize California four years later as "a rich land intimately bound up with the remains of its earlier Mexican character,"[30] *Allegory of California* contains no evidence of these remains. References to Mexican identity that are evident in preliminary sketches for the mural, such as the facial features of the central allegorical figure, are absent in the final version (see p. 102).

Among the most heavily patronized Mexican artists, especially among Hollywood's elite, was Ramos Martínez, formerly the head of the National School of Fine Arts in Mexico. Best known for picturesque images of Mexican women—depersonalized, clad in old-fashioned costumes, and surrounded by fruit and flowers— he executed one series of such works on *Los Angeles Times* newsprint. Although perceived at the time as motivated solely by aesthetic concerns, Ramos Martínez appears to have deliberately chosen the background visible beneath

c
David Alfaro Siqueiros
The Warriors, study for
Tropical America mural,
Los Angeles, c. 1932, graphite
and ink on paper

d
Alfredo Ramos Martínez
Woman with Fruit, 1933,
charcoal and tempera on
newsprint

e
David Alfaro Siqueiros
Tropical America, mural
photographed on its comple-
tion in 1932

f
Postcard of Olvera Street,
with Los Angeles City Hall
visible in the distance,
c. 1930s. Lent by Jim Heimann

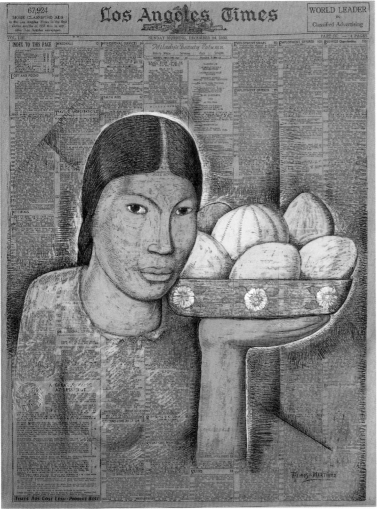

these paintings. He repeatedly depicted primi-
tivistic images of Mexican women on recent
pages from the *Times* beauty section, thereby
juxtaposing two culturally distinct notions of
female attractiveness. He also placed Mexican
field-workers on the employment pages, under-
scoring the difficulties faced by immigrant
laborers. The critical dimension of these works,
however, went unnoticed by American patrons
and the local popular press. In 1932, for example,
the *Times* cheerily featured one such newsprint
image of "pure native types" (Mexican field
laborers) on the cover of its Sunday magazine,
attributing the artist's use of newsprint solely to
the fact that "he likes the tone and texture given
by the 'want ad' section."[31]

Another Mexican emigré, however, overtly
exceeded the limits of acceptability in represent-
ing "Latin America" to California audiences.
David Alfaro Siqueiros's mural *Tropical America*
defied the enduring, hallowed Mission Myth
and offered an explicit critique of Mexican labor
abuses in the United States. *Tropical America*
was commissioned in 1932 to adorn a building on
Los Angeles's Olvera Street, which served then,
as it does today, as both a lively tourist spot and
a site of Mexican commerce and community life.
Siqueiros chose not to reinforce boosterist stereo-
types by painting "a continent of happy men,
surrounded by palms and parrots."[32] Rather, his
mural shows a crucified Indian figure. A bald

140

a

eagle proudly perched on top of the cross lords over the contorted nude body while two armed Indians eye the eagle surreptitiously, evidently making plans to shoot it.

Amazingly, the artistic community in Los Angeles initially either missed or ignored the mural's searing political content and focused instead on matters of aesthetics. Even the politically conservative artist Lorser Feitelson praised the mural for its "tenebrism, illusionism, and also this architectonic quality; it had guts in it!"[33] Yet Siqueiros's indictment of North American imperialism ultimately did gain notice. His request to renew his six-month visa was denied, and *Tropical America* (currently being restored by the Getty Conservation Institute) was whitewashed (partially in 1932, then entirely in 1938).

Amid such silencing of critical perspectives on United States–Mexican relations, there was a "vogue [for] things Mexican" that pervaded many facets of cultural production in California.[34] "Things Mexican" ranged from artwork by Maxine Albro, one of the many creative figures who traveled to Mexico and interacted with Mexican artists in California, to Bauer Pottery's El Chico and La Linda dishware lines. It is perhaps not surprising that commercial ceramists and textile designers served up easily digestible, stereotypical images of Old Mexico to modern consumers. Yet even political leftists such as Albro—for example, in *Fiesta of the Flowers* (1937), painted for the Biltmore Hotel in Montecito—promoted romanticized, primitivistic conceptions. Mexican culture was seen as simple, exotic, colorful, spiritual, preindustrial, and feminine, i.e., as pointedly antithetical to contemporary white American culture.

Similarly, dominant cultural perspectives on Asian identity in California during this period proved exoticizing and aestheticizing. It is fruitful to compare, for example, two works that depict

Chinese subjects: *Where Is My Mother* by Yun Gee, and *Chinese Mother and Child* by Spanish-born José Moya del Piño. Gee, head of the short-lived Chinese Revolutionary Artists' Club, offers a highly personal view. A male figure, most likely the artist, stands in the immediate foreground, serving as an intermediary or buffer between two other Chinese figures and the (presumably white) viewing audience, while the boats in the background suggest the artist's longing to return to China to see his mother again. This sense of displacement is echoed in Gee's 1926 poem of the same title, in which he mourns, "That mother of mine, how it tore my heart /

b

a
Maxine Albro
Fiesta of the Flowers, mural
created for Biltmore Hotel,
Montecito, 1937, oil on canvas

b
Tourist brochure promoting
rail travel to Mexico, c. 1939.
Lent by the California
Historical Society, North
Baker Research Library,
Ephemera Collection

c
Elza Sunderland
Woman's Two-Piece Playsuit,
c. 1940, printed cotton

d
Toyo Miyatake
Untitled, 1930, gelatin-
silver print

e
California Hand Prints
Textile Length, c. 1941,
printed cotton

141

d

c

e

a
Yun Gee
Where Is My Mother, 1926–27,
oil on canvas

b
José Moya del Piño
Chinese Mother and Child,
1933, oil on canvas

142

To leave her across the sea, / I who was part of
her— / She became all of me."[35] In contrast,
in *Chinese Mother and Child* del Piño objectifies
and aestheticizes his subjects, placing a colorful
potted plant in front of the mother on a low
wall, thus distancing the figures from the viewer.
For del Piño, the waterfront behind the figures—
where, in fact, labor unrest was mounting—
merely provides a pleasant, visually appealing
backdrop.

A comparably aestheticized, depersonal-
ized image of Chinese Americans was offered by
Beniamino Bufano, whose portraits of inhabi-
tants of San Francisco's Chinatown reenvisioned
them in decorative terms, as if they were ancient
Chinese statuary. The portrait bust entitled
Elizabeth Gee by Bufano's student Sargent
Johnson—one of the first African American
artists in California to gain widespread recogni-
tion—offers a somewhat more individualized
portrayal of a Chinese American subject.
Johnson depicts his young sitter, who was his
next-door neighbor, as a real girl with a first and
last name (and a strand of hair out of place),
rather than as an abstract type. Generally, how-
ever, images by non-Asians who purported to
honor their Asian subjects tended to be exoticiz-
ing, in line with the long-standing Western
tradition of Orientalism.[36]

California's aesthetic and economic inter-
est in Asia and Latin America culminated in
the Golden Gate International Exposition, held
in 1939 and 1940 on artificially made Treasure
Island in the San Francisco Bay. The exposition
was organized to celebrate the completion of
the Golden Gate and San Francisco–Oakland
Bay bridges and to lay the groundwork for a new
airport (never built, because Treasure Island
turned out to be too small). A central goal of its
organizers, business leaders of the Bay Area,
was to position California—and San Francisco,

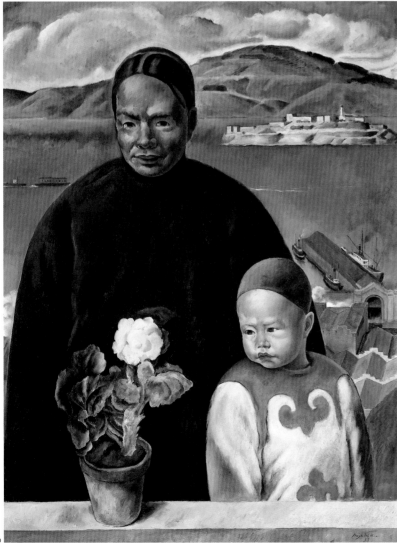

c
Beniamino B. Bufano
Chinese Man and Woman,
1921, stoneware, glazed

d
Sargent Johnson
Elizabeth Gee, 1925,
stoneware, glazed

e
Wing-Kwong Tse
Cup of Longevity, c. 1930,
watercolor on paper

f
Postcard showing a brass
band at the opening of
New Chinatown, Los Angeles
[incorrectly dated 1935].
Lent by Jim Heimann

143

c

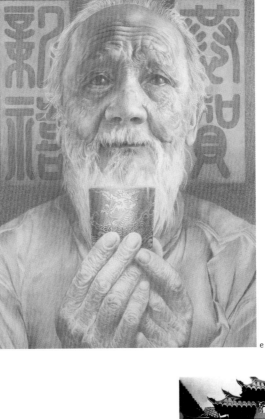

e

f

d

a
Diego Rivera and an
assistant at work on *Pan-
American Unity*, 1939.
Courtesy of City College of
San Francisco Rivera Archives

b
Diego Rivera
Pan-American Unity (detail),
1939, mural, City College of
San Francisco
•

c
Brochure for the
San Francisco World Fair of
1940, with cover illustration
showing Ralph Stackpole's
Pacifica. Lent by Jim Heimann

144

in particular—as the economic and cultural
gateway to the Pacific. The Court of the Pacific,
at the heart of the fair, was devoted to the pro-
motion of Pacific Rim unity, with painted maps
of Pacific cultures by Miguel Covarrubias,
stained-glass windows showing the four Pacific
Rim continents, and dioramas illustrating the
unification of the region. The court's pièce de
résistance was Ralph Stackpole's imposing
eighty-foot statue *Pacifica*, a pan-ethnic West
Coast counterpart to the Statue of Liberty.

To foster amicable relations with Latin
America, as part of the Pacific Basin, Diego
Rivera was invited back to California to paint a
mural entitled *Pan-American Unity* before

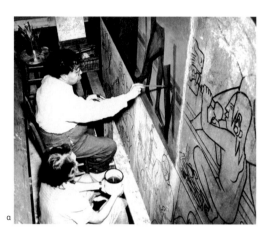

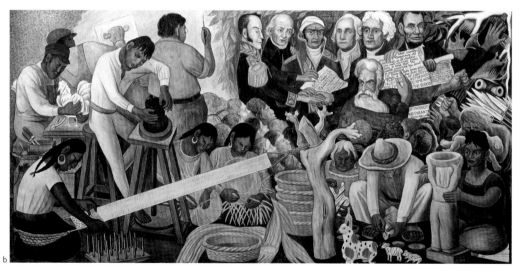

crowds of visitors in an abandoned airplane
hangar on Treasure Island. The well-seasoned
Rivera was undoubtedly a willing participant in
this performance of sorts, and certainly many
artists painted on display throughout the United
States during this period. Yet Rivera appears to
have been ambivalent about the task of celebrat-
ing Pan-Americanism. The ten-panel mural, as
Anthony Lee has noted, is replete with disjunc-
tive imagery and subtle ironies about the power
imbalance inherent in cross-cultural exchanges

between California and Mexico. In one of the
lower panels, for example, Rivera depicts native
peoples laboriously fashioning trinkets and
souvenirs of the sort sold at expositions. An
anthropomorphized tree, to which one figure
has attached her loom, is being strangled in the
process. In the background is an image of the
artist himself painting a mural honoring North
American heroes, who appear rather stiff and
unfeeling above the strangled tree. Rivera thus
comments on the United States's exploitation of
Mexico and its people, including himself, in the
name of fostering cultural exchange. The imagery
in these passages, although possible to miss in
this densely composed mural, undermined the
booster message Rivera was enlisted to convey.[37]

Rivera's *Pan-American Unity* mural asserts
in a quiet way the limited and tenuous nature
of California's "cultural openness" toward its geo-
graphical neighbors during the 1920s and 1930s.[38]
In the following war-torn decade, latent racist atti-
tudes were espoused widely and openly. Indeed,
the Navy's destruction of the Pacifica statue during
World War II, when more than 100,000 people
of Japanese descent were interned in the western
United States, confirmed the official sanctioning
of xenophobia that took place in the 1940s. A
resurgence of the conservative mainstream—
mirrored in the country at large—occurred during
the war years, followed by an effort to suppress
the multiplicity of voices that had surfaced in the
volatile and complex decades between the two
world wars.

1 William E. Leuchtenberg, *The Perils of Prosperity, 1914–32* (Chicago: University of Chicago Press, 1958), 1979.

2 Quoted in William Deverell, introduction to "Los Angeles and the Mexican or What's Typical in Los Angeles History?" (paper delivered during the 1996–97 series Perspectives on Los Angeles: Narratives, Images, History, at the Getty Research Institute, Los Angeles, Feb. 1997), 27–28; see also Deverell, *Whitewashed Adobe: Los Angeles and the Remaking of the Mexican Landscape* (Berkeley and Los Angeles: University of California Press, forthcoming). Deverell cites realtor reports from the Race Relations of the Pacific Coast collection, Hoover Institution Archives, Hoover Institution on War, Revolution, and Peace, Stanford University.

3 Tom Zimmerman, "Paradise Promoted: Boosterism and the Los Angeles Chamber of Commerce," *California History* 64 (winter 1985): 31.

4 For further discussion of the leftist community of artists in San Francisco, particularly in relation to the presence of Diego Rivera in 1930, see Anthony W. Lee, *Painting on the Left: Diego Rivera, Radical Politics, and San Francisco's Public Murals* (Berkeley and Los Angeles: University of California Press, 1999).

5 Panel 26 of Refregier's mural—a chronological history of San Francisco commissioned by the federal government in 1940 and completed in 1946—portrayed the strike of 1934. The panel was criticized by the Veterans of Foreign Wars (VFW) for its depiction of suspected Communist Harry Bridges pointing a finger at the corruption of hiring bosses in the industry. After minor changes that did not appease the VFW, the House Committee on Public Works debated the murals' destruction in 1953 but ultimately decided to leave them standing. See Gray Brechin, "Politics and Modernism: The Trial of the Rincon Annex Murals," in *On the Edge of America: California Modernist Art, 1900–1950*, ed. Paul Karlstrom (Berkeley and Los Angeles: University of California Press, 1996), 68–93.

6 Lee, *Painting on the Left*, 131–36.

7 "Murals on Coit Shaft Hint Plot for Red Cause," *San Francisco Chronicle*, July 3, 1934. See also *San Francisco Examiner*, July 5 and July 9, 1934. For a more lengthy analysis of the tower's reception, with special attention to the Zakheim mural, see Lee, *Painting on the Left*, 143–59. For a history and iconography of the twenty-seven murals, see Masha Zakheim Jewett, *Coit Tower, San Francisco: Its History and Art* (San Francisco: Volcano Press, 1983).

8 Carey McWilliams, *Factories in the Field* (Boston: Little, Brown and Company, 1939), 146.

9 See Lee, *Painting on the Left*, 78.

10 Patricia Junker, "Celebrating Possibilities and Controlling Limits: Painting of the 1930s and 1940s," in Steven A. Nash et al., *Facing Eden: 100 Years of Landscape Art in the Bay Area*, exh. cat. (San Francisco: Fine Arts Museums of San Francisco, in association with University of California Press, Berkeley and Los Angeles, 1995).

11 Kevin Starr, *Endangered Dreams: The Great Depression in California* (New York: Oxford University Press, 1996), 64–65.

12 *Their Blood Is Strong: A Factual Story of the Migratory Agricultural Workers in California* (San Francisco: Simon J. Lubin Society of California, 1938), 26–27.

13 Between 1929 and 1934, 400,000 Mexicans were "repatriated" by the United States government in order to reduce welfare payments during the Depression. See Chon Noriega, "Citizen Chicano: The Trials and Titillations of Ethnicity in the American Cinema, 1935–1962," *Social Research* 58, no. 2 (summer 1991): 415.

14 *Official Tourist Guide* (Los Angeles: All-Year Club, 1935), quoted in Zimmerman, "Paradise Promoted," 33.

15 "Along the Road: Extracts from a Reporter's Notebook," *Fortune*, April 1939, 96.

16 *Touring Topics*, June 1922.

17 See John Ott, "Landscapes of Consumption: Auto Tourism and Visual Culture in California, 1920–1940," in *Reading California: Art, Image, and Identity, 1900–2000* (Los Angeles: Los Angeles County Museum of Art, in association with University of California Press, Berkeley and Los Angeles, 2000).

18 Obata made this statement to a critic in 1931. Quoted in Nash et al., *Facing Eden*, 71.

19 Quoted in James Enyeart, *Edward Weston's California Landscapes* (Boston: Little, Brown and Company, 1984), 11. Weston is quoting phrases that Adams had used previously.

20 See Neal Gabler, *An Empire of Their Own: How the Jews Invented Hollywood* (New York: Crown Publishers, 1988).

21 Lary May, *Screening Out the Past: The Birth of Mass Culture and the Motion Picture Industry* (Oxford: Oxford University Press, 1980), 170–71.

22 In fact, capital investment in the film industry doubled between 1926 and 1933. See Carey McWilliams, *Southern California: An Island on the Land* (1946; reprint, Salt Lake City: Peregrine Smith, 1990), 347.

23 Quoted in John Kobal, *The Art of the Great Hollywood Portrait Photographers, 1925–1940* (New York: Harrison House, 1987), 97.

24 Quoted in Michael Regan, *Hollywood Film Costume*, exh. cat. (Manchester: Whitworth Art Gallery, University of Manchester, 1977), 17.

25 George Hadley-Garcia, *Hispanic Hollywood: The Latins in Motion Pictures* (New York: Carol Publishing Group, 1990), 15.

26 Ibid.

27 See Gary Null, *Black Hollywood: From 1970 to Today* (New York: Carol Publishing Group, 1993), 11–16.

28 Other evidence of discrimination can be found in the burning of a Mexican neighborhood in Los Angeles, without compensation to its residents, in an effort to eradicate the bubonic plague. A precedent for this had been set in 1907 with the destruction of many homes in San Francisco's Chinatown after a plague outbreak. See Mike Davis, *Ecology of Fear: Los Angeles and the Imagination of Disaster* (New York: Henry Holt and Company, 1998), 252–60.

29 "Artists Fight on Employing Mexican 'Red,'" *San Francisco Chronicle*, September 24, 1930.

30 Diego Rivera, *Portrait of America* (New York: Covici, Friede, 1934), 12.

31 *Los Angeles Times Sunday Magazine*, August 21, 1932. Quotation appeared in an accompanying insert, "The Artist Who Drew This Week's Cover," by major Los Angeles art critic Arthur Millier, 18.

32 David Alfaro Siqueiros, *La historia de una insidia. Quiénes son las triadores a la patria? Mi Respuesta* (Mexico City: Ediciones de 'Arte Público,' 1960), 32, quoted in Shifra M. Goldman, "Siqueiros in Los Angeles," in *Los murales de Siqueiros*, ed. Raquel Tibol (Mexico City: Américo Arte Editores, S.A. de C.V. and Conaculta, Instituto Nacional de Bellas Artes, 1998).

33 From Shifra Goldman's interview with Feitelson, "Siqueiros in Los Angeles" (July 1973), quoted in Shifra M. Goldman, "Siqueiros and Three Early Murals in Los Angeles," *Art Journal* 33, no. 4 (summer 1974): 325.

34 See Helen Delpar, *The Enormous Vogue of Things Mexican: Cultural Relations between the United States and Mexico, 1920–1935* (Tuscaloosa: The University of Alabama Press, 1992).

35 Letter dated May 31, 1926. Collection of Yun Gee's daughter, Li-lan.

36 For the key text that initiated a discourse on Orientalism, see Edward Said, *Orientalism* (New York: Pantheon Books, 1978).

37 For further analysis of the iconography and intent of *Pan-American Unity*, see Lee, *Painting on the Left*, 211–12.

38 For further discussion of the motivations behind the Good Neighbor policy and its limitations in fostering understanding between people of the United States and Mexico, see Holly Barnet-Sanchez, "The Necessity of Pre-Columbian Art in the United States: Appropriations and Transformations of Heritage, 1933–1945," in *Collecting the Pre-Columbian Past: A Symposium at Dumbarton Oaks, 6th and 7th October 1990*, ed. Elizabeth Hill Boon (Washington, D.C.: Dumbarton Oaks Research Library and Collection, 1993), 177–207.

Swoon-glo

IN PARACHUTE COLORS

Make Sure it has This Label—Your Proof it's a Cole Original

Cole

OF CALIFORNIA
ORIGINAL

Copr., 1944, by Cole of California, Inc., Los Angeles 11

Sheri Bernstein

In the years between America's entry into World War II in 1941 and the election of President John F. Kennedy in 1960, California's image in the national psyche was shaped by a pervasive wartime mentality. When the battle against fascism ended, the Cold War against Communism replaced it. Even in the prosperous postwar years, defined by optimism in so many respects, the specter of a foreign threat, of impending disorder and catastrophe, remained ever present. And California, which during World War II was touted as the invulnerable gateway to the Pacific Theater, became a symbol of the good life in the postwar period, a haven for safe, comfortable, and affordable living in sunny surroundings. Although the golden image of California as a domesticated Eden was challenged by some who found it constricting, and rejected by others whom it excluded by virtue of ethnicity or class, this boosterist vision unquestionably held sway for nearly two decades. Indeed, the state's image as a bastion of homogeneous, white middle-class suburbia—despite the increase in its actual diversity due to wartime and postwar migration—answered a deep-seated need among Americans for consensus and security.

With America's entry into World War II, California emerged at the forefront of wartime production and reaped major economic benefits. The Hollywood industry, for one, became intimately involved in the war effort, generating scores of propagandistic and jingoistic films. Other major California industries, bolstered by hefty federal funds, also significantly expanded their operations in response to wartime needs. In Los Angeles three major aircraft companies—Lockheed, Douglas, and Vultee—employed thousands of men and women, including many recent arrivals to the region. Shipbuilding burgeoned as well in both Northern and Southern California, attracting tens of thousands of African Americans, mostly from the southern states. (While blacks had been leaving the South steadily since the turn of the century, it was not until this period that they came to California in sizable numbers.) By 1944 African Americans comprised 15 percent of the 9,000-person workforce employed by Los Angeles's shipbuilding companies (predominantly by the "Big Three" located on Terminal Island: the California Shipbuilding Company [Calship], Consolidated Steel, and Western Pipe and Steel Company).[1]

Agriculture was another key aspect of California's wartime production, with the state supplying food to Americans at home and on the battlefront. In order to meet the nation's amplified food needs—in the midst of a labor shortage brought on by the draft and the relocation of the Japanese—the U.S. government instituted the Bracero program in 1942, which called for the temporary importation of Mexican workers into California to harvest crops. The federally sanctioned policy of bringing in *braceros* (strong-armed ones) according to the needs of agribusiness continued through 1964.[2] Although braceros were denied the rights of American citizens and received neither decent wages nor the union

a
Magazine advertisement
for Cole of California's
Swoon-Glo swimwear, 1945.
Illustration by Ren Wicks

b
Page from the model home
brochure *Lakewood:
The Future City as New as
Tomorrow*, 1940s. Lent by
Jim Heimann

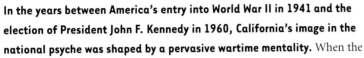

MODEL **29**-A

It's easy to own a home in Lakewood—a home you will
always be proud of. Your low monthly payments help to
build up savings for the future.

b

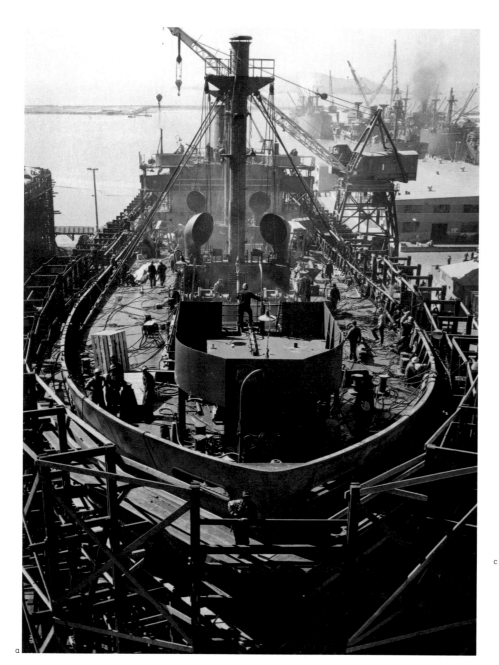

a

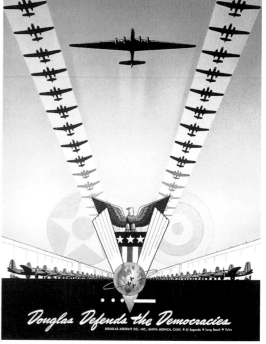

c

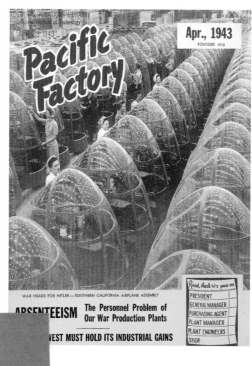

benefits they had been promised, many publicly expressed feelings of pride in their contribution to the war effort.

Yet California was principally known during these years as a producer of instruments of war, not as a provider of crops. Indeed, the booster image of the state at this time became that of a highly productive war machine. Images of seemingly endless rows of perfectly crafted warheads replaced those of golden oranges, which had so forcefully shaped popular perceptions of the state earlier in the century. What linked this wartime view of California to previous boosterist visions, including the Hollywood glamour image of the 1920s and 1930s, was the concept of limitless bounty. California continued to stand for abundance and plenty in the war years, albeit an abundance of tools of combat, rather than of Hollywood beauties or fruits of the land.

a
Photograph documenting the
record-setting construction
of the S.S. *John Fitch*,
Richmond, California, 1942.
Lent by Mrs. Edmund L. Dubois

b
Pacific Factory magazine,
April 1943. Lent by
San Francisco State
University, Labor Archives
and Research Center

c
"Douglas Defends the
Democracies," magazine
advertisement, 1942. Lent by
Jim Heimann

d
Dorothea Lange
*Untitled [End of Shift, 3:30,
Richmond, California,
September 1942]*, 1942,
gelatin-silver print

e
We Also Serve magazine,
1944. Lent by San Francisco
State University, Labor
Archives and Research Center

149

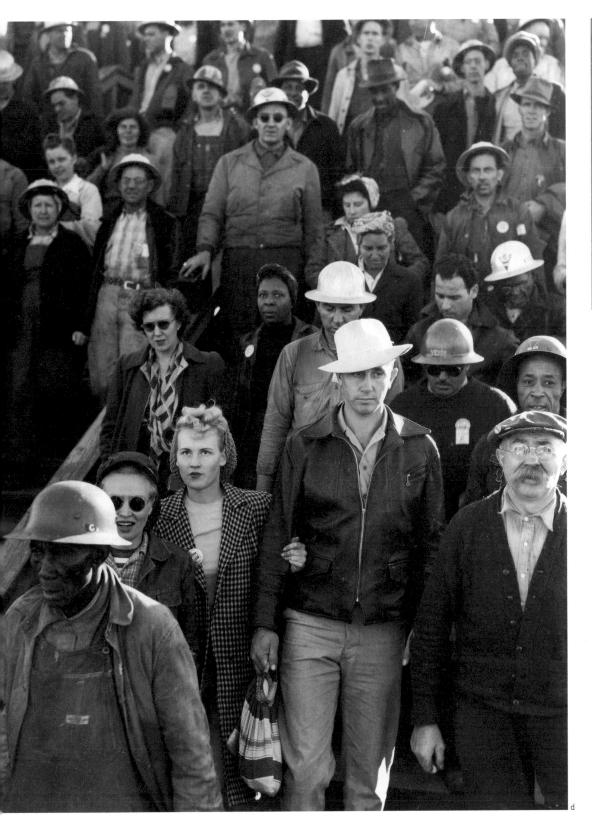

150

a

b

c

a

Charles and Ray Eames
Leg Splints, c. 1943, molded
plywood

b

Art for Victory, brochure
for an exhibition at the
Pasadena Art Institute, 1944.
Lent by the Southwest
Museum, Los Angeles

c

*California Arts and
Architecture* magazine, May
1943, cover design by Ray
Eames. Lent anonymously

d

Richard Neutra
Channel Heights Chair,
1940–42, wood, metal, and
plastic

151

Numerous institutions and individuals in the arts community supported California's booster image as a mainstay of the war effort. While museums and galleries generally showed their patriotism through the traditional avenue of exhibitions—the Pasadena Art Institute, for example, organized *Art for Victory* in 1944— it was designers and architects with practical skills who became most directly involved in war production. Cole of California, for instance, took up parachute manufacturing while continuing to produce women's apparel. Their popular Swoon Suit (see p. 146)—a lace-up two-piece bathing suit available in "parachute colors"—conformed to strict wartime restrictions on the use of rubber for elastic.[3] To highlight its wartime contributions, Cole published numerous advertisements, including one showing a woman in a Swoon Suit beside a paratrooper. The proud caption read, "They Wear the Same Label."[4]

Two of the most important California designers to employ their skills in the service of the war were Charles and Ray Eames. The Los Angeles–based couple devised and manufactured molded plywood leg splints as well as nose cones and other aircraft parts for local aviation companies and the federal government. Similarly, California architects William Wurster and Richard Neutra turned their skills to designing cost-efficient housing and furniture for war workers. Neutra's *Channel Heights Chair*, created from inexpensive everyday materials and usable both indoors and out, was a component of his acclaimed Channel Heights project of the early 1940s, a public housing tract intended for shipyard laborers in Los Angeles. The same principles of economy and fluidity of function that had been developed during the war years continued to inform the housing and furniture designs of Neutra, Wurster, the Eameses, and other creative figures in the postwar period.

Although California was chiefly imaged at this time as an efficient war machine, other more disturbing ideas circulated as well. The mass media also promoted the wartime conception of the state—and of the United States generally—as vulnerable to potential threats by "foreigners," who needed to be kept under strict control. Indeed, conceptions of Americanness became far more restrictive at this time, as widespread uneasiness over the displacement of the country's white male population heightened xenophobia and racism. Among those frequently branded foreigners, in addition to

d

a, b
Pair of anti-Japanese
propaganda posters
produced by Fleet Service
Schools, Visual Education
Department, U.S. Destroyer
Base, 1941. Lent by the
Japanese American National
Museum, gift of Ben and
Teruko Orel

c
Max Yavno
Street Talk, 1946, gelatin-
silver print

d
Sleepy Lagoon Mystery, a play
sympathetic to the defen-
dants in the Sleepy Lagoon
case, by Guy Endore, 1944.
Lent by San Francisco State
University, Labor Archives and
Research Center

152

AMERICA WILL STRAIGHTEN OUT HIS
COCKEYED SLANT ON THE WORLD

a

— LIKE THIS!

b

actual noncitizens, were Americans of non-Anglo ethnicities.

One result of restrictive conceptions of Americanness in California was the targeting of young Mexican males—concentrated in the state's poorer urban centers—by white service-men, civilians, and the legal system. Identifiable by the wide-lapelled, full-cut "zoot suits" they and many black and Filipino youths sported—despite the War Production Board's rationing of cloth—these *pachucos*, as they were called, were stereotyped in the media as juvenile delinquents and were treated with hostility and suspicion by the majority of whites.[5] The very act of wearing a zoot suit was ruled a misdemeanor by the city of Los Angeles during the war. Animosity against this sector of California's residents exploded in the so-called Zoot Suit riots of 1943. The distur-bance started with an attack on a group of pachucos by an estimated 200 white servicemen,

who had entered a Los Angeles barrio looking for a fight while on leave. After beating their victims, they stripped them of their zoot suits (sources of identity and pride) and shaved their heads, thereby asserting power over the youths in paramilitary fashion. Indicative of the racist climate is the fact that the police primarily arrested the Mexicans and blacks who were the objects of these hate crimes, rather than the white perpetrators.

A well-known instance of the rampant racism against minorities during the war was the widely publicized Sleepy Lagoon case of the mid-1940s. This involved the arrest and conviction of twenty-two pachucos for criminal conspiracy, assault, and murder in the death of another Mexican American youth. Playing on widespread wartime animosity toward the Japanese, prose-cuting attorneys accused the Mexican youths of having an "Oriental . . . disregard for the value of life."[6] With the aid of the Sleepy Lagoon Defense Committee, headed by lawyer and jour-nalist Carey McWilliams and including such Hollywood figures as Orson Welles and Rita Hayworth, the convictions were later overturned. A wartime political cartoon in the *Los Angeles Times* depicting Japan's prime minister, Tojo, wearing a zoot suit, revealed a conflation of Mexicans and Asians as foreigners who allegedly could not be trusted.[7] These pervasive negative associations were also reinforced by disparaging portrayals of Mexican, Asian, and African Americans as unsavory characters in many noir films of the 1940s.[8]

With respect to California's artistic com-munity, the impact of wartime racism against ethnic minorities manifested itself in two princi-pal ways. First, there was a marked decline in the attention white artists paid Latin American and Asian aesthetics and subjects compared to the previous two decades, during which these

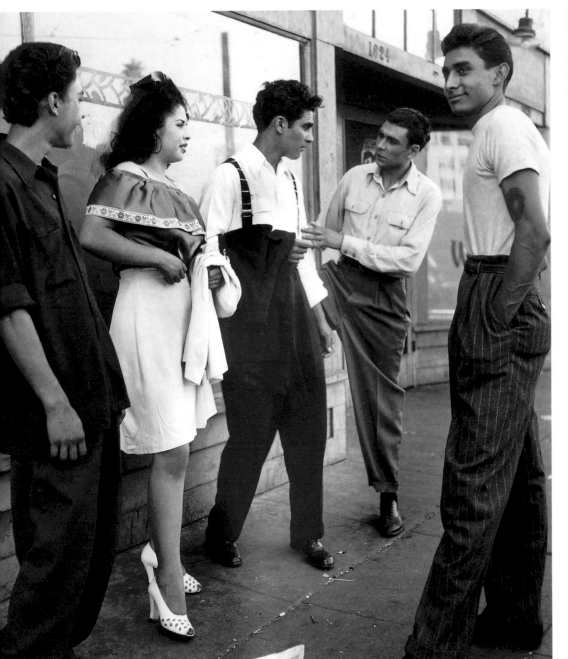

c

d

cultures had been widely celebrated as exotic or picturesque. Second, mainstream California institutions exhibited and collected far fewer works by non-Anglos at this time. In particular, there was notably diminished support for Mexican art, which had enjoyed a considerable popularity in the 1920s and 1930s among museums, galleries, and private patrons. Los Angeles hosted only a single exhibition of Latin American art during the war years, and that was organized by an East Coast institution.[9]

Another distressing manifestation of American wartime xenophobia that affected the arts in California was the internment of the Japanese (most of whom were United States citizens) by the federal government from 1942 to 1945. Los Angeles had the highest Japanese population of any city in the United States before the war, and California had been home to a significant portion of the 110,000 Japanese Americans and Japanese nationals interned in concentration camps in seven western states.

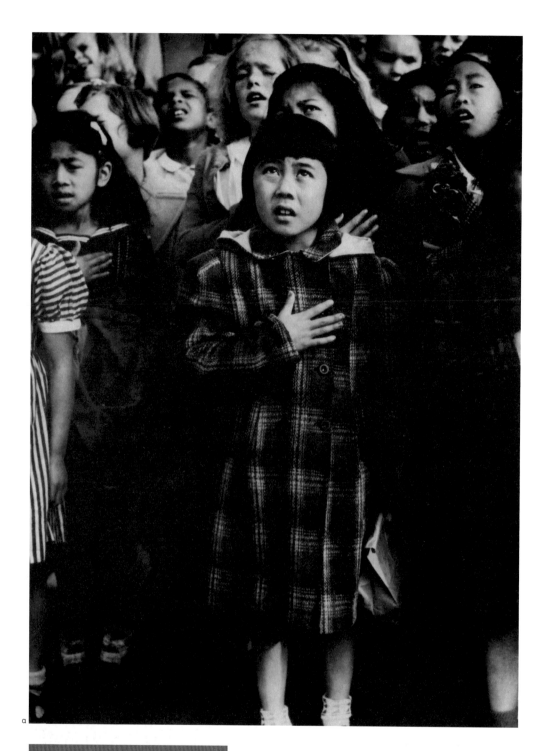

Two of the concentration camps—Manzanar and Tule Lake—were located in California, as were a number of temporary detention centers that initially housed internees. Tule Lake was reserved for political "disloyals," who had given incomplete or conditional responses on the poorly designed loyalty questionnaires administered to all internees.[10]

The considerable body of visual art produced by Japanese internees during the war conveys a wide range of perspectives on the experience. Like many of his fellow Issei (first-generation immigrants), Chiura Obata continued to avoid critical or negative subjects, as he had during the Depression. For example, he painted a wistful image of San Francisco on the day he was interned. Although temporarily turning to genre scenes of daily life in the camps, he soon resumed painting his favorite subject, the natural landscape. Other internees—for example, Henry Sugimoto—treated more sensitive topics. In a dignified portrait of his mother, he suggested the painful irony of her internment by including a reference to the division of the 442nd Regimental Combat Team of which Sugimoto's brother was then a member. This unit of the U.S. Army consisted entirely of Nisei (second-generation Japanese Americans). Yet internees, even Nisei, produced few strident visual protests.[11] The anti-Japanese fervor of the day undoubtedly inspired fears of censorship and other forms of persecution.

While racist perceptions of the Japanese predominated in California during the war—evidenced and perpetuated by venomous publications such as *Once a Jap, Always a Jap*, sponsored by the California Veterans of Foreign Wars of the United States—these were countered by a number of sympathetic voices, which at times emanated from the arts community.[12] Institutions such as Mills College in Oakland and

a
Dorothea Lange
Pledge of Allegiance, at
Raphael Elementary School,
a Few Weeks before
Evacuation/One Nation
Indivisible, April 20, 1942,
1942, gelatin-silver print

b
Once a Jap, Always a Jap,
political tract by T. S.
Van Vleet, 1942. Lent by
UCLA Library, Department of
Special Collections

c
Chiura Obata
Farewell Picture of the Bay
Bridge, April 30, 1942, 1942,
sumi on paper

d
Hisako Hibi
We Had to Fetch Coal for the
Pot-Belly Stove, Topaz, Utah,
1944, oil on canvas

e
Henry Sugimoto
Mother in Jerome Camp, 1943,
oil on canvas

155

the Pasadena Art Institute, for example, exhibited works by Japanese Americans interned in Tanforan Detention Camp near San Francisco, where Obata had rapidly established a sizable art school. Although employed by the government, photographer Dorothea Lange publicly voiced opposition to the internment. Ansel Adams's exhibition and subsequent book *Born Free and Equal: The Story of Loyal Japanese Americans* sympathetically portrayed the internees at Manzanar in an effort to distinguish them from the "disloyal Japanese aliens" held in separate camps. Yet many of Adams's images effectively sanitized the experience of internment. In one example, an attractive, well-dressed young woman smiled for the camera while standing beneath a sign that read, "Relocation." This approach was probably intended to humanize

c

d

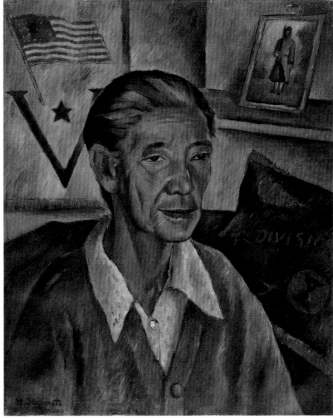
e

a

Ansel Adams

Mt. Williamson, the Sierra Nevada, from Manzanar, California, 1944, printed 1980, gelatin-silver print

b

Title spread from *Born Free and Equal: The Story of Loyal Japanese Americans* by Ansel Adams, 1944. Lent by Mrs. Edmund L. Dubois

c

Toyo Miyatake

Untitled, 1943, gelatin-silver print

d

Clinton Adams

Barrington Street, 1951, egg tempera on paper

e

William Garnett

Lakewood Housing Project, 1950, six gelatin-silver prints

156

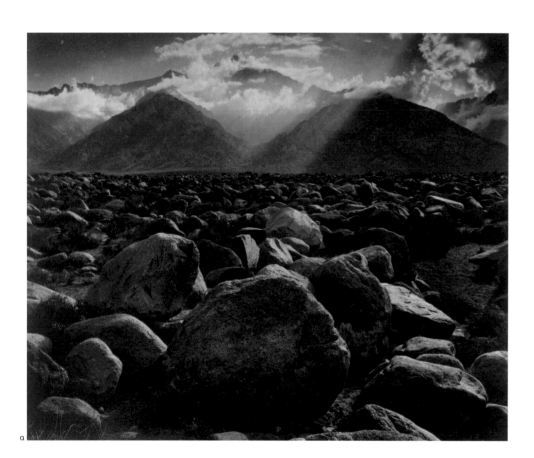

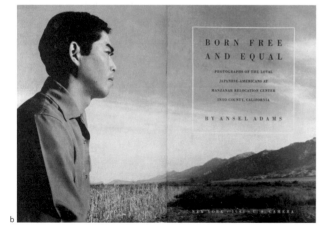

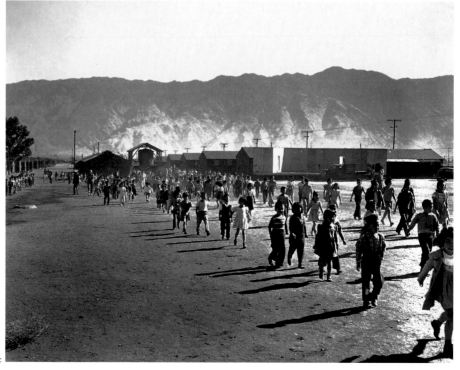

the internees and to emphasize their commonalities with other Americans. For somewhat different reasons, including a desire to normalize the experience and render it less disconcerting to himself and his fellow internees, photographer Toyo Miyatake took a paradoxically positive approach to camp life in many of his images. Yet certain of his other photographs reveal a darker side of camp existence, whereas Adams's never do.[13]

Following the devastating bombing of Hiroshima in August 1945, which brought an end to the war in the Pacific, the United States entered an era of optimism fueled by extensive economic prosperity. The postwar utopian vision of suburban domestic life centered on the nuclear family was promoted tirelessly by the mass media, which now included television.[14] While the Bay Area experienced massive suburban growth during this period,[15] Southern California—where sunshine, jobs, and affordable

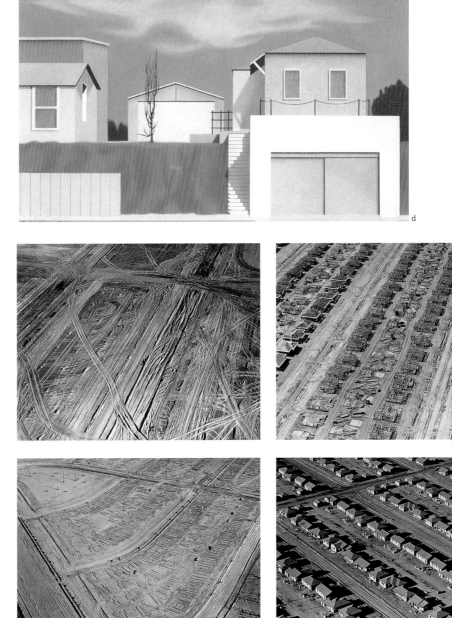

d

housing abounded—was lauded as the ideal. Magazine and newspaper articles with such titles as "Why People Leave Home to Live in the Southland" and "Westward Ho: California Home Styles Invade the Rest of the U.S." touted California's easygoing suburban lifestyle. The one-story ranch house with its "sliding glass walls" opening out onto private backyards with barbecues and swimming pools became a highly desired dwelling.[16]

Like the California bungalow associated with the first half of the century, the ranch house was promoted as affording an easy, healthful lifestyle that involved direct contact with nature. In contrast to the boxlike bungalow, which had been designed in reaction against the perceived excesses of East Coast Victorian architecture, the sprawling ranch house was billed as commodious. It answered the pronounced yearning for comfort and ease of living that followed the arduous Depression and war years.[17] With its self-contained, indoor-outdoor plan, the ranch house offered an appealingly fluid yet controlled environment: a site for recreation as well as habitation, which could be improved upon through the purchase of an endless array of consumer goods. Its principal designers—such as self-trained architect Cliff May, whose custom-made homes became prototypes for tract housing—set out to create efficient, tidy, and livable spaces rather than aesthetic masterpieces.

In tandem with the promotion of the ranch house, Southern California in particular became the nation's hot spot for swimsuit and other sportswear designs that expressly fit the new indoor-outdoor suburban lifestyle.[18] As in housing design, fluidity of function was a major selling point in fashion. A single outfit often had multiple components that could be worn or removed depending on the occasion.

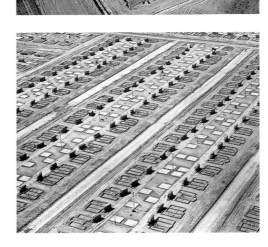

e

158

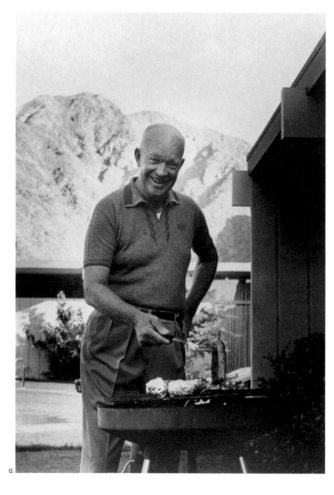

a

b

c

d

a
Sid Avery
Dwight D. Eisenhower in La Quinta, California, 1961, gelatin-silver print

b
Margit Fellegi
Woman's Bathing Suit and Skirt, c. 1944, glazed cotton chintz, cotton, and elastic (Matletex)

Margit Fellegi, who designed for Cole of California, created bathing suits with matching skirts that enabled a smooth transition from poolside to dining room. Textile designs often bore the imprint of suburban leisure, such as the backyard barbecue motif used by designer DeDe Johnson in her classic *Woman's Three-Piece Playsuit* of the late 1950s.

Art photography also bolstered Southern California's suburban booster image. Sid Avery's portrait of a retired and jovial Dwight Eisenhower, barbecuing in his backyard in short sleeves, epitomizes the idyllic vision of the postwar years. Similarly, Max Yavno's ebullient image of a crowd-packed Muscle Beach in Venice encapsulates the optimism of this era and its emphasis on leisure.[19] Previously a member of New York's leftist Photo League, which was dedicated to picturing social ills, Yavno shifted his focus after moving to California. His Muscle Beach photograph,

e

c	d	e	f	g
Catalina Sportswear	**DeDe Johnson**	**James Hansen**	**Max Yavno**	**Larry Silver**
Woman's Two-Piece Bathing Suit and Jacket, late 1940s, printed cotton	*Woman's Three-Piece Playsuit*, late 1950s, printed cotton	*Beach Scene at Santa Monica in 1949*, 1949, watercolor on paper	*Muscle Beach*, 1947, gelatin-silver print	*Newsboy Holding Papers*, 1954, gelatin-silver print

159

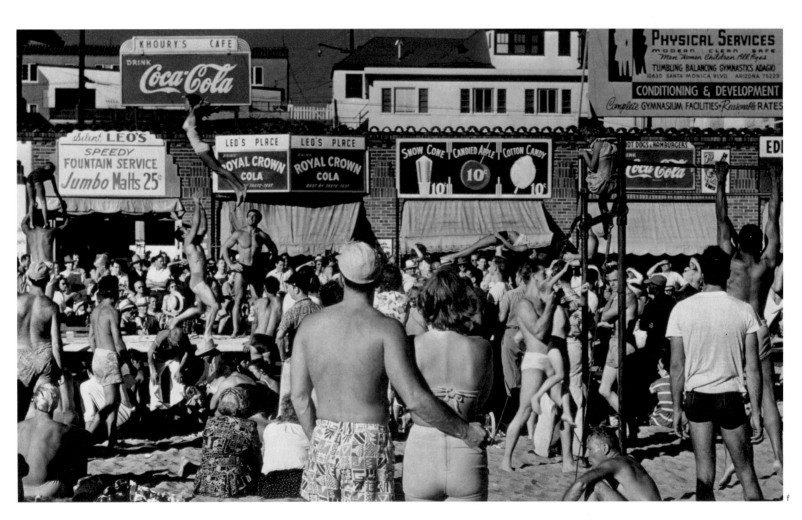

with its sea of white all-American bathing-suited bodies, uncritically conveys the ethnic and class homogeneity intrinsic to the booster vision of suburban Los Angeles. The celebratory nature of this image is underscored by a comparison with Larry Silver's photograph of a black youth selling newspapers on the same beach. Silver's image suggests that postwar suburban leisure was restricted to the dominant culture.

Yet the suburban dream of life in California did, in fact, reach a considerably broader range of Americans than either its boosters or its detractors tended to reveal. At the lower end economically, residential developments such as

160

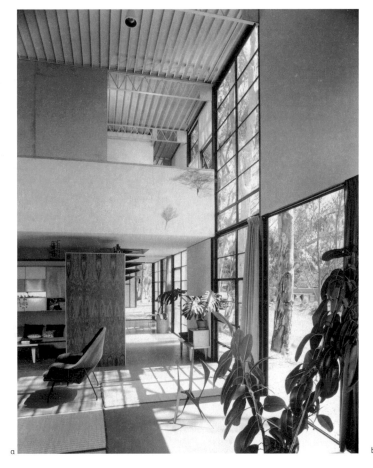

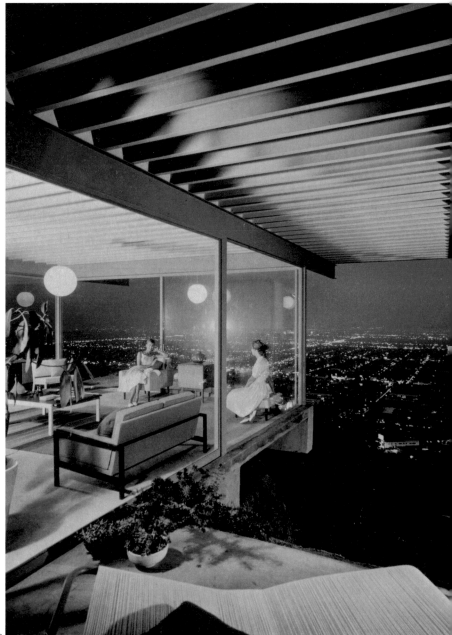

Lakewood, near Long Beach, in Los Angeles County, were publicly billed as solidly middle class while catering to blue-collar aerospace workers then flocking to Southern California. The homes built for the Case Study House Program initiated by John Entenza, editor of the avant-garde Los Angeles–based magazine *Arts and Architecture*, occupied the higher end. The project resulted in the construction of a series of homes designed by a coterie of California architects, including Neutra, the Eameses, Wurster, and Pierre Koenig. Although intended as prototypes for affordable postwar housing, these modernist constructions ultimately catered to an elite clientele. In addition to being relatively expensive, they were too austere to satisfy the taste for cozier dwellings

shared by most of the Middle Americans then pouring into the Southland. Nevertheless, the Case Study homes did kick off a trend in domestic architecture that gradually took hold nationwide.[20]

In addition to economic differences, there was also a greater degree of ethnic diversity in California's suburbs than generally assumed. Catholics and Jews were sometimes excluded as residents, and there continued to be extensive housing restrictions against African Americans, Asians, and Mexicans. However, some black suburbs did exist, for example in Marin City and east Palo Alto in Northern California. As in mainstream white publications, comparable black magazines also championed a boosterist conception of California suburban living—"the

a
Julius Shulman
Case Study House #8, by
Charles and Ray Eames, 1950,
gelatin-silver print

b
Julius Shulman
Case Study House #22, by
Pierre Koenig, 1958, gelatin-
silver print

c
Our World magazine, October
1952. Lent by UCLA Library,
Department of Special
Collections

d
Charles and Ray Eames
*ETR (Elliptical Table, Rod
Base)*, 1951, plywood, plastic
laminate, and wire base

CALIFORNIA LIVING

Midcentury Modern

The story of twentieth-century
design is one of innovation, factory
production, new materials, and the
rise of designers trained in architec-
ture, industrial design, or fine art.
Designers began to use man-made
materials as well as processes such

sports shirt and the convertible, the barbecue
pit out back and the swimming pool."[21] *Ebony*
featured a prominent black judge who lived in
Westwood, indicating that at least a few black
families had entered even the richest Los Angeles
suburbs by the late 1950s.[22]

Integration, however, was not generally
fostered by California housing developers in
the postwar period. Joseph L. Eichler in the
Bay Area was one of the few who attempted to
produce racially integrated suburban neighbor-
hoods. Although California's suburbs were
springing up at an astounding rate, minority
communities tended to remain localized in the
state's poorer urban centers. Twenty-eight
percent of Los Angeles's black population, for
example, reportedly resided in "slums" in 1949.[23]
Similarly, Mexican Americans living in the Bay
Area's Santa Clara Valley were concentrated in
the east San Jose barrio in the 1950s. The suburbs
were expressly promoted as safe havens from
these urban minority populations, which contin-
ued to be associated with crime and disorder

d

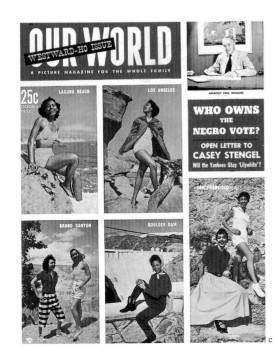

c

as machine molding in plastics, fiber-
glass, metal, glass, and plywood.
Conforming to the modernist credo
established in California through the
work of Schindler and Neutra more
than a decade earlier—that good
design be functional, affordable,
efficient, and durable—midcentury
furniture designers emphasized
versatility, adaptability for indoor
and outdoor use, unadorned struc-
ture, and a unified overall design.
 The California move to postwar
modernism was led by the adven-
turesome and innovative husband-
and-wife team of Charles and Ray
Eames, whose designs—distributed

background
Gregory Ain
(Ain, Johnson, and Day)
*Mar Vista Houses for
Advanced Development
Company, Venice, California,
Aerial Perspective*, 1946–48
•

a
Jerome Ackerman
Ceramic Pieces, 1953–60,
stoneware, glazed

b
Charles and Ray Eames
ESU (Eames Storage Unit),
1951–52, plywood, metal, and
particleboard

c
Elsie Crawford
Zipper Light II, 1965 (this
example, 1997), acrylic

d
**Hendrick Van Keppel and
Taylor Green**
Small Chaise and Ottoman,
1939 (this example, 1959),
enamel-baked steel and
cotton cord

e
Charles and Ray Eames
*Wire Mesh Chair with Low Wire
Base*, 1951–53, wire

a

nationally—exemplified the unfet-
tered L.A. lifestyle. In their production
studio in Venice, California, they
created a design legacy that included
explorations in ergonomics, experi-
mentation with new materials, and
multimedia productions. The resi-
dence that they built for themselves,
the landmark Case Study House #8,
provided an ideal aesthetic environ-
ment for their modern furniture
designs. They believed that living in
a well-designed space with finely
crafted furnishings made for a
healthier, happier individual and
that good design in the service of
progressive modernization could
effect positive social change.

When war was declared in
1941, the Eameses were awarded a
Navy contract for molded plywood
aircraft parts, leg splints, and
litters, a project that influenced
subsequent furniture designs. Their
molding of plywood into supportive
ergonomic shapes resulted in some
of the best-known chairs of the twen-
tieth century. Later furniture used
materials from the defense and
aerospace industries: cast aluminum,
wire mesh, and fiberglass-reinforced
plastic. Eames chairs were designed
for a variety of contexts, from air-
ports to office towers, and remain
among the most familiar forms of
residential, commercial, and public
seating.

The period environment created
for the *Made in California* exhibition
featured seating, a table, a storage
unit, and a folding screen designed

by the Eameses, complemented by
elegant indoor-outdoor furniture
by Hendrick Van Keppel and Taylor
Green, Los Angeles designers known
for inventive, versatile pieces suited
to the casual California lifestyle.
The outdoor aspect of the environ-
ment was further defined by Lagardo
Tackett's modular, geometric glazed
pottery planters and freestanding
sculptures. Home accessories were
distinguished by biomorphic shapes,
geometric decorative elements, and
other organic and space-age motifs
popular during the period.
JO LAURIA

Design should bring the most of the best to the greatest number of people for the least.

CHARLES EAMES

f

Lagardo Tackett
Untitled, c. 1960, ceramic,
glazed

164

a

b

freeway routes cut directly through these urban communities, they had the deleterious effect of increasing white flight to the suburbs and contributing to the decline of nonwhite urban neighborhoods. Another major cause supported by business leaders after the war was the conversion of "blighted" residential areas, such as Bunker Hill in Los Angeles, into profitable new commercial and civic districts. These developments were contested by local liberals and by the neighborhood inhabitants, who fought— ultimately unsuccessfully in the case of Bunker Hill—to refurbish the existing residential communities instead.[24]

Certain artists offered an unreservedly positive view of the processes of urban development in California. Emil Kosa, in his watercolor entitled *Freeway Beginning*, depicts a new freeway artery under construction. It spills out welcomingly into the viewer's space and completely elides the downtown area, which appears only as a benign, picturesque backdrop. Other artists who addressed these developments from an uncritical perspective made use of a sleek, hard-edged visual vocabulary reflective of their modern subjects. Los Angeles realist painter Roger Kuntz depicts a quintessential Southern California subject in *Santa Ana Arrows*, a work aesthetically ahead of its time. East Coast Precisionist Charles Sheeler, whose views of Northern and Southern California were based on three visits he made after the war, presents a

in the local and national press, as they had been during the war.

The 1940s and 1950s witnessed many widely publicized urban renewal and urban development projects—including the expansion of California's infrastructure—which were variously backed and opposed by divergent political factions. The construction of new freeways, for example, spurred by the passage of the $100 billion Interstate Highway Act of 1956, was vigorously promoted by the state's boosters. Yet, as socially minded critics noted, since many new

a
Charles Sheeler
California Industrial, 1957,
oil on canvas

b
Edward Biberman
The Hollywood Palladium,
c. 1955, oil on Celotex on
board

c
Roger Kuntz
Santa Ana Arrows, c. 1950s,
oil on canvas

d
Max Yavno
Night View from Coit Tower,
1947, gelatin-silver print

e
Emil J. Kosa Jr.
Freeway Beginning, c. 1948,
watercolor on paper

165

celebratory vision of the state's new industrial landscape. In his painting *California Industrial*, the heroically rectilinear built environment easily subsumes the curving natural terrain.

Apart from big business and other proponents of urban development, so-called progressive forces—some carried over from the New Deal era—proved more mindful of the plight of California's urban underclass. Despite apparently good intentions, however, these advocates did not always effectively serve the interests of the communities they targeted. The Housing Authority of the City of Los Angeles, originally established during World War II to provide public housing for war workers and their families, offers an apt example. Its publication *A Decent Home: An American Right* featured on

a
Illustration from the
Los Angeles Housing
Authority's booklet *A Decent
Home: An American Right*,
showing the alleged effects
of substandard housing,
1945–49. Lent by the Southern
California Library for Social
Studies and Research

b
Don Normark
Untitled, from La Loma series,
1949, gelatin-silver print

c
Lou Stoumen
Tenements of Bunker Hill,
1948, gelatin-silver print

d–f
Eviction of the Arechiga
family from Chavez Ravine,
May 8, 1959. Lent by USC,
Regional History Center,
Department of Special
Collections

its cover an ethnically diverse group of service-men returning to California after the war. While the Housing Authority ostensibly represented the interests of the working class, its mission to clean up indigent urban neighborhoods was, in fact, informed by a moralistic desire to eradicate "sub-standard behavior patterns," which it attributed to "sub-standard living conditions."[25] In *A Decent Home*, maps and charts addressing "bad housing areas" equated urban social problems such as juvenile delinquency with contagious diseases, viruslike ills that needed to be controlled and eradicated before they spread to "healthy" communities.

The efforts of such city agencies resulted in the proposed development in the early 1950s of several low-income urban housing projects, which at times engaged the energies of socially conscious modernist architects, including leftist Gregory Ain and more moderate liberal Richard Neutra. One such project, Elysian Park Heights, codesigned by Neutra and Robert Alexander, was intended to improve a "depressed" residential area in Los Angeles's Chavez Ravine. The early implementation of plans for this development in 1949 resulted in the temporary, and eventually permanent, displacement of the area's long-standing community of 1,000 Mexican American families. (In fact, most of these residents could not have afforded the proposed housing had it been completed.) The project was red-baited—which is ironic given its impact on the poor local community—and declared evidence of "creeping Socialism" by the *Los Angeles Times* and the city's business leaders, who put a stop to it by 1953.[26] In a controversial decision backed by the mayor, the land "once cluttered with shacks" was given to the newly transplanted Brooklyn Dodgers baseball team for the construction of their new stadium.[27]

In the visual arts some well-intentioned liberals departed from a boosterist perspective to consider the ills that befell ethnic immigrants and other impoverished city dwellers. Photographer Lou Stoumen created a dramatic image of a man (the artist himself) gazing out at a scene of urban blight from a tenement balcony in *Tenements of Bunker Hill*. Stoumen's portrayal of Bunker Hill marks a departure from Millard Sheets's *Angel's Flight* (see p. 104), an earlier sanitized version of the same neighborhood. Yet there was a strong dose of romanticism in this highly theatrical and obviously staged self-portrait: Stoumen was not a resident of Bunker Hill.

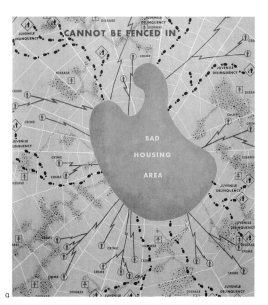

a

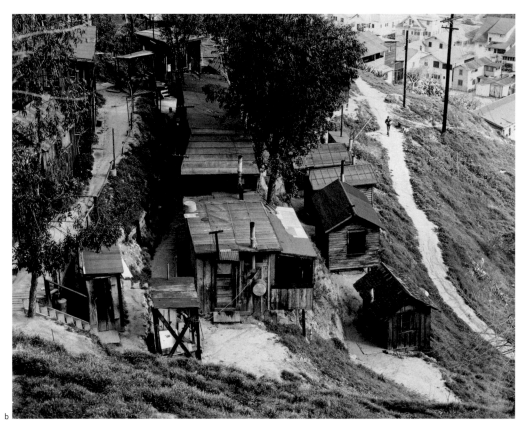

b

167

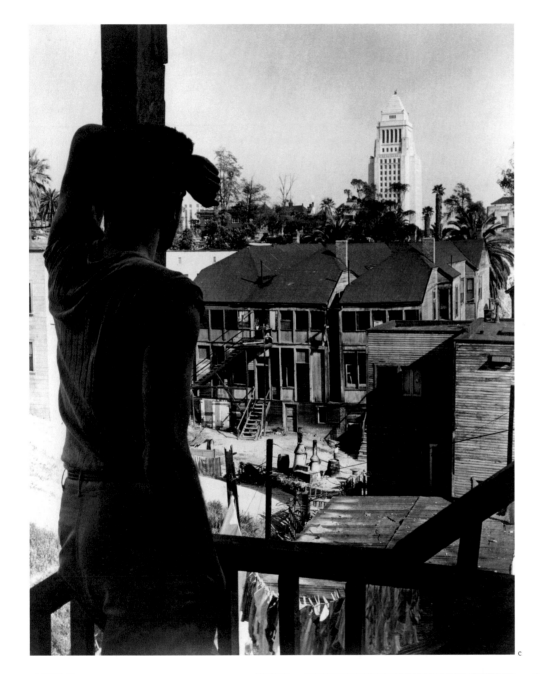

c

A romanticizing spirit also infused the photographs of La Loma, a neighborhood in Chavez Ravine. These were taken by Don Normark in 1949, the same year that Neutra and Alexander received their ill-fated Elysian Park Heights commission. These images of the community that Normark had stumbled upon as a young photographer portray the local residents and their modest surroundings as picturesque. Normark later recalled that he felt he had discovered "a poor man's Shangri-la."[28] An unidentified photojournalist working in 1959 captured in a series of searing images what was then a major media event: the eviction of the last residents of Chavez Ravine, the Arechiga family, who had resisted the city's buyout and lost their home of thirty-six years.

Few images of California generated by members of its working class were widely publicized. Watts Towers, originally titled Nuestra Pueblo (Our Town) by their creator, Italian immigrant Sabato (Simon) Rodia, are a notable exception. Depicted under construction by Dada artist Man Ray—whose sense of alienation as a wartime transplant from Paris to Los Angeles

d

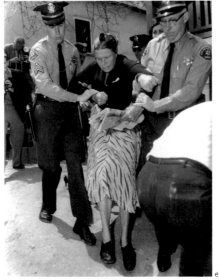

e

f

a
Man Ray
Watts Towers, Los Angeles,
1940s, gelatin-silver print

a

may account for his attraction to this work by a cultural outsider—the Watts Towers were Rodia's personalized vision of a fantasy community. Created over a thirty-year period, they were completed in 1954 at the pinnacle of the Southern California suburban housing boom. The towers offered a distinctly urban counterpoint to the new suburbs, albeit an equally utopian one.[29] Although Rodia intended the work as a celebration rather than as a critical statement, this fanciful grouping of swirling steel structures covered in a colorful mosaic of discarded glass and ceramic fragments effectively flouted the qualities of newness, cleanliness, and homogeneity championed within mainstream suburbia.

From their inception, the Watts Towers served as an icon for the ethnically diverse, working-class residential community of Watts. Not surprisingly, then, the towers were quickly perceived as a threat by the forces that sought

to contain and control this community in the name of urban improvement. Central among these was the Los Angeles Building and Safety Committee, which deemed the towers a public safety hazard and called for their destruction in 1959. Those who fought successfully to keep the towers standing included members of the local arts community, some of whom were producing assemblage works sympathetic to Rodia's junk aesthetic.[30] In subsequent decades, the Watts Towers became an integral aspect of the state's image and were even included on the cover of a 1969 issue of *Time* magazine devoted to California (see p. 193).

In tandem with the dissemination of suburban and urban images of California, the state's natural landscape once again became a common subject, following something of a hiatus during the war. Yet it proved to be a highly contested one during the Cold War years, particularly within the arts. While picturesque scenes of nature were still commonly exhibited by the region's major art institutions, works that portrayed the landscape in expressionistic or abstracted terms were rarely shown in public spaces. When they did appear, such images met with active hostility from the white establishment. This was the case when several modernist landscapes received prizes at one of Los Angeles's uniquely all-inclusive outdoor art festivals, organized by a liberal-minded director of the Municipal Art Department and held in Griffith Park. In response, the conservative City Council's Building and Safety Committee—spurred on by disgruntled landscape painters who had not won awards at the festival—led a public investigation of the festival proceedings, arguing that there had been "a heavy Communist infiltration at this exhibit."[31]

Among the unconventional landscapists castigated as leftist radicals regardless of their

b
Richard Diebenkorn
Berkeley #32, 1955, oil on
canvas

c
Knud Merrild
Flux Bouquet, 1947, oil on
Masonite

d
Helen Lundeberg
*The Shadow on the Road to
the Sea*, 1960, oil on canvas

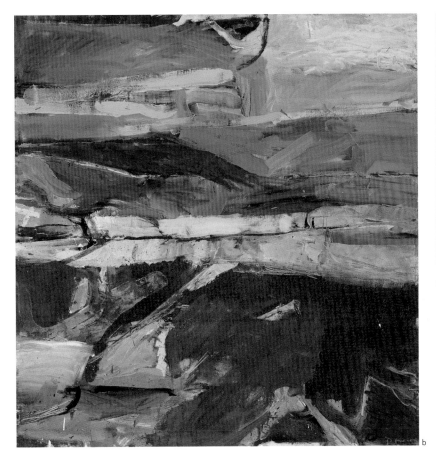

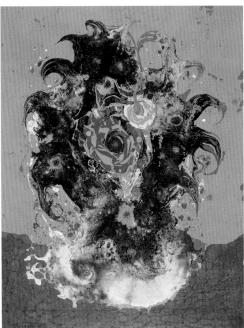

actual political views were Helen Lundeberg
(ironically, a fervent isolationist before and
during the war), Knud Merrild, and Rex Brandt.
Brandt was falsely accused by the City Council
of hiding a hammer and sickle insignia in one
of his expressionistic seascapes.[32] In this climate
of right-wing paranoia, Lundeberg and Merrild
were held under suspicion for their modernist
aesthetics, which yielded—in addition to entirely
abstract works—unconventional depictions
of the California landscape. Lundeberg's cool,
minimalist visions such as *The Shadow on the
Road to the Sea* verge on total abstraction.
Merrild, who had invented a drip technique
called "flux" that predated Jackson Pollock's,
rendered the natural world as an inchoate,
untamed entity in works such as *Flux Bouquet*.

170

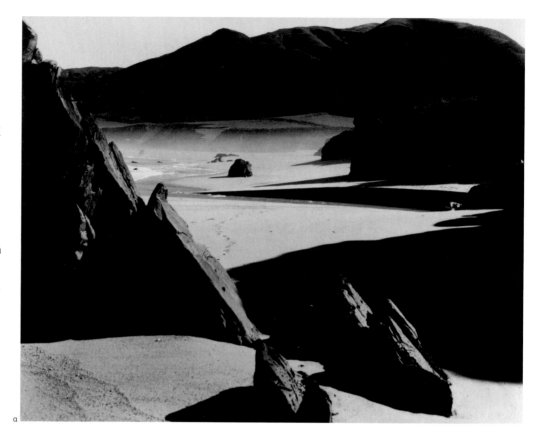

a

Neither these artists nor any of the other so-called subversives of the period supported a picturesque or otherwise reassuringly familiar vision of the landscape.

In contrast, the California painters who were widely esteemed generally upheld a scenic vision of the state, which boosters were once again heavily promoting after the war. The tourist industries and the mass media expended tremendous energy on presenting postwar California as a prime site for recreational activity and visual consumption. A number of artists contributed to this conception. Perhaps most influential in this regard was Ansel Adams, whose inspiring photographs of nature were exhibited and well received in art circles but also held currency at the time with a broader public. In 1951 Adams's work graced the pages of *Time* magazine, accompanied by the caption, "No artist has pictured the magnificence of the western states more eloquently." His arrestingly beautiful images of Yosemite attracted droves of new visitors to this already heavily trafficked national park.[33]

Adams complemented his fine-art projects during the postwar years with straight commercial work for Eastman Kodak and other companies.

In various advertisements for Kodak, he presented the infiltration of the natural landscape by tourists in uncritical terms. One such ad contained a classic, pristine view of the Yosemite Valley juxtaposed to two images of vacationers pointing cameras at the park's Vernal Falls. Adams's grand yet comfortingly picturesque images numbered among the depictions of the California landscape most welcomed by regional and national business. His photographs appeared in the 1954 annual reports of Bank of America, Pacific Gas and Electric, and the Polaroid Corporation, as well as the Curry Company, which ran Yosemite's concessions.[34]

The many nature-oriented theme parks that sprang up in California during the 1950s—Pacific Ocean Park, Mission Bay Aquatic Park, and Marineland, to name a few—reveal the popularity of the domesticated or tamed landscape as a site for postwar recreation. Like Disneyland, which quickly became synonymous with Southern California after its opening in 1955, these parks offered highly mediated experiences of the physical world, which approximated

c

b

a
Brett Weston
Garapata Beach, 1954,
gelatin-silver print

b
Marguerite Wildenhain
Squared Vase, c. 1947,
stoneware, glazed

c
California Holiday in Color,
souvenir book, 1950s.
Lent by the San Diego
Historical Society Research
Archives

d
Ansel Adams
Half Dome and Moon,
Yosemite Valley, California,
c. 1950, gelatin-silver print

171

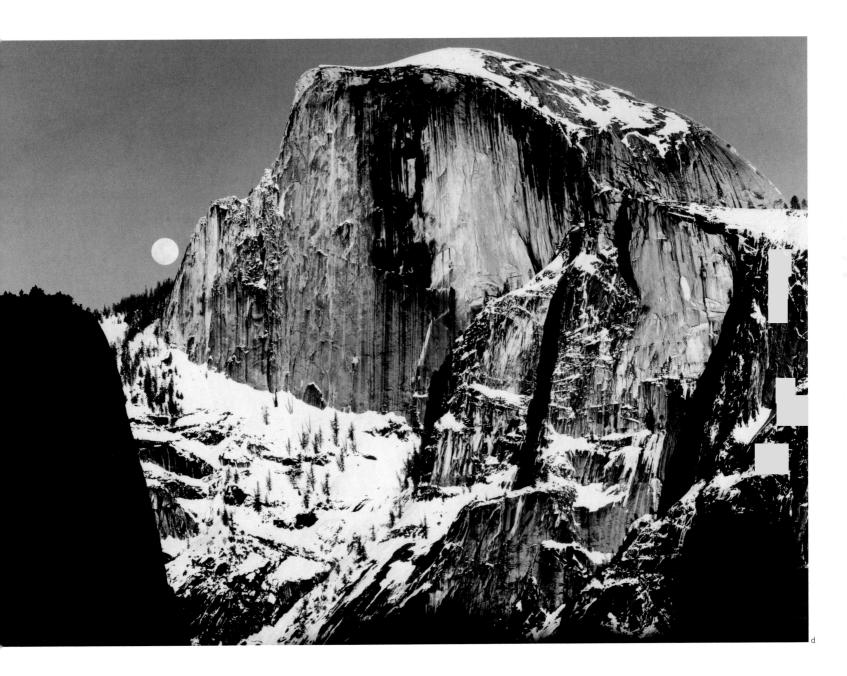

d

172

suburban life in their emphasis on homogeneity
and control. Excluding ethnic difference and
other forms of diversity, Disneyland went fur-
thest of all in mirroring Southern California
suburbia as portrayed by Hollywood and the
popular media.[35]

Another California landscape of sorts
colonized and marketed by boosters after the
war was the human body. From he-men to
Barbie, Southern California personae in particu-
lar were celebrated for their physiques, which
were well known to vast audiences through
Hollywood films, television, and other mass
media. Sid Avery's fan magazine photograph of
a strapping Rock Hudson draped in a bath towel
effectively promoted this boosterist conception
of physique. The ideal postwar California body
exuded youth, good health, and fitness. This is
reflected in a 1954 photograph of robust figures
on Muscle Beach by newly arrived New Yorker
Larry Silver, who in the same series approached
this subject from a very different perspective
(see p. 159). The body was often visually linked
with the local physical environment. Indeed,
what most clearly distinguished popular photo-
graphic images of California beauties from those
of models taken elsewhere was that the former
were shot out-of-doors rather than in a studio.
Like the indigenous natural landscape, the
homegrown California body was associated with
abundance, which in concert with 1950s ideals
of attractiveness meant ample muscles for men
and large breasts for women.

Less-mainstream visions of the California
body also circulated during these years, albeit
within more limited communities. These
included images associated with gay male
culture, still predominantly underground during
this period (although a homophile group
called the Mattachine Society was founded in
Los Angeles in 1950 by Harry Hay and fashion

d

e

f

a
Sid Avery
Rock Hudson, Out of the Shower at His Hollywood Hills Home, 1952, gelatin-silver print

b
Robert Mizer
Quinn Sondergaard, Athletic Model Guild, c. 1954, gelatin-silver print

c
Physique Pictorial magazine, fall 1954. Collection of John Sonsini

d
Paul Wonner
Untitled [Two Men at the Shore], c. 1960, oil and charcoal on canvas

e
Rex Brandt
Surfriders, 1959, oil on canvas

f
Elmer Bischoff
Two Figures at the Seashore, 1957, oil on canvas

174

a

b

c

designer Rudi Gernreich). Homoerotic magazines, posing under the guise of health and fitness publications, disseminated such images regionally, nationally, and internationally to powerful effect. Indeed, British transplant David Hockney has said that the beautiful male bodies pictured in magazines such as *Physique Pictorial* were what first lured him to Los Angeles.[36] *Physique Pictorial* was produced in Los Angeles by Robert Mizer, whose beefcake shots of scantily clad muscle men along with those of Bruce of L.A. subverted narrow 1950s definitions of masculinity by exaggerating them to the point of camp.

Other midcentury California artists who made the body—often the male body—a primary subject of their work were several members of the Bay Area Figurative school, which rejected the Abstract Expressionist idiom then being championed by the New York School in favor of a representational style.[37] These artists, including David Park, Paul Wonner, Elmer Bischoff, and Theophilus Brown, offered a less fetishistic conception of the body than either Mizer or Bruce of L.A. Theophilus Brown went so far as

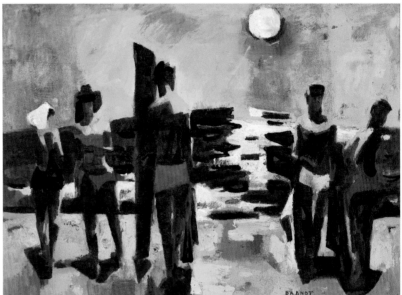

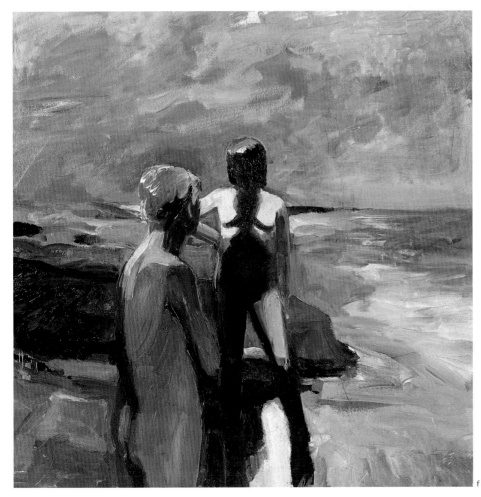

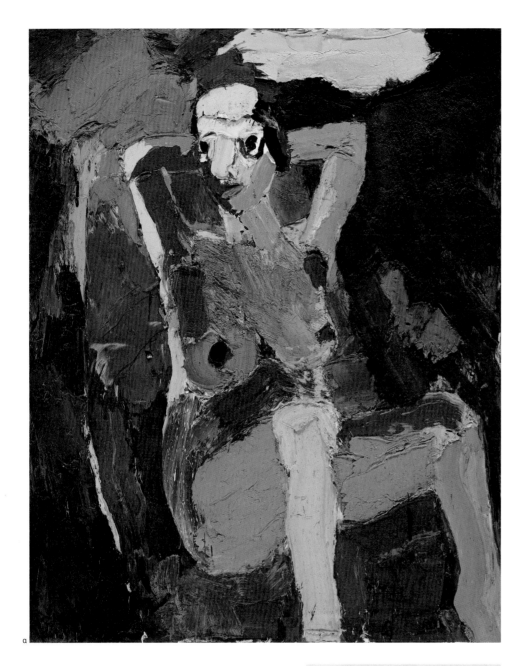

to consult contemporary nudist magazines in his quest for nontraditional ways of rendering the male body in his paintings.[38] Similarly, Joan Brown departed from the conventional aestheticizing of the female body in aggressively expressionistic and intensely hued works such as *Girl in Chair*.

Fashion designer Rudi Gernreich, who in the early 1950s eliminated the constricting boned and padded interior construction common in women's bathing suits of the period— see, for example, Christian Dior's 1956 design— also challenged the conventional image of the California physique. His unconstructed, form-fitting knitted swimsuits were created for less curvaceous figures than those of the voluptuous,

by **Dior** for **Cole** of California

Christian Dior has designed his first—his very first—collection of swimsuits! He has designed them exclusively for Cole of California. He has made them as unmistakably Dior as his great gowns. Will you be the first woman in the world to wear a swimsuit from a Dior collection? Here, the Dior drape of Laton Taffeta, with the bold stroke of pink against pink. Also blue with light blue, gold with yellow, black with grey. $39.95

a
Joan Brown
Girl in Chair, 1962, oil on canvas

b
Magazine advertisement for swimwear by Dior for Cole of California, 1956

c
Rudi Gernreich
Woman's Bathing Suit, 1952, wool knit

d
George Hurrell
Jane Russell, 1946, gelatin-silver print

e
How to Sin in Hollywood, booklet, 1940. Lent by Jim Heimann

f
Philippe Halsman
Dorothy Dandridge, 1953, gelatin-silver print

177

hypersexualized starlets who graced the 1940s and 1950s Hollywood screen. Gernreich's designs were instrumental precursors to the widespread liberation of the female body during the 1960s.

Although still a touchstone for societal definitions of beauty, Hollywood became during the postwar period one of the main fronts on which California was associated with unconventional or subversive activities. The aura of glamour and sophistication that had enveloped the industry and its stars in the prewar and war years was replaced after 1945, in large part, by a cloud of ambiguity.[39] While movie stars were still objects of fascination, they were not emulated to the same degree after the war.[40] This era's steamy starlets were more overtly sexualized than prewar sirens. Accordingly, they were more likely to be regarded as "unwholesome" by mainstream America, particularly given the

a
Virgil Apger
Carmen Miranda, Publicity Photo for "A Date with Judy," 1948, carbro print

b
Robert Frank
Television Studio, Burbank, California, 1956, gelatin-silver print

c
Ely de Vescovi
Hollywood, 1941, oil on canvas

d
Edward Biberman
Conspiracy, c. 1955, oil on board

e
Hans Burkhardt
Reagan—Blood Money, 1945, oil on canvas

178

a

b

c

d

conservative climate of the day. In addition,
the industry itself was threatened by strikes,
competition from television and foreign films,
and, most notably, the events surrounding the
House Un-American Activities Committee inves-
tigation that began in 1947. The blacklisting of
the Hollywood Ten—a group of screenwriters
and directors—following their refusal to testify
before Congress divided the Hollywood commu-
nity and cast a Communist shadow on the indus-
try for years to come. Artists Hans Burkhardt
and Edward Biberman, both of whom had
worked at movie studios, offered dark perspec-
tives on the Hollywood witch-hunt. In *Reagan—
Blood Money*, Burkhardt specifically indicts
Ronald Reagan, then head of the Screen Actors
Guild, for his zealous efforts to purge the studios
of all suspected Communists.

The creative voices in California who
offered possibly the most critical perspective on
postwar consensus culture—and who, in turn,
garnered profound reproach from it—belonged
to the bohemian community of writers and artists
known as the Beats. In the visual arts, figures
such as Bruce Conner, Wallace Berman, and
Jess addressed subjects regarded by the cultural
mainstream as uninteresting, distasteful, or
strictly taboo. Their materials were often the
castoffs and detritus of suburban consumer

e

a
On the Road by Jack Kerouac,
first paperback edition, 1958.
Lent by Sarah Schrank

b
"Squaresville U.S.A. vs.
Beatsville," *Life* magazine,
September 1959

c
Jess
Tricky Cad: Case V, 1958,
colored newspaper, clear
plastic wrap, and black tape
on paperboard

180

culture reconfigured into two-dimensional collages or three-dimensional assemblages. These artists embraced the messy and the combinative, in defiance of the clean, streamlined aesthetic of the day.

While originating in New York, Beat culture soon migrated westward—its pilgrimage mythically recounted by Jack Kerouac in the Beat classic *On the Road* (1957)—and took root in California. It blossomed most notably in the communities of North Beach in San Francisco, and Venice, Topanga, and Hermosa Beach in Southern California. Media coverage such as *Life* magazine's article "Squaresville U.S.A. vs. Beatsville" reinforced the connection between California and the Beats.[41] This piece compared the life of a middle-American family in Hutchinson, Kansas, to that of a Beat family in Venice, California. Here, and in numerous other examples in the popular media, the Beats were recast as "beatniks," with the Russian suffix adding Soviet Communist associations. Whereas the Beats espoused serious counter-cultural convictions that were potentially threatening, the media's "beatniks" were vacuous, comical posers and could therefore be more

d

easily dismissed. They were disparaged as ne'er-do-wells lazing around in squalid apartments, antithetical to upstanding Americans who maintained cleanliness and order in their new appliance- and gadget-filled ranch houses. Emphasizing this point of difference, one caption in "Squaresville U.S.A. vs. Beatsville" described a typical Beat scene as follows: "A seedy-looking fellow is sitting in an old bathtub reading poetry while an artist squats nearby painting garbage cans."[42]

The Beats were also criticized for challenging traditional gender roles, then being anxiously reasserted in American culture following their destabilization on the home front during the war. Another *Life* article disdainfully relayed "a North Beach maxim,...the mature bohemian is one whose woman works *full* time," adding that "the 'chicks' who are willing to support a whiskery male are often middle-aged and fat."[43] *Playboy* magazine also criticized Beat males for not being "real men" (in other words, capable of making money and of keeping their women in line), even while praising them on another level as fellow social rebels.[4]

d

Wallace Berman being
arrested at Ferus Gallery,
Los Angeles, 1957. Lent by
Charles Brittin and Craig Krull
Gallery, Santa Monica

There was, however, an element of
attraction in the country's seemingly negative
preoccupation with beatniks. Tour buses brought
curious visitors to North Beach and Venice,
affording them the opportunity to observe beat-
niks in their "natural habitat." Artists were sub-
jects of particular interest. Female Beat painters
Jay DeFeo and Joan Brown, who were profiled
in women's magazines such as *Cosmopolitan* and
Glamour, received sympathetic treatment in the
press, while male artists often were given less
flattering coverage. A 1958 *Look* magazine article
entitled "The Bored, the Bearded, and the Beat"
reduced Wallace Berman—an artistic linchpin
of the California Beat community—to a carica-
ture, misquoting his philosophy "Art is Love is
God" as "Man, art is cool, and cool is every-
thing."[45] Still, as artist Wally Hedrick has recalled,
the mystique that surrounded Beat artists could
draw considerable interest from onlookers.
He remembers one bar in North Beach that
hired a painter to make art on the premises to
the sound of jazz music: "That was his job . . .
The guy would make four or five paintings in
an evening."[46]

While Beat artists fostered and cashed in
on this mystique at times—Hedrick admits that
he, too, was briefly employed making abstract
art in a coffee-shop window[47]—many created
works that offered pointed statements protesting
society's perceived ills, including sexual repres-
siveness, empty consumerism, and an ethos of
conformity. The assemblages of Bruce Conner—
for example, his abstract portrait of Beat poet
Allen Ginsberg—and the collages of Jess were
some of the many Beat works created from
mainstream society's soiled, discarded goods,
combined and reconstituted in a spirit that
recalled Rodia's eclectic Watts Towers.

d

a
Wallace Berman
Semina, 1955–64,
hand-printed magazine

b
Wallace Berman
Untitled (Jazz Drawing of Slim Gaillard), c. 1940, pencil on paper

c
Palmer Schoppe
Drum, Trombone, and Bass, 1942, gouache and pencil on paper

d–f
Souvenir photos and souvenir photo folios from Los Angeles–area jazz clubs, c. 1940s. Lent by Jim Heimann and John Tolbert

182

a

b

The art of Wallace Berman also embodies the Beat aesthetic of heterogeneity and impurity. Berman's work on exhibition at Ferus Gallery in Los Angeles in 1957 was deemed offensive enough to warrant his arrest and conviction on an obscenity charge, compelling him to leave Los Angeles for the Bay Area. His publication, *Semina*, which included poetry, prose, drawings, and photographs printed on nonuniform, unbound sheets of paper, directly communicated this nonconformist sensibility. The first of its nine issues was published in 1955, the same year that Disneyland opened to the public, and *Semina* offered a powerful counterstatement indeed to this icon of California mainstream culture. Yet whereas Disneyland reached millions, Berman's dissenting voice spoke only to a small underground community of creative figures who congregated in alternative spaces in North Beach such as King Ubu Gallery (later the 6 Gallery, where Ginsberg first recited *Howl*) and City Lights bookstore.

One of the primary means by which the Beats and other cultural dissidents in California asserted their opposition to the dominant mainstream was by valorizing aspects of society that commonly had been denigrated or marginalized, such as black jazz culture. This subculture had existed in Los Angeles and the Bay Area since the 1920s, but it burgeoned during and after the war as the state's African American communities mushroomed. Berman was one of the most avid devotees among the Beats. Sporting a zoot suit and forming friendships with local jazz luminaries, Berman, in his youth, had been a fixture in the many jazz clubs then thriving along Central Avenue in South Central Los Angeles. Some of his first works were surrealistic drawings of jazz figures (one of which became the cover design for a bebop album).[48]

c

183

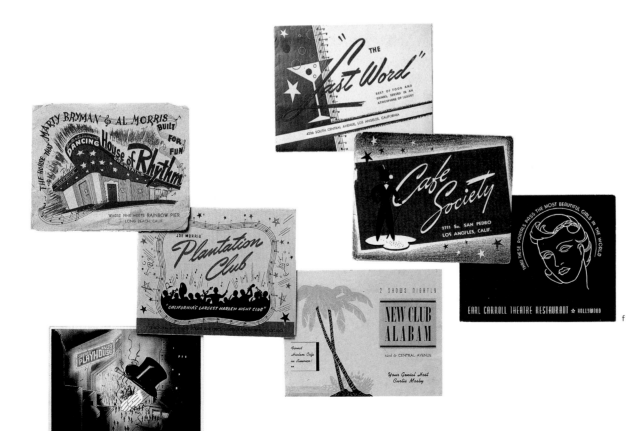

d

e

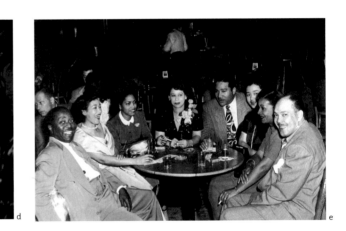

f

a

b

c

a
James Weeks
Two Musicians, 1960, oil on
canvas

b
David Park
Rehearsal, c. 1949–50, oil on
canvas

c
William Claxton
Stan Getz, Hollywood, 1954,
gelatin-silver print

d
Peter Voulkos
Camelback Mountain, 1959,
stoneware with slip, glazed
and gas fired

185

Other Beats also embraced black jazz culture, as much for its outsider status as for its ethos of coolness and spontaneity. This allegiance was not lost on the mainstream media, which associated the Beats derisively with various facets of black culture. In an illustration for another *Life* magazine article bashing the Beats, a prostrate, "shabby" beatnik and his female companion are surrounded by posters from jazz concerts, a Miles Davis album, and a set of bongo drums.[49] For the mainstream press, linking the Beats with black culture demonstrated the alarming extent to which the Beat community had strayed from (white) middle-class norms.

Aside from the Beats, there were other postwar artists with an avid interest in jazz. Among them were the Abstract Expressionist sculptors clustered around master ceramist Peter Voulkos, who taught first at the Los Angeles County Art Institute (now Otis College of Art and Design) from 1954 to 1959, then at the University of California, Berkeley, until 1985. These creators of unconventional, free-form sculptures in ceramic shared many countercultural interests with the Beats, including a predilection for the syncopated and improvisational nature of jazz. Several of the Bay Area Figurative painters were also jazz enthusiasts. In *Rehearsal*, David Park portrays the California School of Fine Arts all-white Studio 13 Jazz Band, in which he played piano and the school's director, Douglas MacAgy, occasionally played drums. James Weeks turned instead to black jazz, depicting the Bay Area's "kings of bebop" in his vibrant portrait *Two Musicians*.[50] Stressing the coolness and virility of his subjects while blocking out individualizing facial features, Weeks universalized these musicians in paying homage to them.

A number of creative figures in California, including many of those aligned with the counterculture, explored aspects of spirituality during

d

186

a

these years. While Los Angeles painter Rico Lebrun turned to the New Testament in darkly expressionistic works inspired by the atrocities of the war, a far greater number of postwar figures took an avid interest in non-Western religions. This trend was fueled by a growing popular fascination in the United States with Zen Buddhism, as distilled by such proponents in the West as Alan Watts, a fixture in the San Francisco Beat community. The minimalistic abstractions of John McLaughlin were strongly informed by Zen precepts as interpreted in Southern California. An Asian-art dealer who had spent two years in Japan in the 1930s before becoming an artist, McLaughlin sought a balance in his paintings that would evoke a meditative calm in the viewer.

b

c

a
Rico Lebrun
The Magdalene, 1950,
tempera on Masonite

b
John Mason
Sculpture [Desert Cross],
1963, stoneware, glazed

c
Matsumi Kanemitsu
Zen Blue, 1961, lithograph

d
John McLaughlin
Untitled, 1952, oil and casein
on fiberboard

e
Minor White
*Sun in Rock (San Mateo
County, California)*, 1947,
gelatin-silver print

187

d

e

a
Wolfgang Paalen
Messengers from the Three Poles, 1949, oil on canvas

188

a

b

Gordon Onslow Ford

Fragment of an Endless (II),
1952, casein on wrinkled
paper

c

Lee Mullican

Space, 1951, oil on canvas

b

A number of creative figures were more
eclectic or generalized in their spiritual affinities.
The artists who constituted the Bay Area–based
group Dynaton (derived from the Greek word
dyn, which they translated as "the possible")—
Gordon Onslow Ford, Wolfgang Paalen, and
Lee Mullican—incorporated aspects of myriad
religions and philosophies in their work. While
Onslow Ford's foremost interest was in Zen and
Paalen's was in Native American spiritualism,
all three sought to visualize an inclusive cosmic
reality by means of spiritual abstract painting.
Another abstractionist of the period with an
interest in spirituality was avant-garde filmmaker
and painter Oskar Fischinger. A German emigré
who had initially come to Hollywood in 1936 to
work for Paramount Pictures, Fischinger quickly
discovered that his spiritual and aesthetic orien-
tation rendered him ill suited to the industry.
In such experimental films as *Radio Dynamics*
(regarded as his most significant work),
Fischinger implicitly decried commercial imagery
in favor of abstract forms that attempted to
visually approximate music.

For some artists in California, alternative
spiritual traditions that existed apart from

c

Oskar Fischinger
Radio Dynamics, 1943, stills
from 16 mm film

190

organized Western religion offered a means of
countering the perceived soullessness of centrist
middle-class culture. California, viewed as a
haven for spiritual exploration since the nine-
teenth century, was an apt place to make such
nonconformist assertions, even while the state
embodied for so many the very values being
challenged. By 1960 these previously marginal-
ized interests began to permeate the mainstream,
voiced in large part by the diverse body of men
and women afforded educational opportunities
by the 1944 GI Bill of Rights.[51] Accordingly in
the turbulent years that followed, an image of
unconventionality and dissent superseded the far
more placid, conformist vision of postwar subur-
ban life that, for a time, had defined California
for the nation and the world.

1 Josh Sides, "Battle on the Home Front: African American Shipyard Workers in WWII Los Angeles," *California History* 75 (fall 1996): 3, 251–63.

2 In the 1950s the Bracero program overlapped with Operation Wetback, the repatriation of undocumented workers.

3 This federal regulation, officially titled General Limitation Order L-85, went into effect in 1942 and significantly limited the amount and type of materials available to civilian designers.

4 This advertisement appeared in the *New Yorker*, October 1943, 13.

5 The term *pachuco* originated with a group of Mexican American youths called Chuco in El Paso, Texas. Pachuco referred to both the youths and the argot they spoke. See Dan Luckenbill, *The Pachuco Era*, exh. cat., University of California, Los Angeles, University Research Library, Department of Special Collections (Los Angeles: Regents of the University of California, 1990), 3. For a key social critique of the pachuco from a Mexican perspective, see "The Pachuco and Other Extremes," in Octavio Paz, *The Labyrinth of Solitude* (1951; reprint, New York: Grove Press, 1985), 9–28.

6 Eric Lott, "The Whiteness of Film Noir," *American Literary History* 9, no. 3 (fall 1997): 551.

7 Ibid.

8 Ibid., 545. Lott references, for example, "the black, Asian, and Mexican urbanscapes and underworlds of [Edward] Dmytryk's *Murder, My Sweet, The Lady from Shanghai, The Reckless Moment*, Rudolph Maté's *D.O.A.* (1950), [and Orson] Welles's *Touch of Evil* (1958)...the self-conscious endpoint of noir and its racial tropes."

9 The single exhibition was called *The Indefinite Period* (1942), a traveling show organized by the Institute of Modern Art in Boston. Los Angeles did not host another exhibition on this subject until 1953. On the presentation and collecting of Mexican art in Los Angeles in the 1920s and 1930s, see Margarita Nieto, "Mexican Art and Los Angeles, 1920–1940," in *On the Edge of America: California Modernist Art, 1900–1950*, ed. Paul Karlstrom (Berkeley and Los Angeles: University of California Press, 1996), 134. For an analysis of wartime anti-Mexican sentiment in light of the interest in Latin American art before the war, see Holly Barnet-Sanchez, "The Necessity of Pre-Columbian Art in the United States: Appropriations and Transformations of Heritage, 1933–1945," in *Collecting the Pre-Columbian Past: A Symposium at Dumbarton Oaks, 6th and 7th October 1990*, ed. Elizabeth Hill Boon (Washington, D.C.: Dumbarton Oaks Research Library and Collection, 1993), 177–207.

10 Brian Niiya, "Internment Chronology," in *The View from Within: Japanese American Art from the Internment Camps, 1942–1945*, exh. cat. (Los Angeles: Japanese American National Museum, UCLA Wight Art Gallery, and UCLA Asian American Studies Center, 1992), 61.

11 Karin M. Higa, "The View from Within," in *The View from Within*, 39.

12 The title of this booklet echoes a racist statement made by U.S. Gen. John DeWitt, commander of the Western Defense Command: "A Jap's a Jap." See Karin Higa and Tim B. Wride, "Manzanar Inside and Out: Photo Documentation of the Japanese Wartime Incarceration," in *Reading California: Art, Image, and Identity, 1900–2000*, ed. Stephanie Barron, Sheri Bernstein, and Ilene Susan Fort (Los Angeles: Los Angeles County Museum of Art in association with University of California Press, Berkeley and Los Angeles, 2000).

13 Ibid.

14 See Lynn Spigel, *Make Room for TV: Television and the Family Ideal in Postwar America* (Chicago: University of Chicago Press, 1992).

15 Among the areas affected were Santa Clara County, Marin County, Sonoma County, and Walnut Creek. The population of Santa Clara Valley, once a strictly agricultural area, nearly tripled between 1940 and 1970, whereas the populations of the major Bay Area cities, San Francisco and Oakland, declined. See Charles Wollenberg, *Golden Gate Metropolis: Perspectives on Bay Area History* (Berkeley and Los Angeles: University of California Press, 1985), 258.

16 *L.A. Examiner*, January 2, 1957; *Life*, March 17, 1952.

17 See Clifford E. Clark Jr., "Ranch-House Suburbia: Ideals and Realities," in *Recasting America: Culture and Politics in the Age of the Cold War*, ed. Lary May (Chicago: University of Chicago Press, 1989), 177.

18 For connections between postwar fashion and architecture, see "California's Bold Look: It Is New, Bright and Bound to Be Seen All over the U.S.," *Life*, June 14, 1954. The article is illustrated by a photograph of a California sportswear model standing in front of Case Study House #8, the Eames House.

19 This image appeared in *The San Francisco Book*, photographs by Max Yavno, text by Herb Caen (Boston: Houghton Mifflin with the Riverside Press, Cambridge, 1948). Yavno published an accompanying book, *The Los Angeles Book*, text by Lee Shippey (Boston: Houghton Mifflin with the Riverside Press, Cambridge, 1950).

20 See Kevin Starr, "The Case Study House Program and the Impending Future: Some Regional Considerations," in *Blueprints for Modern Living: History and Legacy of the Case Study Houses*, exh. cat. (Los Angeles: Museum of Contemporary Art in association with MIT Press, Cambridge, 1989), 131–43.

21 "Los Angeles: The Promised Land," *Sepia*, August 1959, 16.

22 "Casual Elegance in California," *Ebony*, Dec. 1957.

23 See the New York–based African American publication *Our World*. "Hurray for Los Angeles," *Our World*, September 1949.

24 See Don Parson, "'This Modern Marvel': Bunker Hill, Chavez Ravine, and the Politics of Modernism in Los Angeles," *Southern California Quarterly* 75, no. 34 (fall/winter 1993).

25 *A Decent Home: An American Right, 5th, 6th, and 7th Consolidated Report* (Los Angeles: Housing Authority of the City of Los Angeles, n.d. [1945–49]), 16.

26 See Thomas S. Hines, "The Battle of Chavez Ravine; Field of Dreams," *Los Angeles Times*, April 20, 1997.

27 Charles Champlin, "Los Angeles in a New Image: Remodeled Landscape, Redesigned Skyline," *Life*, June 20, 1960, 79.

28 Don Normark, *Chávez Ravine, 1949: A Los Angeles Story* (San Francisco: Chronicle Books, 1999), 11.

29 See Sarah Schrank, "Picturing Watts Towers," in *Reading California*. See also Bud Goldstone and Arloa Paquin Goldstone, *The Los Angeles Watts Towers* (Los Angeles: Getty Conservation Institute and J. Paul Getty Museum, 1997), and Richard Cándida Smith, "The Elusive Quest of the Moderns," in Karlstrom, *On the Edge of America*, 21–38.

30 On Watts Towers in the context of the California assemblage movement, see Thomas Crow, *The Rise of the Sixties: American and European Art in the Era of Dissent* (New York: Harry N. Abrams, 1997), 24–25, 27.

31 See Sarah Schrank, "Envisioning Los Angeles: Civic Culture, Public Art, and the All-City Outdoor Art Festivals" (paper delivered at American Studies Association conference, Seattle, Washington, November 20, 1998), 7, originally quoted in Arthur Millier, "Reaction and Censorship in Los Angeles," *Art Digest*, November 15, 1951, 9. Schrank's insights into the political underpinnings of debates involving the landscape in postwar Los Angeles were formative in the writing of this essay.

32 Peter Plagens, *Sunshine Muse: Art on the West Coast* (1974; reprint, Berkeley and Los Angeles: University of California Press, 1999), 23.

33 "Realism with Reverence," *Time*, June 4, 1951, 69.

34 See Jonathan Spaulding, "Yosemite and Ansel Adams: Art, Commerce, and Western Tourism," *Pacific Historical Review* 65, no. 4 (November 1996): 615–40.

35 On Disneyland, see John M. Findlay, *Magic Lands: Western Cityscapes and American Culture after 1940* (Berkeley and Los Angeles: University of California Press, 1992). See also Karal Ann Marling, ed., *Designing Disney's Theme Parks: The Architecture of Reassurance* (Montreal: Canadian Centre for Architecture, 1997; distributed in U.S. by Flammarion, New York).

36 Jonathan Fineberg, *Art since 1940: Strategies of Being* (New York: Harry N. Abrams, 1995), 242. Quoting the artist in *David Hockney by David Hockney* (New York: Harry N. Abrams, 1977), 93.

37 On the aesthetic achievements and evolution of Bay Area Figurative art, see Caroline A. Jones, *Bay Area Figurative Art: 1950–1965*, exh. cat. (San Francisco: San Francisco Museum of Modern Art in association with University of California Press, Berkeley and Los Angeles, 1990).

38 David McCarthy, "Social Nudism, Masculinity, and the Male Nude in the Work of William Theo Brown and Wynn Chamberlain in the 1960s," *Archives of American Art* 38, nos. 1/2 (1998): 28.

39 Susan Ohmer, "Female Spectatorship and Women's Magazines: Hollywood, *Good Housekeeping*, and World War II," *The Velvet Light Trap* 25 (spring 1990): 62.

40 Ibid.

41 *Life*, September 21, 1959, 31–37.

42 Ibid.

43 Paul O'Neil, "The Only Rebellion Around: But the Shabby Beats Bungle the Job in Arguing, Sulking, and Bad Poetry," *Life*, Nov. 30, 1959, 114. For further discussion of the Beats in the context of the crisis of masculinity in the United States in the 1950s, see Barbara Ehrenreich, *The Hearts of Men: American Dreams and the Flight from Commitment* (Garden City, N.Y.: Anchor Press/Doubleday, 1983), 53–54.

44 See Hugh Hefner, "The Playboy Philosophy," *Playboy*, January 1963, 41.

45 George Leonard, "The Bored, the Bearded, and the Beat," *Look*, August 19, 1958.

46 Wally Hedrick interview no. 1, Archives of American Art, quoted in Richard Cándida Smith, *Utopia and Dissent: Art, Poetry, and Politics in California* (Berkeley and Los Angeles: University of California Press, 1995), 168. There was a widespread Beat practice of painting and reading poetry to jazz.

47 Ibid.

48 Rebecca Solnit, "Heretical Constellations: Notes on California, 1946–1961," in Lisa Phillips, *Beat Culture and the New America: 1950–1965*, exh. cat. (New York: Whitney Museum of American Art in association with Flammarion, Paris, 1996), 71.

49 O'Neil, "The Only Rebellion Around."

50 Jones, *Bay Area Figurative Art*, 67.

51 On the impact of the GI Bill on the arts in California, see Cándida Smith, *Utopia and Dissent*, 67–89.

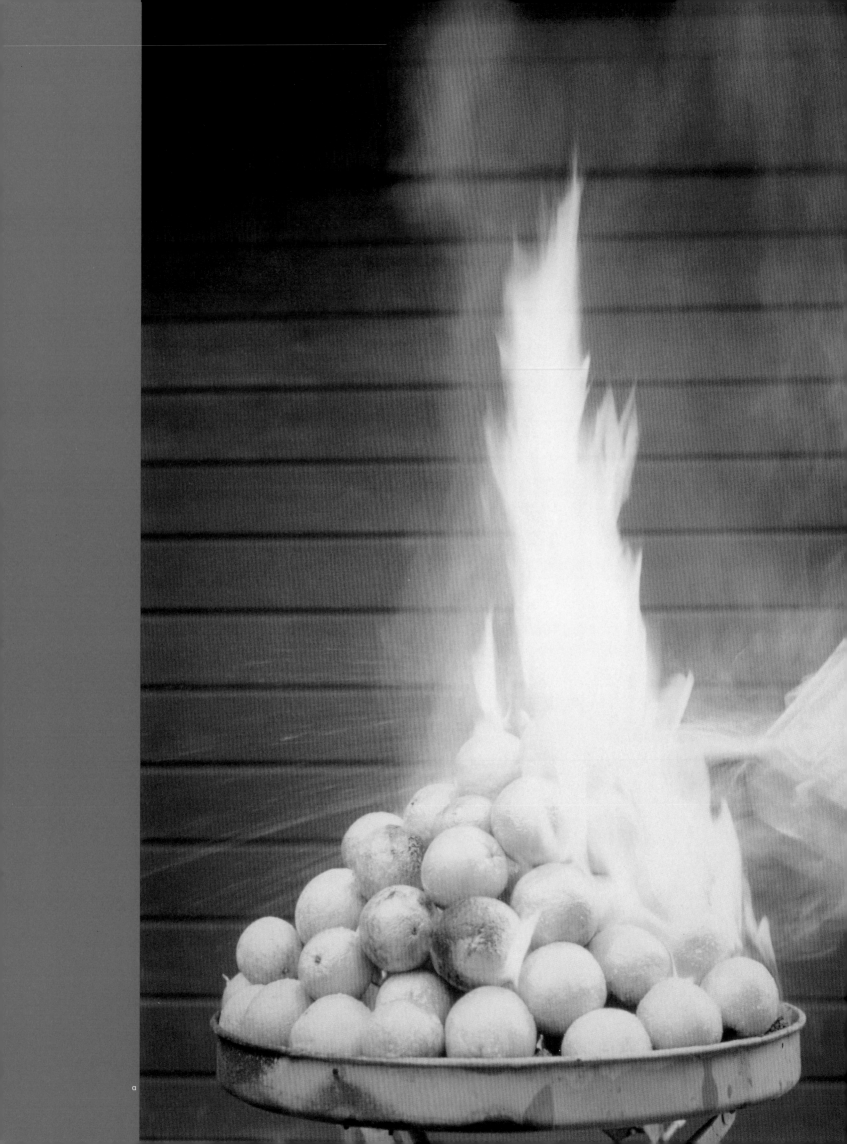

Howard N. Fox

During the 1960s and 1970s, the mythology of California shifted like a tectonic plate, nudging popular conceptions out of place and occasionally thrusting new ones suddenly and violently into national awareness.

The commonplace notion of Southern California in the 1950s, for example, relied upon images of Tinseltown, freeways, and a sprawling, homogenous suburbia, but by 1965 the Watts rebellion reminded the country that the region's capital, Los Angeles, suffered the very real urban ills of other American cities. Similarly, the Bay Area had been nationally profiled as a bastion of old money and high culture leavened with an arty Beat scene. However, events such as the founding of the Free Speech Movement on the campus of the University of California, Berkeley, in 1964; the coalescing of so-called hippie culture around the Haight-Ashbury district of San Francisco in about 1965; and the formation of the revolutionary Black Panther party in Oakland in 1966 revealed an epicenter of potent new social forces that ultimately catalyzed profound changes in the nation and the world. Of course, the revolutionary new spirit—which animated the youth

counterculture, inspired liberationist causes ranging from Chicanismo and Black Pride to feminism, and affected world events and history through the civil rights struggles and the anti–Vietnam War movement—was not unique to California. Much of its drive, however, originated in California and found its most articulate expression there.

On November 7, 1969, *Time* magazine ran a cover story that reiterated the familiar litany of Californiana—enumerating its distinctive clothing, architecture and arts, business ventures, table wines, leisure styles, cults, think tanks, parklands, and Disneyland—opining that "California people have created their own atmosphere, like astronauts." Yet *Time* concluded that California "is not really so different from the rest of the U.S. as it seems: that it is, in fact, a microcosm of modern American life, with all its problems and promises—only vastly exaggerated." Clearly, the mythic exoticism of California had not worn off in the popular imagination, but it was now complicated and enriched with a certain realism. In *Time*'s ringing prophecy, California emerged as "the mirror of America as it will become, or at least as the hothouse for its most rousing fads, fashions, trends and ideas."[1]

Not surprisingly, the art that engaged these concerns throughout the period reflected the full range and complexity of life in California. The landscape and nature-oriented tradition continued with some vitality, but much of the work reveals that the status of the Edenic myth was shifting along a cultural fault line, redefining the relationship between people and nature.

Landscape artists worked in an array of styles that ranged from Llyn Foulkes's *Death Valley, U.S.A.*, which combines aspects of Pop art and Surrealism, to Richard Diebenkorn's highly

a
**Mike Mandel and
Larry Sultan**
Set-up for Oranges on Fire,
1975, printed 1999,
chromogenic development
print

b
Time magazine, November 7,
1969, foldout cover illustration by Milton Glaser

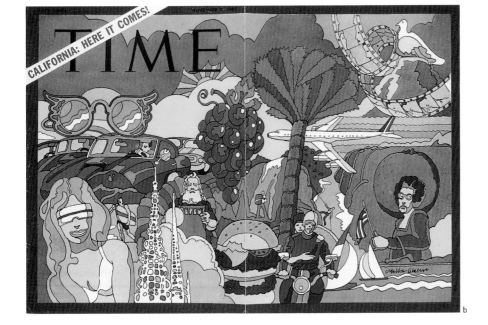

b

194

a

b

abstracted landscapes, such as *Ocean Park Series #49*. The purple mountains' majesty revered by plein air painters in previous decades could still be found in nature but, by the 1960s, was not much found on canvas.

Such depictions as there were of wild California were apt to be about the encroachment of people into the wilderness. Roger Minick's photograph *Woman with Scarf at Inspiration Point, Yosemite National Park*, foregrounds the magnificent vista with an intervening close view of a tourist seen from the back. With only her flimsy souvenir scarf to protect her from the ravages of the untamed elements, she seems an interloper. Robert Dawson's *Untitled #1*, from his Mono Lake series, resembles an eerie Martian landscape in a science fiction movie. The view is somewhat unnatural, considering that Mono Lake, in Northern California, was drained to irrigate the deserts of Southern California, and the strange rock formations are the visible end result of human intervention.

The 1960s saw the advent of what have come to be called earthworks or land projects—artworks created by digging into the land, sculpting it with bulldozers, placing something on it, or otherwise engaging the features and properties of a specific site. A fundamental unnaturalness, however, is implicit in the very vocabulary of such projects. One of the most beautiful land projects, *Running Fence*, was conceived and organized by the New York–based collaborative team of Christo and his wife, Jeanne-Claude. *Running Fence* was a 24-mile-long, 18-foot-high swath of nylon suspended along a system of steel cables like an immense curtain. It zigzagged across rolling pastures from Meacham Hill, near Petaluma, westward to Bodega Bay, where it dipped into the surf. The project was visited by thousands and was copiously documented in film, video, photography,

a
Llyn Foulkes
Death Valley, U.S.A., 1963,
oil on canvas

b
Richard Diebenkorn
Ocean Park Series #49, 1972,
oil on canvas

c
Roger Minick
*Woman with Scarf at
Inspiration Point, Yosemite
National Park*, 1980,
dye-coupler print

d
Jack Welpott
*The Journey—Pescadero
Creek*, 1966, gelatin-silver
print

e
Robert Dawson
Untitled #1, 1979, from the
Mono Lake series, gelatin-
silver print

195

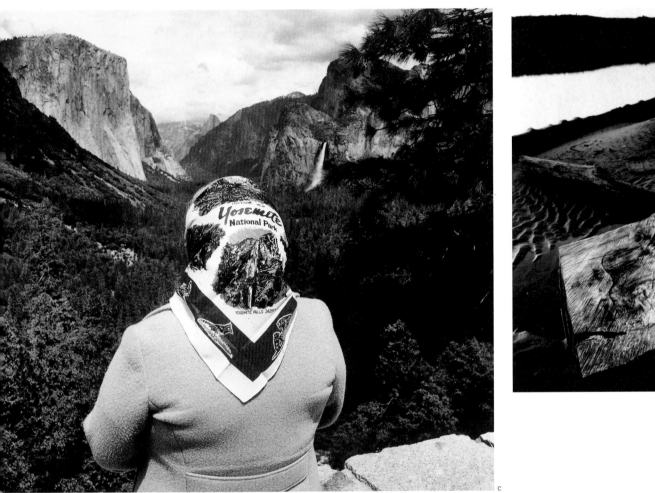
c

d

e

a

Christo and Jeanne-Claude

*Running Fence, Sonoma and
Marin Counties, California,
1972–76*, 1976, photo
documentation of installation

b

Ben Sakoguchi

Capitalist Art Brand, 1975–81,
acrylic on canvas

c

Ansel Adams

*Yosemite Valley, from
Inspiration Point, Yosemite
National Park*, 1969,
photo-offset print on metal
container

196

a

b

c

and books. (The elaborate marketing of fence-related products to offset the project's $3 million budget, which was funded by the artists, was satirized in a parodic orange-crate label, *Capitalist Art Brand*, painted by Ben Sakoguchi.) In a poignant way, *Running Fence*, as with most of the Christos' projects, underscores the incompatibility of art and nature. This spectacular project was after all a colossal intervention into nature and was respectfully withdrawn, as planned, two weeks after its completion.

From the 1960s on, few artists involved with depicting or even directly engaging the landscape could draw upon the romantic inspiration behind, say, Ansel Adams's quasi-mythic paeans that celebrated the pristine, untouched land, isolated from humanity. Adams wryly satirized his own romantic idealism by reproducing the photographic image of majestic snowcapped mountains on, of all things, a coffee can in *Yosemite Valley, from Inspiration Point, Yosemite National Park.* The aesthetics of the sublime simply did not comport with younger artists' more contemporary experience and understanding of nature in California, which was shaped by living with chronic smog; the "water wars" between Northern and Southern California; the depletion of natural habitats and many species

d

d

Helen Mayer Harrison and Newton Harrison
Meditation I from *Meditations on the Condition of the Sacramento River, the Delta, and the Bays of San Francisco,* 1977, satellite photographic map and handwritten text

e

Ester Hernández
Sun Mad, 1982, screenprint

f

John Divola
Zuma No. 21, 1977, from the portfolio *Zuma One*, 1978, dye-imbibition print

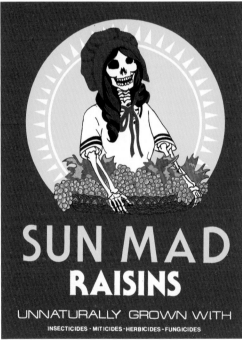

e

of wildlife; and such disasters as a 4 million gallon oil spill in the Santa Barbara Channel in 1969 that helped catalyze environmental activism in the state.[2] It was inevitable that so much of the art that looked at the natural landscape would explore a troubled relationship between humankind and nature.

Some artists, such as the husband-and-wife collaborators Newton Harrison and Helen Mayer Harrison, hoped to improve this situation. Conceptual artists by profession, the Harrisons were also environmental activists. In about 1970 they began importing their environmental concerns into their art, a practice they continue to the present. Their rambling installation concerning the Sacramento River comprises a panorama of maps, posters, and aerial photographs, all annotated with texts in the form of

"meditations" on the unhealthy state of the river and what might be done to restore the balanced ecology of the region. Significantly, the Harrisons' remedy is not strictly scientific, nor even practicable: Their meditations recognize that human behaviors, perceptions, values, and institutions must change before pragmatic steps can be taken toward changing the ecology.

Concerned with the ecology of farming, Ester Hernández contested the traditional notion of California as an agricultural Eden with her silkscreen print *Sun Mad*, replacing the familiar and cheerful trademark image of the Sun Maid with a startling skeleton. *Sun Mad* promotes raisins "unnaturally grown with insecticides, miticides, herbicides, fungicides," substances that pose a health threat to consumers and field-workers, as well as to the environment.

f

a
Lee Friedlander
Los Angeles, California, 1965,
gelatin-silver print

b
Wayne Thiebaud
Down Mariposa, 1979, from
the portfolio *Recent Etchings I*,
pl. 3, etching

c
John Baldessari
Looking East on 4th and C,
1967–68, acrylic and photo
emulsion on canvas

d
Lewis Baltz
*West Wall, Unoccupied
Industrial Building, 20 Airway
Drive, Costa Mesa*, from the
series The New Industrial
Parks near Irvine, California,
1974, gelatin-silver print

198

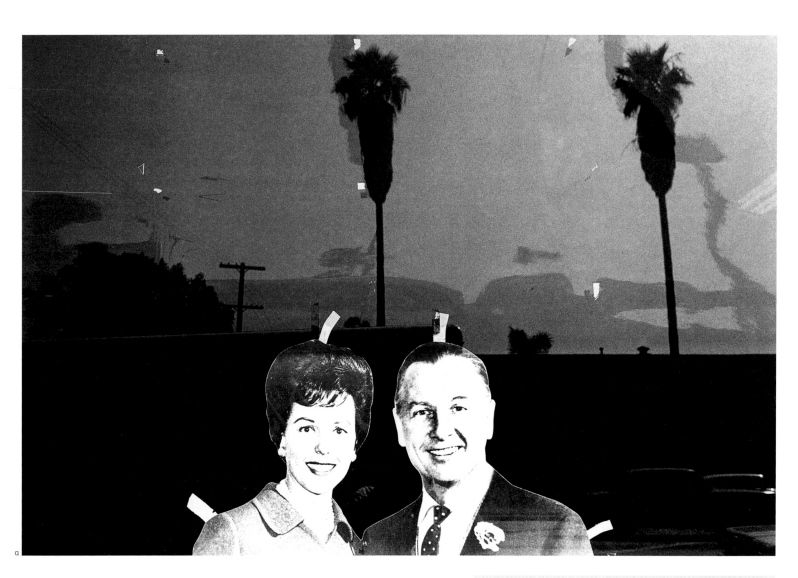

a

b

199

Curiously, although the ubiquitous freeway and automobile now made California's deserts, mountains, and valleys more accessible, most artists who pictured the landscape tended to stay closer to home. They were drawn to the domesticated milieu of California's cities, industrial parks, strip malls, and suburban neighborhoods, where the uneasy relationship between people and their surroundings was also played out. Lee Friedlander's *Los Angeles, California*, captures the reflection of a splendid California sunset above a strip-mall parking lot in a store window, where it vies for attention with an advertisement showing a smiling couple. Lewis Baltz brings a bleaker outlook to his series of black-and-white photographs The New Industrial Parks near Irvine, California. His recurring subject is an assortment of modular prefabricated warehouses and small factories that brood glumly upon the vestiges of a receding natural landscape.

Numerous artists cataloged the unique sprawl of Southern California. In a formal exercise to avoid making pleasing and compositionally "correct" photographic images, John Baldessari set about taking pictures of the nondescript sights in and around his hometown of National City, a suburb of San Diego. The monotony of suburbia became his inadvertent subject. *Looking East on 4th and C* records the dull sense of vacancy that pervades the small town. Similarly, Ed Ruscha made a series of photographs called *Every Building on the Sunset Strip*; and photographers Joe Ray, Bill Owens, and Camilo José Vergara were among those who recorded daily life in the cities and suburbs, sometimes posing proud families in front of their homesteads—bungalows and cottages typical of neighborhoods throughout Southern California.

LOOKING EAST ON 4TH AND C
CHULA VISTA, CALIF.

c

d

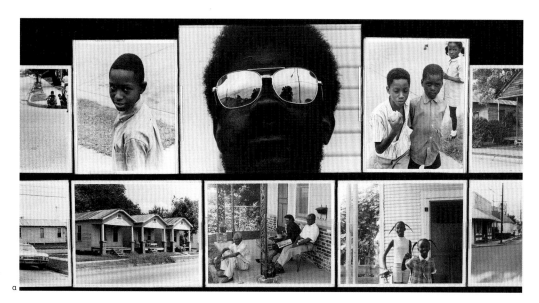

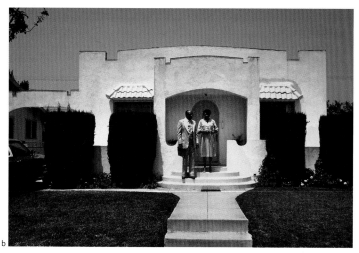

Very few Edenic visions survived into the 1960s and 1970s. The witty images of life in the hills above Los Angeles by British-born expatriate David Hockney—who often shows well-manicured lawns and backyard swimming pools, as in *The Splash*—are the surprising legacy of California plein air painting. Hockney has a somewhat cooler tonality, more restrained play of light, and definitely "cooler" attitude than that of artistic forebears such as Granville Redmond and Guy Rose, though his work shares the outlander's fascination with the region's quality of light, lush natural settings, and ineluctable sense of place—of "Californianess." While their California was a vast, untamed Eden, however, Hockney's is pervasively domesticated, reflecting his time.

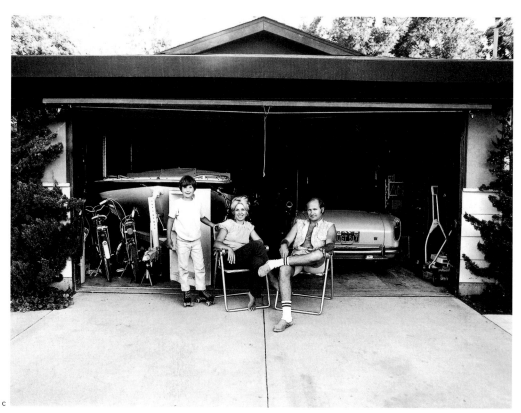

a
Joe Ray
Untitled (detail), 1970–72,
thirty-one gelatin-silver
prints

b
Camilo José Vergara
*Couple on Their Way to Church,
Watts, May 1980*, 1980, silver
dye-bleach (Cibachrome)
print

c
Bill Owens
*Our house is built with the
living room in the back...*,
1970–71, printed 1982,
gelatin-silver print

d
Edward Ruscha
Hollywood, 1968, color
screenprint

e
David Hockney
The Splash, 1966, acrylic on
canvas

201

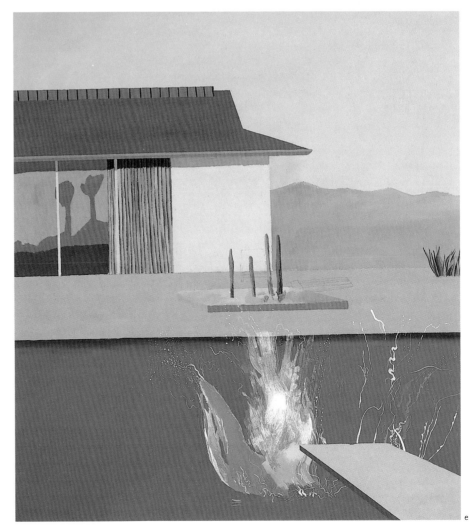

Beach and car culture, inflected by new technologies and materials that brought ever-racier surfaces to surfboards and automobiles, also figure prominently in California art and the American psyche during the 1960s. The California coast, with its rugged northern wilderness and its more tamed southern recreational beaches, remains a rich subliminal image of American destiny in the national subconscious. California was not just a geographic land's end but the culmination of a preordained history. In the previous century this concept, Manifest Destiny, was considered the national birthright, justifying the expansion of the United States and its political, social, and economic dominance across the North American continent to the Pacific shore. According to this boosterist image, the California coast was nature's final gift to Americans, albeit to non–Native Americans.

In the 1960s car ownership was a nearly universal aspiration, and the automobile figures prominently in representations of California life in that era. Indeed, by the mid-1960s, California had more drivers and cars—nearly 10 million of each—and consumed more gasoline than any other state in the nation.[3] The automobile

202

represented an implicit belief in Yankee ingenuity working for the egalitarian benefit of all (who could afford it) and in the individual's freedom to pursue life, liberty, and happiness at whatever cost to the environment. If the automobile began its life as a convenience, it grew to maturity as an extension of the American values of social mobility, independence, and control over one's own destiny.

Only Southern California could have produced such a seamless yoking of two such essentially antithetical mythologies as those of nature and the automobile; but throughout the 1960s, in daily life and in the arts, they did indeed come together. Movies, television, Top 40 music, and fashion magazines promoted the free and easy California lifestyle, a notion of ample time and space, in which casually clad folks go about their business at a leisurely pace and live in houses where indoor and outdoor spaces comfortably communicate in an always agreeable climate. Sunny, mellow California was reflected in bands such as the Beach Boys and surfer girl Gidget movies. An edgier cruiser California came across in flashy custom-decorated autos and, especially among Latinos, in lowriders—cars oufitted with hydraulics that could bounce a chassis up and down in acrobatic display.

Cars and the beach were a heady draw for many artists in California. An artist colony grew up in ramshackle Venice Beach, the seaside patch of Los Angeles originally developed in 1904 around a network of narrow artificial waterways meant to evoke Venice, Italy. Peter Alexander, Billy Al Bengston (a surfer whose lingo and wise-guy demeanor are said to be the basis of the character Moondoggie in the Gidget movies),[4] Ron Davis, Joe Goode, Craig Kauffman, Ken Price, Ed Ruscha, DeWain Valentine, and many other artists gravitated to the district for its low-brow, laid-back lifestyle; its hokey, dilapidated

exoticism; and, of course, its glorious beach. In the 1960s no self-respecting artist living in New York, where the buzzwords for the aesthetics of good Minimalist and Conceptual art were "serious" and "tough," would wish to be identified with anything so frivolous as beaches and cars, but many of their Southern California contemporaries flaunted those associations. Ceramist Ken Price chose a photograph of himself riding a wave as the announcement for a 1961 exhibition at the now-legendary Ferus Gallery, which played a major historical role in establishing the new generation of West Coast artists. Painter Bengston, who not only surfed but also raced motorcycles professionally, and twelve other Los Angeles artists went so far as to be photographed in their cars and pickup trucks for a calendar produced by Joe Goode, under the name of José Bueno.

Several of the Ferus Gallery artists were particularly drawn to the sleek finish and iridescent luster of auto bodies. Bengston's abstract compositions of the time, such as his jazzy oil spill of a painting *Lady for a Night*, were typically made of automobile lacquer dripped or spray-painted-

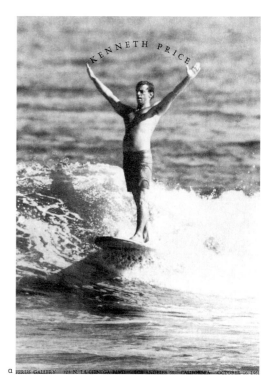

a FERUS GALLERY 725 N. LA CIENEGA BLVD. LOS ANGELES 79. CALIFORNIA OCTOBER 16, 1961

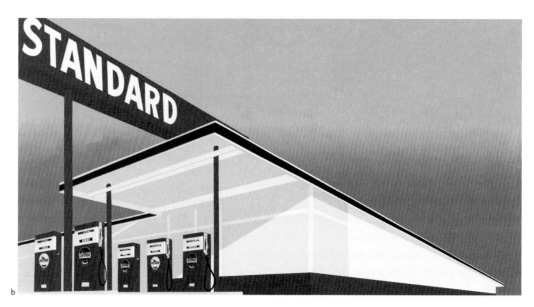

b

a
Ken Price exhibition
announcement, Ferus Gallery,
1961. Lent by Ken Price Studio

b
Edward Ruscha
Standard Station, 1966,
screenprint

c
Anthony Friedkin
Surfboard in the Setting Sun,
Santa Monica, California,
1977, from the Surfing Essay,
gelatin-silver print

c

a
Ken Price exhibition
announcement, Ferus Gallery,
1961. Lent by Ken Price Studio

b
Edward Ruscha
Standard Station, 1966,
screenprint

c
Anthony Friedkin
Surfboard in the Setting Sun,
Santa Monica, California,
1977, from the Surfing Essay,
gelatin-silver print

a

b

c

a
Billy Al Bengston
Lady for a Night, 1970,
lacquer on aluminum

b
Billy Al Bengston exhibition
announcement, Ferus Gallery,
1961. Lent by Billy Al Bengston

c
Judy Chicago
Car Hood, 1964, sprayed
acrylic lacquer on 1964
Corvair hood

d
Calendar of Los Angeles
artists in their cars produced
by José Bueno [Joe Goode],
1970. Lent by Joe Goode

e
Larry Fuente
Derby Racer, 1975, mixed
media in epoxy on fiberglass
Berkeley (car model c. 1962)

205

d

directly onto sheet metal. Judy Gerowitz, who changed her name to Judy Chicago and became famous in the 1970s as one of the foremost feminist artists, was an acolyte of the Ferus "Studs" (as the core group of John Altoon, Robert Irwin, Craig Kauffman, Edward Kienholz, Allen Lynch, Ed Moses, and Bengston semiofficially called themselves). She had enjoyed special status as the only woman allowed to hang out with the Studs at motorcycle races and at their favorite watering hole, Barney's Beanery, where she often smoked cigars.[5] A student of Bengston, she shared his buoyant sense of abstraction, which is clearly evident in the bold mandala and flanking "embroidery" of the decorative lacquer-painted arcs of *Car Hood*. In her bravado identification with L.A. beach and car culture, Chicago goes Bengston one better by painting directly on the hood of an automobile.

The automobile became a significant subject at this time. Artists like Larry Fuente from Mendocino in the north and Gilbert Luján from Los Angeles in the south followed the lead of "Kustom Kar Kulture" enthusiasts such as Ed "Big Daddy" Roth by fetishizing their automobiles, adorning them with copious, elaborate, and outlandish designs, and later exhibiting their art by participating in derbies or driving through the city in motorcades. San Francisco–based Robert Bechtle, an early photorealist, often painted pictures of cars in the parking lots of diners and

neighborhood businesses. His *'67 Chrysler* shows a brand-new coupe sitting in front of a generic stucco house in the early morning sun. He presents the ensemble as an iconic image, abstracted from the reality of daily life. The tableau is curiously lifeless, as if Bechtle were hinting at some dim ineffable wrongness in all of the cheeriness of car culture.

e

a

Robert A. Bechtle

'67 Chrysler, 1967, oil on canvas

b

Dennis Hopper

Double Standard, 1961, printed later, gelatin-silver print

c

Edward Kienholz

Back Seat Dodge '38, 1964, mixed media

d

Chris Burden

Trans-Fixed, 1974, photo documentation of performance

206

If so, Bechtle was not alone. The actor and photographer Dennis Hopper often imaged seedy aspects of urban Los Angeles. His *Double Standard* strikes a smart visual pun, catching a glimpse of two Standard Oil signs photographed through the windshield of a car. Meanwhile another view is reflected in the rearview mirror. Formally, the image toys with the conventions of the picture plane, but a more generalized significance is related to the sense of dislocation and fragmentation people commonly experience while navigating the city in their automobiles.

Edward Kienholz's *Back Seat Dodge '38* has become an icon of what is thought to be a quintessentially American adolescent experience—sex in the backseat of a car. In the mid-1960s

c

Kienholz's artwork was audacious and, to some, indecent.[6] His intent in presenting this greasy-spoon image of patently illicit sex is ambiguous. But it is clear that he conceives the role of the car as conferring unlegislated freedom for people to do as they wish, even to use the backseat of a car as a mobile motel.

Whether car culture could impinge on the very sense of freedom and independence that it seems to engender was a question posed in an event staged by Chris Burden in a nondescript garage one evening in Venice. In *Trans-Fixed*, Burden directed an assistant to drive nails through his palms, attaching him to a Volkswagen Beetle in the manner of a crucifixion. Burden and the car were wheeled out into an alley to be witnessed by a small crowd. The engine was run on high for two minutes, then the car was pushed back inside, and the garage doors were closed. Burden's scenario is open to many interpretations—perhaps America has surrendered its soul to car culture, or the individual has been sacrificed to mass production, or there is redemption and freedom in transcending the automobile—but the fact that Burden had himself nailed to a car, rather than to a tree or a cross, surely suggests an ambivalence about car culture.

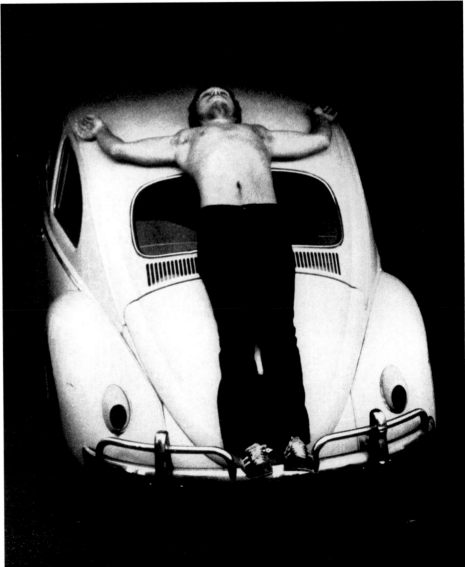

d

a
Craig Kauffman
Untitled Wall Relief, 1967,
acrylic lacquer on vacuum-
formed Plexiglas

b
Road Agent™, custom car
created by Ed "Big Daddy"
Roth, 1963. Lent by Mark
Moriarity

c
Peter Alexander
Cloud Box, 1966, cast
polyester resin

d
Ken Price
Gold, 1968, ceramic, glazed
and painted with acrylic

e
Marvin Lipofsky
California Loop Series, 1970,
glass, paint, and rayon
flocking

208

a

b

Yet automobile and beach culture pre-
vailed over subliminal doubts, and even the sexy
new materials of cars and surfboards—fiberglass,
resins, tinted glass, and a host of other high-tech
products developed by the massive aerospace
industry based in Southern California—had a
pronounced influence on the art world. The
run-down stucco surroundings of Venice were
the perfect foil for this sleek, industry-inspired
art, sometimes called Finish Fetish, or as the
artist and critic Peter Plagens more loosely
described it, the L.A. Look:

*The patented "look" was elegance and simplicity,
and the mythical material was plastic, including
polyester resin, which has several attractions:
permanence (indoors), an aura of difficulty and
technical expertise, and a preciousness (when
polished) rivaling bronze or marble. It has, in short,
the aroma of Los Angeles in the sixties—newness,
postcard sunset color, and intimations of
aerospace profundity.*[7]

Craig Kauffman's *Untitled Wall Relief*, a
new art form straddling painting and sculpture,
is a sleek-surfaced, vacuum-formed capsule
shape that appears to glow from within. It could
be a blown-up detail of some favored zone of
a voluptuous automobile. In fact, it evokes
"Big Daddy" Roth's custom-made *Road Agent*.

c

209

d

Automobile lacquers are the improbable, but brilliantly successful, intensely colored glazes on many of Ken Price's exquisite ovoid and pod-shaped ceramics. In other works, such as *Gold*, Price achieves a similar effect with acrylic paint.

Significantly, despite their industrial-strength materiality, many of the technologically inspired artworks retained unmistakable references to nature. In an enchanting technical tour de force, Peter Alexander's *Cloud Box*, made of cast resins, simulates the startling visual paradox of a cloud caught inside a box. Likewise, in *Roto*, Ron Davis uses acrylic colors, resins, and fiberglass to construct sprawling, irregular polygonal shapes that suggest illusionistic space.

In marked contrast to their Manhattan contemporaries like Carl Andre, Robert Morris, and Richard Serra, who used products of heavy industry such as copper plates, galvanized mesh, and Cor-Ten steel to fabricate severe, hard-edge geometrical forms, the boys of Venice were drawn to high-tech materials more for their ability to allude to natural, often organic forms and to suggest light and space. The same materials that the Finish Fetish artists used to celebrate car and beach culture also lent themselves to expressions of a more ethereal, even spiritual, nature.

e

a
Ron Davis
Roto, 1968, polyester resin
and fiberglass

b
Robert Irwin
Untitled, 1968, acrylic

c
Larry Bell
Cube, 1966, vacuum-coated
glass

d
Lia Cook
Emergence, 1979, rayon and
polyurethane foam

210

a

These evocations of light (often without an obvious source) and indefinite space formed a unique strain of Minimalist art that critic Rosalind Krauss has called "the California Sublime."[8] Larry Bell, Robert Irwin, and James Turrell were interested in new materials, especially in ones so sheer that they bordered on appearing immaterial. Bell's *Cube* employed the technology of dichroic vacuum coating, a method used in the aerospace industry and in optics to apply a tinted film of chemicals to a glass surface. Bell applied these iridescent films, with their luminous colors fading off to invisibility, to the inside surfaces of a glass box to evoke its visual dematerialization. For his part, Irwin made a series of lightly tinted cast-acrylic resin disks that appear as a glow of pure color that spreads out into white nothingness. Irwin's disks, which are extremely difficult to photograph convincingly, are also evocative of immaterial phenomena.

Bell and Irwin used the latest materials to achieve their ethereal effects, whereas James Turrell turned to the most immaterial medium of all: pure light. The work *Afrum Proto* (1966) presents a darkened space in which the uncanny vision of an intensely glowing three-dimensional cube floats in blackness, as if defying gravity. As the viewer approaches the "structure," its crisply defined edges dissolve, and the form disappears altogether. The dramatic illusion is created by a light projector and a perforated filter. It is nothing more than the very worldly consequence of light projected through an opening; but what it evokes is nothing less than sublime.[9]

Zen Buddhism, with its basis in meditation and the attainment of personal enlightenment as well as its unified conception of simultaneous being and nonbeing, had already proved influential on American artists as early as the 1940s and 1950s, and it enjoyed a renaissance during the

b

c

d

Joe Goode
Untitled (Torn Sky), 1971–76,
oil on canvas

Ed Moses
Untitled, 1972, Rhoplex and
acrylic on laminated tissue

Sam Francis
SFP68-29, 1968, acrylic on
canvas

212

a

213

b

1970s and 1980s in reductive painting. Joe Goode made a series of "torn sky" paintings, depicting airy scatterings of clouds, diaphanous wisps floating vaporously in an expanse of celestial blue. These aeroreveries are alarmingly interrupted by large fissures torn in the canvas. Goode's works appear to straddle some middle realm between the ethereal and the material. Similarly, in Ed Moses's *Untitled* (1972), an abstract composition painted on tissue paper with Rhoplex, the brushstrokes of the synthetic medium have dried and formed a delicate gossamer. Sam Francis's *SFP68-29* is a field of bright white animated only at the extreme left and right edges by dancing rivulets of spectral color that seem to aspire upward. The almost entirely void canvas suggests the elusive concept of the absentness of the present.

Other artists were creating spiritually inflected art that was less informed by natural phenomena or reductivist aesthetics than by other cultural and social concerns. Wallace Berman had established himself in the iconoclasm of Beat culture, yet he was also an ardent student of the Jewish mystical tradition of Kabbalah. In these teachings, Scripture is interpreted not only through study of its text and individual words but also through the relationship of its letters and numbers to one another. Berman's *Topanga Seed*, a large rock that he found in Topanga Canyon near Malibu, is inscribed with Hebraic texts. Just as it is unnecessary to understand the inscriptions on the Rosetta stone to experience its spiritual quality, Berman's rock possesses a mysterious presence that transcends literal meaning.

c

<table>
<tr>
<td>a</td>
<td>b</td>
<td>c</td>
<td>d</td>
<td>e</td>
</tr>
<tr>
<td>**George Herms**
Everything Is O.K., 1966,
wood, metal, plaster, and
Plexiglas</td>
<td>**Wallace Berman**
Topanga Seed, 1969–70,
dolomite rock and transfer
letters</td>
<td>**Edmund Teske**
Untitled, 1962, gelatin-
silver print with duotone
solarization</td>
<td>**John Outterbridge**
Together Let Us Break Bread,
1968, assemblage</td>
<td>**Stephen De Staebler**
Seated Kangaroo Woman,
1978, clay, fired</td>
</tr>
</table>

214

a

b

A less mystical artist but one consistently concerned with spirituality and the life of the soul is John Outterbridge, who migrated from Greenville, North Carolina, and settled in Los Angeles in 1963. As artist, activist, and director of the Watts Towers Art Center, he was mentor to several generations of diverse community artists. His altarlike assemblage *Together Let Us Break Bread* was created in the aftermath of the Watts uprisings as a sacramental gesture toward healing racial tension and fostering racial harmony.

Thus the spiritual and landscape traditions in California art of the 1960s and 1970s were rooted in larger cultural and social issues. Unquestionably, the single most commanding influence on culture in California during this period was the advent of counterculture, which embraced a spectrum of causes ranging from "flower power" and hippie culture to radical political organizations, the anti–Vietnam War movement, feminism, and gay liberation.

Counterculture quickly developed nationally and internationally, but many of its manifestations began in California. The urban yet freewheeling San Francisco neighborhood known as Haight-Ashbury attracted successors to the Beat generation—young freethinkers, lifestyle experimenters, and dropouts of every kind. Across the Bay, the more political Free Speech Movement coalesced on the Berkeley campus of the University of California, while in Oakland the Black Panther party was founded in 1966 by Bobby Seale and Huey P. Newton. The Chicano movement took root in the agricultural fields of the Salinas Valley and spread to the Southland barrios, where it quickly inspired a vaster constituency. Women's centers up and down the state, such as the Woman's Building in Los Angeles, were the birthplaces of the women's art movement, an important aspect of feminism. These political movements all had a palpable impact on the cultural life of California and the nation.

The second- and third-generation Beats, the so-called flower children, and the other free spirits of the mid-1960s who congregated around Haight-Ashbury would later come to be called hippies and were certainly the most picturesque people within the new youth movement.[10] Timothy Leary, a Harvard University professor of psychology from 1960 to 1963 who became a drug

stored to re-create California life of the Mexican and early American periods. > The American Indian Movement is formed by Chippewas George Mitchell and Dennis Banks. > *Whole Earth Catalog* offers

215

c

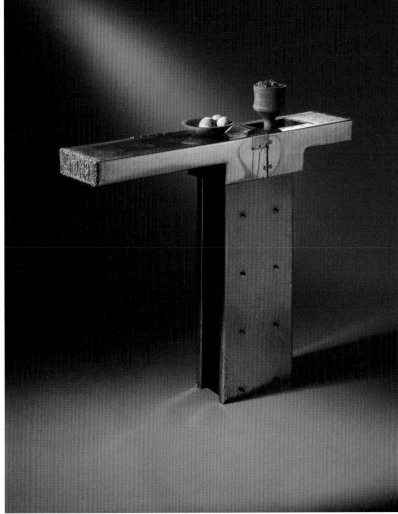

d

e

a–c
Psychedelic posters by Stanley Mouse and Alton Kelley, 1966; Jim Blashfield, photograph by Herb Green, 1967; and Victor Moscoso, 1967, respectively. Lent by Jim Heimann

d
The Hippie Scene, postcard, late 1960s. Lent by Jim Heimann

e
Ruth-Marion Baruch
Shakespeare Couple, Haight-Ashbury, 1967, gelatin-silver print

f
Gage Taylor
Mescaline Woods, 1969, oil on canvas

g
Tales from the Tube, no. 1, 1973, underground comic by Rick Griffin. Lent by the McClelland Collection

h
Richard Marquis and Nirmal Kaur
American Acid Capsule with Cloth Container, 1969–70, solid-worked glass and cloth

216

a

b

c

were exposed to head shops selling all manner of drug paraphernalia, countless secondhand clothing stores, bookstores, and record shops, and were driven by the Fillmore Auditorium, the Carnegie Hall of counterculture music.

With respect to painting and sculpture, however, hippie culture did not produce much. Gage Taylor's psychedelia-inspired landscapes, like *Mescaline Woods*, are a conspicuous exception. In contrast, comic books, psychedelic posters, and other examples of graphic design celebrating the hippie lifestyle or advertising concerts and outdoor gatherings called "be-ins" or "love-ins" proliferated.

Ironically, society at large readily imitated and co-opted the hippie image, particularly in fashion design. Billy Shire's *Untitled Denim Jacket*, with its encrustation of metallic studs and paste stones, and Fred E. Kling's *Wedding Dress*, with its floral and magical rainbow motifs, were unique creations intended for the few who could afford them. Mass-produced clothing—off-the-rack apparel such as bell-bottom jeans, body shirts, and leather boots—and the commodification of the hippie lifestyle in such publications as *The Whole Earth Catalog* enabled millions of people who were not hippies to participate safely and vicariously in the countercultural revolution and to develop a tolerance for ideas and modes of behavior that probably merely fascinated them from afar.

advocate and guru of the counterculture, called upon young people to "turn on, tune in, and drop out," and many in Haight-Ashbury heeded his mantra. The hippies were ubiquitous in the media, and unlike the Beats before them, they proved galvanic in the popular American psyche, which imagined that all hippies engaged in free love and used marijuana and hallucinogenics such as LSD and mescaline. Hippies were portrayed, as in Ruth-Marion Baruch's photograph *Shakespeare Couple, Haight-Ashbury*, as colorful and folksy longhaired youths, many of whom wore beat-up Levi's, tie-dyed T-shirts, macramé headbands and belts, and necklaces symbolizing love and peace called "love beads."

By 1967 the Gray Line bus company added a two-hour San Francisco Haight-Ashbury district "Hippie Hop Tour" to its schedule, promoting it as "the only foreign tour within the continental United States."[11] Tour participants

d

e

f

g

h

a	b	c	d	e	f
Fred E. Kling	**Billy Shire**	**Rudi Gernreich**	**Rudi Gernreich**	**Crawford Barton**	**Tom of Finland**
Wedding Dress, 1973, hand-painted cotton	*Untitled Denim Jacket*, 1973, denim, metallic studs, paste stones, and attached metallic objects	*Unisex Caftan*, 1970, printed silk	*"Topless" Bathing Suit*, 1964, wool knit	*Untitled*, c. 1975, gelatin-silver print	*Untitled*, 1962, graphite on paper

218

A popular by-product of hippie culture, with its lionization of long hair and its casual views of sexuality, was the unisex fashion fad of the 1960s and 1970s. Quickly appropriated by the dominant culture, the unisex craze lent itself to witty ready-to-wear and haute couture, such as Rudi Gernreich's *Unisex Caftan*. Outright sexual display was not ruled out either, as revealed in Gernreich's *"Topless" Bathing Suit*, which let it all hang out. Beyond unisex, even overt homosexuality began to lose some of its taboo through the counterculture. The campy beefcake drawings by Tom of Finland that had previously circulated discreetly in the gay underground now began to come out of the closet.

a

b

c

d

e

f

220

a

Hippie culture allowed for change; the larger counterculture demanded it. The demands for civil rights, equal opportunity, decent wages, health care, union representation, and an end to the Vietnam War were shared by many segments of society—including African Americans, Chicanos, Native Americans, migrant workers, students, women of all backgrounds, homosexuals—who wanted to change the way the country conducted itself. The 1960s and 1970s formed an era of civil protest and calls for empowerment, of which quite a few were gradually fulfilled.

Amid the temper of political struggle, the distinction between photojournalists and fine-art photographers began to blur. Some photographers envisioned their work as an evocation of the spirit of struggle. Pictures such as Harry Adams's *Funeral of Ronald Stokes, 29, Secretary of Mosque #27, Los Angeles, May 5, 1962*, or Charles Brittin's *Arrest (Legs) Downtown Federal Building, Los Angeles, California*, did not merely document episodes of tragedy and turmoil in the history of blacks in Los Angeles during the 1960s. They are also iconic, almost archetypal, images of the battle of an entire people for rights and dignity in a society bound by law and principle to honor those rights. Pirkle Jones's *Window of the Black Panther Party National Headquarters* shows an image of political posters, including the now-famous image of Panther cofounder Huey P. Newton in a wicker peacock chair holding

b

a

Harry Adams

Funeral of Ronald Stokes, 29,
Secretary of Mosque #27, Los
Angeles, May 5, 1962, 1962,
gelatin-silver print

b

Charles Brittin

Arrest (Legs) Downtown
Federal Building, Los Angeles,
California, c. 1965, gelatin-
silver print

c

Cleaver for President, poster,
1968. Lent by the Center
for the Study of Political
Graphics, Los Angeles,
California

d

Pirkle Jones

Window of the Black
Panther Party National
Headquarters, 1968,
gelatin-silver print

221

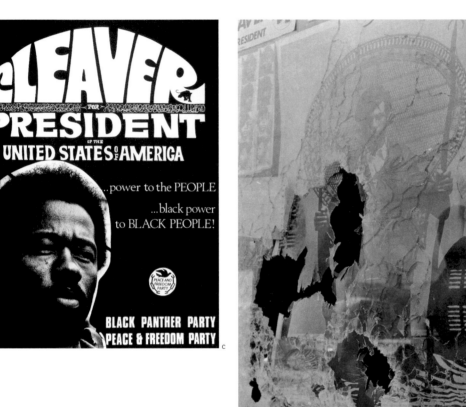

a

Betye Saar

The Liberation of Aunt Jemima, 1972, mixed-media assemblage

b

Noah Purifoy

Sir Watts II, 1996 (replication of lost original, *Sir Watts*, 1966), mixed media

c

David Hammons

Injustice Case, 1970, body print (margarine and powdered pigments) and American flag

222

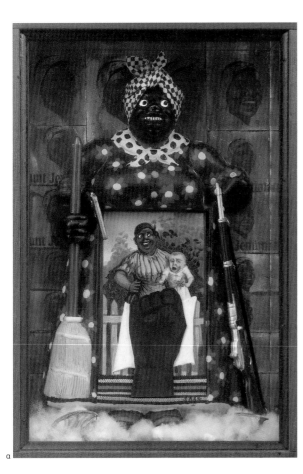

a

a spear in one hand and a rifle in the other, behind glass that has been shattered by bullets. Newton's pose is echoed in Betye Saar's *The Liberation of Aunt Jemima*, which incorporates a mammy figurine wielding a broom in one hand and a rifle in the other.

David Hammons, living in Los Angeles in the 1960s, created another widely known icon of artistic protest, *Injustice Case*. The image is a unique "body print"—a direct transfer image made by pressing paper against a graphite-covered body—that shows a gagged man tied to a chair. The high-relief border that frames the work, visually imprisoning it, is made with an actual American flag. *Injustice Case* assails the treatment of Black Panther cofounder Bobby Seale. In 1969 Seale was a codefendant in the trial of the Chicago 8, who were charged with inciting civil unrest at the Democratic National Convention the year before. During the trial, he was ordered bound and gagged by Judge Julius Hoffman.

b

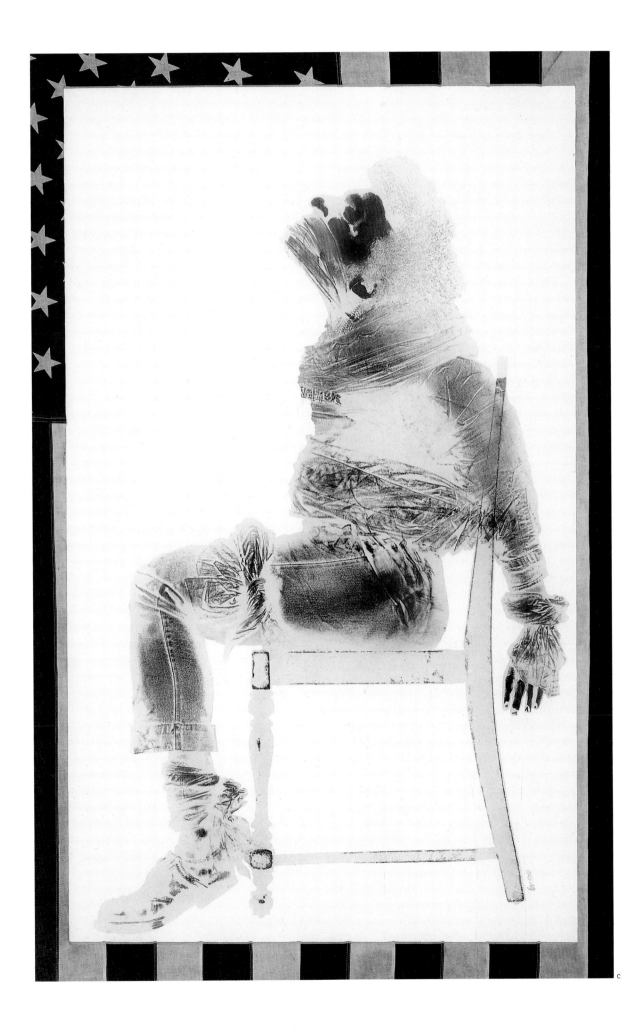

223

224

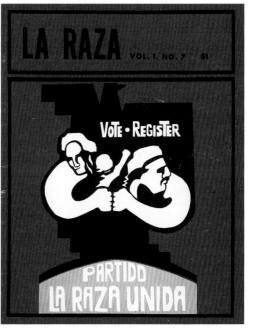

a

c

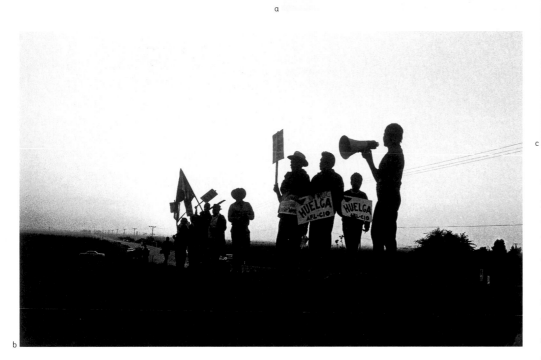

b

The Chicano art movement emerged in California as a remarkable confluence of political, labor, and cultural causes motivated by the discontent and the aspirations of the Mexican and Mexican American population. Once articulated, La Causa quickly inspired similar movements in Texas and other parts of the Southwest and Midwest from the mid-1960s into the 1970s. The actor, playwright, and director Luis Valdez is widely credited with beginning the movement when he founded El Teatro Campesino, or Farm Workers' Theater, which staged improvised performances in the fields and on the roadsides of

the Salinas Valley to support the nascent labor movement being organized by Cesar Chavez and the National Farm Workers Association (later the United Farm Workers). It is probable that this unique coalition of artists and political organizers could only have come together with such a successful program in California. The state had the critical mass of Latino artists necessary to spawn a political and cultural movement, and scarcely any concerted attention from the gallery, museum, and critical establishment to support, or rather to divert, the artists in more customary art world activities.

Teatro Campesino's example inspired many writers, performing artists, and visual artists to take up the cause. Salvador Roberto Torres's oil painting *Viva La Raza* is a heraldic image of the symbol of the United Farm Workers. The Aztec eagle is shown with its wings outspread and its body and tail resembling an inverted Aztec pyramid. *La raza* means "the race" or, more accurately, "the people," and, indeed, the Chicano movement was about a people, a culture, an

a
El Teatro Campesino, poster by Andrew Zermeno, c. 1967. Lent by UCLA Library, Department of Special Collections

b
Emmon Clarke
Untitled, 1960s, gelatin-silver print

c
La Raza, vol. 1, no. 7, 1969. Lent by the UCLA Chicano Studies Research Center Library

d
Salvador Roberto Torres
Viva La Raza, 1969, oil on canvas

225

d

identity. Many Chicano artists aspired to assert their cultural and ethnic identity in the face of neglect, indifference, and denigration. Some even sought, perhaps somewhat romantically, to reclaim the culture's roots in Aztlán—the Aztec homeland, which some Chicanos believe is found in the annexed Mexican territories of the southwestern United States, and which became the name of the movement's new Chicano nation.[12] Numerous Chicano arts organizations emerged during this period: Plaza de la Raza, a community-based gallery and art center opened in Los Angeles in 1969; La Raza Graphic Center, a workshop for graphic artists, opened in San Francisco in 1971; and Self-Help Graphics and Art, a similar workshop and training ground for young artists, opened in Los Angeles in 1972.

In 1974 in Venice, Judith Baca founded the Social and Public Art Resource Center (SPARC), whose mission was to produce and preserve murals by Chicano artists throughout Southern California. Baca, a muralist herself, directed the monumental mural project *The Great Wall of Los Angeles*, painted on some 400 feet of concrete retaining wall along the Tujunga Wash Drainage Canal in the San Fernando Valley in Los Angeles County. *The Great Wall* historicizes an eclectic panoply of Los Angeles events and peoples, including many marginalized groups.

Another major mural project resulted from community opposition in "Barrio Logan," a once-Anglo suburb of San Diego officially called Logan Heights. In the mid-1960s freeway construction cut through the center of the predominantly Chicano neighborhood. When plans were announced in April 1970 to build a Highway Patrol headquarters beneath a massive interchange, residents occupied the site in protest for twelve days, cleaning it up and planting trees. Ultimately the city abandoned its proposal, and Chicano Park was created instead. By 1973 community action

a
Víctor Ochoa et al.
Photo documentation of
Chicano Park murals,
San Diego, 1973–present
(scale reconstruction in
exhibition)

b
**Judith Baca / Social and
Public Art Resource Center
(SPARC)**
The Great Wall of Los Angeles
(detail), 1976–83, mural,
Tujunga Wash, San Fernando
Valley

226

groups had organized a program, later supervised by the Chicano Park Steering Committee, in which both well-known and lesser-established artists throughout California were invited to paint murals on the concrete pilings of the interchange. The project is ongoing. The murals depict religious subjects such as Our Lady of Guadalupe, episodes of Chicano social and political history, themes of community identity, and Aztec-inspired images.[13] Both the SPARC and Chicano Park murals position themselves in the populist tradition of the monumental, polemical muralism of José Clemente Orozco, Diego Rivera, and David Alfaro Siqueiros, whose legacy of visiting and working in California proffered spiritual mentorship to a new generation of Chicano muralists.

Chicano artist collectives developed as well. In Los Angeles, Los Four was a loose confederation of Carlos Almaraz, Roberto (Beto) de la Rocha,

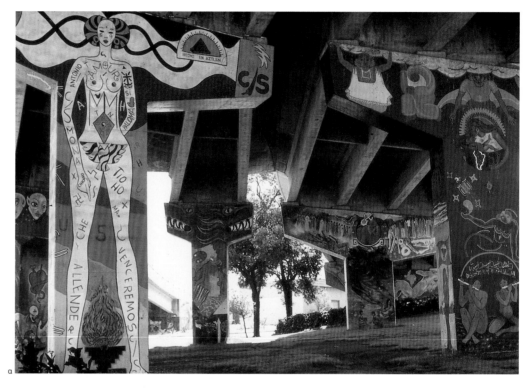

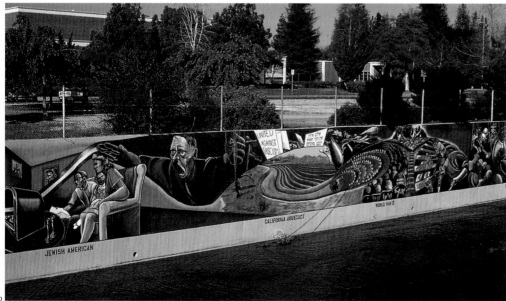

Frank Romero, and Gilbert Sánchez Luján, who were unified in their energetic gestural painting, their bold palette, and most of all in their focus on the sights, rhythms, and pace of Chicano Los Angeles. They showed together off and on as a group over a ten-year period, but they are best remembered for an exhibition titled *Los Four* (1973–74) that was organized at the University of California, Irvine, and subsequently seen at the Los Angeles County Museum of Art (LACMA), where it became known as the first exhibition of Chicano artists at a major museum.

At least officially. Two years earlier, in December of 1972, Asco, another loosely formed L.A. artists' group, spray-painted the names of three of its members on the entrances to LACMA, protesting a principal curator's stated lack of interest in Chicano art. Though the museum painted over the graffiti the same day, Asco envisioned their action as a performance/guerrilla theater/conceptual activity and thus cheekily

c
Los Four: Almaraz/de la Rocha/Luján/Romero,
exhibition catalogue,
UC Irvine and LACMA, 1973–74,
design by Frank Romero

d–f
Asco (Harry Gamboa Jr., Gronk, Willie Herrón, and Patssi Valdez)
Instant Mural, 1974, stills from videotape of Super 8 film of performance

g
Asco (Harry Gamboa Jr., Gronk, Willie Herrón, and Patssi Valdez)
Spray Paint LACMA, 1972, photo documentation of guerrilla art action

227

laid claim to the first Chicano art exhibition at the museum. Asco operated more or less within the Chicano movement, but as the enfant terrible of the family. The four members of Asco—writer Harry Gamboa Jr., painters Patssi Valdez and Gronk, and muralist Willie Herrón, all of whom also did performance art (occasionally joined by Humberto Sandoval and others who drifted in and out of Asco's activities)—in many ways stood against traditionalism and conformity to the received culture of Chicanismo.[14] They satirized Chicano muralism, for example, with *Instant Mural,* in which Gronk used tape to attach Valdez and Sandoval to a wall in East Los Angeles. Not surprisingly, Asco (which means nausea in Spanish) was regarded ambivalently by the Chicano community.

a
Three issues of *El Malcriado*,
the journal of the United Farm
Workers union, 1966–68.
Lent by Shifra M. Goldman

b
Two issues of *The Black
Panther*, the newspaper of
the Black Panther party, from
1969 and 1972. Lent by the
Southern California Library for
Social Studies and Research

c
Illustration from the flyer
*Rally against Racism, War,
Repression*, San Jose, 1972.
Lent by the Southern
California Library for Social
Studies and Research

d
Save Our Sister, 1972,
poster by Rupert García.
Lent by the Center for the
Study of Political Graphics,
Los Angeles, California

e
Judy Dater
Libby, 1971, gelatin-silver
print

228

a

Among the various factions that made
up the countercultural revolution, many groups
acknowledged solidarity and worked in sympathy with one another. *The Black Panther*, the
newspaper of the Black Panther party, ran
cover stories proclaiming solidarity with Native
Americans and with the United Farm Workers.
In San Jose in 1972, a rally protesting racism,
war, and repression was sponsored by a broad
coalition of twenty-two organizations devoted
to civil rights, antiwar, and civil liberties issues.
The flyer announcing the rally featured multiple
emblems and slogans composed in a single
drawing. One group, however, literally cut across
the borders of all revolutionary factions and
included members of all groups: the women's
movement.

b

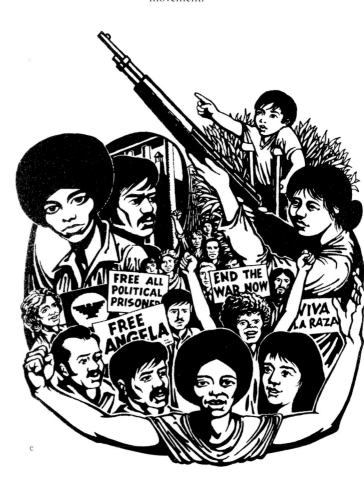

c

229

e

Like the Chicano Causa, the women's art movement was as political as it was artistic, and it likewise flourished outside of the interests of the established art world. Inspired by the civil rights movement, the women's movement was partly focused on achieving equal opportunity and equal representation, in the political arena and the annals of history. Feminism also proposed a new way of conceiving art and the role of the artist. Judy Chicago, former cohort of the Ferus Gallery Studs, began the Feminist Art Program, the first of its kind in the nation, at Fresno State College (now California State University, Fresno) in 1970. Her curriculum stressed innovative art forms rooted in modes of performance and installation; new content expressing feelings, concepts, and issues that related particularly to women; and appreciation of the forgotten, repressed, or ignored history of women in the visual arts. Faith Wilding, a student in the program, recounts how Chicago, instructing her class to make an art project

d

dealing with sexual harassment, provoked a new vision of being an artist:

Never in our previous art education had we been asked to make work out of a real life experience, much less one so emotionally loaded. With license to use any media or form we wanted, we came back the next week with poems, scripts, drawings, photos and performance ideas . . . By fortuitous accident, it seemed, we had stumbled on a way of working: using consciousness-raising to elicit content, we then worked in any medium or mixture of media—including performance, role-playing, conceptual- and text-based art, and other nontraditional tools—to reveal our hidden histories.[15]

It would be difficult to imagine a practice of art making more contrary in intent to the strict formalism and brute materialism of Minimalist art then dominant in New York. Once again, California's critical mass of art activity coupled with its remove from the principal art center in the nation facilitated a new direction in art.

In 1971 Paul Brach, dean of the art school at California Institute of the Arts (CalArts) in Valencia, hired Chicago to establish and codirect, with Miriam Schapiro, another feminist art

program.[16] The CalArts program, which continued through 1975, was largely modeled after Fresno's but also included a significant, now-legendary public venue. Womanhouse was a collaborative, temporary "art environment" created by Chicago, Schapiro, and twenty-one of their students in a condemned but still imposing Hollywood mansion, which was loaned to the group by the city of Los Angeles. The project took six weeks to create and was open to the public from January 30 through February 28, 1972, garnering considerable national attention. Each room of the mansion was the setting for an exploration of the cultural identity of women—the presumptions, perceptions, and expectations that the culture assigns to women. Today Womanhouse is deemed more important for the example it set than for the specific works created there. As feminist art historian Arlene Raven points out, "Because the West Coast became a model and leader for feminist production nationally and internationally, the influence of the transitory collaboration at Womanhouse has been pervasive and lasting."[17]

a
Judy Chicago
Georgia O'Keeffe, Plate #1,
1979, whiteware with china
paint

b
Judy Chicago
*Menstruation Bathroom
from Womanhouse, a
Collaborative Site-Specific
Installation,* 1972, photo
documentation of installation

c
Miriam Schapiro
Night Shade, 1986, acrylic and
fabric collage on canvas

d
Marika Contompasis
Trout Magnolia Kimono, 1977,
wool yarn, loom knitted

e
Claire Campbell Park
Cycle, 1977, coiled raffia

230

a

By the mid-1970s Judy Chicago had
become a leading advocate in the women's art
movement. In 1979 Chicago, aided by some 400
volunteers, exhibited *The Dinner Party,* a vast
triangular dining table with thirty-nine place
settings, each consisting of a unique, highly
sculptural ceramic plate, a ceramic goblet, and
an embroidered place mat. Each honored a
woman in the arts, from Artemisia Gentileschi
to Georgia O'Keeffe, from Sappho to Virginia
Woolf. Controversial since its debut, championed
by many but criticized by antifeminists and
feminists alike on the basis of who was or was
not included and for its pervasive genital
imagery, it remains Chicago's magnum opus.

The paintings of Miriam Schapiro evolved
during the 1970s from works inspired by some of
the earliest computer-generated imagery, reflect-
ing her early interest in technology, to forms and
materials historically associated with women.
Schapiro became interested in pattern and purely

b

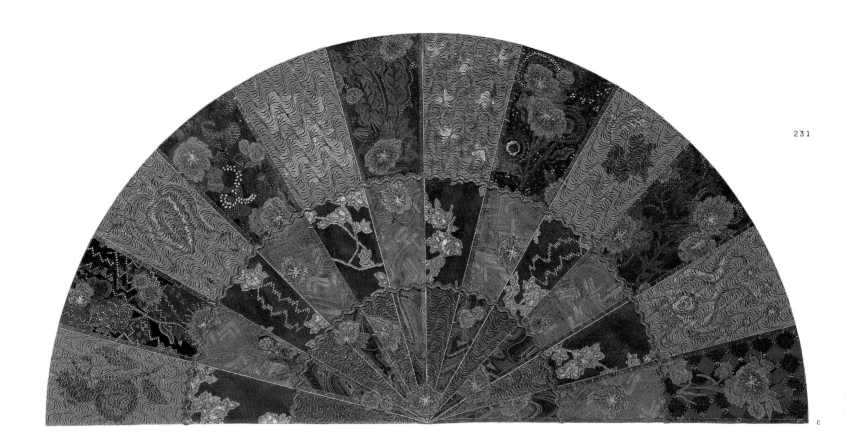

231

decorative elements in painting at a time when such concerns were truly heretical to the prevailing formalism of the New York art world. Her elaborate patterning and sumptuous decoration had a superficial formalism about it, but she stressed its affinity to "feminine" artistic pursuits, such as quilting, embroidery, basketry, pottery, fabric painting, and other decorative arts (all traditionally ranked "minor" in a hierarchy crowned by painting and sculpture). Thus, a work like *Night Shade*, despite its lack of discernible "subject matter," has an implicit and pointedly feminist content.

In 1977 Suzanne Lacy and Leslie Labowitz, collaborating with dozens of other women, staged a multifaceted media event deliberately calculated to bring out the television news crews and newspaper reporters, which it succeeded in doing. *Three Weeks in May* was a form of street theater that utilized performance as "a vehicle for establishing an empowering network" and brought public attention to violence against women.[18] A crusade of sorts, it included public demonstrations and art performances throughout Los Angeles, as well as a large map pinpointing the location of all the reported rapes during the period, which was displayed at City Hall.

There was also another, more introspective wing of the women's art movement, not inimical to the pragmatic political outlook of such exemplars as Chicago, Schapiro, Lacy, and Labowitz but complementary to it. Eleanor Antin was a New Yorker who relocated to Solana Beach in north San Diego County in 1968. Surrounded by a beach culture and new individuals and lifestyles, she began to consider the interplay between self-identity, the immediate world, and the larger culture. She came to perceive that self-realization is a construct, not unlike a work of art, and that she could, to a certain extent, re-create her "self."

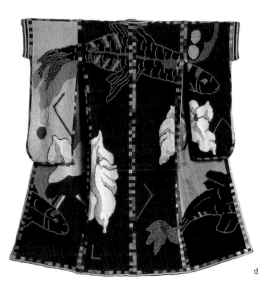

d

e

a
Eleanor Antin
The King of Solana Beach with Young Subjects, from *The King of Solana Beach*, 1974–75, gelatin-silver print mounted on board

b
Lynn Hershman
Roberta Breitmore's Construction Chart, 1973, chromogenic development print

232

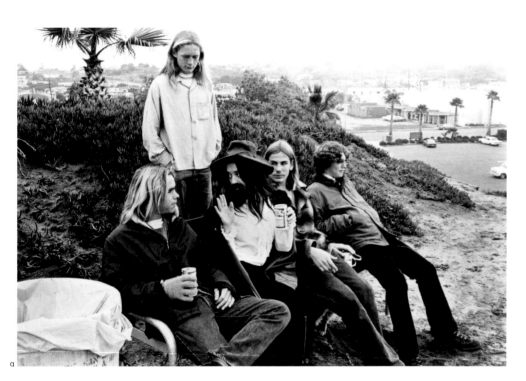

a

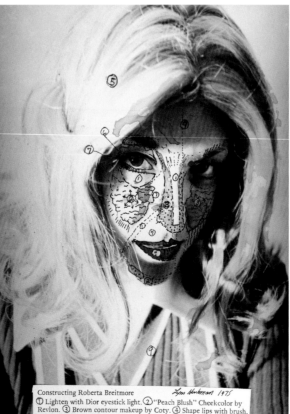

Constructing Roberta Breitmore *Lynn Hershman 1975*
① Lighten with Dior eyestick light. ② "Peach Blush" Cheekcolor by Revlon. ③ Brown contour makeup by Coty. ④ Shape lips with brush, fill in with "Date Mate" scarlet. 5. Blond wig. ⑥ Ultra Blue eyeshadow by Max Factor. ⑦ Maybelline black liner top and bottom. ⑧ $7.98 three piece dress. ⑨ Creme Beige liquid makeup by Artmatic.

b

Antin's first effort at performing another identity was to envision her ideal male self— a benevolent patriarch, a king. Donning a beard, a cape, a pair of leather boots, and a grand chapeau, Antin became the King of Solana Beach. In unannounced performances, Antin walked among her subjects (accompanied by documenting photographer Phel Steinmetz), bestowing greetings, advice, and good wishes. Over the next decade, she developed several personae—all idealized representations of her imagined selves—whose fictitious personal histories became the subject of her art.

Other women artists also explored the possibilities of self-realization through their art. In 1975 Bay Area conceptual artist Lynn Hershman, whose previous work took many forms but had usually revolved around concepts of portraiture, began a three-year project in which she acted out the life of an invented persona.[19] Roberta Breitmore was a character "so fully realized that we could inspect her résumé, bank statements, and other personal data, as well as the room she lived in."[20] The irony of the photographic "map" titled *Roberta Breitmore's Construction Chart* is that it suggests that Breitmore is not, after all, an idée fixe with a prescribed identity. Rather, like all human beings, she is a living personality whose amorphous identity merits exploration.

In 1976 Nancy Angelo and Candace Compton created a video performance titled *Nun and Deviant* at the Woman's Building in Los Angeles. Early in the piece, Angelo declares,

I am an artist . . . I am changing, and my work is about transformation . . . My work is about me being whatever I want to be. It is having permission to say what I want to say. To be heard, to be seen, to be loud. My work is moving away from self-obsession, blindness, dumbness, towards self-definition, new direction, creation of fresh order. [My art] is about expectation and redefinition.[21]

The words are simple, the statement clear and direct, yet the ideas reflect a major revolution in the ideology of empowerment. Angelo's statement reflects the optimistic belief that one can and should change, as long as one has the insightfulness to do so, and the expectation that change is for the better. The work of Antin, Hershman, Angelo, Compton, and many others embodied the more introspective side of feminist practice, getting right down to issues of identity, gender, individual potential, and self-realization.

The drive toward liberation from social constraints and empowerment so vibrant in California in the 1960s and 1970s catalyzed profound social and cultural change within and beyond the art world. In the face of formidable conservative opposition, issues of identity, belonging, and full enfranchisement in a free society were articulated and proclaimed for an entire generation. In the ensuing twenty years, much of that ideology would evolve into very different cultural concerns and new perceptions of American values. The California image would continue to influence the national and international consciousness of contemporary life, and artists would again play a dynamic role in that process.

1 "California: A State of Excitement," *Time*, Nov. 7, 1969, 60.

2 John W. Caughey, *California: History of a Remarkable State*, 4th ed. (Englewood Cliffs, N.J.: Prentice-Hall, 1982), 417.

3 Andrew Rolle, *California: A History*, 4th ed. (Arlington Heights, Ill.: Harlan Davidson, 1987), 506–7.

4 See Alaric Valentin, "Billy Al Bengston," *Long Board* magazine, July 1997, 51–58.

5 Laura Meyer, "From Finish Fetish to Feminism: Judy Chicago's *Dinner Party* in California Art History," in *Sexual Politics: Judy Chicago's "Dinner Party" in Feminist Art History*, ed. Amelia Jones, exh. cat. (Los Angeles: UCLA at the Armand Hammer Museum and Cultural Center in association with the University of California Press, Berkeley and Los Angeles, 1996), 52.

6 When *Back Seat Dodge '38* was exhibited at the Los Angeles County Museum of Art in 1966, the County Board of Supervisors threatened to close down the museum if the work were not removed from the exhibition. A compromise was reached allowing gallery attendants to open the car door upon request, but only when minors were not present.

7 Peter Plagens, *Sunshine Muse: Art on the West Coast, 1945–1970* (1974; reprint, Berkeley and Los Angeles: University of California Press, 1999), 120.

8 Rosalind Krauss, "Overcoming the Limits of Matter: On Revising Minimalism," in *Studies in Modern Art*, no. 1 (New York: Museum of Modern Art, 1991), 133.

9 Turrell's light installations require more space than was available to represent him properly in this exhibition. It was essential, however, to acknowledge his achievement in this discussion.

10 The word *hippie* had been in use since the early 1950s as a synonym for *hipster* or *beatnik*. During the mid-1960s it took on new countercultural connotations.

11 The Rock and Roll Hall of Fame and Museum, *I Want to Take You Higher: The Psychedelic Era, 1965–1969* (San Francisco: Chronicle Books, 1997), 82.

12 "Chicano Glossary of Terms," in *Chicano Art: Resistance and Affirmation, 1965–1985*, ed. Richard Griswold del Castillo, Teresa McKenna, and Yvonne Yarbro-Bejarano, exh. cat. (Los Angeles: Wight Art Gallery, University of California, Los Angeles, 1994), 361.

13 See Larry R. Ford and Ernst Griffin, "Chicano Park: Personalizing an Institutional Landscape," *Landscape* 25, no. 2 (1981): 42–48.

14 For an excellent discussion of the history of Asco, see Harry Gamboa Jr., "In the City of Angels, Chameleons, and Phantoms: Asco, a Case Study of Chicano Art in Urban Tones (or Asco Was a Four-Member Word)," in *Chicano Art: Resistance and Affirmation*, ed. del Castillo, McKenna, and Yarbro-Bejarano, 121–30.

15 Faith Wilding, "The Feminist Art Programs at Fresno and CalArts, 1970–1975," in *The Power of Feminist Art: The American Movement of the 1970s, History and Impact*, ed. Norma Broude and Mary D. Garrard (New York: Harry N. Abrams, 1994), 34.

16 California Institute of the Arts was created in 1961 through the incorporation of the Los Angeles Conservatory of Music (est. 1883) and Chouinard Art Institute. Chouinard was founded in Los Angeles in 1921 and later funded in part by Walt Disney to train students in filmmaking and related arts.

17 Arlene Raven, "Womanhouse," in *The Power of Feminist Art*, ed. Broude and Garrard, 50.

18 Josephine Withers, "Feminist Performance Art: Performing, Discovering, Transforming Ourselves," in *The Power of Feminist Art*, ed. Broude and Garrard, 171.

19 Moira Roth, "Toward a History of California Performance: Part One," *Arts Magazine* 52 (Feb. 1978): 101.

20 Withers, "Feminist Performance Art," in *The Power of Feminist Art*, ed. Broude and Garrard, 167.

21 Transcribed by the author from the videotape.

The Merced River, Yosemite Valley, Sept 1982 #20. David Hockney

a

Howard N. Fox

The countercultural revolutions of the 1960s and 1970s propelled a growing national fascination with California. By the 1980s and 1990s, as California's social and cultural mix grew ever more diverse, multiple views of the state began to emerge. Many of these new images were unlike either the white-bread boosterism of California's promoters or the revolutionary idealism of its youth movements, and they complicated and unsettled many long-standing notions about the Golden State. Some of what percolated through the popular consciousness indeed perpetuated the idea of California as a land of the new and the exotic: The advent of the personal computer and its ever more breathtaking technologies was centered in "Silicon Valley" (in the northwest quarter of Santa Clara County, south of San Francisco Bay); the Internet was developed in part at UCLA and

other universities in California; "fusion cooking," which might cross, say, Thai cuisine with Central American ingredients or traditional Japanese fare with nouvelle French techniques, began in California and quickly became an international phenomenon.

Even as California's eclecticism and complexities received greater exposure, however, one vision of the state dominated: an almost morbid fixation with California's considerable ills and woes. By the 1980s tabloid-style television news coverage provided round-the-clock sensationalism and had effectively reimaged California. Minutes after the Loma Prieta earthquake struck on October 17, 1989, the shocking images of motorists being rescued from a car teetering on

a
David Hockney
The Merced River, Yosemite Valley, California, September 1982, 1982, photo collage

b
The original Apple Macintosh personal computer, 1984

c
Keith Cottingham
Triplets, from the Fictitious Portraits series, 1993, dye-coupler print from a digitized source

236

a

b

c

the edge of a collapsed section of the Bay Bridge were telecast live by news helicopters over San Francisco Bay. Horrific visions of mayhem and a city afire were broadcast live from Los Angeles via satellite worldwide for several days in April 1992, when communities throughout the city combusted in racial outrage following not-guilty verdicts in the criminal case against four white policemen accused of beating a black man,

Rodney King. The astonishing prime-time spectacle on June 17, 1994, of police pursuing murder suspect O. J. Simpson's white Bronco from Orange County to the Simpson estate in the Brentwood section of Los Angeles quickly spawned a daily TV diet of aerial images of high-speed freeway chases, which virtually became a local spectator sport. The tabloidized California image saturated the national airwaves, with pictures of gun-toting schoolboys and infant victims of stray bullets in gang-related drive-bys and shoot-outs; of El Niño water walls, landslides, drought, and catastrophic forest fires, some set by arsonists, from Malibu to Monterey; of preschool teachers charged with multiple child molestation; and of mass suicides in bizarre religious cults. The visions of California that the world has come to know and believe are all but apocalyptic and routinely have made the state the butt of late-night TV talk show jokesters.

Time magazine—not an arbiter in the matter but certainly a longtime observer of the scene—may serve as a reliable index of the changing conception of California in American popular culture. In its November 7, 1969, cover story, *Time* colorfully labeled California the "state of excitement"; twenty-two years later, on its cover of November 18, 1991, it ominously brooded about California's "endangered dream"; and on April 19, 1993, a year after the cataclysmic civil unrest of the Rodney King affair, *Time* gravely asked, "Is the City of Angels Going to Hell?"

Following the riots, "much of what seemed modern and alluring about Los Angeles," *Time* opined, "now seems terribly shortsighted and ugly...Increasingly, the rest of America hopes the latest in L.A. trends will stay right where they started."[1] Indeed, the idea of California conjured up by the image of Los Angeles had become so suspect—so reviled—that Pacific Northwesterners

d

a
San Francisco–Oakland Bay
Bridge damaged by the
Loma Prieta earthquake,
San Francisco, 1989

b
Shop owners at the site of a
building leveled during the
1992 Los Angeles riots

c
The low-speed police pursuit
of O. J. Simpson on a Southern
California freeway, 1994

d
Anthony Hernandez
#24, 1989, from the series
Landscapes for the Homeless,
silver dye-bleach
(Cibachrome) print

e
John Gilbert Luebtow
April 29, 1992, 1992,
glass and steel cable

f
Willie Robert Middlebrook
In His "Own" Image, from the
series Portraits of My People,
1992, sixteen gelatin-silver
prints

237

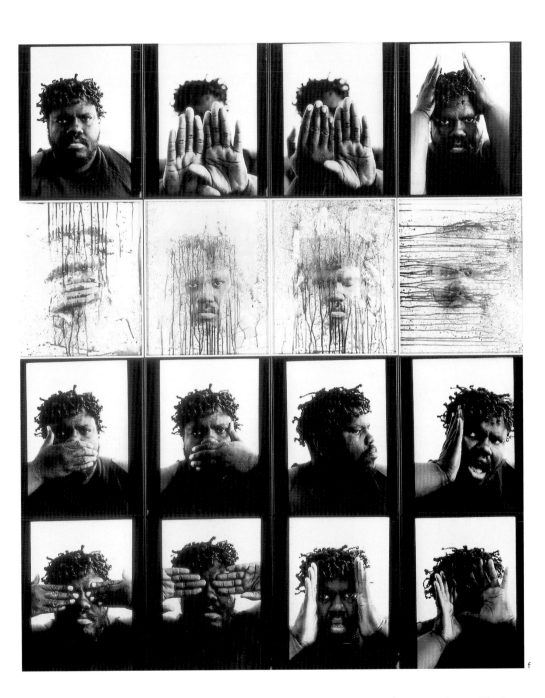

Right does not win out over wrong; God did create man in his own image, as long as you're not Black.
I came to this conclusion from the first time I heard the verdicts that were handed down in the
King Case and from watching and listening to how the media covered the aftermath of the verdicts.
WILLIE ROBERT MIDDLEBROOK

a
Sharon Lockhart
Untitled [Ocean], 1996,
chromogenic development
print

b
Intae Kim
*Death Valley, Sunrise, Sand
Dune*, 1989, printed 1994,
gelatin-silver print

c
Margaret Honda
Perennial, 1996, fresh
chrysanthemums, stainless
steel, and water

238

c

a

b

had taken to actively shunning the influx of
Californians seeking weekend and vacation
homesteads. A popular bumper sticker summed
up the Oregonian attitude toward a botched
California that they, and many other Americans,
feared: Don't Californicate Oregon.

Clearly, mythologies were changing and
dropping away, and the original myth of
California as a natural paradise was among the
first to fall. Many of the state's grand expanses
of pristine wilderness became casualties of their
own allure, and the national parks were trans-
formed into denaturalized theme parks. There
was so much contention about the invasion of
automobiles, recreational vehicles, motorcycles,
motorboats, and even airplanes into the wilds
that conservationist groups like the Sierra Club
lobbied—often successfully, as in the case of sev-
eral national parks—to limit visitors to relatively
small tourist zones, while true wilderness areas
were virtually sealed off to all but the most
intrepid backpackers. Such measures segregated
humans from the wilds and limited access to
the selfsame locales where previously people had
been encouraged to commingle with nature.
In a stunning reversal of fortune over the cen-
tury, the California landscape now had to be
isolated in truly remote areas to save it.

The displacement of nature had repercus-
sions in the visual arts. Fewer artists than ever
before trained their primary attention on the
natural world. Those who did, generally operated

d
Kris Dey
Ancho II, 1991, painted
cotton strips

e
Gyongy Laky
Evening, 1995, London plane
tree, doweled

f
Sam Maloof
Rocking Chair, 1997, cherry
wood and ebony

239

apart from of nature, as does Los Angeles–based
Margaret Honda, who has sequestered a bit of
nature inside her studio. A main focus of Honda's
ongoing project is the study of the life cycles of a
box tortoise inside an elaborate terrarium that
she constructed. Related to this project is her
ironically titled installation *Perennial*, in which
hundreds of freshly cut chrysanthemums gradu-
ally decay in a shallow container of water that
resembles a giant petri dish. A faint sadness under-
lies Honda's contemplative art, which preserves
life while accepting mortality. Nature also comes
indoors in Gyongy Laky's *Evening*, a construction
of slender tree branches that resembles an open-
worked vessel, and in Sam Maloof's cherry wood
Rocking Chair. But artists who represent nature
in such benign ways are in the minority.

Even David Hockney (hardly a pessimist,
rather more of a booster) often depicts the
California landscape as distorted and fragmented.
His *Merced River, Yosemite Valley, California,
September 1982*, is composed of multiple photo-
graphs pieced together to form a single view.
Whether photographing the sprawl of Los Angeles,
the scruffiness of the Mojave Desert, or the

240

a

b

splendors of the Yosemite Valley, he seems to treat the California landscape as if it had been shattered and needed to be put back together.

In most artistic representations of the last twenty years, humans and nature appear roiled in a stormy divorce. Throughout the 1980s and 1990s, as commercial development displaced natural habitats and pushed the wilderness ever farther away; as environmental mismanagement was more apparent; and as California's man-made and natural disasters became the televised erotica of popular culture, the relationship of man to nature grew increasingly inimical if not outright adversarial. With a few notable excep-tions (such as the 1980 volcanic explosion of Mount St. Helens in Washington State and the ravaging of Florida and Louisiana by Hurricane Andrew in 1992) there was no finer theater of cruelty between man and nature than California. Like the media and its audience, artists were transfixed by the forces that traumatized humans and their habitats up and down the state.

a
Joel Sternfeld
After a Flash Flood, Rancho Mirage, California, 1979, chromogenic development print

b
Richard Misrach
T.V. Antenna, Salton Sea, California, 1985, printed 1996, dye-coupler print

c
Poster for the film *Volcano*, 1997

d
Joe Deal
Colton, California, from the portfolio *The Fault Zone*, 1981, gelatin-silver print

241

Exemplary of that ghoulish fascination is Joel Sternfeld's photograph *After a Flash Flood, Rancho Mirage, California*. It presents the grisly image of a massive heap of compostlike debris vomited up into an idyllic suburban backyard. The even more stealthy menace of seismic upheaval lurks underground in vast regions of California, atop which lie some of the most densely populated areas of the nation. Joe Deal's *Colton, California* (from the portfolio *The Fault Zone*), depicts an especially rugged landscape. Giant boulders loom high above the piteously vulnerable houses below. To any seasoned observer the situation portends inevitable, if not imminent, disaster.

Hollywood films followed the news media in playing up the theme of nature's vengeance against Californians' monumental hubris. *Volcano* (1997) is an update of sensational disaster films of the 1970s such as *Earthquake* (1974) but with a twist: The La Brea Tar Pits become

c

the escape valve for a massive underground ocean of boiling magma that erupts, taking with it the adjacent Los Angeles County Museum of Art and the nearby Beverly Center, an upscale shopping mall. In the nature-as-monster films *Tremors* (1990) and its sequel *Tremors 2: Aftershocks* (1996), prehistoric killer worms, which are endowed with razor-sharp teeth and have been trapped underground for eons, are disinterred in an earthquake and go on a feeding frenzy for their favorite food, human flesh.

a

Mike Davis's *Ecology of Fear:*
Los Angeles and the
Imagination of Disaster,
1998, cover illustration by
James Doolin

b

Faith Ringgold
Double Dutch on the Golden
Gate Bridge, 1988, acrylic on
canvas, printed, dyed, and
pieced fabric

c

William Leavitt
Untitled, 1990, pastel on
paper

d

Mark Klett
San Francisco Panorama after
Muybridge (detail), 1990,
thirteen gelatin-silver prints

e

Sandow Birk
Bombardment of Fort Point,
1996, oil and acrylic on
canvas

f

Catherine Wagner
Arch Construction IV, George
Moscone Site, San Francisco,
California, 1981, gelatin-
silver print

242

a

It was not only artists and popular culture that reimaged California. In his book *Ecology of Fear: Los Angeles and the Imagination of Disaster* (1998), historian Mike Davis debunks the abundance myth of Southern California as a land of sunshine and oranges with a backyard for all. Davis replaces that fancy with his vision of a land—largely defined as the Los Angeles megalopolis—of pervasive natural perils and apocalyptic natural disasters, criminally negligent overdevelopment, and sociocultural dysfunction rooted in pandemic racism and ethnic mistrust of the Other. Whither went Gidget? On the same turf where bands like the Beach Boys sunnily rhapsodized about an endless summer, Davis pronounces that "no other city seems to excite such dark rapture."[2]

Examining the urban disaster genre in a century's worth of popular literature and entertainment, Davis asserts that the destruction of London (fictionally the most persecuted city from 1885 to 1940, after which it was supplanted in literature and film by Los Angeles) was imagined as "equivalent to the death of Western civilization itself," whereas "the obliteration of Los Angeles, by contrast, is often depicted as, or at least secretly experienced as, a victory for

civilization."[3] By way of evidence Davis observes that in the movie *Independence Day* (1996), the "devastation wreaked by aliens is represented first as tragedy (New York) and then as farce (Los Angeles)…[with] a comic undertone of 'good riddance.'"[4] The "aliens" Davis refers to here are from outer space, but in his analysis, the "abiding hysteria of the Los Angeles disaster fiction…is rooted in racial anxiety," and the "secret meaning" of the invasion of space aliens is a barely concealed "racial hysteria…typically expressed as fear of invading hordes (variously yellow, brown, black, red, or their extra-terrestrial metonyms)."[5]

No less remarkable than the role reversal ascribed to nature was a dramatically revised perception of human habitats. California's cities, which earlier in the century had been touted nationally to prospective residents as nestled in the bosom of an easy and nurturing Mother Nature, might now be accused of attempted matricide. In *San Francisco Panorama*, for example, photographer Mark Klett takes a second look at the city as depicted by Eadweard Muybridge in a famous panoramic photograph of 1878 by setting up his own camera in the same spot atop Nob Hill in 1990. Where Muybridge captured the image of a bustling city still in the process of taking root in a majestic natural setting, Klett records a metropolis covered by mile after mile of urban clutter and masses of nondescript high-rise buildings, all vying to block out whatever remains of the natural vistas.

In California's sprawling urban centers, especially those in the south, where most people live, the demographic patterns suggest less a place of domesticity than something closer to nomadism. Boosters of Los Angeles today proudly proclaim its "multiculturalism": In 1998, for example, the Los Angeles Convention and Visitors Bureau distributed a glossy booklet

featuring a series of "cultural itineraries" focusing on African American, gay/lesbian, Jewish, Latino, and Asian cultures and neighborhoods.[6] For all its diversity and long history of ethnic and cultural overlap, however, Los Angeles is one of the most segregated cities in the world. No melting pot, greater Los Angeles is regularly balkanized and rebalkanized into a myriad of shifting enclaves based on race, nationality, and ethnic identity. Population groups pull up roots and seemingly go out of their way to avoid one another throughout the Southland.

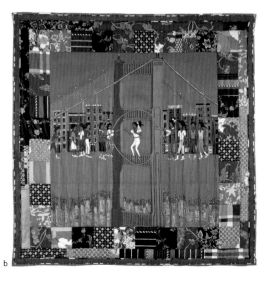

b

c

243

d

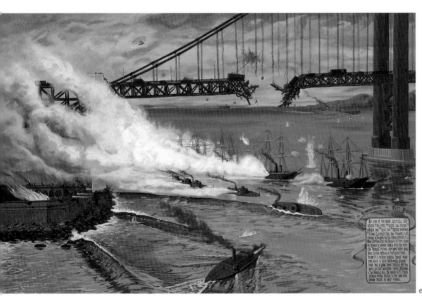

e

f

a
Judy Fiskin
Untitled #195, 1982, from the
Dingbat series, gelatin-silver
print

b
Ron Corbin
Untitled, 1990, printed 1994,
gelatin-silver print

c
Manuel Ocampo
*Untitled (Ethnic Map of
Los Angeles)*, 1987, acrylic on
canvas

d
Chris Burden
L.A.P.D. Uniform, 1993,
thirty uniforms and thirty
Beretta handguns, wool serge,
wood, and metal

244

a

b

Watts, for example, home to an almost
entirely black populace in the 1960s, became by
the mid-1990s predominantly Mexican American.
Little Tokyo, which sits just south of City Hall in
downtown Los Angeles, is currently home to an
elderly and dwindling population of Japanese
Americans who have little engagement with the
nearby "colonies" of artists who began reclaiming
and inhabiting factory and loft buildings in the
1970s. Since the early 1980s a huge population
of Taiwanese and mainland Chinese has gathered
in Monterey Park and Alhambra, suburbs that
when heavily developed in the 1940s and the
postwar period were largely Anglo. In 1984 the
community of West Hollywood incorporated as a
separate city, nearly one-third of whose citizens
were gay men. Beginning in the mid-1980s a
major influx of relatively affluent South Koreans
settled in the Mid-Wilshire district, establishing a
thriving middle-class economy. One result has
been the displacement of a sizable community
of Central Americans, many of whom have
moved to the eastern fringe of Hollywood, where
the great majority of the resident Armenian
community made room for them by relocating
to suburban Glendale.

Although such demographic shifts cannot
always be predicted, the familiar pattern of
whole neighborhoods moving on as people of
other backgrounds replace them is a historical
commonplace in many American cities. "White
flight" from city to suburb goes back at least to
the 1950s all over the country, but it is played
out in epic proportion in Southern California,
where the flight is not just "white." As if to
prove Mike Davis's theory of racial hysteria,
everybody seems to want to move away from
everybody else.

This behavior and all its concomitant ten-
sions, animosities, and suspicions is addressed
head-on by Philippine-born California artist

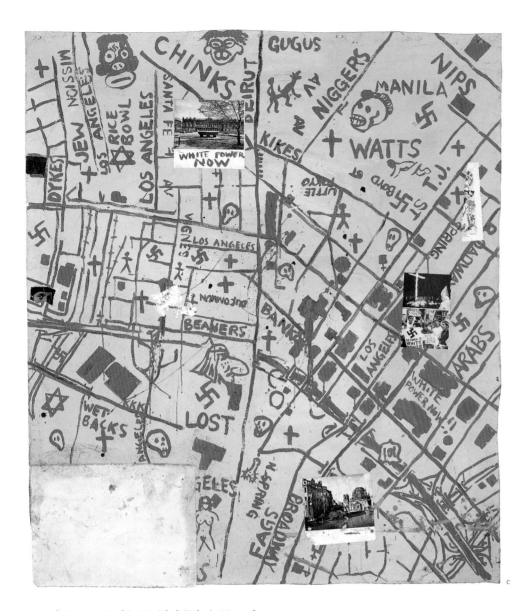

c

245

Manuel Ocampo in his *Untitled (Ethnic Map of Los Angeles)*. A sardonic parody of a page from the *Thomas Guide*—the spiral-bound street atlas that can be found in practically every operable car in Southern California—the painting resembles a crude map of a war zone, carving the city into occupied sectors. Ocampo labels the territories and ironically casts shameful epithets on all the wrangling factions: "dykes," "kikes," "niggers," "beaners," "fags," "chinks," "nips," and so on. Equally disconcerting, though oddly more lighthearted in its cartoonlike style, is Frank Romero's *Freeway Wars*, which depicts the occupants of two automobiles careening down a freeway engaged in a gunfight. One wonders what kind of peacekeeping force would be needed in such a beleaguered city. Perhaps it is represented by Chris Burden's *L.A.P.D. Uniform*, a vast installation that confronts the viewer with an intimidating gauntlet of thirty police uniforms, each a grotesquely authoritarian

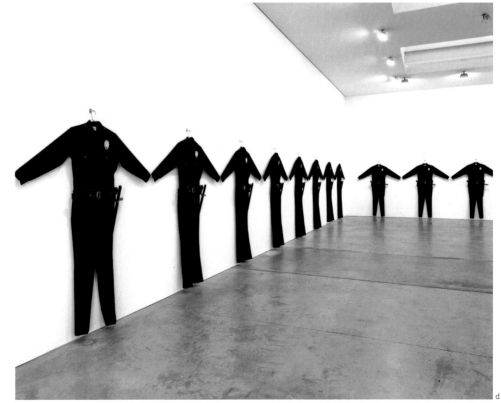

d

a

b

c

a
Chaz Bojórquez
Los Avenues, 1987, serigraph

b
Graffiti, East Los Angeles,
1987

c
Homies action figures,
created by David Gonzales

d
Carlos Almaraz
Suburban Nightmare, 1983,
oil on canvas

247

seven and a half feet tall, complete with a Beretta handgun and a badge giving license to use it.

Actually labeling, or tagging, entire regions of Los Angeles as war zones, graffiti scrawled by gang youths became as much a part of the cityscape as the buildings it was written on. Although it was mostly Puerto Rican taggers in New York City who, to much fame and infamy, turned subway cars into the venue of choice during the 1970s, it has been documented that the graffiti tradition in the United States took root decades earlier in the Mexican American neighborhoods of Los Angeles.[7] Chaz Bojórquez, a Los Angeles–based artist and former tagger, uses the brush-painted calligraphic rhythms and terse gestures of old-time graffiti (from the days before quick spray-painting) as a basic element in his art. His serigraph *Los Avenues*, in which a death's-head cockily sports a fedora and floats on a sea of graffiti, captures the vital energy and deadly force that looms in the avenues and alleys of the barrios.

This is not to say that the portrayal of gang life was entirely bleak: a wise, winking humor brought California and the nation "Homies" (home boys—neighborhood boys or, more specifically, gang members). These tiny action figures, clad head to toe in the regalia of knitted caps, bandanas, T-shirts, and baggy pants, were sold in gumball machines. Their creator, David Gonzales, maintains that Homies are simply caricatures of real people from the barrios, such as the one where he grew up near San Jose.[8] Los Angeles police detectives, however, tried to dissuade vendors from selling the figurines, claiming that they glamorized violent gang culture, and some members of the Latino community agreed that the dolls perpetuated negative stereotypes.[9]

Not only cities seemed unsettled in California. The tidy ideals of the middle-class white suburb—homogeneity, quiescence, prosperity—were challenged too. There is a long tradition of satirizing American suburbia.[10] In California, however, shifts in demographics actually altered the complexion and the concord of daily life in the suburbs and led to a changed image. This new conception was reflected in artistic representations of the suburban dream.

This is nowhere more hauntingly represented than in *Suburban Nightmare* by Carlos Almaraz, a member of Los Four in the 1970s. The painting depicts a row of three identical tract houses, each with an identical car parked in front. The middle house is being consumed by a fire, its flames lighting up the sky in a cataclysmic rage of color. Although it is possible to interpret the painting at face value, as a captivating picture of a burning house, it can also be thought of

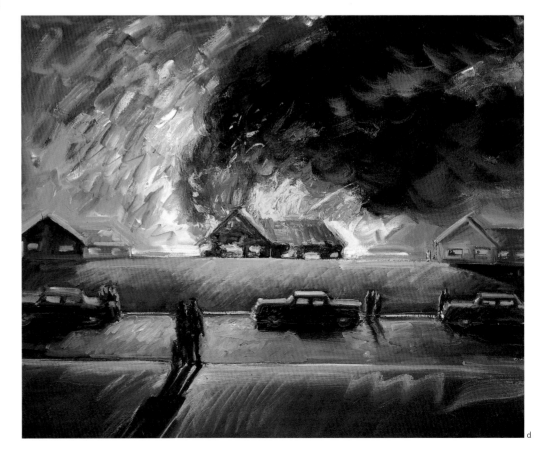

d

a
Todd Gray
Goofy (Body) #6, 1993, hand-
varnished gelatin-silver print,
installed with metal bands

b
Enrique Chagoya
When Paradise Arrived, 1988,
charcoal and pastel on paper

c
Tseng Kwong Chi
Disneyland, California, 1979,
gelatin-silver print

248

a

metaphorically, as the destruction of the (white)
American Dream by forces beyond control.
Almaraz's painting does not represent a changed
neighborhood so much as the vulnerability of a
treasured cultural icon.

In California's climate of social and
cultural contentiousness, even Disneyland and
Disney cartoon characters, once emblems of
innocence, could take on sinister new overtones.
In *Goofy (Body) #6*, a black-and-white photo-
graphic manipulation by Todd Gray, Disney's
lovable hound is transformed into a looming
human-size phantom, immediately familiar but
eerily estranged. In a comparably large drawing,
Enrique Chagoya depicts a young Latina about
to be flicked off the face of the earth (or at least
out of the picture plane) by a giant gloved hand
instantly recognizable as that of Mickey Mouse.
The wry title, *When Paradise Arrived*, alludes to
the imperiousness of corporate American culture
and its alleged disregard for minorities and
indigenous peoples.

For that matter, indigenous cultures have
not eluded ironic role reversals either. Native
American tribes, for example, have established
Las Vegas–style gambling casinos on reservations,
land set aside for the preservation of tribal cul-
tures. As essayist Richard Rodriguez has noted,
"The part of me that I will always name Western
first thrilled at the West in VistaVision at the
Alhambra Theater in Sacramento, in those last
years before the Alhambra was torn down for a
Safeway. In the KOOL summer dark, I took the
cowboy's side. The odds have shifted. All over the
West today Indians have opened casinos where
the white man might test the odds."[11] While
Indian gaming provides considerable revenue for
reservations and arguably may result in tribal
self-sufficiency and cultural stability, modern
casinos are surely not authentic to traditional
tribal cultures or identity. If the example of

b

249

California's indigenous tribes adopting the style
of Las Vegas is any indication, it appears that the
proud celebrations of racial, ethnic, and cultural
identity that once so deeply motivated a spectrum
of countercultural revolutionary ideals in the
1960s and 1970s no longer inspire such unalloyed
identification with the happenstance of race,
ancestry, place of origin, or received traditions.

Following the empowerment struggles of
the 1960s and 1970s, a wholesale reexamination
of the determinants of individual identity—an
array of issues often called "identity politics"—
became a compelling topic of national discussion
in cultural and political life in the United States
in the 1980s and 1990s. In its early phases at
least, much of this discourse was scripted within
the University of California system. Countless
young Americans were asking what it meant to
be a woman, a Latino, an African American, a
Native American, a Jew, a homosexual. The explo-
rations that emerged are hardly unique to art in
California, but once again, the state's artists were
in the forefront of defining the issues and chart-
ing the trajectory of a national and international
direction in visual art.

c

a
David Levinthal
Untitled #3, from the Barbie
series, 1997–98, dye-diffusion
transfer (Polaroid) print

b
John Humble
*Selma Avenue at Vine Street,
Hollywood, January 23, 1991,*
1991, printed 1995,
chromogenic development
print

c
**Tim Hawkinson and
Issey Miyake**
Jumpsuit, from Pleats Please
Guest Artist Series No. 3,
1998, polyester

d
Playboy magazine, June 1998,
Baywatch special issue

e
Robert Williams
California Girl, 1985, acrylic
on imitation brick

250

Identity starts with the body: Nothing could be more universal or personal. Any discussion of the determinants of self-identity must necessarily address the body, and a correlative of identity politics was the emergence of corporeality as a central issue in the arts in the 1980s and 1990s. In addition to the philosophical basis of that inquiry, the AIDS crisis (which disproportionately affected the art world) came to the fore in the 1980s and further fostered the frank investigation of the body as subject.

California was fertile territory for the theme of the body in the visual arts. Hollywood and the fashion industry had long promulgated popular ideals of the human form, particularly the female physique, as a matter of worldwide commerce. Body type is equivalent to currency in

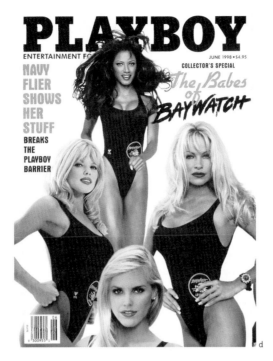

d

251

c

e

these industries, and certain parts of Los Angeles—
Hollywood, the Sunset Strip, West Hollywood—
are wallpapered with fashion billboards showing
scantily clad youthful models. The situation is
so extreme that it is nearly self-parodying.
While not fashion advertisements, a series of
billboards featuring the curvaceous Angelyne, a
"professional celebrity" who hires herself out to
attend swank Tinseltown parties, was ubiquitous
throughout Los Angeles in the 1980s and 1990s.
One of these ads appears in John Humble's
photograph *Selma Avenue at Vine Street,
Hollywood, January 23, 1991.* Angelyne is not a
performer, rather she is a "presence," which
she advertises by cruising the Sunset Strip in a
pink Corvette and by renting billboards bearing
her voluptuous image. Like Mae West in the
1930s, sexpot Angelyne is virtually a female
impersonator and functions as a sort of inverted
cultural icon.

The conventionally idealized California
body—healthy, suntanned, and gorgeous—had
long been a worldwide export through Hollywood
films and television and may have attained its
apotheosis in the television series *Baywatch.*
Beginning in 1989, *Baywatch* related the heroic
exploits and romantic escapades of a squad of
lifeguards on the beach in Southern California
(transplanted ten years later to Hawaii). It is
widely acknowledged that the show appealed
less for its formulaic story lines than for the
bevy of almost perfectly formed, mostly Anglo,

California girls and guys who appeared in highly
revealing beachwear cavorting through their
weekly adventures. But at the same time that
Baywatch prevailed as the most popular television
series ever (with 1 billion viewers and distribu-
tion in 140 countries), many artists in California
(and around the world) were dealing with more
normal bodies—bodies that didn't conform to
the California ideal: Bodies that are, for example,
differently colored or proportioned; that might
be "imperfect" or abnormal to begin with; that
are subject to psychological insult and physical
injury; that grow old; that become diseased;
that die.

Laura Aguilar's *Nature #7 Self-Portrait*
shows the artist from the back sitting nude on
the desert floor. Her rounded, hulking form is
visually echoed in the shape of the rocks that
surround her. One of the few artists of the period
to assert an identity in tune with nature, she
presents herself as a kind of timeless earth
mother. Aguilar intended this work as an homage

a	b	c	d	e	f
Laura Aguilar	**Robin Lasser and**	**Enrique Martínez Celaya**	**Catherine Opie**	**Georganne Deen**	**Liz Young**
Nature #7 Self-Portrait, 1996,	**Kathryn Silva**	*Map*, 1998, oil on fabric over	*Self-Portrait*, 1993,	*Mary's Lane: Family Room*,	*The Birth/Death Chair with*
gelatin-silver print	*Extra Lean*, 1998, iris print	canvas	chromogenic development	1993, oil on linen	*Rawhide Shoes, Bones, and*
			(Ektacolor) print		*Organs*, 1993, chair, rawhide
					shoes, and cast iron, bronze,
					and lead

252

a

b

to Northern California portrait photographer Judy Dater, whose sitters express a diversity of sexual orientations and lifestyles. Catherine Opie likewise explores the body and aspects of sexual identity. To create her arresting and wrenching photograph *Self-Portrait*, Opie had a friend carve an image into her (Opie's) back with a scalpel. The resulting picture (which resembles a child's drawing, except that the medium is blood seeping from Opie's cut skin) depicts two girls standing in front of a house. The photograph of this act of scarification documents a physical injury and evokes a deep psychological pain. Opie, a lesbian who was practicing sadomasochism during the time the photograph was made, recently commented that making the work was partly a private gesture of reconciliation with herself and partly a public gesture toward social acceptance.[12]

The body is a frequently recurring theme in the work of performance artist and sculptor Liz Young. In *The Birth/Death Chair with Rawhide Shoes, Bones, and Organs*, Young's chair looks like a traditional birthing chair, yet its straps and braces also suggest an instrument of confinement in which one might be tortured, or worse. On the floor near the chair are metal castings shaped like kidneys, lungs, spleen, liver, and heart, an ensemble of human viscera linked along a spine of heavy chain. A pair of rough leather shoes at the foot of the chair evokes the presence of an invisible sitter. It is not necessary to know a central fact of the artist's life—that she has been wheelchair-bound since the age of eighteen, when she was paralyzed from the waist down in an automobile accident—to perceive the suggestion of a body constrained by circumstance and fate.

253

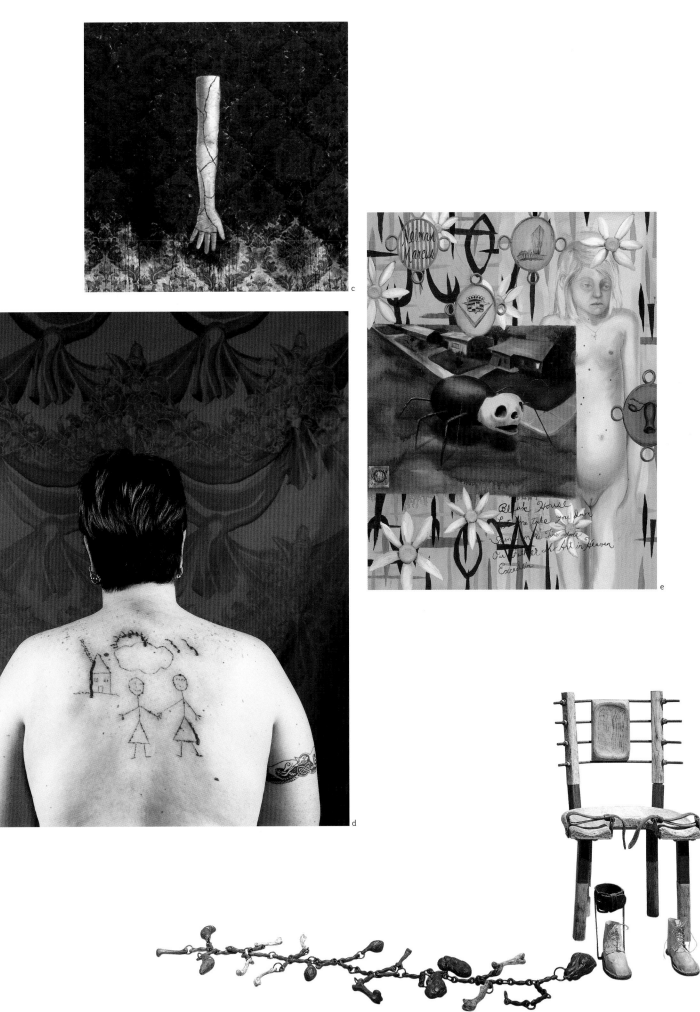

c

d

e

f

a
Rachel Lachowicz
Sarah #3, 1994, lipstick and wax

b
Alexis Smith
Madame X, 1982, mixed-media collage

c
Liza Lou
Super Sister, 1999, polyester resin and glass beads

d
Gaza Bowen
The American Dream, 1990, neoprene, sponge, clothespins, found objects, plywood, pressboard, and kidskin

e
Amalia Mesa-Bains
Venus Envy: Chapter One (or The First Holy Communion Moments before the End), 1993, vanity table, chair, mirror, and mixed media

f
Erika Rothenberg
America's Joyous Future, 1990, Plexiglas and aluminum display case with plastic letters

254

a

b

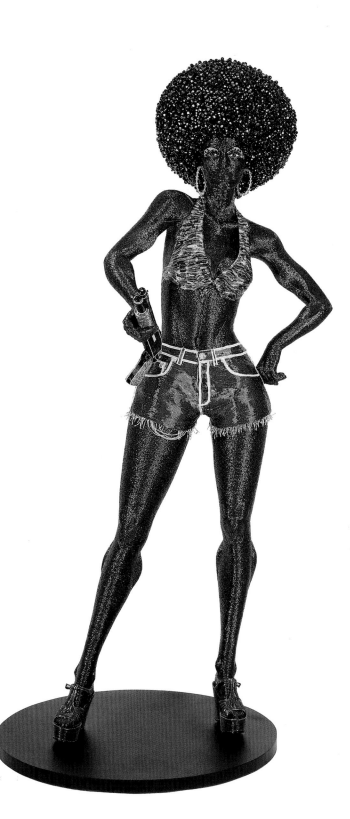

c

255

d

EVENINGS AT 7
IN THE PARISH HALL

MON ALCOHOLICS
ANONYMOUS

TUE ABUSED SPOUSES

WED EATING
DISORDERS

THU SAY NO TO
DRUGS

FRI TEEN SUICIDE
WATCH

SAT SOUP KITCHEN

SUNDAY SERMON
8 A.M.

"AMERICA'S JOYOUS
FUTURE"

f

e

256

a

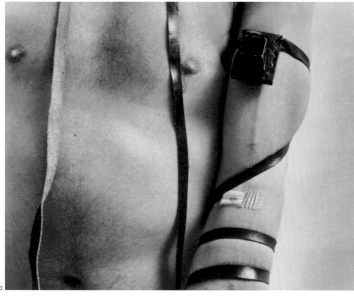

b

Closely related to art dealing with the body is art dealing with AIDS. Lari Pittman is one of the foremost American painters to explore issues relating to a gay lifestyle and sexual identity. His *Spiritual and Needy* is from a series that reflects his discontent with gay promiscuity, with straight responses to the AIDS crisis, and with what he views as a general profligacy and excessiveness in aspects of American life. The dominant image is an outrageously and exquisitely decorative rendering of an inflamed anus awaiting lubrication from a pitcher of oil. The dominant motif is fever: a thermometer glows ruby red; a fire roars in a fireplace; flames and heat radiate everywhere. The work is suffused with too much passion, too much anger, too much need, too much of "too much." For his part, Masami Teraoka brought some levity to his commentary on the AIDS crisis in *Geisha and AIDS Nightmare*, but his cross-cultural art (combining contemporary content with traditional Japanese style) serves as a reminder that AIDS is not restricted to persons of one particular sexual orientation, race, or nationality—a lesson well learned by California and the nation when Los Angeles Lakers basketball hero Earvin "Magic"

c

a
Masami Teraoka
Geisha and AIDS Nightmare, 1990, watercolor on paper

b
Albert J. Winn
Akedah, 1995, gelatin-silver print

c
AIDS awareness march, San Francisco, 1987

d
Lari Pittman
Spiritual and Needy, 1991–92, acrylic and enamel on wood panel

e
John Sonsini
Mad Dog "Andreas" Maines, 1995, oil on canvas

f
Mike Kelley
Frankenstein, 1989, found stuffed animals and basket

257

e

f

d

Johnson announced that he was infected with the HIV virus.

Mortality as the final consequence of being born and living a lifetime in one's body is an idea that pervades the work of Mike Kelley. His *Frankenstein*, an assemblage made of thrift store plush toys, expresses the artist's occasional preoccupation with corporeality as well as an attitude (true to his Catholic background) implicit in much of his work from the period that humans are born imperfect, as if fallen from an ideal. For Kelley, the body is the basis of identity. Like Frankenstein's creation, all humans are botched from the outset, at once laughable and pitiable, even monstrous.

a
Robert Arneson
California Artist, 1982,
stoneware, glazed

b
Viola Frey
He Man, 1983, ceramic, glazed

258

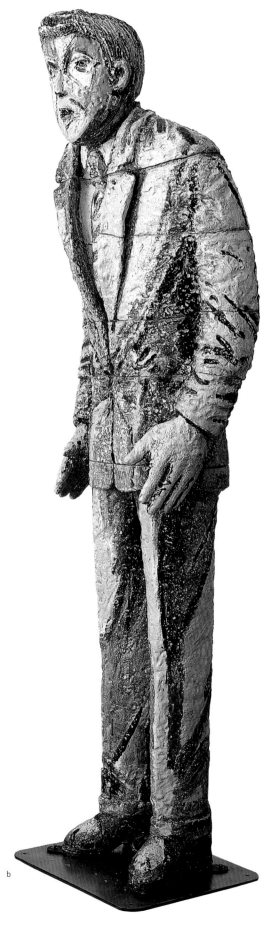

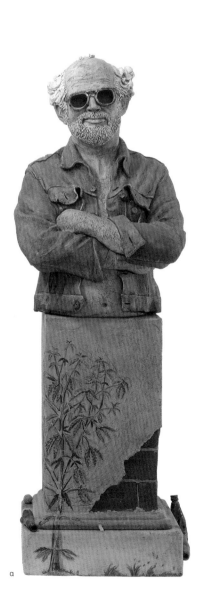

Issues of identity, then, are indivisible
from the body, a circumstance that readily fosters
stereotyping. The word *stereotype* is defined as
"a simplified and standardized conception or
image invested with special meaning and held in
common by members of a group."[13] The concept
is clear, but the notion of "special meaning" is
fraught with ambiguity. To whom is the meaning
special? To the observer or to the observed?
Who is defining whose identity and through
what insight? That gray zone has been the locus
of numerous artistic explorations—some playful,
others full of misgiving—into identity issues in
California.

A prevalent stereotype in American
culture is the fearless and stalwart masculine
breadwinner, a notion that suffered a serious
blow in the wake of feminism. Robert Arneson,
a pioneer in Pop art ceramics, lampooned his
own cultivated persona as a scampy Bay Area
bohemian, a counterculture carryover, in
California Artist. The sculpture is a life-size
self-portrait in which the figure's hairy potbelly
protrudes from his denim jacket and inelegantly
rests on a crumbling pedestal. At the base a beer
bottle and a marijuana plant attest to an "arty"
lifestyle, while holes in the eyeglasses satirically
hint at the artist's airheadedness. Viola Frey,
another ceramist with Pop art affinities, looked
to the other end of the social scale in her corpo-
rate suit-and-tie businessman, the nine-foot-tall
He Man, a cartoonish giant to be scoffed at.
More anxious and less parodic is Jonathan
Borofsky's *Flying Man with Briefcase, at No.
2816932,* in which a silhouetted figure—another
anonymous urban type in standardized business
attire—floats as if he were the disembodied or
estranged ghost of a "real" self.

a

b

c
Charles Ray
Male Mannequin, 1990,
fiberglass mannequin

d
Jonathan Borofsky
*Flying Man with Briefcase,
at No. 2816932*, 1983–86,
multiple sculpture, painted
Gatorfoam

e
Christina Y. Smith
The Commitment, 1997,
sterling silver

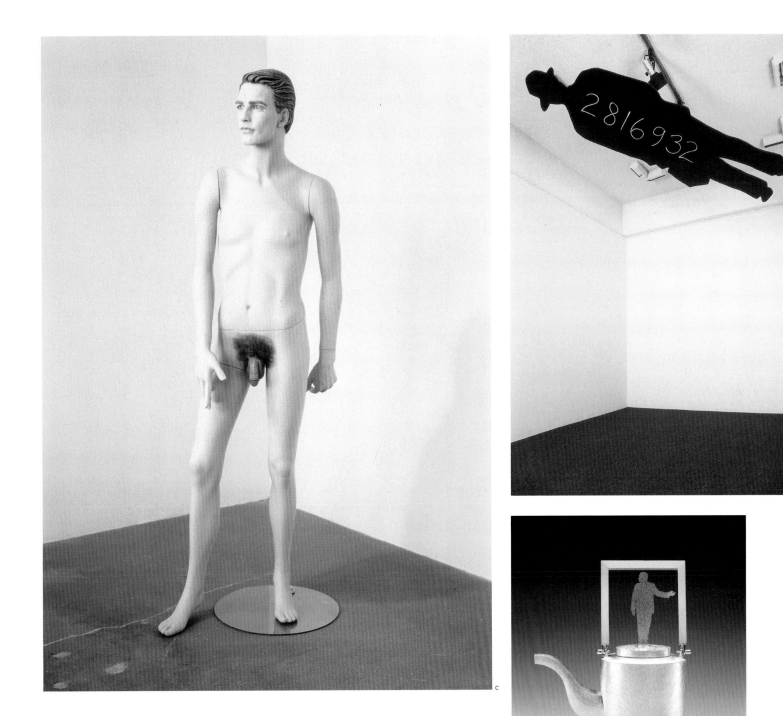

a

Candace Kling

Enchanted Forest, 1989,
buckram, Varaform, cording,
Polyfil, satin, braze rods,
and epoxy

b

Ina Kozel

*Our Lady of Rather Deep
Waters*, 1985, urethane foam
and hand-painted silk

c

Ana Lisa Hedstrom

Video Weave Kimono, 1982,
silk crepe de chine, resist
dyed

260

a

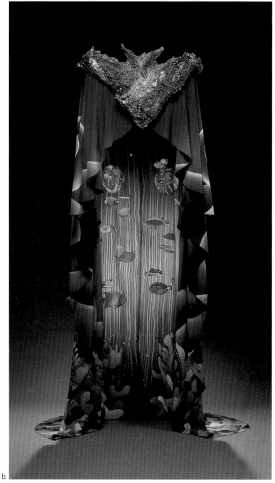

b

Not all of the interest in identity, types,
and cultural idioms was satiric or ironic; indeed,
some artists dynamically engaged the artistic
traditions and symbols of cultures outside their
own in a quest for new sources of inspiration.
Along with the emergence of the counterculture
in the 1960s, there came a revival—which
persists in American culture—of the handcraft
tradition. Led largely by middle-class, college-
educated whites, the revival initially stressed
traditional forms, back-to-basics techniques, and
natural materials. In the 1980s and 1990s, how-
ever, as ethnic assertions became more integral in
American social life, a sizable constituency of the
American craft movement integrated the styles,
techniques, and motifs of many different cultures
into their work. Ana Lisa Hedstrom's *Video
Weave Kimono* combines timeless Japanese
hand dyeing with a postindustrial sensibility,
while Jean Williams Cacicedo's *Tee Pee: An Indian*

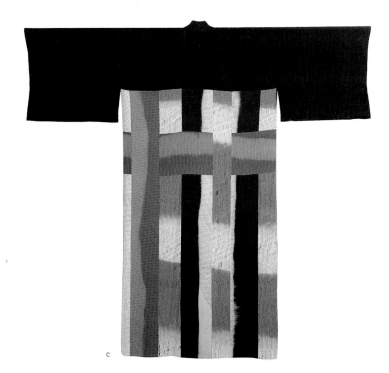

c

d
K. Lee Manuel
Maat's Wing #3, 1994, painted
feathers

e
Jean Williams Cacicedo
Tee Pee: An Indian Dedication,
1988, wool, felted, hand dyed,
reverse appliquéd

f
Janet Lipkin
Santa Fe Cape #2, 1987, wool
knit, hand dyed

261

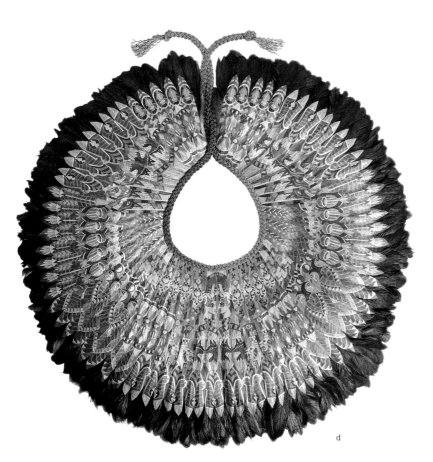

d

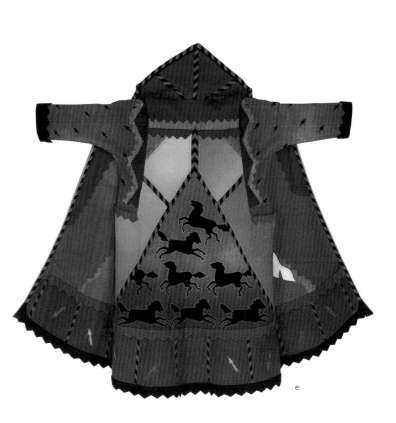

e

Dedication includes references to early Native American life. These are examples of artists of one culture adopting and reinterpreting the markers of other cultures with respectful appreciation. Similar tendencies are apparent in the use of ancient Egyptian motifs in K. Lee Manuel's *Maat's Wing #3*, and in the confluence of imagery of the American Southwest with geometrical designs evocative of African textiles in Janet Lipkin's *Santa Fe Cape #2*. Such open-armed receptivity to various visual vocabularies was relatively free of ironic positioning, and it enriched and complicated the handcraft revival on the West Coast with pronounced international influences.

Respectful adaptations notwithstanding, concepts and the markers of identity became prickly issues. As the image of California—and especially Southern California—continued to shift from that of a bastion of white middle-class citizenry to a contested and culturally diverse society,

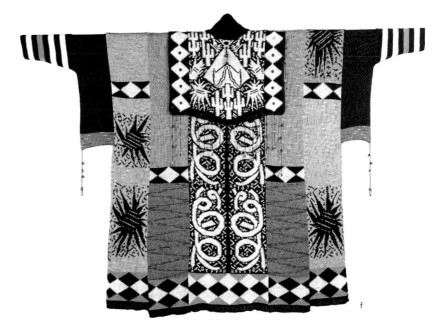

f

a
Bruce and Norman Yonemoto
Golden, 1993, gold leaf on
projection screen

b
Travis Somerville
Untitled (Dixie), 1998, oil and
collage on ledger paper

c
Rubén Ortiz-Torres
*California Taco, Santa
Barbara, California*, 1995,
silver dye-bleach
(Cibachrome) print

d
Guillermo Gómez-Peña
Border Brujo, 1990,
photo documentation of
performance
•

e
Einar and Jamex de la Torre
Marte y Venus, 1997, glass
and mixed media

262

the act of asserting and advocating gender, race, ethnicity, or national origin as the fundamental basis of identity began to seem uncomfortably close to advocating (gender, racial, ethnic, or national) stereotyping itself. Many younger artists came to understand American society and their identity within it as more complex and hybrid than an essentialist interpretation could sustain.

Bruce and Norman Yonemoto, video artists and filmmakers from Los Angeles, have long explored their Japanese and American backgrounds in works such as their mock soap operas and gay pornographic films. *Golden* consists of a portable film projection screen, like the kind used in grade school classrooms. The Yonemotos have covered their screen in gold leaf, punning verbally on the Hollywood "silver screen" of their American upbringing and visually on the gilded screens of their Asian heritage.

Born in Mexico, Los Angeles artist Rubén Ortiz-Torres is similarly interested in his dual

a

b

263

c

d

e

background and, more generally, in the cultural ambiguities of life in Southern California. His photograph *California Taco, Santa Barbara, California*, documents the incongruity of a blond girl in traditional Mexican dress riding in a parade float shaped like a giant taco. Although the float may be thought of by an outsider as an innocuous icon, using a taco to represent Mexican culture is akin to representing African American culture with a watermelon, and smacks of insensitive stereotyping. Rather than assailing the stereotype, however, the photograph reveals the artist's ironic bemusement.

Ortiz-Torres's *Alien Toy* (1997) similarly focuses on a stereotype of Chicano culture—the lowrider. This plaything for "aliens," a life-size car painted in typical lowrider fashion, mimics the classic hydraulic lifts and spins of tricked-out lowriders but with highly exaggerated results. The custom-made contraption bounces, gyrates, and whirls around, flinging itself into pieces that must be put back together to perform its wildly comic dance anew. The absurdity of this piece implies that taking the "special meaning" of any stereotype too seriously, or of treating a cultural icon too sanctimoniously, is itself absurd.

a
Alison Saar
Topsy Turvy, 1999, wood, tar,
plaster, fabric, and ceiling tin

b
Mildred Howard
Black Don't Crack, 1997,
mixed-media assemblage

264

a

b

Alison Saar is of mixed African, Irish, and Native American heritage but is often "classified" as African American. Her enigmatic *Topsy Turvy* incorporates, among other elements, a life-size effigy of a pickaninny. The title suggests that the figure may represent the character Topsy from Harriet Beecher Stowe's abolitionist novel, *Uncle Tom's Cabin* (1852). The child hangs upside down above the viewer, her feet nailed into the ceiling and her dress hanging down over her torso. The tableau evokes an act of violence, something like a lynching, in which Saar's pickaninny is suspended in a kind of limbo, displaced and alien, as are all stereotyped individuals.

In another startling displacement based on stereotyping, James Luna, a Native American of the Luiseño/Diegueño people, presented *The Artifact Piece* (1987). The project appeared within an anthropological exhibit of American Indian culture at San Diego's Museum of Man. After viewing dioramas, which "miniaturize good Indians, going about their benign ways, as seen through the museum haze that forgets colonial disruption and destruction,"[14] visitors happened upon Luna, supine on a display table with only his loins covered. The impact of the piece derived from viewers' sudden, shocked realization that they were staring at a live human being. Luna's presentation of himself as if he were an object ironically recalls the Painted Desert exhibit at the 1915 Panama-California Exposition (also held in San Diego), in which Native Americans were put on display going about "typical" domestic chores in "typical" domestic settings. Luna's performance demonstrates that Native Americans, as well as other ethnic groups, are similarly depersonalized and objectified in contemporary California.

Perhaps nowhere else in the United States have the issues of race, ethnicity, and national origin and identity come together more potently

c
**David Avalos and
Deborah Small**
Mis•ce•ge•NATION, 1991,
mixed-media installation

d
James Luna
The Artifact Piece, 1987,
documentation of
performance

e
Linda Nishio
*Kikoemasu ka? (Can You Hear
Me?)*, 1980, twelve gelatin-
silver prints

265

than in the matter of immigration in California in the 1980s and 1990s. California was not alone in receiving an influx of foreigners during this period: Houston, Miami, Chicago, and New York were also magnets for various groups from regions around the world. Yet California was perceived nationally as ground zero, the locus of a profound demographic shift in the national makeup (in much the same way that New York City was viewed in the late nineteenth and early twentieth centuries, when it was the site of massive waves of immigration from Ireland, Germany, Italy, eastern Europe, and Russia).

California, and especially Los Angeles, became the golden gate of entry for huge numbers of Koreans, Taiwanese, Japanese, Vietnamese, Cambodians, Laotians, Burmese, and Filipinos, all of whom now represent major population groups in Southern California. The region also became a gathering point for many

c

d

KI-KO-E-MA-SU KA?

e

a
Peter Goin
Impenetrable Border, 1987,
gelatin-silver print

b
Insurgent Squeegee
*Stop the Fence—Open the
Border*, 1979, screenprint
poster by Lincoln Cushing in
collaboration with Groundwork
Books, San Diego
•

c
Malaquías Montoya
¡Sí Se Puede!, 1988–89,
screenprint

d
Armando Rascón
*Border Metamorphosis:
The Binational Mural Project*,
c. 1998, documentation of
art project

266

(post-revolution) Iranian emigrés, as well as Israelis, Russians, Armenians, and Africans of many nationalities. California represented a land of opportunity for people from every region of Central America. But it was undocumented Mexicans who generated the most notice and notoriety, engendering impassioned responses in the United States and in Mexico. The border with Mexico is one of the most salient aspects of life in Southern California, and the issues that emanate from it encompass the relation of people to the California landscape and a whole gamut of questions concerning identity in a cosmopolitan society. The border has also become a quintessential element in the national perception of California, especially with regard to what the state's experience portends for the nation.

With respect to modern California's relationship to the historical region, Richard Rodriguez recounts that as a boy he had read Richard Henry Dana's *Two Years before the Mast* (1840) and was struck by the romanticism of the book:

Twenty-five years ago [in the early 1970s] in L.A., one could sense anxiety over some coming "change" of history. Rereading Dana, I am struck by the obvious. Dana saw California as an extension of Latin America. Santa Barbara, Monterey, San Francisco—these were Mexican ports of call. Dana would not be surprised, I think, to find Los Angeles today a Third World capital teeming with Aztecs and Mayans. He would not be surprised to see that California has become what it already was in the 1830s.[15]

Maybe Dana would not have been surprised, but many modern Californians were, and they feared the economic impact of newly arrived Mexicans on the job market, housing, schools, public health services—in every conceivable aspect of civic life. Many Californians fought

a

the immigration. In November 1989 a quasi-vigilante group calling itself Light Up the Border began a series of monthly demonstrations at a site in San Diego County that was well known as a porous entry zone for undocumented Mexicans and Central Americans. The demonstrators, congregating at dusk in their cars and vans, trained their headlights along the international boundary, illuminating groups of Latin Americans waiting for dark to cross illegally into the United States. The loose coalition demanded that U.S. authorities increase surveillance and control of the border. By the spring of 1990 the monthly border lightings were drawing hundreds of demonstrators.

PARE LA CERCA
STOP THE FENCE

ABRE LA FRONTERA
OPEN THE BORDER

b

267

countless artists who used it to express their refusal to accept the moral legitimacy of the regime that built it, Rascón and numerous collaborators in the United States and Mexico painted elaborate abstract murals with Olmec-inspired designs on both sides of a 2.5 mile stretch of metal wall separating the towns of Calexico (in the United States) and Mexicali (in Mexico). It is an attempt to reclaim and transcend the wall by transforming it into a work of art.

The Chicano art movement began in the 1960s as an attempt by people of Mexican heritage living in the United States to recover and reassert their historical roots in a Mexican culture that extends back to the era before the Spanish Conquest. In the rethinking of identity issues during the 1980s and 1990s, aspects of that aspiration came to be perceived by some as ironic and, in

c

The campaign also swiftly galvanized those who repudiated a demonstration that they could view only as anti-immigration and racist. Chanting "¡No más racismo!" (No more racism!), the counterdemonstrators held up mirrors and other reflective materials, turning the harsh glare of the headlights back into the eyes and hearts of the campaign sponsors. For one of the monthly events, counterdemonstrators rented an airplane trailing a banner that read, "One Thousand Points of Fear ... A New Berlin Wall." This message was a sharply ironic reference to statements by then-president George Bush that had called for "a kinder, gentler America" symbolized by "a thousand points of light" and "a new world order" heralded by the tearing down of the Berlin Wall.[16]

The United States built its own wall in California along the border with Mexico, and an artistic response to it was organized by Armando Rascón. Begun in 1998, *Border Metamorphosis: The Binational Mural Project* is still a work in progress as of this writing. In an action that recalls the appropriation of the Berlin Wall by

d

a, b

David Avalos, Louis Hock, and Elizabeth Sisco
Arte Reembolso/Art Rebate, 1993, documentation of event

c

Anti–Proposition 187 political cartoon by Lalo Alcaraz, 1994

d

Ricardo Duffy
The New Order, 1996, screenprint

e

Jason Rhoades and Jorge Pardo
#1 NAFTA Bench, 1996, marble, plywood, plastic buckets and lids, fabric pillow, vinyl-covered cushion, PVC plastic pipes, clamps, and battery-operated vibrator

268

effect, as promulgating a sort of colony of cultural exiles. Today, activity in the Chicano movement has become more cosmopolitan and more oriented toward a future free of borders and exiles. As cultural historian José David Saldívar maintains in his study of the cultural, political, and social implications of what he calls "border matters":

Cultural forms can no longer be exclusively located within the border-patrolled boundaries of the nation-state. Chicano/a America therefore defines itself as a central part of an extended frontera. Its cultures are revitalized through a "re-Hispanicization" of migratory populations from Mexico and Central America . . . [The] cultures and politics, Central and North American, of the extended borderlands have become the very material for hybrid imaginative processes that are redefining what it means to be a Chicano/a and U.S. Latino/a.[17]

Historically, the assimilation of diverse newcomers has been the American Way, and it has led to an accommodation of hybridized concepts of cultural, ethnic, and national identity. Yet Mexican nationals—especially undocumented ones—are patently and routinely regarded by many U.S. citizens as "alien" and Other. During the mid-1980s and well into the 1990s throughout California, private citizens and coalitions called for an end to the use of public funds to pay for the essential services—medical care, welfare, education—associated with absorbing the immigration of "illegals." To dramatize the plight of impoverished immigrants (and also to encourage national debate over the likewise culturally charged issue of government support for the arts), San Diego artists David Avalos, Louis Hock, and Elizabeth Sisco organized a project in 1993 titled *Arte Reembolso/Art Rebate*. The artists converted a grant of $5,000 received

a

from the National Endowment for the Arts into $10 bills, then distributed the money to day laborers and migrant workers, who were free to spend it, thus circulating the money back into the community. The artists' action was intended to stir up controversy, and it succeeded.

The adversarial climate continued to heat up with respect to border issues, culminating in the passage of Proposition 187 in 1994. Proposition 187, which California voters passed by a 59 percent majority, forbade the use of state and local funds for public social services for illegal aliens. The manner in which the proposition was drafted and put on the ballot raised serious questions about governance in California. Peter Schrag, writing in *Paradise Lost: California's Experience, America's Future*, persuasively contends that Californians have forsaken the principle of representative government, supplanting the legislative process with sweeping ballot initiatives, many of which have been put forth by special interest groups.[18] Schrag argues that the effect is not only the enactment of measures that

b

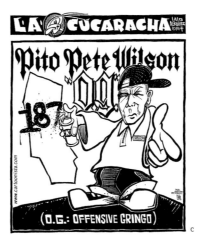

c

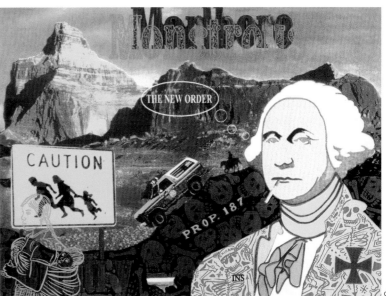

d

may have disastrous side effects but also the diminishment of—and, in the long run, the erosion of faith in—democratic institutions. In California, he concludes, we behold the corrosion of American democratic principles; and, what is worse, California's experience may foreshadow America's future.

A federal court found most of Proposition 187 unconstitutional shortly after it was passed, and a final ruling in 1999 effectively killed it. The fact that it had been a voter initiative to begin with, however, indicates that political, social, and artistic border matters, which signify the interpenetration of cultures across impediments and boundaries of all kinds, thrive in California, probably more than anywhere else in the United States. Such border matters also

e

a, b
Languages and cultures
intermixing on the streets of
Los Angeles

c
Robbert Flick
Pico B, 1998–99, silver
dye-bleach (Cibachrome)
print

270

a

b

have begun to define the world's future. In an age of instantaneous international communication, when television, cellular telephones, fax machines, and the Internet have made possible the global dissemination of information of every sort (at least to those who have access to such means, which is a considerable qualifier), the efficacy of geographical borders and physical boundaries has diminished.

Increasingly, cultures may indeed be defined less by race, ethnicity, and national borders than by voluntary participation in a field of more or less fixed values and experiences. California functions today as a vast webwork of discordant but relatively peaceable diverse populations living together, more or less, in the same indefinable space, perpetuating what they wish and adapting as they will. Almost every culture and every individual in California today has been imported from somewhere else. The civilization of California, now and in the future, is a clamorous gathering of peoples in diaspora.

For all its problems, the chaotic multiculturality of California stands against a global backdrop that includes such banes as a belligerent fundamentalism that besets various religious factions in the Middle East; xenophobia and nationalism astir in pockets of Western Europe; tribal warfare that recurrently combusts in several African nations; the malignancy of ethnic cleansing and genocide in Eastern Europe; and race- and class-based culture wars that are never won or otherwise resolved here in the United States. California—especially the inchoate megalopolis of Southern California, with its ever-mutating mosaic of territories and neighborhoods and its polyglot cultural matrix—may be, for better or for worse, a model of the world to come.

California remains one of the most imagined places in the American psyche. Although situated on the western edge of the national

map, California is central to the mythology of America. Its history over the past century, embodied in the legacy of its arts, narrates a psychodrama of national dreams and nightmares. The Golden State is no longer the epitome of the regional and parochial fantasy that it once seemed. Earlier envisioned as a Garden of Eden, California has been portrayed more recently in both popular and critical forums as a Tower of Babel. As life in California—increasingly presumed to mirror the nation's character and to presage the world's destiny—continues to evolve in its fitful and unfathomable manner, its extraordinary accommodation of all that is new and beyond traditional cultures may prove to be its greatest strength. And the arts will doubtless continue to offer keen insights into the significance of "real" and imagined California.

The timeline was based on information compiled by Sarah Schrank.

c

1 Richard Lacayo, "Unhealed Wounds," *Time*, April 19, 1993, 28.

2 Mike Davis, *Ecology of Fear: Los Angeles and the Imagination of Disaster* (New York: Metropolitan Books, Henry Holt and Company, 1998), 277.

3 Ibid.

4 Ibid.

5 Ibid., 281–82.

6 See Frances Anderton, "Selling Ethnic L.A.," *The Big Issue*, no. 5, 1998, 6–8.

7 Susan A. Phillips, *Wallbangin': Graffiti and Gangs in L.A.* (Chicago: University of Chicago Press, 1999), 15, 74.

8 Evelyn Larrubia, "'Homies' Toys Anger Anti-Gang Forces," *Los Angeles Times*, May 24, 1999, A-1, A-19.

9 Ibid., A-19.

10 As far back as the 1950s there has been a literary and artistic tradition of holding up the WASP American suburb as typically dysfunctional and dystopic. Novels such as John Cheever's *The Wapshot Chronicle* (1957), plays such as Edward Albee's *Who's Afraid of Virginia Woolf* (1962), and films like Mike Nichols's *The Graduate* (1967) all satirized white middle-class America and its values, stereotypically defined in popular culture by television series like *Ozzie and Harriet* and *The Dick Van Dyke Show*.

11 Richard Rodriguez, "True West: Relocating the Horizon of the American Frontier," *Harper's*, September 1996, 41.

12 In conversation with the author, May 4, 1999.

13 *The Random House Unabridged Dictionary*, 2nd ed.

14 Andrea Liss, "The Art of James Luna: Postmodernism with Pathos," in *James Luna: Actions and Reactions: An Eleven-Year Survey of Installation/Performance Work, 1981–1992* (Santa Cruz: Mary Porter Sesnon Art Gallery, University of California, Santa Cruz, 1992), 9.

15 Rodriguez, "True West," 43.

16 Patrick McDonnell, "Counter-Protesters Greet 'Light Up the Border' Group," *Los Angeles Times* (San Diego ed.), April 28, 1990, B8.

17 José David Saldívar, *Border Matters: Remapping American Cultural Studies* (Berkeley and Los Angeles: University of California Press, 1997), 128–29.

18 Other nationally noted California ballot initiatives, in addition to Proposition 187, include Proposition 13 (1978), which severely limited property taxes that paid for public education, and Proposition 209 (1996), which outlawed affirmative action programs in the public sector. See Peter Schrag, *Paradise Lost: California's Experience, America's Future* (New York: New Press, 1998).

WHERE THE POPPIES GROW

Richard Rodriguez

The world met itself in California. Karl Marx, that cast-iron oracle of the nineteenth century, saw the California Gold Rush as an event unprecedented in history. In 1849, Chilean and Scot and Chinese and Aussie and Mexican and Yankee—people of every age and tongue and disused occupation—waded knee-deep through the mud of Amador County.

All my life I have lived within the irony created by the many Californians. Though, finally, there are only two: I mean those who came here from elsewhere and the native born.

The first California natives, a laid-back tribe, watched the approach, in the distance, of Junípero Serra—"the father of California"—paternity thus stalking them with a limping gait. I am so thoroughly Californian as to imagine the genesis cinematically; the camera shuttling back and forth between distance and foreground—rather, between foreground and foreground (two cameras, that's the point)—obliterating distance, bisecting narrative, eventually making one of twain.

My own domestic comedy reflected that first splice: My parents from Mexico; their children born at the destination. My Mexican parents' ambition was California. Mine was to join the greater world.

I didn't get far. I live today in a San Francisco Victorian subdivided by memory. Upstairs, Arizona. Across the hall, Tennessee. Downstairs, Alabama—the sweetest landlord in the world, Alabama. My neighbors seem at home in this city; it is theirs. I am the uneasy tenant, for I was born at St. Joseph's Hospital, less than a mile from where I write these words. St. Joseph's Hospital no longer exists.

A common, early theme of America was the theme of leaving home; almost an imperative for writers and other misfits. The subordinate theme was the impossibility of return—*you can't go home again*. I always read the theme primarily as East Coastal or Midwestern; I construed from it the gravity of tall cities rather than the constriction of towns. There is a newer American refrain, a western refrain: *What happens when home leaves you?* I hear it now in places like Houston, where natives say they rarely meet one another because their city has filled, so quickly, with people from elsewhere. Or from Coloradans who remark that everyone they know seems to have arrived last year from California.

California's nativist chagrin is older and louder because California has, for so long, played America's America. The end of the road. Or a second shot at the future. California has served also as Asia's principal port of entry. Now, too, the busiest border crossing from Latin America.

California's native-born children—whatever our color or tongue—realize very early that California takes every impression. Our parents, on the other hand, are often surprised by how many Californias they find when they get here. Nothing at all like they expected. Nothing like the movie.

My early intuition as a native son was that California was dreamed into being elsewhere. I noticed that paradigmatic Californians weren't so by birth. Richard Diebenkorn came from Oregon. Cesar Chavez was born in Yuma. Willie Mays, Louis B. Mayer, Jack Kerouac, Richard Neutra, Lucy and Desi, Edward Teller—all of them from far away. All of them living forever in California on the same street.

Mickey Mouse was conceived aboard the Santa Fe, westward bound. Minnie was drawn from his rib, born here. As was John Steinbeck, born in Salinas; his house still stands. Steinbeck's generosity was to invent the Joad family's first view of orange groves, to believe that Oklahoma Joads were more important to the myth of California than their native-born grandchildren who live in suburban Bakersfield and complain about "the changes."

When I was a kid, the nationally advertised version of California was the GI version. Early in the forties, thousands of young men had seen California light from train windows—light receding as they shipped out toward tragedy. And in the midst of tragedy, they remembered, perhaps, some bong in the air that promised to redeem them.

After the war, the survivors returned with narrowed eyes, with the GI Bill, with FHA loans, to build a pacific ever-after. They buried the shudder of death beneath hard sentimental weight; beneath lawns, green lawns, all-electric kitchens, three bedrooms, two kids, a boy and a girl, and an orderly succession of Christmas lights, tacked up with much goddammit.

Many of these veterans were middle-aged by the time I was their newspaper boy. Many had jobs in the defense industry, because they would forbid tragedy. Each afternoon, I folded and lobbed the world onto their porches. But I was otherwise complicitous in their cover-up. I willingly played the inno-cent—the native—as did their two towheaded children, a boy and a girl, whooping through the bushes with pheasant feathers tied onto our heads.

I played another role. I played the son of the Old Country, the tragedian. For I lived in "el norte," a memory of dread, which I took from my parents' eyes. I also put on Bombay eyes—my uncle came from India. My Mexican parents and my Indian uncle saw California as a refuge from chaos, but they understood that tragedy was preeminently natural.

My California was also imagined in the Azores, the wraith of some Atlantic storm. I grew up among Portuguese, Irish. My Catholic nuns came from Ireland and brought with them—as if it were ground into the glass of the spectacles they wore—a tragic vision. This despite the luxurious light of California opening over all. Can it have been a coincidence that my first allegiance to a writer was to William Saroyan, who had grown up in Fresno, under a cloudless sky, listening to Armenian grand-mothers' tales of genocide?

Eureka! (I have found it.) California's official motto should be mistranslated: *I have brought it.* I folded California into my portmanteau and carried it over the sea, then across the Sierra. Or I invented California in my Kwangtung village, from the gaunt letters Hong-on Sam sent his long-dead wife. I sketched California on the steps of my parents' brownstone in Brooklyn, listening to my grandfather's stories of castles in Poland. What did he know from castles? We were peasants. Very few people do know castles. I'll prove it. What did I do when I got to Hollywood? I put his damn palaces into my movies and now the whole world takes my grandfather's version of how Greta Garbo should behave in a palace. All a barnyard dream.

I grew up in Sacramento, in a Prairie house decorated with Mexican statues with imprecisely painted sclera and stigmata. Outside my window were camellias, every winter, red and white globes.

Any sense I have of California is beholden to the importations of Iowa and Spain and New England and Oklahoma and the Philippines. Without the prompting of Midwestern artisans, I would never have noticed the austerity, the utility, the beauty of California Indian baskets. Without the cues of

newcomers, I would not have noticed the austerity, the beauty of California: Nancy, describing in letters from Ohio—this was years after she had left Stanford—her yearning for the scent of eucalyptus and the smell of salt; her longing for brown hills and the chemical distance of the Santa Clara Valley, an ostensible autumn haze—*L'Amertume* (a poem she wrote, she admitted, having just learned the word).

My own naive first impression of Stanford was to wonder why no one watered it. Old brown hills. For my sense of pre-California, as of pre-Californians, was one of parchment, of absence—nakedness, leisure, freedom, pacificism.

Gertrude Stein's famous skepticism concerning Oakland sounds native to me, though she wasn't. No "there" there. Why not extend that koan to the entire state? If you list California's famous exports to the world, you come up with a volley of blanks. I mean spiceless tacos, accentless newscasters, birth control pills, strip malls, tract homes, hula hoops, cyberspace, Marilyn Monroe.

And yet, as a Californian, having taken so many impressions, I feel at home any place in the world.

And yet, California has invented so much of the postmodern world that most places in the world are packing away their idiosyncrasies in order to more closely resemble California.

Louis Kahn, the Philadelphia architect, gave California one of our best modernist buildings, the Salk Institute (named for Jonas Salk, a native New Yorker). Kahn's method, before starting any construction, was to brood over the landscape in several lights, several weathers. *What does this space want to become?* One imagines the soil of Bangladesh or Fort Worth responding more forthrightly to Kahn's question than the cloudless idiot, California.

California is never more recognizable than when it supports a completely incongruous construction. A giant orange or a giant donut or a statue of John Wayne. The landscape otherwise seems without an idea of itself.

I went to a party in a house by the sea. The house, a famous California house, was imagined into being by Midwesterners. The principal architect, Charles Greene (of the brothers Greene and Greene, Ohio-born), had been commissioned by a client from Kansas City. The house successfully reconciles England with Spain, Protestantism with Catholicism, Robert Louis Stevenson with Alfred Hitchcock, the nineteenth with the twentieth century, and, what's more, Northern with Southern California. The front yard is the Pacific Ocean—sometimes undulant, the color of antifreeze; sometimes monotonous, gray.

The house was left to the son after his parents died. But then (decades later; a decade ago) the son died; the house passed to the son's children. (Here the plot shifts from Midwestern immigrant to California native.) Such a burden the house had become in recent years—too big and too drafty, too leaky, too weathered, too expensive to maintain. (The daughters knew what very few know: life in a castle.) The daughters decided to sell. They located a buyer besotted by California, a Chicago businessman. The new owner has restored the house to its pristine austerity.

So there we were on a colorless Saturday, summer fog gathering as we gathered about a wood-burning brazier in the courtyard. On trestle tables were the latest-fangled California salads. The correct Cabernets. With the other guests, I wandered through rooms that had already passed into someone else's privacy. I noticed the swift and silent appraisals of the new owner's paintings and books, some still bearing the auction-house tags.

All afternoon, I had the sense of the two Californias. On the one hand, glamorous Midwestern California. (Upon the mantels and atop the piano, the founding family's photographs and mementos had been returned for the occasion. We saw the parents' lives—they were theatricals—the beauty of their youths, their famous friendships; the books they had written, including the book for a Broadway musical about the Midwest.) On the other, the leisured puritanism of the native Californians. Jeans and faded shirts, no makeup, sun-bleached hair, sensible hors d'oeuvres.

There was something British about the afternoon—not American and certainly not Kansan. The native daughters were consigned by history the role of docents within their grandparents' house.

I am thinking now of those women, the first American generation of native-born Californians, born in the gold country. They came of age in the 1860s, naming themselves "Native Daughters of the Golden West"—California's first historical society. They organized their "parlor" in a foothill town and recruited others like themselves to the observances of memory. The sole requirement for membership in the Native Daughters was California nativity. The pioneers the sorority honored, however, were people who were born elsewhere.

What the Daughters knew, a generation after their parents' ambition had spent itself in the gold fields, was that the audacity of their parents would be forgotten as soon as the cabins and schools and churches they built fell to ruin. The Daughters preserved things in order to remember lives. But the task of preserving the past is a thankless one, even comic, in a state given to futurism—like trying to preserve a fifties moderne bowling alley. The heedless vulgarity of the bowling alley is distorted the moment it becomes (from our postmodern vantage point) worthy of preservation.

Joan Didion discloses in her 1965 essay "Notes from a Native Daughter" that she comes "from a family, or a congeries of families, that has always been in the Sacramento Valley." Californians immediately note the ironic weight of "always" in her native syntax. Though some families may still have Spanish land grants tucked away (one notices occasionally in obituaries), one need not live very long in California to qualify as "old family." Didion describes Sacramento in the late fifties (the Valley town becoming the city I came to know) as "a place in which a boom mentality and a sense of Chekhovian loss meet in uneasy suspension."

As I recall, my own Russian summer ended each year with a blast of heat, the threat of school, the smell of unbroken denim. Summer's last stand was the California State Fair on Stockton Boulevard. I loved especially the domed Victorian-style pavilion, with booths of arranged fruits and vegetables from every county and climate. Inevitably, my Victorian fair was replaced by something ugly and new across town. "Cal Expo" was built on an amusement-park model and boasted third-rate lounge acts and destruction derbies. This was the first time I remember having to come to terms with my meaning in California.

I decided it was OK for them, but I didn't go. I was an old-timer at the age of twelve.

One needle-sharp morning in 1968, I was walking up Madison Avenue, where I happened upon the funeral of John Steinbeck. I paused at the edge of the crowd of celebrities. I saw Steinbeck's casket— an expensive affair covered with boughs of evergreen—carried down the steps of St. James Episcopal. This I approved—approved the approbation of the East Coast—as a native Californian would.

Hard for anyone not born at the destination to understand my preoccupation with originals, with provenance. I grew up in California dreaming of elsewhere—as did Saroyan, as did Didion, as did Steinbeck. I wondered about those places of which California had always seemed the mirage. Jalisco. Minnesota. Bombay. And New York, especially New York—which had concocted ideas of "the Coast" as its Hegelian opposite.

At my present age, I have forsaken the study of contributing strains, original forms, for a pleasure in the hybrid itself. Indeed, I impatiently listen when native Californians, far afield, tell me they have abandoned the crowds and cost of California for a simpler grid. The native daughter, for example, (still restless, I notice) sits beside a pool in Phoenix and deplores the traffic in Los Angeles. Having departed California, where she was forever bemoaning the loss of the department stores of her youth, she becomes a tiresome seer in Arizona. Nothing does she see more clearly than the coming of California. California coming to Austin and Portland. In Boulder, she is dismayed by tract houses along the front range that remind her of Anaheim a generation ago. She can't wait to say, "I told you so."

In our parents' generation, too, there had been talk of divorce—a legal separation of North from South. All to do with water rights and political incompatibilities. The North represented agriculture, abstemiousness; a liberal coast. The South was heedless, sprawling, splashy, wasteful; a conservative coast. In the fifties, I remember, too, an ethical resentment. The Central Valley resented the playful urbanity of the coast.

The boldness of the fifties, however, was that Californians came up with ideas of the state larger than their differences. By mid-century, when California became the most populous state in the union, our parents felt themselves resistant enough to tragedy to celebrate. California constructed eight-lane freeways to join city and country; built a sub-urban architecture with two-car garages and sliding glass walls to allow each Californian simultaneity—inside and outside at once.

California's most flamboyant reconciliation was the horizontal city, in distinction to the verticality of the East Coast. Separate freeway exits, even separate climates, distinct neighborhoods, faiths, languages—all were annexed to one another, stood united beneath a catholic abstraction called "San Jose" or "Sacramento" or—the greatest horizontal abstraction in the world—"L.A." The horizontal city not only tolerated incoherence and disharmony, it found its meaning in the juxtaposition of a chic restaurant, a Jesus Saves storefront, a taco stand. The horizontal city was crisscrossed by freeways that promised escape from complicity while also forcing complexity. The surfer, who grew up on the premises in loco parentis, grew up knowing (without having to learn exactly) nakedness, leisure, freedom, pacifism, also chopsticks and Spanish.

Didn't Walt Disney tantalize California with the idea of floating over street-level congestion on a monorail? In the fifties, Disney purchased some flower farms from Japanese families in Orange County and plowed them under. Then he plowed under someone else's citrus grove. Walt Disney's new crop was to be innocence. Disney had come from Chicago, so immediately he got the point of California. He constructed very different magic kingdoms, side by side. In that first summer after Disneyland opened, I happily made my way through the chambers of Walt Disney's rather interesting imagination.

Only in one respect did Disney seem at odds with his adopted state. Prudishly, he insisted upon a discretion among the several kingdoms analogous to the nonpermeable black lines that surround cartoon characters. Main Street must never betray a knowledge of Tomorrowland. Costumed employees

were required to travel through underground tunnels, before and after their shifts, thus maintaining strict narrative borders, thus precluding surrealism. Cinderella will never meet Davy Crockett in the Magic Kingdom.

Whereas within the horizontal city, California's children grew up accustomed to disjunction. In the light of day, and at street level, all over California, Fantasyland is right next door to Frontierland. And the adolescents of alternate fantasies began to blend and marry one another. Which is why California is famous today for the tofu burrito and the highest rate of miscegenation in the mainland U.S.

Disneyland was so little rooted in California, it flourished here. Disneyland was so little rooted in California that the Disney corporation could pack it up and ship it entire to Florida and Tokyo and France, where it flourished as emblematic of California.

A few years ago, I spent a day with a friend who worked in the art department of the Warner Brothers studio in Burbank. My perception of Warner Brothers had always been of a purveyor of secular cartoons, as opposed to the Disney insistence upon a spiritual dimension to their product. Disney cartoons were not funny. Warner Brothers cartoons were not charming. The Warner Brothers lot was clearly an industrial park. We toured the studio in a golf cart. There was no discretion between miracles at Warner Brothers—between Batman's Gotham and the parting of the Red Sea. We had lunch at the commissary.

In late afternoon, my friend left me for a time, and I wandered alone through a wooden warehouse—the costume department—a temporary structure surviving from the forties. One side of the building was open to the spring air. A door, like the sliding door of a freight car, had been rolled aside. There was no one about.

I began to smell what I can only describe as California. I remember the moment most clearly as a scent—of optimism, or perhaps its residue—not some quail-colored, reedy smell of country but the smell of my family's kitchen, now long gone: An overheated electrical cord, scorched fabric, steam, starch, a spring day. The joined smells of imagination and making do; smells of dream and industry. Here was room after room of costumes and all the appliances of fantasy—scepters, masks, tiaras, gloves, window dressings from stricken sets. Yards and yards of every imaginable silk and tartan and shape and period-dance. So many dreams, folded into boxes or hanging in rows; a confusion of narratives unaccountably readied for a return to the potent light of day. This gladdened me.

Out of sorts. I should think you would be, too, if you had been sweating blood on the Santa Monica Freeway for an hour—even though she waited till well after the rush, it took that long. Let them honk! Go on. Go on. Over an hour from Santa Monica and she found the lots filled. What? This lot is full, ma'am. You have to go around *that* way. *That* way. What? And so on.

And now the museum is crowded with schoolchildren—rolling thunder, static electricity, indecipherable bird calls—her hearing aid takes its adjectives from vast storm-laden canvases surrounding her in the atrium. She decides to do the exhibition in reverse—"flee the children's hour." Work back to the beginning in peace and quiet. And see without precedent, as if such a thing were possible.

But in no gallery is she free of racket, the crude translations of the serpentlike coil in her ear, which is the knowledge that she is getting too old for this. This being everything. The supermarket. The drugstore. What? Christmas. An atrium full of schoolchildren.

She is not one of those old women who is afraid of children. She had been a grammar-school teacher before the war, and just after. She cannot imagine being afraid of a child. She reads in the paper of fearful teachers and she cannot imagine it. The business of the child is to push at the perimeters. The business of the teacher is to push back. Her own grandchildren don't interest her very much, in truth. They don't push at all. Since they turned fourteen, they know everything there is to know. They smile, and school's fine, thank you, and may I be excused as soon as possible? *There, there, mother.* Well, they're so jaded. They don't take delight in anything. Nothing is wonderful to them, is it? Except loud. They seem to like loud.

She deposits her gloves in her purse. Fishes for her glasses case. What would she tell them, the children in the atrium, about California? About anything? Don't get old in the first place. *gnszzzz*, sneers the hearing aid. Oh, do shut up! She fiddles with the little wheel behind her ear, turns it the wrong way till it shrieks with pain. She reverses the wheel. *shhhhhh.*

Imported to California, in the second place, she silently corrects the banner over the exit sign: MADE IN CALIFORNIA. She is reminded of how many versions of California...

You will notice, boys and girls, how many artists in this exhibit came from elsewhere...

A lucky place. They were lucky to live here. Felt themselves lucky. She had known one or two of these painters, before the war. *He* was a bit of an old goat, as she recalls. But that's just it, she can't recall. The half-life of emotions! The impression more lasting than the incident; color more lasting than fugitive form.

You should memorize the things that please you; then when you're old and sitting by yourself, you'll have something...

Silently instructing the children, as if they were her boys and girls of yore, even though she had left the children behind in the first room, left all consideration of children behind in a life she couldn't completely recollect. But were they lucky to live here? She didn't know anymore.

Her own parents from Wisconsin: Her father a gentle architect of bungalows. Of the hundreds of bungalows her father built—well, she doesn't know; they were all over the place—but of the ones in Santa Monica only seven remain, mainly in the blocks off Montana. They weren't brilliant houses, no. They were meant to be comfortable and solid, to withstand the wear and tear of ordinary lives. Solid floors. Solid cupboards. *Knock-knock.* Good plumbing. Good light. The light was the thing. Good porches, rooms of good size, and good light.

The light remains. You have to go away to see it again. Then come back, and there it is. Different from anyplace else. California light.

She raised her own three children—she tried to raise her children with a sense of place and history. All have moved away; seem to feel nothing for California. Well, maybe they do. They wanted the paintings. (*Knock-knock.*) But they always expect her to visit them. Boston. Phoenix. Denver. Whereas she was always haunted by the California that had been bequeathed to her... Now why is it, she irritably addresses the hearing aid, why is it someone is always stacking cartons in my left ear? *Knock-knock*, says the hearing aid. What? Oh, very well, who's there? *It's your own footsteps, stupid old woman.* She looks down. Takes a step. So it is—it's this parquet.

After the children went away to school, she had formed many a committee in Santa Monica. To save things. But not for the sake of her children, as she would once have said. Or for any children. Just

for the sake of the things themselves. Like a scholar's lonely knowledge. Intrinsic value. A few old places out on the pier. Houses in Venice. An old hotel on Ocean Avenue. "Madame Full Charge," Jack used to call her. "Scourge of City Hall." Well, and they did groan when they saw me coming with my straw basket full of mimeographs.

She is becalmed now by a roomful of pastoral paintings from the twenties. Her hearing aid, dozing off, broadcasts only a neutral plane of sound, like the air in jet cabins.

I know which one I should buy...

She is inevitably reminded of her mother's voice whenever she enters a gallery. Her mother was "artistic," a sobriquet ready at hand for a woman who kept a kiln in her back shed; a leitmotif, no more—as others in her mother's circle might be "musical" or "well read" or "devout Catholics" or "sharp as tacks." Native sarcasm waited to harvest any ambition that grew higher than a hollyhock. But Mother was a painter, truly, quite a good painter. Mother's "masterpiece," as the family always referred to the oil above the mantel (in that same vein of California sarcasm)—*Capitola, 1911*—would not suffer in comparison with this one. She puts on her glasses to read the legend; removes them to regard Prussian blue and blue violet, zinc...

Her reverie is interrupted by a clap of thunder, several claps, then a deluge—the arrival of the schoolchildren at the 1920s. Look at them all! Those tennis shoes. Like puppies not yet grown into their feet. Lately California had become such a mystery to her. Everything starting to melt. To slide. To quicken and to rust. What is the point? Boys and girls, indeed! Look at them, only interested in that earphone tour thing.

Click. Click.

Still, the faces interest her; those boys over there with their pants falling down interest her. Black parents, obviously. But something else, too. Mexican, I suppose. How do they keep their pants on? A question for her grandchildren.

Then, beyond the nervous boys, she notices the girl in a pale green dress. Not much of a dress, but it is properly ironed. Vietnamese? Homely, solitary—as she was, too, at that age. Probably bright, and their parents make them work. There is a serenity about the child for which the hearing aid can gather no simile. The girl's lips part slightly. Then the girl moves one hand to shade her eyes, as if she is searching the distance of the landscape before her. Good girl. Good girl. She has clearly entered the landscape. And welcome: Granville Redmond, *California Poppy Field*, c. 1926.

The girl's classmates have tumbled off together, clicking their gizmos, rubber soles screeching like violins into the next gallery.

The girl stays.

Granville Redmond. The Vietnamese teenager. The Native Daughter of the Golden West. Each is united to the others in thinking he sees the same thing.

A field of flowers, a painting of a field of flowers, a Vietnamese girl considering a painting of a field of flowers.

California, c. 2000.

CHECKLIST OF THE EXHIBITION

The checklist is complete as of July 31, 2000.

Entries are listed alphabetically by artist. Multiple works under one artist are chronological.

Dates of individual works within a series are given when they differ from the series date. Undated series are ongoing in most cases.

Life dates are furnished whenever available.

Height precedes width. Depth, when given, follows height and width.

Abbreviations:
CB: center back
D: diameter
H: height
L: length

Kim Abeles
United States, b. 1952

Forty Days and Forty Nights of Smog, 1991
Particulate matter (smog) on Plexiglas, auto
mufflers, detritus, chiffon, and wood
30 x 38 x 56 in. (76.2 x 96.5 x 142.2 cm)
Lent by the artist

Jerome Ackerman
United States, b. 1920

*Bowl with Black and White Matte Glazes;
Covered Jar with Black and White Matte Glazes;
Fruit Bowl with Black Matte Glaze; Tall Bottle
with Blue and Black Glazes; Tall Vase with
White Matte Glaze; Wine Decanter and Four
Cups with White Matte Glaze*, 1953–60
Stoneware, glazed
H: 2⅜ in. (6 cm), D: 6½ in. (16.5 cm); H: 7⅞ in.
(20 cm), D: 4⅝ in. (11.8 cm); 4¾ x 14¼ in.
(12.1 x 36.2 cm); H: 14¾ in. (37.5 cm), D: 2¾ in.
(7 cm); H: 14¾ in. (37.5 cm), D: 2¾ in. (7 cm);
H: 16 in. (40.6 cm), D: 2½ in. (6.4 cm)
Lent by the artist
p. 162

Orange and Ochre Wall Sconce, 1956
Porcelain enamel on steel
4 x 14¾ x 6 in. (10.2 x 37.5 x 15.2 cm)
Lent by the artist

Ansel Adams
United States, 1902–1984

*Monolith, the Face of Half Dome, Yosemite
National Park*, 1927, printed 1980
Gelatin-silver print
19¼ x 14½ in. (48.9 x 36.8 cm)
LACMA, gift of the artist in memory
of Robin Cranston
p. 129

*Mt. Williamson, the Sierra Nevada, from
Manzanar, California*, 1944, printed 1978
Gelatin-silver print
15½ x 18¾ in. (39.4 x 47.6 cm)
Anne and Arnold Porath
p. 156

*Half Dome and Moon, Yosemite Valley,
California*, c. 1950
Gelatin-silver print
21½ x 30 in. (54.6 x 76.2 cm)
LACMA, gift in memory of Helen Green Cross
p. 171

*Yosemite Valley, from Inspiration Point,
Yosemite National Park*, 1969
Photo-offset print on metal container
H: 7 in. (17.8 cm); D: 6¼ in. (15.9 cm)
Courtesy George Eastman House
p. 196

Clinton Adams
United States, b. 1918

Barrington Street, 1951
Egg tempera on paper
13½ x 20 in. (34.3 x 50.8 cm)
Mel and Sharlene Leventhal
p. 157

Harry Adams
United States, 1918–1988

*Funeral of Ronald Stokes, 29, Secretary of
Mosque #27, Los Angeles, May 5, 1962*, 1962
Gelatin-silver print
11 x 14 in. (27.9 x 35.6 cm)
Center for Photojournalism and Visual History,
California State University, Northridge
p. 220

Allan Adler
United States, b. 1916

Flatware Place Setting for Six, "Roundend," 1944
Sterling silver
Varied dimensions
Lent by the artist

Centerpiece with Firepots, c. 1950
Sterling silver and glass
H: 6 in. (15.2 cm); D: 24 in. (61 cm)
Lent by the artist

Amy Adler
United States, b. 1966

Ace, 1997
Silver dye-bleach (cibachrome) print
50 x 34 in. (127 x 86.4 cm)
Collection of Barry Sloane

Gilbert Adrian
United States, 1903–1959

*Costume for Greta Garbo, created for
"Inspiration,"* MGM, 1930
Silk crepe, paste stones, and rhinestones
CB (with train): 75½ in. (191.8 cm); Sleeve L:
20 in. (50.8 cm)
Museum Collection, The Fashion Institute of
Design & Merchandising, from the Department
of Recreation and Parks, City of Los Angeles
p. 132

*Costume for Joan Crawford, created for
"Letty Lynton,"* MGM, 1932
Silk crepe and sequins
CB: 54 in. (137.2 cm)
Museum Collection, The Fashion Institute of
Design & Merchandising, from the Department
of Recreation and Parks, City of Los Angeles
p. 131

*Two-Piece Dress and Cape, "Shades
of Picasso,"* 1944
Rayon crepe
Top CB: 27 in. (68.6 cm); Skirt CB: 41 in.
(104 cm); Cape CB: 56 in. (142.2 cm)
LACMA, gift of the artist

Laura Aguilar
United States, b. 1959

Nature #7 Self-Portrait, 1996
Gelatin-silver print
16 x 20 in. (40.6 x 50.8 cm)
Lent by the artist
p. 252

Gregory Ain
United States, 1908–1988

*Anselem A. Ernst Residence, Los Angeles,
Perspective Elevation*, 1937
Graphite on paper
20 x 30 in. (50.8 x 76.2 cm)
Architecture and Design Collection,
University Art Museum, UCSB

John Alberts
United States, 1886–1931

Windswept Trees, 1916
Monotype
8½ x 12¾ in. (21.6 x 32.4 cm)
Victoria Dailey

Herman Oliver Albrecht
Germany, active United States, 1876–1944

Three Women in White, c. 1910
Gelatin-silver print
9⅝ x 5¼ in. (24.5 x 13.3 cm)
The Wilson Center for Photography
p. 96

Maxine Albro
United States, 1903–1966

Fiesta of the Flowers, 1937
Oil on canvas
108 x 104 in. (274.3 x 264.2 cm)
Robert Bijou Fine Arts
p. 140

Lynn Aldrich
United States, b. 1944

Breaker, 1999
Steel, wood, fiberglass, and garden hoses
36 x 32 x 50 in. (91.4 x 81.3 x 127 cm)
LACMA, Modern and Contemporary Art
Council, 2000 Art Here and Now purchase

Anders Aldrin
Sweden, active United States, 1889–1970

Zabriskie Point, Death Valley, 1932
Color woodcut
12⅛ x 15 in. (30.8 x 38.1 cm)
The Annex Galleries

Peter Alexander
United States, b. 1939

Cloud Box, 1966
Cast polyester resin
10 x 10 x 10 in. (25.4 x 25.4 x 25.4 cm)
Private collection, Los Angeles
p. 209

Neda Al-Hilali
Czechoslovakia, active United States, b. 1938

Untitled #216, 1981
Hand-painted plaited paper
48 x 48 in. (121.9 x 121.9 cm)
Collection of Lydia and Chuck Levy

Carlos Almaraz
Mexico, active United States, 1941–1989

Suburban Nightmare, 1983
Oil on canvas
37 x 45 in. (94 x 114.3 cm)
The Buck Collection, Laguna Hills, California
p. 247

City Bridge, 1989
Lift-ground aquatint
30½ x 24 in. (77.5 x 61 cm)
LACMA, gift of Elsa Flores Almaraz
and Maya Almaraz

D. L. Alvarez
United States, b. 1962

Redwood (pbn#18), 1996
Blue pencil on paper
31 x 26 in. (78.8 x 66 cm)
Collection of John Bransten

Mabel Alvarez
United States, 1891–1985

Dream of Youth, 1925
Oil on canvas
58 x 50¼ in. (147.3 x 127.6 cm)
Collection of Jeri L. Waxenberg

Laura Andreson
United States, 1902–1999

Teapot, 1944
Earthenware, glazed
5 x 6½ x 9½ in. (12.7 x 16.5 x 24.1 cm)
Scripps College, Claremont, California,
Marer Collection

Bowl, c. 1955
Earthenware
H: 7 3/16 in. (17.8 cm); D: 7⅛ in. (18.1 cm)
LACMA, gift of Bernard Kester

Lawrence Andrews
United States, b. 1964

*And They Came Riding into Town on Black
and Silver Horses*, 1992
Videotape (color, with sound, thirty minutes)
Lent by the artist, courtesy Gallery
Paule Anglim

Nancy Angelo
United States
Candace Compton
United States

Nun and Deviant, 1976
Videotape (black and white, with sound,
twenty minutes)
Lent by Video Data Bank

Ant Farm
Chip Lord (United States, b. 1944), Doug
Michaels (United States, b. 1944), and Curtis
Schreier (United States, b. 1944)

Media Burn, 1975
Videotape (color, with sound, twenty-three
minutes) of media event in Oakland, California
Lent by Video Data Bank

Eleanor Antin
United States, b. 1935

The King of Solana Beach, 1974–75
Eleven gelatin-silver prints mounted on board;
one text panel
Each: 6 x 9 in. (15.2 x 22.9 cm)
Collection of Gary and Tracy Mezzatesta
p. 232

Virgil Apger
United States, 1903–1994

*Carmen Miranda, Publicity Photo for
"A Date with Judy,"* MGM, 1948
Carbro print
9¾ x 8 in. (24.8 x 20.3 cm)
Sid Avery/Motion Picture and Television
Photo Archive
p. 178

Robert Arneson
United States, 1930–1992

John with Art, 1964
Ceramic, glazed with polychrome epoxy
34½ x 18 in. (87.6 x 45.7 cm)
Collection of the Seattle Art Museum, gift
of Manuel Neri

California Artist, 1982
Stoneware, glazed
68¼ x 27½ in. (173.36 x 69.85 cm)
San Francisco Museum of Art, gift of the
Modern Art Council
p. 258

Skip Arnold
United States, b. 1957

Hood Ornament, 1992
Videotape (black and white, without
sound, ninety seconds) of a public activity
in Sun Valley, California
Lent by the artist

John Arvanites
United States, b. 1943

The Theo Tapes, 1986
Videotape (color, with sound, twenty-five
minutes)
Lent by the artist

Kyoko Asano
Japan, active United States, b. 1933

Sea, 1987
Lithograph
30 x 29 15/16 in. (76.2 x 76 cm)
LACMA, purchased with funds provided
by the Graphic Arts Council, gift of Cirrus
Editions

Ruth Asawa
United States, b. 1926

Untitled, 1959
Monel in tubular knit
84 x 24 in. (213.4 x 61 cm)
Lent by the artist

Asco
Harry Gamboa Jr. (United States, b. 1951),
Gronk (United States, b. 1954), Willie Herrón
(United States, b. 1951), and Patssi Valdez
(United States, b. 1951)

Spray Paint LACMA, 1972
Photo documentation of guerrilla art action
by Harry Gamboa Jr., transferred to videotape
for this exhibition
Lent by Harry Gamboa Jr.
p. 227

Instant Mural, 1974
Super 8 film of performance (color, without
sound, ninety seconds), transferred to
videotape
Lent by Harry Gamboa Jr.
p. 227

David Avalos
United States, b. 1947
Louis Hock
United States, b. 1948
Elizabeth Sisco
United States, b. 1954

Arte Reembolso/Art Rebate, 1993
Excerpts from videotape documentation
(news coverage; color, with sound, fourteen
minutes) of event in San Diego, California
Lent by Louis Hock
p. 268

David Avalos
United States, b. 1947
Deborah Small
United States, b. 1948

Mis•ce•ge•NATION, 1991
Photo documentation of installation at
Colorado University Art Gallery, University
of Colorado, Boulder, transferred to videotape
for this exhibition
Lent by the artists
p. 265

Ramona: Birth of a Mis•ce•ge•NATION, 2000
Coproduced with William Franco (United
States, b. 1957) and Miki Seifert (United States,
b. 1958)
Excerpts from videotape (color, with sound,
twenty-five minutes), used in original
installation
Lent by David Avalos and Deborah Small

Sid Avery
United States, b. 1918

*Rock Hudson, Out of the Shower at His
Hollywood Hills Home*, 1952
Gelatin-silver print
11 x 14 in. (27.9 x 35.6 cm)
Sid Avery/Motion Picture and Television
Photo Archive
p. 174

*Dwight D. Eisenhower in La Quinta,
California*, 1961
Gelatin-silver print
11 x 14 in. (27.9 x 35.6 cm)
Sid Avery/Motion Picture and Television
Photo Archive
p. 158

Glenna Boltuch Avila
United States, b. 1953

Untitled, 1986
Screenprint
25 x 38¼ in. (63.5 x 97.2 cm)
LACMA, purchased with funds provided
by the Art Museum Council

Anthony Aziz
United States, b. 1961
Sammy Cucher
Venezuela, active United States, b. 1958

Plasmorphica #8
From the series Plasmorphica, 1996
Chromogenic development (Ektacolor) print
40⅛ x 30 in. (101.9 x 76.2 cm)
LACMA, Ralph M. Parsons Fund

Ernest Bachrach
United States, 1899–1973

Dolores Del Rio, 1932
Gelatin-silver print
10 x 8 in. (25.4 x 20.3 cm)
Sid Avery/Motion Picture and Television
Photo Archive
p. 133

John Baldessari
United States, b. 1931

Looking East on 4th and C, 1967–68
Acrylic and photo emulsion on canvas
59 x 45 in. (149.9 x 114.3 cm)
San Francisco Museum of Modern Art,
Accessions Committee Fund: gift of Evelyn and
Walter Haas, Mr. and Mrs. Donald G. Fisher,
Modern Art Council, and Norman C. Stone
p. 199

California Map Project, Part I: California, 1969
Assisted by George and Judy Nicolaidis
Eleven chromogenic development prints and
typewritten text on paper, mounted on board
Each print: 8 x 10 in. (20.3 x 25.4 cm); Text:
8½ x 11 in. (21.6 x 27.9 cm)
Private collection, Munich

Adele Elizabeth Balkan
United States, 1907–1999

*Sketch for Costume for Anna May Wong, created
for "Daughter of the Dragon,"* Paramount, 1936
Gouache on board
20¼ x 15 in. (51.4 x 38.1 cm)
LACMA, gift of Adele Elizabeth Balkan
p. 134

Lewis Baltz
United States, b. 1945

*East Wall, Nees Turf Supply Company, 38T
Pullman, Costa Mesa*
From the series The New Industrial Parks
near Irvine, California, 1974
Gelatin-silver print
6 x 9 in. (15.2 x 22.9 cm)
LACMA, Ralph M. Parsons Fund

*West Wall, Unoccupied Industrial Building,
20 Airway Drive, Costa Mesa*
From the series The New Industrial Parks
near Irvine, California, 1974
Gelatin-silver print
6 x 9 in. (15.2 x 22.9 cm)
LACMA, promised gift of an anonymous donor,
Los Angeles
p. 199

*11777 Foothill Boulevard, Los Angeles,
California*, 1991, printed 1992
Silver dye-bleach (Cibachrome) print,
edition 1/3
48 x 96 in. (129.6 x 243.8 cm)
LACMA, commissioned with funds provided by
Michael R. Kaplan, M.D., Gary B. Sokol, and
the Horace W. Goldsmith Foundation

Travis Banton
United States, 1894–1958

*Costume for Marlene Dietrich, created
for "Desire,"* Paramount, 1935
Silk chiffon, silk crepe, and fox fur
Dress CB: 50½ in. (128.3 cm); Jacket CB: 29 in.
(73.7 cm)
Museum Collection, The Fashion Institute of
Design & Merchandising, from the Department
of Recreation and Parks, City of Los Angeles
p. 132

Uta Barth
Germany, active United States, b. 1958

Field #3, 1995
Chromogenic development (Ektacolor)
print on wood panel
23 x 28¾ in. (58.4 x 73 cm)
Collection of Merle and Gerald Measer

Crawford Barton
United States, 1943–1993

Untitled, c. 1975
Gelatin-silver print
14 x 8 in. (35.6 x 20.3 cm)
GLBT Historical Society of Northern California
p. 219

Loren Barton
United States, 1893–1975

Sunny Day at Balboa, c. 1945
Watercolor and graphite on paper
24⅛ x 30¼ in. (61.3 x 76.9 cm)
LACMA, the California Water Color Society
Collection of Water Color Paintings

Ruth-Marion Baruch
United States, 1922–1998

Shakespeare Couple, Haight-Ashbury, 1967
Gelatin-silver print
7 x 10 in. (17.8 x 25.4 cm)
Estate of Ruth-Marion Baruch
p. 217

Black Panther Guard, 1968
Gelatin-silver print
10 x 8 in. (25.4 x 20.3 cm)
Estate of Ruth-Marion Baruch

Ernest Allan Batchelder
United States, 1875–1957
Batchelder Tile Company, United States,
1909–32

Five Tiles with Mayan Motifs, 1912–32
Earthenware
4: 4 x 4 in. (10.2 x 10.2 cm); 1: 4 x 5 in.
(10.2 x 12.7 cm)
Collection of Norman Karlson

Tile with the Santa Barbara Mission, 1912–32
Earthenware
8 x 8 in. (20.3 x 20.3 cm)
Collection of Norman Karlson

Tile Panel, c. 1915–20
Earthenware
24½ x 24½ in. (62.2 x 62.2 cm)
LACMA, gift of Theodore C. Coleman

Tile, c. 1925
Earthenware
8¾ x 8¾ in. (22.2 x 22.2 cm)
LACMA, purchased with funds provided
by Mrs. Logan Henshaw, Caroline Blanchard
Brownstein, and Mrs. Edwin Greble

Bauer Pottery
United States, 1885–1962

*One Orange and One Yellow Garden
Oil Jar*, c. 1920
Ceramic
Each: 16 x 12 x 12 in. (40.6 x 30.5 x 30.5 cm)
Ron and Susan Vander Molen

Milo Baughman
United States
For Glenn of California, United States,
c. 1952–c. 1979

Desk, c. 1975
Wood
29¾ x 57¾ in. (75.6 x 146.7 cm)
Courtesy Susan and Michael Rich

Gustave Baumann
Germany, active United States, 1881–1971

Sequoia Forest, 1928
Color woodcut
12⅞ x 12¾ in. (32.8 x 32.4 cm)
Lent by Museum of Fine Arts, Museum of
New Mexico, purchased with funds raised
by the School of American Research

Windswept Eucalyptus, c. 1929
Color woodcut
9⅝ x 11½ in. (24.4 x 29.2 cm)
Lent by Museum of Fine Arts, Museum of
New Mexico, purchased with funds raised
by the School of American Research
p. 69

Robert A. Bechtle
United States, b. 1932

'67 Chrysler, 1967
Oil on canvas
36 x 40 in. (91.4 x 101.6 cm)
Lent by Ruth and Alfred Heller, courtesy
Gallery Paule Anglim, San Francisco
p. 206

Larry Bell
United States, b. 1939

Cube, 1966
Vacuum-coated glass
12 x 12 x 12 in. (30.5 x 30.5 x 30.5 cm)
LACMA, gift of Frederick Weisman Company
p. 211

Jordan Belson
United States, b. 1926

Allures, 1960
16 mm film (color, with sound, seven minutes)
Lent by the artist

Billy Al Bengston
United States, b. 1934

Lady for a Night, 1970
Lacquer on aluminum
36 x 34 in. (91.4 x 86.4 cm)
Lent by the artist
p. 204

Mark Bennett
United States, b. 1956

Home of Mike & Carol Brady, 1986–95
Ink and pencil on graph vellum paper
24¼ x 36¼ in. (61.5 x 92.1 cm)
Collection of Suzanne and Howard Feldman

Home of Francis "Gidget" Lawrence, 1995
Ink and pencil on graph vellum paper
24½ x 36¼ in. (62.2 x 92.1 cm)
Lent by the artist, courtesy Mark Moore
Gallery

Fletcher Benton
United States, b. 1931

Synchronetic c-4400-s Series, 1966
Aluminum and motorized Plexiglas panels
70 x 60 x 9 in. (177.8 x 152.4 x 22.9 cm)
LACMA, gift of Peter and Cynthia Williams,
Livermore, California

David Berg
United States, b. 1956

Negative Painting No. 6, 1997
Gelatin-silver print; oil on Mylar
16 x 20 in. (40.6 x 50.8 cm); 2½ x 2½ in.
(6.4 x 6.4 cm)
LACMA, Ralph M. Parsons Fund

Tony Berlant
United States, b. 1941

Venus, 1966
Photomechanical reproduction on sheet
metal, nailed to painted wood construction
and ceramic
15 x 10 x 14 in. (38.1 x 25.4 x 35.6 cm)
Collection of Helen and Tony Berlant

Wallace Berman
United States, 1926–1976

Untitled (Jazz Drawing of Slim Gaillard),
c. 1940
Pencil on paper
12⅝ x 10¹⁵⁄₁₆ in. (32 x 25 cm)
Collection of the Estate of Wallace Berman
p. 182

Semina, 1955–64
Hand-printed magazines (nine issues)
Varied dimensions; minimum: 5½ x 3⅛ in.
(14 x 7.9 cm); maximum: 11 x 9 in.
(27.9 x 22.9 cm)
Private collection, courtesy L.A. Louver Gallery
p. 182

Topanga Seed, 1969–70
Dolomite rock and transfer letters
38 x 47 x 46 in. (96.5 x 119.4 x 116.8 cm)
The Grinstein Family
p. 214

Cindy Bernard
United States, b. 1959

Topography: Dry Head Agate #9 (Detail 1), 1995
Chromogenic development (Ektacolor) print,
edition 2/3
30 x 40 in. (76.2 x 101.6 cm)
LACMA, Ralph M. Parsons Fund

Edward Biberman
United States, 1904–1986

Mandalay Beach, 1937
Oil on canvas
30 x 20 in. (76.2 x 50.8 cm)
Collection of Suzanne W. and Tibor Zada

Conspiracy, c. 1955
Oil on board
26½ x 41½ in. (67.3 x 105.4 cm)
Courtesy Suzanne W. Zada of Gallery "Z"
p. 179

The Hollywood Palladium, c. 1955
Oil on Celotex on board
36 x 48 in. (91.4 x 121.9 cm)
Irell & Manella, LLP
p. 164

Sepulveda Dam, n.d.
Oil on canvas
20 x 35 in. (50.8 x 88.9 cm)
The Oakland Museum of California, gift of
the Estate of Marjorie Eaton by exchange
p. 108

Sandow Birk
United States, b. 1964

Bombardment of Fort Point, 1996
Oil and acrylic on canvas
54 x 43 in. (137.2 x 109.2 cm)
Peter and Isabel Blumberg
p. 243

Elmer Bischoff
United States, 1916–1991

Blues Singer, 1954
Oil on canvas
55 x 72 in. (139.7 x 182.9 cm)
The Oakland Museum of California, gift
of Bruce and Betty Friedman in memory
of Frederic P. Snowden

Two Figures at the Seashore, 1957
Oil on canvas
56⅞ x 56⅞ in. (144.5 x 144.5 cm)
Collection of the Orange County Museum of
Art, museum purchase with additional funds
provided by the National Endowment for the
Arts, a federal agency
p. 175

Franz Bischoff
Austria, active United States, 1864–1929

Vase with Roses, c. 1908
Porcelain
H: 14¼ in. (34.9 cm)
The Irvine Museum, Irvine, California

California Poppies Vase, n.d.
Porcelain
H: 13¾ in. (33.21 cm)
The Irvine Museum, Irvine, California
p. 78

Ginny Bishton
United States, b. 1967

Walking 1, 1998
Photo collage on paper
17 x 18½ in. (43.2 x 47 cm)
LACMA, Modern and Contemporary Art
Council, 1998 Art Here and Now purchase

Lee Everett Blair
United States, 1911–1993

Dissenting Factions, 1940
Watercolor on paper
15 x 28½ in. (38.1 x 72.4 cm)
Collection of Nancy and John Weare
p. 112

Nayland Blake
United States, b. 1960

Hans Bellmer as Monsieur Dolmance, 1991–93
Wood, cloth, and metal
73 x 14 x 12 in. (185.4 x 35.6 x 30.5 cm)
Courtesy Matthew Marks Gallery, New York

Porter Blanchard
United States, 1886–1973

Coffee Set and Tray, 1930–50
Pewter and hardwood
Tray D: 18½ in. (47 cm)
LACMA, gift of Jo Ann and Julian Ganz Jr.
p. 110

Anton Blazek
Czechoslovakia, active United States, 1902–1974

*Chartreuse Bottle-Vase; Red and White Ridged
Pitcher; Striated Orange Bottle*, 1945–55
Slip cast, glazed
H: 15⅝ in. (39.7 cm), D: 2 in. (5.1 cm); H: 11⅛
in. (28.3 cm), D: 2 in. (5.1 cm); H: 17⅞ (45.4
cm), D: 2 in. (5.1 cm)
Private collection

Chaz Bojórquez
United States, b. 1949

Los Avenues, 1987
Serigraph
51 x 39 in. (129.5 x 99.1 cm)
Lent by the artist
p. 246

Jonathan Borofsky
United States, b. 1942

*Flying Man with Briefcase,
at No. 2816932*, 1983–86
Multiple sculpture, painted Gatorfoam
94½ x 24½ x 1 in. (240 x 62.2 x 2.5 cm)
Collection of Joanna Giallelis
p. 259

Dorr Bothwell
United States, b. 1902

Hollywood Success, 1940
Oil on canvas
36 x 30⅛ in. (91.4 x 76.5 cm)
Fine Arts Museums of San Francisco,
Museum Collection

Translation from the Maya, 1940
Oil on Celotex
23 x 19 in. (58.4 x 48.3 cm)
Collection of the Orange County Museum of Art
p. 136

Cornelis Botke
Holland, active United States, 1887–1954

Foam and Cypress, Point Lobos, 1928
Etching
11½ x 10¾ in. (29.2 x 27.3 cm)
Mr. and Mrs. William A. Botke

Gaza Bowen
United States, b. 1944

The American Dream, 1990
Neoprene, sponge, clothespins, found objects,
plywood, pressboard, and kidskin
17 x 15 x 15 in. (43.2 x 38.1 x 38.1 cm)
Fine Arts Museums of San Francisco, Museum
Purchase, gift of the Textile Arts Council
p. 255

Robert Brady
United States, b. 1946

Innocence: An Open Book, 1997–98
Mixed media
23½ x 24 in. (59.7 x 61 cm)
Courtesy Braunstein/Quay Gallery

Rex Brandt
United States, b. 1914

Surfriders, 1959
Oil on canvas
26 x 36 in. (66 x 91.4 cm)
The E. Gene Crain Collection
p. 175

Maurice Braun
Hungary, active United States, 1877–1941

Bay and City of San Diego [also known
as *San Diego from Point Loma*], 1910
Oil on canvas and board
30⅛ x 34⅛ in. (76.5 x 86.7 cm)
Mr. and Mrs. William R. Dick Jr.

Moonrise over San Diego Bay, 1915
Oil on canvas
22 x 28 in. (55.9 x 71.1 cm)
Collection of Joseph Ambrose and Michael
Feddersen
p. 75

California Valley Farm, c. 1920
Oil on canvas
40 x 50 in. (101.6 x 127 cm)
Collection of Joseph L. Moure

Brayton Laguna Pottery
United States, 1927–68

Two Tiles with Sleeping Mexican Motifs,
1927–68
Earthenware, glazed
7 x 7 in. (17.8 x 17.8 cm); 6 x 6 in.
(15.2 x 15.2 cm)
Collection of Norman Karlson

Anne M. Bremer
United States, 1868–1923

The Sentinels, c. 1918
Oil on canvas
44½ x 49½ in. (113 x 125.7 cm)
Mills College Art Museum, Oakland, California
p. 126

An Old Fashioned Garden, n.d.
Oil on canvas
20 x 24 in. (50.8 x 61 cm)
Mills College Art Museum, Oakland, California
p. 80

Anne W. Brigman
United States, 1869–1950

Infinitude, c. 1905
Gelatin-silver print
5⁷⁄₁₆ x 9⁹⁄₁₆ in. (13.9 x 24.4 cm)
The Wilson Center for Photography
p. 83

The Lone Pine, c. 1908
Gelatin-silver print
9⁹⁄₁₆ x 7¹¹⁄₁₆ in. (24.3 x 19.6 cm)
The Wilson Center for Photography
p. 29

The Strength of Loneliness, 1914
Gelatin-silver print
9⁹⁄₁₆ x 7½ in. (24.3 x 19.1 cm)
The Wilson Center for Photography

Horace Bristol
United States, 1908–1998

*Demonstrations Were Almost a Daily
Occurrence in San Francisco during the
Depression*, 1935
Gelatin-silver print
6 x 9 in. (15.2 x 22.9 cm)
Estate of Horace Bristol

Trimming the Bark of a Redwood Log, 1937
Gelatin-silver print
9½ x 10½ in. (24.1 x 26.7 cm)
Estate of Horace Bristol

Joad Family Applying for Relief, 1938
Gelatin-silver print
12¹¹⁄₁₆ x 9¹¹⁄₁₆ in. (32.2 x 24.6 cm)
Estate of Horace Bristol
p. 121

Migrant Worker under Culvert, 1938
Gelatin-silver print
7½ x 9½ in. (19.1 x 24.1 cm)
Estate of Horace Bristol

Charles Brittin
United States, b. 1928

*Arrest (Legs) Downtown Federal Building,
Los Angeles, California*, c. 1965
Gelatin-silver print
16 x 20 in. (40.6 x 50.8 cm)
Lent by the artist, courtesy Craig Krull Gallery,
Santa Monica
p. 220

Jessica Bronson
United States, b. 1963

Lost Horizon, 1998
CAV laser disc, white television, laser disc
player, wall-mounted monitor shelf, and cables,
edition 1/3
22 x 18 x 18 in. (55.9 x 45.7 x 45.7 cm)
Lent by the artist

Jeff Brouws
United States, b. 1955

Interstate 40, Needles, California, 1995
Chromogenic development print
18 x 18 in. (45.7 x 45.7 cm)
Lent by the artist, courtesy Craig Krull Gallery,
Santa Monica

Joan Brown
United States, 1938–1990

Girl in Chair, 1962
Oil on canvas
60 x 48 in. (152.4 x 121.9 cm)
LACMA, gift of Mr. and Mrs. Robert H. Ginter
p. 176

[William] Theophilus Brown
United States, b. 1919

Muscatine Diver, 1962–63
Oil on canvas
60 x 40 in. (152.4 x 101.6 cm)
The Oakland Museum of California, gift
of the artist

Bruce of L.A. [Bruce Bellas]
United States, 1907–1974

Untitled (Gene Hilbert), 1951
Gelatin-silver print
10 x 8 in. (25.4 x 20.3 cm)
Private collection, Santa Monica

Untitled (Dick Pardee), 1960
Gelatin-silver print
10 x 8 in. (25.4 x 20.3 cm)
Collection of John Sonsini

Nancy Buchanan
United States, b. 1946

California Stories, 1983
Videotape (color, with sound, ten minutes)
Lent by the artist

Nancy Buchanan
United States, b. 1946
Barbara Smith
United States, b. 1931

With Love from A to B, 1977
Videotape (color, with sound, nine minutes)
Lent by the artists

Beniamino B. Bufano
Italy, active United States, c. 1898–1970

Chinese Man and Woman, 1921
Stoneware, glazed
31½ x 12½ x 7½ in. (80 x 31.8 x 19.1 cm)
Lent by The Metropolitan Museum of Art,
gift of George Blumenthal, 1924
p. 143

C. S. [Clarence Sinclair] Bull
United States, 1895–1979

Anna May Wong, 1927
Gelatin-silver print
11¾ x 9 in. (29.8 x 22.9 cm)
Collection of Louis F. D'Elia
p. 134

Wynn Bullock
United States, 1902–1975

The Limpet, 1969
Gelatin-silver print
5⁵⁄₁₆ x 12¹⁄₁₆ in. (12.9 x 30.7 cm)
LACMA, gift of the Wynn and Edna
Bullock Trust

288

Chris Burden
United States, b. 1946

Trans-Fixed, 1974
Photo documentation of performance
Lent by the artist
p. 207

Relic from "Trans-Fixed," 1974
Two nails
L (of each nail): 1¾ in. (4.5 cm); D (of each
nail head): ½ in. (1.27 cm)
Collection of Jasper Johns

L.A.P.D. Uniform, 1993
Thirty uniforms and thirty Beretta handguns,
wool serge, wood, and metal
Each uniform: 88 x 72 x 6 in. (223.5 x 182.9 x
15.2 cm)
Lent by the artist (nos. 1–12, 14–16), the Fabric
Workshop (nos. 23, 28, 30), Stephen Oakes
and Olivia Georgia (no. 13), Gilbert and Lila
Silverman (no. 29), Marion Boulton Stroud
(nos. 20–22, 24–27), and Dr. Lothar Tirala
(nos. 17–19)
p. 245

Hans Burkhardt
Switzerland, active United States, 1904–1994

Reagan—Blood Money, 1945
Oil on canvas
29 x 22 in. (73.7 x 55.9 cm)
Hans G. and Thordis W. Burkhardt
Foundation, courtesy Jack Rutberg Gallery,
Los Angeles
p. 179

Andrew Bush
United States, b. 1956

*Man travelling southeast on the 101 Freeway
at approximately 71 mph somewhere around
Camarillo, California, on a summer evening
in 1995*
From the Freeway series, 1995
Chromogenic development print
30 x 40 in. (76.2 x 101.6 cm)
Lent by the artist

Jean Williams Cacicedo
United States, b. 1948

Tee Pee: An Indian Dedication, 1988
Wool, felted, hand dyed, reverse appliquéd
51 x 60 in. (129.5 x 152.4 cm)
Collection of Julie Schafler Dale, courtesy of
Julie: Artisans' Gallery, New York
p. 261

John Cage
United States, 1912–1992

Seven Day Diary/Not Knowing, 1978
Seven prints using etching, drypoint, and
aquatint on Rives papers
Each sheet: 12 x 17 in. (30.7 x 43 cm)
Fine Arts Museums of San Francisco, Crown
Point Press Archive, Gift of Kathan Brown

Jerome Caja
United States, 1958–1995

Virgin at the Hamper, 1989
Nail polish
9 x 7¼ in. (22.9 x 18.4 cm)
Collection of Anna van der Meulen

Bloody Marys from Heaven, 1994
Nail polish, enamel, and white-out
13½ x 13½ in. (34.3 x 34.3 cm)
Collection of Anna van der Meulen

Head of John the Baptist, n.d.
Charles Sexton's ashes and nail polish on resin
D: 11 in. (27.9 cm)
Collection of Anna van der Meulen

Toasted White Bread (Having a Nice Day), n.d.
Nail polish, enamel, and white-out on paper
12½ x 9¾ in. (31.8 x 24.8 cm)
Collection of Anna van der Meulen

California China Products Company
United States, 1911–17

San Diego Backcountry, 1911–13
Kaospar clay, glazed
6 x 48 in. (15.2 x 121.9 cm)
Lent by Estelle and Jim Milch

California Clay Products Company (CALCO)
United States, 1918–33

Three Tiles with Mayan Motifs, 1923–33
Earthenware
6 x 6 in. (15.2 x 15.2 cm); 8 x 7 in. (20.3 x
17.8 cm); 8 x 8 (20.3 x 20.3 cm)
Collection of Norman Karlson

Tile with Parrots, 1923–33
Earthenware
16³⁄₁₆ x 5⅝ in. (41.6 x 14.3 cm)
Collection of Norman Karlson

Two Tiles with Peacock Motifs, 1923–33
Earthenware
11¼ x 5½ in. (28.6 x 14 cm); 11 x 5 in.
(27.9 x 12.7 cm)
Collection of Norman Karlson

California Faience
United States, 1915–30

Bowl, c. 1920
Earthenware
H: 2 in. (5.1 cm); D: 5⅝ in. (14.3 cm)
LACMA, Art Museum Council Fund

Vase, c. 1920
Earthenware
H: 7⅛ in. (18.1 cm); D: 4 in. (10.2 cm)
LACMA, gift of Max Palevsky

Vase, c. 1920
Earthenware
H: 6⅜ in. (16.2 cm); D: 4⅛ in. (10.5 cm)
LACMA, purchased with funds provided by
the William Randolph Hearst Collection

Vase, c. 1920
Earthenware
H: 6 in. (15.2 cm); D: 3½ in. (8.9 cm)
LACMA, purchased with funds provided
by Arthur Hornblow Jr.
p. 88

Vase, c. 1920
Earthenware
H: 5 in. (12.7 cm); D: 5⅞ in. (14.9 cm)
LACMA, purchased with funds provided by
Mrs. Leonard Martin, the Los Angeles County,
Mrs. Charles Otis, Emma Gillman in memory
of Edith O. Bechtel, Mrs. Edwin Greble, and
Edwin C. Vogel

Vase, c. 1920
Earthenware
H: 6⅜ in. (16.2 cm); D: 4⅛ in. (10.5 cm)
LACMA, gift of Max Palevsky
p. 88

Vase, c. 1925
Porcelain
H: 10⅜ in. (26.4 cm); D: 8¼ in. (21 cm)
LACMA, gift of Max Palevsky

California Hand Prints
United States, founded c. 1940

Textile Length, c. 1941
Printed cotton
61¼ x 48 in. (155.6 x 121.9 cm)
LACMA, gift of Esther Ginsberg and Harry Eden
in honor of Bob and Rhonda Heintz
p. 141

California Porcelain
United States, c. 1925

Vase, c. 1925
Porcelain
H: 12 in. (30.5 cm); D: 8 in. (20.3 cm)
LACMA, gift of Max Palevsky

Garry Carthew
United States
For Peter Pepper Products, United States

Viking Clock, 1957
Painted wood and clockworks
15 x 2 in. (38.1 x 5.1 cm)
LACMA, gift of Jerome and Evelyn Ackerman

Catalina Sportswear
United States, founded 1907

Woman's Two-Piece Bathing Suit and Jacket,
late 1940s
Printed cotton
Jacket CB: 28 in. (71.1 cm); Top L: 42 in.
(106.7 cm); Shorts CB: 17 in. (43.2 cm)
LACMA, gift of Harry Eden and Esther
Ginsberg in honor of Michael, Linda,
and Alice Eisenberg
p. 158

Enrique Martínez Celaya
Cuba, active United States, b. 1964

Map, 1998
Oil on fabric over canvas
48 x 48 x 2½ in. (121.9 x 121.9 x 6.4 cm)
Collection of Stephen Cohen, Los Angeles
p. 253

Vija Celmins
Latvia, active United States, b. 1938

Untitled (Ocean), 1968
Graphite on acrylic ground on paper
13¾ x 18½ in. (34.9 x 47 cm)
Collection of Helen and Tony Berlant

Enrique Chagoya
Mexico, active United States, b. 1953

When Paradise Arrived, 1988
Charcoal and pastel on paper
80 x 80 in. (203.2 x 203.2 cm)
di Rosa Preserve, Napa, California
p. 249

Wah Ming Chang
United States, b. 1917

Chinatown, c. 1927
Woodblock on paper
10¼ x 8¼ in. (26 x 21 cm)
The Michael D. Brown Collection

Jean Charlot
France, active United States and Mexico,
1898–1979

Idol, 1933
Color lithograph
11¼ x 8⁹⁄₁₆ in. (28.6 x 21.7 cm)
LACMA, gift of Marie and Jack Lord

Woman Standing, Child on Back, 1933
Color lithograph
14¹³⁄₁₆ x 10³⁄₁₆ in. (37.6 x 25.9 cm)
LACMA, gift of Marie and Jack Lord

Woman Washing, 1933
Color lithograph
11¼ x 8⁹⁄₁₆ in. (28.6 x 21.7 cm)
LACMA, gift of Marie and Jack Lord

Judy Chicago
United States, b. 1939

Car Hood, 1964
Sprayed acrylic lacquer on 1964 Corvair hood
48 x 48 x 5 in. (121.9 x 121.9 x 12.7 cm)
The Sutnar Foundation
p. 204

*Menstruation Bathroom from Womanhouse,
a Collaborative Site-Specific Installation*, 1972
Excerpt from *Womanhouse* by Johanna
Demetrakas, 16 mm film documentation (color,
with sound, forty-three minutes) of installation,
transferred to videotape for this exhibition
Lent by the artist and Johanna Demetrakas
p. 230

Georgia O'Keeffe Plate #1, 1979
Whiteware with china paint
14⅞ x 14⅝ in. (37.8 x 37.2 cm)
San Francisco Museum of Modern Art,
gift of Mary Ross Taylor
p. 230

The Dinner Party, 1979
Excerpt from *Right Out of History: The Making
of Judy Chicago's "Dinner Party"* by Johanna
Demetrakas, 16 mm film documentation (color,
with sound, seventy-six minutes) of installation,
transferred to videotape for this exhibition
Lent by the artist and Johanna Demetrakas

Christo [Christo Javacheff]
Bulgaria, active United States, b. 1935

*Running Fence, Project for Sonoma and Marin
Counties, California. Collage 1975*, 1975
Pencil, fabric, charcoal, crayon, technical data,
ballpoint pen, and tape
22 x 28 in. (56 x 71 cm)
Collection of Christo and Jeanne-Claude

Christo [Christo Javacheff]
Bulgaria, active United States, b. 1935
Jeanne-Claude [Jeanne-Claude de Guillebon]
Morocco, active United States, b. 1935

*Running Fence, Sonoma and Marin Counties,
California, 1972–76*, 1976
Photo documentation of installation
Lent by the artists
p. 196

David P. Chun
United States, 1899–1989

To the Coit Tower, 1934–35
Color lithograph
Sheet: 15½ x 15⅝ (39.4 x 39.7 cm)
United States Government Treasury
Department, Public Works of Art Project,
Washington, D.C., on permanent loan to
LACMA

Unemployed, n.d.
Woodcut
7¾ x 10⅝ in. (19.69 x 27 cm)
San Francisco Museum of Modern Art, Albert
M. Bender Collection, gift of Albert M. Bender

Julius Cindrich
United States, 1890–1981

Evening, Green Bay, c. 1925
Gelatin-silver bromide print
10¹¹⁄₁₆ x 13¹¹⁄₁₆ in. (27.2 x 34.7 cm)
Dennis and Amy Reed Collection
p. 125

Robin Charles Clark
United States, b. 1956

My Favorite Flagpole, 1995
Oil on currency mounted on redwood
11 x 8½ x 1½ in. (27.9 x 21.6 x 3.7 cm)
Collection of Bill Rush

Emmon Clarke
United States, b. 1933

Untitled, 1960s
Gelatin-silver print
11 x 14 in. (27.9 x 35.6 cm)
Center for Photojournalism and Visual History,
California State University, Northridge
p. 224

William Claxton
United States, b. 1927

Stan Getz, Hollywood, 1954, printed 1999
Gelatin-silver print, edition 5/25
23⅜ x 18⁵⁄₁₆ in. (59.4 x 46.5 cm)
Lent by the artist, courtesy Fahey/Klein Gallery,
Los Angeles
p. 184

Marian Clayden
England, active United States, b. 1937

Rainforest Coat, 1987
Silk, permanently pleated, discharge
and clamp resist dyed
Coat CB: 60 in. (152.4 cm)
Lent by the artist

Stiles Clements
United States, 1883–1966
Morgan, Walls, and Clements, United States,
1920–37

*The Mayan Theater, Los Angeles, Hill Street
Façade*, 1926–27
Graphite on tracing paper
34 x 52 in. (86.4 x 132.1 cm)
Courtesy The Huntington Library, San Marino,
California

Alvin Langdon Coburn
United States, 1882–1966

Giant Palm Trees, California Mission, 1911
Platinum print
15⅞ x 12¼ in. (40.4 x 31.1 cm)
Courtesy George Eastman House, gift
of Alvin Langdon Coburn
p. 90

Robert Colescott
United States, b. 1925

I Gets a Thrill Too When I Sees De Koo, 1978
Acrylic on canvas
84 x 66 in. (213.4 x 167.6 cm)
Rose Art Museum, Brandeis University,
Waltham, Massachusetts. Gift of Senator
and Mrs. William Bradley, 1978

Will Connell
United States, 1898–1961

*Southern California Edison Plant
at Long Beach*, 1932
Gelatin-silver print
16 x 20 in. (40.6 x 50.8 cm)
Collection of Michael Dawson

Make-Up
From the publication *In Pictures*, c. 1937
Gelatin-silver print
16¹³⁄₁₆ x 13¾ in. (42.7 x 35 cm)
Photographic History Collection, National
Museum of American History, Smithsonian
Institution
p. 133

Bruce Conner
United States, b. 1933

PORTRAIT OF ALLEN GINSBERG, 1960
Wood, fabric, feathers, wax, tin can, metal,
string, and spray paint
20 x 11¼ x 21⅜ in. (50.8 x 28.6 x 54.3 cm)
Whitney Museum of American Art, New York,
purchased with funds from the Contemporary
Painting and Sculpture Committee

Marika Contompasis
United States, b. 1948

Trout Magnolia Kimono, 1977
Wool yarn, loom knitted
56 x 56 in. (142.2 x 142.2 cm)
Collection of Julie Schafler Dale, courtesy of
Julie: Artisans' Gallery, New York
p. 231

Lia Cook
United States, b. 1942

Emergence, 1979
Rayon and polyurethane foam
69 x 58⅜ x 3 in. (175.3 x 148.3 x 7.6 cm)
Collection American Craft Museum, New York.
Gift of Dr. Richard Gonzalez in memory
of Lorraine Gonzalez, 1981. Donated to the
American Craft Museum by the American
Craft Council, 1990
p. 211

Presence/Absence: Legs and Knees, 1997
Cotton and rayon, handwoven jacquard
58 x 40 in. (147.3 x 101.6 cm)
Lent by the artist

Miles Coolidge
United States, b. 1963

Near Tulare Lake
From the Central Valley series, 1998
Chromogenic development print
10¼ x 132½ in. (26 x 336.6 cm)
Lent by the artist, courtesy ACME, Los Angeles

Ron Corbin
United States, b. 1943

Untitled, 1990, printed 1994
Gelatin-silver print
9⅝ x 9⅝ in. (24.4 x 24.4 cm)
LACMA, Ralph M. Parsons Fund
p. 244

Untitled, 1990, printed 1994
Gelatin-silver print
9¹¹⁄₁₆ x 9⅝ in. (24.6 x 24.4 cm)
LACMA, Ralph M. Parsons Fund

Keith Cottingham
United States, b. 1965

Triplets
From the Fictitious Portraits series, 1993
Dye-coupler print from a digitized source,
edition 3/15
22 x 18½ in. (55.9 x 47 cm)
LACMA, Ralph M. Parsons Fund
p. 235

Craig Cowan
United States, 1947–1993

Untitled: Nude, 1992
Hand-toned internal dye-diffusion transfer
(Polaroid) print
4½ x 3½ in. (11.4 x 8.9 cm)
LACMA, purchased with funds provided
by Dr. Eugene Rogolsky, M.D.

Elsie Crawford
United States, 1913–1999

Zipper Light I and II, designed 1965, fabricated
1997
Acrylic
(I) H: 18 in. (45.7 cm); D: 26 in. (66 cm);
(II) H: 26½ in. (67.3 cm); D: 12 in. (30.5 cm)
LACMA, gift of the artist
p. 163

Russell Crotty
United States, b. 1956

Letter from South Lagoon, 1989
Black ink on paper
72 x 48 in. (182.9 x 121.9 cm)
Collection of Barry Sloane

Rinaldo Cuneo
United States, 1877–1939

California Landscape, 1928
Oil on canvas set in three-part screen
Overall: 66 x 66 in. (167.6 x 167.6 cm)
Private collection
p. 117

Imogen Cunningham
United States, 1883–1976

Aloe Bud, 1930
Gelatin-silver print
12½ x 9¼ in. (31.8 x 23.5 cm)
LACMA, Los Angeles County Fund
p. 123

Darryl Curran
United States, b. 1935

777, 1968
Gelatin-silver print, high-contrast lithographic
film, wood, metal, and glass
14 x 11½ x 2 in. (35.6 x 29.2 x 5.1 cm)
Lent by Darryl and Doris Curran

Edward S. Curtis
United States, 1868–1952

The Burden Basket—Coast Pomo
From *The North American Indian*, vol. 14
(1924), pl. 472
Gelatin-silver print
10 x 8 in. (25.4 x 20.3 cm)
Lent by the Southwest Museum, Los Angeles

Canoe of Tules—Pomo
From *The North American Indian*, vol. 14
(1924), pl. 489
Photogravure
11½ x 15½ in. (29.2 x 39.4 cm)
Lent by the Southwest Museum, Los Angeles

A Desert Cahuilla Woman
From *The North American Indian*, vol. 15
(1924), pl. 522
Photogravure
15½ x 11½ in. (39.4 x 29.2 cm)
Lent by the Southwest Museum, Los Angeles
p. 93

Mitat—Wailaki
From *The North American Indian*, vol. 14
(1924), pl. 472
Photogravure
15½ x 11½ in. (39.4 x 29.2 cm)
Lent by the Southwest Museum, Los Angeles
p. 93

*"Pomo," a Cherokee Who Migrated
to California*, 1924
Gelatin-silver print
9½ x 8 in. (24.1 x 20.3 cm)
Lent by the Southwest Museum, Los Angeles

Dana and Towers Photography Studio
United States, c. 1906

*#115. Looking South from Stockton
and Sutter*, 1906
Gelatin-silver print
3½ x 11¾ in. (8.9 x 29.8 cm)
Collection of Mrs. Nancy Dubois

#121. Looking East on Market Street, 1906
Gelatin-silver print
3½ x 11⅛ in. (8.9 x 28.3 cm)
Collection of Mrs. Nancy Dubois
pp. 66–67

Lowell Darling
United States, b. 1942
Dana Atchley
United States, b. 1941

Campaign Tapes, 1980
Videotape documentation (color, with sound,
six minutes) by Atchley of Darling's campaign
for governor of California
Lent by Dana Atchley

William Dassonville
United States, 1879–1957

*Half Dome and Clouds, Merced River,
Yosemite Valley*, c. 1905
Platinum print
7⅜ x 9⅛ in. (18.7 x 23.2 cm)
Courtesy Paul Hertzmann, Susan Herzig, and
Paul M. Hertzmann, Inc., San Francisco
pp. 72–73

Grasses, c. 1920
Gelatin-silver print
10 x 8 in. (25.5 x 20.4 cm)
The Wilson Center for Photography

*Untitled, Oil Refinery, Richmond,
California*, c. 1920
Gelatin-silver print
8 x 10 in. (20.5 x 25.5 cm)
The Wilson Center for Photography

Judy Dater
United States, b. 1941

Libby, 1971
Gelatin-silver print
14 x 11 in. (35.6 x 27.9 cm)
Lent by the artist
p. 229

Nehemiah, 1975, printed 1981
Gelatin-silver print
10⅜ x 13½ in. (26.4 x 34.3 cm)
Santa Barbara Museum of Art, gift
of Arthur and Yolanda Steinman

Arthur Bowen Davies
United States, 1862–1928

Pacific Parnassus, Mount Tamalpais, c. 1905
Oil on canvas
26¼ x 40¼ in. (66.7 x 102.2 cm)
Fine Arts Museums of San Francisco, Museum
Purchase, gift of The Museum Society Auxiliary
p. 83

Ron Davis
United States, b. 1937

Roto, 1968
Polyester resin and fiberglass
62 x 136 in. (157.5 x 345.4 cm)
LACMA, Contemporary Art Council Fund
p. 210

Robert Dawson
United States, b. 1950

Untitled #1, 1979
From the Mono Lake series
Gelatin-silver print
7⅛ x 12 in. (18.1 x 30.5 cm)
LACMA, gift of Sue and Albert Dorskind
p. 195

*Polluted New River, Mexican/American Border,
Calexico, California*, 1989
From the project *Farewell, Promised Land*
Gelatin-silver print
16 x 20 in. (40.6 x 50.8 cm)
Lent by the artist

Richard Day
Canada, active United States, 1896–1972

California Boom, before 1932
Lithograph
9 x 14 in. (22.9 x 35.5 cm)
Victoria Dailey

Joe Deal
United States, b. 1947

Colton, California, 1978
From the portfolio *The Fault Zone*, 1981
Gelatin-silver print
8 x 10 in. (20.3 x 25.4 cm)
LACMA, gift of Lewis Baltz
p. 241

Georganne Deen
United States, b. 1951

Mary's Lane: Family Room, 1993
Oil on linen
58 x 48 in. (147.3 x 121.9 cm)
Jeff Kerns, Los Angeles
p. 253

Jay DeFeo
United States, 1929–1989

The Jewel, 1959
Oil on canvas
120 x 55 in. (304.8 x 139.7 cm)
LACMA, gift of the 1998 Collectors Committee
p. 181

Stephen De Hospodar
Hungary, active United States, 1902–1959

Rhythm, c. 1930
Woodcut
9¼ x 5½ in. (23.5 x 14 cm)
Victoria Dailey

Einar de la Torre
Mexico, active United States, b. 1963
Jamex de la Torre
Mexico, active United States, b. 1960

Marte y Venus, 1997
Glass and mixed media
62 x 25 in. (157.5 x 63.5 cm)
Lent by the artists, courtesy Daniel Saxon
Gallery
p. 263

Pedro de Lemos
United States, 1882–1954

Path to the Sea, c. 1920
Color woodcut
19 x 14¾ in. (48.3 x 37.5 cm)
Victoria Dailey

292

Paul de Longpré
France, active United States, 1855–1911

Roses La France and Jack Noses with Clematis on a Lattice Work, No. 36, 1900
Watercolor on paper
27 ¼ x 14 ¾ in. (69.2 x 37.5 cm)
LAM/OCMA Art Collection Trust,
gift of Nancy Dustin Wall Moure
p. 80

Neil M. Denari
United States, b. 1957

Westcoast Gateway, WG11: View from Helicopter, 1989
Ink on Mylar
18 x 24 in. (45.7 x 61 cm)
Lent by the architect, Neil M. Denari Architects

Lewis deSoto
United States, b. 1954

Tideline, 1981–82
Photo documentation of sitework at Leucadia, California, transferred to videotape for this exhibition
Lent by the artist

Ellipse Tide, 1982
Photo documentation of sitework, transferred to videotape for this exhibition
Lent by the artist

Plans for Wave System, 1983
Photo documentation of Diazo print drawing for sitework at San Marcos State Beach, transferred to videotape for this exhibition
Lent by the artist

Wave System, 1983
Photo documentation of sitework at San Marcos State Beach, transferred to videotape for this exhibition
Lent by the artist

Plans for Tideline 2, 1984
Photo documentation of Diazo print drawing for sitework at Leucadia, California, transferred to videotape for this exhibition
The Museum of Photographic Arts, San Diego

Tideline 2, 1984
Photo documentation of sitework at Leucadia, California, transferred to videotape for this exhibition
The Museum of Photographic Arts, San Diego

Stephen De Staebler
United States, b. 1933

Seated Kangaroo Woman, 1978
Clay, fired
74 x 19 in. (188 x 48.3 cm)
Lent by the artist
p. 215

Mary Ann DeWeese
United States, b. circa 1914
For Catalina Sportswear, founded 1907

Woman's Bathing Suit, mid-1940s
Hand-printed Lastex
CB: 16 in. (40.6 cm)
LACMA, gift of The Fashion Group, Inc., of Los Angeles

Kris Dey
United States, b. 1949

Ancho II, 1991
Painted cotton strips
72 x 96 x 1 in. (182.9 x 243.8 x 2.5 cm)
Lent by the artist
p. 239

Richard Diebenkorn
United States, 1922–1993

Berkeley #32, 1955
Oil on canvas
59 x 57 in. (149.9 x 144.8 cm)
Richard E. Sherwood Family Collection
p. 169

Freeway and Aqueduct, 1957
Oil on canvas
23 ¼ x 28 in. (59.1 x 71.1 cm)
LACMA, gift of William and Regina Fadiman
p. 30

Ocean Park Series #49, 1972
Oil on canvas
93 x 81 in. (236.2 x 205.7 cm)
LACMA, purchased with funds provided by Paul Rosenberg & Co., Lita A. Hazen, and the David E. Bright Bequest
p. 194

Phil Dike
United States, 1906–1990

Surfer, c. 1931
Oil on canvas
32 x 29 in. (81.3 x 73.7 cm)
Collection of A. Lawrence and Anne Spooner Crowe
p. 127

Dominic Di Mare
United States, b. 1932

Domus #8/Where the River Meets the Sea, 1984
Horsehair, gold leaf, wood, and photograph
60 x 23 in. (152.4 x 58.4 cm)
American Craft Museum, New York

Kim Dingle
United States, b. 1951

Two Girls, One with Head in Heaven, 1992
Oil on linen
72 x 60 in. (182.9 x 152.4 cm)
Collection of Kimberly Light

Christian Dior
France, 1905–1957
For Cole of California, United States, founded 1923

Woman's Bathing Suit, 1956
Laton taffeta
CB: 19 in. (48.3 cm)
LACMA, gift of Fred Cole of Cole of California

John Divola
United States, b. 1949

Zuma No. 21, 1977
From the portfolio *Zuma One*, 1978
Dye-imbibition print, edition 7/30
14 ½ x 18 in. (36.8 x 45.7 cm)
LACMA, Ralph M. Parsons Fund
p. 197

Boats at Sea #1
Isolated Houses #3
Occupied Landscapes #3
Stray Dogs #2
From the portfolio *Four Landscapes*, 1993
Gelatin-silver prints
Each print: 17 ⅞ x 17 ⅞ in. (45.4 x 45.4 cm)
LACMA, promised gift of Jeffrey Leifer

Maynard Dixon
United States, 1875–1946

Airplane, c. 1930
Gouache on paper
19 x 17 ½ in. (48.3 x 44.5 cm)
Automobile Club of Southern California
p. 108

Arthur Burnside Dodge
United States, 1865–1952

Taking in the News, 1891
Watercolor on paper
14 x 16 ½ in. (35.6 x 41.9 cm)
Collection of Dr. Oscar and Trudy Lemer

Taken by Surprise, n.d.
Watercolor on paper
14 ⅝ x 15 in. (37.1 x 38.1 cm)
Collection of Dr. Oscar and Trudy Lemer
p. 97

Alex Donis
United States, b. 1964

Rio, por no Ilorar, 1988
Screenprint
39 x 26 in. (99.1 x 66 cm)
LACMA, purchased with funds provided by the
Art Museum Council

Harold Lukens Doolittle
United States, 1883–1974

Plaque, c. 1915
Brass and glass
11 x 8 in. (27.9 x 20.3 cm)
LACMA, purchased with funds provided by the
Art Museum Council

Ricardo Duffy
United States, b. 1951

The New Order, 1996
Screenprint
20 x 26 in. (50.8 x 66 cm)
LACMA, purchased with funds provided by the
Art Museum Council
p. 269

Raymond Duncan
United States, 1874–1966

Scarf, c. 1920
Wool crepe, block printed and brush dyed
57 x 25 in. (144.8 x 63.5 cm)
The Oakland Museum of California, the Estate
of Phoebe H. Brown

Tony Duquette
United States, 1914–1999

Console Table and Mirror, c. 1960
Cast resin, gold leaf, and mirror
Table: 96 x 24 in. (243.8 x 61 cm);
Mirror: 39 x 27 in. (99.1 x 68.6 cm)
Courtesy Hutton Wilkinson

Eliot Duval
United States, 1909–1990

Third Street Traffic, Bunker Hill, 1932
Watercolor on paper
9 x 11¾ in. (22.9 x 29.8 cm)
Duval Estate, George Stern Fine Arts,
Los Angeles

Mexican Town, Chavez Ravine, c. 1939
Watercolor on paper
14¼ x 21 in. (36.2 x 53.3 cm)
LACMA, gift of Tamara Eliot

Fannie Duvall
United States, 1861–1934

Confirmation Class, San Juan Capistrano, 1897,
1897
Oil on canvas
20 x 30 in. (50.8 x 76.2 cm)
Lent by the Bowers Museum of Cultural Art,
Santa Ana, gift of Miss Vesta A. Olmstead
and Miss Frances Campbell

Charles Eames
United States, 1907–1978
Ray Eames
United States, 1912–1988

Plywood Stretcher, 1943
Molded plywood
72½ x 45 in. (184.2 x 114.3 cm)
Lucia Eames

Leg Splint, c. 1943
Molded plywood
42 x 6 in. (106.7 x 15.2 cm)
LACMA, gift of Don Menveg

Leg Splints and Packaging Box, c. 1943
Molded plywood and cardboard box
Each splint: 42 x 6 in. (106.7 x 15.2 cm)
Courtesy Andrew H. and Lydia Sussman
p. 150

FSW (Folding Screen Wood), 1946
Wood and canvas
Screen open: 67½ x 60 in. (171.5 x 152.4 cm)
LACMA, gift of the Employees of Herman
Miller, Inc.

LCW (Low Chair Wood), c. 1946
Molded ash plywood, metal, and rubber
shock mounts
26½ x 21¾ in. (67.3 x 55.2 cm)
Anonymous lender

Three Plastic Armchairs, 1950–53
Plastic, steel base (two examples), wood base
(one example), and rubber shock mounts
Each: 36 x 24 in. (91.4 x 61 cm)
Courtesy Andrew H. and Lydia Sussman

ETR (Elliptical Table, Rod Base), 1951
Plywood, plastic laminate, and wire base
10 x 89¼ in. (25.4 x 226.7 cm)
Mrs. A. Quincy Jones
p. 161

ESU (Eames Storage Unit), 1951–52
Plywood, metal, and particleboard
30¼ x 77¾ in. (76.8 x 197.5 cm)
LACMA, gift of Sid Avery and James Corcoran
p. 163

Wire Mesh Chair with Low Wire Base, 1951–53
Wire
24 x 18 in. (61 x 45.7 cm)
Courtesy Andrew H. and Lydia Sussman
p. 163

La Fonda Chair, c. 1963
Aluminum, plastic, vinyl, and fiberglass
24½ x 22 in. (62.2 x 55.9 cm)
LACMA, gift of the Employees of Herman
Miller, Inc.

Ray Eames
United States, 1912–1988

Sea Things, 1945
From the *Stimulus Collection*, produced
by Schiffer Prints, division of Mil-Art
Company, Inc., 1949
Cotton, screenprinted and hand printed
53 x 49 in. (134.6 x 124.5 cm)
LACMA, Curatorial Special Purpose Fund

John Paul Edwards
United States, 1884–1968

William Ritschel Painting by the Ocean, c. 1920
Bromoil print
11⅛ x 9 in. (28.3 x 22.9 cm)
The Oakland Museum of California, gift
of Mrs. John Paul Edwards

Craig Ellwood
United States, 1922–1992

*Art Center College of Design, Pasadena,
Rendered Perspective*, 1974
Drawing by Carlos Diniz
Ink on paper
24½ x 72 in. (62.6 x 182.9 cm)
Collection of Carlos Diniz

Charles A. Elsenius
United States, 1883–1963
Woolenius Tile Company (later Elsenius
Tile and Mantel Company), United States,
1927–39

Tiles with Mayan Motifs, 1927–39
Earthenware
5 x 9 in. (12.7 x 22.9 cm); 8 x 8 in.
(20.3 x 20.3 cm)
Collection of Norman Karlson

Jules Engel
Hungary, active United States, b. 1915

Brilliant Moves, 1946
Gouache on paper
19 x 25 in. (48.3 x 63.5 cm)
Mr. and Mrs. Albert Kallis, Los Angeles

MacDuff Everton
United States, b. 1937

Golden Gate Bridge from Fort Point, c. 1990
Chromogenic development print
96 x 48 in. (243.8 x 121.9 cm)
LACMA, Ralph M. Parsons Fund

Manny Farber
United States, b. 1917

Roads and Tracks, 1981
Oil on board
89 x 57 in. (226.1 x 144.8 cm)
Courtesy Quint Contemporary Art

Sohela Farokhi
Iran, active United States, b. 1956
Lars Lerup
Sweden, active United States, b. 1940

House of Flats, Proposed Site in San Francisco,
Working Drawing #2, 1989
Mixed media on Bristol paper
30³⁄₁₆ x 22⅝ in. (76.7 x 57.5 cm)
San Francisco Museum of Modern Art,
Visionary San Francisco Commission

Fred Fehlau
United States, b. 1958

Between a Rock and a Hard Place
(Inside/Outside), 1991
Screenprint
15⅛ x 15⅛ in. (38.4 x 38.4 cm)
LACMA, gift of Eileen and Peter Norton

Lorser Feitelson
United States, 1898–1978

Magical Space Forms, No. 12, 1951
Oil on Masonite
30 x 40 in. (76.2 x 101.6 cm)
LACMA, gift of Mrs. June Wayne

Margit Fellegi
Hungary, active United States, c. 1908–1975
For Cole of California, United States,
founded 1923

Woman's Two-Piece Bathing Suit,
"Swoon Suit," 1942
Acetate satin
Top L: 42 in. (106.7 cm); Shorts CB: 13½ in.
(34.3 cm)
LACMA, gift of the artist

Woman's Bathing Suit and Skirt, c. 1944
Glazed cotton chintz, cotton, and elastic
(Matletex)
Bathing suit CB: 15½ in. (39.4 cm);
Skirt CB: 43 in. (109.2 cm)
LACMA, gift of The Fashion Group, Inc.,
of Los Angeles
p. 158

Woman's Bathing Suit Dress, 1946
Velvet and elastic (Matletex)
CB: 48 in. (121.9 cm)
LACMA, gift of the artist

Arline Fisch
United States, b. 1931

Halter and Skirt, 1968
Sterling silver and printed velvet
Halter: 22 x 11 in. (55.9 x 27.9 cm);
Skirt: 46 x 24 in. (116.8 x 61 cm)
American Craft Museum, New York

Hal Fischer
United States, b. 1950

Signifiers for a Male Response
From the series Gay Semiotics, 1977
Gelatin-silver print
18½ x 12⁷⁄₁₆ in. (47 x 31.8 cm)
San Francisco Museum of Modern Art,
gift of Richard Lorenz

Oskar Fischinger
Germany, active United States, 1900–1967

Abstraction, 1943
Oil on panel
18 x 22 in. (45.7 x 55.9 cm)
LACMA, purchased with funds provided by the
Austin and Irene Young Trust by exchange

Radio Dynamics, 1943
16 mm film (color, with sound, twelve minutes)
Lent by Fischinger Archive
p. 190

Frederick Fisher
United States, b. 1949

Jorgensen House (Conceptual Sketch),
Los Angeles, 1980
Graphite, metallic powder, and oil pastel on
paper
31 x 23½ in. (78.7 x 59.7 cm)
Lent by Frederick Fisher

George Fiske
United States, 1835–1918

Dancing on the Overhanging Rock at Glacier
Point, 5,200 ft., c. 1895–1905
Albumen print
4½ x 7½ in. (11.4 x 19.1 cm)
Yosemite Museum, National Park Service

Judy Fiskin
United States, b. 1945

Untitled #195, 1982
From the Dingbat series, 1981–83
Gelatin-silver print
2¾ x 2¾ in. (7 x 7 cm)
LACMA, gift of John Rollins
p. 244

Untitled #163, 1983
From the Dingbat series, 1981–83
Gelatin-silver print
2¾ x 2¾ in. (7 x 7 cm)
LACMA, gift of Dr. and Mrs. Merle S. Glick

Untitled #199, 1983
From the Dingbat series, 1981–83
Gelatin-silver print
2¾ x 2¾ in. (7 x 7 cm)
LACMA, gift of Patricia Faure

Bob Flanagan
United States, 1952–1996
Sheree Rose
United States, b. 1945

Leather from Home, 1983
Videotape (color, with sound, eight minutes)
Lent by Sheree Rose

Bob Flanagan
United States, 1952–1996
Mike Kelley
United States, b. 1954
Sheree Rose
United States, b. 1945

100 Reasons, 1991
Text by Mike Kelley, concept by Bob Flanagan
and Sheree Rose
Videotape (color, with sound, six minutes)
Lent by Sheree Rose

Louis Fleckenstein
United States, 1866–1942

Rose Dance of the South, c. 1916
Gelatin-silver bromide print
9¹⁄₁₆ x 6¹⁄₁₆ in. (23.1 x 15.5 cm)
Dennis and Amy Reed Collection

Christine Fletcher
United States, 1872–1961

Fog from the Pacific (No. 4), c. 1931
Gelatin-silver print
13½ x 10⅛ in. (34.3 x 25.7 cm)
LACMA, gift of Susan and G. Ray Hawkins
p. 128

Frank Morley Fletcher
England, active United States, 1866–1949

California 2. Mt. Shasta, c. 1930
Color woodcut
11⅝ x 15⅞ in. (29.6 x 40.3 cm)
Fine Arts Museums of San Francisco,
Achenbach Foundation for Graphic Arts,
Museum Purchase
p. 129

Robbert Flick
Holland, active United States, b. 1939

Along Pico Looking North, from Appian Way,
Santa Monica, to Central Avenue, Los Angeles
(Pico B), 1998–99
Silver dye-bleach (Cibachrome) print
38 x 48 in. (96.5 x 121.9 cm)
LACMA, Ralph M. Parsons Fund
p. 271

Peter Forakis
United States, active 1950s

Poster for the 6 Gallery, Poetry Reading,
October 7, 1955, 1955
Color screenprint
21 1/16 x 12 13/16 in. (53.5 x 32.5 cm)
Fine Arts Museums of San Francisco,
Achenbach Foundation for Graphic Arts, Gift
of José Ramon Lerma in memory of Ruth Wall

Helen Forbes
United States, 1891–1945

Manley's Beacon, Death Valley, c. 1930
Oil on canvas
24 x 40 in. (61 x 101.6 cm)
The National Museum of Women in the Arts,
gift of Richard York
p. 123

Myoshi, c. 1935
Oil on canvas
26 x 22 in. (66 x 55.9 cm)
LACMA, promised gift of Nancy Dustin
Wall Moure

Robert F. Foss
United States

F. H. Lemon Residence, Pasadena, East Front
Elevation, 1912
Ink on linen
16 13/16 x 23 3/16 in. (42.7 x 58.5 cm)
Courtesy The Huntington Library, San Marino,
California

Llyn Foulkes
United States, b. 1934

Death Valley, U.S.A., 1963
Oil on canvas
65 1/2 x 64 3/4 in. (166.4 x 164.5 cm)
Betty and Monte Factor Collection,
Santa Monica, California
p. 194

Sam Francis
United States, 1923–1994

SFP68-29, 1968
Acrylic on canvas
101 x 86 in. (256.5 x 218.4 cm)
Jonathan Novak, Los Angeles
p. 213

Robert Frank
Switzerland, active United States, b. 1924

Covered Car, Long Beach, California, 1956
Gelatin-silver print
11 x 13 7/8 in. (27.9 x 35.2 cm)
The Museum of Contemporary Art,
Los Angeles, The Ralph M. Parsons
Foundation Photography Collection
p. 41

Movie Premiere, Hollywood, 1956
Gelatin-silver print
13 7/8 x 11 in. (35.2 x 27.9 cm)
The Museum of Contemporary Art,
Los Angeles, The Ralph M. Parsons
Foundation Photography Collection

Television Studio, Burbank, California, 1956
Gelatin-silver print
11 x 13 7/8 in. (27.9 x 35.2 cm)
The Museum of Contemporary Art,
Los Angeles, The Ralph M. Parsons
Foundation Photography Collection
p. 178

Viola Frey
United States, b. 1933

He Man, 1983
Ceramic, glazed
109 x 37 in. (276.8 x 94 cm)
Frederick R. Weisman Art Foundation,
Los Angeles
p. 258

Anthony Friedkin
United States, b. 1949

Surfboard in the Setting Sun, Santa Monica,
California, 1977
From the Surfing Essay
Gelatin-silver print
16 x 20 in. (40.6 x 50.8 cm)
Lent by the artist
p. 203

Clockwork, Malibu, 1978
From the Surfing Essay
Gelatin-silver print
16 x 20 in. (40.6 x 50.8 cm)
Lent by the artist

Lee Friedlander
United States, b. 1934

Los Angeles, California, 1965
Gelatin-silver print
11 x 14 in. (27.9 x 35.6 cm)
The Museum of Contemporary Art,
Los Angeles, The Ralph M. Parsons
Foundation Photography Collection
p. 198

Larry Fuente
United States, b. 1947

Derby Racer (completed for the San Francisco
Museum of Modern Art's "Artist Soap Box
Derby" event), 1975
Mixed media in epoxy on fiberglass Berkeley
(car model c. 1962)
43 x 151 in. (109.2 x 377.5 cm)
Lent by the artist
p. 205

Kip Fulbeck
United States, b. 1965

Banana Split, 1991
Videotape (color, with sound,
thirty-eight minutes)
Lent by Video Data Bank

Coco Fusco
United States, b. 1960
Paula Heredia
El Salvador, active United States, b. 1957

The Couple in the Cage: Guatianaui
Odyssey, 1993
Videotape (color, with sound, thirty-one
minutes)
Lent by Video Data Bank

James Galanos
United States, b. 1924

Woman's Coat, 1970
Denim and sable fur
Coat CB: 51 in. (129.5 cm); Belt L: 38 1/2 in.
(97.8 cm)
LACMA, gift of the artist

John Marshall Gamble
United States, 1863–1957

Breaking Fog, Hope Ranch,
Santa Barbara, c. 1908
Oil on canvas
24 x 34 in. (61 x 86.4 cm)
The Fieldstone Collection
p. 71

Harry Gamboa Jr.
United States, b. 1951

The Great Wall (of East L.A.), 1978,
printed 1999
Gelatin-silver print
16 x 20 in. (40.6 x 50.8 cm)
Lent by the artist

Patssi Valdez, 1980, 1980, printed 1999
Gelatin-silver print
20 x 16 in. (50.8 x 40.6 cm)
Lent by the artist

Rupert García
United States, b. 1941

Ruben Salazar Memorial Group Show, 1970
Color screenprint
26 x 20 in. (66 x 50.8 cm)
Fine Arts Museums of San Francisco,
Achenbach Foundation for Graphic Arts,
gift of Mr. and Mrs. Robert Marcus

U.S. Out Now!, 1972
Screenprint on orange paper
23¼ x 17¾ in. (54.1 x 45.1 cm)
Fine Arts Museums of San Francisco,
Achenbach Foundation for Graphic Arts,
gift of Mr. and Mrs. Robert Marcus

William Garnett
United States, b. 1916

Lakewood Housing Project, 1950
Six gelatin-silver prints
Each: 8 x 10 in. (20.3 x 25.4 cm)
Collection of Kathy and Ron Perisho
p. 157

Frances Hammel Gearhart
United States, 1869–1958

Low Tide, c. 1910s
Color woodcut
10¹⁄₁₆ x 11¹⁄₁₆ in. (25.6 x 28 cm)
Fine Arts Museums of San Francisco,
Achenbach Foundation for Graphic Arts,
California State Library Long-Term Loan

Autumn Brocade (Big Bear Lake), c. 1920
Color woodcut
12 x 9⁵⁄₁₆ in. (30.5 x 23.7 cm)
LACMA, gift of Ellen and Max Palevsky

Sinererias, c. 1920
Color woodcut
10½ x 11¾ in. (26.7 x 29.9 cm)
Victoria Dailey

On the Salinas River, 1920s
Color woodcut
9¼ x 6⅝ in. (23.5 x 16.9 cm)
LACMA, gift of the Associate Members
of the Printmakers Society of California
p. 70

May Gearhart
United States, 1872–1951

The Rim of the World, c. 1910s
Color woodcut
7¹⁄₁₆ x 4¹⁵⁄₁₆ in. (18 x 12.5 cm)
Fine Arts Museums of San Francisco,
Achenbach Foundation for Graphic Arts,
California State Library Long-Term Loan

Yun Gee
China, active United States, 1906–1963

Where Is My Mother, 1926–27
Oil on canvas
20⅛ x 16 in. (51.1 x 40.6 cm)
Collection of Li-lan
p. 142

Chinese Musicians, c. 1927
Oil on paperboard
19¾ x 15 in. (50.2 x 38.1 cm)
Hirshhorn Museum and Sculpture Garden,
Smithsonian Institution, gift of Joseph H.
Hirshhorn Purchase Fund, 1972

Frank Gehry
Canada, active United States, b. 1929

The Bubbles Lounge Chair, 1987
Corrugated cardboard, birch, and metal
interior supports
30 x 81 in. (76.2 x 205.7 cm)
LACMA, gift of Robert H. Halff

*Drawings of the Walt Disney Concert Hall,
Los Angeles*, 1991
Ink on paper
9 x 12 in. (22.7 x 30.5 cm)
Frank O. Gehry & Associates
p. 42

Arnold Genthe
Germany, active United States, 1869–1942

Chinese Family, 1897
Gelatin-silver print
9¼ x 12 in. (23.5 x 30.5 cm)
Collection of Mrs. Nancy Dubois

*Chinatown, San Francisco [Corner of DuPont
and Jackson]*, 1898
Gelatin-silver print
9½ x 13¹³⁄₁₆ in. (24.1 x 35.1 cm)
Collection of Mrs. Nancy Dubois
p. 55

On DuPont Street, 1898
Gelatin-silver print
8⅞ x 12⅞ in. (22.5 x 32.7 cm)
Collection of Mrs. Nancy Dubois

The Opium Fiend, 1905
Gelatin-silver print
10 x 12⅛ in. (25.4 x 30.8 cm)
The J. Paul Getty Museum, Los Angeles
p. 95

Rudi Gernreich
Austria, active United States, 1922–1985

Woman's Bathing Suit, 1952
Wool knit
CB: 23 in. (58.4 cm)
LACMA, gift of Walter Bass
p. 176

"Topless" Bathing Suit, 1964
Wool knit
CB: 15 in. (38 cm)
LACMA, gift of the artist
p. 219

*Bathing Suit and Hip Boots, Matching Belt,
and Sun Visor*, 1965
Hip boots by Capezio
Sun visor (reproduction) by Layne Nielson
(United States, b. 1938)
Wool knit bathing suit, vinyl belt, and
vinyl boots
CB: 7¼ in. (18.4 cm); Belt: 37 x ⅞ in.
(94 x 2.2 cm); Boots: 32 x 10¼ x 3 in.
(81.3 x 26 x 7.6 cm)
Gift of Rudi Gernreich, Museum Collection,
The Fashion Institute of Design &
Merchandising

Unisex Caftan, 1970
Printed silk
CB: 71½ in. (181.6 cm)
Gift of Rudi Gernreich, Museum Collection,
The Fashion Institute of Design &
Merchandising
p. 219

Selden Conner Gile
United States, 1877–1947

The Soil, 1927
Oil on canvas
30 x 36 in. (76.2 x 91.4 cm)
Private collection
p. 117

Boat and Yellow Hills, n.d.
Oil on canvas
30½ x 36 in. (77.5 x 91.4 cm)
The Oakland Museum of California, gift
of Dr. and Mrs. Frederick Novy Jr.
p. 74

Irving J. Gill
United States, 1870–1936

*Nelson E. Barker Residence, San Diego,
Perspective Elevation*, 1911–12
Graphite, colored pencil, and gouache on paper
12 x 18 in. (30.5 x 45.7 cm)
Architecture and Design Collection, University
Art Museum, UCSB

Gladding McBean Pottery
United States, 1923–79

Encanto Chinese Red Vase, c. 1930
Ceramic
H: 7¾ in. (19.7 cm); D: 5 in. (12.7 cm)
Ron and Susan Vander Molen
p. 135

*Pair of Matching Garden Vases in Blue
Crystalline Glaze*, c. 1930
Ceramic
Each: H: 26 in. (66 cm); D: 14 in. (35.6 cm)
Ron and Susan Vander Molen

W. Edwin Gledhill
Canada, active United States, 1888–1976

Santa Barbara Mission, c. 1920
Gelatin-silver print
11¼ x 8½ in. (28.6 x 21.6 cm)
Santa Barbara Museum of Art, gift
of Keith Gledhill
p. 92

Peter Goin
United States, b. 1951

Impenetrable Border, 1987
Gelatin-silver print
11 x 14 in. (27.9 x 35.6 cm)
The Oakland Museum of California, The
Shirley Burden Fund for Photography
p. 266

Jim Goldberg
United States, b. 1953

*Russian Roulette, Breeze, Stratford Hotel,
S.F.*, 1987
From the series Raised by Wolves, 1985–95
Gelatin-silver print
16 x 20 in. (40.6 x 50.8 cm)
Lent by the artist

Hollywood Blvd., 3 a.m., 1988
From the series Raised by Wolves, 1985–95
Gelatin-silver print
16 x 20 in. (40.6 x 50.8 cm)
Lent by the artist

Ken Gonzales-Day
United States, b. 1964

Untitled #63, 1998
From the series The Bone-Grass Boy: Secret
Banks of the Conejos River, 1995–99
Chromogenic development (Ektacolor) print
8 x 10 in. (20.3 x 25.4 cm)
Lent by the artist

Michael Gonzalez
United States, b. 1953

Comp. w/ Y, B, and R #15, 1994
Plastic bags, acrylic, and fasteners
17 x 14 x 1½ in. (43.2 x 35.6 x 3.8 cm)
LACMA, gift of Eileen and Peter Norton,
Santa Monica

Joe Goode
United States, b. 1937

House Drawing (aHOUSEd1), 1963
Pencil on tracing paper
26 x 21¾ in. (66 x 55.3 cm)
The Museum of Contemporary Art,
Los Angeles, purchased with funds provided
by Ruth and Murray Gribin

Untitled (Torn Sky), 1971–76
Oil on canvas
60 x 60½ in. (152.4 x 153.7 cm)
Collection of Hiromi Katayama
p. 212

Robert Graham
United States, b. 1938

Lise I, 1977
Bronze
H: 28 in. (71.1 cm)
LACMA, purchased with matching funds
provided by the National Endowment for the
Arts and Mr. and Mrs. Morley Benjamin

Grand Feu Art Pottery
United States, c. 1913–16

Vase, c. 1913–16
Stoneware
H: 10⅝ in. (27 cm); D: 4⅝ in. (11.7 cm)
LACMA, purchased with funds provided by
the William Randolph Hearst Collection and
the Los Angeles County

Vase, c. 1913–16
Stoneware
H: 11⅛ in. (28.3 cm); D: 4⅛ in. (10.5 cm)
LACMA, gift of Max Palevsky

Vase, c. 1913–16
Stoneware
H: 10⅛ in. (25.7 cm); D: 8⅛ in. (20.6 cm)
LACMA, gift of Max Palevsky

Todd Gray
United States, b. 1954

Goofy (Body) #6, 1993
Hand-varnished gelatin-silver print, installed
with metal bands, edition 3/4
81 x 50 in. (205.7 x 127 cm)
LACMA, gift of Richard and Diane Dunn
p. 248

Phyllis Green
United States, b. 1950

Spark: Green Stockings, 1994
Mixed media
19½ x 9 in. (49.5 x 22.9 cm)
Lent by the artist

Charles Sumner Greene
United States, 1868–1957
Henry Mather Greene
United States, 1870–1954
Greene and Greene, United States, 1893–1922

*Lantern from the Henry M. Robinson House,
Pasadena*, 1906
Steel and slag glass
24¼ x 32¾ in. (61.5 x 83.2 cm)
LACMA, gift of Max Palevsky

*Robert R. Blacker House, Pasadena, South
Elevation, Drawing #6*, 1907
Black ink on linen
14⅛ x 36 in. (35.9 x 91.4 cm)
Avery Architectural and Fine Arts Library,
Columbia University, New York
pp. 88–89

*Bedroom Cabinet from the Robert R. Blacker
House, Pasadena*, 1907
Mahogany, ebony, oak, boxwood, copper,
silver-plated steel, and abalone
24 x 20 in. (61 x 50.8 cm)
LACMA, Museum Acquisition Fund
p. 89

*Bedroom Rocking Chair from the Robert R.
Blacker House, Pasadena*, 1907
Mahogany, ebony, oak, boxwood, copper, silver-
plated steel, abalone, and cotton upholstery
37⅝ x 25⅞ in. (95.6 x 65.7 cm)
LACMA, Museum Acquisition Fund
p. 89

*Living Room Ceiling Fixture from the Freeman
A. Ford House, Pasadena*, 1907
Mahogany, ebony, leaded glass, and iron
12 x 45¼ in. (30.5 x 114.9 cm)
LACMA, gift of Max Palevsky

*Dining Table from the William R. Thorsen
House, Berkeley*, 1908–9
Honduran mahogany and ebony with
fruitwood, oak, and abalone inlays
Without leaves: 29¼ x 67¼ in. (74.3 x 170.2 cm)
The Gamble House, USC, anonymous bequest

*Sideboard from the William R. Thorsen House,
Berkeley*, 1908–9
Honduran mahogany and ebony with
fruitwood, oak, and abalone inlays
36½ x 79¼ in. (92.7 x 201.3 cm)
The Gamble House, USC, anonymous bequest

*Two Host Chairs and Two Side Chairs from the
William R. Thorsen House, Berkeley*, 1908–9
Honduran mahogany and ebony with fruit-
wood, oak, and abalone inlays; leather seats;
and brass pins
Host: 43 x 25 in. (109.2 x 63.5 cm); Side: 42¼ x
21 in. (107.3 x 53.3 cm)
The Gamble House, USC, anonymous bequest

298

Bookcase from the Cordelia A. Culbertson House, Pasadena, c. 1911
Mahogany, ebony, and glass
82 x 54 in. (208.3 x 137.2 cm)
LACMA, gift of Linda and James Ries in memory of Dorothy and Harold Shrier

Greta Grossman
Sweden, active United States, c. 1920s–1999

Black Gooseneck Desk Lamp, c. 1950
Painted metal and plated steel
Lamp H: 13 in. (33 cm); Shade D: 11 in.
(27.9 cm)
Courtesy Fat Chance, Los Angeles, California

Raul Guerrero
United States, b. 1945

Untitled, 1974
Screenprint
21 11/16 x 21 5/8 in. (55.1 x 54.9 cm)
LACMA, purchased with funds provided by the Director's Roundtable, and gift of Cirrus Editions

John Gutmann
Germany, active United States, 1905–1998

The Cry, 1939
Gelatin-silver print
9¾ x 7¾ in. (24.8 x 19.7 cm)
LACMA, Ralph M. Parsons Fund
p. 114

Otto Hagel
Germany, active United States, 1909–1973

Labor Workers, c. 1935
Gelatin-silver print
14 x 11 in. (35.6 x 27.9 cm)
Collection of Stephen White II

Untitled [Maritime Workers Looking for Work], c. 1935
Gelatin-silver print
14 x 11 in. (35.6 x 27.9 cm)
Collection of Stephen White II
p. 115

John Charles Haley
United States, 1905–1991

Berkeley Street Scene, c. 1931
Gouache on paper
9 x 12 in. (22.9 x 30.5 cm)
The E. Gene Crain Collection

Doug Hall
United States, b. 1944

Storm and Stress, 1986
Videotape (color, with sound, forty-eight minutes)
Lent by Video Data Bank

Philippe Halsman
United States, 1906–1979

Dorothy Dandridge, 1953
Gelatin-silver print
10¼ x 7¼ in. (26 x 18.4 cm)
Collection of Louis F. D'Elia
p. 177

David Hammons
United States, b. 1943

Injustice Case, 1970
Body print (margarine and powdered pigments) and American flag
63 x 40½ in. (160 x 102.9 cm)
LACMA, Museum Acquisition Fund
p. 223

James Hansen
United States, 1917–1993

Beach Scene at Santa Monica in 1949, 1949
Watercolor on paper
18¼ x 13 in. (46.4 x 33 cm)
Automobile Club of Southern California
p. 158

Harwell H. Harris
United States, 1903–1990

Grandview Gardens, Chinatown, Los Angeles, 1940
Colored pencil on paper
13¾ x 21¾ in. (34.9 x 55.2 cm)
The Harwell Hamilton Harris Papers, The Alexander Architectural Archive, The General Libraries, The University of Texas at Austin

Weston Havens House, Berkeley, Exterior Perspective, 1940
Colored pencil on paper
8 x 11½ in. (20.3 x 29.2 cm)
The Harwell Hamilton Harris Papers, The Alexander Architectural Archive, The General Libraries, The University of Texas at Austin

Helen Mayer Harrison
United States, b. 1929
Newton Harrison
United States, b. 1932

Meditation I from *Meditations on the Condition of the Sacramento River, the Delta, and the Bays of San Francisco*, 1977
Satellite photographic map with oil paint and handwritten text mounted on canvas with ten accompanying posters, ink on paper
Map: 90 x 76 in. (228.6 x 193 cm); Each poster: 17 x 11 in. (43.2 x 27.9 cm)
Lent by the artists
p. 197

Robert Harshe
United States, 1879–1938

Sunrise over Skyline (Near Portola), 1910
Oil on canvas
Each one of three sections: 14¼ x 20¼ in.
(36.2 x 51.4 cm)
The Oakmont Corporation

Ernest Haskell
United States, 1876–1925

Fallen Centuries, c. 1920
Drypoint
10¼ x 15¼ in. (26.1 x 38.7 cm)
LACMA, gift of Hildegard Heartt Haskell, oldest daughter of Ernest Haskell

Childe Hassam
United States, 1859–1935

California Oil Fields, 1927
Etching
8⅞ x 13⅞ in. (22.5 x 35.2 cm)
San Francisco Museum of Modern Art, gift of Mrs. Childe Hassam
p. 106

Tim Hawkinson
United States, b. 1961
Issey Miyake
Japan, b. 1938

Dress
From Pleats Please, Guest Artist Series No. 3, 1998
Polyester
CB: 52½ in. (133.4 cm)
LACMA, gift of Dale Carolyn Gluckman

Jumpsuit
From Pleats Please, Guest Artist Series No. 3, 1998
Polyester
CB: 57 in. (144.8 cm)
LACMA, gift of Dale Carolyn Gluckman
p. 251

Miki Hayakawa
Japan, active United States, 1904–1953

Telegraph Hill, n.d.
Oil on canvas
29 x 34 in. (73.7 x 86.4 cm)
Perlmutter Fine Arts, San Francisco
p. 104

Edith Heath
United States, b. 1911
Heath Ceramics, United States, founded c. 1947

Pitcher, c. 1948, manufactured 1950s
Stoneware, glazed
H: 8 in. (20.3 cm); D: 6 in. (15.2 cm)
Collection of Cathy Callahan

Set of Tumblers, c. 1948, manufactured 1950s
Stoneware, glazed
Each: H: 2⅞ in. (7.3 cm); D: 3¾ in. (9.5 cm)
Collection of Cathy Callahan

Ana Lisa Hedstrom
United States, b. 1943

Video Weave Kimono, 1982
Silk crepe de chine, resist dyed
CB: 51½ in. (130.8 cm)
Collection of Laura Fisher
p. 260

Robert Heinecken
United States, b. 1931

T.V. Dinner/After, 1971
Emulsion on formed canvas, chalk, and resin,
edition 8/11
12 x 15 x 1 in. (30.5 x 38.1 x 2.5 cm)
Collection of Joyce Neimanas

Robert Henri
United States, 1865–1929

Tam Gan, 1914
Oil on canvas
24 x 20 in. (61 x 50.8 cm)
Albright-Knox Art Gallery, Buffalo, New York,
Sarah A. Getes Fund, 1915
p. 96

George Herms
United States, b. 1935

Everything Is O.K., 1966
Wood, metal, plaster, and Plexiglas
H: 4 in. (10.2 cm); D: 13¾ in. (34.9 cm)
LACMA, gift of Drs. Katherina and
Judd Marmor
p. 214

Bomb Scare Box, 1970
Wood, paper, found objects, and paint
6 15/16 x 31 15/16 x 3⅛ in. (17.7 x 81.2 x 7.9 cm)
LACMA, gift of Barry Lowen

Anthony Hernandez
United States, b. 1947

#24, 1989
From the series Landscapes for the Homeless,
1988–91
Silver dye-bleach (Cibachrome) print
48 x 58 in. (121.9 x 147.3 cm)
Collection of Creative Artists Agency
p. 236

#18, 1990
From the series Landscapes for the Homeless,
1988–91
Silver dye-bleach (Cibachrome) print
34 x 65 in. (86.4 x 165.1 cm)
Collection of Jeffrey Leifer

Ester Hernández
United States, b. 1944

Sun Mad, 1982
Screenprint
22 x 17 in. (55.9 x 43.2 cm)
Lent by the artist
p. 197

Lynn Hershman
United States, b. 1941

Roberta Breitmore's Construction Chart, 1973
Chromogenic development print
30 x 40 in. (76.2 x 101.6 cm)
Lent by the artist
p. 232

Hisako Hibi
Japan, active United States, 1907–1991

*We Had to Fetch Coal for the Pot-Belly Stove,
Topaz, Utah*, 1944
Oil on canvas
20 x 24 in. (50.8 x 61 cm.)
Fine Arts Museums of San Francisco,
gift of Ibuki Hibi Lee
p. 155

Matsusaburo (George) Hibi
Japan, active United States, 1886–1947

Block #9, Topaz, 1945
Oil on canvas
23 x 26 in. (58.4 x 66 cm)
Fine Arts Museums of San Francisco,
gift of Ibuki Hibi Lee

Elizabeth Hickox
United States, 1873–1947

Lidded Trinket Basket with Design, 1900–1930
Twined maidenhair fern and myrtle shoots
11½ x 8½ in. (29.2 x 21.6 cm)
Lent by the Southwest Museum, Los Angeles,
gift of Mrs. Caroline Boeing Poole
p. 94

Charles Christopher Hill
United States, b. 1948

Cuando vayas a cagar…, 1974
Screenprint
23⅞ x 30¼ in. (60.6 x 76.8 cm)
LACMA, Cirrus Editions Archive, purchased
with funds provided by the Ducommun and
Gross Endowment Income Fund, and gift
of Cirrus Editions

Louis Hock
United States, b. 1948

*The Mexican Tapes: A Chronicle of Life Outside
the Law*, 1986
Videotape series (color, with sound, four sixty-
minute programs)
Lent by the artist

David Hockney
England, active United States, b. 1937

The Splash, 1966
Acrylic on canvas
72 x 72 in. (183 x 183 cm)
Collection of Mr. and Mrs. Norman Pattiz
p. 201

*The Merced River, Yosemite Valley, California,
September 1982*, 1982
Photocollage (chromogenic development prints)
52 x 61 in. (132.1 x 154.9 cm)
Collection of Pico Holdings, Inc.
p. 234

Margaret Honda
United States, b. 1961

Perennial, 1996
Fresh chrysanthemums, stainless steel,
and water
H: ⅞ in. (2.22 cm); D: 42 in. (106.7 cm)
Courtesy the artist and Shoshana Wayne
Gallery
p. 238

Dennis Hopper
United States, b. 1936

Double Standard, 1961, printed later
Gelatin-silver print, edition 13/15
16 x 24 in. (40.6 x 61 cm)
LACMA, gift of Bob Crewe
p. 206

Donal Hord
United States, 1902–1966

Mayan Mask, 1933
Polychromed and gilded mahogany
14¼ x 10 x 8½ in. (36.2 x 25.4 x 21.6 cm)
Steve Turner Gallery, Beverly Hills
p. 136

George Hoshida
Japan, active United States, 1907–1985

*Two Drawings from "American World War II
Concentration Camp Sketches,"* 1942–43
Ink and watercolor on paper
Each: 9½ x 6 in. (24.1 x 15.2 cm)
Japanese American National Museum, gift
of June Hoshida Honma, Sandra Hoshida,
and Carole Hoshida Kanada

John Langley Howard
United States, b. 1902

The Unemployed, 1937
Oil on cardboard
24 x 30¼ in. (61 x 76.8 cm)
The Oakland Museum of California,
gift of Anne and Stephen Walrod
p. 114

Mildred Howard
United States, b. 1945

Black Don't Crack, 1997
Mixed-media assemblage
18 x 23 x 10 in. (45.7 x 58.4 x 25.4 cm)
Lent by the artist, courtesy Gallery
Paule Anglim
p. 264

Robert Hudson
United States, b. 1938

Running through the Woods, 1975
Stuffed deer, wood, rock, globe, metal, string,
feathers, found objects, and acrylic
77 x 62 x 50¾ in. (195.6 x 157.5 x 128.9 cm)
Lent by Mr. and Mrs. C. David Robinson,
Sausalito, California

Leopold Hugo
United States, 1863–1933

Untitled, c. 1920
Gum bichromate print
13⅞ x 10⅞ in. (35.3 x 27.8 cm)
The Wilson Center for Photography
p. 71

John Humble
United States, b. 1944

*Selma Avenue at Vine Street, Hollywood,
January 23, 1991*, 1991, printed 1995
Chromogenic development print, edition 1/15
38½ x 30 in. (97.8 x 76.2 cm)
LACMA, Ralph M. Parsons Fund
p. 250

George Hurrell
United States, 1904–1992

Norma Shearer, 1929
Gelatin-silver print
13 x 10 in. (33 x 25.4 cm)
Collection of Louis F. D'Elia
p. 130

Ramon Novarro, 1930
Gelatin-silver print
11¼ x 7¼ in. (28.6 x 18.4 cm)
Collection of Louis F. D'Elia
p. 130

William Haines, 1930
Gelatin-silver print
13¼ x 7¼ in. (33.7 x 18.4 cm)
Collection of Louis F. D'Elia

Joan Crawford, 1932
Gelatin-silver print
12¼ x 7¼ in. (31.1 x 18.4 cm)
Collection of Louis F. D'Elia
p. 131

Jean Harlow, 1933
Gelatin-silver print
12¼ x 7¼ in. (31.1 x 18.4 cm)
Collection of Louis F. D'Elia

Ann Sheridan, c. 1945
Gelatin-silver print
13½ x 10¼ in. (34.4 x 26 cm)
Collection of Louis F. D'Elia

Jane Russell, 1946
From the portfolio *Hurrell II*, 1980–81
Gelatin-silver print, edition 95/250
15 x 19⁵⁄₁₆ in. (38.1 x 49 cm)
LACMA, gift of the Hollywood Photographers
Archive
p. 177

Randy Hussong
United States, b. 1955

It's My Party, 1993
Vinyl on metal
47 x 25 x 4 in. (119.4 x 63.5 x 10.2 cm)
Lent by the artist, courtesy Gallery Paule
Anglim

Helen Hyde
United States, 1868–1919

Imps of Chinatown, 1910s
Etching with hand coloring
7⁷⁄₁₆ x 6 in. (19 x 15.2 cm)
Fine Arts Museums of San Francisco,
Achenbach Foundation for Graphic Arts,
Museum Collection
p. 96

Robert Wilson Hyde
United States, 1875–1951

A House Book, 1906
Suede and brass cover, suede flyleaves,
parchment, wove rag paper, and ink
11½ x 8¾ x 1⅜ in. (29.2 x 22.2 x 3.5 cm)
LACMA, gift of Max Palevsky in honor
of the museum's twenty-fifth anniversary
p. 87

Alex Ignatieff
Active United States, 1932

Angel's Flight, c. 1932
Watercolor on paper
21 x 27½ in. (53.3 x 69.9 cm)
The Fieldstone Collection

George Inness
United States, 1825–1894

California, 1891, later dated 1894
Oil on canvas
60 x 48 in. (152.4 x 121.9 cm)
The Oakland Museum of California, gift of
the estate of Helen Hathaway White and the
Women's Board of the Oakland Museum
Association

David Ireland
United States, b. 1930

500 Capp Street, 1975–2000
Videotape documentation (color, with sound,
six minutes) of the ongoing installation work,
which is the artist's home
Lent by the artist

Robert Irwin
United States, b. 1928

Untitled, 1968
Acrylic
D: 60 in. (152.4 cm)
LACMA, gift of the Kleiner Foundation
p. 211

Frank Israel
United States, 1945–1996

Drager Residence, Berkeley, Roof Plan, 1993
Conte crayon on tracing paper
40 x 27½ in. (101.6 x 69.9 cm)
Dr. Sharon B. Drager

Shinsaku Izumi
Japan, active United States, 1880–1941

Tunnel of Night, c. 1931
Gelatin-silver print
13⁵⁄₁₆ x 10⅝ in. (33.8 x 27 cm)
LACMA, Los Angeles County Fund
p. 106

Everett Gee Jackson
United States, 1900–1995

Tehuantepec Women, 1927
Oil on canvas
32 x 32 in. (81.3 x 81.3 cm)
Steve Turner and Victoria Dailey

Ferne Jacobs
United States, b. 1942

Container for a Wind, 1974–75
Coiled and waxed linen
44 x 11 x 4 in. (111.8 x 27.9 x 10.2 cm)
Palm Beach Institute of Contemporary Art

Veil, 1996
Coiled and twined waxed linen
87¾ x 7 x 4 in. (222.9 x 17.8 x 10.2 cm)
Lent by the artist

Jon Adams Jerde
United States, b. 1940

Universal CityWalk, Universal City, 1993
Mixed media on paper
12 x 68 in. (30.5 x 172.7 cm)
The Jerde Partnership International

Jess [Burgess Collins]
United States, b. 1923

Robert Duncan, Poet, c. 1952
Black chalk on paper
10¹⁵⁄₁₆ x 8½ in. (27.8 x 21.5 cm)
Fine Arts Museums of San Francisco,
Achenbach Foundation for Graphic Arts,
gift of Julian Silva

Tricky Cad: Case V, [1958]
Colored newspaper, clear plastic wrap,
and black tape on paperboard
13¼ x 24¹⁵⁄₁₆ in. (33.7 x 63.4 cm)
Hirshhorn Museum and Sculpture Garden,
Smithsonian Institution, Joseph H. Hirshhorn
Purchase Fund, 1989
p. 180

DeDe Johnson
United States, b. circa 1914

Woman's Three-Piece Playsuit, late 1950s
Printed cotton
Blouse CB: 16½ in. (41.9 cm); Skirt CB: 31½ in.
(80 cm); Shorts CB: 16 in. (40.6 cm)
LACMA, gift of Esther Ginsberg and James
Morris in memory of Don Morris
p. 158

Sargent Johnson
United States, 1888–1967

Elizabeth Gee, 1925
Stoneware, glazed
13⅛ x 10¾ x 7½ in. (33.3 x 27.3 x 19.1 cm)
San Francisco Museum of Modern Art, Albert
M. Bender Collection, gift of Albert M. Bender
p. 143

A. Quincy Jones
United States, 1913–1979

*Smalley Residence, Los Angeles, Perspective,
Looking North*, 1970
Drawing by Donald C. Picken
Ink on Mylar
30 x 42 in. (76.2 x 106.7 cm)
Courtesy A. Quincy Jones Architecture Archive

Pirkle Jones
United States, b. 1914

Grape Picker, Berryessa Valley, California, 1956
Gelatin-silver print
13 x 10½ in. (33 x 26.3 cm)
LACMA, gift of Mark Story

*Window of the Black Panther Party National
Headquarters*, 1968
Gelatin-silver print
14 x 11 in. (35.6 x 27.9 cm)
Lent by the artist
p. 221

Frida Kahlo
Mexico, active United States and Mexico,
1907–1954

Frida and Diego Rivera, 1931
Oil on canvas
39⅜ x 31 in. (100 x 78.7 cm)
San Francisco Museum of Modern Art, Albert
M. Bender Collection, gift of Albert M. Bender
p. 138

Arthur Kales
United States, 1882–1936

The Sun Dance, c. 1920
Gelatin-silver print
10½ x 13⅜ in. (26.7 x 34 cm)
The Wilson Center for Photography
p. 84

The White Peacock, Gloria Swanson, c. 1920
Gelatin-silver print
10⅜ x 13⅜ in. (26.5 x 34 cm)
The Wilson Center for Photography

Matsumi Kanemitsu
Japan, active United States, 1922–1992

Zen Blue, 1961
Lithograph
30 x 22 in. (76.2 x 55.9 cm)
LACMA, gift of the Michael and Dorothy
Blankfort Tamarind Collection through
the Contemporary Art Council
p. 186

Ray Kappe
United States, b. 1927

*Kappe Residence, Pacific Palisades, Section
Perspective*, 1965
Graphite on paper
30 x 42 in. (76.2 x 106.7 cm)
Kappe Architects/Planners

Allan Kaprow
United States, b. 1927

Fluids, 1967
Photo documentation of event in Los Angeles,
California, photographs by Dennis Hopper,
transferred to videotape for this exhibition
Lent by Dennis Hopper

Taizo Kato
Japan, active United States, 1888–1924

Untitled [Nature Study], c. 1923
Gum bichromate print
4½ x 6½ in. (11.4 x 16.5 cm)
Collection of Stephen White II

Craig Kauffman
United States, b. 1932

Untitled Wall Relief, 1967
Acrylic lacquer on vacuum-formed Plexiglas
52½ x 78¼ x 12 in. (133.4 x 198.8 x 30.5 cm)
LACMA, gift of the Kleiner Foundation
p. 208

Hilja Keading
United States, b. 1960

Oh Happy Day, 1996
Videotape (color, with sound, four minutes)
Lent by the artist

Kirby Kean
United States, 1908–1999

Night Scene near Victorville, c. 1937
Gelatin-silver print
13³⁄₁₆ x 10³⁄₁₆ in. (33.5 x 25.9 cm)
The J. Paul Getty Museum, Los Angeles
p. 122

William Keith
Scotland, active United States, 1838–1911

*Looking across the Golden Gate from
Mount Tamalpais*, c. 1895
Oil on canvas
40 x 50⅝ in. (101.6 x 128.6 cm)
Private collection
p. 74

Mike Kelley
United States, b. 1954

Frankenstein, 1989
Found stuffed animals and basket
12½ x 78 x 28 in. (31.8 x 198.1 x 71.1 cm)
Judy and Stuart Spence
p. 257

Rockwell Kent
United States, 1882–1971

Coffeepot from "Our America," 1939
Manufactured by Vernon Kilns (United States,
1931–58)
Earthenware
H: 8 in. (20.3 cm); D: 8½ in. (21.6 cm)
Museum of California Design, Bill Stern
Bequest

302

Martin Kersels
United States, b. 1960

MacArthur Park, 1996
Painted wood, speaker, CD player, stereo
receiver, and CD
At rest: 62 x 32 x 24 in. (157.5 x 81.3 x 61 cm)
Collection of Dean Valentine and Amy
Adelson, Los Angeles

Sant Khalsa
United States, b. 1953

Seven Oaks Dam Site, 1992
From Crossroads: The Santa Ana River
Project
Gelatin-silver print
13½ x 8½ in. (34.3 x 21.6 cm)
Lent by the artist

Edward Kienholz
United States, 1927–1994

Illegal Operation, 1962
Mixed media
59 x 48 x 54 in. (149.9 x 121.9 x 137.2 cm)
Betty and Monte Factor Collection,
Santa Monica, California

Back Seat Dodge '38, 1964
Mixed media
66 x 120 x 156 in. (167.6 x 304.8 x 396.2 cm)
LACMA, purchased with funds provided
by the Art Museum Council
p. 207

Intae Kim
Korea, active United States, b. 1947

Death Valley, Sunrise, Sand Dune, 1989,
printed 1994
Gelatin-silver print, edition 5/50
15¾ x 19¾ in. (40 x 50.2 cm)
LACMA, Ralph M. Parsons Fund
p. 238

Dong Kingman
United States, 1911–2000

Jack Thrasher Welds for America, c. 1942
Watercolor on paper
20½ x 15½ in. (52.1 x 39.4 cm)
Collection of Jonathan Quincy Weare

Maria Kipp
Austria, active United States, 1900–1988

Textile Length for Drapery, c. 1938
Mohair, Lurex, and chenille
113 x 45 in. (287 x 114.3 cm)
LACMA, Costume Council Fund
p. 111

Hiromu Kira
Japan, active United States, 1898–1991

Study—Paper Work, 1927
Gelatin-silver bromide print
12⅛ x 9⅝ in. (30.8 x 24.4 cm)
LACMA, Los Angeles County Fund

Mark Klett
United States, b. 1952

San Francisco Panorama after Muybridge, 1990
Thirteen gelatin-silver prints
Each: 20 x 16 in. (50.8 x 40.6 cm)
LACMA, Ralph M. Parsons Fund
pp. 242–43

Candace Kling
United States, b. 1948

Enchanted Forest, 1989
Buckram, Varaform, cording, Polyfil, satin,
braze rods, and epoxy
19 x 13½ x 23½ in. (48.3 x 34.3 x 59.7 cm)
Lent by the artist
p. 260

Fred E. Kling
United States, b. 1944

Wedding Dress, 1973
Hand-painted cotton
CB: 47 in. (119.3 cm)
Marna Clark
p. 218

Cindy Kolodziejski
United States, b. 1962

Pajama Party, 1997
Whiteware
H: 15¾ in. (40 cm); D: 5 in. (12.7 cm)
Lent by Anne and Marvin H. Cohen

Paul Kos
United States, b. 1942
Marlene Kos
United States

Riley, Roily River, 1975
Videotape (black and white, with sound,
one minute)
Lent by Video Data Bank

Lightning, 1976
Videotape (black and white, with sound,
two minutes)
Lent by Video Data Bank

Emil J. Kosa Jr.
France, active United States, 1903–1968

Freeway Beginning, c. 1948
Watercolor on paper
22 x 30⅜ in. (55.9 x 77.2 cm)
The Buck Collection, Laguna Hills, California
p. 165

Hirokazu Kosaka
Japan, active United States, b. 1948

Amerika Maru, 1990
Excerpts of videotape (color, with sound,
nine minutes) of performance at Japan
America Center, Los Angeles
Lent by the artist

Ina Kozel
Lithuania, active United States, b. 1944

Our Lady of Rather Deep Waters, 1985
Urethane foam and hand-painted silk
CB (with train): 80 in. (203.2 cm); H: 72 in.
(182.9 cm)
Lent by the artist
p. 260

Roger Kuntz
United States, 1926–1975

Santa Ana Arrows, c. 1950s
Oil on canvas
50 x 60 in. (127 x 152.4 cm)
The Buck Collection, Laguna Hills, California
p. 165

Rachel Lachowicz
United States, b. 1964

Sarah #3, 1994
Lipstick and wax
40 x 24 x 24 in. (101.6 x 61 x 61 cm)
Collection of Shoshana and Wayne Blank
p. 254

Suzanne Lacy
United States
Leslie Labowitz
United States

Three Weeks in May, 1977
Photo documentation of performance/media
event at Los Angeles City Hall, May 1977,
transferred to videotape for this exhibition
Lent by the artists

Gyongy Laky
United States, b. 1944

Evening, 1995
London plane tree, doweled
21 x 24 in. (53.3 x 61 cm)
Philadelphia Museum of Art, gift
of the Women's Committee
p. 239

Paul Landacre
United States, 1893–1963

Desert Wall, 1931
Wood engraving
5½ x 7 in. (14 x 17.9 cm)
LACMA, gift of Joseph M. Landacre and Barbara Mcreery
p. 122

Breaking Ground, 1933–34
Wood engraving
15⅜ x 10⅝ in. (39.1 x 27 cm)
United States Government Treasury Department, Public Works of Art Project, Washington, D.C., on permanent loan to LACMA

Dorothea Lange
United States, 1895–1965

Five Workers against a Concrete Wall, Industrial District, San Francisco, 1933
Gelatin-silver print
9½ x 9⅝ in. (24.1 x 24.5 cm)
San Francisco Museum of Modern Art, Accessions Committee Fund

A Sign of the Times—Depression—Mended Stockings—Stenographer, San Francisco, c. 1934
Gelatin-silver print
11½ x 8½ in. (29.2 x 21.6 cm)
The Oakland Museum of California, gift of Paul S. Taylor. Copyright the Dorothea Lange Collection
p. 115

Filipinos Cutting Lettuce, Salinas Valley, California, c. 1935
Gelatin-silver print
8³⁄₁₆ x 7⅝ in. (20.8 x 19.4 cm)
The Oakland Museum of California, gift of Paul S. Taylor. Copyright the Dorothea Lange Collection
p. 119

Drought Refugees from Oklahoma, Blythe, California, 1936
Gelatin-silver print
14 x 11 in. (35.6 x 27.9 cm)
The J. Paul Getty Museum, Los Angeles

Migrant Mother, Nipomo, California, 1936, printed later
Gelatin-silver print
13⅞ x 10¹⁵⁄₁₆ in. (35.2 x 27.7 cm)
LACMA, promised gift of Barbara and Buzz McCoy
p. 120

Resettled, El Monte, California, 1936
Gelatin-silver print
8 x 10¹⁄₁₆ in. (20.3 x 25.6 cm)
LACMA, gift of Susan Ehrens
p. 57

Jobless on the Edge of a Pea Field, Imperial Valley, California, 1937
Gelatin-silver print
8 x 10 in. (20.3 x 25.4 cm)
The J. Paul Getty Museum, Los Angeles

Pledge of Allegiance, at Raphael Elementary School, a Few Weeks before Evacuation/One Nation Indivisible, April 20, 1942, 1942
Gelatin-silver print
10 x 8 in. (25.4 x 20.3 cm)
The Oakland Museum of California, gift of Paul S. Taylor. Copyright the Dorothea Lange Collection
p. 154

Untitled [End of Shift, 3:30, Richmond, California, September 1942], 1942
Gelatin-silver print
13½ x 10½ in. (34.3 x 26.7 cm)
The Oakland Museum of California, gift of Paul S. Taylor. Copyright the Dorothea Lange Collection
p. 149

Robin Lasser
United States, b. 1956
Kathryn Sylva
United States, b. 1947

Extra Lean, 1998
Iris print
42 x 28 in. (106.7 x 71.1 cm)
Lent by the artists
p. 252

Alma Lavenson
United States, 1897–1989

Carquinez Bridge, 1933
Gelatin-silver print
7 x 9½ in. (18 x 24 cm)
The Wilson Center for Photography
p. 107

Dinh Q. Le
Vietnam, active United States, b. 1968

The Buddha of Compassion, 1997
Chromogenic development prints and linen tape
44½ x 30 in. (113 x 76.2 cm)
Collection of Eileen and Peter Norton, Santa Monica

William Leavitt
United States, b. 1941

Untitled, 1990
Pastel on paper
15 x 44 in. (38.1 x 111.8 cm)
Joel Marshall
p. 243

Untitled, 1991
Pastel on paper
15 x 44 in. (38.1 x 111.8 cm)
Margo Leavin Gallery

Rico Lebrun
Italy, active United States, 1900–1964

The Yellow Plow, 1949
Oil on Upson board
80 x 36 in. (203 x 91.4 cm)
Munson-Williams-Proctor Institute Museum of Art, Utica, New York, 50.16

The Magdalene, 1950
Tempera on Masonite
63 x 48 in. (160 x 121.9 cm)
Santa Barbara Museum of Art, gift of Wright F. Ludington
p. 186

Betty Lee
United States, b. 1949

Documented Memory #1
From the Livelihood series, 1995
Gelatin-silver print
40 x 50 in. (101.6 x 127 cm)
LACMA, Ralph M. Parsons Fund

David Levinthal
United States, b. 1949

Untitled #3
From the Barbie series, 1997–98
Dye-diffusion transfer (Polaroid) print
40 x 30¼ in. (101.6 x 76.8 cm)
LACMA, Ralph M. Parsons Fund
p. 250

Joe Lewis
United States, b. 1953

Watts Riots 2010, 1999
Gelatin-silver print
20 x 24 in. (50.8 x 61 cm)
Lent by the artist

Janet Lipkin
United States, b. 1948

Santa Fe Cape #2, 1987
Wool knit, hand dyed
CB: 52 in. (132.1 cm)
Eileen R. Solomon
p. 261

Marvin Lipofsky
United States, b. 1938

California Loop Series, 1970
Glass, paint, and rayon flocking
10 x 8 in. (25.4 x 20.3 cm)
Lent by the artist
p. 209

304

Sharon Lockhart
United States, b. 1964

Untitled [Ocean], 1996
Chromogenic development print, edition of 6
49 x 61⅛ in. (124.5 x 155.3 cm)
Collection of Gary and Tracy Mezzatesta
p. 238

John Lofaso
United States, b. 1961

Black and White Cow #6, 1991
Gelatin-silver print
12 x 20 in. (30.5 x 50.8 cm)
Lent by the artist, courtesy Craig Krull Gallery,
Santa Monica

Yolanda M. López
United States, b. 1942

*Portrait of the Artist as the Virgin
of Guadalupe*, 1978
Oil and pastel on paper
32 x 24 in. (81.3 x 61 cm)
Lent by the artist

Erle Loran
United States, b. 1905

San Francisco Bay, 1940
Lithograph
9¼ x 12 in. (23.5 x 30.5 cm)
San Francisco Museum of Modern Art, Albert
M. Bender Collection, gift of Albert M. Bender

Chip Lord
United States, b. 1944

Awakening from the 20th Century, 1999
Videotape (color, with sound, thirty-five
minutes)
Lent by Video Data Bank

Los Angeles Fine Arts Squad
Victor Henderson (United States, b. 1939) and
Terry Schoonhoven (United States, b. 1945)

Isle of California, 1973
Pencil and acrylic on photograph
29½ x 39½ in. (74.9 x 100.3 cm)
LACMA, the Michael and Dorothy Blankfort
Collection
p. 61

Liza Lou
United States, b. 1969

Super Sister, 1999
Polyester resin and glass beads
98 x 36 x 34 in. (248.9 x 91.4 x 86.4 cm)
Collection of Vicki and Kent Logan,
San Francisco
p. 254

Homette, 1999–2000
Trailer, mixed media with beads
144 x 96 x 420 in. (365.8 x 243.8 x 1066.8 cm)
Courtesy Deitch Projects

John Gilbert Luebtow
United States, b. 1944

April 29, 1992, 1992
Glass and steel cable
108 x 18 in. (274.3 x 45.7 cm)
Lent by the artist
p. 237

Gilbert (Magu) Sánchez Luján
United States, b. 1940

Fragment from "Tribute to Mesoamerica,"
1974, replicated 2000
Found objects and mixed media
Approximately 71 x 108 x 48 in. (180.3 x
274.3 x 121.9 cm)
Lent by the artist

Glen Lukens
United States, 1887–1967

Gray Bowl, c. 1940
Earthenware
H: 3⅛ in. (7.9 cm); D: 11¼ in. (28.6 cm)
LACMA, gift of Howard and Gwen Laurie
Smits in honor of the museum's twenty-fifth
anniversary
p. 111

Bertha Lum
United States, 1879–1954

Point Lobos, 1921
Color woodcut
16¾ x 10¹⁵⁄₁₆ in. (42.6 x 27.8 cm)
Roger Epperson and Carol Alderdice
p. 76

James Luna
United States, b. 1950

The Artifact Piece, 1987
Photo documentation of performance
Lent by the artist
p. 265

*The History of the Luiseno People: La Jolla
Reservation—Christmas 1990*, 1993
Videotape (color, with sound, twenty-seven
minutes)
Lent by Video Data Bank

Helen Lundeberg
United States, 1908–1999

*The History of Transportation in California
(Panel 1), study for mural in Centinela Park,
Inglewood*, 1940
Gouache on paper
7 x 34 in. (17.9 x 86.4 cm)
Tobey C. Moss Gallery

*The History of Transportation in California
(Panel 8), study for mural in Centinela Park,
Inglewood*, 1940
Gouache on paper
7 x 26 in. (17.9 x 66 cm)
Tobey C. Moss Gallery
p. 109

The Shadow on the Road to the Sea, 1960
Oil on canvas
40 x 50 in. (101.6 x 127 cm)
Perlmutter Fine Arts, San Francisco
p. 169

Fernand Lungren
United States, 1859–1932

Wall Street Canyon, n.d.
Oil on canvas
36 x 27 in. (91.4 x 68.6 cm)
Mr. and Mrs. Robert Veloz

Stanton MacDonald-Wright
United States, 1890–1973

Cañon Synchromy (Orange), c. 1920
Oil on canvas
24⅛ x 24⅛ in. (61.3 x 61.3 cm)
Lent by the Frederick R. Weisman Art Museum,
University of Minnesota, gift of Ione and
Hudson Walker
p. 135

Santa Monica, 1933
Pencil on paper
21½ x 27½ in. (54.6 x 69.9 cm)
LACMA, gift of Merle Armitage

Revolt, 1936
Lithograph
18 x 12½ in. (45.7 x 31.8 cm)
Sragow Gallery, New York
p. 119

Helen MacGregor
England, active United States, 1876–c. 1954

Reclining Woman with Guitar, c. 1921
Gelatin-silver print
18 x 14 in. (45.7 x 35.6 cm)
The Wilson Center for Photography
p. 90

Reginald Machell
England, active United States, 1854–1927

Katherine Tingley's Chair, The Theosophical Society, Point Loma, c. 1905–10
Carved and painted wood
52½ x 29½ x 25 in. (133.4 x 74.9 x 63.5 cm)
The Theosophical Society (Pasadena)
p. 86

Mark Mack
Austria, active United States, b. 1949

Baum Residence, Berkeley, Oblique Plan and Elevations, 1987
Ink on board
40 x 30 in. (101.6 x 76.2 cm)
San Francisco Museum of Modern Art, gift of the artist

Meg Mack
United States, b. 1962

Superfreak, 1996
Wood and spray paint
90 x 24 x 10 in. (228.6 x 61 x 25.4 cm)
San Francisco Museum of Modern Art, gift of Robert Harshorn Shimshak and Marion Brenner

Malibu Potteries
United States, 1926–1932

Tile with Mayan Image, 1926–32
Earthenware
10 x 10 in. (25.4 x 25.4 cm)
Collection of Norman Karlson

Arturo Mallmann
Uruguay, active United States, b. 1953

The New L.A. #40, 1994
Acrylic on Masonite
30 x 36 in. (76.2 x 91.4 cm)
Iturralde Gallery Collection

Sam Maloof
United States, b. 1916

Rocking Chair, 1997
Cherry wood and ebony
26 x 32 in. (66 x 81.3 cm)
LACMA, funds provided by the Decorative Arts Council Acquisition Fund
p. 239

Man Ray [Emmanuel Radnitsky]
United States, 1890–1976

Watts Towers, Los Angeles, 1940s
Gelatin-silver print
11⅝ x 9½ in. (29.5 x 24.1 cm)
Sandor Family Collection
p. 168

Mike Mandel
United States, b. 1950
Larry Sultan
United States, b. 1946

Set-up for Oranges on Fire, 1975, printed 1999
Chromogenic development print
20 x 24 in. (50.8 x 61 cm)
Lent by Larry Sultan, courtesy the artists
p. 192

K. Lee Manuel
United States, b. 1936

Maat's Wing #3, 1994
Painted feathers
D: 23½ in. (59.7 cm)
Collection of Julie Schafler Dale, courtesy of Julie: Artisans' Gallery, New York
p. 261

Tom Marioni
United States, b. 1937

Café Society, 1979
Excerpts from the videotape *San Francisco, 1984* (color and black and white, with sound, ten minutes) of artists gathering at Breen's Café in San Francisco
Lent by the artist

Richard Marquis
United States, b. 1945

Hexagonal Star Bottle and Stars and Stripes Bottle, 1969
Blown glass, *murrine* and *a canne* techniques
4¼ x 3 in. (10.8 x 7.6 cm); 2¾ x 2½ in. (7 x 6.4 cm)
Courtesy Elliott Brown Gallery, Seattle

Hexagonal Bottles with "Fuck" Text, 1969–70
Blown glass, *filigrana* and *murrine* techniques
4¼ x 2¾ in. (10.8 x 7 cm); 2¾ x 2½ in. (7 x 6.4 cm)
Courtesy Elliott Brown Gallery, Seattle

Display Box of Lord's Prayer Murrine, 1972
Glass *murrine* and specimen box
2¾ x 3¼ in. (7 x 8.3 cm)
Courtesy Elliott Brown Gallery, Seattle

Richard Marquis
United States, b. 1945
Nirmal Kaur
United States, b. circa 1948

American Acid Capsule with Cloth Container, 1969–70
Solid-worked glass and cloth
2 x 4 in. (5.1 x 10.2 cm)
Collection of Pam Biallas
p. 217

Fletcher Martin
United States, 1904–1979

Trouble in Frisco, c. 1935
Lithograph
19 x 13¹⁵⁄₁₆ in. (48.3 x 35.4 cm)
LACMA, gift of Jean Martin Wexler
p. 112

Daniel J. Martinez
United States, b. 1957

Museum Tags: Second Movement (Overture); or, Ouverture con Claque (Overture with Hired Audience Members), 1993
Thirty-six tags from performance at 1993 Whitney Biennale
Varied dimensions
Collection Tom Patchett, Los Angeles

Patricia Marx
Australia, active United States

Obmaru, 1952
16 mm film (color, with sound, four minutes)
Lent by Dr. William Moritz

John Mason
United States, b. 1927

Sculpture [Desert Cross], 1963
Stoneware, glazed
42 x 13 x 11 in. (109.2 x 33 x 27.9 cm)
Courtesy Sheppard Gallery, University of Nevada, Reno
p. 186

T. Kelly Mason
United States, b. 1964

Los Angeles from the Air, May 16, 1995
From the project *High Points Drifter*, 1995
Fifteen aerial photographs of Los Angeles and a topographical map
Each photo: 16 x 20¹¹⁄₁₆ in. (40.6 x 53 cm); map: 30 x 38 in. (76.2 x 96.5 cm)
Lent by the artist

Arthur Frank Mathews
United States, 1860–1945

California, 1905
Oil on canvas
26 x 23½ in. (66 x 59.7 cm)
The Oakland Museum of California, gift of Concours d'Antiques, the Art Guild
p. 82

305

Arthur Frank Mathews
United States, 1860–1945
Lucia Kleinhans Mathews
United States, 1870–1955
Mathews Furniture Shop, United States,
1906–20

Desk, c. 1910
Carved and painted maple [?], oak, tooled
leather, and replaced hardware
59 x 48 x 20 in. (149.9 x 121.9 x 50.8 cm)
The Oakland Museum of California, gift
of Mrs. Margaret R. Kleinhans
p. 82

Three-Panel Screen, c. 1913
Wood, carved and painted
36 x 65¾ in. (91.4 x 167 cm)
The Oakland Museum of California, gift of the
Estate of Marjorie Eaton

Rectangular Box with Lid, 1929
Painted wood
5 x 16 in. (12.7 x 40.6 cm)
The Oakland Museum of California, gift
of Concours d'Antiques, the Art Guild
p. 80

Oscar Maurer
United States, 1871–1965

*Eucalyptus Grove Silhouetted against a Cloudy
Sky, Golden Gate Park, San Francisco*, c. 1915
Gelatin-silver print
9½ x 6½ in. (24.1 x 16.5 cm)
The Oakland Museum of California, gift
of the artist
p. 69

Bernard Maybeck
United States, 1862–1957

*First Church of Christ, Scientist, Berkeley, South
Elevation*, 1910
Watercolor on paper
27 x 41 in. (68.6 x 104.1 cm)
First Church of Christ, Scientist

Paul McCarthy
United States, b. 1945

Sauce, 1974
Videotape (color, with sound, fifteen minutes)
Lent by the artist

Pinocchio Plug, 1994
Modeling clay, plaster, and broomstick
42 x 18 x 17 in. (106.7 x 45.7 x 43.2 cm)
LACMA, purchased with funds provided by
the Modern and Contemporary Art Council

Robert McChesney
United States, b. 1913

Bebop, c. 1944
Watercolor on paper
22½ x 14½ in. (57.2 x 36.8 cm)
Collection of Nancy and John Weare

John McCracken
United States, b. 1934

Don't Tell Me When to Stop, 1966–67
Fiberglass and lacquer on plywood
120 x 20½ x 3½ in. (304.8 x 52.1 x 8.9 cm)
LACMA, gift of the Kleiner Foundation

Harrison McIntosh
United States, b. 1914

Lidded Jar, 1959
Stoneware with sgraffito stripes
H: 11 in. (27.9 cm); D: 9 in. (22.9 cm)
Collection of Mr. and Mrs. George E. Brandow

John McLaughlin
United States, 1898–1976

Untitled, 1952
Oil and casein on fiberboard
32⅛ x 48⅛ in. (81.6 x 122.2 cm)
Hirshhorn Museum and Sculpture Garden,
Smithsonian Institution, Joseph H. Hirshhorn
Purchase Fund, 1991
p. 187

Untitled, 1955
Oil on Masonite
48 x 32 in. (121.9 x 81.3 cm)
Collection of Fannie and Alan Leslie

Michael C. McMillen
United States, b. 1946

Nipomo, 1980
Mixed media
74 x 11 x 11 in. (188 x 27.9 x 27.9 cm)
LACMA, Mac L. Sherwood, M.D., Memorial
Fund and the Modern and Contemporary Art
Council, Young Talent Purchase Award

Central Meridian, The Garage, 1981
Mixed media
Dimensions variable
Long-term loan to LACMA by the artist
p. 46

Rebecca Medel
United States, b. 1947

Labyrinth with White Window, 1996
Linen; three squares of ikat, resist dyed;
and square-knotted net, stiffened
67⅜ x 67 x 9 in. (171.1 x 170.1 x 22.9 cm)
The Art Institute of Chicago, gift of Joan
Cochran Rieveschl

Richard Meier
United States, b. 1934

*The Getty Center, Los Angeles, Museum
Entrance Area*, 1991
Graphite on yellow tracing paper
24 x 24 in. (61 x 61 cm)
Lent by the artist

Hansel Meith
Germany, active United States, 1909–1998

Untitled, c. 1935
Gelatin-silver print
14 x 10½ in. (35.6 x 26.7 cm)
Collection of Stephen White II

James Melchert
United States, b. 1930

Leg Pot I, 1962
Stoneware, lead, and cloth
11 x 32 in. (27.9 x 81.3 cm)
American Craft Museum, New York, gift of the
Johnson Wax Company, from Objects: USA,
1977, donated to the American Craft Museum
by the American Craft Council, 1990

Knud Merrild
Denmark, active United States, 1894–1954

Exhilaration, 1935
Mixed-media collage on wood-pulp board
14⅞ x 18¾ in. (37.8 x 47.6 cm)
The Buck Collection, Laguna Hills, California

Flux Lepidoptera, 1944
Oil on Masonite
18½ x 14 in. (47 x 35.6 cm)
LACMA, gift of Mr. and Mrs. Irving Stone

Flux Bouquet, 1947
Oil on Masonite
19 x 14½ in. (48.3 x 36.8 cm)
LACMA, gift of Dr. William R. Valentiner
p. 169

Amalia Mesa-Bains
United States, b. 1943

*Venus Envy: Chapter One (or, The First Holy
Communion Moments before the End)*, 1993
Vanity table, chair, mirror, and mixed media
60 x 48 x 36 in. (152.4 x 121.9 x 91.4 cm)
Lent by the artist, courtesy Bernice Steinbaum
Gallery, Miami, Florida
p. 255

306

Henry Meyers
United States, 1867–1943

Building for the Board of Home Missions and
Church Extensions of the M. E. Church, Corner
Washington and Stockton Streets, 1911
Graphite and watercolor on paper
17½ x 20 in. (44.5 x 50.8 cm)
Lent by the Documents Collection, College
of Environmental Design, UC Berkeley

Meyers Pottery Company
United States, dates unknown

"California Rainbow" Garden Vase, c. 1930
Ceramic
H: 18 in. (45.7 cm); D: 10½ in. (26.7 cm)
Ron and Susan Vander Molen

Willie Robert Middlebrook
United States, b. 1957

In His "Own" Image
From the series Portraits of My People, 1992
Sixteen gelatin-silver prints
Each: 24 x 20 in. (61 x 50.8 cm); Overall:
96 x 80 in. (243.8 x 203.2 cm)
LACMA, Ralph M. Parsons Fund
p. 237

Barse Miller
United States, 1904–1973

Apparition over Los Angeles, 1932
Oil on canvas
50 x 60 in. (127 x 152.4 cm)
The Buck Collection, Laguna Hills, California
p. 105

Migrant America, 1939
Oil on canvas
30 x 40 in. (76.2 x 101.6 cm)
Collection of the Orange County Museum
of Art, Museum purchase with funds provided
through prior gift of Lois Outerbridge
p. 121

Branda Miller
United States, b. 1952

L.A. Nickel, 1983
Videotape (color, with sound, nine minutes)
Lent by Video Data Bank

Roger Minick
United States, b. 1944

Woman with Scarf at Inspiration Point,
Yosemite National Park, 1980
Dye-coupler print
16 x 20 in. (40.6 x 50.8 cm)
Lent by the artist, courtesy Jan Kesner Gallery
p. 195

Richard Misrach
United States, b. 1949

T.V. Antenna, Salton Sea, California, 1985,
printed 1996
Dye-coupler print, edition 5/7
30 x 40 in. (76.2 x 101.6 cm)
LACMA, Ralph M. Parsons Fund
p. 240

Peter Mitchell-Dayton
United States, b. 1962

The Source, 1998–99
Graphite on paper
38 x 50 in. (96.5 x 127 cm)
Lent by the artist

Toyo Miyatake
Japan, active United States, 1895–1979

Untitled, 1929
Gelatin-silver print
13⅜ x 10⅜ in. (34 x 26.6 cm)
Archie Miyatake, Miyatake Collection
p. 137

Untitled, 1930
Gelatin-silver print
13⅜ x 10⅜ in. (34 x 26.6 cm)
Archie Miyatake, Miyatake Collection
p. 141

Untitled, 1943
Gelatin-silver print
7⁹⁄₁₆ x 9½ in. (19.2 x 24.1 cm)
Archie Miyatake, Miyatake Collection

Untitled, 1943
Gelatin-silver print
10⅜ x 13¼ in. (26.4 x 33.7 cm)
Archie Miyatake, Miyatake Collection
p. 156

Untitled, 1943
Gelatin-silver print
7⁷⁄₁₆ x 9½ in. (18.9 x 24.1 cm)
Archie Miyatake, Miyatake Collection

Robert Mizer
United States, 1922–1992

Don Silvis, Athletic Model Guild, c. 1947
Gelatin-silver print
4 x 3 in. (10.2 x 7.6 cm)
Collection of John Sonsini

Quinn Sondergaard, Athletic Model Guild,
c. 1954
Gelatin-silver print
4 x 5 in. (10.2 x 12.7 cm)
Collection of John Sonsini
p. 174

Gerald Sullivan, Athletic Model Guild, c. 1957
Gelatin-silver print
4 x 5 in. (10.2 x 12.7 cm)
Collection of John Sonsini

Susan Mogul
United States

Take Off, 1974
Videotape (black and white, with sound,
ten minutes)
Lent by the artist

Linda Montano
United States

Chicken Woman, 1972
Photo documentation of performance,
transferred to videotape for this exhibition
Lent by the artist

Roberto Montenegro
Mexico, active United States, 1885–1968

Margo, 1937
Oil on canvas
25 x 19½ in. (63.5 x 49.5 cm)
LACMA, The Bernard and Edith Lewin
Collection of Mexican Art
p. 134

Malaquías Montoya
United States, b. 1938

¡Sí Se Puede!, 1988–89
Screenprint
32 x 23 in. (81.3 x 58.4 cm)
LACMA, purchased with funds provided
by the Art Museum Council
p. 267

Moore, Lyndon, Turnbull, and Whitaker
United States, 1962–70
Charles W. Moore (United States, 1925–1993),
Donlyn Lyndon (United States, b. 1936),
William Turnbull (United States, b. 1935), and
Richard R. Whitaker (United States, b. 1929)

Sea Ranch Condominium 1, Perspective, 1963
Graphite on tracing paper
17 x 34 in. (43.2 x 86.4 cm)
San Francisco Museum of Modern Art, gift
of William Turnbull

Julia Morgan
United States, 1872–1957

Hearst Castle, San Simeon, Elevation of Entry,
1922–26
Charcoal on paper
14 x 24 in. (35.6 x 61 cm)
Special Collections and University Archives,
Kennedy Library, California Polytechnic
University, San Luis Obispo

308

Yasumasa Morimura
Japan, active United States, b. 1951

Self-Portrait (Actress)/After Black Marilyn
From the Self-Portrait (Actress) series, 1996
Silver dye-bleach (Ilfochrome) print
49 x 39 in. (124.5 x 99.1 cm)
Collection of Eileen and Peter Norton,
Santa Monica

Morphosis
United States, founded 1975
Thom Mayne, United States, b. 1944

*Diamond Ranch High School, Pomona, Digital
Model, Aerial View*, 1997
Digital print
40 x 20 in. (101.6 x 50.8 cm)
Lent by Morphosis

Ed Moses
United States, b. 1926

Untitled, 1972
Rhoplex and acrylic on laminated tissue
79 x 93 in. (200.7 x 236.2 cm)
Lent by the artist
p. 213

Eric Moss
United States, b. 1943

Culver City Complex, 1988
Ink on Mylar
30 x 36 in. (76.2 x 91.4 cm)
Eric Owen Moss Architects

José Moya del Piño
Spain, active United States, 1891–1969

Chinese Mother and Child, 1933
Oil on canvas
40 x 30 in. (101.6 x 76.2 cm)
Private collection
p. 142

Lee Mullican
United States, 1919–1998

Space, 1951
Oil on canvas
40 x 50 in. (101.6 x 127 cm)
LACMA, partial and promised gift
of Fannie and Alan Leslie
p. 189

Ron Nagle
United States, b. 1939

Blue Sabu Two, 1998
Earthenware, overglazed
4 x 5 in. (10.2 x 12.7 cm)
Collection of Wendy Barrie Brotman

Rock 'n' Block, 1998
Earthenware, overglazed
4 x 4⅝ in. (10.2 x 11.7 cm)
Courtesy Frank Lloyd Gallery

Trick Tracy, 1998
Earthenware, overglazed
4 x 5 in. (10.2 x 12.7 cm)
Courtesy Michael and Patti Marcus

Kentaro Nakamura
Japan, active United States, active 1920s–30s

Evening Wave, c. 1926
Gelatin-silver bromide print
13⁹⁄₁₆ x 10⁹⁄₁₆ in. (34.5 cm x 26.9 cm)
Dennis and Amy Reed Collection
p. 127

Henry Nappenbach
Germany, active United States, 1862–1931

*Chinese New Year Celebration,
San Francisco*, 1904
Oil on canvas
16 x 20 in. (40.6 x 50.8 cm)
Collection of Dr. Oscar and Trudy Lemer
p. 96

San Francisco, Chinatown, 1906
Oil on canvas
16 x 20 in. (40.6 x 50.8 cm)
Collection of Dr. Oscar and Trudy Lemer

Gertrud Natzler
Austria, active United States, 1908–1971
Otto Natzler
Austria, active United States, b. 1908

Teapot, Creamer, Sugar Bowl, and Cups, 1943
Earthenware, uranium glaze
Approximate measurements: Teapot: 6 in.
(15.2 cm); Creamer: 3 in. (7.6 cm); Sugar bowl:
4 in. (10.2 cm); Cups: 3 in. (7.6 cm)
Courtesy Susan and Michael Rich

Bruce Nauman
United States, b. 1941

Black Balls, 1969
Super 8 film (color, without sound, eight
minutes), transferred to videotape for this
exhibition
Lent by Electronic Arts Intermix

Charles P. Neilson
Scotland, active United States, active
1890s–1900s

In Fish Alley, Chinatown, San Francisco, 1897
Watercolor on paper
13 x 19½ in. (33 x 49.5 cm)
The Buck Collection, Laguna Hills, California

Manuel Neri
United States, b. 1930

Hombre Colorado, c. 1957–58
Plaster, oil-based enamel, wood, wire,
and canvas
69 x 16 x 20¼ in. (175.3 x 40.6 x 51.4 cm)
Lent by the artist, courtesy Campbell Thiebaud
Gallery, San Francisco

Richard Neutra
Austria, active United States, 1892–1970

*Lovell Health House, Los Angeles, Elevations
and Perspective*, 1927
Graphite on paper
12¼ x 14½ in. (31.1 x 36.8 cm); 11 x 13½ in.
(27.9 x 34.3 cm)
UCLA Library, Department of Special
Collections

Cantilever Chair, 1929
Redesigned by Dion Neutra, reissue manufac-
tured by Prospettive, Italy, 1992
Chrome-plated steel with upholstery
24¼ x 26 in. (61.5 x 66 cm)
LACMA, gift of ICF (International Contract
Furnishing, Inc.)

Channel Heights Chair, 1940–42
Wood, metal, and plastic
35 x 37 in. (88.9 x 94 cm)
LACMA, gift of Dr. Thomas S. Hines
p. 151

Daniel Nicoletta
United States, b. 1954

MindKamp Kabaret, 1976
Gelatin-silver print
11 x 14 in. (27.9 x 35.6 cm)
Lent by the artist

Suit, 1994
Chromogenic development print
16 x 20 in. (40.6 x 50.8 cm)
Lent by the artist

Linda Nishio
United States, b. 1952

Kikoemasu ka? (Can You Hear Me?), 1980
Twelve gelatin-silver prints
Overall: 58 x 38 in. (147.3 x 96.5 cm)
Lent by the artist
p. 265

Don Normark
United States, b. 1928

La Loma, 1949
Artists book with sixty-three photographs,
sixty-eight pages
9 x 8⅜ x 1 in. (22.9 x 21.3 x .16 cm)
Lent by the artist

Untitled
From La Loma series, 1949
Gelatin-silver print
11 x 14 in. (27.9 x 35.6 cm)
Lent by the artist
p. 166

Chiura Obata
Japan, active United States, 1885–1975

Untitled (Alma, Santa Cruz Mountains), 1922
Sketchbook: *sumi* and silk mounted on board
14½ x 16½ in. (36.8 x 41.9 cm)
Lent by the Obata Family

New Moon, Eagle Peak, 1927
Sumi and watercolor on paper
15¾ x 11 in. (40 x 28 cm)
Lent by the Obata Family
p. 128

El Capitan: Yosemite National Park,
California, 1930
Color woodcut
15¾ x 11 in. (40 x 28 cm)
Lent by the Obata Family

Farewell Picture of the Bay Bridge,
April 30, 1942, 1942
Sumi on paper
15⅛ x 20⅞ in. (38.5 x 53 cm)
Fine Arts Museums of San Francisco,
Achenbach Foundation for Graphic Arts,
Gift of the Obata Family
p. 155

Manuel Ocampo
Philippines, active United States, b. 1965

Untitled (Ethnic Map of Los Angeles), 1987
Acrylic on canvas
66½ x 59 in. (168.9 x 149.9 cm)
Collection Tom Patchett, Los Angeles
p. 245

Víctor Ochoa
United States, b. 1948

Border Bingo/Loteria Fronteriza, 1987
Serigraph on paper
36½ x 26 in. (92.8 x 66 cm)
LAM/OCMA Art Collection Trust, partial gift of
Charlie Miller and partial museum purchase
with funds provided by the National
Endowment for the Arts, a federal agency

Claes Oldenburg
Sweden, active United States, b. 1929

Profile Airflow, 1968–69
Molded polyurethane over lithograph
33½ x 65½ in. (85.1 x 166.4 cm)
Gemini G.E.L., Los Angeles, California

Otis Oldfield
United States, 1890–1969

Telegraph Hill, c. 1927
Oil on canvas
40 x 33¼ in. (101.6 x 84.5 cm)
The Delman Collection, San Francisco

Bay Bridge Series, 1937
Lithograph
19 x 14¼ in. (48.3 x 36.2 cm)
United States Government Treasury
Department, Public Works of Art Project,
Washington, D.C., on permanent loan
to LACMA

Gordon Onslow Ford
England, active United States, b. 1912

Fragment of an Endless (II), 1952
Casein on wrinkled paper
31½ x 67 in. (80 x 170.2 cm)
Lent by the artist
p. 189

Catherine Opie
United States, b. 1961

Self-Portrait, 1993
Chromogenic development (Ektacolor) print
40 x 30 in. (101.6 x 76.2 cm)
LACMA, Audrey and Sydney Irmas Collection
p. 253

Ted Orland
United States, b. 1941

Clearing Winter Storm, San Mateo Freeway,
c. 1965
Gelatin-silver print
6¾ x 9¼ in. (17.1 x 23.5 cm)
Collection of Mrs. Nancy Dubois

Orry-Kelly
Australia, active United States, 1897–1964

Costume for Dolores Del Rio, created
for "In Caliente," Warner Bros., 1935
Silk crepe and silk fringe
CB: 54 in. (137.2 cm)
Warner Bros.

Rubén Ortiz-Torres
Mexico, active United States and Mexico,
b. 1964

California Taco, Santa Barbara, California, 1995
Silver dye-bleach (Cibachrome) print,
edition 4/20
16 x 22½ in. (40.6 x 57.2 cm)
Lent by the artist, courtesy Jan Kesner Gallery
p. 263

Alien Toy, 1997
Custom lowrider Nissan pickup truck with
hydraulics and video
Assembled: approximately 60 x 174 x 72 in.
(152.4 x 442 x 182.9 cm)
Collection Tom Patchett, Los Angeles, courtesy
Track 16 Gallery, Santa Monica

Alien Toy, 1998
Videotape (color, with sound, ten minutes)
Lent by the artist

John O'Shea
Ireland, active United States, 1876–1956

The Madrone, 1921
Oil on canvas
25½ x 29¼ in. (64.8 x 74.3 cm)
Mills College Art Museum, Oakland,
California, gift of Albert M. Bender
p. 68

John Outterbridge
United States, b. 1933

Together Let Us Break Bread, 1968
Assemblage
76 x 64 x 16 in. (193 x 162.6 x 40.6 cm)
Dr. and Mrs. Stanley C. Patterson
p. 215

Bill Owens
United States, b. 1938

Our house is built with the living room in the
back, so in the evenings we sit out front of the
garage and watch the traffic go by, 1970–71,
printed 1982
Gelatin-silver print
8⅛ x 10½ in. (20.6 x 26.7 cm)
LACMA, promised gift of anonymous donor,
Los Angeles
p. 200

Wolfgang Paalen
Austria, active Mexico and United States,
1907–1959

Messengers from the Three Poles, 1949
Oil on canvas
91 x 83 in. (231.1 x 210.8 cm)
Private collection
p. 188

Phil Paradise
United States, 1905–1997

Ranch near San Luis Obispo,
Evening Light, c. 1935
Oil on canvas
28 x 34 in. (71.1 x 86.4 cm)
The Buck Collection, Laguna Hills, California
p. 116

310

Claire Campbell Park
United States, b. 1951

Cycle, 1977
Coiled raffia with wood base
Sculpture and base: 6 x 42 x 15 in.
(15.2 x 106.7 x 38.1 cm)
Collection of Erin Younger and Ed Liebow
p. 231

David Park
United States, 1911–1960

Rehearsal, c. 1949–50
Oil on canvas
46 x 35¾ in. (116.8 x 90.8 cm)
The Oakland Museum of California, gift of the
Anonymous Donor Program of the American
Federation of Arts
p. 184

Bather with Knee Up, 1957
Oil on canvas
56 x 50 in. (142.2 x 127 cm)
Collection of the Orange County Museum
of Art, gift of Mr. and Mrs. Roy Moore

Patricia Patterson
United States, b. 1941

*La Casita en La Colonia Altamira calle
Rio de Janiero no. 6757, Tijuana*, 1997
Photo documentation of installation in Tijuana,
transferred to videotape for this exhibition
Lent by the artist

Charles Payzant
Canada, active United States, 1898–1980

Wilshire Boulevard, c. 1930
Watercolor on paper
19 x 24 in. (48.3 x 61 cm)
The McClelland Collection
p. 105

Agnes Pelton
Germany, active United States, 1881–1961

Sandstorm, 1932
Oil on canvas
30¼ x 22 in. (76.8 x 55.9 cm)
Anonymous lender
p. 123

Alchemy, 1937–39
Oil on canvas
36¼ x 26 in. (92.1 x 66 cm)
The Buck Collection, Laguna Hills, California

Irving Penn
United States, b. 1917

Hell's Angel (Doug), San Francisco, 1967
Gelatin-silver print
20 x 24 in. (50.8 x 61 cm)
Collection of Stephen I. Reinstein

Frederic Penney
United States, 1900–1988

Madonna of Chavez Ravine, c. 1932
Watercolor on paper
16 x 20 in. (40.6 x 50.8 cm)
Collection of Edmund F. Penney and
Mercedes A. Penney
p. 105

Charles Rollo Peters
United States, 1862–1928

Adobe House on the Lagoon, n.d.
Oil on canvas
16 x 24¼ in. (40.6 x 61.5 cm)
Collection of G. Breitweiser
p. 91

Raymond Pettibon
United States, b. 1957

Untitled [Don't you see], 1985
Pen and ink on paper
11 x 8½ in. (27.9 x 21.6 cm)
Courtesy Regen Projects, Los Angeles

Untitled [For truth, justice], 1989
Pen and ink on paper
14 x 11 in. (35.6 x 27.9 cm)
Courtesy Regen Projects, Los Angeles

Untitled [Here and there it], 1995
Pen and ink on paper
17 x 14 in. (43.2 x 35.6 cm)
Courtesy Regen Projects, Los Angeles

Untitled [My best side], 1996
Pen and ink on paper
18 x 12¼ in. (45.7 x 31.1 cm)
Courtesy Regen Projects, Los Angeles

Timothy Pflueger
United States, 1892–1946

*San Francisco Bay Bridge, Architectural
Detail #4*, c. 1936
Graphite on tissue paper
22⅞ x 18⅛ in. (58.2 x 46 cm)
Fine Arts Museums of San Francisco,
Achenbach Foundation for Graphic Arts, gift
of Ronald E. Bornstein in memory of Anna
Louise Wilson

Gottardo Piazzoni
Switzerland, active United States, 1872–1945

Untitled Triptych, n.d.
Oil on canvas
Overall: 23½ x 49¾ in. (59.7 x 126.4 cm)
The Buck Collection, Laguna Hills, California
p. 83

Lari Pittman
United States, b. 1952

Spiritual and Needy, 1991–92
Acrylic and enamel on wood panel
82 x 66 in. (208.3 x 167.6 cm)
Alice and Marvin Kosmin
p. 257

Patti Podesta
United States, b. 1959

Ricochet, 1981
Videotape (color, with sound, two minutes)
Lent by the artist

Bruce Porter
United States, 1865–1953

Presidio Cliffs, 1908
Oil on canvas
27 x 32 in. (68.6 x 81.3 cm)
Private collection

Clayton S. Price
United States, 1874–1950

Coastline, c. 1924
Oil on canvas
40⅛ x 50 in. (101.9 x 127 cm)
Hirshhorn Museum and Sculpture Garden,
Smithsonian Institution, gift of Joseph H.
Hirshhorn Purchase Fund, 1966
p. 126

Ken Price
United States, b. 1935

Untitled, Mound, 1959
Ceramic, glazed
21 x 20 in. (53.3 x 50.8 cm)
Collection of Billy Al Bengston

S. D. Green, 1966
Stoneware, with automotive lacquer and acrylic
5 x 9½ in. (12.7 x 24.1 cm)
Collection of Joan and Jack Quinn,
Beverly Hills

Gold, 1968
Ceramic, glazed and painted with acrylic
9¼ x 8 in. (23.5 x 20.3 cm)
Ken and Happy Price
p. 209

Antonio Prieto
Spain, active United States, 1913–1967

Bottle, 1959–60
Stoneware, glazed
H: 8½ in. (21.6 cm); D: 8¼ in. (21 cm)
Scripps College, Claremont, California, gift
of Mr. and Mrs. Fred Marer

J. John Priola
United States, b. 1960

Hole, 1993
Gelatin-silver print
23¼ x 20¼ in. (59.1 x 51.4 cm)
LACMA, Ralph M. Parsons Fund

Noah Purifoy
United States, b. 1917

Sir Watts II, 1996 (replication of lost original,
Sir Watts, 1966)
Mixed media
34 x 30 in. (86.4 x 76.2 cm)
The Oakland Museum of California, gift
of the Collector's Gallery
p. 222

Marcos Ramirez ERRE
Mexico, active United States, b. 1961

Toy an Horse, 1997
Photo documentation of public sculpture
at United States–Tijuana border crossing,
transferred to videotape for this exhibition
Lent by the artist

Alfredo Ramos Martínez
Mexico, active United States and Mexico,
1872–1946

Aztec Profile, 1932
Conte crayon on newsprint
20⅞ x 15⅝ in. (53 x 39.7 cm)
Private collection, courtesy Louis Stern Gallery

Woman with Fruit, 1933
Charcoal and tempera on newsprint
22⅝ x 16⅝ in. (57.5 x 42.2 cm)
Mimi Rogers
p. 139

Susan Rankaitis
United States, b. 1949

#15
From the Ravine Series, 1981
Gelatin-silver print, toned
13¾ x 11 in. (34.9 x 27.9 cm)
LACMA, promised gift of an anonymous donor,
Los Angeles

Armando Rascón
United States, b. 1956

*Border Metamorphosis: The Binational Mural
Project*, c. 1998
Videotape documentation (color, with sound,
fifteen minutes) of art project in Calexico,
California, and Mexicali, Baja California
Lent by the artist
p. 267

Alan Rath
United States, b. 1959

Watcher, 1998
Cathode-ray tubes, aluminum, and electronics
24 x 42 x 13 in. (61 x 106.7 x 33 cm)
Private collection, La Jolla

Charles Ray
United States, b. 1953

Male Mannequin, 1990
Fiberglass mannequin
73½ x 15 x 14 in. (186.7 x 38.1 x 35.6 cm)
The Broad Art Foundation, Santa Monica
p. 259

Joe Ray
United States, b. 1944

Untitled, 1970–72
Thirty-one gelatin-silver prints
Overall: 52 x 52 in. (132.1 x 132.1 cm)
LACMA, Modern and Contemporary
Art Council, Young Talent Award
p. 200

Granville Redmond
United States, 1871–1935

By the Sea, c. 1910
Oil on canvas
12 x 16 in. (30.5 x 40.6 cm)
Collection of Joseph L. Moure

California Poppy Field, n.d.
Oil on canvas
40¼ x 60¼ in. (102.2 x 153 cm)
LACMA, gift of Raymond Griffith
pp. 78–79

Charles Reiffel
United States, 1862–1942

Late Afternoon Glow, c. 1925
Oil on canvas
34 x 37 in. (86.4 x 94 cm)
Masterpiece Gallery
p. 122

Frederick Hurten Rhead
England, active United States, 1880–1942

Footed Bowl, c. 1915
Earthenware
H: 3¾ in. (9.5 cm); D: 10⅜ in. (26.2 cm)
LACMA, Art Museum Council Fund

Jason Rhoades
United States, b. 1965
Jorge Pardo
Cuba, active United States, b. 1963

#1 NAFTA Bench, 1996
Marble, plywood, three plastic buckets, eight
plastic lids, fabric pillow, vinyl-covered cushion,
PVC plastic pipes, clamps, and battery-operated
vibrator
Bench: 28 x 144 x 28 in. (71.1 x 365.8 x 71.1 cm);
Horse leg D: 55 x 5 in. (139.7 x 12.7 cm)
Collection of Rosa and Carlos de la Cruz
p. 269

William S. Rice
United States, 1873–1963

Chinatown—Monterey, 1903
Watercolor on paper
10 x 16¼ in. (25.4 x 41.3 cm)
From the collection of Roberta Rice Treseder

John Hubbard Rich
United States, 1876–1954

Madam Yup See, c. 1919
Oil on canvas
36 x 28 in. (91.4 x 71.1 cm)
LACMA, gift of Mrs. Ruth Rich and
the Kenneth C. Rich Sr. Family

Rigo
Portugal, active United States, b. 1966

One Tree, 1999
Photo documentation, transferred to videotape
for this exhibition
Lent by the artist

Faith Ringgold
United States, b. 1930

Double Dutch on the Golden Gate Bridge, 1988
Acrylic on canvas and printed, dyed, and
pieced fabric
68½ x 68½ in. (174 x 174 cm)
Private collection
p. 242

Diego Rivera
Mexico, active France, Mexico, and
United States, 1886–1957

*Study for "Allegory of California" (also known as
"Riches of California"), mural in Stock Exchange
Building, San Francisco*, 1931
Graphite on paper
24¾ x 19 in. (62.9 x 48.3 cm)
Collection of Lisa and Douglas Goldman
p. 138

312

A. J. Roberts
Active United States, 1910s–1930
For San Diego Decorating Company,
United States, c. 1913

*Fanciful Interpretation of What the Panama-
California Exposition Would Look Like*, c. 1913
Oil on board
48 x 84 in. (121.9 x 213.3 cm)
San Diego Historical Society, gift of
Mr. and Mrs. John Cuchna, 1986

Fred H. Robertson
United States, 1868–1952

Vase, c. 1915
Stoneware
H: 6 11/16 in. (17.1 cm); D: 3¾ in. (9.5 cm)
LACMA, Art Museum Council Fund

Frank Romero
United States, b. 1941

Freeway Wars, c. 1987
Oil on canvas
63½ x 75 in. (161.3 x 190.5 cm)
LACMA, gift of Franci Seiniger

Guy Rose
United States, 1867–1925

The Old Oak Tree, c. 1916
Oil on canvas
29⅞ x 28¼ in. (75.9 x 71.8 cm)
Edenhurst Gallery
p. 68

Carmel Dunes, c. 1918–20
Oil on canvas
24 1/16 x 29 1/16 in. (61.2 x 73.8 cm)
LACMA, gift of Mr. and Mrs. Reese H. Taylor
p. 77

Martha Rosler
United States

Semiotics of the Kitchen, 1975
Videotape (black and white, with sound,
six minutes)
Lent by Video Data Bank

Ed Rossbach
United States, b. 1914

Constructed Color, 1965
Synthetic raffia braiding
57 x 71 in. (144.8 x 180.3 cm)
The Museum of Modern Art, New York,
Purchase

Erika Rothenberg
United States

America's Joyous Future, 1990
Plexiglas and aluminum display case with
plastic letters
36 x 24 x 2¾ in. (91.4 x 61 x 7 cm)
Robert and Mary Looker
p. 255

Jerry Rothman
United States, b. 1933

Sky Pot, 1960
Stoneware
28½ x 25 in. (72.4 x 63.5 cm)
Scripps College, Claremont, California,
gift of Mr. and Mrs. Fred Marer

Michael Rotondi
United States, b. 1949
Clark Stevens
United States, b. 1963
RoTo Architects, Inc., United States,
founded 1991

Carlson-Reges House, Los Angeles, Composite,
1990
Mixed media on digital print
60 x 36 in. (152.4 x 91.4 cm)
Lent by RoTo Architects Inc.

Ross Rudel
United States, b. 1960

Untitled #128, 1993
Stained wood
H: 6 in. (15.2 cm); D: 17 in. (43.2 cm)
Collection of Morris T. Grabie and Sherry
Latt Lowy

Allen Ruppersberg
United States, b. 1944

Al's Café, 1969
Photo and audio documentation of installa-
tion/performance in downtown Los Angeles,
transferred to videotape for this exhibition
Lent by the artist

Edward Ruscha
United States, b. 1937

Joe, c. 1962
Oil on paper
12 x 12 in. (30.5 x 30.5 cm)
Joe Goode

Twenty-Six Gasoline Stations, 1962
Artists book with photomechanical
reproductions
Book closed: 7 x 5½ in. (17.8 x 14 cm)
LACMA, Balch Library Acquisition Fund

Burning Gas Station, 1965–66
Oil on canvas
21¾ x 39⅛ in. (55.2 x 99.4 cm)
Collection of Vicki and Kent Logan,
San Francisco
p. 37

Every Building on the Sunset Strip, 1966
Artists book (accordion fold) with
photomechanical reproductions
Book closed: 7⅛ x 5⅝ in. (18.1 x 14.3 cm)
LACMA, Balch Library, Special Collections

Standard Station, 1966
Screenprint
26¼ x 40¼ in. (66.7 x 102.2 cm)
LACMA, Museum Acquisition Fund
p. 202

Thirty-Two Parking Lots in Los Angeles, 1967
Artists book with photomechanical
reproductions
Book closed: 10 x 8 in. (25.4 x 20.3 cm)
LACMA, Balch Library Acquisition Fund

Hollywood, 1968
Color screenprint
17½ x 44½ in. (44.5 x 113 cm)
LACMA, Museum Acquisition Fund
p. 201

Edward Ruscha
United States, b. 1937
Mason Williams
United States, b. 1938
Patrick Blackwell
United States, b. 1935

Royal Road Test, 1966
Artists book (spiral bound) with
photomechanical reproductions
Book closed: 9½ x 6¼ in. (24.1 x 15.9 cm)
LACMA, Library Acquisitions Fund

Alison Saar
United States, b. 1956

Topsy Turvy, 1999
Wood, tar, plaster, fabric, and ceiling tin
43 x 14 x 9 in. (109.2 x 35.6 x 22.9 cm)
Smith College Museum of Art, Northampton,
Massachusetts, purchased with the Janet
Wright Ketcham, class of 1953, Fund and the
Kathleen Compton Sherrerd, class of 1954,
Fund for American Art
p. 264

Betye Saar
United States, b. 1926

The Liberation of Aunt Jemima, 1972
Mixed-media assemblage
11¾ x 8 x 2¾ in. (29.8 x 20.3 x 7 cm)
UC Berkeley, Art Museum, purchased with the
aid of funds from the National Endowment for
the Arts
p. 222

Ben Sakoguchi
United States, b. 1938

Atomic Brand, 1975–81
Acrylic on canvas
10 x 11 in. (25.4 x 27.9 cm)
Collection of Patricia S. Cornelius

Capitalist Art Brand, 1975–81
Acrylic on canvas
10 x 11 in. (25.4 x 27.9 cm)
Collection of Philip Cornelius
p. 196

Furs for M'Lady Brand, 1975–81
Acrylic on canvas
10 x 11 in. (25.4 x 27.9 cm)
Collection of Michelle Montgomery
and David Kent

Paul Sample
United States, 1896–1974

Celebration, 1933
Oil on canvas
40 x 48 in. (101.6 x 121.9 cm)
Paula and Irving Glick
p. 121

Sandoval
United States, dates unknown

Drop Leaf Desk, c. 1934–36
Carved mahogany
21 x 50 in. (53.3 x 127 cm)
Courtesy Robert Bijou Fine Arts

J. T. Sata
Japan, active United States, 1896–1975

Untitled (Portrait), 1928
Gelatin-silver print
7 x 9 in. (17.8 x 22.9 cm)
Collection of Frank T. Sata, Pasadena
p. 137

Adrian Saxe
United States, b. 1943

Elvis/Lives, 1990
Porcelain, lusters, quartz crystals, wood,
and silver leaf
32 x 52 in. (81.3 x 132.1 cm)
The Oakland Museum of California, gift of
the William F. and Helen S. Reichel Trust

Miriam Schapiro
United States, b. 1923

Night Shade, 1986
Acrylic and fabric collage on canvas
48 x 96 in. (129.9 x 243.8 cm)
Collection of Frank Miceli
p. 231

Rudolph Schindler
Austria, active United States, 1887–1953

*Lighting Fixture from the Wolfe Commission,
Avalon, Catalina Island*, 1928–29, reproduction
1997
Wood and glass, with electrical cord
5 x 12 in. (12.7 x 30.5 cm)
Modernica

*Milton Shep Residence [Project], Los Angeles,
Perspective Elevation*, 1934–35
Colored pencil on paper
22⅝ x 32¾ in. (57.5 x 83.2 cm)
Architecture and Design Collection,
University Art Museum, UCSB
p. 110

*Armchair and Ottoman from the Shep
Commission, Los Angeles*, 1936–38
Gumwood and wool upholstery (replaced)
25¾ x 33½ x 35½ in. (65.4 x 85.1 x 90.2 cm);
25 x 25 x 12½ in. (63.5 x 63.5 x 31.8 cm)
LACMA, gift of Ruth Shep Polen
p. 111

*Bedroom Dresser with Hinged Half-Round
Mirror and Stool from the Shep Commission,
Los Angeles*, 1936–38
Gumwood, mirror, and wool upholstery
(replaced)
Overall: 70¾ x 105 in. (179.7 x 266.7 cm)
LACMA, gift of Ruth Shep Polen
p. 111

*Dining Table with Folding Top from the Shep
Commission, Los Angeles*, 1936–38
Gumwood and metal
36 x 47½ in., opens to 36 x 89 in.
(91.4 x 120.7 cm, opens to 91.4 x 226.1 cm)
LACMA, gift of Ruth Shep Polen

*Large Storage Chest from the Shep Commission,
Los Angeles*, 1936–38
Gumwood and glass top
L: 105 in. (266.7 cm)
LACMA, gift of Ruth Shep Polen

*Radio End Table from the Shep Commission,
Los Angeles*, 1936–38
Gumwood, glass (two pieces), and radio inset
22 x 26 in. (55.9 x 66 cm)
LACMA, gift of Ruth Shep Polen

*Three-Section Sofa from the Shep Commission,
Los Angeles*, 1936–38
Gumwood and wool upholstery (replaced)
Overall: 27 x 85 in. (68.6 x 215.9 cm)
LACMA, gift of Ruth Shep Polen

*Pair of Dining Chairs with Backs from the Shep
Commission, Los Angeles*, 1936–38
Gumwood and wool upholstery (replaced)
Each: 29 x 18 in. (73.7 x 45.7 cm)
LACMA, gift of Ruth Shep Polen

Palmer Schoppe
United States, b. 1912

Drum, Trombone, and Bass, 1942
Gouache and pencil on paper
16 x 22 in. (40.7 x 55.9 cm)
Nora Eccles Harrison Museum of Art,
Purchase: The Charter Member Endowment
Fund
p. 183

Frederick J. Schwankovsky
United States, 1885–1974

Woman at the Piano, c. 1925
Oil on canvas
26 x 20¼ in. (66 x 51.4 cm)
LAM/OCMA Art Collection Trust,
gift of the artist
p. 87

Eduardo Scott
United States, 1897–1925

San Francisco Embarcadero, 1924
Black crayon and graphite on wove paper
21 1/16 x 26¾ in. (53.5 x 68 cm)
Fine Arts Museums of San Francisco,
Achenbach Foundation for Graphic Arts,
Museum Purchase

Ilene Segalove
United States, b. 1950

Why I Got into TV and Other Stories, 1983
Videotape (color, with sound, ten minutes)
Lent by the artist

Kay Sekimachi
United States, b. 1926

Nagare (Flow) III, 1968
Nylon monofilament, four-layered weave
and tubular weave
87 x 15 in. (221 x 38.1 cm)
American Craft Museum, New York. Gift of the
Johnson Wax Company

Allan Sekula
United States, b. 1951

*Twentieth Century Fox Set for "Titanic" and
Mussel Gatherers, Popotla, Baja California*
(diptych)
From Dead Letter Office, 1997
Two silver dye-bleach (Ilfochrome) prints
25 x 66 in. (63.5 x 167.6 cm)
Courtesy Christopher Grimes Gallery,
Santa Monica, California

Jim Shaw
United States, b. 1952

Beach Boys Weekend, 1988
Pencil on paper
17 x 14 in. (43.2 x 35.6 cm)
Collection Barry Sloane

Charles Sheeler
United States, 1883–1965

California Industrial, 1957
Oil on canvas
25 x 33 in. (63.5 x 83.8 cm)
Richard York Gallery, New York
p. 164

Millard Sheets
United States, 1907–1989

Angel's Flight, 1931
Oil on canvas
50¼ x 40 in. (127.6 x 101.6 cm)
LACMA, gift of Mrs. L. M. Maitland
p. 104

Old Mill, Big Sur, 1933
Watercolor on paper
22 x 30 in. (55.9 x 76.2 cm)
The E. Gene Crain Collection

California, c. 1935
Oil on canvas
30 x 40 in. (76.2 x 101.6 cm)
The Fieldstone Collection
p. 116

Migratory Camp near Nipomo, 1936
Watercolor on paper
16½ x 23 in. (41.9 x 58.4 cm)
The Michael Johnson Collection
p. 120

Readying Pan Am Clipper Flight, 1936
Watercolor on paper
15 x 22 in. (38.1 x 55.9 cm)
The McClelland Collection

Working Carrots, Imperial Valley, 1936
Watercolor on paper
13½ x 21 in. (34.3 x 53.3 cm)
The Michael Johnson Collection

Bonnie Sherk
United States

Portable Park I–III, 1970
Videotape excerpt (color, with sound,
eight minutes)
Lent by the artist

Kaye Shimojima
Japan, active United States, active 1920s–30s

Edge of the Pond, c. 1928
Gelatin-silver print
13⁷⁄₁₆ x 10½ in. (34.1 x 26.7 cm)
LACMA, gift of Karl Struss
p. 125

Billy Shire
United States, b. 1951

Untitled Denim Jacket, 1973
Denim, metallic studs, paste stones,
and attached metallic objects
CB: 26½ in. (67.3 cm)
Lent by the artist
p. 218

Peter Shire
United States, b. 1947

Mexican Bauhaus (Teapot), 1980
Ceramic, glazed
8½ x 15⅞ in. (21.6 x 40.3 cm)
Courtesy Frank Lloyd Gallery

Henrietta Shore
Canada, active United States, 1880–1963

Women of Oaxaca, c. 1925–35
Chalk on paper
19½ x 24⅛ in. (49.5 x 61.3 cm)
The Mitchell Wolfson Jr. Collection, The
Wolfsonian, Florida International University,
Miami Beach, Florida

Untitled (Cypress Trees, Point Lobos), c. 1930
Oil on canvas
30¼ x 26¼ in. (76.8 x 66.7 cm)
Private collection
p. 125

The Artichoke Pickers, 1936–37
Oil on canvas
29 x 74 in. (73.7 x 188 cm)
State Museum Resource Center, California
Department of Parks and Recreation

Julius Shulman
United States, b. 1910

Case Study House #8, 1950
Gelatin-silver print
5 x 4 in. (12.7 x 10.2 cm)
Lent by the artist, courtesy Craig Krull Gallery,
Santa Monica
p. 160

Lovell "Health" House, 1950
Gelatin-silver print
4 x 5 in. (10.2 x 12.7 cm)
Lent by the artist, courtesy Craig Krull Gallery,
Santa Monica
p. 109

Case Study House #22, 1958
Gelatin-silver print
10 x 8 in. (25.4 x 20.3 cm)
Lent by the artist, courtesy Craig Krull Gallery,
Santa Monica

Chuey House, 1958
Gelatin-silver print
10 x 8 in. (25.4 x 20.3 cm)
Lent by the artist, courtesy Craig Krull Gallery,
Santa Monica

Case Study House #22, 1960, printed later
Gelatin-silver print
14 x 11 in. (35.6 x 27.9 cm)
Lent by the artist, courtesy Craig Krull Gallery,
Santa Monica
p. 160

Singleton House, 1960
Gelatin-silver print
5 x 4 in. (12.7 x 10.2 cm)
Lent by the artist, courtesy Craig Krull Gallery,
Santa Monica

Ernest Silva
United States, b. 1948

*Deer on a Raft—Rough Water,
Long Journey*, 1991
Oil on canvas
30 x 36 in. (76.2 x 91.4 cm)
Dr. Charles C. and Sue K. Edwards

Larry Silver
United States, b. 1934

Contestants, Muscle Beach, California, 1954
Gelatin-silver print
11 x 14 in. (27.9 x 35.6 cm)
LACMA, gift of Bruce Silverstein
p. 173

Handstand, 1954
Gelatin-silver print
14 x 11 in. (35.6 x 27.9 cm)
LACMA, gift of Bruce Silverstein

Newsboy Holding Papers, 1954
Gelatin-silver print
11 x 14 in. (27.9 x 35.6 cm)
LACMA, gift of Bruce Silverstein
p. 159

Burr Singer
United States, 1912–1992

Only on Thursday, 1940
Watercolor on paper
Framed: 14½ x 17½ in. (36.9 x 44.5 cm)
John Tolbert

David Alfaro Siqueiros
Mexico, active Mexico and United States,
1896–1975

"The Warriors," study for "Tropical America"
mural, Los Angeles, c. 1932
Graphite and ink on paper
18¾ x 22¾ in. (47.6 x 57.8 cm)
San Francisco Museum of Modern Art, Albert
M. Bender Collection, gift of Albert M. Bender
p. 139

Rex Slinkard
United States, 1887–1918

Infinite, c. 1915–16
Oil on canvas
29½ x 33½ in. (74.9 x 85.1 cm)
Iris and B. Gerald Cantor Center
for Visual Arts at Stanford University,
bequest of Florence Williams
p. 85

Alexis Smith
United States, b. 1949

Christmas Eve, 1943, #27, Coconut Grove, 1982
Mixed-media collage
21¼ x 18½ in. (54 x 47 cm)
The Museum of Contemporary Art,
Los Angeles, gift of Robert B. Egelston

Madame X, 1982
Mixed-media collage
21⅜ x 18½ in. (54.3 x 47 cm)
Collection of Richard Rosenzweig
and Judy Henning
p. 254

Sea of Tranquility, 1982
Mixed-media collage
20⅜ x 17⅝ x 1½ in. (51.8 x 44.8 x 3.8 cm)
LACMA, purchased with funds provided
by James Burrows, Jerry and Joy Monkarsh,
Stanley and Elyse Grinstein, Laura S. Maslon,
and Terri and Michael Smooke
p. 26

Wild Life, 1985
Mixed-media collage
18½ x 16⅜ x 2½ in. (47 x 41.6 x 6.4 cm)
Santa Barbara Museum of Art, gift of
Bruce Murkoff

Barbara Smith
United States, b. 1931

Ritual Meal, 1969
Excerpt from 16 mm film (black and white,
with sound, twelve minutes) by William
Ransom and Smith of performance event in
Brentwood, California
Lent by the artist

Christina Y. Smith
United States, b. 1951

The Commitment, 1997
Sterling silver
10 x 9 x 6 in. (25.4 x 22.9 x 15.2 cm)
Collection of Mr. and Mrs. David Charak
p. 259

Sixteen Years, 1997
Sterling silver
10 x 7¾ in. (25.4 x 19.7 cm)
Collection of Margery and Maurice Katz

Elizabeth Paige Smith
United States, b. 1968

Curve Coffee Table, 1998
Resin-coated balsa wood
and powder-coated steel
42 x 35 in. (106.7 x 88.9 cm)
Jenny Armit Design and Decorative Art, Inc.

Harry Smith
United States, 1923–1991

Film No. 7, 1952
16 mm film (color, without sound,
six minutes)
Lent by Dr. William Moritz

Paul Soldner
United States, b. 1921

Floor Pot, 1959
Stoneware, glazed
H: 55 in. (139.7 cm); D: 12 in. (30.5 cm)
Collection of Doug and Joelle Lawrie

Travis Somerville
United States, b. 1963

Untitled (Dixie), 1998
Oil and collage on ledger paper
60 x 41 in. (152.4 x 104.1 cm)
Fine Arts Museums of San Francisco,
Achenbach Foundation for Graphic Arts,
Museum Purchase, Wallace Anderson Gerbode
Foundation Grant
p. 262

John Sonsini
United States, b. 1950

Mad Dog "Andreas" Maines, 1995
Oil on canvas
67 x 48 in. (170.2 x 121.9 cm)
Lent by the artist
p. 257

Peter Stackpole
United States, 1913–1997

The Lone Riveter, 1935
Gelatin-silver print
9¾ x 6¹⁵⁄₁₆ in. (24.8 x 15.75 cm)
San Francisco Museum of Modern Art,
Gift of Ursula Gropper
p. 107

Robert Stacy-Judd
England, active United States, 1884–1975

The Aztec Hotel, Monrovia, Front Elevation,
Right Section, 1924–25
Pastel on paper
30 x 48 in. (76.2 x 121.9 cm)
Architecture and Design Collection,
University Art Museum, UCSB

Frances Stark
United States, b. 1967

…a rainbow, 1997
Carbon, water, oil crayon, and papers
50 x 38½ in. (127 x 97.8 cm)
LACMA, Modern and Contemporary Art
Council, 1997 Art Here and Now Purchase

Linda Stark
United States, b. 1956

Be Mine, 1994–95
Oil on canvas on panel
13½ x 13½ in. (34.3 x 34.3 cm)
LACMA, purchased with funds provided
by the Marvin B. Meyer Family Endowment
in memory of Nan Uhlmann Meyer

Joel Sternfeld
United States, b. 1944

After a Flash Flood, Rancho Mirage,
California, 1979
Chromogenic development print
24 x 20 in. (61 x 50.8 cm)
LACMA, gift of the artist
p. 240

Lou Stoumen
United States, 1917–1991

Tenements of Bunker Hill, 1948
Gelatin-silver print
11 x 14 in. (27.9 x 35.6 cm)
The Collection of the Law Firm of Latham
and Watkins
p. 167

Karl Struss
United States, 1886–1981

Monterey Coast, 1910–15
Gelatin-silver print
4 9/16 x 3 5/8 in. (11.5 x 9.2 cm)
The J. Paul Getty Museum, Los Angeles
p. 84

John Sturgeon
United States, b. 1946

Spine/Time, 1982
Videotape (color, with sound, twenty minutes)
Lent by the artist

Henry Sugimoto
Japan, active United States, 1900–1990

Mother in Jerome Camp, 1943
Oil on canvas
22 x 18 in. (55.9 x 45.7 cm)
Japanese American National Museum, gift
of Madeleine Sugimoto and Naomi Tagawa
p. 155

Self-Portrait in Camp, 1943
Oil on canvas
23 x 18 in. (58.4 x 45.7 cm)
Japanese American National Museum, gift
of Madeleine Sugimoto and Naomi Tagawa

Elza Sunderland
Hungary, active United States, b. 1903

Woman's Two-Piece Playsuit, c. 1940
Printed cotton
Top L: 16 1/2 in. (41.9 cm); Shorts CB: 18 in.
(45.7 cm)
LACMA, gift of Mr. and Mrs. Jon Gluckman
p. 141

Untitled Textile Design, c. 1941
Gouache on paper
19 x 16 1/2 in. (48.3 x 41.9 cm)
LACMA, gift of the artist

Textile Design, Loquats and Taro Vine, c. 1945
Gouache on board
18 x 22 in. (45.7 x 55.9 cm)
LACMA, gift of the artist

Charles Surendorf
United States, 1906–1979

Chinatown Shineboys, c. 1939
Wood engraving
10 1/2 x 7 3/8 in. (26.7 x 18.8 cm)
United States Government Treasury
Department, Public Works of Art Project,
Washington, D.C., on permanent loan
to LACMA

Mitchell Syrop
United States, b. 1953

Routine Reorganization, 1986
Mounted photo-mural paper
40 x 26 1/2 in. (101.6 x 67.3 cm)
LACMA, anonymous gift

Second Nature, 1986
Mounted photo-mural paper
40 x 26 1/2 in. (101.6 x 67.3 cm)
LACMA, anonymous gift

Lagardo Tackett
United States
For Architectural Pottery, United States,
1951–89

Untitled [Three Stacked Sculptures], c. 1960
Ceramic, glazed
H: 66 in. (167.6 cm), D: 12 in. (30.5 cm);
H: 99 in. (251.5 cm), D: 13 in. (33 cm); H: 52 in.
(132.1 cm), D: 25 in. (63.5 cm)
Collection of Max Lawrence, Los Angeles
p. 163

Hourglass Planter (Model T-120), n.d.
Ceramic, matte white glaze
H: 20 in. (50.8 cm); D: 10 1/2 in. (26.7 cm)
Anonymous lender

Planter (Model L-20), n.d.
Ceramic, matte white glaze
H: 20 in. (50.8 cm); D: 13 1/2 in. (34.3 cm)
Anonymous lender

Henry Takemoto
United States, b. 1930

Flag, 1960
Stoneware, glazed
36 3/4 x 26 in. (93.4 x 66 cm)
Scripps College, Claremont, California,
gift of Mr. and Mrs. Fred Marer

Janice Tanaka
United States

Memories from the Department of Amnesia,
1989–91
Videotape (color, with sound, twelve minutes)
Lent by the artist

Max Tatch
United States, 1898–1963

Los Angeles, 1937
Gelatin-silver print
11 x 14 in. (27.9 x 35.6 cm)
Sid Avery/Motion Picture and Television
Photo Archive

Gage Taylor
United States, b. 1942

Mescaline Woods, 1969
Oil on canvas
26 1/4 x 30 1/2 in. (66.7 x 77.5 cm)
The Haggin Museum, Stockton, California
p. 217

Harold A. Taylor
United States, 1878–1960

Going from Mass, San Juan Capistrano
From the book *For the Soul of Raphael*, c. 1920
Gelatin-silver print
12 1/4 x 9 7/8 in. (31.1 x 25.1 cm)
Smith College Museum of Art, Northampton,
Massachusetts, purchased with the Hillyer-
Tryon-Mather Fund, with funds given in
memory of Nancy Newhall (Nancy Parker, class
of 1938) and in honor of Beaumont Newhall,
and with funds given in honor of Ruth
Wedgwood Kennedy

Masami Teraoka
Japan, active United States, b. 1936

Geisha and AIDS Nightmare, 1990
Watercolor on paper
106 1/4 x 74 in. (269.9 x 188 cm)
Catharine Clark Gallery
p. 256

Edmund Teske
United States, 1911–1996

Untitled, 1962
Gelatin-silver print with duotone solarization
13 5/8 x 10 3/4 in. (34.6 x 27.3 cm)
LACMA, Ralph M. Parsons Fund
p. 215

Robert Therrien
United States, b. 1947

No Title (Snowman), 1983–84
Silver on cast bronze
H: 36 in. (91.4 cm); D: 16 in. (40.6 cm)
Collection Teresa Bjornson, Los Angeles

Wayne Thiebaud
United States, b. 1920

Down Mariposa, 1979
From the portfolio *Recent Etchings I*, pl. 3
Etching
16 x 20 in. (40.6 x 50.8 cm)
Fine Arts Museums of San Francisco, Crown
Point Press Archive, gift of Kathan Brown
p. 198

Dorothy Thorp
United States

Platter (from Tea Service), c. 1930
Etched glass
H: 2½ in. (6.4 cm); D: 24 in. (61 cm)
Courtesy Anne and Marvin H. Cohen

Tom of Finland [Touko Laaksonen]
Finland, active United States, 1920–1991

Untitled, 1962
Graphite on paper
11¾ x 8¼ in. (29.9 x 21 cm)
Collection Tom of Finland Foundation,
Los Angeles,
p. 219

Untitled, 1962
Graphite on paper
11¾ x 8¼ in. (29.9 x 21 cm)
Collection Tom of Finland Foundation,
Los Angeles

Fred Tomaselli
United States, b. 1956

Booth for Isolation or Romance, 1988–95
Mixed wood, Plexiglas, Formica, metal, enamel,
and sea grass
85 x 37 x 38½ in. (215.9 x 94 x 97.8 cm)
Lent by the artist, courtesy Christopher
Grimes Gallery

Salvador Roberto Torres
United States, b. 1936

Viva La Raza, 1969
Oil on canvas
53 x 42 in. (134.6 x 106.7 cm)
Lent by the artist
p. 225

Channel P. Townsley
United States, 1867–1921

Mission San Juan Capistrano, 1916
Oil on canvas
32 x 40 in. (81.2 x 101.6 cm)
Joan Irvine Smith Fine Arts, Inc.,
Laguna Beach, California
p. 92

Wesley H. Trippett
United States, 1862–1913

Bonbon Box, c. 1904–9
Earthenware
H: 2 in. (5.1 cm); D: 3¼ in. (8.3 cm)
LACMA, Art Museum Council Fund

Flower Bowl, c. 1904–9
Earthenware
H: 3 in. (7.6 cm); D: 3½ in. (8.9 cm)
LACMA, Art Museum Council Fund

Covered Bowl, c. 1910
Earthenware
H (including cover): 3½ in. (8.9 cm);
D: 5⅝ in. (8.9 cm)
LACMA, Art Museum Council Fund

Wing-Kwong Tse
China, active United States, 1902–1993

Cup of Longevity, c. 1930
Watercolor on paper
16½ x 13 in. (41.9 x 33 cm)
The Michael D. Brown Collection
p. 143

Tseng Kwong Chi
Hong Kong, active Canada and United States,
1950–1990

Disneyland, California, 1979
Gelatin-silver print
7½ x 7⅜ in. (19.1 x 18.7 cm)
LACMA, Ralph M. Parsons Fund
p. 249

Paul Tuttle
United States, b. 1918

Pisces III, 1997
Crafted by Bud Tullis
Maple, ApplyPly, and glass
Overall: 15½ x 60½ in. (39.4 x 153.7 cm)
Architecture and Design Collection, University
Art Museum, UCSB, gift of Suzanne Duca

Tokio Ueyama
Japan, active United States, 1889–1954

Cove, Monterey, 1924
Oil on canvas
32 x 40 in. (81.3 x 101.6 cm)
The Michael D. Brown Collection

Underwood and Underwood Publishers
United States, active 1880s–1940s

Yosemite Valley, 1902, printed c. 1905
Twenty-three stereographic prints stored
in custom case
Each: 3½ x 7 in. (8.9 x 17.8 cm)
Collection of David Knaus
p. 73

Unknown Artist

[Title Unknown: City Hall], 1906
Gelatin-silver print
9⅝ x 6⅛ in. (24.4 x 15.6 cm)
Collection of Mrs. Nancy Dubois

*[Title Unknown: Fire Following the
Earthquake]*, 1906
Gelatin-silver print
7⁹⁄₁₆ x 9½ in. (19.3 x 24.1 cm)
Collection of Mrs. Nancy Dubois

[Title Unknown: View from a Hill], 1906
Gelatin-silver print
5¼ x 9⅜ in. (13.3 x 23.8 cm)
Collection of Mrs. Nancy Dubois

Unknown Artists

*Cahuilla Basket with Design of Abstract
Flowers*, 1890–1920
Coiled juncus
2¾ x 14 in. (7 x 35.6 cm)
Lent by the Southwest Museum, Los Angeles,
gift of Miss Margaret A. Feeney
p. 94

Basket, c. 1900
Juncus
H: 5½ in. (14 cm); D: 10 in. (25.4 cm)
Lent by the Southwest Museum, Los Angeles,
gift of Mr. George Wharton James
p. 94

*Karok Basket with Design of Serrated Diamonds
and Triangles*, 1900–1930
Twined willow root, maidenhair fern, and dyed
porcupine quill
4½ x 6⅜ in. (11.4 x 16 cm)
Lent by the Southwest Museum, Los Angeles,
gift of Mrs. Caroline Boeing Poole

Karok Food Serving Basket, 1900–1930
Twined conifer root and bear grass
3¾ x 7½ in. (9.5 x 19.1 cm)
Lent by the Southwest Museum, Los Angeles,
gift of Colonel John Hudson Poole and
Mr. John Hudson Poole Jr.

Pomo Basket with Design of Stepped Triangles,
1900–1930
Coiled sedge root and bracken fern
5½ x 13½ in. (14 x 34.3 cm)
Lent by the Southwest Museum, Los Angeles,
gift of Mrs. Caroline Boeing Poole

*Pomo Ceremonial Basket with Design of Bands
of Triangles*, 1900–1930
Coiled winter redbud shoots and sedge roots
9¼ x 16½ in. (23.5 x 41.9 cm)
Lent by the Southwest Museum, Los Angeles,
gift of Mrs. Caroline Boeing Poole

Yokuts Basket with Design of Animals and Geometric Motifs, 1900–1930
Coiled sedge root, redbud and bracken fern
6 ¾ x 10 in. (17.2 x 25.4 cm)
Lent by the Southwest Museum, Los Angeles, gift of Mrs. Caroline Boeing Poole

Pomo Basket, c. 1930
Coiled sedge root, feathers, clam shell beads, abalone, and cotton cord
H: 2 in. (5.1 cm); D: 6 ¼ in. (15.9 cm)
Lent by the Southwest Museum, Los Angeles, gift of Colonel John Hudson Poole and Mr. John Hudson Poole Jr.

Patssi Valdez
United States, b. 1951

The Kitchen/La cocina, 1988
Acrylic on canvas
48 x 36 in. (121.9 x 91.4 cm)
Collection of Curtis M. Hill

Manuel Valencia
United States, 1856–1935

Santa Barbara Mission at Night, n.d.
Oil on canvas
30 x 20 in. (76.2 x 50.8 cm)
Courtesy DeRu's Fine Arts, Laguna Beach
p. 91

Jeffrey Vallance
United States, b. 1955

The Viewing Room: Blinky's Coffin and St. Francis Niche, c. 1989
Coffin with plastic chicken replica, paper towel, ceramic, plaster, acrylic, enamel, candle, and flower vases
Dimensions variable
Collection of Barry Sloane

Deborah Valoma
United States, b. 1955

Cunning Comes in Trouble, 1998
Waxed linen, woven and stitched
112 x 30 in. (284.5 x 76.2 cm)
Lent by the artist

Willard Van Dyke
United States, 1906–1986

Death Valley Dunes, 1930
Gelatin-silver print
9 ½ x 7 ½ in. (24.1 x 19.1 cm)
The Wilson Center for Photography

Dirk Van Erp Copper Shop
United States, 1908–77

Vase, 1911
Copper
H: 15 ⅛ in. (38.4 cm); D: 10 ⅛ in. (25.7 cm)
LACMA, gift of Max Palevsky

Table Lamp, c. 1915
Copper and mica
H: 26 in. (66.1 cm); D: 19 ⅝ in. (49.9 cm)
LACMA, gift of Max Palevsky
p. 89

Hendrick Van Keppel
United States, 1914–1987
Taylor Green
United States, 1914–1991

Small Chaise and Ottoman, 1939, manufactured 1959
Enamel-baked steel and cotton cord (replaced)
24 ½ x 21 in. (62.2 x 53.3 cm); 12 x 21 in. (30.5 x 53.3 cm)
LACMA, gift of Dan Steen in remembrance of Taylor Green
p. 163

Garden Table, c. 1950
Metal with wooden slat top
20 ⅛ x 18 in. (51.1 x 45.7 cm)
LACMA, anonymous gift

Six-Light Candelabra, c. 1950
Iron
12 ¾ x 22 ³⁄₁₆ in. (32.4 x 56.8 cm)
LACMA, anonymous gift

Outdoor Candelabra, 1952–53
Steel with glass
40 x 24 in. (101.6 x 61 cm)
Collection of Max Lawrence

Sofa, 1952–53
Steel frame and vinyl upholstery
63 x 30 in. (160 x 76.2 cm)
Collection of Max Lawrence

Wicker Arm Chair, 1952–53
Steel frame and wicker
43 x 30 in. (109.2 x 76.2 cm)
Collection of Max Lawrence

Cabinet from Van Keppel's House, mid-1950s
Tropical hardwoods, plywood, and vinyl
30 ¼ x 77 ¾ in. (76.8 x 197.5 cm)
LACMA, anonymous gift

Dining Table from Van Keppel's House, mid-1950s
Steel frame with cast-resin top
25 x 42 in. (63.5 x 106.7 cm)
LACMA, anonymous gift

Six Dining Chairs from Van Keppel's House, mid-1950s
Steel frame with vinyl-coated cord
Each: 30 x 17 in. (76.2 x 43.2 cm)
LACMA, anonymous gift

Small Chaise, c. 1959
Enamel-baked steel and cotton cord (replaced)
24 ½ x 21 in. (62.2 x 53.3 cm)
Courtesy Bernard Kester

Gustavo Vázques
Mexico, active United States, b. 1954
Guillermo Gómez-Peña
Mexico, active United States, b. 1955

The Mojado Invasion (The Second U.S.-Mexican War), 1999
Videotape (color, with sound, twenty-six minutes)
Lent by Video Data Bank

Camilo José Vergara
Mexico, active United States and Mexico, b. 1944

Couple on Their Way to Church, Watts, May 1980, 1980
Silver dye-bleach (Cibachrome) print
16 x 20 in. (40.6 x 50.8 cm)
Lent by the artist
p. 200

Vernon Kilns
United States, 1931–51

Place Settings for Six, from "Imperial Vernonware," c. 1955–56
Earthenware
Dinner plate D: 10 in. (25.4 cm); Salad plate D: 7 ½ in. (19.1 cm); Soup bowl D: 6 ⅛ in. (15.6 cm); Cup D: 4 ¾ in. (12.1 cm); Saucer D: 6 ⅛ in. (15.6 cm); Coffeepot with lid H: 10 ½ in. (26.7 cm); Teapot with lid D: 9 in. (22.9 cm); Covered casserole D: 9 ¾ in. (24.8 cm); Creamer H: 4 ¾ in. (12.1 cm); Sugar bowl with lid H: 4 ¾ in. (12.1 cm)
Private collection

Ely de Vescovi
Italy, active United States and Mexico, 1909–1998

Hollywood, 1941
Oil on canvas
30 x 24 in. (76.2 x 61 cm)
Collection of Donald and DeAnne Todd
p. 178

Bill Viola
United States, b. 1951

Anthem, 1983
Videotape (color, with sound, twelve minutes)
Lent by the artist

Herman Volz
Switzerland, active United States, 1904–1990

San Francisco Waterfront Strike, 1934
Lithograph
11 ⅞ x 16 ⅛ in. (30.2 x 41 cm)
Rob Roberts
p. 112

318

Bernard von Eichman
United States, 1899–1970

China Street Scene No. 1, 1923
Oil on cardboard
19¼ x 16¼ in. (48.9 x 41.3 cm)
The Oakland Museum of California,
gift of Louis Siegriest
p. 135

Peter Voulkos
United States, b. 1924

Camelback Mountain, 1959
Stoneware with slip, glazed and gas fired
45½ x 19½ in. (115.6 x 49.5 cm)
Collection of Museum of Fine Arts, Boston,
gift of Mr. and Mrs. Stephen D. Paine, 1978
p. 185

Adam Clark Vroman
United States, 1856–1916

San Gabriel Mission, c. 1910
Gelatin-silver print
6½ x 9½ in. (16.5 x 24.1 cm)
Collection of Stephen White II
p. 93

Edouard A. Vysekal
Czechoslovakia, active United States, 1890–1939

Springtime, 1913
Oil on paper, mounted
30 x 57 in. (76.2 x 144.8 cm)
Garzoli Gallery, San Rafael, California
p. 85

Marion (Kavanaugh) Wachtel
United States, 1876–1954

Sunset Clouds #5, 1904
Watercolor on paper
20 x 16 in. (50.8 x 40.6 cm)
Robert and Ann Steiner
p. 69

Catherine Wagner
United States, b. 1953

*Arch Construction III, George Moscone Site,
San Francisco, California*, 1981
Gelatin-silver print
14 x 18 in. (35.6 x 45.7 cm)
LACMA, gift of Hal Fischer

*Arch Construction IV, George Moscone Site,
San Francisco, California*, 1981
Gelatin-silver print
14 x 18 in. (35.6 x 45.7 cm)
LACMA, gift of Hal Fischer
p. 243

Anne Walsh
United States

Two Men Making Gun Sounds, 1996
Two-channel video installation
Dimensions variable
Lent by the artist, courtesy Banff Centre
for the Arts

June Wayne
United States, b. 1918

Silent Wind, 1975
Lithograph on nacre paper
25 x 37⅛ in. (63.5 x 94.4 cm)
Lent by the artist

Kem Weber
Germany, active United States, 1889–1963

Airline Armchair, c. 1934–35
Hickory, alder, maple, metal, and leather
30½ x 25 x 34 in. (77.5 x 63.5 x 86.3 cm)
Architecture and Design Collection, University
Art Museum, UCSB
p. 109

James Weeks
United States, 1922–1998

Two Musicians, 1960
Oil on canvas
84 x 66 in. (213.4 x 167.6 cm)
San Francisco Museum of Modern Art,
Thomas W. Weisel Fund purchase
p. 184

Thomas Weir
United States, b. 1935

Renee Oracle, 1968
Gelatin-silver print
D: 9⅝ in. (24.8 cm)
Norton Simon Museum, Pasadena, California,
Museum Purchase, 1971

Jack Welpott
United States, b. 1923

The Journey—Pescadero Creek, 1966
Gelatin-silver print
9½ x 7⅜ in. (24.1 x 18.7 cm)
The Oakland Museum of California, The
Oakland Museum of California Founders Fund
p. 195

William Wendt
Prussia, active United States, 1865–1946

Malibu Coast [Paradise Cove], c. 1897
Oil on canvas
18 x 28 in. (45.7 x 71.1 cm)
Private collection
p. 77

The Silent Summer Sea, 1915
Oil on canvas
25 x 30 in. (63.5 x 76.2 cm)
Private collection

Where Nature's God Hath Wrought, 1925
Oil on canvas
50⁵⁄₁₆ x 60¹⁄₁₆ in. (127.8 x 152.6 cm)
LACMA, Mr. and Mrs. Allan C. Balch Collection
p. 70

Henry Wessel Jr.
United States, b. 1942

Southern California, 1985
Gelatin-silver print
10⅜ x 15¹¹⁄₁₆ in. (26.4 x 39.8 cm)
LACMA, gift of Lewis Baltz

Brett Weston
United States, 1911–1993

Garapata Beach, 1954
Gelatin-silver print
11 x 14 in. (27.9 x 35.6 cm)
Margaret W. Weston, Weston Gallery, Inc.
p. 170

Edward Weston
United States, 1886–1958

Eel River Ranch, 1937
Gelatin-silver print
9½ x 7½ in. (24.1 x 19.1 cm)
LACMA, anonymous gift

Tomato Field, 1937
Gelatin-silver print
8 x 10 in. (20.3 x 25.4 cm)
The Huntington Library, Art Collections
and Botanical Gardens
p. 116

Twenty Mule Team Canyon, Death Valley, 1938
Gelatin-silver print
9½ x 7½ in. (24.1 x 19.1 cm)
LACMA, anonymous gift
p. 124

Drift Stump, Crescent Beach, 1939
Gelatin-silver print
9½ x 7½ in. (24.1 x 19.1 cm)
LACMA, anonymous gift

Daniel Wheeler
United States, b. 1961

Untitled [Exam], 1993
Wood, X-ray photograph, glass, and
found objects
28⅜ x 18⅞ x 16⅜ in. (72.1 x 47.9 x 41.6 cm)
Collection of Michael Simental and Phill Starr,
Los Angeles, courtesy Newspace, Los Angeles

320

Minor White
United States, 1908–1976

Song without Words, 1947
Artists book with twenty-three
gelatin-silver prints
Book open: 12 x 20 in. (30.5 x 50.8 cm)
LACMA, Ralph M. Parsons Fund

*Sun in Rock (San Mateo County,
California)*, 1947
Gelatin-silver print
3½ x 4⅝ in. (9 x 11.7 cm)
The Minor White Archive, Princeton University
p. 187

Pae White
United States, b. 1963

Pantone 5115C Pony, 1997
Pair of women's shoes (size 10), cowhide and
frog skin
Each: 9½ x 3½ x 6 in. (24.1 x 8.9 x 15.2 cm)
Lent by the artist

James Whitney
United States, 1921–1982

Yantra, 1955
16 mm film (color, with sound, seven minutes)
Lent by Dr. William Moritz

Ren Wicks
United States

Untitled (Family Beach Scene), 1952
Watercolor on paper
28 x 25½ in. (71.2 x 64.8 cm)
Automobile Club of Southern California

Marguerite Wildenhain
France, active United States, 1896–1985

Squared Vase, c. 1947
Stoneware, glazed
4¾ x 4 in. (12.1 x 10.2 cm)
Lent by the Frederick R. Weisman Art Museum,
University of Minnesota, Museum Purchase
p. 170

Vase, c. 1950
Stoneware
5¾ x 5 in. (14.6 x 12.7 cm)
Lent by the Frederick R. Weisman Art Museum,
University of Minnesota, gift of Warren and
Nancy MacKenzie

William T. Wiley
United States, b. 1937

Cage and Bait, 1976
Watercolor on paper
30 x 22 in. (76.2 x 55.9 cm)
The Museum of Contemporary Art,
Los Angeles, gift of the Melville J. Kolliner
Family Trust in memory of Beatrice S. Kollin

Robert Williams
United States, b. 1943

California Girl, 1985
Acrylic on imitation brick
60 x 48 in. (152.4 x 121.9 cm)
Collection of Anthony Kiedis
p. 251

John William Joseph Winkler
Austria, active United States, 1894–1979

Oriental Alley, 1920
Etching
7⅞ x 5⅛ in. (20 x 13 cm)
The Annex Galleries
p. 95

Fruit Stall, n.d.
Etching
5 x 7⁷⁄₁₆ in. (12.7 x 18.9 cm)
The Annex Galleries

Albert J. Winn
United States, b. 1947

Akedah, 1995
Gelatin-silver print
20 x 24 in. (50.8 x 61 cm)
Lent by the artist
p. 256

Paul Wonner
United States, b. 1920

Untitled [Two Men at the Shore], c. 1960
Oil and charcoal on canvas
50 x 40 in. (127 x 101.6 cm)
Bedford Family Collection
p. 175

Beatrice Wood
United States, 1894–1998

Tea Service with Cups, c. 1960
Earthenware, glazed
Teapot D: 11 in. (27.9 cm); Creamer D: 5 in.
(12.7 cm); Open sugar D: 4½ in. (11.4 cm);
Four cups D: 4¼ in. (10.8 cm); Four saucers
D: 6 in. (15.2 cm)
Collection of Gloria and Sonny Kamm

Willard Worden
United States, 1868–1946

Untitled [Sand Dunes], c. 1915
Gelatin-silver print
13⁵⁄₁₆ x 10⅝ in. (33.9 x 27 cm)
The Wilson Center for Photography

Max Yavno
United States, 1911–1985

Street Talk, 1946
Gelatin-silver print
8½ x 7¹⁄₁₆ in. (21.6 x 17.9 cm)
LACMA, gift of the artist
p. 153

Muscle Beach, 1947
Gelatin-silver print
26 x 16 in. (50.8 x 40.6 cm)
Collection of Sue and Albert Dorskind
p. 159

Night View from Coit Tower, 1947
Gelatin-silver print
10½ x 13½ in. (26.7 x 34.3 cm)
The Marjorie and Leonard Vernon Collection
p. 165

The Leg, 1949
Gelatin-silver print
20 x 16 in. (50.8 x 40.6 cm)
Collection of Sue and Albert Dorskind

Premiere at Carthay Circle, 1949
Gelatin-silver print
20 x 16 in. (50.8 x 40.6 cm)
LACMA, gift of Sue and Albert Dorskind

Bruce Yonemoto
United States, b. 1949
Norman Yonemoto
United States, b. 1946

Golden, 1993
Gold leaf on projection screen
59 x 42½ x 24 in. (149.9 x 108 x 61 cm)
Collection of Eileen and Peter Norton,
Santa Monica
p. 262

Liz Young
United States, b. 1958

*The Birth/Death Chair with Rawhide Shoes,
Bones, and Organs*, 1993
Chair, rawhide shoes, and cast iron, bronze,
and lead
48 x 84 x 36 in. (121.9 x 213.4 x 91.4 cm)
LACMA, purchased with funds provided by
the Betty Asher Memorial Fund through the
Modern and Contemporary Art Council
p. 253

Eva Zeisel
Hungary, active Germany, Russia,
and United States, b. 1906

*Riverside China: Water Jug with Six Tumblers,
Large Serving Bowl*, c. 1946–47
Porcelain, glazed
Tumblers H: 4⅛ in. (10.5 cm); Jug H: 8¼ in.
(24.1 cm); Bowl D: 14¾ in. (37.5 cm)
Private collection

Jody Zellen
United States, b. 1961

Untitled, 1998
Iris print on Mylar with Plexiglas
10 x 8 in. (25.4 x 20.3 cm)
Lent by the artist

Untitled, 1998
Iris print on Mylar with Plexiglas
10 x 8 in. (25.4 x 20.3 cm)
Lent by the artist

Andrea Zittel
United States, b. 1965

A–Z Travel Trailer, 1995
Unit customized by Miriam and Gordon Zittel
Trailer: steel, wood, glass, carpet, aluminum,
and found objects
115 x 94 x 204 in. (292.1 x 238.8 x 518.2 cm)
Lent by the artist, courtesy Andrea Rosen
Gallery, New York

Marguerite Zorach
United States, 1887–1968

Man among the Redwoods, 1912
Oil on canvas
25¾ x 20¼ in. (65.4 x 51.4 cm)
Curtis Galleries, Minneapolis

Linking the two centers of the museum, LACMA
East and LACMA West, most of the works listed
below were intended to transform the entire
campus into a site for art. Others reached
beyond the museum's physical borders in an
effort to engage the larger Los Angeles commu-
nity. All were newly commissioned, except
Untitled (Nordman), first conceived
and executed in 1973, refabricated in 1995, then
refurbished in 2000 for this exhibition, and
What you lookn at? (Williams), originally
made in 1992, then refabricated in 2000 for
this exhibition.

David Avalos
United States, b. 1947
Louis Hock
United States, b. 1948
Scott Kessler
United States, b. 1955
Elizabeth Sisco
United States, b. 1954
Deborah Small
United States, b. 1948

Oracle@LaBrea, 2000
Video slot machine, surveillance cameras,
and text
Robert O. Anderson Building, LACMA East

Robbie Conal
United States, b. 1944

Ghost in the Machine (The Fifties), 2000
Billboard from original oil on photomontage
LACMA-area street

Eileen Cowin
United States, b. 1947

Yearning for Perfection II, 2000
Original billboard installation
LACMA-area street

Richard Jackson
United States, b. 1939

Who's Afraid of Red, Yellow, and Blue, 2000
Used car, acrylic paint, cement, and hardware
LACMA West Green (Wilshire Boulevard)

Margaret Kilgallen
United States, b. 1967

Temporary wall painting (untitled at press
time), 2000
LACMA parking garage, Ogden Street, between
LACMA East and LACMA West

José López
United States, b. 1956

*Neighborhood Heart (Good Fences Make Good
Neighbors)*, 2000
Light projection on southern face of
Ahmanson Building, LACMA East

Barry McGee
United States, b. 1966

Temporary wall painting (untitled at press
time), 2000
LACMA parking garage, Ogden Street, between
LACMA East and LACMA West

Maria Nordman
United States, b. 1943

Untitled, 1973/1995

Untitled, *1973, located since 1995 at the
Alameda Street loading dock of the Museum
of Contemporary Art's Geffen Contemporary,
will be on view again from November 2000
through February 2001 in conjunction with the
Los Angeles County Museum of Art's exhibition
Made in California.*

*The collaboration between the two
institutions and travel by museum visitors
(and chance passers-by) through Los Angeles
from LACMA to MOCA constitute elements of
the work and make material the continuing
question, Is the city a potential sculpture?*
MARIA NORDMAN

Pat Ward Williams
United States, b. 1948

What you lookn at?, 1992/2000
Billboard from dot-screen mural print and
spray paint
LACMA-area street

321

322

Eleven participatory environments engaging
children and their families were commissioned
by LACMALab, a new experimental research
and development division within the museum.
LACMALab's inaugural exhibition, *Made in
California:* NOW, included three generations of
California-based artists.

Eleanor Antin
United States, b. 1935

The Freebooters, 2000
Fiberglass, wood, yellow rubber boots, and
miscellaneous found objects and materials
Boone Children's Gallery, LACMA West;
LACMA West Green (Wilshire Boulevard);
Ahmanson Building, permanent collection
galleries, LACMA East; Belzberg Atrium,
LACMA East

Michael Asher
United States, b. 1943

A student reinstallation of the Leona Palmer
Gallery, nineteenth-century European art,
LACMA East; photo documentation of ongoing
project, Boone Children's Gallery, LACMA West

Victor Estrada
United States, b. 1956

Reflections on Poetry, 2000
Sand, wood, cardboard, paint, and miscella-
neous drawings
LACMA West Green (Sixth Street)

Jacob Hashimoto
United States, b. 1973

Watertable, 2000
Fiberglass, wood, water, and miscellaneous
materials
Boone Children's Gallery, LACMA West

Jim Isermann
United States, b. 1955

UNTITLED (PLOCK) (1000) 2000, 2000
Wood, drywall, metal, plaster, wall paint, vinyl
decals, Naugahyde cushions
Boone Children's Gallery, LACMA West

Allan Kaprow
United States, b. 1927
Bram Crane-Kaprow
United States, b. 1989

No Rules Except…, 2000
Pillows, rope, wood, metal, punching bags,
lighting, mirrors, amplifiers, and speakers
Boone Children's Gallery, LACMA West

Martin Kersels
United States, b. 1960

Musical Sound Garden, 2000
Wood, miscellaneous hardware, steel drum,
water
Boone Children's Gallery, LACMA West

Dave Muller/Three Day Weekend
United States, b. 1964

A series of Three Day Weekend participatory
and collaborative events involving artists,
musicians, and audience, 2000–2001
Boone Children's Gallery, LACMA West; and
other locations

John Outterbridge
United States, b. 1933

A Third Eye Dreaming, 2000
Wood, sand, cloth, metal, rock, photographs,
and miscellaneous objects
Boone Children's Gallery, LACMA West

Erika Rothenberg
United States

Hey kid, wanna be famous? and *The Garden of
Fame*, 2000
Wood, video projection, steel tubing, concrete,
microphones, speakers, paint, paper, crayons
LACMA West Green (Sixth Street)

Jennifer Steinkamp
United States, b. 1958
Jimmy Johnson
United States, b. 1969

Anything You Can Do, 2000
Computer-generated video and audio, steel,
swings, rubber flooring
Boone Children's Gallery, LACMA West

The following were commissioned by LACMA
for this exhibition:

Murals

*Diego Rivera's "Allegory of California" (also
known as "Riches of California"), Stock Exchange
Building, San Francisco (now Stock Exchange
Tower, City Club of San Francisco), 1931*
Reconstruction by John Lodge, 2000
Lacquer, acrylic paint, plywood, Plexiglas,
photographic prints, and fabric
72 x 36 x 30 in. (182.9 x 91.4 x 76.2 cm)
Permission to reconstruct courtesy Stock
Exchange Tower Associates

*Selected murals from Coit Tower, San Francisco,
1934*
Reconstruction by John Lodge, 2000
Lacquer, acrylic paint, plywood, Plexiglas, and
photographic prints
18 x 51 x 51 in. (45.7 x 129.5 x 129.5 cm)
Included Victor Arnautoff, *City Life*; John
Langley Howard, *California Industrial Scenes*;
Suzanne Scheuer, *Newsgathering*; Ralph
Stackpole, *Industries of California*; Frede Vidar,
Department Store; and Bernard Zakheim,
Library

*Selected murals from Chicano Park, San Diego,
1975–91*
Reconstruction by John Lodge, 2000
Latex paint, plywood, steel, and photographic
prints
Two rows of pilings: 168 x 48 x 48 in. (426.7 x
121.9 x 121.9 cm); 144 x 48 x 48 in. (365.8 x 121.9
x 121.9 cm)
Included Felipe Adame, *Aztec Warrior*, 1978,
and *La Adelita*, 1978; Felipe Adame, Socorro
Gamba, and Roger Lucero, *Serpiente*, 1978–91;
Felipe Adame, Octavio Gonzalez, and
Guillermo Rosete, *Chicano Park Takeover*,
1978–91; Vidal Aguirre, *Archer*, 1987; Tony de
Vargas, *Chicano Pinto Union*, 1978; Raul
Espinoza and Michael Schnorr, *Huelga Eagle*,
1978–91; Rupert García and Víctor Ochoa,
Los Grandes, 1978; Raul José Jacques, Alvaro
Millan, Víctor Ochoa, and Armando
Rodríguez, *¡Varrio Sí, Yonkes No!*, 1977; Víctor
Ochoa et al., *Varrio Logan*, 1978; Víctor Ochoa,
Ché, c. 1978; Michael Schnorr and Susan
Yamagata, *Coatlicue*, 1978, and *Death of a
Farmworker*, 1979; Mario Torero, *Virgen de
Guadalupe*, 1978

California Murals, 1980–2000
Created by James Prigoff and Robin J. Dunitz, 2000
Photo documentation of seventy selected murals on loop, without sound, twelve minutes
Representative images from California's "museum of the streets," demonstrating that the heart of the mural movement has been and continues to be imagery inspired by the political and social struggles that periodically challenge the country.

History and Culture

Selling Eden #1, 1898–1920
Created by Morgan Neville, 2000
Documentary short, without sound, three minutes
How early motion-picture photography promoted California's natural wonders to the world. Scenes of Yosemite, the Mojave Desert, and the Golden Gate were included.

Selling Eden #2, 1903–28
Created by Morgan Neville, 2000
Documentary short, without sound, four minutes
Compilation of early travelogues that helped to construct a mythologized urban image of California, including footage documenting disasters such as the San Francisco earthquake of 1906 as well as the city's reemergence with the Panama-Pacific International Exposition of 1915.

Mistaken Identities: Images of Latinos and Asians in California, 1897–1926
Created by Morgan Neville, 2000
Documentary short, without sound, six minutes
This piece demonstrated how Californians employed movies to romanticize—and sometimes demonize—the state's ethnic minorities for racial, political, and promotional ends. In particular, it explored the way in which the state's Latino and Chinese populations have long been caricatured in Hollywood and elsewhere as exotic and dangerous.

Hollywood Glamour, 1918–39
Created by David Haugland, 2000
Documentary film, with sound, seven minutes
With newsreel and behind-the-scenes live-action footage, this piece brought to life the inception and growth of Hollywood studios in the 1920s and 1930s as "glamour factories," where teams of moguls, designers, photographers, craftspeople, and actors created and exported motion-picture images that embodied the American Dream.

California in the Depression, 1930–41
Created by Morgan Neville, 2000
Selected documentary clips (approximately one minute each), with sound and a viewer-activated random-access system
A selection of news, documentary, and propaganda footage demonstrated in stark terms the great challenges California went through in the 1930s. The state's urbanized labor, spearheaded by figures such as Harry Bridges and Upton Sinclair, fought battles for its future, while its agrarian poor struggled to survive.

The Grapes of Wrath
Created by Morgan Neville, 2000
Compilation of film clips, with sound, four minutes
A selection of clips from the 1940 film *The Grapes of Wrath*, directed by John Ford.
Courtesy Twentieth Century Fox

California Goes to War, 1942–45
Created by Morgan Neville, 2000
Newsreel short, with sound, five minutes
An examination of one of the most pivotal times in twentieth-century California history. Segments included newsreel footage of Japanese American relocations, women entering the war industry, Hollywood's wartime efforts, and the Bracero program.

Suburbia, 1945–60
Created by Morgan Neville, 2000
Montage of film clips, with sound, three minutes
Selections from an array of home movies that revealed how Southern Californians lived in the prosperous wake of World War II.

California Noir, 1944–58
Created by Morgan Neville, 2000
Compilation of film clips, with sound, nine minutes
A selection of clips from seven iconic noir films, including *Double Indemnity* (1944) and *The Lady from Shanghai* (1948), that exposed the underbelly of the California Dream.

Naming Names, 1948–52
Created by Morgan Neville, 2000
Repeating one-minute loops, with sound, on five video monitors
A video installation that presented friendly and unfriendly witnesses before the House Un-American Activities Committee, the government's search for Communist infiltration of the film industry during the late 1940s and early 1950s. Filmed testimony gave voice to the perspectives of key figures.

The Capital of the Teenage World, 1955–67
Created by Morgan Neville, 2000
Documentary short, with sound, six minutes
A montage of two of California's most youth-centric cultures—the beach and the car—with photography, early surf films, magazines, and music. This short film explored how camp exaggerations of Hollywood's Gidget and hot-rod movies came to supplant those original cultures.

California Counterculture—The Sixties
Created by David Inocencio and Minette Siegel, 2000
Multi-image presentation with slide projection, with sound, fifteen minutes
An array of projected imagery that showcased the cultural and political revolutions of the 1960s widely associated with California, including hippie culture in San Francisco and the Haight-Ashbury district's "Summer of Love"; the Free Speech Movement at the University of California, Berkeley; the Native American assertion of "Red Power" at Alcatraz; strikes by the United Farm Workers; and the Black Panther movement.

Historical Timeline, 1900–2000
Compiled by Sarah Schrank
Designed by Louise Sandhaus, with Tim Durfee and Iris Regn
Fabricated by Promotion Products, Inc., Portland, Oregon
Each part: 60 x 96 x 20 in. (152.4 x 243.8 x 61 cm)
A five-part educational timeline of facts, images, and objects pertaining to the art, popular culture, and local histories of California.

Music and Poetry

California in Music, 1920–2000
Created by George Lipsitz, 2000
Musical selections, listener-activated random-access system
A two-hour compact disc with selections of California music, from Kid Ory's "Creole Trombone" of the 1920s to Chicano punk and Rock en Español of the 1990s.

Beat Poetry and the San Francisco Renaissance, 1948–61
Created by S. S. Kush and Steven Watson, 2000
Audio selection of poetry, listener-activated random-access system
Recordings of fifteen poets (including Allen Ginsberg, Kenneth Rexroth, Lawrence Ferlinghetti, and Gary Snyder) reading selections from their works.

Made in California: Art, Image, and Identity, 1900–2000, incorporated approximately 400 ephemeral objects culled from some thirty institutions and fifteen private collections. The exhibition highlighted material culture to suggest complex historical and cultural trends through visual means. Books, brochures, programs, flyers, magazines, newspapers, advertisements, calendars, album covers, posters, photo albums, documentary photographs, telegrams, letters, and state and government publications were included. Several three-dimensional objects also appeared in the thirty thematic cases: for example, pennants, buttons, a souvenir can of smog, and a Barbie doll.

Some display cases focused on the point of view of a specific group: for instance, the tourist industry or political activists. Others presented a wide range of perspectives on one of the state's salient features, such as agriculture, the California body, or Beat culture. In addition, some of the ephemera related closely to the art exhibited, as in the case of Rudi Gernreich fashions of the 1960s, art produced by the Ferus Gallery group, or the early-twentieth-century taste for Native American baskets. Other cases presented concepts or issues more removed from art, such as the construction of the Los Angeles aqueduct, the Bracero program, and the Black Panther movement.

The state's sizable tourist industry produced much of the ephemera prior to World War II. Throughout the first half of the century, California's tourist literature celebrated not only its famous vacation spots in the wilderness and iconic urban destinations but also various loci of "heritage" tourism, such as Los Angeles's Olvera Street and San Francisco's Chinatown. The cases spotlighted the agencies most responsible for the rosy-hued images of California, directed at potential visitors and settlers alike. The local business community, including individual enterprises such as the Hotel Del Monte and corporate coalitions like the All-Year Club of Southern California, was the most prominent booster. Railroad companies created enormous amounts of tourist propaganda well into the 1960s. In addition, the exhibition vitrines traced the unusually prolific tradition of ritualized tourist spaces and events, from world's fairs and the Tournament of Roses to Disneyland and Pacific Ocean Park. While tourism has largely been run by and targeted at the Anglo population, particularly in the first half of the century, an effort was made to document the state's wide diversity of participants.

A second category of objects contained various political artifacts. In the early sections of the exhibition, aspects of California Progressivism were considered through documentation of the Indian Reform movement, mission preservation societies, and the Sierra Club's opposition to the Hetch Hetchy dam. The dark side of California's Progressive consensus was revealed in campaign literature espousing virulent anti-Asian sentiment, already a long tradition by 1900. Later periods bore witness to the polarization of the state's political culture. On the political left, the explosive impact of the labor movement in both the cities and the fields during the 1930s is still felt today. Prewar material, such as an illustrated history of the International Longshoremen's and Warehousemen's Union from the 1930s, was followed by the material culture of community-based political organizations, like the Black Panthers, the United Farm Workers labor movement, and the Chicano movement. Cases devoted to the political right documented the antilabor activities of agribusiness, attacks on art and culture by anticommunists, and the xenophobia of World War II, which ranged from the institutional racism of the Japanese internment camps to the interpersonal violence of the Zoot Suit riots.

A third group of documents charted urban development and the growth of the state's infrastructure. The public works of the 1930s, like the Golden Gate and San Francisco–Oakland Bay bridges, gave way to wartime production and later to the state's freeway system, athletic stadiums, and the explosive postwar housing boom. At times, urban development and "renewal" came at the expense of poor minority communities, like those of Chavez Ravine in Los Angeles and the Fillmore District in San Francisco.

The remaining material generally fell into the broad category of cultural history. Within the purview of high culture, a number of pieces elucidated the emergence of assorted and often loose coalitions of artists and writers: from the Carmel artist colony to the Mexican muralists in California, from the Beats to Teatro Campesino and Womanhouse. A few items traced LACMA's own institutional history, from its Pan-American exhibition of 1925 to the Los Four show of 1974. A larger array of documents represented many examples of popular culture, from Hollywood, West Coast jazz, beach culture, the rock and hippie countercultures to California's car culture, including lowriders and the artists of the Kustom Kar Kulture (such as Big Daddy Roth). Although the bulk of the exhibition ephemera was grouped into the categories outlined above, the individual objects reflected the wide range of voices that defined California throughout the last century and in this exhibition.

Documentary materials were selected by Eulogio Guzman and John Ott, with the assistance of Carolyn Peter.

LENDERS TO THE EXHIBITION

This list is complete as of July 31, 2000.

Academy of Motion Picture Arts & Sciences
Albright-Knox Art Gallery, Buffalo
American Craft Museum, New York
Gallery Paule Anglim
The Annex Galleries
Jenny Armit Design and Decorative Art, Inc.
The Art Institute of Chicago
Automobile Club of Southern California
Sid Avery/Motion Picture and Television
 Photo Archive
Estate of Ruth-Marion Baruch
Estate of Wallace Berman
Robert Bijou Fine Arts
The Bowers Museum of Cultural Art, Santa Ana
Brandeis University, Rose Art Museum, Waltham,
 Massachusetts
Estate of Horace Bristol
The Broad Art Foundation, Santa Monica
Burbank Public Library
Hans G. and Thordis W. Burkhardt Foundation
California Historical Society, North Baker Research
 Library, San Francisco
California Polytechnic State University, Kennedy
 Library, Special Collections, University
 Archives, San Luis Obispo
California State Railroad Museum, Sacramento
California State University, Fullerton, Pollak
 Library
California State University, Los Angeles, John F.
 Kennedy Memorial Library
California State University, Northridge, Center for
 Photojournalism and Visual History
California State University, Northridge, Special
 Collection Archives
Caltrans Transportation Library
Campbell Thiebaud Gallery, San Francisco
Iris and B. Gerald Cantor Center for Visual Arts at
 Stanford University
Center for the Study of Political Graphics,
 Los Angeles
Catharine Clark Gallery
Columbia University, Avery Architectural and
 Fine Arts Library, New York
Creative Artists Agency
Curtis Galleries, Minneapolis
Deitch Projects
Neil M. Denari Architects
DeRu's Fine Arts, Laguna Beach
di Rosa Preserve, Napa
Walt Disney Archives
Duval Estate, George Stern Fine Arts, Los Angeles
George Eastman House, International Museum of
 Photography, Rochester
Edenhurst Gallery
Electronic Arts Intermix
The Fabric Workshop
Fahey/Klein Gallery, Los Angeles
The Fashion Institute of Design & Merchandising,
 Museum Collection, Los Angeles

Fat Chance, Los Angeles
Fine Arts Museums of San Francisco, Achenbach
 Foundation for Graphic Arts
Fine Arts Museums of San Francisco, M. H.
 de Young Memorial Museum
Ron Finley's Midnight Matinee
First Church of Christ, Scientist
Fischinger Archive
GLBT Historical Society of Northern California,
 San Francisco
The Gamble House, Pasadena, University of
 Southern California
Garzoli Gallery, San Rafael
Frank O. Gehry & Associates
Gemini G.E.L., Los Angeles
The J. Paul Getty Museum, Los Angeles
The Haggin Museum, Stockton
Paul Hertzmann, Susan Herzig, and Paul M.
 Hertzmann, Inc., San Francisco
The Huntington Library, Art Collections, and
 Botanical Gardens, San Marino
The iota Center
Irell & Manella LLP
The Irvine Museum
Iturralde Gallery Collection
Japanese American National Museum, Los Angeles
The Jerde Partnership International
A. Quincy Jones Architecture Archive
Kappe Architects/Planners
Jan Kesner Gallery
Craig Krull Gallery, Santa Monica
L.A. Louver Gallery
LAM/OCMA Art Collection Trust
Margo Leavin Gallery
Frank Lloyd Gallery, Santa Monica
Los Angeles County Museum of Art
Los Angeles County Museum of Art, Balch Library
Los Angeles County Museum of Natural History,
 Seaver Center for Western History Research
Los Angeles Public Library, Rare Books
 Department
Matthew Marks Gallery, New York
Masterpiece Gallery
Mattel, Inc.
The Metropolitan Museum of Art, New York
Mills College Art Museum, Oakland
Modernica
Mark Moore Gallery, Santa Monica
Morphosis
Eric Owen Moss Architects
Tobey C. Moss Gallery
Munson-Williams-Proctor Institute, Museum of
 Art, Utica, New York
Museum of California Design, Los Angeles
The Museum of Contemporary Art, Los Angeles
Museum of Fine Arts, Boston
Museum of Fine Arts, Museum of New Mexico,
 Santa Fe

The Museum of Modern Art, New York
The Museum of Photographic Arts, San Diego
The National Museum of Women in the Arts,
 Washington, D.C.
The Oakland Museum of California
The Oakmont Corporation
Orange County Museum of Art, Newport Beach
El Pachuco Zoot Suits, Fullerton
Palm Beach Institute of Contemporary Art
Perlmutter Fine Arts, San Francisco
Philadelphia Museum of Art
Pico Holdings, Inc.
Princeton University, The Minor White Archive
Quint Contemporary Art
Regen Projects, Los Angeles
Andrea Rosen Gallery, New York
RoTo Architects Incorporated
San Diego Historical Society
San Diego Historical Society, Research Archives
San Diego State University, Library and
 Information Access
San Francisco Museum of Modern Art
San Francisco Public Library, San Francisco
 History Center
San Francisco State University, Labor Archives and
 Research Center
San Jose State University, Center for Steinbeck
 Studies
Sandroni Rey
Santa Barbara Museum of Art
Daniel Saxon Gallery
Scripps College, Claremont
Seattle Art Museum
Sierra Madre Public Library
Norton Simon Museum, Pasadena
Smith College Museum of Art, Northampton,
 Massachusetts
Joan Irvine Smith Fine Arts, Laguna Beach
Smithsonian Institution, Hirshhorn Museum and
 Sculpture Garden
Smithsonian Institution, National Museum of
 American History
Southern California Library for Social Studies and
 Research, Los Angeles
The Southwest Museum, Los Angeles
Sragow Gallery, New York
State Museum Resource Center, California,
 Department of Parks and Recreation
Bernice Steinbaum Gallery, Miami
Sunset Magazine, Menlo Park
Tacoma Public Library
The Theosophical Society, Pasadena
Tom of Finland Foundation, Los Angeles
Steve Turner Gallery, Beverly Hills
University of California, Berkeley, Art Museum
University of California, Berkeley, The Bancroft
 Library

University of California, Berkeley, College of
Environmental Design, Documents
Collection
University of California, Davis, Shields Library
University of California, Irvine, Libraries, Special
Collections
University of California, Los Angeles, Chicano
Studies Research Center Library
University of California, Los Angeles, Library,
Department of Special Collections
University of California, Santa Barbara, University
Art Museum, Architecture and Design
Collection
University of Minnesota, Frederick R. Weisman
Art Museum, Minneapolis
University of Nevada, Sheppard Gallery, Reno
University of Southern California, Doheny Library,
Los Angeles
University of Southern California, Regional
History Center, Los Angeles
The University of Texas at Austin, The General
Libraries, The Alexander Architectural
Archive
Utah State University, Nora Eccles Harrison
Museum of Art, Logan
Video Data Bank
Warner Bros.
Shoshana Wayne Gallery
Frederick R. Weisman Art Foundation, Los Angeles
Margaret W. Weston, Weston Gallery, Inc.
Whitney Museum of American Art, New York
The Wolfsonian-Florida International University,
The Mitchell Wolfson Jr. Collection,
Miami Beach
The Yosemite Museum, National Park Service
Gallery "Z," Beverly Hills

Kim Abeles
Jerome Ackerman
Allan Adler
Laura Aguilar
Terry Allen and Allen Ruppersberg
Joseph Ambrose and Michael Feddersen
Lawrence Andrews
Skip Arnold
John Arvanites
Ruth Asawa
Dana Atchley
David Avalos
Armando M. Avila and Family
Bedford Family Collection
Jordan Belson
Billy Al Bengston
Mark Bennett
Helen and Tony Berlant, Santa Monica
Pam Biallas
Teresa Bjornson, Los Angeles
Marilyn Blaisdell Collection
Shoshana and Wayne Blank
Peter and Isabel Blumberg
Chaz Bojórquez
Mr. and Mrs. William A. Botke
John P. Bowles
Matthew A. Boxt and Aida Mostkoff Linares,
Culver City
Robert Brady
Mr. and Mrs. George E. Brandow
John Bransten
G. Breitweiser
Charles Brittin
Jessica Bronson
Wendy Barrie Brotman
Jeff Brouws
The Michael D. Brown Collection
Nancy Buchanan
The Buck Collection, Laguna Hills
Chris Burden
Andrew Bush
Cathy Callahan
Mr. and Mrs. David Charak
Judy Chicago
Christo and Jeanne-Claude
Marna Clark
William Claxton
Marian Clayden
Anne and Marvin H. Cohen
Stephen Cohen
Bob Coleman
Lia Cook
Miles Coolidge
Patricia S. Cornelius
Philip Cornelius
E. Gene Crain Collection
A. Lawrence and Anne Spooner Crowe
Larry Cuba
Darryl and Doris Curran

Victoria Dailey
Julie Schafler Dale
Judy Dater
Michael Dawson
Robert Dawson
Rosa and Carlos de la Cruz
Einar de la Torre and Jamex de la Torre
Louis F. D'Elia
The Delman Collection, San Francisco
Johanna Demetrakas
Lewis deSoto
Stephen De Staebler
Kris Dey
Mr. and Mrs. William R. Dick Jr.
Carlos Diniz
Sue and Albert Dorskind
Sharon B. Drager
Nancy Dubois
Tony Duquette
Lucia Eames
Charles C. and Sue K. Edwards
Roger Epperson and Carol Alderdice
Betty and Monte Factor Collection, Santa Monica
Suzanne and Howard Feldman
The Fieldstone Collection
Frederick Fisher
Laura Fisher
Robbert Flick
William Franco
Ron and Nancy Frank and Edward Frank
Anthony Friedkin
Larry Fuente
Harry Gamboa Jr.
Frank O. Gehry
Joanna Giallelis
Paula and Irving Glick
Jim Goldberg
Lisa and Douglas Goldman
Shifra M. Goldman
Ken Gonzales-Day
Joe Goode
Morris T. Grabie and Sherry Latt Lowry
Phyllis Green
Daniel Gregory
The Grinstein Family
Helen Mayer Harrison and Newton Harrison
Jeff Haskin
Jim Heimann
Ruth and Alfred Heller
Ester Hernández
Lynn Hershman
Charles and Victoria Hill
Curtis M. Hill
Louis Hock
Margaret Honda
Dennis Hopper
Mildred Howard
Randy Hussong
David Ireland

Richard Jackson
Ferne Jacobs
Jasper Johns
The Michael Johnson Collection
Elaine K. Sewell Jones
Pirkle Jones
Mr. and Mrs. Albert Kallis, Los Angeles
Gloria and Sonny Kamm
Norman Karlson
Hiromi Katayama
Margery and Maurice Katz
Hilja Keading
Jeff Kerns, Los Angeles
Bernard Kester
Sant Khalsa
Anthony Kiedis
Candace Kling
David Knaus
Hirokazu Kosaka
Alice and Marvin Kosmin
Ina Kozel
Leslie Labowitz
Suzanne Lacy
Robin Lasser
Max Lawrence
Doug and Joelle Lawrie
Jeffrey Leifer
Oscar and Trudy Lemer
Fannie and Alan Leslie
Mel and Sharlene Leventhal
Lydia and Chuck Levy
Joe Lewis
Kimberly Light
Li-lan
Marvin Lipofsky
John Lofaso
Vicki and Kent Logan, San Francisco
Robert and Mary Looker
Yolanda M. López
John Gilbert Luebtow
Gilbert (Magu) Sánchez Luján
James Luna
Mike Mandel
Ray Manzarek
Michael and Patti Marcus
Tom Marioni
Richard Marquis
Joel Marshall
T. Kelly Mason
Paul McCarthy
The McClelland Collection
Barbara and Buzz McCoy
Barry McGee
Michael C. McMillen
Merle and Gerald Measer
Richard Meier
Amalia Mesa-Bains
Gary and Tracy Mezzatesta
Frank Miceli

Estelle and Jim Milch
Roger Minick
Peter Mitchell-Dayton
Archie Miyatake, Miyatake Collection
Susan Mogul
Linda Montano
Michelle Montgomery and David Kent
Mark Moriarity
William Moritz
Ed Moses
Joseph L. Moure
Nancy Dustin Wall Moure
Ron Nagle
Joyce Neimanas
Manuel Neri
Daniel Nicoletta
Linda Nishio
Don Normark
Eileen and Peter Norton, Santa Monica
Jonathan Novak, Los Angeles
Stephen Oakes and Olivia Georgia
The Obata Family
Gordon Onslow Ford
Rubén Ortiz-Torres
Tom Patchett, Los Angeles
Patricia Patterson
Dr. and Mrs. Stanley C. Patterson
Mr. and Mrs. Norman Pattiz
Edmund F. Penney and Mercedes A. Penney
Kathy and Ron Perisho
Carolyn Peter
Charles Phoenix
Patti Podesta
Anne and Arnold Porath
Ken and Happy Price
Joan and Jack Quinn, Beverly Hills
Marcos Ramirez ERRE
Armando Rascón
Dennis Reed and Amy Reed Collection
Stephen I. Reinstein
Susan and Michael Rich
Rigo
Rob Roberts
Mr. and Mrs. C. David Robinson, Sausalito
Steve Roden and Dan Goodsell
Mimi Rogers
Frank Romero
Sheree Rose
Richard Rosenzweig and Judy Henning
Bill Rush
Sandor Family Collection
Frank T. Sata, Pasadena
Sarah Schrank, San Diego
Ilene Segalove
Miki Seifert
Allan Sekula
Bonnie Sherk
Richard E. Sherwood Family Collection
Billy Shire

Peter Shire
Julius Shulman
Gilbert and Lila Silverman
Michael Simental and Phill Starr
Barry Sloane
Deborah Small
Barbara Smith
Eileen R. Solomon
John Sonsini
Judy and Stuart Spence
Stecyk Family
Robert and Ann Steiner
Daniel Strebin
Marion Boulton Stroud
John Sturgeon
Larry Sultan
Lydia and Andrew H. Sussman
Sutnar Foundation
Kathryn Sylva
Janice Tanaka
Selwyn Ting and Clover Lee
Lothar Tirala
Donald and DeAnne Todd
John Tolbert
Fred Tomaselli
Salvador Roberto Torres
Roberta Rice Treseder
Peter Turman
Steve Turner
Dean Valentine and Amy Adelson, Los Angeles
Deborah Valoma
Anna van der Meulen
Ron and Susan Vander Molen
Mr. and Mrs. Robert Veloz
Camilo José Vergara
The Marjorie and Leonard Vernon Collection
Bill Viola
Anne Walsh
Jeri L. Waxenberg
June Wayne
Jonathan Quincy Weare
Nancy and John Weare
Roger Webster
Pae White
Stephen White II
Hutton Wilkinson
Wilson Center for Photography
Albert J. Winn
Erin Younger and Ed Leibow
Suzanne W. and Tibor Zada
Jody Zellen
Andrea Zittel
and anonymous lenders

ACKNOWLEDGMENTS

The development and production of an exhibition on the scale of *Made in California: Art, Image, and Identity, 1900–2000* would not have been possible without the cooperation of the many colleagues, artists, and lenders who contributed to the project over the past six years. The exhibition required an unusual level of collaboration among nine programmatic departments, as well as early and consistent participation from the exhibitions, publications, and graphic design departments at LACMA. In recognition of their efforts, these acknowledgments are written on behalf of the core team of LACMA curators and educators who labored on this extraordinary exhibition.

Made in California began with a desire to explore the rich subject of California art of the twentieth century from many points of view and in many mediums. Ilene Susan Fort, Curator of American Art, was an early enthusiastic collaborator. Together she and I led the team approach that made this exhibition possible. Her extensive knowledge of American and Californian art and well-honed research and curatorial skills helped to guide the exhibition and shape its two related publications. Sheri Bernstein served as full-time Exhibition Associate for the project. Bernstein played a pivotal role in bringing us all together and in conceptualizing both the exhibition and its publications. She worked closely with many museum colleagues and helped to chart our course throughout many discussions about the nature and purpose of the exhibition. We have all benefited from her focus on the project and from her diplomatic skill. She has written extensively in the present catalogue, weaving together the themes of the exhibition. It would have been impossible to conceive and mount *Made in California* without her.

The core group of curators who worked on the project came from the LACMA departments of American art, costume and textiles, decorative arts, modern and contemporary art, photography, and prints and drawings. Early in the development of the exhibition, the curatorial team expanded to include the LACMA departments of film, music, and education. One colleague in particular, the late Bruce S. Davis, Curator of Prints and Drawings, brought clarity, intelligence, and wit to the development process. His untimely death in 1997 cut short his involvement. We dedicate this volume to his memory.

During the final two years of preparation, Eulogio Guzman joined the team as research assistant. Guzman assumed the primary role of locating, selecting, and coordinating loans of architectural drawings and ferreting out a wide variety of ephemeral material from 1940 to 2000. For his dedication and indefatigable effort on many aspects of the show's development, we are grateful. We were also significantly aided by research assistant John Ott, who not only selected documentary material covering the years from 1900 to 1940 for the exhibition but also wrote for the accompanying anthology and compiled the bibliography included in this volume. Our research team was assisted by Carolyn Peter in San Francisco. Peter worked tirelessly in the Bay Area, visiting archives, museums, collectors, dealers, and scholars on LACMA's behalf. We are grateful for her collegial cooperation throughout the project. Guzman, Ott, and Peter contributed significantly to the conceptualization and realization of the project.

The work of the LACMA team was enriched by contributions from numerous scholars working in fields outside our areas of specialization. While the programmatic expertise of the LACMA team is extensive, we felt the need to expand our horizons by inviting scholars in other disciplines to discuss the project with us. In fall 1997, team member Paul Holdengräber, now Director of the LACMA Institute for Art and Cultures, brought together colleagues from outside the museum for our first colloquium, a weekend of roundtable discussion. For that event, LACMA's multidisciplinary team was joined by twenty-three writers, geographers, critics, filmmakers, film and art historians, educators, critical and cultural studies scholars, artists, and librarians who helped us enormously in refining our topic and approach. It was an exhilarating experience and moved the project forward immeasurably. The early and enthusiastic support of State Librarian Kevin Starr, who embraced our project as the largest California-related presentation during the state's sesquicentennial, was particularly helpful. During the summer of 1998, in a series of five seminars, LACMA team members had the opportunity to work closely with a new group of scholars, who came to the museum to review the exhibition outline and share with us yet another range of perspectives on the project. For their generous participation we thank all who attended these sessions; their engagement greatly influenced this project. Their names are listed on page 334.

The following authors contributed to the anthology volume, *Reading California: Art, Image, and Identity, 1900–2000*, that accompanies this catalogue: Blake Allmendinger, John P. Bowles, Margaret Crawford, Ilene Susan Fort, Howard N. Fox, Karin Higa, Paul J. Karlstrom, Norman M. Klein, Anthony W. Lee, George Lipsitz, Chon A. Noriega, John Ott, Carolyn Peter,

Dana Polan, Sarah Schrank, Peter Selz, Kevin Starr, Sally Stein, Tim B. Wride, and Lynn Zelevanksy. We would also like to thank authors Sheri Bernstein, Michael Dear, Howard N. Fox, and Richard Rodriguez, whose thoughtful contributions enrich the present volume.

Made in California was planned to occur on the cusp of a new century and to encompass the contributions of many departments. The decision was therefore made to give the show an unusual amount of space and to have it on view for an extended period. We are grateful for the enthusiastic and consistent support received from Andrea L. Rich, LACMA President and Director, as well as from former LACMA director Graham W. J. Beal, and from the museum's Board of Trustees.

The exhibition covered more than 45,000 square feet in two buildings on five floors. A related exhibition, *Made in California: NOW*, was mounted in the Boone Children's Gallery at LACMA West. The extensive physical space allocated to *Made in California* underscored important issues about the installation process and its impact on visitors. How would visitors follow the chronology, themes, and interpretations of more than 800 works of art and more than 400 documents and examples of material culture and absorb two dozen audio and video presentations, not to speak of text panels, timelines, and other didactic materials? It became apparent early on that designing the exhibition for maximum visitor understanding would be a challenge. For undertaking this responsibility we are enormously grateful to our design team, led by Tim Durfee and Louise Sandhaus, with Iris Regn, who in the past two years have been integral members of our team, attending countless meetings and engaging in many discussions related to content, approach, interpretation, and meaning. Their imaginative, innovative, and thoughtful design has responded to very complicated issues of intention, audience, and presentation. Designer Bernard Kester not only worked with Assistant Curator of Decorative Arts Jo Lauria in conceptualizing and executing the three lifestyle environments, but also assisted in crucial ways with important design issues throughout the project. They have all worked closely with LACMA Senior Designer Scott Taylor to present the rich installation that is so critical to the exhibition's point of view. Exhibition-related environmental design, particularly in the public spaces, was the result of their collaboration with Jim Drobka, head of graphic design at LACMA, who supervised the entire design effort. We are grateful to all of our designers for their sensitive response to the challenges presented by the project.

Such a complex and ambitious exhibition and its related publications are costly to plan and execute. Our deepest thanks go to the S. Mark Taper Foundation for providing early, sustained, and major funding for the exhibition. We are greatly indebted to President Janice Taper Lazarof, Executive Director Ray Reisler, and the foundation's board for their close cooperation with the LACMA team.

Grateful acknowledgment is also made to the Donald Bren Foundation, which underwrote a significant portion of the exhibition. The National Endowment for the Arts and Bank of America also supported the project, as did Helen and Peter Bing, who provided early research and planning support. Additional thanks go to the Peter Norton Family Foundation, See's Candies, the Brotman Foundation of California, and Farmers Insurance. The project received generous in-kind support from FrameStore and KLON 88.1 FM. Printing of both *Made in California* volumes in California was made possible by generous in-kind support from Gardner Lithograph in Buena Park and an in-kind donation of paper from Appleton Coated LLC. Tom Jacobson, director of development at LACMA, approached the task of funding this project with imagination and his customary professionalism.

Aya Yoshida, lead curatorial administrator on the project, masterfully engineered extensive databases to manage the great amount of loan information and correspondence generated by the project; we are deeply grateful for her tenacity and good cheer. Yoshida worked closely with curatorial administrators Maile Pingel, Eve Schillo, Danielle Sierra, Krishanti Wahla, and Margo Zelinka, who were resourceful and helpful at all stages. Carol Matthieu, curatorial administrator in the department of modern and contemporary art, assumed many additional responsibilities in keeping team members informed and on track through scores of meetings and communications; her superior abilities are much appreciated. We are also grateful for the assistance of Jill Martinez, former curatorial assistant, modern and contemporary, as well as our invaluable volunteers Beatrice Farber, Sharon Gillespie, Betty Helfen, Roz Leader, Lee Marcuse, Lois Sein, and Cambra Stern; department of costume and textiles interns Lopa Pal, Kentura Persellin, and Zoe Whitley; the exemplary research skills of our Ralph M. Parsons Intern in Photography, Karen Weldon Roswell, and former Richard E. Sherwood Memorial Intern P. Eric Perry. Exhibition assistant Shana Rosengart joined the team to assist with final exhibition details and education programs. Anne

Diederick, librarian in the museum's Balch Research Library, responded with customary good grace to countless interlibrary loan requests. Virginia Fields, Curator of Pre-Columbian Art, assisted with the selection and installation of Native American basketware in the exhibition.

Essential to the five exhibit sections, each of which covers two decades of the twentieth century, are a series of media stations composed of rare footage and other archival materials. Commissioned from Morgan Neville, David Haugland, and the studio of David Inocencio and Minette Siegel, these contributions richly enhanced the exhibition and complemented the adjacent selections of art. Sections 3 through 5 of the exhibition, covering 1940 to the present, offered opportunities to present artist films and video, performance, and installation art. For his guidance in the history of film, video, and performance, we are grateful to Peter Kirby, who was an exceptionally generous colleague. In collaboration with LACMA curators, Kirby played a significant role in choosing the works in those mediums included in the exhibition. Historian George Lipsitz chose selections of popular music relating to the twenty-year sections, and Steven Watson and S. S. Kush produced an audio anthology of Beat-generation poetry.

To convey the importance of murals in California in the twentieth century, we turned to photographer and mural specialist James Prigoff, who, assisted by Robin Dunitz, selected images of nearly seventy contemporary murals that could be viewed on one monitor. Architectural model maker John Lodge created three stations that provide views of murals in situ. Another key component of the exhibition was the timeline that introduced each section. For sensitively combining well-known historical events with facts specific to California history, tracing waves of migration and the growth of museums and schools, and weaving political and economic events into a fascinating and imaginative sequence illustrated with photographs and archival documents, we are grateful to historian Sarah Schrank.

Victoria Clare, administrative assistant in the departments of modern and contemporary art and education and public programs, deserves special acknowledgment for being such an able liaison with each of these outside specialists. Clare has worked closely with me during the development of the project and has been responsible for coordinating twenty-four commissioned productions and ensuring the smooth delivery of materials. She played a particularly helpful role in the conceptualization and production of the popular music stations.

I am very grateful to her for this and for her excellent assistance during the past four years. General Counsel Deborah Kanter has been supportive throughout the project and has guided us through several potentially problematic situations; we are grateful for her creative and enthusiastic participation.

Lenders to the exhibition, without whom it would have been impossible to realize this project, are listed on pages 325–27. The Oakland Museum has been particularly supportive with extensive loans and general advice. We are grateful to Director Philip E. Linhares, Senior Curator Harvey L. Jones, and colleagues Suzanne Baizerma, Imogen Gieling, Drew Johnson, Karen Tsujimoto, and Joy Walker for their warm friendship during this project. Additionally, Director David A. Ross and colleagues Janet Bishop and Rose Candelaria of the San Francisco Museum of Modern Art and Robert Flynn Johnson and Karin Breuer of the Achenbach Center for the Graphic Arts of the Fine Arts Museums of San Francisco have made numerous artworks available to the exhibition. We are also especially grateful to Jerome and Evelyn Ackerman, Gerald and Bente Buck, Dr. Louis F. D'Elia, and Michael G. Wilson, who have all lent generously from their collections.

The concept for *Made in California* relied heavily upon the contextualization of artworks from the last 100 years in relation to a rich assortment of documentary material such as travel brochures, posters, letters, telegrams, documentary photographs, maps, books, magazines, and newspaper articles. We were very fortunate to be able to draw upon the remarkable reserves of dozens of special libraries, archives, and collections of books and ephemera throughout the state in building this major component of the exhibition. Recently the Getty Research Institute for the History of Art and the Humanities published *Cultural Inheritance L.A.: A Directory of Less-Visible Archives and Collections in the Los Angeles Region* (1999). Many of the Southern California archives we consulted are included in this remarkable volume. The following public and private archives have been particularly generous with loans, and we are grateful to their directors and staffs for research and loan assistance: Archives of American Art, West Coast Branch; Bancroft Library, University of California, Berkeley; California Historical Society; California State Railroad Museum; California State University, Northridge, Special Collections and Archives; Center for the Study of Political Graphics; James N. Gamble House; The Huntington Library, Art Collections, and Botanical Gardens; Museum of the Moving Image, Astoria, New York;

National Resource Center, Japanese American National Museum; Seaver Center for Western History Research, Natural History Museum of Los Angeles County; San Diego Historical Society; San Francisco History Center at the San Francisco Public Library; Southwest Museum Library; Archive and Collections, Universal Studios, Los Angeles; University of California, Irvine, Special Collections and University Archives; University of California, Los Angeles, Special Collections; Regional History Center, Department of Special Collections, University of Southern California; and the Corporate Archive, Warner Brothers, Los Angeles.

A number of private collectors of ephemeral materials have been remarkably helpful and generous with information and loans. We are particularly grateful to Victoria Dailey, Ron Finley, Shifra Goldman, Jim Heimann, Gordon McClelland, John Sonsini, Craig Stecyk, and Steve Turner for their passion and commitment to their subjects and for lending so unstintingly to the exhibition.

During the planning of the project we were guided by advice and assistance offered by many generous individuals. In addition to those listed on page 334, catalogue and anthology authors, and others mentioned above, the LACMA team would like to thank the following: Leith Adams, Jerome Adamson, Louise Barco Allrich, Susan Anderson, Paule Anglim, the Art Museum Council, James Bassler, Billy Al and Wendy Bengston, Thomas Benitez, John Berggruen, Bill Berkson, Dan Bernier, Marla Berns, Barbara Beroza, Janet Blake, Shoshana Blank, Irving Blum, Lois Boardman, Rena Bransten, Virginia Brier, Ruth Britton, Inez Brooks-Myers, John Cahoon, Anne Caiger, G. B. Carson, Roland Charles, Erin Chase, Cathy Cherbosque, Bill Clark, Catharine Clark, Stephen Cohen, Bolton Colburn, Anne Cole, Candace Crockett, Katherine Crum, Julie Shafler Dale, Elizabeth Daniels, Kimberly Davis, Michael Dawson, Kirk Delman, Eames Demetrios, Stephen De Staebler, Carlos Diniz, Alan Donant, Jackie M. Dooley, Lynn Downey, Dr. Sharon B. Drager, Janice Driesbach, Lucia Eames, Kate Elliot, John English, David Fahey, Patricia Faure, Rosamund Felsen, Marc Foxx, Ron and Nancy Frank, Mary Anne Friel, Whitney Ganz, Kathleen Garfield, Tony Gardner, Ed Gilbert, Esther Ginsberg, Ann Goldstein, Pat Gomez, Rita Gonzalez, Joe Goode, Joni Gordon, Peter Goulds, Christopher Grimes, Jeff Gunderson, Cheryl Haines, Nora Halpern, Gerald Haslam, Kurt Helfrich, Kimi Hill, Terry Hinte, Henry Hopkins, Jan-Christopher Horak, Joyce Hunsaker, Rupert Jenkins, Christy

Johnson, Mark Johnson, Caroline Jones, Elaine K. Sewell Jones, Sam Jornlin, Patricia Juneker, Alan Jutzi, Cindy Keefer, Jeff Kelly, Kent Kirkton, Anne Kohs, Marti Koplin, Giles Kotcher, Craig Krull, Wayne Kuwada, Molly Lambert, Susan Landauer, Margo Leavin, Melissa Leventon, Leah Levy, Connie Lewellen, Mark Line, Frank Lloyd, Pamela Ludwig, Susan Martin, Anne Matranga, Signe Mayfield, Mathilda McQuaid, Susan Menconi, Sharon Merrow, Jean Milant, Eudora Moore, William Moritz, Chris Morris, Tobey Moss, Nancy D. W. Moure, Eugene Moy, Maggie Paxton Murray, James Nottage, Octavio Olvera, Gordon Onslow Ford, Daniel Ostroff, John Outterbridge, Patrick Painter, Jang Park, John Perrault, Jan Peter, Charles Phoenix, Bryn Potter, Ken Price, Rennie Pritiken, Jeff Rankin, Peter Rathbone, Ray Redfern, Shaun Caley Regen, Matthew W. Roth, Ramon Ruelas, Jack Rutberg, Kay Sakamachi, Barry Sanders, Richard Sandor, Lawrence Schaffer, Laura Schlesinger, Dennis Sharp, Susan and the late David Sheets, Steven Shortridge, Ann Sievers, Patterson Sims, Daniel J. Slive, Rochelle Slovin, Weldon Smith, Paul Soldner, Randy Sommer, Bill Stern, George Stern, Jean Stern, Louis Stern, Bob Stockdale, Robin Stropko, Bob Sweeney, Sharon Tate, Dace Taube, Richard Telles, Christa Mayer Thurman, Patricia Trenton, Mark Trieb, Cameron Trowbridge, Peter Turman, James Tyler, Anna van der Meulen, Peter Voulkos, Sarah Watson, Hannah Wear, Adam Weinberg, Katherine Westphal, Kathleen Whitaker, Donald Woodman, Eric Lloyd Wright, Matthew Yokobosky, Richard York, Masha Zakheim, Michael Zakian, and David Zeidberg.

Bob Sain, director of a new research and development department at the museum called LACMALab, organized the *Made in California: NOW* exhibition in the Boone Children's Gallery in collaboration with Lynn Zelevansky, Curator of Modern and Contemporary Art. Eleven Los Angeles artists were commissioned to create works related to California's cultural, natural, and built landscape in the form of dynamic, interactive environments for children, families, and teachers. Artists were encouraged to use the museum's collection as a resource and to involve children as appropriate in the planning, fabrication, and testing of the installations. For their participation in *Made in California: NOW* we thank the artists, as well as LACMALab Coordinator Kelly Carney, Associate Museum Educator Elizabeth Caffry, and graphic designer Amy McFarland, as well as architects Elaine René-Weissman and Hsuan-ying Chou for their imaginative design of the exhibition.

Our colleagues Ian Birnie, Head of Film Programs, and Dorrance Stalvey, Head of Music Programs, have each embraced the opportunity to plan innovative and extensive programs during the run of the exhibition. Both were integral members of the exhibition team. They were assisted by Tom Vick and Annissa Lui, respectively. Birnie organized nine thematic film series on aspects of California cinema, from iconic crime films to a weekend of John Steinbeck. Stalvey planned four concerts, ranging from the works of emigrés Arnold Schoenberg and Igor Stravinsky to the avant-garde composers of the 1960s.

Although all major exhibitions rely on a significant team of museum professionals, a project of this magnitude necessarily tapped and challenged an extensive range of talents at LACMA. The audiovisual, conservation, operations, and art preparation and installation departments all merit special attention for their efforts, as does the registrar's office. The exhibition programs department, led by Assistant Director Irene Martin, expertly and gracefully oversaw all phases of the project. For their enthusiastic and hands-on assistance we are profoundly grateful to Coordinator Christine W. Lazzaretto, who kept us on track, and to Beverley Sabo, Financial Analyst, who kept us within budget. Assistant Director of Collections Management Renee Montgomery, Registrar Ted Greenberg, Assistant Registrar Christine Vigiletti, and the registrarial staff were key to the assembly of more than 1,000 objects from local, domestic, and foreign sources. For their expert handling of the deinstallation of the permanent collection and a complicated installation schedule, we are grateful to Manager of Art Preparation and Installation Lawrence Waung and his staff. Victoria Blyth Hill, Director of Conservation, and our capable team of conservators Don Menveg, furniture; Sabrina Carli, John Hirx, Vanessa Muros, and Maureen Russell, objects; Joe Fronek and Virginia Rasmussen, paintings; Margot Healey and Chail Norton, paper; and Catherine McLean and Susan Schmalz, textiles, readied numerous works for presentation and found imaginative solutions to display problems.

The divisions of administration and external affairs, under the direction of Senior Vice President Melody Kanschat, responded sensitively to the challenges posed by the exhibition. Mark Mitchell, Budget and Financial Planning Officer, provided critical budgetary guidance. Assistant Vice President of Protective Services Erroll Southers was effective at anticipating many situations involving our visitors. Art Owens, Assistant Vice President, Operations and Facility Planning, approached the responsibility of constructing a complex 45,000-square-foot installation, as well as the installation of *Made in California: NOW,* with his customary great skill. He was ably assisted by Bill Stahl, Manager of Construction, and his staff. In collaboration with Peter Kirby, Megan Mellbye, Ken Olsen, and Elvin Whitesides of the audiovisual department provided extensive technical assistance. Assistant Director of Communications and Marketing Keith McKeown and staff members Adam Coyne, Kirsten Schmidt, Mark Thie, and Janine Vigus oversaw *Made in California* press and marketing.

The education and public programs division at LACMA played a critical role in the development and interpretation of *Made in California.* The educational aspect of the exhibition was paramount from the beginning. We were committed to creating an exhibition that would work on a variety of levels and for a diverse audience. Our education team has been instrumental in achieving this goal. Jane Burrell, Chief, Art Museum Education, provided invaluable assistance throughout the project. Bridget Cooks, Assistant Museum Educator, Special Exhibitions, worked closely on the planning and implementation of the exhibition's educational components. Cooks has been an integral member of the team from the outset, and her counsel and enthusiasm have been much appreciated by all. We are grateful to Paul Holdengräber of the LACMA Institute for Art and Cultures and to Bob Sain of LACMALab, who planned a number of events related to *Made in California.* Writer Barbara Isenberg conducted a number of fascinating interviews with artists, excerpts from which were included in the exhibition and audio tour.

Garrett White, Director of Publications, has ably overseen development and production of this catalogue and the related anthology volume. I am indebted to him for his guidance throughout. LACMA editors Nola Butler and Thomas Frick undertook the critical role of editing the two volumes. They sensitively shaped the texts of more than two dozen authors with skill and consummate professionalism. Additional editorial assistance was provided by LACMA Associate Editor Margaret Gray, along with Michelle Ghaffari and Denise Pierre. Both publications relied upon new and existing photography. We thank Peter Brenner, Supervising Photographer, Photographic Services, and staff member Steve Oliver for overseeing quality control of the images. Cheryle Robertson, Coordinator of Rights and Reproductions, assisted by Giselle Arteaga-Johnson, Shaula Coyl, and Joey Crawford, skillfully

oversaw the daunting task of securing licensing agreements for hundreds of images in the exhibition and related publications.

The extraordinary design of the present catalogue is the work of Senior Designer Scott Taylor; assistance with the layout of the anthology volume was provided by Theresa Velázquez. Working closely with curators and editors, Taylor contributed immeasurably to the content of the volume, and his thoughtful treatment of text and images is a credit to the entire project. We are deeply indebted to him not only for his design of the publications but also for his supervision and execution of the exhibition design, accomplished in collaboration with designers Sandhaus, Durfee, and Regn. Rachel Ware Zooi oversaw the production of both volumes, assisted by Chris Coniglio and Karen Knapp. Additional assistance was provided by LACMA graphic designers Katherine Go, Amy McFarland, Paul Wehby, and Daniel Young, along with outside designer Agnes Sexty. At UC Press, it was a pleasure to work with Director Jim Clark and Fine Arts Editor Deborah Kirshman and their staff.

This undertaking began many years ago with the idea of exploring the richness and complexity of twentieth-century art in the state of California. Although not without challenges, the opportunity to bring together colleagues with different points of view and varying frames of reference has been thoroughly exciting, surprising, and above all rewarding. The success of *Made in California* is perhaps measured by the fact that it is ultimately far richer and more varied than any one of us could have achieved or for that matter even imagined alone. This team approach, favored at the moment by a number of fellow institutions in New York and Europe, may signal a new chapter in museum exhibitions and presentation strategies. We are profoundly grateful to all of the many colleagues whose contributions helped to create *Made in California*.

Finally, as a native New Yorker but a resident of California since the mid-1970s, I have long been intrigued by the complexity of California's image and the role artists have played in the state's history. I would like to thank my son Max, a native Californian, who has helped his mother learn and understand so much about the richness and diversity of this remarkable state.

Stephanie Barron
Vice President of Education and Public Programs
Senior Curator of Modern and Contemporary Art

LACMA *Made in California*
Programmatic Team

Stephanie Barron
Senior Curator, Modern and
Contemporary Art; Vice President,
Education and Public Programs

Sheri Bernstein
Exhibition Associate

Ian Birnie
Head of Film Programs

Victor Carlson
Curator of Prints and Drawings
(retired 2/00)

Bridget Cooks
Assistant Educator, Education
Department

Bruce S. Davis
Curator of Prints and Drawings
(deceased)

Carol S. Eliel
Curator of Modern and
Contemporary Art

Ilene Susan Fort
Curator of American Art

Howard N. Fox
Curator of Modern and
Contemporary Art

Dale Gluckman
Curator of Costume and Textiles

Sharon Goodman
Curatorial Assistant, Prints and Drawings

Peter Kirby
Curator of New Media (Adjunct)

Jo Lauria
Assistant Curator of Decorative Arts

Kaye Spilker
Assistant Curator of Costume and Textiles

Dorrance Stalvey
Head of Music Programs

Sharon Takeda
Curator of Costume and Textiles

Tim B. Wride
Associate Curator of Photography

Lynn Zelevansky
Curator of Modern and
Contemporary Art

Participants in *Made in California*
Advisory Meetings, 1997–1998

Rodolfo Acuña
Professor of Chicano/a Studies, California State University, Northridge

Ron Alcalay
Film historian and author

Blake Allmendinger
Professor of English, University of California, Los Angeles

David Avalos
Professor of Visual and Performing Arts, California State University, San Marcos

Anne Ayres
Director of Exhibitions, Graduate Studies Faculty, Otis College of Art and Design, Los Angeles

Aaron Betsky
Curator of Architecture, Design, and Digital Projects, San Francisco Museum of Modern Art

John F. Bowles
Ph.D. candidate, Art History, University of California, Los Angeles

Leo Braudy
Professor and Chair, Department of English, University of Southern California

Richard Cándida Smith
Associate Professor of History, University of Michigan

Bernard Cooper
Author; Instructor of Creative Writing, Antioch University

Margaret Crawford
Professor of Urban Planning and Design Theory, Graduate School of Design, Harvard University

Robert Dawidoff
Professor of History, Claremont Graduate University

Michael Dear
Professor of Geography and Director of Southern California Studies Center, University of Southern California

Bram Dijkstra
Cultural historian; Professor of American and Comparative Literature, University of California, San Diego

John Espey
Author; Emeritus Professor of English, University of California, Los Angeles

Robbert Flick
Photographer; Professor of Art, University of Southern California

Michael Golino
Director of Projects, InSITE 2000

Merril Greene
Author and film producer

Lisbeth Haas
Associate Professor of History, University of California, Santa Cruz

Anthony Hernandez
Photographer

Karin Higa
Director of Curatorial and Exhibitions Department, Senior Curator of Art, Japanese American National Museum, Los Angeles

Thomas S. Hines
Professor of History of Architecture and Urban Design, University of California, Los Angeles

Gregory Hise
Professor of Urban History and Planning, University of Southern California

Paul Holdengräber
Director, LACMA Institute for Art and Cultures

Barbara Isenberg
Author/journalist

Steven Isoardi
Researcher and interviewer, Central Avenue Sounds Series, University of California, Los Angeles, Oral History Program

David James
Professor of Critical Studies, School of Cinema-Television, University of Southern California

Paul J. Karlstrom
Regional Director, Archives of American Art, Smithsonian Institution at The Huntington Library

Elaine Kim
Professor of Ethnic Studies, University of California, Berkeley

Anthony Kirk
American cultural and environmental historian

Norman M. Klein
Professor of Critical Studies, California Institute of the Arts, Valencia

Christopher Knight
Art critic, *Los Angeles Times*

Steven D. Lavine
President, California Institute of the Arts, Valencia

George Lipsitz
Professor of Ethnic Studies, University of California, San Diego

Valerie Matsumoto
Associate Professor of History, University of California, Los Angeles

Rick Moss
Program Manager and Curator of History, California African American Museum, Los Angeles

Margarita Nieto
Professor of Chicano/a Studies, California State University, Northridge

Chon A. Noriega
Associate Professor of Critical Studies, School of Theater, Film, and Television, University of California, Los Angeles

Andrew Perchuck
Ph.D. candidate, History of Art, Yale University

Susan Phillips
Lecturer, Department of Anthropology, University of California, Los Angeles

Dana Polan
Chair, Division of Critical Studies, School of Cinema-Television, University of Southern California

Ralph Rugoff
Director, California College of Arts and Crafts Institute

Carolyn See
Author; Adjunct Professor of English, University of California, Los Angeles

Rebecca Solnit
Essayist and historian

Lynn Spigel
Professor of Critical Studies, School of Cinema-Television, University of Southern California

Kevin Starr
State Librarian of California; University Professor, University of Southern California

Steve Wasserman
Editor, Book Review, *Los Angeles Times*

Cécile Whiting
Professor of Art History, University of California, Los Angeles

Robert Winter
Professor of History, Emeritus, Occidental College

Charles Wollenberg
Professor of History, Chair of Social Sciences, Vista Community College

Sally Woodbridge
Architectural critic and historian

Victor Zamudio-Taylor
Curator of International Exhibitions, Institute of Visual Arts, University of Wisconsin, Milwaukee; Advisor, Televisa Cultural Foundation, Mexico City

SELECTED BIBLIOGRAPHY

Compiled by John Ott

Visual Art

The works listed in this bibliography were either used in the conceptualization of the exhibition or are recommended for further reading. Selections were divided into two categories, "Visual Art" and "History and Culture," the latter of which includes fiction and literary nonfiction. An effort was made to cite works accessible to the general public (no dissertations, specialized journals, or archival materials). In addition, this bibliography focuses on the last fifteen years of scholarship, a period of genuine florescence for California studies. Readers curious about specific topics, personalities, media, or communities may use the works enumerated as a springboard for further inquiry, since many include useful bibliographies as well.

　　Like the *Made in California* exhibition itself, the bibliography is necessarily selective. Relevant exhibition catalogues alone number in the hundreds; therefore, it would be impossible to provide here a truly comprehensive guide to writings on California art, culture, and history. Due to space limitations, it was necessary to omit monographs on individual artists. The bibliography at hand concentrates instead on examinations of broad trends. Similarly, this list includes studies of the culture and history of Hollywood rather than explications of individual films. Finally, this bibliography was not conceived as a literary "greatest hits" but is directed toward those works, fictional and nonfictional, that were informed by and in turn contributed to the image of California.

Adams, Ansel, and Toyo Miyatake. *Two Views of Manzanar: An Exhibition of Photographs.* Exh. cat. Los Angeles: Wight Art Gallery, UCLA, 1978.

Albright, Thomas. *Art in the San Francisco Bay Area, 1945–1980.* Berkeley and Los Angeles: University of California Press, 1985.

Amerika ni ikita Nikkeijin gakatachi: kibo to kuno no hanseiki, 1896–1945 (Japanese and Japanese American Painters in the United States: A Half Century of Hope and Suffering, 1896–1945). Tokyo: Tokyo Metropolitan Teien Art Museum in association with Nihon Terebi Hosomo, 1995.

Andersen, Timothy J., Eudorah M. Moore, and Robert W. Winter, eds. *California Design 1910.* Exh. cat. Pasadena: Pasadena Center. Pasadena: California Design Publications, 1974.

Anderson, Susan M., and Robert Henning Jr. *Regionalism, the California View: Watercolors, 1929–1945.* Exh. cat. Santa Barbara: Santa Barbara Museum of Art, 1988.

Art in California: A Survey of American Art with Special Reference to Californian Painting, Sculpture, and Architecture Past and Present, Particularly as Those Arts Were Represented at the Panama-Pacific International Exposition. Exh. cat. 1916. Reprint, Irvine: Westphal Publishing, 1988.

Bailey, Margaret J. *Those Glorious Glamour Years: The Great Hollywood Costume Designs of the 1930s.* Secaucus, N.J.: Citadel Press, 1982.

Baird, Joseph Armstrong, Jr., ed. *From Exposition to Exposition: Progressive to Conservative Northern California Painting, 1915–1939.* Sacramento: Crocker Art Museum, 1981.

Baldon, Cleo, and Ib Melchior. *Reflections on the Pool: California Designs for Swimming.* New York: Rizzoli, 1997.

Banham, Reyner. *Los Angeles: The Architecture of Four Ecologies.* 1971. Reprint, Hammondsworth, Eng.: Penguin Books, 1990.

Barron, Stephanie. *Art in Los Angeles: The Museum as Site—Sixteen Projects.* Exh. cat. Los Angeles: Los Angeles County Museum of Art, 1981.

———, ed. *California: Five Footnotes to Modern Art History.* Exh. cat. Los Angeles: Los Angeles County Museum of Art, 1977.

Beard, Tyler. *One Hundred Years of Western Wear.* Layton, Utah: Gibbs Smith, 1993.

Belloli, Jay, et al. *Radical Past: Contemporary Art and Music in Pasadena, 1960–1974.* Pasadena: Armory Center for the Arts and Art Center College of Design, 1999.

Betsky, Aaron, et al. *Experimental Architecture in Los Angeles.* Los Angeles: Los Angeles Forum for Architecture and Urban Design in association with Rizzoli, New York, 1991.

Bibby, Brian. *The Fine Art of California Indian Basketry.* Exh. cat. Sacramento: Crocker Art Museum in association with Heyday Books, 1996.

Boas, Nancy. *Society of Six: California Colorists.* San Francisco: Bedford Arts Publishers, 1988.

The Border Art Workshop, 1984–1989. Exh. cat. San Diego: Border Art Workshop/Taller de Arte Fronterizo, 1988.

Bray, Hazel V. *The Potter's Art in California, 1885–1955.* Exh. cat. Oakland: Oakland Museum, 1980.

Breuer, Karin, Ruth E. Fine, and Steven Nash. *Thirty-Five Years at Crown Point Press: Making Prints, Doing Art.* Exh. cat. San Francisco: Fine Arts Museums of San Francisco in association with University of California Press, Berkeley and Los Angeles, 1997.

Brookman, Philip, and Guillermo Gómez-Peña, eds. *Made in Aztlán.* Exh. cat. San Diego: Centro Cultural de la Raza, 1986.

Broude, Norma, and Mary Garrard, eds. *The Power of Feminist Art: The American Movement of the 1970s, History and Impact.* New York: Harry N. Abrams, 1994.

Brown, Kathan, ed. *Ink, Paper, Metal, Wood: Painters and Sculptors at Crown Point Press.* San Francisco: Chronicle Books, 1996.

Brown, Michael D. *Views from Asian California, 1920–1965: An Illustrated History.* San Francisco: Michael Brown, 1992.

Bullis, Douglas. *Art and Style: California Fashion Designers.* Layton, Utah: Gibbs Smith, 1987.

Butterfield, Jan. *The Art of Light and Space*. New York: Abbeville Press, 1993.

California Arts Commission. *The Arts in California: A Report to the Governor and the Legislature by the California Arts Commission on the Cultural and Artistic Resources of the State of California*. Sacramento: California Arts Commission, 1966.

California Women in Crafts: An Invitational Exhibition Recognizing Women in Creative Leadership Roles in Contemporary Craft Forms and Media. Exh. cat. Los Angeles: Craft and Folk Art Museum, 1977.

Cándida Smith, Richard. *Utopia and Dissent: Art, Poetry, and Politics in California*. Berkeley and Los Angeles: University of California Press, 1995.

Charles, Roland, and Toyomi Igus, eds. *Life in a Day of Black L.A.: The Way We See It— L.A.'s Black Photographers Present a New Perspective on Their City*. Exh. cat. Los Angeles: CAAS Publications, University of California, Los Angeles, 1992.

Clearwater, Bonnie, ed. *West Coast Duchamp*. Exh. cat. Santa Monica: Shoshana Wayne Gallery in association with Grassfield Press, Miami Beach, 1991.

Cockcroft, Eva Sperling, and Holly Barnet-Sanchez, eds. *Signs from the Heart: California Chicano Murals*. 1990. Reprint, Albuquerque: University of New Mexico Press; Venice: Social and Public Art Resource Center, 1993.

Colburn, Bolton T. *Across the Street: Self-Help Graphics and Chicano Art in Los Angeles*. Exh. cat. Laguna Beach: Laguna Art Museum, 1995.

Constantine, Mildred, and Jack Lenor Larsen. *The Art Fabric: Mainstream*. Exh. cat. New York: Van Nostrand Reinhold, 1980.

Contemporary Art: Official Catalog, Department of Fine Arts, Division of Contemporary Painting and Sculpture. Exh. cat. San Francisco: Golden Gate International Exposition, Department of Fine Arts, 1939.

Crowe, Michael F. *Deco by the Bay: Art Deco Architecture in the San Francisco Bay Area*. New York: Viking Studio Books, 1995.

Dale, Julie Schafler. *Art to Wear*. New York: Abbeville Press, 1986.

Davis, Bruce. *Made in L.A.: The Prints of Cirrus Editions*. Exh. cat. Los Angeles: Los Angeles County Museum of Art, 1995.

de Alcuaz, Marie. *Ceci n'est pas le Surrealisme: California, Idioms of Surrealism*. Exh. cat. Los Angeles: Fisher Gallery, University of Southern California, in association with Art in California Books, Los Angeles, 1983.

Desmarais, Charles. *Proof: Los Angeles Art and Photography, 1960–1980*. Exh. cat. Laguna Beach: Laguna Art Museum in association with the Fellows of Contemporary Art, 1992.

The Dilexi Years: 1958–1970. Exh. cat. Oakland: Oakland Museum, 1984.

Dominik, Janet Blake. *Early Artists in Laguna Beach: The Impressionists*. Exh cat. Laguna Beach: Laguna Art Museum, 1986.

Draher, Patricia, ed. *The Chicano Codices: Encountering the Art of the Americas*. Exh. cat. San Francisco: Mexican Museum, 1992.

Drescher, Tim. *San Francisco Bay Area Murals: Communities Create Their Muses, 1904–1997*. 3d ed. St. Paul: Pogo Press, 1998.

Dunitz, Robin J., and James Prigoff. *Painting the Towns: Murals of California*. Los Angeles: RJD Enterprises, 1997.

Ehrlich, Susan, ed. *Pacific Dreams: Currents of Surrealism and Fantasy in California Art, 1934–1957*. Exh. cat. Los Angeles: Armand Hammer Museum of Art and Cultural Center, University of California, Los Angeles, 1995.

Fahey, David, and Linda Rich. *Masters of Starlight: Photographers in Hollywood*. Exh. cat. Los Angeles: Los Angeles County Museum of Art, 1987.

Feinblatt, Ebria. *Los Angeles Prints, 1883–1980*. Exh. cat. Los Angeles: Los Angeles County Museum of Art, 1980.

Fifty California Artists. Exh. cat. San Francisco: San Francisco Museum of Art, with the assistance of the Los Angeles County Museum, 1962.

Fine, Ruth E. *Gemini G.E.L.: Art and Collaboration*. Exh. cat. Washington, D.C.: National Gallery of Art in association with Abbeville Press, New York, 1984.

Finson, Bruce, ed. *Rolling Renaissance: San Francisco Underground Art in Celebration, 1945–1968*. Exh. cat. San Francisco: Intersection and the Glide Urban Center, 1968.

Flint, Janet A., ed. *Eight from California*. Exh. cat. Washington, D.C.: National Collection of Fine Arts, Smithsonian Institution, 1974.

Foley, Suzanne. *Space, Time, Sound: Conceptual Art in the San Francisco Bay Area: The 1970s*. Exh. cat. San Francisco: San Francisco Museum of Modern Art, 1981.

Fort, Ilene Susan, and Arnold Skolnick, eds. *Paintings of California*. Berkeley and Los Angeles: University of California Press, 1997.

Forty Years of California Assemblage. Exh. cat. Los Angeles: Wight Art Gallery, UCLA, 1989.

Four Leaders in Glass. Exh. cat. Los Angeles: Craft and Folk Art Museum, 1980.

Friis-Hansen, Dana, et al., eds. *L.A. Hot and Cool: The Eighties*. Exh. cat. Cambridge: List Visual Arts Center in association with MIT Press, 1987.

Gauss, Kathleen. *New American Photography*. Exh. cat. Los Angeles: Los Angeles County Museum of Art, 1983.

Gauss, Kathleen, and Sheryl Conkelton. *Deliberate Investigations: Recent Works by Four Los Angeles Artists*. Exh. cat. Los Angeles: Los Angeles County Museum of Art, 1989.

Gebhard, David. *Architecture in California, 1868–1968*. Exh. cat. Santa Barbara: Art Gallery, University of California, Santa Barbara, in association with the Standard Printing of Santa Barbara, 1968.

———. *Los Angeles in the Thirties, 1931–1941*. Los Angeles: Hennessey and Ingalls, 1989.

Gerdts, William H., ed. *All Things Bright and Beautiful: California Impressionist Paintings from the Irvine Museum*. Exh. cat. Irvine: Irvine Museum, 1998.

Goldman, Shifra. "A Public Voice: Fifteen Years of Chicano Posters." *Art Journal* 44, no. 1 (spring 1984): 50–57.

Goldstone, Bud, and Arloa Paquin Goldstone. *The Los Angeles Watts Towers*. Los Angeles: Getty Conservation Institute and the J. Paul Getty Museum, 1997.

Griswold del Castillo, Richard, et al., eds. *Chicano Art: Resistance and Affirmation, 1965–1985*. Los Angeles: Wight Art Gallery, UCLA, 1991.

Hailey, Gene, ed. *California Art Research*. 20 vols. 1936–37. Microfiche reprint, intro. and rev. by Ellen Schwartz, La Jolla: L. McGilvery, 1987.

Halpern, Nora, and Amy Winter. *Dynaton— Before and Beyond: Works by Lee Mullican, Gordon Onslow Ford, and Wolfgang Paalen*. Exh. cat. Malibu: Frederick R. Weisman Museum of Art, Pepperdine University, 1992.

Hart, James David. *Fine Printing in California*. Berkeley: California Library Association, 1960.

Heimann, Jim, and Rip Georges. *California Crazy: Roadside Vernacular Architecture*. San Francisco: Chronicle Books, 1980.

Heyman, Therese Thau, ed. *Picturing California: A Century of Photographic Genius.* Exh. cat. Oakland: Oakland Museum in association with Chronicle Books, San Francisco, 1989.

————. *Seeing Straight: The f.64 Revolution in Photography.* Exh. cat. Oakland: Oakland Museum, 1992.

Higa, Karen M. *The View from Within: Japanese American Art from the Internment Camps, 1942–1945.* Exh. cat. Los Angeles: Japanese American National Museum; Wight Art Gallery, UCLA; and the Asian-American Studies Center, UCLA, 1992.

Hively, William, ed. *Nine Classic California Photographers.* Exh. cat. Berkeley: Friends of the Bancroft Library, University of California, 1980.

Hopkins, Henry T. *Painting and Sculpture in California: The Modern Era.* Exh. cat. San Francisco: San Francisco Museum of Modern Art; Washington, D.C.: National Collection of Fine Arts, Smithsonian Institution, 1977.

————. *Fifty West Coast Artists: A Critical Selection of Painters and Sculptors Working in California.* San Francisco: Chronicle Books, 1981.

Hughes, Edan M. *Artists in California, 1786–1940.* 2d ed. San Francisco: Hughes Publishing Co., 1989.

Hurlburt, Laurance P. *The Mexican Muralists in the United States.* Albuquerque: University of New Mexico Press, 1989.

Impressionism, The California View: Paintings, 1890–1930. Exh. cat. Oakland: Oakland Museum, 1981.

Ingle, Marjorie I. *The Mayan Revival Style: Art Deco Mayan Fantasy.* Salt Lake City: Peregrine Smith Books, 1984.

Isenberg, Barbara. *State of the Arts: California Artists Talk about Their Work.* New York: HarperCollins, 2000.

James, George Wharton. *Indian Basketry.* 3d ed., rev. and enl., 1903. Reprint, Glorieta, N.M.: Rio Grande Press, 1970.

Jewett, Masha Zakheim. *Coit Tower, San Francisco: Its History and Art.* San Francisco: Volcano Press, 1983.

Johnstone, Mark. *Contemporary Art in Southern California.* Sydney: Craftsman House, G and B Arts International, 1999.

Jones, Amelia, et al. *Sexual Politics: Judy Chicago's "Dinner Party" in Feminist Art History.* Exh. cat. Los Angeles: Armand Hammer Museum of Art and Cultural Center, University of California, Los Angeles, in association with University of California Press, Berkeley and Los Angeles, 1996.

Jones, Caroline A. *Bay Area Figurative Art, 1950–1965.* Exh. cat. San Francisco: San Francisco Museum of Modern Art in association with University of California Press, Berkeley and Los Angeles, 1990.

Jones, Harvey. *San Francisco: The Painted City.* Salt Lake City: Peregrine Smith Books, 1992.

Kamerling, Bruce A. "Theosophy and Symbolist Art: The Point Loma School." *Journal of San Diego History* 26, no. 4 (fall 1980).

————. *One Hundred Years of Art in San Diego: Selections from the Collection of the San Diego Historical Society.* Exh. cat. San Diego: San Diego Historical Society, 1991.

Kaplan, Sam Hall. *L.A. Lost and Found: An Architectural History of Los Angeles.* New York: Crown, 1987.

Karlstrom, Paul J., ed. *On the Edge of America: California Modernist Art, 1900–1950.* Berkeley and Los Angeles: University of California Press, 1996.

Karlstrom, Paul J., and Susan Ehrlich. *Turning the Tide: Early Los Angeles Modernists, 1920–1956.* Exh. cat. Santa Barbara: Santa Barbara Museum of Art, 1990.

Katzman, Louise. *Photography in California, 1945–1980.* Exh. cat. San Francisco: San Francisco Museum of Modern Art in association with Hudson Hills Press, New York, 1984.

Knight, Christopher. *Last Chance for Eden: Selected Art Criticism by Christopher Knight, 1979–1994.* Ed. Malin Wilson. Los Angeles: Art Issues Press, 1995.

Kobal, John. *The Art of the Great Hollywood Portrait Photographers, 1925–1940.* New York: Knopf, 1980.

Lacy, Bill, and Susan deMenil, eds. *Angels and Franciscans: Innovative Architecture from Los Angeles and San Francisco.* New York: Rizzoli, 1992.

Lagoria, Georgiana. *Northern California Art of the Sixties.* Exh. cat. Santa Clara: de Saisset Museum, University of Santa Clara, 1982.

Lancek, Lena, and Gideon Bosker. *Making Waves: Swimsuits and the Undressing of America.* San Francisco: Chronicle Books, 1988.

Landauer, Susan. *The San Francisco School of Abstract Expressionism.* Laguna Beach: Laguna Art Museum in association with the University of California Press, Berkeley and Los Angeles, 1996.

————, et al. *California Impressionists.* Exh. cat. Atlanta: Georgia Museum of Art; Irvine: Irvine Museum, 1996.

Langsner, Jules. *Four Abstract Classicists.* Exh. cat. San Francisco: San Francisco Museum of Art, 1959.

LaPena, Frank. "Contemporary Northern California Native American Art." *California History* 71, no. 3 (fall 1992): 386–401.

The Last Time I Saw Ferus, 1957–1966. Exh. cat. Newport Beach: Newport Beach Art Museum, 1976.

Lee, Anthony W. *Painting on the Left: Diego Rivera, Radical Politics, and San Francisco's Public Murals.* Berkeley and Los Angeles: University of California Press, 1999.

Leese, Elizabeth. *Costume Design in the Movies.* New York: Frederick Ungar Publishing Co., 1977.

Loeffler, Carl E., ed., and Darlene Tong, assoc. ed. *Performance Anthology: Source Book for a Decade of California Performance Art.* Contemporary Documents, vol. 1. San Francisco: Contemporary Arts Press, 1980.

Longstreth, Richard. *On the Edge of the World: Four Architects in San Francisco at the Turn of the Century.* Berkeley and Los Angeles: University of California Press, 1998.

Los Four: Almaraz/de la Rocha/Luján/Romero. Exh. cat. Irvine: University of California, Irvine, 1973.

Made in California: An Exhibition of Five Workshops. Exh. cat. Los Angeles: Grunwald Graphic Arts Foundation, Dickson Art Center, University of California, Los Angeles, 1971.

Maeder, Edward. *Hollywood and History: Costume Design in Film.* Los Angeles: Los Angeles County Museum of Art in association with Thames and Hudson, London, 1987.

Marling, Karal Ann, ed. *Designing Disney's Theme Parks: The Architecture of Reassurance.* Exh. cat. Montreal: Canadian Centre for Architecture in association with Flammarion, Paris, 1997.

Marshall, Richard, and Suzanne Foley. *Ceramic Sculpture: Six Artists.* Exh. cat. New York: Whitney Museum of American Art, 1981.

338

Martin, Gloria Rexford. *A Painter's Paradise: Artists and the California Landscape.* Exh. cat. Santa Barbara: Santa Barbara Museum of Art, 1996.

Martinez, Natasha Bonilla, ed. *La Frontera/ The Border: Art about the Mexico/United States Border Experience.* Exh. cat. San Diego: Centro Cultural de la Raza and Museum of Contemporary Art, 1993.

McClelland, Gordon T., and Jay T. Last. *California Orange Box Labels: An Illustrated History.* 1985. Reprint, Santa Ana: Hillcrest Press, 1995.

———. *The California Style: California Watercolor Artists, 1925–1955.* Beverly Hills: Hillcrest Press, 1985.

McCoy, Esther. *Modern California Houses: Case Study Houses, 1945–1962.* New York: Reinhold Publishing Corp., 1962.

———. *Five California Architects.* 1960. Reprint, Los Angeles: Hennessey and Ingalls, 1987.

Medeiros, Walter. *San Francisco Rock Poster Art.* Exh. cat. San Francisco: San Francisco Museum of Modern Art, 1976.

Mills, Paul. *Contemporary Bay Area Figurative Painting.* Exh. cat. Oakland: Oakland Art Museum, 1957.

Moore, Joe Louis. "In Our Own Image: Black Artists in California, 1888–1970." *California History* 75, no. 3 (fall 1996): 265–71.

Moore, Sylvia, ed. *Yesterday and Tomorrow: California Women Artists.* New York: Midmarch Arts Press, 1989.

Moure, Nancy Dustin Wall. *Painting and Sculpture in Los Angeles, 1900–1945.* Exh. cat. Los Angeles: Los Angeles County Museum of Art, 1980.

———. *California Art: Four Hundred and Fifty Years of Painting and Other Media.* Los Angeles: Dustin Publications, 1998.

———, et al. *Drawings and Illustrations by Southern California Artists before 1950.* Exh. cat. Laguna Beach: Laguna Beach Museum of Art, 1982.

Nash, Steven A., ed. *Facing Eden: One Hundred Years of Landscape Art in the Bay Area.* Exh. cat. San Francisco: Fine Arts Museums of San Francisco in association with the University of California Press, Berkeley and Los Angeles, 1995.

New Deal Art, California. Exh. cat. Santa Clara: de Saisset Art Gallery and Museum, University of Santa Clara, 1976.

Nittve, Lars, and Helle Crenzien. *Sunshine and Noir: Art in L.A., 1960–1997.* Exh. cat. Humlebaek, Denmark: Louisiana Museum of Modern Art, 1997.

One Hundred Years of California Sculpture. Exh. cat. Oakland: Oakland Museum, 1982.

Perine, Robert. *Chouinard: An Art Vision Betrayed.* Encinitas: Arta Publishing, 1985.

Perkins, Constance. *A Pacific Profile of Young West Coast Painters.* Exh. cat. Pasadena: Pasadena Art Museum, 1961.

Perry, Claire. *Pacific Arcadia: Images of California, 1600–1915.* Exh. cat. Iris and B. Gerald Cantor Center for Visual Arts, Stanford University. New York: Oxford University Press, 1999.

Plagens, Peter. *Sunshine Muse: Art on the West Coast.* 1974 [*Sunshine Muse: Contemporary Art on the West Coast*]. Reprint, Berkeley and Los Angeles: University of California Press, 2000.

Polledri, Paolo, ed. *Visionary San Francisco.* Exh. cat. San Francisco: San Francisco Museum of Modern Art, 1990.

Roth, Moira, ed. *Connecting Conversations: Interviews with Twenty-Eight Bay Area Women Artists.* Oakland: Eucalyptus Press, Mills College, 1988.

Rugoff, Ralph, ed. *Scene of the Crime.* Exh. cat. Los Angeles: Armand Hammer Museum of Art and Cultural Center, University of California, Los Angeles, in association with MIT Press, Cambridge, 1997.

Schenker, Heath, ed. *Picturing California's Other Landscape: The Great Central Valley.* Exh. cat. Stockton: Haggin Museum in association with Heyday Books, Berkeley, 1999.

Schimmel, Paul, et al. *Helter Skelter: L.A. Art in the 90s.* Exh. cat. Los Angeles: Museum of Contemporary Art, 1992.

Selz, Peter. *Funk.* Exh. cat. Berkeley: University Art Museum, University of California, Berkeley, 1967.

Shape: Forming the L.A. Look. Exh. cat. Fullerton: Main Art Gallery, California State University, Fullerton, 1995.

Smith, Elizabeth A. T., ed. *Blueprints for Modern Living: History and Legacy of the Case Study Houses.* Exh. cat. Los Angeles: Museum of Contemporary Art in association with MIT Press, Cambridge, 1989.

Solnit, Rebecca. *Secret Exhibition: Six California Artists of the Cold War Era.* San Francisco: City Lights Books, 1990.

Starr, Sandra Leonard. *Lost and Found in California: Four Decades of California Assemblage.* Exh. cat. Santa Monica: James Corcoran Gallery, organized in cooperation with Shoshana Wayne Gallery and Pence Gallery, 1988.

Stern, Jean, et al. *Romance of the Bells: The California Missions in Art.* Exh. cat. Irvine: Irvine Museum, 1995.

Stofflet, Mary. *California Cityscapes.* Exh. cat. San Diego: San Diego Museum of Art, 1991.

Sunset Magazine, in collaboration with Cliff May. *Sunset Western Ranch Houses.* San Francisco: Lane Publishing Co., 1946.

Tamarind Lithography Workshop, Inc., Catalogue Raisonné, 1960–1970. Albuquerque: Art Museum, University of New Mexico, 1989.

Tanner, Marcia. *Bad Girls West.* Exh. cat. Los Angeles: Wight Art Gallery, UCLA, 1994.

Trapp, Kenneth, ed. *The Arts and Crafts Movement in California: Living the Good Life.* Exh. cat. Oakland: Oakland Museum in association with Abbeville Press, New York, 1993.

Trapp, Kenneth, et al. *Nine Decades: The Northern California Craft Movement, 1907 to Present.* Exh. cat. San Francisco: San Francisco Craft and Folk Art Museum, 1993.

Trenton, Patricia, ed. *Independent Spirits: Women Painters of the American West, 1890–1945.* Exh. cat. Los Angeles: Autry Museum of Western Heritage in association with the University of California Press, Berkeley and Los Angeles, 1995.

Trenton, Patricia, and William H. Gerdts, eds. *California Light: 1900–1930.* Exh. cat. Laguna Beach: Laguna Art Museum in association with the Dixon Gallery and Gardens, Memphis, 1990.

Truettner, William H., ed. *The West as America: Reinterpreting Images of the Frontier, 1820–1920.* Washington, D.C.: Smithsonian Institution Press, 1991.

Tuchman, Maurice. *A Report on the Art and Technology Program of the Los Angeles County Museum of Art, 1967–1971.* Los Angeles: Los Angeles County Museum of Art, 1971.

———, ed. *Art in Los Angeles: Seventeen Artists in the Sixties.* Exh. cat. Los Angeles: Los Angeles County Museum of Art, 1981.

Weitze, Karen J. *California's Mission Revival.* Los Angeles: Hennessey and Ingalls, 1984.

Westphal, Ruth L., ed. *Plein Air Painters of California: The North.* Irvine: Westphal Publishing, 1986.

———, et al. *Plein Air Painters of California: The Southland*. Irvine: Westphal Publishing, 1990.

Westphal, Ruth L., and Janet Blake Dominik, eds. *American Scene Paintings, California 1930s and 1940s*. Irvine: Westphal Publishing, 1991.

Wilson, Michael Greg, and Dennis Reed. *Pictorialism in California: Photographs 1900–1940*. Exh. cat. Malibu: J. Paul Getty Museum; San Marino: Henry E. Huntington Library and Art Gallery, 1994.

Winter, Robert, ed. *Toward a Simpler Way of Life: The Arts and Crafts Architects of California*. Berkeley and Los Angeles: University of California Press, 1997.

Woodbridge, Sally, ed. *Bay Area Houses*. Salt Lake City: Peregrine Smith Books, 1988.

Yard, Sally, ed. *inSITE 94: A Binational Exhibition of Installation and Site-Specific Art*. Exh. cat. San Diego: Installation Gallery, 1995.

Young, Joseph E. *Three Graphic Artists*. Exh. cat. Los Angeles: Los Angeles County Museum of Art, 1971.

Young, Stanley. *The Big Picture: Murals of Los Angeles*. Boston: Little, Brown, 1988.

Abelmann, Nancy, and John Lie. *Blue Dreams: Korean Americans and the Los Angeles Riots*. Cambridge: Harvard University Press, 1995.

Acuña, Rodolfo. *Anything but Mexican: Chicanos in Contemporary Los Angeles*. London: Verso Books, 1996.

Allmendinger, Blake. *Ten Most Wanted: The New Western Literature*. New York: Routledge, 1998.

Almaguer, Tomás. *Racial Fault Lines: The Historical Origins of White Supremacy in California*. Berkeley and Los Angeles: University of California Press, 1994.

Austin, Mary Hunter. *The Land of Little Rain*. 1903. Reprint, New York: Penguin Books, 1997.

Bahr, Diana Meyers. *From Mission to Metropolis: Cupeno Indian Women in Los Angeles*. Norman: University of Oklahoma Press, 1993.

Barron, Stephanie, Sheri Bernstein, and Ilene Susan Fort. *Reading California: Art, Image, and Identity, 1900–2000*. Los Angeles: Los Angeles County Museum of Art in association with University of California Press, Berkeley and Los Angeles, 2000.

Beasley, Delilah Leontium. *The Negro Trail Blazers of California*. 1919. Reprint, New York: G. K. Hall, 1997.

Bezzerides, A. I. *Thieves' Market*. 1949. Reprint, Berkeley and Los Angeles: University of California Press, 1997.

Bottles, Scott. *Los Angeles and the Automobile: The Making of the Modern City*. Berkeley and Los Angeles: University of California Press, 1987.

Boyle, T. Coraghessan. *T. C. Boyle Stories: The Collected Stories of T. Coraghessan Boyle*. New York: Viking, 1998.

Brechin, Gray A. *Imperial San Francisco: Urban Power, Earthly Ruin*. Berkeley and Los Angeles: University of California Press, 1999.

Bright, Brenda Jo. "Remappings: Los Angeles Low Riders." In Brenda Jo Bright and Liza Bakewell, eds., *Looking High and Low: Art and Cultural Identity*. Tucson: University of Arizona Press, 1995.

Bronson, William. *How to Kill a Golden State*. Garden City, N.Y.: Doubleday, 1968.

Brook, James, Chris Carlsson, and Nancy J. Peters, eds. *Reclaiming San Francisco: History, Politics, Culture*. San Francisco: City Lights Books, 1998.

Broussard, Albert S. *Black San Francisco: The Struggle for Racial Equality in the West, 1900–1954*. Lawrence: University Press of Kansas, 1993.

Broyles-González, Yolanda. *El Teatro Campesino: Theater in the Chicano Movement*. Austin: University of Texas Press, 1994.

Bryant, Clora, et al., eds. *Central Avenue Sounds: Jazz in Los Angeles*. Berkeley and Los Angeles: University of California Press, 1998.

Bryman, Alan. *Disney and His Worlds*. London: Routledge, 1995.

Bukowski, Charles. *Post Office: A Novel*. 1971. Reprint, Santa Rosa: Black Sparrow Press, 1991.

Butler, Octavia. *Parable of the Sower*. New York: Four Walls Eight Windows, 1993.

Cain, James M. *The Postman Always Rings Twice*. 1934. Reprint, New York: Vintage Crime/Black Lizard, 1992.

———. *Double Indemnity*. 1943. Reprint, New York: Vintage Crime/Black Lizard, 1992.

California Pop-Up Book. Los Angeles: Los Angeles County Museum of Art in association with Universe Publishing, 2000.

Ceplair, Larry, and Steven Englund. *The Inquisition in Hollywood: Politics in the Film Community, 1930–1960*. 1980. Reprint, Berkeley and Los Angeles: University of California Press, 1983.

Chan, Sucheng. *Asian Californians*. San Francisco: MTL/Boyd and Fraser, 1991.

Chandler, Raymond. *The Big Sleep*. 1939. Reprint, New York: Vintage Books, 1992.

Chang, Edward T., and Russell C. Leong, eds. *Los Angeles: Struggles toward Multiethnic Community: Asian American, African American, and Latino Perspectives*. Seattle: University of Washington Press, 1994.

Chinn, Thomas W. *Bridging the Pacific: San Francisco Chinatown and Its People*. San Francisco: Chinese Historical Society of America, 1989.

Clark, Clifford E., Jr. "Ranch-House Suburbia: Ideals and Realities." In Lary May, ed., *Recasting America: Culture and Politics in the Age of the Cold War*. Chicago: University of Chicago Press, 1989.

Cleaver, Eldridge. *Soul on Ice*. 1967. Reprint, New York: Delta Trade Paperbacks, 1999.

Coleman, Wanda. *Heavy Daughter Blues: Poems and Stories, 1968–1986*. Santa Rosa: Black Sparrow Press, 1987.

Conrat, Maisie, comp. *Executive Order 9066: The Internment of 110,000 Japanese Americans*. Cambridge: MIT Press for the California Historical Society, 1972.

Cornford, Daniel, ed. *Working People of California*. Berkeley and Los Angeles: University of California Press, 1995.

Crawford, Dorothy Lamb. *Evenings on and off the Roof: Pioneering Concerts in Los Angeles, 1939–1971*. Berkeley and Los Angeles: University of California Press, 1995.

Cross, Brian. *It's Not about a Salary: Rap, Race, and Resistance in Los Angeles*. London: Verso, 1993.

Crouchett, Lorraine Jacobs. *Filipinos in California: From the Days of the Galleons to the Present*. El Cerrito: Downey Place Pub. House, 1982.

Dana, Richard Henry, Jr. *Two Years before the Mast*. 1840. Reprint, New York: Penguin Books, 1986.

Daniel, Cletus E. *Bitter Harvest: A History of California Farmworkers, 1870–1941*. Ithaca: Cornell University Press, 1981.

Daniels, Douglas Henry. *Pioneer Urbanites: A Social and Cultural History of Black San Francisco*. 1980. Reprint, Berkeley and Los Angeles: University of California Press, 1990.

Daniels, Roger. *The Politics of Prejudice: The Anti-Japanese Movement in California and the Struggle for Japanese Exclusion*. 2d ed. Berkeley and Los Angeles: University of California Press, 1977.

Dardis, Tom. *Some Time in the Sun: The Hollywood Years of Fitzgerald, Faulker, Nathanael West, Aldous Huxley, and James Agee*. New York: Charles Scribner's Sons, 1976.

Davis, Clark. "From Oasis to Metropolis: Southern California and the Changing Context of American Leisure." *Pacific Historical Review* (1992): 357–86.

———. *Company Men: White-Collar Life and Corporate Cultures in Los Angeles, 1892–1941*. Baltimore: Johns Hopkins University Press, 2000.

Davis, Margaret L. *Rivers in the Desert: William Mulholland and the Inventing of Los Angeles*. New York: HarperCollins, 1993.

Davis, Mike. *City of Quartz: Excavating the Future in Los Angeles*. 1990. New York: Vintage Books, 1992.

———. *Ecology of Fear: Los Angeles and the Imagination of Disaster*. New York: Metropolitan Books, 1998.

———. *Magical Urbanism: Latinos Reinvent the U.S. Big City*. New York: Verso, 2000.

Davis, Susan G. *Spectacular Nature: Corporate Culture and the Sea World Experience*. Berkeley and Los Angeles: University of California Press, 1997.

Dawson, Robert, and Gray Brechin. *Farewell, Promised Land: Waking from the California Dream*. Berkeley and Los Angeles: University of California Press, 1999.

Dear, Michael J., H. Eric Schockman, and Greg Hise, eds. *Rethinking Los Angeles*. Thousand Oaks: Sage Publications with the Southern California Studies Center of the University of Southern California, 1996.

DeLeon, Richard Edward. *Left Coast City: Progressive Politics in San Francisco, 1975–1991*. Lawrence: University Press of Kansas, 1992.

Deverell, William, and Tom Sitton, eds. *California Progressivism Revisited*. Berkeley and Los Angeles: University of California Press, 1994.

Didion, Joan. *Slouching towards Bethlehem*. 1968. Reprint, New York: Simon and Schuster, 1979.

———. *Play It as It Lays: A Novel*. 1970. Reprint, New York: Noonday Press, 1990.

DjeDje, Jacqueline Cogdell, and Eddie S. Meadows, eds. *California Soul: Music of African Americans in the West*. Berkeley and Los Angeles: University of California Press, 1998.

Dobrin, Michael, Philip E. Linhares, and Pat Ganahl. *Hot Rods and Customs: The Men and Machines of California's Car Culture*. Exh. cat. Oakland: Oakland Museum of California, 1996.

Doherty, Thomas Patrick. *Projections of War: Hollywood, American Culture, and World War II*. New York: Columbia University Press, 1993.

Dunne, John Gregory. *Delano: The Story of the California Grape Strike*. New York: Farrar, Straus and Giroux, 1967.

Edwards, William A., and Beatrice Harraden. *Two Health-Seekers in Southern California*. Philadelphia: Lippincott, 1896.

Ellis, Bret Easton. *Less than Zero*. 1985. Reprint, New York: Vintage Contemporaries, 1998.

Ellroy, James. *The Big Nowhere*. 1988. Reprint, New York: Warner Books, 1998.

Fante, John. *Ask the Dust*. 1939. Reprint, Santa Rosa: Black Sparrow Press, 1980.

Federal Writers' Project. *California: A Guide to the Golden State*. 1939. Reprint, New York: Hastings House, 1954.

Findlay, John M. *Magic Lands: Western Cityscapes and American Culture after 1940*. Berkeley and Los Angeles: University of California Press, 1992.

Fitzgerald, F. Scott. *The Love of the Last Tycoon: A Western*. Ed. Matthew J. Bruccoli. 1941 [*The Last Tycoon*]. Reprint, New York: Scribner's, 1995.

Flamm, Jerry. *Good Life in Hard Times: San Francisco's '20s and '30s*. San Francisco: Chronicle Books, 1999.

Fogelson, Robert M. *The Fragmented Metropolis: Los Angeles, 1850–1930*. 1967. Reprint, Berkeley and Los Angeles: University of California Press, 1993.

Forming: The Early Days of L.A. Punk. Exh. cat. Track 16 Gallery. Santa Monica: Smart Art Press, 1999.

Friedrich, Otto. *City of Nets: A Portrait of Hollywood in the 1940s*. 1986. Reprint, Berkeley and Los Angeles: University of California Press, 1997.

Gabler, Neal. *An Empire of Their Own: How the Jews Invented Hollywood*. New York: Crown Publishers, 1988.

George, Lynell. *No Crystal Stair: African-Americans in the City of Angels*. London: Verso, 1992.

Gibson, William. *Virtual Light*. New York: Bantam Spectra, 1994.

Ginsberg, Allen. *Howl and Other Poems*. 1956. Reprint, San Francisco: City Lights Books, 1996.

Gleason, Ralph J. *The Jefferson Airplane and the San Francisco Sound*. New York: Ballantine Books, 1969.

Godfrey, Brain J. *Neighborhoods in Transition: The Making of San Francisco's Ethnic and Nonconformist Communities*. Berkeley and Los Angeles: University of California Press, 1988.

Gómez-Quiñones, Juan. *Mexican Students Por La Raza: The Chicano Student Movement in Southern California, 1967–1977*. Santa Barbara: Editorial La Causa, 1978.

Gooding-Williams, Robert, ed. *Reading Rodney King: Reading Urban Uprising*. New York: Routledge, 1993.

Gordon, Robert. *Jazz West Coast: The Los Angeles Jazz Scene of the 1950s*. London: Quartet, 1986.

Gottlieb, Robert, and Irene Wolt. *Thinking Big: The Story of the Los Angeles Times, Its Publishers, and Their Influence on Southern California*. New York: Putnam, 1977.

Gregory, James Noble. *American Exodus: The Dust Bowl Migration and Okie Culture in California.* New York: Oxford University Press, 1989.

Gutierrez, David. *Walls and Mirrors: Mexican Americans, Mexican Immigrants, and the Politics of Ethnicity.* Berkeley and Los Angeles: University of California Press, 1995.

Haas, Lisbeth. *Conquests and Historical Identities in California, 1769–1936.* Berkeley and Los Angeles: University of California Press, 1995.

Hadley-Garcia, George. *Hispanic Hollywood: The Latins in Motion Pictures.* New York: Carol Publishing Group, 1990.

Hansen, Gladys, Emmet Condon, and David Fowler, eds. *Denial of Disaster: The Untold Story and Photographs of the San Francisco Earthquake and Fire of 1906.* San Francisco: Cameron and Co., 1989.

Hanson, Dirk. *The New Alchemists: Silicon Valley and the Microelectronics Revolution.* Boston: Little, Brown, 1982.

Hart, James D. *A Companion to California.* Berkeley and Los Angeles: University of California Press, 1987.

Haslam, Gerald W. *Workin' Man Blues: Country Music in California.* Berkeley and Los Angeles: University of California Press, 1999.

Hayden, Dolores. *The Power of Place: Urban Landscapes as Public History.* Cambridge: MIT Press, 1995.

Henstell, Bruce. *Sunshine and Wealth: Los Angeles in the Twenties and Thirties.* San Francisco: Chronicle Books, 1984.

Himes, Chester B. *If He Hollers Let Him Go.* 1945. Reprint, New York: Thunder's Mouth Press, 1995.

Hine, Robert V. *California's Utopian Colonies.* 1953. Reprint, Berkeley and Los Angeles: University of California Press, 1983.

Hise, Greg. *Magnetic Los Angeles: Planning the Twentieth-Century Metropolis.* Baltimore: Johns Hopkins University Press, 1997.

Horne, Gerald. *Fire This Time: The Watts Uprising and the 1960s.* Charlottesville: University Press of Virginia, 1995.

Hoskyns, Barney. *Waiting for the Sun: Strange Days, Weird Scenes, and the Sound of Los Angeles.* New York: St. Martin's Press, 1996.

Houston, Jeanne Wakatsuki, and James D. Houston. *Farewell to Manzanar.* 1973. Reprint, New York: Bantam Books, 1995.

Huxley, Aldous. *After Many a Summer Dies the Swan.* 1939 [*After Many a Summer*]. Reprint, Chicago: Ivan R. Dee, 1993

Hyde, Anne F. "From Stagecoach to Packard Twin Six: Yosemite and the Changing Face of Tourism, 1880–1930." *California History* 69, no. 2 (summer 1990): 154–69.

Isherwood, Christopher. *A Single Man.* 1964. Reprint, New York: North Point Press, 1996.

Issell, William, and Robert W. Cherny. *San Francisco, 1865–1932: Politics, Power, and Urban Development.* Berkeley and Los Angeles: University of California Press, 1986.

Jackson, Helen Hunt. *Ramona: A Story.* 1884. Reprint, New York: Penguin Books, 1988.

Jenkins, J. Craig. *The Politics of Insurgency: The Farm Worker Movement in the 1960s.* New York: Columbia University Press, 1985.

Jensen, Joan M., and Gloria Ricci Lothrop. *California Women: A History.* San Francisco: Boyd and Fraser Pub. Co., 1987.

Johnson, Marilynn S. *The Second Gold Rush: Oakland and the East Bay in World War II.* Berkeley and Los Angeles: University of California Press, 1994.

Jones, Holway R. *John Muir and the Sierra Club: The Battle for Yosemite.* San Francisco: Sierra Club, 1965.

Kampion, Drew. *Stoked: A History of Surf Culture.* Santa Monica: General Publishing Group, 1997.

Keil, Roger. *Los Angeles, Globalization, Urbanization, and Social Struggles.* New York: J. Wiley and Son, 1998.

Kelley, Ron. *Irangeles: Iranians in Los Angeles.* Berkeley and Los Angeles: University of California Press, 1993.

Kerouac, Jack. *On the Road.* 1957. Reprint, New York: Penguin Books, 1998.

———. *The Dharma Bums.* 1958. Reprint, New York: Penguin Books, 1990.

Kim, Elaine H., and Eui-Young Yu, eds. *East to America: Korean American Life Stories.* New York: New Press, 1996

Kingston, Maxine Hong. *The Woman Warrior: Memories of a Girlhood Among Ghosts.* 1976. Reprint, New York: Vintage Books, 1989.

Klein, Norman M. *The History of Forgetting: Los Angeles and the Erasure of Memory.* New York: Verso Books, 1997.

Klein, Norman M., and Martin J. Schiesl, eds. *Twentieth-Century Los Angeles: Power, Promotion, and Social Conflict.* Claremont: Regina Books, 1993.

Kling, Rob, Spencer Olin, and Mark Poster. *Postsuburban California: The Transformation of Orange County since World War II.* Berkeley and Los Angeles: University of California Press, 1991.

Knight, Brenda. *Women of the Beat Generation: The Writers, Artists, and Muses at the Heart of Revolution.* Berkeley: Conari Press, 1996.

Kroeber, Theodora. *Ishi in Two Worlds: A Biography of the Last Wild Indian in North America.* 1961. Reprint, Berkeley and Los Angeles: University of California Press, 1989.

Kurutz, K. D., and Gary Kurutz. *California Calls You: The Art of Promoting the Golden State, 1870–1940.* Sausalito: Windgate Press, 2000.

Lai, H. Mark, ed. and trans. *Island: Poetry and History of Chinese Immigrants on Angel Island, 1910–1940.* 1980. Reprint, Seattle: University of Washington Press, 1991.

Lambert, Gavin. *The Slide Area: Scenes of Hollywood Life.* 1959. Reprint, New York: Serpent's Tail, 1998.

Leach, Patricia, and Steve Hank. *This Side of Eden: Images of Steinbeck's California.* Exh. cat. Salinas: National Steinbeck Center, 1998.

Lemke-Santangelo, Gretchen. *Abiding Courage: African American Migrant Women and the East Bay Community.* Chapel Hill: University of North Carolina Press, 1996.

Lipsitz, George. "Cruising around the Historical Bloc: Postmodernism and Popular Music in East Los Angeles." In *Time Passages: Collective Memory and American Popular Culture.* Minneapolis: University of Minnesota Press, 1990.

Longstreth, Richard. *City Center to Regional Mall: Architecture, the Automobile, and Retailing in Los Angeles, 1920–1950.* Cambridge: MIT Press, 1997.

Lotchin, Roger W. *Fortress California, 1910–1961: From Warfare to Welfare.* New York: Oxford University Press, 1992.

———, ed. *The Way We Really Were: The Golden State in the Second Great War.* Urbana: University of Illinois Press, 2000.

Loza, Steven Joseph. *Barrio Rhythm: Mexican American Music in Los Angeles.* Urbana: University of Illinois Press, 1993.

Marin, Marguerite V. *Social Protest in an Urban Barrio: A Study of the Chicano Movement, 1966–1974.* Lanham, Md.: University Press of America, 1991.

Masumoto, David Mas. *Epitaph for a Peach: Four Seasons on My Family Farm.* San Francisco: Harper San Francisco, 1995.

Matsumoto, Valerie J. *Farming the Home Place: A Japanese American Community in California, 1919–1982*. Ithaca, N.Y.: Cornell University Press, 1993.

Matsumoto, Valerie J., and Blake Allmendinger, eds. *Over the Edge: The American West.* Berkeley and Los Angeles: University of California Press, 1999.

May, Lary. *Screening Out the Past: The Birth of Mass Culture and the Motion Picture Industry.* 1980. Reprint, Chicago: University of Chicago Press, 1983.

Maynard, John Arthur. *Venice West: The Beat Generation in Southern California.* New Brunswick, N.J.: Rutgers University Press, 1991.

Mazon, Mauricio. *The Zoot-Suit Riots: The Psychology of Symbolic Annihilation.* Austin: University of Texas Press, 1984.

McClung, William A. *Landscapes of Desire: Anglo Mythologies of Los Angeles.* Berkeley and Los Angeles: University of California Press, 2000.

McCulley, Johnston. *The Mark of Zorro.* 1924. Reprint, New York: Grosset and Dunlap, 1952.

McWilliams, Carey. *Factories in the Field: The Story of Migratory Farm Labor in California.* 1939. Reprint, Berkeley and Los Angeles: University of California Press, 2000.

———. *North from Mexico: The Spanish-Speaking People of the United States.* 1940. Reprint, New York: Greenwood Press, 1990.

———. *Southern California: An Island on the Land.* 1946 [*Southern California Country: An Island on the Land*]. Reprint, Salt Lake City: Gibbs Smith, 1994.

———. *California: The Great Exception.* 1949. Reprint, Berkeley and Los Angeles: University of California Press, 1998.

Merrill-Mirsky, Carol, ed. *Exiles in Paradise.* Exh. cat. Los Angeles: Hollywood Bowl Museum in association with Los Angeles Philharmonic Association, 1991.

Mesa-Bains, Amalia, and Tomás Ybarra-Frausto. *Lo del Corazón: Heartbeat of a Culture.* Exh. cat. San Francisco: Mexican Museum, 1986.

Miller, Henry. *Big Sur and the Oranges of Hieronymus Bosch.* 1957. Reprint, New York: New Directions, 1978.

Mitchell, Greg. *The Campaign of the Century: Upton Sinclair's Race for Governor of California and the Birth of Media Politics.* New York: Random House, 1992.

Monroy, Douglas. *Rebirth: Mexican Los Angeles from the Great Migration to the Great Depression.* Berkeley and Los Angeles: University of California Press, 1999.

Muir, John. *My First Summer in the Sierra.* 1911. Reprint, New York: Penguin Books, 1997.

Mullins, William H. *The Depression and the Urban West Coast, 1929–1933: Los Angeles, San Francisco, Seattle, and Portland.* Bloomington: Indiana University Press, 1991.

Muñoz, Carlos. *Youth, Identity, Power: The Chicano Generation.* New York: Verso, 1989.

Murase, Ichiro Mike. *Little Tokyo: One Hundred Years in Pictures.* Los Angeles: Visual Communications/Asian American Studies Central, 1983.

Naremore, James. *More than Night: Film Noir in Its Contexts.* Berkeley and Los Angeles: University of California Press, 1998.

Navasky, Victor S. *Naming Names.* New York: Viking Press, 1980.

Noriega, Chon. "Citizen Chicano: The Trials and Titillations of Ethnicity in the American Cinema, 1935–1962." *Social Research* 58, no. 2 (summer 1991): 413–38.

Norris, Frank. *The Octopus: A Story of California.* 1901. Reprint, New York: Penguin Books, 1994.

Null, Gary. *Black Hollywood: The Negro in Motion Pictures.* 1975. Reprint, New York: Carol Publishing Group, 1990.

Nunis, Doyce B., Jr., ed. *A Southern California Historical Anthology.* Los Angeles: Historical Society of Southern California, 1984.

Okubo, Mine. *Citizen 13660.* 1947. Reprint, Seattle: University of Washington Press, 1983.

Ovnick, Merry. *Los Angeles: The End of the Rainbow.* Los Angeles: Balcony Press, 1994.

Parson, Don. "'This Modern Marvel': Bunker Hill, Chavez Ravine, and the Politics of Modernism in Los Angeles." *Southern California Quarterly* 75, nos. 3/4 (fall/winter 1993).

Phillips, George Harwood. *The Enduring Struggle: Indians in California History.* San Francisco: Boyd and Fraser, 1981.

Phillips, Sandra S., et al. *Crossing the Frontier: Photographs of the Developing West, 1849 to Present.* Exh. cat. San Francisco: San Francisco Museum of Modern Art in association with Chronicle Books, 1996.

Pitt, Leonard, and Dale Pitt. *Los Angeles, A to Z: An Encyclopedia of the City and County.* Berkeley and Los Angeles: University of California Press, 1997.

Pynchon, Thomas. *The Crying of Lot 49.* 1966. Reprint, New York: Perennial Library, 1986.

Rawls, James. "California Mission as Symbol and Myth." *California History* 71, no. 3 (fall 1992): 342–60.

Rawls, James J., and Walton Bean. *California: An Interpretive History.* 6th ed. New York: McGraw-Hill, 1993.

Reed, Ishmael. *Yellow Back Radio Broke-Down.* 1969. Reprint, Normal, Ill.: Dalkey Archive Press, 2000.

Reisner, Marc. *Cadillac Desert: The American West and Its Disappearing Water.* 1986. Rev. and updated ed. New York: Penguin Books, 1993.

Rice, Richard B., William A. Bullough, and Richard J. Orsi. *The Elusive Eden: A New History of California.* 2d ed. New York: Knopf, 1988.

Rieff, David. *Los Angeles: Capital of the Third World.* New York: Simon and Schuster, 1991.

Rivers, William L. *A Region's Press: Anatomy of Newspapers in the San Francisco Bay Area.* Berkeley: Institute of Governmental Studies, University of California, 1971.

Rodriguez, Richard. *Hunger of Memory: The Education of Richard Rodriguez.* 1981. Reprint, New York: Penguin Books, 1992.

Rolle, Andrew F. *California: A History.* 5th ed., rev. and exp. Wheeling, Ill.: Harlan Davidson, 1998.

Romo, Ricardo. *East Los Angeles: History of a Barrio.* Austin: University of Texas Press, 1983.

Rorabaugh, W. J. *Berkeley at War: The 1960s.* New York: Oxford University Press, 1989.

Roszak, Theodore. *From Satori to Silicon Valley: San Francisco and the American Counterculture.* San Francisco: Don't Call It Frisco Press, 1986.

Ruíz, Vicki. *Cannery Women, Cannery Lives: Mexican Women, Unionization, and the California Food Processing Industry, 1930–1950.* Albuquerque: University of New Mexico Press, 1987.

Runte, Alfred. *Yosemite: The Embattled Wilderness.* Lincoln: University of Nebraska Press, 1990.

———. "Promoting the Golden West: Advertising and the Railroad," *California History* 70, no. 1 (spring 1991): 62–75.

Rydell, Robert. "The Expositions in San Francisco and San Diego: Toward the World of Tomorrow." In *All the World's a Fair: Visions of Empire at American International Expositions, 1876–1916.* Chicago: University of Chicago Press, 1984.

Sanchez, George J. *Becoming Mexican American: Ethnicity, Culture, and Identity in Chicano Los Angeles, 1900–1945.* New York: Oxford University Press, 1993.

Saxton, Alexander. *The Indispensable Enemy: Labor and the Anti-Chinese Movement in California.* 1971. Reprint, Berkeley and Los Angeles: University of California Press, 1995.

Schrag, Peter. *Paradise Lost: California's Experience, America's Future.* New York: New Press, 1998.

Schrepfer, Susan R. *The Fight to Save the Redwoods: A History of Environmental Reform, 1917–1978.* Madison: University of Wisconsin Press, 1983.

Schulberg, Budd. *What Makes Sammy Run?* 1941. Reprint, New York: Vintage Books, 1993.

Scott, Allen J., and Edward W. Soja, eds. *The City: Los Angeles and Urban Theory at the End of the Twentieth Century.* Berkeley and Los Angeles: University of California Press, 1997.

Scott, Mel. *The San Francisco Bay Area: A Metropolis in Perspective.* 2d ed. Berkeley and Los Angeles: University of California Press, 1985.

Seale, Bobby. *Seize the Time: The Story of the Black Panther Party and Huey P. Newton.* 1970. Reprint, Baltimore: Black Classic Press, 1991.

See, Carolyn. *Golden Days.* 1987. Reprint, Berkeley and Los Angeles: University of California Press, 1996.

Selvin, David F. *A Terrible Anger: The 1934 Waterfront and General Strikes in San Francisco.* Detroit: Wayne State University Press, 1996.

Seth, Vikram. *The Golden Gate: A Novel in Verse.* 1986. Reissue, New York: Vintage Books, 1991.

Sinclair, Upton. *Oil! A Novel.* 1927. Reprint, Berkeley and Los Angeles: University of California Press, 1997.

Soja, Edward. *Thirdspace: Journeys to Los Angeles and Other Real-and-Imagined Places.* Cambridge: Blackwell, 1996.

Solnit, Rebecca. *Savage Dreams: A Journey into the Landscape Wars of the American West.* Berkeley and Los Angeles: University of California Press, 1999.

Sonenshein, Raphael. *Politics in Black and White: Race and Power in Los Angeles.* Princeton: Princeton University Press, 1993.

Starr, Kevin. *Americans and the California Dream, 1850–1915.* 1973. Reprint, New York: Oxford University Press, 1986.

———. *Inventing the Dream: California through the Progressive Era.* New York: Oxford University Press, 1985.

———. *Material Dreams: Southern California through the 1920s.* New York: Oxford University Press, 1990.

———. *Endangered Dreams and the Great Depression in California.* New York: Oxford University Press, 1996.

———. *The Dream Endures: California Enters the 1940s.* New York: Oxford University Press, 1997.

Stecyk, C. R., with Bolton Colburn. *Kustom Kulture: Von Dutch, Ed "Big Daddy" Roth, Robert Williams, and Others.* Exh. cat. Laguna Beach: Laguna Art Museum in association with Last Gasp, San Francisco, 1993.

Steinbeck, John. *The Grapes of Wrath.* 1939. Reprint, New York: Penguin Books, 1999.

———. *Cannery Row.* 1945. Reprint, New York: Penguin Books, 1993.

Sterling, Christine. *Olvera Street: Its History and Restoration.* Los Angeles: Old Mission Print Shop, 1933.

Streatfield, David C. *California Gardens: Creating a New Eden.* New York: Abbeville Press, 1994.

Stryker, Susan, and Jim Van Buskirk. *Gay by the Bay: A History of Queer Culture in the San Francisco Bay Area.* San Francisco: Chronicle Books, 1996.

Takaki, Ronald T. *Strangers from a Different Shore: A History of Asian Americans.* Updated and rev. ed. Boston: Little, Brown, 1998.

Tan, Amy. *The Joy Luck Club.* New York: Putnam, 1989.

Taylor, John Russell. *Strangers in Paradise: The Hollywood Emigrés, 1933–1950.* New York: Holt, Rinehart, and Winston, 1983.

Thompson, Hunter S. *Hell's Angels: A Strange and Terrible Saga.* 1967. Reprint, New York: Ballantine Books, 1996.

Thompson, William Irwin. *At the Edge of History: Speculations on the Transformation of Culture.* New York: Harper and Row, 1971.

Tunstall, Jeremy. *Media Made in California: Hollywood, Politics, and the News.* New York: Oxford University Press, 1981.

Tygiel, Jules. *The Great Los Angeles Swindle: Oil, Stocks, and Scandal during the Roaring Twenties.* Berkeley and Los Angeles: University of California Press, 1994.

Valdez, Luis. *Zoot Suit and Other Plays.* Houston: Arte Publico Press, 1992.

Villa, Raul. *Barrio-Logos: Space and Place in Urban Chicano Literature and Culture.* Austin: University of Texas Press, 2000.

Vorspan, Max, and Lloyd P. Gartner. *History of the Jews of Los Angeles.* San Marino: Huntington Library, 1970.

Waldie, D. J. *Holy Land: A Suburban Memoir.* New York: W. W. Norton, 1996.

Warner, Charles Dudley. *Our Italy.* New York: Harper and Brothers, 1891.

Watts Writers' Workshop. *From the Ashes: Voices of Watts.* Ed. and intro. by Budd Schulberg. New York: New American Library, 1967.

Waugh, Evelyn. *The Loved One: An Anglo-American Tragedy.* 1948. Reprint, Boston: Little, Brown, 1999.

Weibel-Orlando, Joan. *Indian Country, L.A.: Maintaining Ethnic Community in Complex Society.* Rev. ed. Urbana: University of Illinois Press, 1999.

Weschler, Lawrence. *Mr. Wilson's Cabinet of Wonder: Pronged Ants, Horned Humans, Mice on Toast, and Other Marvels.* New York: Vintage Books, 1996.

West, Nathanael. *The Day of the Locust.* 1939. Reprint, New York: New American Library, 1983.

Wollenberg, Charles. *Golden Gate Metropolis: Perspectives on Bay Area History.* Berkeley: Institute of Governmental Studies, University of California, 1985.

Wong, K. Scott. "Cultural Defenders and Brokers: Chinese Responses to the Anti-Chinese Movement." In K. Scott Wong and Sucheng Chan, eds., *Claiming America: Constructing Chinese American Identities during the Exclusion Era.* Philadelphia: Temple University Press, 1998.

Wood, Samuel E., and Alfred E. Heller. *California Going, Going: Our State's Struggle to Remain Beautiful and Productive.* Sacramento: California Tomorrow, 1962.

Wyatt, David. *Five Fires: Race, Catastrophe, and the Shaping of California.* Reading, Mass.: Addison-Wesley Publishing Co., 1997.

Yung, Judy. *Unbound Feet: A Social History of Chinese Women in San Francisco.* Berkeley and Los Angeles: University of California Press, 1995.

Zimmerman, Tom. "Paradise Promoted: Boosterism and the Los Angeles Chamber of Commerce." *California History* 64, no. 1 (winter 1985): 22–33.

ILLUSTRATION CREDITS

Most photographs are reproduced courtesy of the creators and lenders of the material depicted. For certain artwork and documentary photographs we have been unable to trace copyright holders. We would appreciate notification of additional credits for acknowledgment in future editions.

30 © Estate of Richard Diebenkorn
37 © Edward Ruscha
38–39 © David Hockney
42 Courtesy of Frank O. Gehry & Associates
46 © Michael C. McMillen
48 Reproduced by permission of the Syndics of Cambridge University Library
49 Courtesy of the Bancroft Library, University of California, Berkeley
50 left: Santa Barbara Mission Archive Library
50 right: Courtesy of the Bancroft Library, University of California, Berkeley
52 Fine Arts Museums of San Francisco, gift of Mrs. Harold R. McKinnon and Mrs. Harry L. Brown, 1962.21
52 top: The Huntington Library, Art Collections and Botanical Gardens, San Marino, California
52 bottom: Fine Arts Museums of San Francisco, gift of Mrs. Harold R. McKinnon and Mrs. Harry L. Brown
53 The Huntington Library, Art Collections and Botanical Gardens, San Marino, California
55 left: California Historical Society, Los Angeles Area Chamber of Commerce Collection, Department of Special Collections, USC Library
56 top: California Historical Society, Los Angeles Area Chamber of Commerce Collection, Department of Special Collections, USC Library
56 bottom: © The Dorothea Lange Collection, The Oakland Museum of California
58 U.S. Department of Agriculture, National Archives
59 top: Southern California Library for Social Studies and Research
59 bottom: Photograph by John Malmin; Los Angeles Times Syndicate
60 Courtesy of Common Threads Artists Group
61 © L.A. Fine Arts Squad
66a Los Angeles County Museum of Natural History
67c Private collection; photograph courtesy of Maxwell Galleries, Ltd.
72a Photograph by Paul M. Hertzmann
75e Los Angeles County Museum of Natural History
80b Photograph by Philip Cohen
85d Photograph © Stefan Kirkeby Photography
88 background: Charles Sumner Greene and Henry Mather Greene; courtesy Avery Architectural and Fine Arts Library, Columbia University, New York
92b Photograph by Scott McClaine
95f Photograph © The J. Paul Getty Museum

100a Charles E. Young Research Library, UCLA
102 © 2000 Reproduction authorized by the Instituto Nacional de Bellas Artes y Literatura and the Banco de México, Fiduciary and Trust of the Estates of Diego Rivera and Frida Kahlo; photograph © John Lodge
104b © Estate of Millard Sheets
106d © 1997 Peter Stackpole Estate; photograph by Ben Blackwell
109d Photograph © Douglas M. Parker Studio. All rights reserved
109f © Julius Shulman
110 background: Architectural Drawing Collection, University Art Museum, University of California, Santa Barbara
115d © 2000 Center for Creative Photography, The University of Arizona Foundation
115e © The Dorothea Lange Collection, The Oakland Museum of California
116a © 1981 Center for Creative Photography, Arizona Board of Regents
116b © Estate of Millard Sheets
116d Courtesy of Fine Arts Museums of San Francisco; photograph by Joseph McDonald
118a © 2000 Reproduction authorized by the Instituto Nacional de Bellas Artes y Literatura and the Banco de México, Fiduciary and Trust of the Estates of Diego Rivera and Frida Kahlo; courtesy of UC Berkeley Art Museum; photograph by Ben Blackwell
119d © The Dorothea Lange Collection, The Oakland Museum of California
120a © Estate of Millard Sheets
121c © Estate of Horace Bristol/Corbis. All rights reserved
121d Photograph by Tsantes Photography
123e © 1974 Imogen Cunningham Trust
124a © 1981 Center for Creative Photography, Arizona Board of Regents
124c University of Southern California, University Libraries, Regional History Center, Department of Special Collections
126a Photograph by Philip Cohen
126b Photograph by Lee Stalsworth
128c © Chiura Obata; photograph by Ben Blackwell
129d © 2000 by the Trustees of the Ansel Adams Publishing Rights Trust. All rights reserved
130a–c © Estate of George Hurrell
131d Courtesy of Universal Studios and the Academy of Motion Picture Arts and Sciences
132a, b Courtesy of Universal Studios and the Academy of Motion Picture Arts and Sciences
133c © Estate of Will Connell
133d Photograph © 1978 Sid Avery/Motion Picture and Television Archive
136a Photograph © 1999 Douglas M. Parker Studio. All rights reserved
137d Reproduction courtesy of the Miyako Hotel

138a © 2000 Reproduction authorized by the Instituto Nacional de Bellas Artes y Literatura and the Banco de México, Fiduciary and Trust of the Estates of Diego Rivera and Frida Kahlo; photograph by Ben Blackwell
138b © 2000 Reproduction authorized by the Instituto Nacional de Bellas Artes y Literatura and the Banco de México, Fiduciary and Trust of the Estates of Diego Rivera and Frida Kahlo
139c © Estate of David Alfaro Siqueiros/ SOMAAP, Mexico/VAGA, New York; photograph by Ben Blackwell
139e © Estate of David Alfaro Siqueiros/ SOMAAP, Mexico/VAGA, New York; courtesy of El Pueblo de Los Angeles Historical Monument
142b Photograph by Joseph McDonald
143c Photograph © 1992 The Metropolitan Museum of Art
143d Photograph by Don Myer
143f © 1935 Quillen
144b © 2000 Reproduction authorized by the Instituto Nacional de Bellas Artes y Literatura and the Banco de México, Fiduciary and Trust of the Estates of Diego Rivera and Frida Kahlo
146a Reproduced with permission of Authentic Fitness Corp. for Cole of California. All rights reserved
148c Used with permission of Boeing Management Company
149d © The Dorothea Lange Collection, The Oakland Museum of California
150a © Lucia Eames dba Eames Office
150b T/Sgt. William Lauritzen; reproduced by permission of the Norton Simon Museum Archives, Pasadena
152c © 1998 Center for Creative Photography, The University of Arizona Foundation
152d Illustrated by Giacomo Patri
155a © The Dorothea Lange Collection, The Oakland Museum of California
155c © Chiura Obata
156a © 2000 by the Trustees of the Ansel Adams Publishing Rights Trust. All rights reserved
156b © 1999 by the Trustees of the Ansel Adams Publishing Rights Trust. All rights reserved
157e Photograph by Kaz Tsuruta
158a Photograph © 1978 Sid Avery/Motion Picture and Television Archive
158b, c Reproduced with permission of Authentic Fitness Corp. for Cole of California. All rights reserved
159f © 1998 Collection Center for Creative Photography, The University of Arizona Foundation
160a, b © Julius Shulman
161e © Lucia Eames dba Eames Office
162 background: Architectural Drawing Collection, University Art Museum, University of California, Santa Barbara
163b, e © Lucia Eames dba Eames Office
164a Photograph © Tom Jenkins
165d © 1998 Center for Creative Photography, The University of Arizona Foundation

345